T0189151

RADIOGRAPHIC PHOTOGRAPHY
and Imaging Processes

RADIOGRAPHIC PHOTOGRAPHY
and Imaging Processes

David Jenkins

MRC Pneumoconiosis Unit
Llandough Hospital, South Glamorgan, Wales

KLUWER ACADEMIC PUBLISHERS
DORDRECHT / BOSTON / LONDON

Distributors

for the United States and Canada: Kluwer Academic Publishers, PO Box 358,
Accord Station, Hingham, MA 02018–0358, USA
for all other countries: Kluwer Academic Publishers Group, Distribution
Center, PO Box 322, 3300 AH Dordrecht, The Netherlands

British Library Cataloguing in Publication Data

Jenkins, D J
 Radiographic photography and imaging processes.
 1. Radiography
 I. Title
 621.36′73 TR750

 ISBN 0–85200–208–4

Copyright

© 1980 David Jenkins

All rights reserved. No part of this publication may be reproduced, stored in
a retrieval system, or transmitted in any form or by any means, electronic,
mechanical, photocopying, recording or otherwise, without prior permission
from the publishers, Kluwer Academic Publishers BV, PO Box 17, 3300 AA
Dordrecht, The Netherlands.

Published in the United Kingdom by Kluwer Academic Publishers,
PO Box 55, Lancaster, UK.

Kluwer Academic Publishers BV incorporates the publishing programmes of
D. Reidel, Martinus Nijhoff, Dr W. Junk and MTP Press.

Printed in Great Britain by Redwood Burn Ltd, Trowbridge, Wiltshire

Contents

	Preface	vii
1	Fundamentals of radiographic imaging	1
2	Film behaviour to exposure	15
3	Film materials	36
4	Control of film stocks	48
5	Intensifying screens	59
6	Cassettes	77
7	Exposure factor manipulation and control	90
8	Automatic exposure control	110
9	The radiographic image (I)	127
10	The radiographic image (II)	149
11	Identification, presentation and viewing of radiographs	157
12	Film processing: the darkroom, silver recovery and pollution	166
13	Film processing: equipment and procedures	190
14	Image quality control	222
15	Automated film handling	236
16	Imaging techniques and processes	248
	Appendix 1 Testing exposure timer accuracy	283
	Appendix 2 The sensitometer	285
	Appendix 3 Relative speed	286
	Appendix 4 Estimation of kV	290
	Appendix 5 The transfer function	292
	Appendix 6 System faults in film processing	295
	Index	298

Preface

The imaging aspects of radiography have undergone considerable change in the last few years and as a teacher of radiography for many years I have often noticed the lack of a comprehensive reference book for students. This book is an attempt to correct that situation and I hope this text will be of value not only to student radiographers but also practising radiographers as well.

Much of the information is based on personal experiment and the knowledge gained of students' difficulties in studying this subject. I have attempted to gather together in one book all the information required to understand the fundamentals of the subject both for examination and for practice. Some topics are treated in considerable depth and I feel this is justified for those radiographers studying for higher qualifications or for those who have management responsibilities in a department, however small. Teachers of the subject as well as students should find the book a useful source of reference and I would welcome comments and criticisms for any future edition.

The contents of the book are basic to radiography but do not attempt to cover nuclear medicine, ultrasonics or computed tomography as I feel these are too specialized, each requiring a book of their own for the information to be of practical use.

In preparing the book, information was sought from many sources and was in general freely given when requested and this is gratefully acknowledged. In particular I would like to express my sincere thanks for help and information to Mr J. Day of DuPont (UK) Ltd. particularly for the information and illustrations in the chapter on automated film handling; Mr D. Harper and Mr R. Black of Kodak Ltd.; Fujimex Ltd.; CEA of Sweden; 3M (UK) Ltd.; Wardray Products Ltd.; D.A. Pitman Ltd.; Agfa-Gevaert; PSR Ltd. for their help with information on silver recovery, and Radiatron Ltd. for their help with safelighting. All were most helpful in my many requests for information.

To Mrs A. Dalton and Mrs P. Griffiths a special thankyou is due for the painstaking way in which they typed the manuscript, and to Mr Harrison of the Royal Lancaster Infirmary and Mr R. Harris of the MRC Pneumoconiosis Unit for the photographs. I also wish to express my thanks to all my colleagues, in particular Mr B. Gale, for their advice, criticisms and many discussions and arguments which have culminated in the publication of this book. To the publishers I express my appreciation for their patience and help in the preparation of the manuscript.

Finally to my wife and children I say thankyou for putting up with the long hours of silence while the book was being written.

David Jenkins

1
Fundamentals of Radiographic Imaging

INTRODUCTION

The discovery of X-rays by Professor W. Roentgen towards the end of the last century has resulted in the development of one of the most important medical diagnostic tools. At the time of discovery it was quickly realized that X-rays could be used to produce an image of the internal structures of the human body either on a photographic plate or a screen which emits light when bombarded with X-rays. This new method of imaging was an immense step forward for medical science and its introduction generally as a diagnostic aid was very rapid indeed throughout the world. It was unfortunate in those early days that the pioneers did not appreciate the health hazard involved in, what was then, the uncontrolled use of this new type of radiation, and many suffered dreadfully as a result.

The present day situation is very different indeed. Whole industries have developed to meet the needs of this type of imaging; medical physics departments in hospitals and universities together with those performing X-ray imaging are actively engaged in research in this field; extensive training programmes have been developed (and are still developing) for personnel entering this field; many millions of pounds have been invested by the Health Service in X-ray equipment, safety measures, training and research with the result that radiography has become an extremely complex science. In comparison with the early days the quality of the images now produced is vastly superior, the amount of X-radiation required to produce them is very much less and the possibility of biological damage occurring similar to that found in many of the pioneers is negligible when the correct and appropriate procedures are adopted. Present day radiodiagnostic departments responsible for X-ray imaging can be very large with a considerable range of very expensive equipment, many staff and a large continuing expenditure on consumable imaging material and other items. Such staff at any level within such a department must possess considerable technical skill if they are to fulfil the responsibility placed on them and justify the expenditure on this service.

The end result of a radiographer's effort is an image which must be used for diagnosis, and a thorough understanding of all factors involved in image production, structure and suitability is of fundamental importance. It is intended that what follows, in this chapter, should be a general introduc-

tion to imaging with X-rays with discussion in depth left to later chapters.

THE IMAGING PROCESS

Simply, the principle of imaging with X-rays is to pass a beam of X-radiation through an area of the human body producing absorption of some parts of the beam while allowing the remainder to pass through. The transmitted beam so obtained is allowed to fall on an image receptor, such as a film, where the information it contains is recorded (Figure 1.1). The film must then be chemically processed (p. 192) before it can be finally viewed.

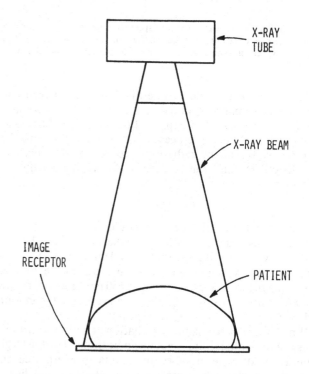

Figure 1.1 Schematic diagram of the imaging process. A film is the simplest image receptor. In more complex examples an intensifying screen may be used or a secondary radiation grid used in addition to the film

ELECTROMAGNETIC RADIATION

The X-rays used in medical imaging are classed as electromagnetic radiation. The term electromagnetic radiation is used to describe a particular form of energy having wave-like characteristics. If the wavelength of this form of energy is changed then so are its properties. Radio waves, visible light, ultraviolet and infrared radiation, X-rays and γ-rays are all forms of this type of energy that are identical in structure but of different wavelengths. In addition they all travel with the same velocity in free space, $3 \times 10^{-8}\,\mathrm{m\,s^{-1}}$, denoted by c. Part of the spectrum of electromagnetic radiation is shown in Figure 1.2 with the sections important in diagnosis placed according to their respective wavelengths.

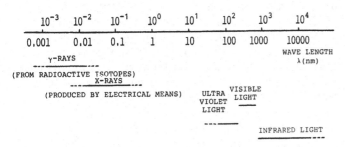

Figure 1.2 Part of the electromagnetic spectrum showing the relationship of electromagnetic waves to their wavelength. The dotted lines indicate that no precise wavelength can be given which divides one type of radiation from another

In general there is no precise dividing line between one type of electromagnetic radiation and an adjacent one, and overlap occurs. This has happened because of the historical way in which some have been named, generally due to the method by which the radiations are produced. Since the wavelength (λ) and the frequency (ν) are related by the equation

$$\nu = c / \lambda$$

the various types of radiation could just as simply be arranged according to their frequencies. All electromagnetic waves having the same wavelength, and hence the same frequency, have similar properties. For example, electromagnetic waves with $\lambda = 650\,\mathrm{nm}$ and therefore $\nu = 4.6 \times 10^{14}\,\mathrm{Hz}$ would stimulate the eye to see the colour red.

What does electromagnetic radiation actually consist of? This is a difficult question, but it can be thought of as a large number of discrete 'bundles' or quanta of energy, called photons, each of which travels with velocity c and has a wavelength and frequency associated with it. The energy of each photon (E) is proportional to its frequency and hence inversely proportional to its wavelength:

$$E \propto \nu \; ; E \propto c / \lambda$$

X-rays are chosen for imaging in radiography because of their ability to pass through solid matter and because their wavelength is small enough to 'see' details in the object being radiographed.

PRODUCTION OF THE X-RAY BEAM

X-rays are produced when high-energy electrons bombard a metal target. Figure 1.3 shows a typical X-ray tube insert,

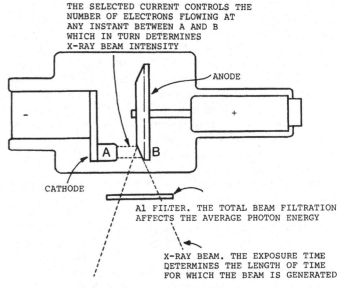

Figure 1.3 Diagram of a typical X-ray tube

where a high voltage applied between cathode (A) and anode (B) in an evacuated glass envelope causes a flow of electrons with high kinetic energy, and hence a current, from A to B. X-ray photons are emitted from B when the electrons strike it. The applied voltage determines the X-ray photon energy, while both tube current and applied voltage influence X-ray beam intensity (defined as the number of photons crossing a given cross-sectional area of the beam in a given length of time). The usual diagnostic range of applied voltage is about 25–150 kV. This produces a heterogeneous X-ray beam containing X-ray photons of all different energies from the highest, with

$$\lambda\,\mathrm{min} = \frac{1.24}{(\text{applied voltage in kV})} \quad \text{nanometres}$$

to the lowest, the latter having insufficient energy to be useful in the imaging process but causing damage in biological tissues. A typical X-ray unit control panel is shown in Figure 1.4.

Figure 1.4 Typical X-ray unit control panel

When X-ray photons pass through matter, they may either be transmitted, absorbed or scattered. Which of these occurs depends both on the nature of the material and the energy of the photon. Absorption and scattering tend to reduce the intensity (attenuation) of the transmitted beam, and for a heterogeneous object in the beam, such as a human body, in which different organs, bone, tissue etc. absorb X-rays by varying amounts, the transmitted beam will contain a pattern, across its width, of varying intensities. For this pattern to be characteristic of the part of the body through which the beam passes, the incident or primary beam must be devoid of any such pattern. In other words there must be a relatively uniform intensity across the primary beam otherwise any irregular pattern at this stage would be superimposed on the pattern characteristic of the body part and the resulting image would be difficult to interpret. Because of the way in which the X-ray beam is produced there is a small and gradual variation in intensity across the primary beam, but for practical purposes this can be considered insignificant as a source of interference with the transmitted radiation intensity pattern (Figure 1.5).

As well as absorption, scattering occurs, in which the X-ray photon is deflected from its original direction and can lose some or all of its energy. The lost energy is transferred to the tissue in which the interaction takes place, causing possible cell damage. Scattered X-ray photons are not wanted in the imaging process and every effort is normally made to stop them reaching the image receptor especially when a high percentage of the transmitted X-ray beam may consist of scattered X-ray photons. An X-ray photon may be scattered more than once, transferring energy each time, until all its energy is dissipated, at which point it ceases to exist. This transfer of energy constitutes absorption and the disappearance of a photon in this way represents a reduction in X-ray beam intensity, in other words attenuation. Other photons of sufficient energy pass through the body without

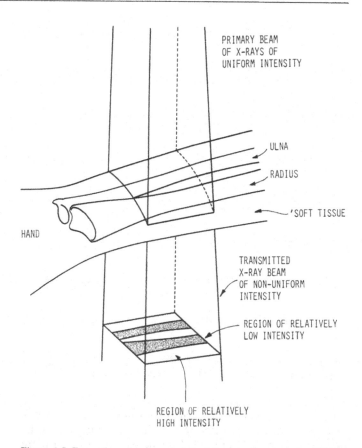

Figure 1.5 Formation of a characteristic pattern in the transmitted X-ray beam

any interaction occurring. These are called *primary* X-ray photons to distinguish them from X-ray photons which have been scattered. Primary X-ray photons are essential in the imaging process.

The degree of attenuation of the X-ray beam is different for different tissues of the body (p. 150). The extent of the difference depends on the voltage chosen to generate the X-ray beam. If the voltage is too low, that is if the photon energy is too low, then attenuation may be total, irrespective of the tissue type, and no image is formed. This is a potentially dangerous situation since all the X-ray beam energy is transferred to the body. If the voltage, and therefore the photon energy, is too high there may be little difference in the attenuation of the beam by different tissues with very little difference in the transmitted radiation intensities. This lack of 'contrast' will render the image useless, as the information it contains cannot be visually retrieved (p. 149).

It is thus necessary to select the correct beam energy and intensity for the particular application. The maximum photon energy is controlled by varying the applied voltage, and the lower energy photons are filtered out by introducing

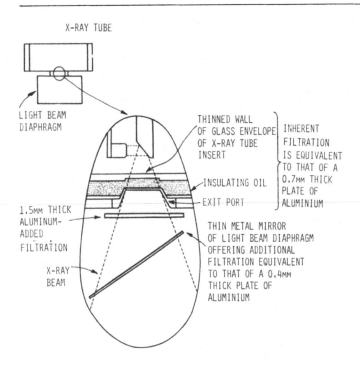

X-RAY TUBE

LIGHT BEAM
DIAPHRAGM

THINNED WALL
OF GLASS ENVELOPE
OF X-RAY TUBE
INSERT

INHERENT
FILTRATION
IS EQUIVALENT
TO THAT OF A
0.7mm THICK
PLATE OF
ALUMINIUM

INSULATING OIL

EXIT PORT

1.5mm THICK
ALUMINUM-
ADDED
FILTRATION

THIN METAL MIRROR
OF LIGHT BEAM DIAPHRAGM
OFFERING ADDITIONAL
FILTRATION EQUIVALENT
TO THAT OF A 0.4mm
THICK PLATE OF
ALUMINIUM

X-RAY
BEAM

Figure 1.6 Inherent and added filtration in the X-ray beam

into the beam various obstructions which attenuate lower energy X-rays while offering very little attenuation to the high energy photons required for image formation (Figure 1.6). It will be seen that the construction of the X-ray tube exit port necessarily introduces some filtration into the beam (known as inherent filtration) but additional beam filtration is necessary to comply with safety regulations. This is to prevent excessive absorption of X-radiation by body tissues.

Beam filtration is expressed in terms of aluminium (Al) equivalent. For example, in Figure 1.6 the total beam filtration is 2.6 mm Al equivalent. This means there may be several filters in the beam, not all necessarily aluminium, but combined they will have the same beam filtration effect at a particular kV as a 2.6 mm thickness of aluminium.

To achieve a desired image result in practice, the most appropriate kilovoltage value can be selected but unfortunately the most appropriate beam filtration cannot normally be selected. Regulations relating to radiation protection dictate that the minimum beam filtration should be fixed according to the maximum kV the equipment is capable of providing. The total beam filtration is set at the time the equipment is installed and cannot be reduced by the radiographer. Mostly the equipment is operated at kV values well below the maximum so for the majority of the time excessive beam filtration is used and this does affect image quality.

Having selected kV, the beam intensity is then controlled by the current allowed to flow across the X-ray tube, which corresponds to the current value selected at the control panel (p. 93). The selected exposure time (p. 97) then controls the length of time for which the X-ray beam is allowed to act. The current and exposure time may be selected manually or controlled by an automatic exposure device (p. 110). With some equipment the voltage is also automatically controlled for certain applications.

THE IMAGE RECEPTOR

The film (Chapter 3) is the simplest image receptor, but in many cases an intensifying screen pair (Chapter 5) is used with the film. In addition, a secondary radiation grid (p. 104) is often employed but these will be considered later. The most common image receptor used in radiography is the X-ray film and this must be considered in a little more detail.

To enable it to respond to electromagnetic radiation of the wavelengths used in radiography and produce a visible image after processing, the X-ray film uses an emulsion containing photosensitive chemicals (p. 9). These are chemicals which undergo change when exposed to certain wavelengths of electromagnetic radiation. The change may be visible if the exposure is very large but practical radiographic exposures produce no visible change. A latent (hidden) change takes place (p. 190).

The basic photosensitive chemical used is silver bromide which is one of the silver halides and has a useful natural sensitivity to electromagnetic radiation of all wavelengths less than about 510 nm. The degree of sensitivity depends on the wavelength of the electromagnetic radiation, being greatest at about 440–450 nm (Figure 1.7). An exposure to

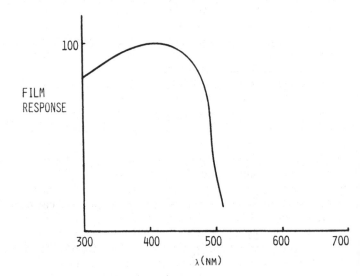

100

FILM
RESPONSE

300 400 500 600 700

λ(NM)

Figure 1.7 Spectral sensitivity of a silver bromide emulsion

light or X-rays produces in the emulsion a small quantity of black metallic silver from silver bromide. It is this which is referred to as the latent image. Exposure of the film to electromagnetic radiation in the blue/ultraviolet region of the spectrum normally produces the strongest latent image. An X-ray exposure of equivalent intensity would result in a weaker image being formed. The exposure to electromagnetic radiation normally received by the film is insufficient to produce any visible image. The further process of chemical development is necessary to achieve this. If development was not employed, an enormous exposure would be required to show any visible image on the film. Following development, further processing stages are needed to render the visible image permanent.

The principle of image formation as a result of the transmitted radiation beam acting on the film is shown in Figure 1.8. In practice the relatively large distance shown here between patient and film would be made as small as possible to limit blurring in the image. The histogram represents the various degrees of film blackening corresponding to the various radiation intensities. The histogram pattern is dependent on many factors including the exposure factors, patient part structure, type of film and intensifying screens, and the processing conditions for the film.

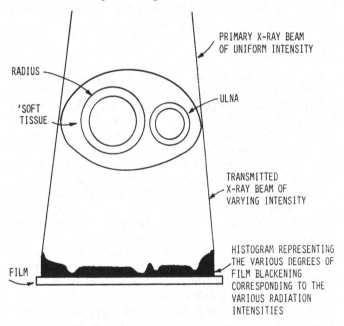

Figure 1.8 Obtaining an image from the X-ray beam as a pattern of degrees of blackening of a film

The structure of the body part can be recognized by its image and, it is hoped, so can any abnormality. There are alternative methods of imaging, some quite different from that described, others offering only a slight variation on the above. Some of these will be described later.

EQUIPMENT CALIBRATION

To function correctly the equipment should operate in a manner related to the selected exposure parameters of voltage, current and exposure time. The operator should be confident that if 70 kVp 400 mA and 0.03 s is selected as an exposure, for example, then that is what will be obtained. X-ray equipment requires calibration to achieve this with periodic checks to ensure consistency. Often it is found in practice that calibration is inadequate and, for example, a change from 70 kVp to 80 kVp at the control panel may in reality be considerably more or less. This makes exposure factor manipulation impossible, the only solution being recalibration. If the X-ray equipment is incorrectly calibrated and this is often the case, then the potential applied across the tube may not correspond exactly with the value preselected on the control panel. This is one reason why two similar X-ray systems do not produce the same result when used under identical conditions. This rarely matters in practice since it is the continuing performance of a given X-ray system which is usually of prime importance to the radiographer, together with how selected exposure values relate to one another when changing from one set of factors to another.

INTENSIFYING SCREENS

With the widespread use of potentially harmful X-rays the importance of radiation protection, as well as the need to improve image quality in certain types of examination, has led in the past to the development of intensifying screens and image intensifier tubes. Automatic exposure devices are also being more widely used to ensure that the correct radiation dose for the imaging process is not exceeded. An intensifying screen consists of a suitable base coated with a phosphor material which emits light when irradiated with X-rays. Phosphor materials most often used are calcium tungstate, a 'rare-earth' oxysulphide or oxybromide, barium fluorochloride, barium strontium sulphate or barium lead sulphate.

On exposure, energy from the X-ray photons is transferred to the phosphor grains forming the screen fluorescent layer. This energy is then emitted in all directions by the phosphor grains as electromagnetic radiation with

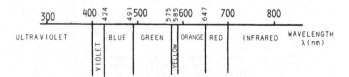

Figure 1.9 The visible light spectrum. The divisions shown are not seen as regions of abrupt change from one colour to another, but are designed to show as near as possible where one colour ends and another begins

wavelengths far greater than those of the X-ray photons. The range of wavelengths in the emitted radiation depends on the type of phosphor but normally lies with the range extending from ultraviolet, $\lambda = 300$ nm, to red, $\lambda = 700$ nm (Figure 1.9). The amount of light emitted by the screen is proportional to the X-radiation intensity. Light has a greater photographic effect on the film than X-rays so a smaller exposure is required when an intensifying screen is used. These emitted light photons, being of longer wavelength than the X-ray photons, each have less energy than an X-ray photon. The principle of energy conservation implies that the energy transferred from a single X-ray photon must be shared between many light photons. Thus a single X-ray photon must cause the emission of many light photons (Figure 1.10).

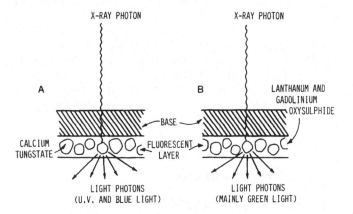

Figure 1.10 Diagrammatic sections through two single intensifying screens. In A the phosphor material is calcium tungstate and in B it is a mixture of gadolinium and lanthanum oxysulphides activated with terbium. To form an image the film would be placed in contact with the front of the intensifying screen

These factors result in the intensification of the effect of X-rays on the photographic film hence the name intensifying screen. The screens are mostly used in pairs with a film sandwiched between them, to achieve an even greater reduction in exposure. Figure 1.11 shows a section of an X-ray

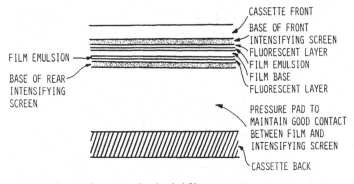

Figure 1.11 Section through a loaded X-ray cassette

cassette, housing intensifying screens and a film, to show the arrangement. The pressure pad shown is necessary for good contact so as to avoid image blur.

FILM SENSITIVITY

Chemical Sensitizers

The natural sensitivity of a silver bromide emulsion can be increased so that for a given exposure to light or X-rays a stronger latent image is formed. This is achieved using chemical sensitizers. A non-screen (direct exposure) film is an X-ray film specially designed for use without intensifying screens and gold compounds, for example, have been used as chemical sensitizers to increase the sensitivity of such films to X-rays.

Chemical sensitizers are used to produce a range of film materials each having a different speed (sensitivity) for a particular wavelength of electromagnetic radiation. Which speed of film is used in practice will depend on the imposed exposure and processing conditions and the image quality which can be considered as acceptable. Generally, the higher the speed of the film the smaller the exposure required to produce the image. Unfortunately, the higher the film speed the poorer the image quality since the image acquires a progressively grainier appearance.

Emulsion Types

Silver bromide emulsions of the type just described are sensitive mainly to one colour of light, usually blue, and are loosely termed monochromatic emulsions. While the film sensitivity within a particular range of wavelengths can be increased, it is also possible to extend the range of wavelengths of electromagnetic radiation to which the film emulsion is sensitive. Extending spectral sensitivity in this way is achieved using optical dye sensitizers in the emulsion.

Orthochromatic and panchromatic films are examples of films which have extended ranges. An orthochromatic emulsion is sensitive to all wavelengths less than about 620 nm, while a panchromatic emulsion is sensitive to the whole of the visible spectrum including all the shorter wavelengths. The image produced on each of these different types of film is 'black and white' and so none of them can be described as being a 'colour' film.

Most screen-type and all non-screen-type films used in radiography may be loosely described as monochromatic. Non-screen films are exposed only to X-rays, whereas screen-type films used with single or paired intensifying screens are exposed mainly to the emission from the phosphor of the intensifying screen when the phosphor absorbs energy from the incident X-ray photons. Film response is greatest to radiation around a wavelength of 400–450 nm and a phosphor is chosen which emits its

greatest light intensity at or around this wavelength. Maximum film sensitivity and maximum intensity of screen emission are thus closely matched with respect to radiation wavelength.

It may be found that certain phosphors are more efficient in their detection and conversion of X-ray energy to light energy and the film sensitivity may then be matched to the phosphor emission spectrum rather than the other way around. A particular example is that of the 3M Trimax system. This system employs a phosphor material for its intensifying screens which has its highest intensity of emission around 540–560 nm and the film matched to this has an orthochromatic emulsion. The Kodak Lanex system employs a similar matching. Figure 1.12 illustrates the matching of an intensifying screen phosphor emission spectrum to the spectral sensitivity of the monochromatic film, when using calcium tungstate intensifying screens.

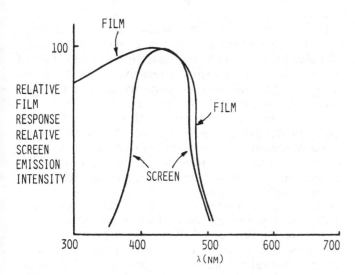

Figure 1.12 Emission and response curves for monochromatic film and calcium tungstate intensifying screen

Instead of employing intensifying screens, the image may be recorded on film via a lens system, the image being taken from the output phosphor of an image intensifier (Figures 1.13 and 1.14).

The image is normally formed at the input phosphor as a light image. This is transferred to the output phosphor as an electron image and reconverted by the output phosphor to a light image suitable for transfer onto film (photofluorography). At the output phosphor the image is much smaller and much brighter than at the input side. The output phosphor typically emits electromagnetic radiation of wavelengths about 440–640 nm (predominantly green), the highest emission intensity occurring around 530–560 nm. The film in the camera receives its image from the image intensifier output phosphor via the mirror in the optical

Figure 1.13 Typical image intensifying unit, shown diagrammatically in Figure 1.14

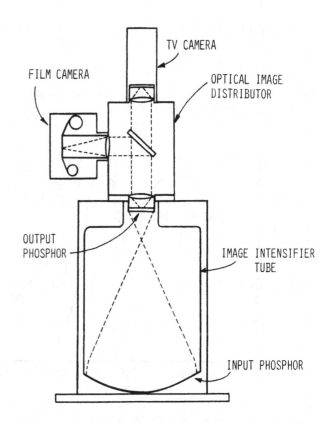

Figure 1.14 Diagram of typical image intensifying unit

image distributor, and the greatest film response is achieved with the least radiation dose to the patient, if a film emulsion is used which has its maximum sensitivity around 530–560 nm and has a reasonable, if not equal, response to the remainder of the emitted spectrum. Both orthochromatic and panchromatic emulsions are suitable for this purpose. Figure 1.15 shows the matching of orthochromatic film spectral sensitivity to the emission spectrum of the output phosphor. The optical image distributor also enables the image to be viewed via a TV camera.

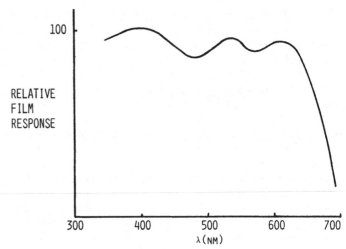

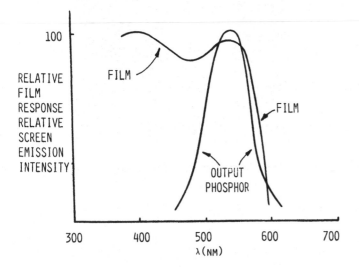

Figure 1.15 Emission and response curves for image intensifier tube output phosphor and orthochromatic film

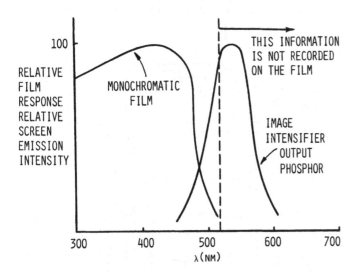

Figure 1.16 Emission and response curves for image intensifier output phosphor and monochromatic film

Figure 1.17 Response curve for a panchromatic film

If a monochromatic film were used to record the image from the output phosphor of this image intensifier, no useful film blackening would be produced by the emitted light of wavelengths beyond the spectral sensitivity range of the film (Figure 1.16). The spectral sensitivity curve for a panchromatic emulsion is shown in Figure 1.17. The sensitivity of the panchromatic film extends throughout the visible spectrum and provides a more equal film response to the whole of the emitted light spectrum from the image intensifier tube. This means that the panchromatic film has a greater sensitivity than orthochromatic film to the light of longer wavelengths emitted by the output phosphor, and these longer wavelengths will produce greater film blackening on the panchromatic film following processing.

70 mm, 100 mm, and 105 mm fluorographic films are orthochromatic while most cine films for cinefluorography are panchromatic. Cinefluorography is performed using 16 mm or 35 mm cinefilm (roll film) at film speeds up to 250 frames per second (f.p.s.). 70 mm, 100 mm and 105 mm films are used for single exposure techniques and for rapid sequence exposures, usually up to 6 f.p.s.

When selecting an imaging system in conjunction with a film material careful consideration should always be given to the emission spectrum of the intensifying screens or to the output side of the image intensifier tube. Choice should also be guided by the cost, the convenience, the image quality of the required result, and of course the radiation dose necessary to produce an acceptable image.

FILM STRUCTURE

Figures 1.18 and 1.19 show an enlarged view of a corner of a double- and single-sided film respectively, indicating the layers of which they are composed.

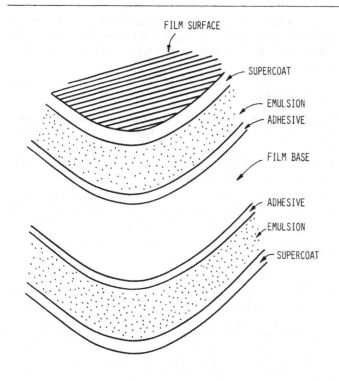

Figure 1.18 Section through double-sided (duplitized) X-ray film

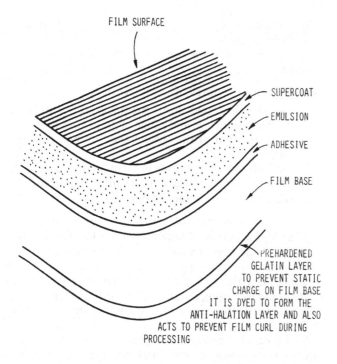

Figure 1.19 Section through single-sided X-ray film

The Supercoat

This is a protective layer, often called the anti-abrasive layer. It is a thin layer of hardened, pure gelatin, with a relatively hard and shiny surface which allows for durability and ease of movement through automatic film changers and automatic film processors. It is also less likely to pick up dirt and dust, or to be scratched. On the other hand, it should not be too hardened otherwise chemical penetration will be retarded during processing. It is treated to achieve anti-static behaviour.

The Emulsion

The emulsion is the radiation-sensitive layer of the film, consisting of silver halide grains suspended in pure gelatin which contains certain additives to give the emulsion its required properties. It is delicate and easily damaged by chemical, mechanical or thermal means. It is sandwiched between the supercoat and the adhesive layer and is thus afforded some protection, but it must be prehardened to protect it against the effects of pressure which occur in automatic processing and film handling in general. Mishandling the film can produce film faults manifested in many different ways, all detrimental to image quality.

If the silver bromide content of the emulsion is increased, a greater film response will be obtained. This does not mean that any individual silver bromide grain is more sensitive, but that the total effect is greater because there are more grains. This is one reason why films used in radiography are usually double-sided (duplitized), i.e. they have emulsion coated on both sides of the film base.

It can be seen from Figure 1.20 that increasing the thickness of the emulsion layer is much more effective in enhancing the latent image in the case of exposure to X-rays,

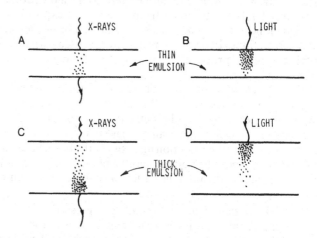

Figure 1.20 Effect of emulsion thickness on film response in the case of X-rays (A and C) and light (B and D)

than in the case of exposure to light. Screen-type films, for exposure mainly to the light from intensifying screens, have thin emulsion layers, since all the light is absorbed near the surface of the emulsion, and thus increasing the thickness of the emulsion indefinitely would not result in uniformly increasing density. In fact, the density would increase slightly at first but then no further increase would be noticed, because the light could not reach the deeper layers of the emulsion. It should be noted that when discussing increasing the thickness of the emulsion, it is assumed that the amount of silver halide, the 'coating weight', also increases in proportion. The thinness of screen-film emulsions enables them to be processed rapidly in an automatic processor. In contrast, to achieve a useful response from a non-screen film which is subjected to the effect of X-rays alone, a much thicker emulsion is required, since there is more opportunity for scattering and hence absorption of the higher energy photons. Where the film is to be processed in an automatic processor, increasing the emulsion thickness means that a longer processing time is necessary, and to avoid this, increased sensitivity is achieved using sensitizers instead of increasing the coating weight. Rapid processing is thus possible. The sensitizers used are usually very costly and the films can be more expensive than conventional non-screen films for manual processing. The tendency is to use a high resolution screen–film combination thus eliminating the necessity for non-screen film except in dental work. The use of such a combination allows a large reduction to be made in the exposure required, with little, if any, noticeable loss in image quality.

Film Blackening

For a given exposure, the degree of blackening of the film after a given development can be taken as an indication of film speed relative to some fixed value. For exposure to X-rays alone, screen-type films have a smaller response than non-screen films. However, screen-type film used with intensifying screens produce a faster system than non-screen film.

Film blackening depends on the product of radiation intensity and exposure time. Radiation intensity of a beam of X-rays depends on tube current and voltage and increasing either will produce an increase in radiation intensity. For example, the radiation intensity of the beam varies as the square of the tube voltage and the intensity of radiation reaching the film through the patient also increases because:

(i) the incident radiation intensity is greater,
(ii) the X-ray photons have a greater energy, and
(iii) the scatter produced has a higher energy, takes place in a more forward direction (deviates less) and more easily reaches the film.

It should be noted that increasing the voltage results in fewer and fewer scattered photons being produced, but more and more of those which are produced are able to reach the image receptor.

Coating Weight

Silver bromide is the main constituent of screen-type and non-screen (direct exposure) type films. The amount of silver halide in an emulsion is referred to in terms of the coating weight. Manual process non-screen films have a higher coating weight than screen-type films. Consideration should always be given to the possible coating-weight differences between different types of film and the effect this can have on the amount of silver obtained in a silver recovery process.

Emulsion Characteristics

The emulsion layer like the other film layers is flexible to allow film bending which is necessary for use in curved cassettes, film changers and automatic processors. This layer must also hold together the latent image and the final image and must not allow any change in the relationship of the relative parts of the image, even during high temperature processing. This is achieved by pre-hardening the gelatin in this layer.

The characteristics of the emulsion depend on the way it is made and on what it contains. The manufacturing process controls:

(i) the average size of the silver halide grains (to control film speed), and
(ii) the range of grain sizes (to control a quality called film contrast).

The important features of manufacture are

(i) the chemical and heat treatment to control individual grain size and range of grain sizes following the formation of the silver halide by precipitation, and
(ii) the addition of sensitizers to form 'sensitivity centres' enabling latent image formation on exposure and final image formation on development.

The basic constituents of a typical emulsion are silver halide and pure gelatin. Many different additives are used before the final film emerges. By using pure gelatin and adding sensitizers the speed of the film can be closely controlled. Gelatin is used because it is readily available in quantity, and providing certain additives are used, has all the desired properties for emulsion manufacture and subsequent use in the imaging process.

The hardener employed for pre-hardening the gelatin allows the emulsion to withstand the high temperatures encountered in automatic processing without damage to the image structure. It facilitates quick drying because the

emulsion would swell more if it were not hardened. It limits pressure damage from handling and from the passage of the film between the rollers of an automatic processor. It also prevents cracking of the emulsion as a result of large temperature or pH changes.

Film Layers

In addition to the film emulsion there are several other layers in the construction of an X-ray film and these are described below.

Adhesive Layer
This is also called the subbing layer and is necessary for proper adhesion of the film base to the emulsion layer. This layer is a mixture of gelatin and film base.

Film Base
This is a transparent plastic material (polyester) which is virtually untearable, and since it is stronger than other film base materials it can be made thinner. This allows a slight improvement to be made in definition when viewing the image formed on a double-sided (duplitized) film, especially under magnification. The film base acts as a support for all the other film layers and the majority of X-ray films have emulsion coated on both sides of the film base which is the reason for the term double-sided or duplitized.

Anti-halation Backing
When the image is formed by light in a single-coated film, light is reflected at the film base–air interface on the opposite side to the emulsion. This light passes back to the emulsion

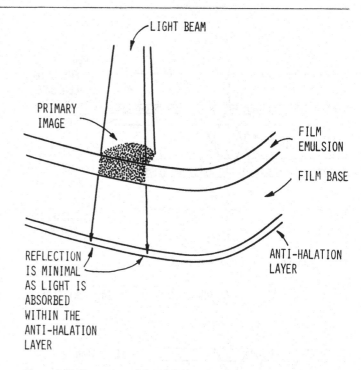

Figure 1.22 Prevention of halation in a single-sided film

producing a diffuse halo or fogging around the image parts. The addition of the backing prevents this effect, known as 'halation', by absorbing the light and preventing reflection. The anti-halation substance is relatively opaque to light and must be bleached out during processing otherwise the film cannot be viewed.

There is no anti-halation layer in duplitized film but all single emulsion films have an anti-halation layer. Halation is illustrated in Figure 1.21 and the effect of the anti-halation layer is shown in Figure 1.22. Since there is no anti-halation layer in a duplitized film, a type of halation called the cross-over effect occurs which increases the amount of image unsharpness. No radiographic image is truly sharp and all image detail outlines are blurred to some extent as a result of the imperfect imaging systems used. Cross-over effect is just one of the many factors contributing to image unsharpness (Figure 1.23). In Figure 1.24, the arrowed lines represent the emission of light from a single fluorescent grain of phosphor material in the front intensifying screen and a single fluorescent grain (opposite the first) in the back screen. Light emitted from each of the grains will affect not only the adjacent film emulsion layer but also the opposite layer as shown. Since the emitted light forms a diverging beam, the effect on the opposite emulsion is more widespread producing a halo or penumbra (Figure 1.24). The only way this effect can be eliminated is by using a single intensifying screen and a single emulsion film having an anti-halation backing. This, of course, effectively reduces the speed of the

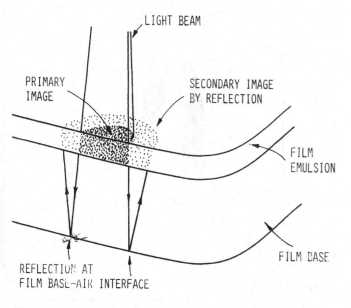

Figure 1.21 Halation in a single-sided film without anti-halation layer

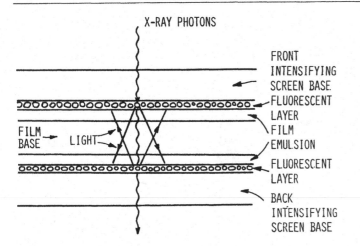

Figure 1.23 The cross-over effect

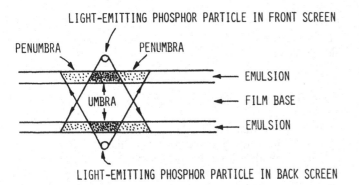

Figure 1.24 Formation of penumbra due to cross-over effect

imaging system necessitating the use of a larger radiation dose to produce the required image.

The Kodak X-omatic film-intensifying screen system for extremity radiography employs duplitized X-ray film and paired intensifying screens, yet the unsharpness in the image due to cross-over effect is effectively half that of a similar system employing conventional calcium tungstate intensifying screens, but of course the system speed is far less. Nevertheless it is considerably faster than a non-screen imaging system while producing a most acceptable image quality. The reduction in cross-over effect is probably due in part to the good film–screen contact in the particular cassette used and to the screen structure. There would appear to be little need to employ a non-screen imaging system in routine radiographic practice except for specific applications such as, for example, dental radiography, open kidney surgery and radiography of specimens.

The Effect of Duplitizing
In the following discussion the term 'density' is used. The black metallic silver deposits forming the image have a light-

stopping capability varying according to the amount of black metallic silver per unit volume. Density is a measure of their light-stopping capability. The greater the amount of black metallic silver per unit volume the greater will be the density. Density is measured by comparing the light incident upon a small area of film with that transmitted. The image density is usually termed 'optical density' (D) and is defined as

$$D = \log_{10} \left[\frac{I(0)}{I(t)} \right]$$

where $I(0)$ is the incident light intensity and $I(t)$ is the transmitted light intensity.

This definition is used because, approximately, density is proportional to the amount of silver deposit per unit area. In addition, the logarithm is used because in a completely transparent area $I(t) = I(0)$ producing a density of zero. Also if two densities are superimposed then the total density is simply the sum of the two densities, but this is considered in greater detail in Chapter 2. Figure 1.25 shows a film on a viewing box with incident and transmitted light intensities shown. The transmitted light intensity values depend on the light-stopping power of the black silver deposits in the film emulsion. As an example three transmitted intensities $I(t_1)$, $I(t_2)$, $I(t_3)$ are shown giving densities for the three image parts of $D_1 = \log_{10} [I(0)/I(t_1)]$, $D_2 = \log_{10} [I(0)/I(t_2)]$ and $D_3 = \log_{10} [I(0)/I(t_3)]$. In practice a diffuse transmission

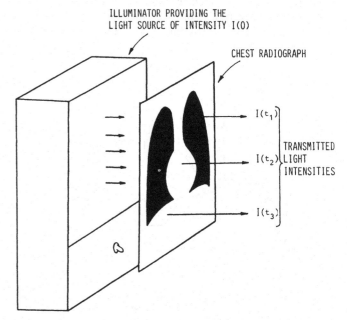

Figure 1.25 A film on a viewing box, showing incident and transmitted light intensities. Note that a radiographic image is usually viewed by transmitted light as shown here

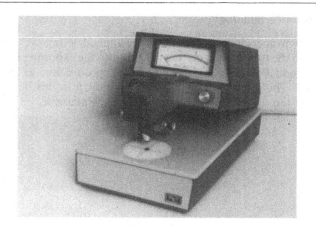

Figure 1.26 A typical densitometer

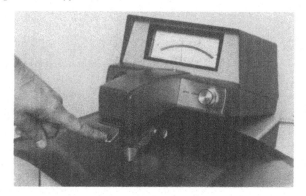

Figure 1.27 Measuring density over the heart in a chest radiograph. In this case the density is read off the top scale

densitometer is used to measure diffuse density where the film is illuminated with non-diffused (specular) light forming the incident light beam and all light transmitted by the film (specular and diffuse) is sensed by the photocell. Diffuse light is light scattered by the silver deposits in the film. Figures 1.26 and 1.27 show the densitometer and how an image density is measured.

Duplitized films are used in radiography for the following reasons:

(i) Increasing film speed. This means that a lower exposure is necessary since twice the density will be produced in comparison with a single emulsion film. A lower exposure can be used with a lower patient radiation dose. A shorter exposure time, or a longer focus to film distance (FFD) can be used when the object to film distance (OFD) is large and likely to cause an unacceptable degree of image unsharpness.

(ii) Increased imaging system speed. This is achieved because paired intensifying screens can be used with a duplitized film. This is not the case with a single emulsion film.

(iii) Increased contrast. Radiographic image contrast (C) may be defined as the difference between two adjacent areas of the film image, i.e.

$$C = D_2 - D_1 \qquad (D_2 > D_1)$$

Assume, for example, that $D_2 = 1.0$ and $D_1 = 0.5$ in a single emulsion (Figure 1.28). If these are doubled as in the case of a duplitized film the contrast is also doubled (Figure 1.29), since superimposed densities can be added. Here D_1 is duplitized to give $2D_1 = 1.0$. Likewise, $2D_2 = 2.0$. The contrast in the image is then $C = 2 - 1 = 1.0$, which is double that achieved with only one emulsion.

(iv) There is emulsion on both sides of the film base so it does not matter which way round the film is loaded into the cassette. Cassette loading and film handling are easier.

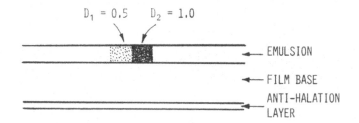

Figure 1.28 Densities in a single emulsion film

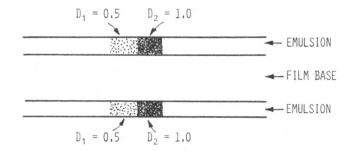

Figure 1.29 Densities in a duplitized film

Unfortunately there are disadvantages to duplitizing:

(i) Increased cost, since twice the quantity of emulsion is required

(ii) The processing chemicals are exhausted more quickly

(iii) There is a greater chance of incurring film damage

(iv) There is a slight loss in definition under magnification as there is greater unsharpness in comparison with single emulsion film.

Film Storage

The non-screen-type films for autoprocessing have sensitizers added to increase their response to X-rays. Unfortunately this also increases their response to other radiations of short wavelength such as cosmic rays. This means that this type of film will have a shorter shelf-life during storage because it is continually exposed to such radiations.

Note on Terminology

Radiographers invariably refer to the applied voltage as 'the kV', to the tube current as 'the mA', and to the exposure, i.e. the product of the tube current and the exposure time, as the 'mAs'. This usage will be adopted henceforth in this book unless the text demands a more accurate statement.

2

Film Behaviour to Exposure

INTRODUCTION

When using film material it is essential to know how it will react under the imaging conditions chosen. For example, when a film is exposed to the X-ray beam transmitted by the patient and then processed, will it be possible visually to retrieve from the image all the information that was contained in the beam? Is it possible by altering the voltage and the mA to increase the amount of information in the image and is it then possible to see this information? What effect will the use of intensifying screens have on the retrieval of information? How can the 'best' image be obtained? These are just some of the important questions that require an answer and unfortunately a few cannot be satisfactorily answered. As an attempt to answer some of these questions the characteristic curve must first be introduced.

When a film is exposed to X-radiation (Figure 2.1) a latent image is formed and following processing the image is seen as an area of film blackening. This film blackening can be measured using a densitometer and a particular density value ascribed to it. Sensitometry is the quantitative study of the relationship between exposure and film response and the information obtained is normally displayed in the form of a

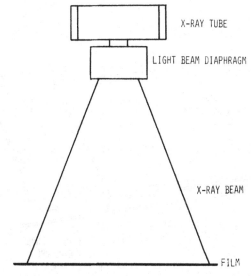

Figure 2.1 The radiographic process

characteristic curve. Before discussing the characteristic curve in detail consider first the visibility of image information.

VISIBILITY OF IMAGE INFORMATION

In Chapter 1 the visibility of image information was considered in terms of image brightness differences or density differences. If the difference in density between adjacent areas of the image is less than about 5% it becomes impossible to see any difference and the information such a difference represents is lost to the eye. Density differences are described in terms of contrast, and to retrieve image information visually there must be sufficient contrast in the various parts of the image. Image densities result from the various exposures (radiation intensities) received by the film from the transmitted X-ray beam. This X-ray beam will have a radiation intensity pattern characteristic of the patient part through which the beam passed and it is important to know how the film will react. Will the resulting density differences be large enough to be seen? Can they be made larger? What must be done to achieve this and are there any relative disadvantages in doing so? The answers to these questions will become apparent below.

THE CHARACTERISTIC CURVE

The characteristic curve, first described by Hurter and Driffield in 1890, is a graphical representation of the relationship between the exposure received by the film and the density the exposure produces following processing. The characteristic curve of a typical screen-type film is shown in Figure 2.2. Such a curve can be obtained by giving the film material a graded series of exposures, processing the film under a standardized set of conditions and measuring and plotting the resulting image densities against the respective exposures.

Factors Affecting the Characteristic Curve

Each characteristic curve describes the film behaviour under the set of conditions used to produce the curve. Change the

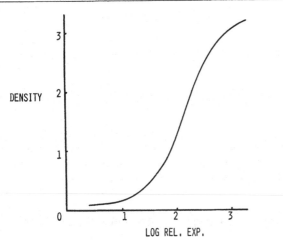

Figure 2.2 Characteristic curve for a typical screen-type film exposed with intensifying screens

conditions and the film will behave differently. It is very important that this fact be appreciated, as in practice this can be the reason why the image results obtained may not be as predicted by the film manufacturer. Important factors influencing the shape and position of the characteristic curve relative to the axes are:

(i) the film material used,
(ii) the processing conditions,
(iii) the exposing spectrum of electromagnetic radiation,
(iv) the kV used if a stepwedge (see below, Figure 2.6) is employed in producing the series of graded exposures.

Producing a Characteristic Curve

In radiographic practice information is required about the performance of one film or imaging system relative to another. Relative and not absolute values of exposure are important, so once suitable values are selected, relative exposures can be obtained by using multiples of some chosen exposure time providing the exposure timer is both accurate and consistent. (This can always be checked using a suitable spinning top. The Wisconsin Timing and mAs test tool (Figure 2.3) is very easy to use for this purpose being suitable for testing timer accuracy even on constant potential and capacitor discharge units because its spinning top is driven by a synchronous motor. The use of this instrument for timer testing is described in Appendix 1. A capacitor discharge unit should not be used for producing a characteristic curve by this method since equipment giving a constant dose rate is required. With a capacitor discharge unit the dose rate falls with increasing exposure time until all the stored energy of the capacitor is dissipated, when the dose rate from the X-ray tube supplied by the capacitor will be zero.)

The apparatus for producing a characteristic curve using varying exposure times for comparing two different films is shown in Figure 2.4. The aim is to produce a series of densities on each film extending from the smallest to the largest each film is able to record. It is convenient to place two film halves in a cassette with intensifying screens if screen-type films are used, or in a light-tight envelope if direct exposure films are used. If a comparison is not required only the film whose characteristic curve is wanted need be exposed in this fashion. Note that a stepwedge is not used, and that the two films should normally be employed

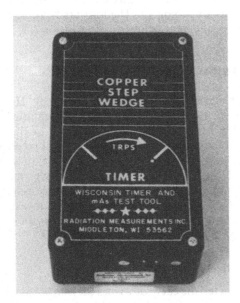

Figure 2.3 Wisconsin timer and mAs test tool – Model 121. (By courtesy of D.A. Pitman Ltd.)

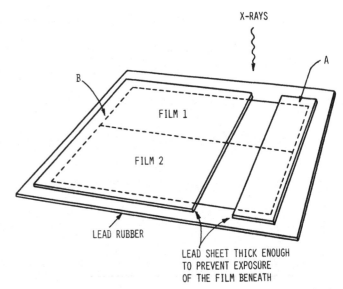

Figure 2.4 Apparatus for producing a characteristic curve arranged for the first exposure

with the same type of intensifying screen. The piece of lead sheet (A) remains in the same position for all exposures to allow assessment of fog level (for definition of fog see p. 19). For the first exposure, with an exposure time of 0.01 s, the kV and mA should be made large enough to produce a density approximately equal to fog density on the faster of the two films. A copper filter may be inserted in the beam to approximate the attenuation of a patient, and a focus to film distance (FFD) of at least 1.5 m should be used.

After the first exposure the exposed portion is covered with an additional piece of lead and the lead sheet (B) is moved to uncover a further strip of film for the next exposure. A series of exposures is made, each one increasing the exposure time to some known multiple of the first exposure time. Once the choice of kV and mA has been made, it should not be changed; the only variable should be exposure time. The X-ray beam should be centred to the middle of the strip being exposed: using a small beam area at a large FFD should avoid any intensity variation across the beam which could cause a density variation across any particular strip.

Both film halves are then identically processed and the density of each strip measured at its middle and recorded. A sample set of results is given in Table 2.1 and the resultant curves characteristic of the conditions used are shown in Figure 2.5. Note that each curve exhibits a toe, straight-line portion and shoulder. The extent of the toe and shoulder depends on the length of the straight-line portion. In some cases the division is quite arbitrary since there is no well-defined straight-line portion, but in any case this terminology is not used for quantitative purposes. A criticism of this method is that variations can occur from exposure to exposure introducing errors into the results, but for most practical purposes they can be ignored.

There are other methods of producing a characteristic

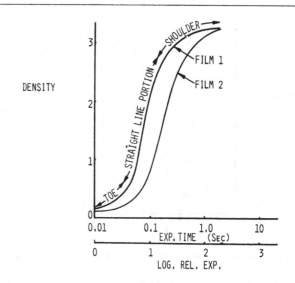

Figure 2.5 Characteristic curves plotted from Table 2.1

curve. One of particular interest is that using a calibrated stepwedge (Figure 2.6). The stepwedge is designed to provide a constant difference per step in log exposure and then it is possible to plot density against step number using a linear scale. Unfortunately the use of a stepwedge alters the quality of radiation reaching the film through each step, but this can usually be ignored as a significant source of error. To produce curves by this method the arrangement shown in Figure 2.6 is used and a single exposure made. Density is plotted against step number (Figure 2.7). The structure of the stepwedge and the kV value chosen for the exposure will affect the shape of the characteristic curves produced and is unlikely to match exactly the shape of the characteristic curves produced by the first method described.

An approximate characteristic curve for a film–inten-

Table 2.1 Sample results of a characteristic curve measurement

Exposure time (s)	Relative exposure value	Log relative exposure value*	Density (film 1)	Density (film 2)
0.01	1	0.0	0.15	0.17
0.04	4	0.6	0.20	0.50
0.05	5	0.7	0.30	1.00
0.10	10	1.0	0.75	2.00
0.20	20	1.3	1.75	2.70
0.50	50	1.7	2.75	3.20
1.00	100	2.0	3.20	3.25
2.00	200	2.3	3.3	3.3

*Some of the log values are not exact but the error is very small and the results are certainly accurate enough for practical purposes even ignoring the effect of reciprocity failure

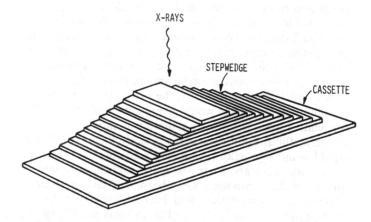

Figure 2.6 Arrangement for producing a characteristic curve using a stepwedge

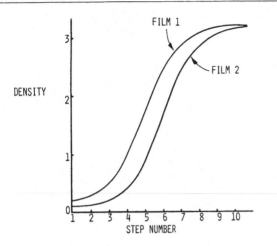

Figure 2.7 Characteristic curves obtained using a stepwedge as in Figure 2.6

sifying screen combination can be produced by either of these methods providing the small density variations due to reciprocity failure occurring with the first method are ignored.

A different approach to this problem of producing a characteristic curve for a film–intensifying screen combination is to use a sensitometer. This instrument exposes both sides of the duplitized film (in the same way as a pair of intensifying screens) by using a suitable light source and filter to approximate the emission spectrum of the intensifying screens being considered. A series of graded exposures is given and the characteristic curve plotted using the results obtained from the processed film (see Appendix 2).

Relative Film Speed

The relative speed of two films is the inverse ratio of the exposure times required for each to produce the same density, the kV, mA and all other exposure and processing conditions remaining constant. For example, if at 60 kV and 100 mA, film 1 requires 0.04 s to produce a density $D = 1$, and film 2 requires 0.08 s to produce the same density, then the relative speed is 2:1, or just 2. This simply means that film 1 is twice the speed of film 2. The relative speed of two films at any given density can be obtained from their pair of characteristic curves. However, the two methods described for obtaining the curves would give slightly different results for relative speed because the radiation quality used in each of the methods is different. This is hardly likely to be too troublesome in practice because a precise figure for relative speed is not necessary. No two patients are alike, so radiation quality of the transmitted X-ray beam will vary producing slight variations in relative speed. If a reasonable guide to the relative speed figure can be obtained this is all that is required in practice.

There is a simpler method of obtaining a measure of

relative speed which does not involve the plotting of characteristic curves and this is described in Chapter 3.

Log Relative Exposure

In Figure 2.5 the horizontal axis employs a logarithmic scale for exposure time. This is necessary to compress the curve to reasonable proportions and also because using this scale, a screen-type film exposed with intensifying screens often shows a straight-line relationship throughout the most useful range of image densities. This is not usually the case with non-screen films. It is also common practice, to enable the graph to be conveniently placed relative to the axes, to label the smallest exposure value used as zero. All other exposure values are then assigned a value relative to zero. A log relative exposure axis is thus formed.

Scales

A further convention is to use the same scale for both vertical and horizontal axes. This makes it possible to measure the angle the curve makes with the horizontal axis which is not possible if the scales for each axis are different, and thus express the slope of the curve as the tangent of this angle.

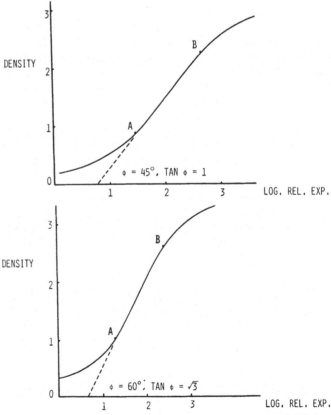

Figure 2.8 The same characteristic curve drawn using axes of different scales

Figure 2.8 shows two characteristic curves both representing the same film. The slope or gradient of the curve between A and B is 1 in both cases but only in the graph with similar scales for both axes is it possible to measure the angle ϕ as 45° and thus obtain the slope as tan ϕ . Scales are irrelevant however if a suitable mathematical expression, $f(x)$, is available and describes the characteristic curve. Then $df(x)/dx$ describes the gradient at any point and $f(x_2)-f(x_1)/x_2-x_1$ describes the average gradient between x_1 and x_2.

Net Density

An X-ray film, which has received no exposure, will show a measurable density when processed. It is usual to subtract this density from each of the density values measured on a similar type of film which has received an exposure and the same processing. The resulting density values are then called net density values and may be used to plot the characteristic curve. Whether or not net density is used is usually clearly indicated on the vertical axis of the characteristic curve. If in doubt look at the density value at which the curve starts. Only if it is zero has net density been used.

Fog Level

The density of the processed film which has not received an exposure is easily measured with the densitometer. This density is usually between $D=0.1$ and $D=0.2$. It is this density which is referred to as fog, basic fog or gross fog. Basic fog consists of the summed contributions from:

(i) the density produced by the development of unexposed silver halide,
(ii) the density of the film base, and
(iii) the density of the emulsion matrix.

The developer used in the first stage of film processing will have a more pronounced effect on the unexposed silver halide, producing a higher fog density, if:

(i) Development time is increased,
(ii) Developer energy is increased (i.e. increased concentration), and
(iii) Developer temperature is increased.

Films with a high basic fog level produce low contrast images. Image contrast is related to the slope of the characteristic curve and small increases in fog level as a result of a change in processing conditions may be accompanied by an increase in contrast, but this apparent contradiction will be discussed more fully in a later chapter.

Other factors which influence basic fog level are:

(i) Age of the film. The older the film the higher basic fog level is likely to be
(ii) Film storage conditions. Adverse storage conditions lead to an increased basic fog level

(iii) Film speed. In general, the higher the film speed the greater is the basic fog level
(iv) The pH of the fixer. The fixer is used in film processing to render the visible image permanent. Careful attention should thus be paid to fixer solution replenishment and the maintenance of a given pH value. A pH rise can increase fog level.

Contrast

As used above, the word 'contrast' refers to the contrast in the radiographic image and is more correctly called radiographic contrast. Other meanings can be attached to the word 'contrast' and these will be dealt with in due course. Contrast is an important concept when discussing image quality because it is one of the controlling factors determining the visibility of image detail.

Radiographic contrast may be defined as being subjective or objective. The word 'subjective' refers to the assessment made by the individual using their eyes. It is a purely personal thing and is likely to be quite different from the subjective assessment of another individual. Subjective contrast is not to be confused with subject contrast which is dealt with in Chapter 10. Subjective radiographic contrast may be defined as the difference in brightness between two adjacent areas on the film when viewed on an illuminator. The brightness difference experienced varies from individual to individual, and even varies for the same individual from time to time. The greater the brightness differences, the easier it is to differentiate between the two adjacent areas, and the contrast is said to be high. Alternatively the brightness difference can be so small that it cannot be experienced as a difference by the eye. Image information is then lost as there is now no contrast at all. The subjective radiographic contrast perceived by an individual is dependent on several factors including the viewing conditions and the age and visual capability of the individual, as well as the degree of experience in viewing radiographs.

The word 'objective' refers to a quantity which can be measured and assigned a value and is independent of the personal assessment of the individual. Objective radiographic contrast has previously been defined as the difference in density between two adjacent areas on the film, i.e.

$$\text{contrast} = D_2 - D_1$$

While the response of the eye to variations in light intensity is approximately logarithmic in nature there is not necessarily any proportionality between changes in objective radiographic contrast and the accompanying changes in subjective radiographic contrast. Relating variations in the two is not possible in terms of any simple equation.

Notwithstanding these difficulties it is possible to obtain an indication of the degree of difference in image contrast to

be obtained by comparing the characteristic curves of different films or film–intensifying screen combinations.

D_{max}

The shoulder of the characteristic curve represents the so-called 'region of overexposure', while the toe is the 'region of underexposure'. D_{max} is the density recorded for a gradient of zero in the region of overexposure (Figure 2.9). D_{max} cannot be exceeded for a given emulsion because it represents the state where practically all of the silver halide has been reduced to black metallic silver.

Reversal

In certain cases it has been possible by further increasing exposure beyond that required to produce D_{max} and yet produce reduced densities for these larger and larger exposures. This region of the characteristic curve is called the 'region of reversal' or 'solarization' (Figure 2.10). An image produced using only this region of the curve would produce a 'positive' image compared to the 'negative' image produced using only the other half of the curve. The latent image is formed as a result of the reduction of silver halide in the emulsion, and experimental evidence suggests that as exposure increases to larger and larger values recombination of silver and halide occurs and this is responsible for the phenomenon of reversal. With present day autoprocess films the emulsion is structured to prevent recombination of silver and bromine once silver bromide is reduced by the radiographic exposure. Thus it is virtually impossible to cause recombination once reduction has occurred so that solarization is rarely possible by overexposure.

The region of reversal does have a practical application in the copying or duplication of radiographs. The original film to be copied is placed in contact with the emulsion side of the duplicating film (emulsion on one side only) and the duplicating film is exposed through the original film usually using an ultraviolet light source. Should a higher contrast be required in the copy then a white light source may be used. The characteristic curve for a duplicating film (Figure 2.11) slopes in the opposite direction to the characteristic curve for a typical screen-type film. Thus a large density in the original film will transmit a low intensity light and this will produce a high density in the copy (duplicating film). Similarly a low density in the original will produce a low density in the copy. Density differences in the original must also be the same in the copy if it is to be, as the name suggests, a true copy.

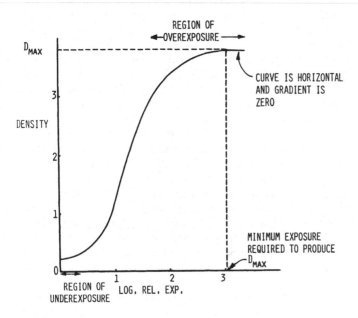

Figure 2.9 Estimation of D_{max} from a characteristic curve

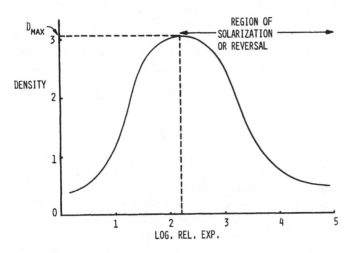

Figure 2.10 Characteristic curve showing region of reversal or solarization

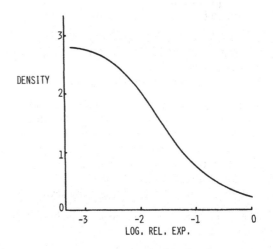

Figure 2.11 Characteristic curve for a duplicating film

Gamma

The gamma of a characteristic curve is defined as the gradient of the straight-line portion. Modern X-ray films do not usually have a well-defined straight-line portion so gamma as a concept is of little practical use.

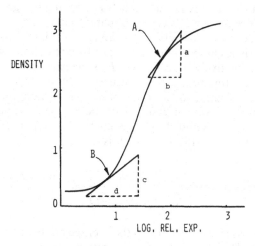

Figure 2.12 Tangents to a characteristic curve. In practice, tangents are difficult to draw accurately and information obtained in this way can only be used as a rough guide

Gradient

The gradient, G, at any particular point on the characteristic curve is the same as the slope of the tangent to the curve at that point (Figure 2.12). The gradient describes how density varies with exposure and G may therefore be defined as the rate of change of density. As will be seen later, the higher the rate of change of density the greater will be the image contrast for a given set of exposure and processing con-

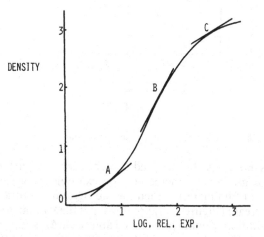

Figure 2.13 Tangents to a curve at points A, B and C. Their gradients are respectively G_1, G_3 and G_2

ditions. G is also called film contrast or inherent film contrast. Its value depends upon where it is measured on the curve and its value will be greatest at the steepest part of the curve. The value of G for a given film material at a given point on the curve will also depend on processing conditions and whether or not intensifying screens are used. For screen-type film material G increases from 0 in the toe region to a maximum in the middle of the straight-line portion to 0 again at D_{max} (Figures 2.13 and 2.14).

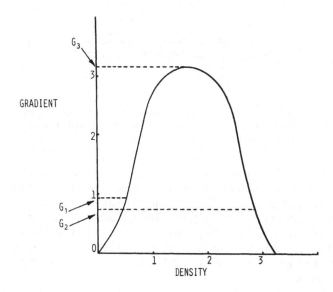

Figure 2.14 Gradient of a characteristic curve as a function of density

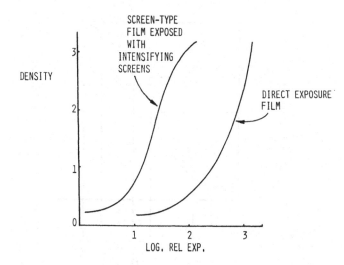

Figure 2.15 Two characteristic curves for typical radiographic films

Figure 2.15 illustrates two characteristic curves for typical films used in radiography. A small log exposure difference, equivalent to a small subject contrast (Figures

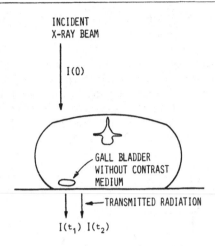

Figure 2.16 A case of small subject contrast, with very little difference between $I(t_1)$ and $I(t_2)$. Subject contrast may be defined as $I(t_2)/I(t_1)$, where $I(t_2) > I(t_1)$

2.16 and 2.17) gives rise to different radiographic (image) contrasts depending on the value of the exposure used to produce the incident X-ray beam. To make best use of the film material it is important to choose the correct exposure such that small but diagnostically important subject contrasts are registered as large image contrasts. From Figure 2.16, subject contrast may be defined as $I(t_2)/I(t_1)$, where $I(t_2) > I(t_1)$.

AVERAGE GRADIENT

The visualization of information in the radiographic image depends among other things on the radiographic contrast. The larger the value this has, the easier it becomes to distinguish visually between two adjacent image areas.

Of course there are disadvantages to having too great an image contrast as will become apparent later.

Consider two densities D_1 and D_2 related to the characteristic curve (Figure 2.18), produced by exposures E_1 and E_2 respectively. Log E_2 - log E_1 is the particular subject contrast relating to E_1 and E_2 which in this case will again remain a constant, say k. The slope of the straight line AB represents the average gradient of the characteristic curve between points A and B. AC is equal to $(D_2 - D_1)$ and BC is equal to $(\log E_2 - \log E_1)$, which is k. Hence

$$\text{average gradient } (\bar{G}) = \frac{(D_2 - D_1)}{(\log E_2 - \log E_1)} = \frac{(D_2 - D_1)}{k}$$

so $(D_2 - D_1)$ is proportional to the average gradient between A and B. This means that for a constant exposure interval, the radiographic contrast obtained depends on the average slope of the characteristic curve throughout that interval.

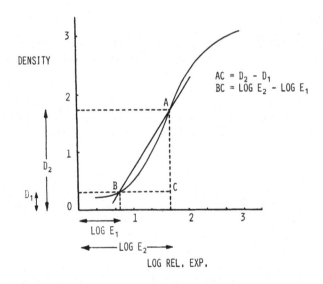

Figure 2.18 Average gradient of a characteristic curve

It is now possible to predict with certainty that if the average gradient is increased, for example by a suitable change of film material, then the radiographic contrast will also increase (Figure 2.19) provided that the kV and processing conditions remain unchanged and the mAs is adjusted to compensate for any speed difference that may exist between the films.

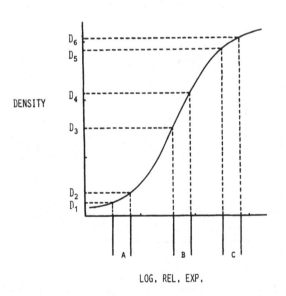

Figure 2.17 The same subject contrast (a, b and c) at different exposure values (i.e. different incident X-ray beam intensities) gives different values of image contrast (($D_2 - D_1$), ($D_4 - D_3$) and ($D_6 - D_5$)). The characteristic curve is steepest at its middle (i.e. G is a maximum) and it is here that greatest image contrast is obtained

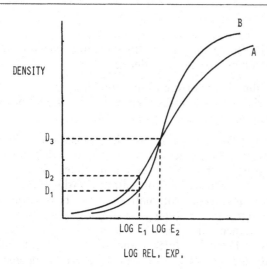

Figure 2.19 Different gradients over the same exposure intervals for two films. Below the cross-over point, film B has a larger gradient than film A, and hence produces a greater radiographic contrast

Density Range

The word 'range' means the difference between the maximum and minimum values of some quantity, and here the quantity is density. The term 'average gradient' is, for practical purposes, generally used to refer to the slope of the straight line joining the two points forming the limits of the most useful interval of the characteristic curve (Figure 2.20). For example, the two points chosen might correspond to net densities of $D_1 = 0.25$ and $D_2 = 2$ and $(D_2 - D_1)$ would then represent the useful density range (Figure 2.21). Of course, densities greater than 2 might be considered useful for registering small contrasts provided they can be adequately visualized, perhaps using a high intensity light source.

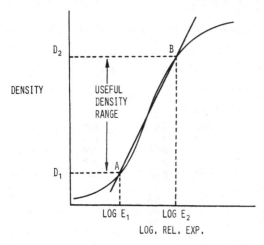

Figure 2.20 A and B are the limits of the most useful portion of the characteristic curve. The slope of AB gives the average gradient

Figure 2.21 Where D_1 and D_2 represent the minimum and maximum useful densities in a radiograph, then $(D_2 - D_1)$ is the useful density range

Consider the characteristic curve in Figure 2.22 for a typical screen-type X-ray film–intensifying screen combination. Using the equation for radiographic contrast, we obtain

radiographic contrast
= gradient of the line XY × (log E_2 – log E_1)

= gradient of the line PQ × log (E_2/E_1)

= \bar{G} × log (E_2/E_1)

Assume that the two densities, D_3 and D_4, both lie outside the 'useful' range of densities. Average gradient as defined above can no longer be used since the gradient of the line

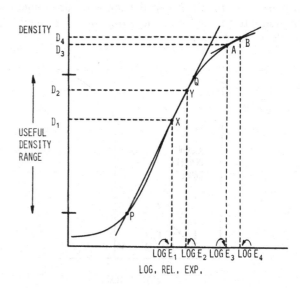

Figure 2.22 Density intervals lying inside (D_1, D_2) and outside (D_3, D_4) the useful density range

joining AB has a much smaller value. In this case,

$$\text{radiographic contrast} = \text{gradient of the line} \\ \text{AB} \times \log (E_4/E_3)$$

Log (E_4/E_3) is the same as log (E_2/E_1), but now the value of the gradient is less, so the value for radiographic contrast will be much smaller. A similar reasoning applies if the two densities lie below the 'useful' range of densities.

Recording small subject contrasts using densities lying above the useful range, and using a high intensity illuminator to view them, can mean that the radiographic contrast is so small that the densities cannot be differentiated visually and the information is lost. This information might well be visible if recorded as density differences using densities from within the useful density range. This is another reason why exposure factors should be carefully chosen, especially when an automatic exposure device is not available.

Average gradient is the same as average inherent film contrast over the useful density range. Average gradient may be denoted by \overline{G}. The straight-line portion is often a reasonable approximation to a straight line so radiographic contrast is reasonably constant (for a given subject contrast) throughout this interval. Thus average gradient will give a very useful indication of the magnitude of the radiographic contrast which can be expected in the radiographic image. It is useful when making a relative assessment of two different film types. The film with the higher average gradient will give the greater radiographic contrast.

Log Exposure Range

This refers to the difference between the largest and smallest log exposure values for the log exposure interval being considered. A special case is the log exposure range corresponding to the useful density range which is called 'film latitude' (Figure 2.23).

LATITUDE

The word 'latitude' means breadth or extent, and it is used in radiographic photography to define

 (i) a film characteristic (film latitude), and
 (ii) a characteristic associated with exposure (exposure latitude).

The word 'latitude' is also used in association with the development of a film (development latitude), which may be defined as the range of development times (at a given developer temperature and concentration) which lead to an acceptable radiograph. Alternatively it can be the range of developer temperatures (at a given developer concentration and development time) which also lead to an acceptable radiograph. There is a further and more recent use of the word 'latitude' and this relates to the available degree of variation of exposure factors, particularly relevant since the introduction of high speed, rare-earth imaging systems. As an example of this, consider Table 2.2, which gives the available settings of exposure time and mA. It should be noted in making a choice of mAs that if the mAs chosen is large, then a small error in setting this mAs on the control panel will have a negligible effect on image density. For example, if the usual mAs for a particular projection is 32, and 200 mA at 0.16 s is normally set, then a change to 600 mA will mean 32 mAs cannot be obtained. At 600 mA either 30 mAs (using 0.05 s) or 36 mAs (using 0.06 s) can be obtained. The errors here are –2 mAs (a 6% error) and +4 mAs (a 12% error) respectively. Errors of this magnitude may reasonably be regarded as acceptable. On the other hand the exposure normally chosen for a particular patient part could have been 8 mAs, say, obtainable by selecting 100 mA at 0.08 s on the control panel. Now if a change to 600 mA is made, the choice of exposure times is limited to either 0.01 s or 0.02 s. The first of these gives 6 mAs (a 25%

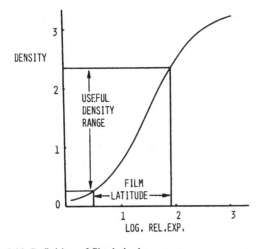

Figure 2.23 Definition of film latitude

Table 2.2 **Available values of exposure time and tube current (mA)**

Exposure times (s)		Tube current (mA)
1.0	0.1	600
0.9	0.09	500
0.8	0.08	400
0.7	0.07	300
0.6	0.06	200
0.5	0.05	100
0.4	0.04	50
0.3	0.03	
0.24	0.02	
0.2	0.01	
0.16		
0.12		

error) while the second gives 12 mAs (a 50% error). Neither of these errors can be regarded as negligible or acceptable. It can be argued that a compensatory change in kV can be made, but this will change radiographic contrast. Alternatively a change can be made in FFD but this would produce changes in magnification (p. 102) and unsharpness in the image (p. 127) which can be disadvantageous.

Assume the kV is kept constant, and that a particular patient part requires 20 mAs when using a fast tungstate intensifying screen image recording system. How many ways can 20 mAs be chosen from the above mA and exposure time values without incurring unacceptable errors? Now change the image recording system to one that is four times faster – a high speed, rare-earth system for example – and look again at the above mA and exposure time values. How many ways can 5 mAs be chosen from these figures, again without incurring unacceptable errors? It should be obvious that practically, the faster the system becomes, the more limited becomes the choice of individual exposure factors.

Film Latitude

This refers to the ability of a film to respond to a range of exposures and record them as useful densities. As stated above it is the magnitude of the log exposure range which results in useful densities to which the name 'film latitude' is given.

Exposure and Film Latitude

The radiation intensity pattern transmitted by an object and reaching the film gives rise to the density patterns which form the image. Each of the different intensities gives rise to a different density, so it is these different intensities multiplied by a constant time factor (the exposure time) which constitute the different exposures (E_1, E_2, E_3, etc.) the film receives.

Consider the characteristic curve of Figure 2.24. Log E_1 and log E_2 are the log exposure values producing D_1 and D_2 respectively. Since D_1 and D_2 are at the ends (limits) of the useful density range, then log E_1 and log E_2 will determine the limits of the film latitude. Again the word 'range' refers to the distance between log E_1 and log E_2 (i.e. the difference in magnitude between log E_1 and log E_2). (Log E_2 – log E_1) is the range, labelled film latitude, which is representative of the exposure range within which useful film densities can be produced. For example, exposures x and y lie within the designated exposure range and produce useful densities (i.e. D_x and D_y) whereas exposures U and V, and Z and W do not, since it is not possible to distinguish between D_u and D_v or D_w and D_z because the contrast is insufficient.

Average Gradient and Film Latitude

The magnitude of the film latitude depends on the average gradient of the characteristic curve measured between the

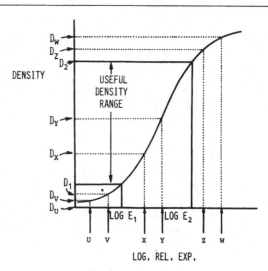

Figure 2.24 Useful and non-useful densities

two points determined by D_1 and D_2 (the densities at the extremes of the useful density range). Since the value for these densities depends on many factors it is not possible to give a precise value to film latitude. What can be done is to use film latitude in a relative sense, i.e. for a given set of conditions, which of two films has the greater film latitude can be determined for any given useful density range. This is of greater practical value than an absolute measurement.

From Figure 2.24 we can see that

$$\text{film latitude} = \log E_2 - \log E_1$$

and

$$\text{useful density range} = D_2 - D_1$$

It has already been stated that

$$\text{average gradient} = (D_2 - D_1)/(\log E_2 - \log E_1)$$

from which it can be concluded that

$$\text{average gradient} = \frac{\text{'useful density range'}}{\text{film latitude}}$$

$$\text{or} \quad \text{film latitude} = \frac{\text{useful density range}}{\text{average gradient}}$$

If useful density range is considered to be a constant then,

$$\text{film latitude} \quad \propto \quad \frac{1}{\text{average gradient}}$$

So if the average gradient increases, then the magnitude of the film latitude decreases. This is shown in Figure 2.25, in which film A has a larger average gradient and a smaller film latitude than film B. (The position of both films relative to the log relative exposure axis has been adjusted so that the curves coincide at point C.)

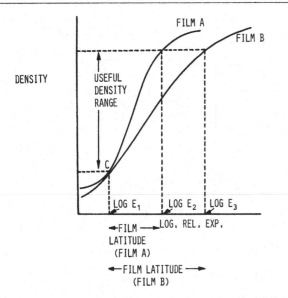

Figure 2.25 Film latitudes for two films of different average gradient

Information Content and Film Latitude

The larger the log exposure range the film can accommodate, the greater the amount of information it is possible to record as useful densities in the image, but unfortunately, the smaller is the value of the average gradient for the film. A small average gradient for a film implies a low film contrast resulting in a low radiographic contrast. Even though a great deal of extra information can be recorded when the film

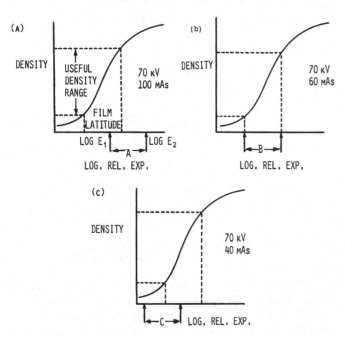

Figure 2.26 The same log exposure range at three different exposure factors with the same film

latitude is increased, it is recorded, along with the original information, at a much lower radiographic contrast. In fact the radiographic contrast may be so low that information may be lost because it cannot be visually detected. It is more important to have a high average gradient to gain sufficient radiographic contrast than have an extremely large film latitude. Even though such a film would have a small film latitude, the exposure can be adjusted so that all or most of the required information falls within the boundaries defined by the film latitude.

Figure 2.26 illustrates the effect of exposure adjustment (in terms of mAs only) needed to record the required information as densities lying within the useful range of densities.

A, B, and C are the log exposure ranges of equal magnitude. The exposure factors given for each of the cases are the factors required to produce the incident X-ray beam which when modified by the patient gives rise to these log exposure ranges. Each of the curves represents the same film. When the mAs alters so will the values for E_1 and E_2. Since only the mAs is being changed the subject contrast will not change and thus the magnitudes of the ranges A, B and C will all be the same. It is just the *positions* of A, B and C on the axis which change when mAs is altered. In Figure 2.26(a) and (c) some of the information is recorded as densities outside the useful range, and under normal viewing conditions this information would be lost to the viewer. In Figure 2.26 (b) all the available information is recorded as densities within the useful range. This emphasizes the importance of using the correct exposure in terms of mAs and the correct use of an automatic exposure device to achieve this cannot be overstressed.

The use of a high contrast film with a small film latitude requires the exposure to be selected very accurately in terms of mAs, especially if the log exposure range for the patient is as large as the film latitude (as it is in Figure 2.26(b)). It is unfortunate that in many cases where a low kV is required to provide the necessary diagnostic information, the log exposure range far exceeds the magnitude of the film latitude. An example is mammography.

Multiple Radiography

Figure 2.27 illustrates the effect of average gradient upon film latitude. In Figure 2.27(a) a relatively large amount of information can be recorded because the film latitude for this film is relatively large, and the log exposure range which can be accommodated by the film is large. Unfortunately, because of the large film latitude, the average gradient and hence the film contrast will have a low value, and much of the recorded information might be quite difficult to distinguish because of the low radiographic contrast. In Figure 2.27(b), the recorded information will be very easy to see, but less information is recorded as useful densities.

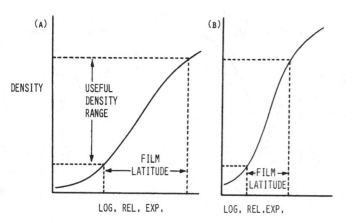

Figure 2.27 The effect of average gradient on film latitude

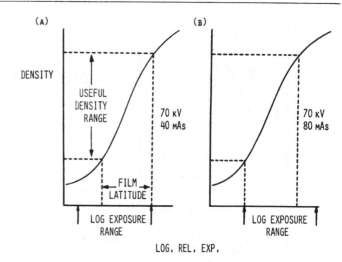

Figure 2.28 The principle of multiple radiography

In an attempt to overcome this problem, two or more films of the type in Figure 2.27(b) can be exposed at the same kV but different mAs values to yield all the available information. Although several different exposures would not normally be attempted in practice (because of the radiation dose to the patient) it is possible to expose, simultaneously, several films in a single cassette, each film being placed between different speed intensifying screens. This achieves the same result and forms the basis of the technique called 'multiple radiography'.

The principle of the technique of obtaining the required information using two similar films (or similar film–intensifying screen combinations) is illustrated in Figure 2.28. The log exposure range for the patient part is the same in each case and is far larger than the film latitude. In Figure 2.28(a) the use of a low mAs has allowed about three-quarters of the information to be recorded as useful densities. To record the remaining information, a higher mAs (or faster film–intensifying screen combination with a similar film latitude) is required. This can be seen in Figure 2.28(b) where the information not recorded as useful densities in (a) is now within the film latitude, and thus recorded as useful densities. It should be noted in Figure 2.28(b) that, while information at the lower end of the log exposure range is now recorded as useful densities, information at the other end is not. The two films, Figures 2.28(a) and (b), have recorded the same information but at different density levels, and so between them will reveal all the necessary information. Here, two films are required to reveal this information. In this case information is provided with a reasonably high radiographic contrast. A single film could have been used provided it had a much lower average gradient and hence a larger film latitude, but the information provided would have been at a very low radiographic contrast in comparison. This may actually result in loss of information. The significance of multiple radiography should now be apparent.

kV Variation and Film Latitude

Another way of overcoming this problem is to use a single exposure but at a higher kV, and only expose one film. The higher kV has the effect of compressing the transmitted intensity range so that it fits into the boundaries defined by the film latitude. In other words the log exposure range for the patient part is made to decrease with increasing kV. Unfortunately, in using a higher kV the radiographic contrast decreases and, as already mentioned several times, this can result in a loss of information in the image. When using a higher kV, care must be taken that the mAs value chosen is correct. Otherwise, although the log exposure range for the patient part might have been compressed to fit the film latitude, it might be displaced relative to the range defined by the film latitude. Some image densities may then be too high or too low to be useful.

This is demonstrated in Figure 2.29 (a), (b), (c) and (d). A,B,C and D represent the different log exposure ranges for the same patient part for each of the radiographic exposures quoted. The magnitudes of the ranges B,C and D are all the same, while A is much greater. It can be seen that changing kV alters the magnitude of the transmitted intensity range and hence the log exposure range. It can further be seen from Figure 2.29 (a) and (b) that an increase in kV compresses the log exposure range so that it will fit within the boundaries defined by the film latitude. Thus all the information required is contained within the useful range of densities but only if the correct mAs is used. Figure 2.29 (c) and (d) show the effect of using the correct kV but incorrect mAs.

Exposure Latitude

Consider Figure 2.30, in which, for the same film type in each case, the useful density range and the film latitude defined by it are shown. Assume that at 70 kV and 20 mAs, for example,

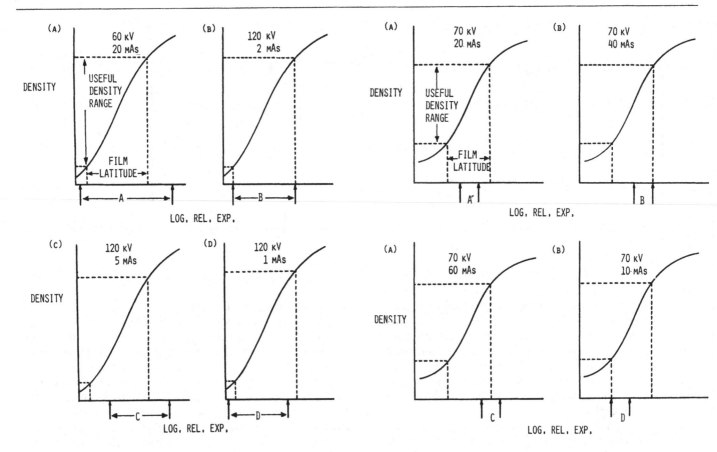

Figure 2.29 Matching the log exposure range to the film latitude by altering kV and mAs

Figure 2.30 Effect of varying mAs, illustrating exposure latitude

a particular patient part produces the log exposure range shown and labelled A (Figure 2.30(a)). It can be seen that this range is easily accommodated by the film latitude. Let the mAs be increased to, say, 40 mAs (Figure 2.30(b)). Now the log exposure range has moved to the right within the boundaries defined by the film latitude but has not changed in magnitude. Increasing the exposure still further to 60 mAs produces the result shown in Figure 2.30(c). A part of the log exposure range lies outside the range bounded by the film latitude. Thus some information is recorded as non-useful densities, and this information will be lost. It is certainly not desirable to lose information, so it would seem that the maximum exposure (at 70 kV) which can be given without losing information is 40 mAs. Figure 2.30(d) shows that 10 mAs is the minimum mAs which can be given (at 70 kV) without losing information. At 70 kV, then, the exposure range in mAs, which can safely be used without losing information in the image extends from 10 mAs to 40 mAs, i.e. a range of 30 mAs. This range of 30 mAs is often referred to as the degree of exposure mistake which can be tolerated while still producing a film containing all the required information in the image.

The log exposure range for the patient part when subtracted from the film latitude produces a quantity called the 'exposure latitude'. Here the exposure latitude has been related to an example in which actual mAs values have been used. Exposure latitude will vary with the object being radiographed since different objects give rise to different log exposure ranges. If the log exposure range increases then the exposure latitude decreases because less variation is possible within the boundaries defined by the film latitude. Even though film latitude is a constant for a given film material, exposure latitude will vary according to the object being radiographed and the kV selected.

If the kV is increased then the log exposure range is compressed and a greater variation in exposure (mAs) is possible within the boundaries defined by the film latitude. This increase in kV produces an increase in the exposure latitude. This can be demonstrated as follows:

(i) Produce two radiographs of a stepwedge using the same image recording system for both. Use 60 kVp for one and 100 kVp for the other, adjusting mAs in each to produce a reasonably good image

(ii) Now, first using 60 kVp, produce another radiograph choosing an mAs that will reduce the density such that the density difference between the two steps of lowest film density is just indistinguishable

(iii) Now do the same thing at 100 kVp using the same two steps as before

(iv) Notice that a bigger mAs reduction is required at high kV to make the information disappear than is required at low kV. This demonstrates that at high kV the exposure latitude is greater.

Summarizing the foregoing information:

(i) For a given film latitude, the exposure latitude depends on the object being radiographed and the kV selected

(ii) An object having a high subject contrast will transmit a large range of radiation intensities and the exposure latitude will be small

(iii) An object having a low subject contrast will transmit a small range of radiation intensities and the exposure latitude will be large

(iv) For a given object, if the film latitude increases, so will the exposure latitude

(v) For a given object and film latitude, an increase in kV results in an increase in exposure latitude. (It is assumed that the most important range of intensities transmitted by the object produces a log exposure range that fits within the boundaries defined by the film latitude.)

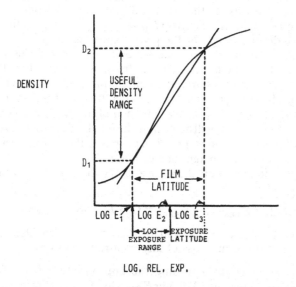

Figure 2.31 Relation between film latitude, log exposure range and exposure latitude

From Figure 2.31 it will be seen that

$$\bar{G} = \frac{D_2 - D_1}{\log E_3 - \log E_1} = \frac{\text{useful density range}}{\text{film latitude}}$$

and

$$(\log E_3 - \log E_1) = (\log E_3 - \log E_2) + (\log E_2 - \log E_1)$$

i.e. film latitude = exposure latitude + log exposure for the patient part

or exposure latitude = film latitude − log exposure range for the patient part

Now, for a given set of conditions, film latitude is a constant, so decreasing the log exposure range makes the right-hand side of the preceding equation larger and the exposure latitude thus becomes larger. It has been stated already that increasing kV makes the log exposure range smaller, so increasing kV must make exposure latitude larger. Perhaps when unsure of an exposure, a higher than normal kV should be tried in an effort to avoid an over-exposed or under-exposed image (providing that the resulting radiographic contrast is acceptable).

DETERMINATION OF RELATIVE FILM SPEED

Film speed describes the response of a given film emulsion (in terms of density) to a given exposure, and is defined as the exposure required to produce a given density. Relative film speed provides a comparison of exposures required to produce the same density (whatever value is chosen) in two different film emulsions.

If a graph of log exposure against net density is plotted then a good approximation to a straight line is obtained through the useful range of densities, i.e. for this range the ratio of density to log exposure may be regarded as constant. When measuring film speed a density value is chosen from within the linear region. In practice relative film speed is the important measure required and even then only a reasonable approximation to the true value is required as a guide to choosing exposure factors. $D = 1.0$ is often chosen as the value at which to make the measurement of relative film speed.

The method of obtaining this measure of relative film speed is described in Chapter 3. The following formula may be used:

$$\frac{S_1}{S_2} = \frac{mAs_2}{mAs_1}$$

where S_1 and S_2 are the film speeds and mAs_1 and mAs_2 are

the exposures required at a given kV and set of processing conditions to give the same density. From this formula it can be seen that the speed of one film relative to that of another is simply the inverse ratio of the mAs required in each case to produce a particular film density. The figure obtained from mAs_2/mAs_1 indicates how many times faster one film is in comparison with the other at the particular density value chosen.

The relative speed of two films can be obtained at any given density by considering their respective characteristic curves provided they are plotted using the same pair of axes and with the curves in their correct positions relative to one another (Figure 2.32). This method clearly illustrates that relative speed can vary according to the density chosen to make the measurement. In the case of the two films in Figure 2.32, the higher the density chosen at which to measure relative film speed the smaller the log E difference becomes. The log E difference can be represented by ($\log E_2 - \log E_1$).

Now
$$(\log E_2 - \log E_1) = \log \frac{E_2}{E_1}$$

Since ($\log E_2 - \log E_1$) becomes smaller with increasing density so does $\log(E_2/E_1)$ which implies that (E_2/E_1) gets smaller. (E_2/E_1) can be represented by (mAs_2/mAs_1). This means that the higher the density chosen at which to measure relative speed, the smaller is the difference in the speed between the two films.

Of course, it is not necessary to even consider mAs when obtaining a measure of relative speed by the method shown in Figure 2.32. For example, assume for one of the three log E

differences illustrated that log $E_1 = 1$ and log $E_2 = 2$. Then log E_2 - log $E_1 = 2 - 1 = 1$. The antilog of 1 is 10. Thus film 1 is 10 times faster than film 2 at the density chosen. Curves like these are rarely available because in practice comparisons are often made between films from different manufacturers. The curves are then unlikely to be produced under the same conditions, thus invalidating any comparison. The method of Chapter 3 is then applicable.

DISCUSSION

The following is presented in an attempt to relate all the foregoing points and indicate their relevance.

If X-radiation is projected into a patient, the emerging radiation pattern corresponds to the structure of the patient part irradiated. The emergent radiation beam intensity will vary from point to point in the beam. At one or more of these points, the intensity will be less than anywhere else in the beam.

Image density is proportional to the intensity of radiation reaching the film.

The difference between the highest intensity (I_{max}) and the lowest intensity (I_{min}) is stated as ($I_{max} - I_{min}$) and is defined as the intensity range.

The highest intensity (I_{max}) corresponds to the greatest exposure (E_{max}) to the film, while I_{min} corresponds to E_{min}. ($E_{max} - E_{min}$) is defined as the exposure range.

For the purpose of plotting these exposure values on the horizontal axis of the graph of the characteristic curve, the log values of exposure must be used. Log E_{max} corresponds to E_{max} and log E_{min} corresponds to E_{min} (log E_{max} - log E_{min}) is defined as the log exposure range.

E_{max} gives rise to the greatest density (D_{max}), while E_{min} gives rise to the least density (D_{min}). ($D_{max} - D_{min}$) is defined as the density range for the given exposure.

The maximum useful density and the minimum useful density form the limits of the useful density range. Exactly what these densities are, and hence what density range the useful density range covers, is difficult to say because it is subjective. Once an approximate useful density range is assumed, then this will determine the film latitude for a given film material. For most practical purposes, the useful density range will have a magnitude of about 2.

Referring to Figure 2.33, the aim of choosing an exposure is to make:

(i) ($\log E_{max} - \log E_{min}$) = ($\log E_x - \log E_y$), and

(ii) $\log E_{max} = \log E_x$ and $\log E_{min} = \log E_y$, provided this does not result in a loss of any important contrasts.

(i) is achieved by choosing the appropriate kV, or, for example, increasing kV if ($\log E_{max} - \log E_{min}$) > ($\log E_x - \log E_y$). Reducing ($\log E_{max} - \log E_{min}$) in this way, by increasing

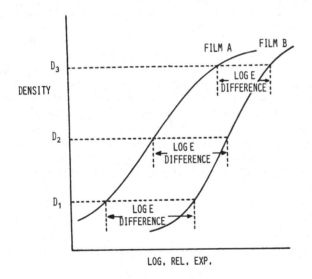

Figure 2.32 The relative speeds of two films varies depending on the density at which log E difference is measured

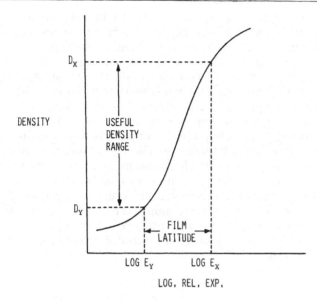

Figure 2.33 Useful density range and film latitude

kV, also reduces the resulting density range on the film. This is identical to reducing radiographic contrast until the magnitude of the density range, resulting from exposure, equals the accepted useful density range. This means that all the available information is recorded as useful densities.

Unfortunately, in compressing the log exposure range so that it fits just within the film latitude, some of the smallest density differences (i.e. image contrasts) may be reduced to a level where they cannot be distinguished (i.e. there will be less than roughly 5% difference between these densities). This is a dilemma. In the first instance, the use of too low a kV produces a log exposure range greater than the film latitude so information will be lost. Secondly, if a kV is chosen so that log exposure range is compressed to match the film latitude, information may again be lost. Of course, in practice a kV value is chosen that will ensure that the densities forming the information required are all useful and that the density differences are easily visualized.

If the densities forming the required information are all recorded as useful densities and yet it is very difficult to distinguish between them, what alternative is available? Assume that a medium speed film with fast tungstate intensifying screens is being used. Would it help if instead a film with a greater average gradient was used? To answer this, consider Figure 2.34, which shows the original situation in which all the information is recorded as useful densities but some of the contrasts cannot be visualized. Figure 2.35(b) shows the characteristic curve obtained by using the new film with the original intensifying screens. The mAs has been changed slightly to account for the increased speed of the new film but the kV and hence the log exposure range has not been changed. Notice that this combination has a smaller

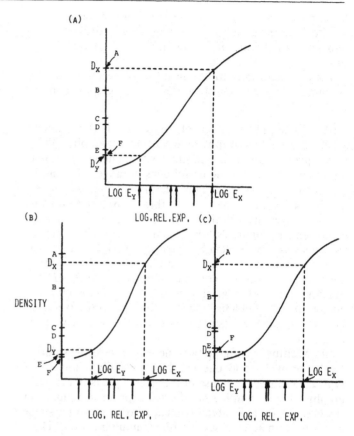

Figure 2.34 Attempts to achieve visible contrasts within the useful density range – a, b, c, d, e and f are particular densities forming the image; the differences between them represent the image contrasts

film latitude, and while some of the information is now being recorded with a greater radiographic contrast other equally important information is being lost. Figure 2.34(c) shows the situation in which the kV has been increased to compress the

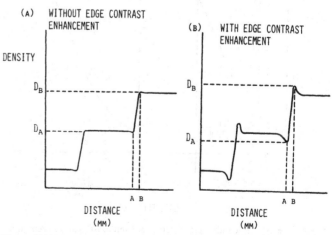

Figure 2.35 Edge enhancement

log exposure range and make it fit the new film latitude so as not to lose information. In doing this, notice what has happened to the density differences in the image. This is obviously not the solution.

Possible solutions to the problem of recording all the required information with sufficient radiographic contrast are:

(i) 'Edge enhancement' of image detail which can be achieved using xerography or 'electron radiography'. These techniques increase image contrast without necessarily altering the magnitude of the useful density range. This can be seen from the graphs (Figure 2.35) showing how image density varies across the image of three steps of a stepwedge, using xerography. Notice that in the image with edge enhancement, Figure 2.35(b), it is the density differences at the edges of image details which are made greater. This makes it easier to see them. It can be seen that for points a and b in the image, the contrast between them, $(D_b - D_a)$, is much greater with edge enhancement. Unfortunately, edge enhancement is not a technique which is generally available, because not all X-ray departments have the necessary equipment.

(ii) Multiple radiography is the second possible solution to the problem, and one which is generally available. A typical example of the use of this technique is in mammography where a number of different exposures are made at the same kV (or to limit radiation dose to the patient, a single exposure is made on several films simultaneously. These films would have approximately the same average gradient, but different film speeds). In Figure 2.36 the same film type (or single emulsion film, single intensifying screen) is used

for each of the two exposures (same kV but different mAs values). In Figure 2.36(a) information between P and Q is lost, but the remainder, between Q and R, is satisfactorily recorded. Figure 2.36(a) represents the case where for example the nipple and periphery of the breast tissue might be demonstrated, while the breast base is recorded as too low a density to provide useful information. Now, keeping kV constant (i.e. maintaining the same log exposure range), mAs is increased by the appropriate amount, and the situation shown in Figure 2.36(b) results. The information contained in the lower portion of the log exposure range (that between P and Q in Figure 2.36(a)) is now recorded as useful densities, but the information at the other end (corresponding to breast periphery and nipple) is recorded as densities too high to be useful. Thus, by using (a) and (b) together, all the required information can be recorded without reducing any contrasts.

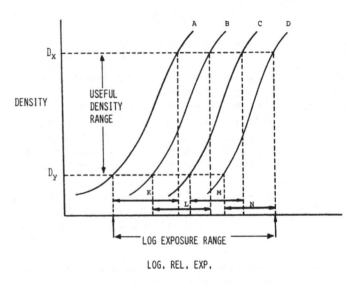

Figure 2.37 Multiple radiography using four different films with overlapping film latitudes

Figure 2.37 illustrates the case of a single exposure, made on several different films (of different speeds) simultaneously, indicated by the curves A, B, C and D. Each of these films has, approximately, the same average gradient, thus maintaining the same level of average image contrast for comparison.

The film latitudes K, L, M and N for each of the films A, B, C and D overlap. This means that all the available information in the log exposure range is recorded in sections by the four films, without any image contrast reduction. This is the principle of the multifilm pack for mammography.

(iii) Besides the above two methods of recording all the available information with sufficient radiographic contrast, there are additional methods whereby image information

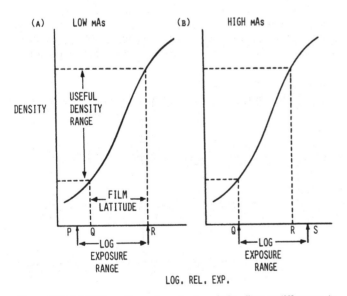

Figure 2.36 Multiple radiography using two similar films at different mAs values

can be made more readily visible. One method does not involve the patient in any further radiation dose beyond that of the original film. The process involved is a photographic one and is called two-stage photographic harmonization.

Harmonization of a radiograph involves a transformation of the image whereby the overall background ('macrocontrast') is diminished while the fine detail in the image is preserved. A blurred positive mask is made from the original radiograph by diffusing the image through a thin sheet of opal Perspex (the front of a viewing box) onto an unexposed film placed underneath as shown in Figure 2.38. The image so produced lacks the detail of the original, registering only the background. By superimposing this positive film on the original radiograph, with emulsion sides together, part of the background is cancelled out with consequent subjective enhancement of detail. What has happened is that the more obvious contrasts are reduced to zero without greatly affecting the less obvious contrasts. Subjectively, they are then more noticeable. The small contrasts have not been increased; on the contrary, they have probably been reduced somewhat by the superimposition of the more or less uniform density of the positive mask film. Even so, these small contrasts are now more noticeable.

Figure 2.38 Stage 1 of two-stage photographic harmonization

To complete the first stage, a copy is made of the two superimposed films. A single emulsion duplicating film is suitable for this. The success of the first stage depends on the exposure used to produce the subtraction mask (positive copy). Unless this exposure is correct, subtraction of the more obvious background information will not be entirely successful. In general, the greater the densities in the original radiograph, the greater must be the densities in the subtraction mask to achieve successful subtraction.

The second stage involves superimposing the original radiograph on the copy obtained as the end result of the first stage. The emulsion side of the copy film is placed in contact with the radiograph. The image resulting from this arrangement of films is copied on duplicating film. The final image will show that the background contrast has been restored to normal but the image detail is now, as it were, represented twice and the contrast of this detail is thus increased. Detail perceptibility will be improved provided that the inevitable reduction in resolution is acceptable.

(iv) The last method to be mentioned uses Medichrome film, which is a product of Agfa Gevaert Ltd. Only one exposure is necessary on a single film used with a single intensifying screen in the case of mammography and possibly extremities, or with paired screens for most other examinations. The film requires special processing solutions and cannot be processed in the conventional autoprocess chemicals. The resulting image is blue and grainfree since the silver image is replaced by a blue dye image during processing. The effective average gradient for the characteristic curve for this film is dependent on the spectrum of light used to view it. Progressing gradually from blue to red through the spectrum produces a gradually increasing average gradient. A high contrast image is produced using red light while a very low contrast is achieved using blue. Thus various degrees of image contrast can be achieved with only one exposure.

Returning to point (ii) on p. 30, i.e. making $\log E_{max} = \log E_x$ and $\log E_{min} = \log E_y$, it is noted that previously kV was increased to make the log exposure range and the film latitude the same magnitude, but unless the mAs is correct, the log exposure range may not coincide with film latitude on the $\log E$ axis (Figure 2.39). In Figure 2.39(a) the log exposure range is too great so kV is increased to compress it to the same magnitude as the film latitude (Figure 2.39(b)). Here the log exposure range has certainly been compressed and its magnitude is the same as the film latitude. Unfortunately the two do not coincide and image information is lost. What is needed is an mAs increase to increase all the exposures in the log exposure range thus shifting it *en bloc* to the right. If the correct mAs increase is chosen then the endpoints of the log exposure range can be made to coincide with the endpoints of the film latitude. This is the same as requiring $\log E_{max} = \log E_x$ and $\log E_{min} = \log E_y$ once $(\log E_{max} - \log E_{min}) = (\log E_x - \log E_y)$ is achieved. If an approximate characteristic curve has been produced for this film–intensifying screen combination using a method similar to that given on pp 16–17, then the amount of exposure increase can be calculated.

The situation of Figure 2.39(b) is shown again in Figure 2.40 where it is seen that the highest useful exposure in the log exposure range (A) produces a net density of $D = 1.2$ and the film is considered 'underexposed'. For a correctly

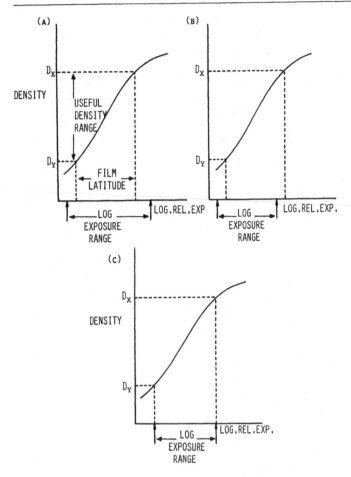

Figure 2.39 Fitting log exposure range to film latitude

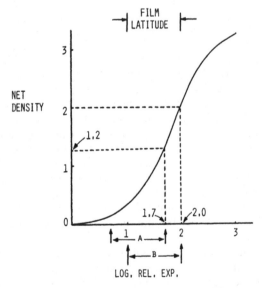

Figure 2.40 Increasing the exposure in order to achieve correct density range

exposed film a net density of $D = 2.0$ is required, as with log exposure range (B). The log relative exposure ($\log E_1$) producing the density of 1.2 is 1.7 while the log relative exposure ($\log E_2$) producing $D = 2.0$ is 2.0.

Therefore $\qquad \log E_2 - \log E_1 = 2.0 - 1.7 = 0.3$
and \qquad antilog $0.3 = 2$

Thus the exposure must be increased by a factor of 2 to produce the situation of Figure 2.39(c); in other words double the exposure (mAs) is required.

In practice it is unlikely that the log exposure values will be known but the basis of a practical method is now available. It is assumed that the correct kV has been used, but that the mAs chosen results in an underexposed film. Further assume that for the prevailing processing conditions the approximate characteristic curve for the film–intensifying screen combination used has been produced. The useful density range can be taken as 0.25–2.0 (net density) and \bar{G} for this range can be measured. Let $\bar{G} = 2.7$ for this example. This value can be used each time the same film–intensifying screen combination is employed provided that there is no significant change in processing conditions. (If a densitometer is not always available then a stepwedge image can be produced on which the density values for each step are marked. Image densities can then be assessed by comparison with the stepwedge image. A stepwedge image with 15–20 steps with a density change of 0.2 to 0.3 at each step is suitable.)

Assume that comparison of the under-exposed film with a correctly exposed film of the same type from some other patient indicates that on average the density of the important detail is $D_2 = 1.0$. In the under-exposed film for the same image area $D_1 = 0.5$. How much should the mAs be increased to achieve a density $D_2 = 1.0$? Now,

$$\bar{G} = \frac{\Delta D}{\Delta \log E} = \frac{D_2 - D_1}{\log E_2 - \log E_1}$$

Here the sign 'Δ' is used to mean 'a change in'. \bar{G} is 2.7, while the change in density required is from 0.5 to 1.0. It is not necessary to know $\log E_1$ and $\log E_2$.

Hence, $\qquad 2.7 = \frac{(1.0 - 0.5)}{\Delta \log E} = \frac{0.5}{\Delta \log E}$

or, $\qquad \Delta \log E = \frac{0.5}{2.7} = 0.18$

and, antilog $0.18 \simeq 1.5 =$ change in E

Thus the mAs used to produce the under-exposed film must be multiplied by 1.5 to produce a correctly exposed film.

This method is certainly adequate for practical purposes and is better than just guessing when an exposure mistake in

terms of mAs has been made. It is quick and simple, just requiring a stepwedge image and familiarity with a set of log tables; extreme accuracy is not required. This procedure can also be applied where an over-exposed film (in terms of mAs) must be repeated. Here the answer obtained will be the factor by which the mAs must be reduced.

The objective has been achieved, but if the log exposure range were made less than the film latitude then, although all the information would be recorded, there would be less than optimum radiographic contrast for showing all the required information. Notice that at this point a situation has been reached in which there is no exposure latitude. This is a highly desirable situation, unless there is no idea of what the exposure factors should be.

To overcome the problem of not knowing what mAs to use, automatic exposure devices are available, which if used correctly produce excellent results. The problem of not knowing what kV to use would require the use of a system such as 'Anatomically Programmed Radiography' produced by Philips Medical Systems. Systems like this are unlikely to be generally available for some years, so an understanding of the problems involved in the imaging process is necessary and attempts must be made to overcome them using the facilities generally available.

Finally, to summarize, in practice within the confines of a given imaging system the aim is:

(i) To compress (or expand) the log exposure range by increasing (or decreasing) kV so that the magnitude of the log exposure range conveying diagnostic information is the same as that of the film latitude. This ensures that the optimum radiographic contrast under these particular circumstances is achieved.

(ii) To make sure that the limits of the log exposure range coincide with those of the film latitude by adjusting mAs (once the appropriate kV has been selected). This ensures that all the diagnostically useful information is recorded as 'useful' densities.

3

Film Materials

INTRODUCTION

X-ray films are an essential and integral part of the imaging system. The behaviour of an X-ray film under the imaging conditions chosen will determine the quality of the final image. A variety of film materials is available for use and an understanding of the behaviour of these under different imaging conditions depends initially on a knowledge of their individual properties. These will be discussed in the following sections and a few examples given of how these properties relate to the required image quality.

CONTRAST AMPLIFICATION

Except in a few special cases, films used in radiography as image-recording media act as contrast amplifiers. This is particularly important in soft tissue radiography where subject contrast is low and a non-screen film imaging system may be used.

Consider an imaging system where the subject contrast is represented by the log exposure difference on the log relative exposure axis shown in Figure 3.1. For the given log exposure difference ($\log E_2 - \log E_1$) a far larger image density difference results because the value for average gradient here is greater than 1.

If $\bar{G} = 1$, then from $\bar{G} = \dfrac{D_2 - D_1}{\log E_2 - \log E_1}$

$$\log E_2 - \log E_1 = D_2 - D_1$$

and no contrast amplification is achieved. It should be noted that the use of intensifying screens increases both relative speed and average gradient. The increase in average gradient provides greater contrast amplification. Overall contrast amplification depends on \bar{G} but contrast amplification also depends on G and hence varies from point to point on the curve. Figure 3.2 shows two characteristic curves for the same film type but one is exposed with intensifying screens while the other is not. Note the differences in both G and \bar{G} between the two curves. Note also the relative speed differences at different density levels two of which are shown, 32 at D_1 and 64 at D_2.

It is interesting to consider the image contrast obtained for a given small log exposure difference at different density levels and for different film types. Figure 3.3 shows two

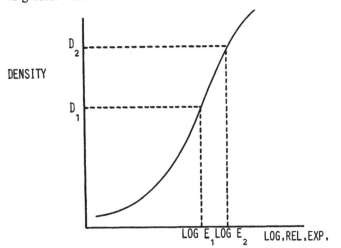

Figure 3.1 Contrast amplification when $\bar{G} > 1$

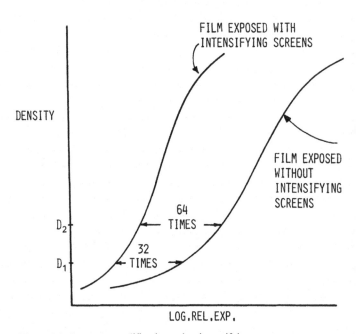

Figure 3.2 Contrast amplification using intensifying screens

36

typical characteristic curves, in which A, B and C represent the log exposure differences for different mAs values but the same kV. In the low density region the gradient of the curve A is greater than B and a higher image contrast is obtained. The reverse is true for higher densities. High image contrasts are required at low densities in mammography, for example, and for this A is considered better than B provided the resolution of the imaging system is adequate.

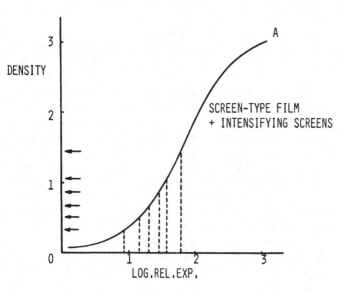

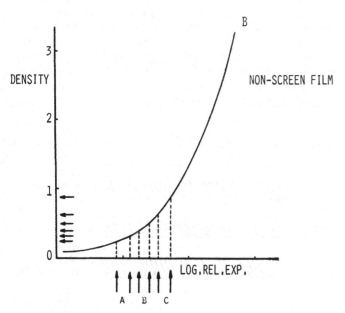

Figure 3.3 Characteristic curves for different film types, showing varying contrasts at different image densities

FILM TYPES

Several different film types have application in radiography:

(i) duplitized and single emulsion film for use with intensifying screens
(ii) duplitized, non-screen (direct exposure) film
(iii) single emulsion film for photofluorography
(iv) single emulsion film for photographic subtraction
(v) single emulsion film for the copying of radiographs
(vi) Polaroid Land film
(vii) radiation monitoring film.

Groups (i)–(v) are used in radiographic imaging techniques while a common application of (vi) is in medical ultrasonics for scan imaging. Radiation monitoring film is not used for radiographic imaging but for recording a film density proportional to a radiation dose. Films from groups (i)–(iii) are available in a variety of speeds and contrasts each having their own particular application.

Which of the different types and characteristics are selected for use in a given department will depend on a number of factors such as

(a) standard of image result
(b) relative advantages and disadvantages of each type
(c) processing requirements
(d) cost and availability
(e) storage capacity
(f) rate of use and shelf-life
(g) accessory equipment required, method and ease of use.

Often, because of the large number of patients dealt with, large film throughput and a large staff complement, there is much to be said for procedural simplification and standardization to avoid errors leading to film wastage and increased patient radiation dose. Consideration of factors such as

(a) mistakes in use of film type
(b) confusion as to type to use
(c) simplification of darkroom procedures with standardization
(d) simplification of stock control with faster stock turn-over
(e) simplification of in-service training

leads normally to the conclusion that standardization using the minimum number of different film types, speeds and contrasts compatible with acceptable image quality is necessary. Adopting this approach may lead to an apparent rather than actual deterioration in image quality over part of the range of work because of limiting the number of different film types used.

Whatever approach is used to this problem the film materials chosen should have the right balance between

speed, contrast, film latitude and resolution for integration into the imaging system for use in a particular range of work. Fog level should be low so as to have the smallest effect on contrast and fog level should change little under suitable storage conditions. A poor understanding of changes in film characteristics with storage and use can often result in storage, exposure and processing conditions which produce an image quality inferior to that expected from manufacturers' claims. Manufacturers are often unfairly blamed. Tests requiring access to a densitometer should always be carried out to assess comparative image quality under existing conditions and, where practicable, changes made in these conditions to try and effect improvements. All results can be recorded and graphed to allow interpolation where required.

Screen-type Films

These may be duplitized or have a single emulsion and can be either monochromatic or orthochromatic.

Duplitized screen-type film, both monochromatic and orthochromatic, is designed for use sandwiched between a pair of intensifying screens and for high speed automatic processing. If necessary it can also be processed manually. The modern autoprocess films have lower coating weights than the older manual process film, and are more durable due to the emulsion layers being pre-hardened to a greater extent. A relatively large range of films is available giving a good choice of film size (metric), film speed, contrast and resolution, and exposure latitude. It is not possible to select a film in which each of the individual characteristics is exactly right, since they are interrelated and only a compromise can be obtained. For example, an emulsion giving a high film contrast will have low exposure latitude particularly at low kV. The high contrast and the low kV are necessary when investigating radiographically a patient part of low subject contrast. Because of the low exposure latitude for the film, the exposure chosen must be accurate since even a small degree of exposure mistake will decrease the amount of diagnostic information available in the image.

Screen-type films are not generally intended for use without intensifying screens since the image contrast will be much lower, but they have been tried for extremity work. When used without intensifying screens, screen-type films are exposed to X-rays alone, and it is the X-rays which form the latent image. When used with intensifying screens the latent image is formed mainly by the intensifying screen emission. The X-rays do play a small part in directly forming the latent image but it is insignificant in comparison with that due to screen emission. The emission from the intensifying screen as a result of excitation by X-ray photons intensifies the imaging effect of the X-ray beam allowing smaller radiation doses to be used in practice.

In general two speeds of screen-type film are available, the slower film usually being classed as 'standard' or 'medium' speed, and the other as 'fast'. The faster film is very useful where it is necessary to keep the radiation dose to a minimum, but the quality of the image is not usually as good as that obtainable with the medium speed film. Medium and fast films from one manufacturer are not necessarily the same speed as medium and fast films from another manufacturer, and when changing films it is essential to have a measure of relative film speed. This is also necessary when changing from medium to fast films or vice versa.

Film–Intensifying Screen Combinations

Since screen-type films are used with intensifying screens, it is essential to ensure that the best combination is chosen. This may be done by objective testing, by visual comparison, and of course by consideration of manufacturers' recommendations. What the 'best' combination is will depend on the circumstances prevailing and the image quality required. It must be remembered that the 'best' film–intensifying screen combination for a particular case will not be fully appreciated unless the other parts of the system (including exposure factors) are optimized. Screen-type films are made to match the intensifying screens produced by the same manufacturer. It is unlikely that a gain in objective image quality will be obtained by not matching a film with the recommended intensifying screens.

A single emulsion film–single intensifying screen combination for mammography is arranged in a different way to a duplitized film–screen system due to the low kV values used (Figure 3.4). If the intensifying screen were placed between the X-ray beam and the film, a small proportion of the beam would be attenuated by the screen with little or no screen emission and some under-exposure would result. Perhaps more importantly, when a back intensifying screen is used the image is formed by emission from the upper layers of the screen adjacent to the film emulsion. With a front intensifying screen the emission comes from the deeper layers thus increasing unsharpness (Figure 3.5).

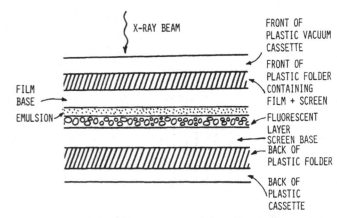

Figure 3.4 Section through a vacuum cassette used in mammography

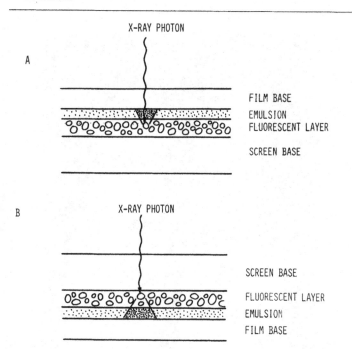

Figure 3.5 A front screen (B) forms a larger, more diffuse image than a back screen (A) because of the greater distance of the emitting phosphor particle from the emulsion

When used with their respective intensifying screen system single emulsion films have a lower relative film speed than duplitized films. Their \bar{G} is also lower but this is to be expected with a single emulsion film. Although the single emulsion film has these relative disadvantages, it does have superior resolution, and, when compared with a duplitized, non-screen imaging system, has a higher relative speed and a higher \bar{G} when used with its matched single intensifying screen. In comparison with a duplitized film–paired intensifying screen system the only advantage is one of higher resolution, mainly because of the smaller phospher particles in the screen and the absence of cross-over.

Duplitized film in conjunction with paired intensifying screens can now be used for virtually all radiographic techniques. Intensifying screen pairs are generally available in several different speeds, the slowest having the higher resolution. By choosing suitable combinations of film–speed and intensifying screen–speed and resolution, various imaging systems can be obtained suitable for virtually all radiography. In all cases the spectral sensitivity of the film emulsion must be matched to the spectral emission of the intensifying screen to achieve the optimum response.

Non-screen Film

Direct exposure film is designed for use without intensifying screens, the latent image being formed solely by X-rays. Direct exposure films are used contained in light-tight

Figure 3.6 Prepacked Kodak direct exposure film in paper envelope

envelopes (cassettes) made of either plastic or cardboard, or in paper envelopes prepacked by the manufacturer (Figure 3.6).

If the film is to be processed in an automatic processor of the 90-second type, its emulsion layers must have a coating weight no greater than that of a screen-type film otherwise incomplete processing occurs in the short processing time allowed. Increasing coating weight is an effective way of increasing a non-screen film emulsion response to X-rays, but such films can only be processed manually. Industrial non-screen films originally used in mammography and also used for radiography of specimens in research departments have high coating weights and relatively thick emulsion layers and are only suitable for manual processing. Auto-process non-screen films overcome the problem of a reduced coating weight by the use of sensitizers during emulsion preparation.

The main advantage of a non-screen image recording medium is its superior resolution compared with film–intensifying screen combinations. Provided the correct technique is employed this superior resolution allows much finer detail to be visualized in the image, even under considerable optical enlargement. Because of the relatively low speed of a non-

screen system, and hence the relatively high radiation dose required, this type of film is only suitable for extremity radiography and radiography of other body parts – e.g. teeth, surgically exposed kidney, mammary glands. Even in these cases the use of non-screen films is only justified when other faster recording systems lack the resolution to provide the image detail required. Nowadays the use of a slow non-screen imaging system can rarely be justified for medical radiography. The non-screen film designed for radiography of an exposed kidney is specially shaped and is contained in an envelope which can be cold sterilized. The film is suitable for processing in a high speed automatic processor. The special shape allows anatomical identification to be made and makes easy the positioning of the film around the renal blood vessels (Figure 3.7).

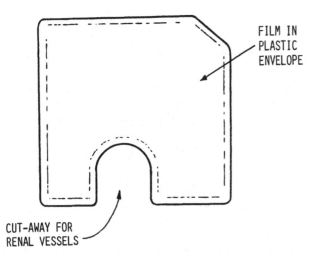

Figure 3.7 Film for kidney surgery. This Kodak film is approximately 10 cm by 13 cm

Dental Film
Dental films are non-screen films. They are duplitized and contained in light-tight envelopes prepacked by the manufacturer (Figure 3.8). The periapical dental film is the smallest and is designed for radiography of individual teeth or small groups of teeth. The occlusal type of dental film is larger and designed for radiography of mandibles and maxillae while being held in the occlusal plane. The tab on the 'bite-wing' film is for holding between the teeth thus holding the film vertically against both upper and lower teeth. The typical periapical and occlusal films are contained in light-tight envelopes sandwiched between sheets of paper next to a thin sheet of lead foil (Figure 3.9). An embossed dot is used as an identification system as these films are too small to allow the use of anatomical markers. It is essential to use these films with the correct side facing the X-ray tube because of the presence of the lead foil acting as a radiation attenuator.

Figure 3.8 Kodak dental film. The 'bite-wing' film is shown at the top

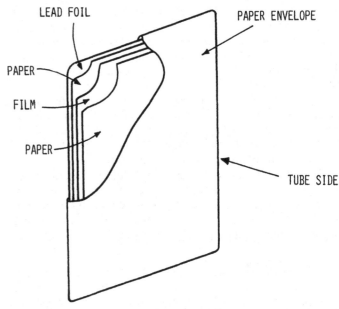

Figure 3.9 The wrappings of a typical dental film

Films for Subtraction and Duplication

These are specially designed single emulsion films. Their behaviour is best understood from a consideration of their characteristic curves and this will be left until Chapter 15. Both films are used for contact printing of original X-ray films. The subtraction film produces a positive image, the reverse of the original, while the duplicating film is designed to produce a copy of the original. 100 mm duplicating films are available to copy original radiographs but special equipment is necessary to produce a copy since contact printing is not possible if the whole of the original image is to be reduced onto the 100 mm film.

All subtraction and duplicating films have an anti-halation layer. The emulsion side of the film is usually identified by means of one or more notches cut out of the edge of the film near one corner. When the notch is at the upper right-hand corner, the emulsion side faces you. Subtraction and duplicating films are available which can be processed in a 90-second automatic processor.

Fluorographic Films

Fluorographic films are designed to photograph the image produced at:

(i) the output phosphor of an image intensifier tube
(ii) the fluorescent screen of a camera unit (e.g. Odelca camera)
(iii) a TV monitor screen (kinefluorography).

All fluorographic films have a single emulsion and anti-halation layer.

16 mm and 35 mm roll film (Figure 3.10) is used for cine recording of the image at the image intensifier tube output phosphor (cinefluorography). The output phosphor emission spectrum of a typical intensifier tube is shown in Figure 3.11 and the cinefilm must have either an orthochromatic or panchromatic emulsion to respond to this. The majority are panchromatic. 16 mm cinefilm is used for kinefluorography. 70 mm, 100 mm, and 105 mm films are available for single or rapid sequence exposures usually up to 6 frames per second but higher frame speeds have been used. These are not cine films but they are used in conjunction with an image intensifier. The films, depending on format, are available as roll film or sheet film (cut film), and all have orthochromatic emulsions. 70 mm and 105 mm are roll films, 100 mm is available as single sheet film. The Old Delft Odelca camera uses 70 mm roll film or 100 mm sheet (cut) film depending on camera model (Figure 3.10).

Polaroid Film

This has been used in theatre radiography, placed in a special cassette with a single intensifying screen. The end result is a positive image on paper which is viewed by reflected light. In

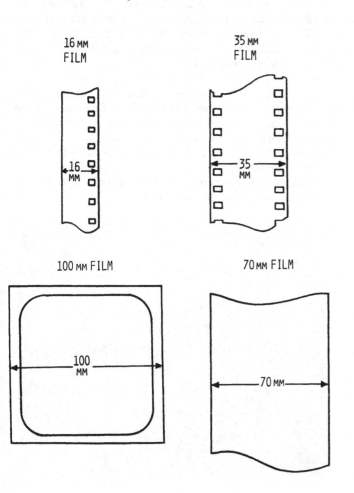

Figure 3.10 Sizes of X-ray film

Figure 3.11 Spectral emission from the output phosphor of a typical image intensifier tube

Figure 3.12 TV monitor camera attachment loaded with Polaroid film

X-ray departments using diagnostic ultrasound, for example, Polaroid films are used to photograph the image produced on the cathode ray tube of the ultrasound equipment (Figure 3.12). However there is an increasing tendency to use single emulsion, orthochromatic film for such applications.

Figure 3.13 Structure of Polaroid film

The Polaroid material (Figure 3.13) consists of two layers:

(i) The top layer is formed from light sensitive film, and here the latent image is formed on exposure to light. During processing the final image is formed as a result of image transfer from this layer to the lower layer. The top layer is discarded following processing.

(ii) The lower layer is not light sensitive, and this layer holds the final image. The image must be viewed by reflected light since it is supported on an opaque paper base.

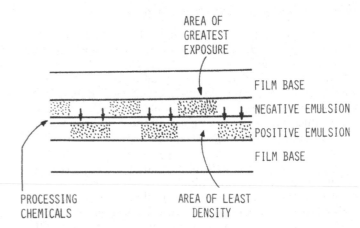

Figure 3.14 Development of Polaroid film

The image formed on the top layer is described as negative, while the image on the lower layer is positive. The two film layers are only brought together after exposure. The sealed container of processing jelly is ruptured, the chemicals spread evenly over the surfaces of the film layers as a result of pulling the film through a narrow opening in the camera, and film processing commences.

In the negative film the latent image is made visible, following the reduction of the exposed silver halide forming the negative image. Silver ions from the unexposed areas diffuse across to the positive film (Figure 3.14) to form an image which is the reverse, in terms of densities, of that on the negative film. The positive image can be viewed when the two films are peeled apart when processing is complete after 10–15 sec. A typical result is shown in Figure 3.15, which is an ultrasound scan of a pregnant uterus.

Figure 3.15 B-scan of a pregnant uterus recorded on Polaroid film

Radiation Monitoring Film

This is similar in appearance to dental film (22 mm × 36 mm) but has an identification number embossed on it. The most common type is duplitized but the coating on each side of the base is not the same; one coating has a high speed while the other emulsion coating is of lower speed. The faster of the two emulsions is arranged to face the front of the film badge when used. The use of two emulsions of different speeds allows a very wide range of exposure dose levels to be assessed. Small exposures are recorded and assessed using the faster emulsion, as they have no effect on the slow emulsion. Large exposures are likely to produce densities too great to be accurately measured in which case the fast emulsion must be removed and the density on the slow emulsion measured. This density is then used to assess the exposure dose received.

Examples of characteristic curves for the two emulsions are shown in Figure 3.16. While small exposures produce no film effect above gross fog on the slow emulsion, its gross fog level though very small will be superimposed on the density (D_2) recorded by the fast emulsion. The high exposure is recorded as D_3 on the fast emulsion and D_1 on the slow emulsion. D_3 is too high to be accurately measured, but if the fast emulsion is removed the exposure can be assessed from D_1. Required film characteristics are sufficient relative speed to respond to small but significant exposure doses of X- or γ-rays, constant speed from batch to batch for a given set of processing conditions, constant low fog level, and minimum latent image fading throughout the period worn.

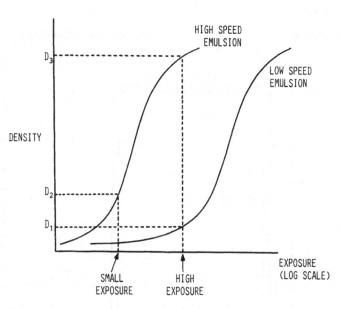

Figure 3.16 Low and high exposures of the two emulsions in radiation monitoring film

Film Sizes

The commoner metric film sizes are given in Table 3.1.

Table 3.1 Metric film sizes

Dental film (mm)	Screen-type and direct exposure film (cm)	Fluorographic film (mm)	
22 x 35	13 x 18	16	
27 x 54	15 x 13	35	roll film
32 x 41	15 x 40	70	
57 x 76 (occlusal)	18 x 24	105	
	20 x 40		
	24 x 30		
	30 x 40	100	(cut film)
	35 x 35		
	35 x 43		
	40 x 40		

Film Packaging

Film material supplied by the manufacturer is packed and sealed in such a way that the films are fully protected against the adverse effects of fumes and high relative humidity. Once opened, full protection is no longer available. Some gases and high relative humidity can produce an increase in the fog level of unprocessed film. High temperatures and extreme temperature variations also cause an increase in fog level and unfortunately the packing cannot protect against this. The choice of film storage conditions is aimed at reducing the rate of increase of fog level during the storage period.

Films for use with intensifying screens are available packed with interleaved paper to facilitate handling, though this is not essential. Films for use without intensifying screens can be obtained with each prepacked in its own light-tight paper envelope ready for use.

Handling and Processing

All film material should be handled as little as possible and then at the edges or corners with hands that are clean and dry, otherwise marks can be left on films which can be clearly visible after processing. They may interfere with image detail visualization. Film material should be handled with care as pressure marks can be formed which appear as high or low density marks on the film after processing. Films should be handled only under the correct safe-lighting conditions and then for the shortest possible time necessary to complete the film handling task. Incorrect safe-lighting conditions or excessive film handling times can lead to unacceptable film fogging.

All the above faults are avoided if a correctly functioning automated film handling system ('Daylight' system) is employed. The handling of film and its introduction into an

automatic processor, or the film loading of an automated film handling system, is best learnt by practical example. All sheet film suitable for automatic processing should be fed to an automatic processor in a systematic manner, since replenishment rates for processing chemicals are based in part on an agreed method of film feed. Single emulsion film is usually fed into the processor emulsion side down. Small format, single emulsion roll film can be processed in a 90-second processor used for large sheet film but care should be taken with replenishment rates where a long film is to be processed. This will be discussed in more detail in Chapter 12.

RELATIVE SPEED EVALUATION

When using a number of different film types it is necessary to have some idea of the speed (p. 29) of one relative to another so that exposure factor conversion can easily be carried out. An estimate of relative film speed, sufficiently accurate for practical purposes, can be obtained by the method described below. The test described relates to two different speed films normally used with similar intensifying screens and need only be done for one set of conditions, because this is a test of relative speed and the result will therefore apply to other sets of conditions. Whenever such a test is carried out, it must be remembered that, to provide reasonably useful results, identical test conditions must apply to both films (this test is limited to two films, but more than two could be tested at one time).

The materials required are:

(1) Aluminium stepwedge, wide enough to cover the whole cassette, with 10–20 steps.
(2) A single cassette loaded with half of one test film adjacent to half of the other film. To achieve this the test films must be cut in half, and the two film halves should not overlap in the cassette. The cassette contains a pair of intensifying screens which would normally be used with these types of film. 24 cm × 30 cm is a suitable cassette size so that the stepwedge is of reasonable proportions and the film halves are a suitable size for handling and processing. A single cassette is used so that similar conditions apply to both films simultaneously.
(3) A means of identifying the films and recording the exposure received is necessary. A series of lead letters could be used.
(4) X-ray equipment to make the required exposures.
(5) Densitometer. If one is not available, densities must be visually compared.
(6) Lead rubber pieces of suitable size and lead equivalent.
(7) Automatic processing facilities to ensure similar film processing.

Initially, to determine which of the two film halves has the greater speed, a single exposure is used, exposing the two film halves simultaneously. After this, a whole film is loaded into the same cassette and, making use of the lead rubber pieces, the film is given a series of different length exposures at the same kV as before. (It is convenient to hold the mA fixed and vary the times as for this test reciprocity failure can be ignored. Reciprocity failure is discussed in Chapter 7.) It is assumed that the exposure timer is accurate. The mAs used will depend on the speed of the intensifying screens, the type of X-ray equipment, and the FFD.

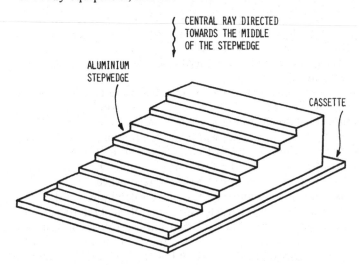

Figure 3.17 Stepwedge for measurement of relative film speed

Method

A single exposure is made with the equipment arranged as in Figures 3.17 and 3.18. 60–80 kV$_p$ is chosen with sufficient

Figure 3.18 Arrangement of films for measurement of relative film speed

mAs to produce, on one of the film halves, a series of step densities approximately covering the useful density range. The FFD chosen should be constant throughout. Following exposure the two film halves are processed together. On the film half which appears correctly exposed, a step density near the middle of the useful density range is measured. The step number and density value should be noted. Assume that it is the middle step with $D = 1.0$. Relative to this the other film half may be under-exposed, over-exposed or correctly exposed. If the other film half has a middle step density of 1.0 then the two films have the same relative speed and the test is complete. If, however, its middle step density is higher or lower than 1.0 then additional exposures are required to determine relative speed. Consider the case of under-exposure. The procedure is as follows:

(i) The same cassette is reloaded with this slower film. It is not necessary to cut the film.

(ii) A series of increasing exposures is made, changing only the exposure time; the other exposure factors and related details remain the same as for the initial exposure. The lead rubber pieces are used to cover all the cassette except the strip being exposed (Figure 3.19), which is moved for each exposure. The idea is that one of the exposed strips will have a middle step density $D \simeq 1.0$, in other words will have a middle step density approximately equal to that on the correctly exposed film half. A series of some 5 to 8 exposures will usually be sufficient commencing with an exposure time just greater than that used for the initial exposure and terminating with an exposure which is thought to give a middle step density greater than one.

(iii) This film is processed in the same way as before and each of the middle step densities measured. One of them should have $D \simeq 1.0$, and the exposure time used to produce this is noted. The ratio of this

exposure time to the exposure time used for the initial exposure for the two film halves gives the relative film speed for this density. If a densitometer is not available, approximately equal middle step densities can be judged by visual comparison. The density $D = 1.0$ can be assessed by placing the film over a sheet of printing, which should only just be visible through the film.

As an example, let the initial exposure time be 0.4 s and the exposure time required to produce an approximately equal middle step density on the under-exposed film be 0.8 s. The speed ratio is then 0.8:0.4 or 2:1, which means that one film is twice the speed of the other. This approximate measure of relative film speed can be applied satisfactorily at any kV within the diagnostic range.

If an automatic exposure device is used the second part of the test is somewhat different. Instead of making a series of exposures by altering the exposure time, the autotimer sensitivity setting is altered at each exposure. The correct setting may be judged by comparing midstep densities.

Often in practice it is necessary to have some idea of relative exposure values for different film–intensifying screen combinations where the films have different spectral sensitivities and the screens employ different phosphor materials with quite different emission spectra. Here, unfortunately, the relative speed figure obtained will vary with kV and with the properties of the stepwedge or other interposed attenuator, and only a rough guide to relative speed can be obtained for use in practice. This will be considered in more detail in Chapter 5.

Knowledge of relative speed is also required when changing from a non-screen imaging system to a film–intensifying screen combination in extremity radiography or mammography. Again the relative speed is dependent on the kV and the amount of scattered radiation reaching the intensifying screens, but in this particular example only small

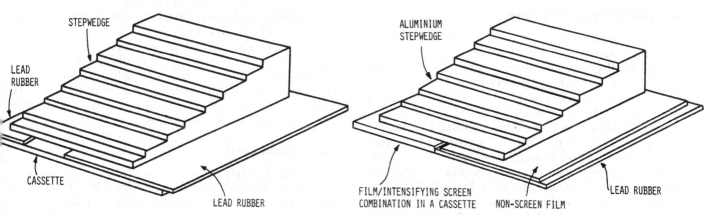

Figure 3.19 Arrangement of lead rubber sheets for measurement of relative film speed

Figure 3.20 Measurement of relative speeds of a non-screen film and film–screen combination: arrangement for first exposure

patient parts are likely to be radiographed and the percentage scatter content of the beam is likely to be small. The stepwedge can satisfactorily be used to obtain the approximate measure for relative speed using a kV value representative of that used for extremity radiography (50–55 kVp) or mammography (25–35 kVp) as the case may be. The steps in the procedure are similar to those described above (see Figures 3.20 and 3.21). The relative speed measure obtained can be used satisfactorily over the limited kV range normally used for this type of radiography.

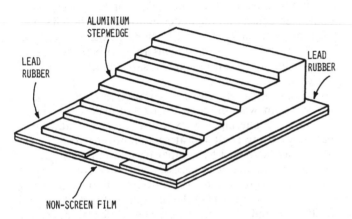

Figure 3.21 Measurement of relative speeds of a non-screen film and film–screen combination: arrangement for series of separate exposures

Finally a relative speed measurement may be required for two or more different non-screen films. In this case the test procedure is identical to that described previously but a non-screen film holder (cassette) is used to hold the films. A different method of relative system speed evaluation is considered in Appendix 3, page 286. A stepwedge calibration is employed and for continued use the method is simpler than that described above but there are pitfalls and these are discussed.

Factors Affecting Relative Speed

Where intensifying screens are used which employ different phosphor materials then the kV at which the test is performed will affect the value obtained for relative speed. For example, when comparing a calcium tungstate intensifying screen–film combination with a rare-earth intensifying screen–film combination, relative speed increases with increasing kV for a large part of the diagnostic kV range.

Imaging media with different speeds and average gradients (\bar{G}) will show a variation of relative speed depending on the density value at which densities are compared even though the kV remains constant. Figure 3.22 gives an example of this. The log exposure differences for two imaging systems A and B are measured at $D = 1.0$ and $D = 2.0$.

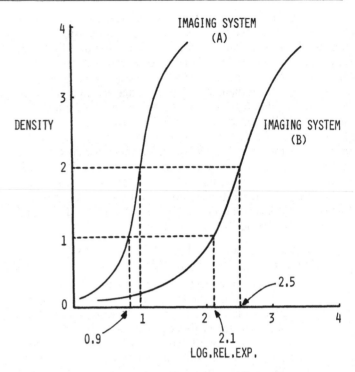

Figure 3.22 Characteristic curves for two different imaging systems, showing different relative speeds measured at different densities

$$\Delta \log E \text{ at } D = 1.0 \text{ is } (2.1 - 0.9) = 1.2$$
$$\text{antilog } 1.2 \simeq 16$$

$$\Delta \log E \text{ at } D = 2.0 \text{ is } (2.5 - 1.0) = 1.5$$
$$\text{antilog } 1.5 \simeq 32$$

Therefore at $D = 1.0$, A is some 16 times faster than B, while at $D = 2.0$, A is some 32 times faster than B. If the film contrast at all points is the same for the two imaging media then their relative speed is independent of density.

Processing conditions affect both density and film contrast and will thus affect relative speed, but providing an automatic processor is used and is working within accepted limits the effect of processing can be disregarded for practical purposes. Film speed falls with increasing storage time and average gradient also decreases. Both of these factors affect relative speed at different densities but the effect is normally small with correct storage conditions.

Characteristic Curves

Figure 3.23 illustrates typical characteristic curve shapes and relative positions for many modern X-ray films. Figure 3.24 shows curves for duplicating and subtraction film.

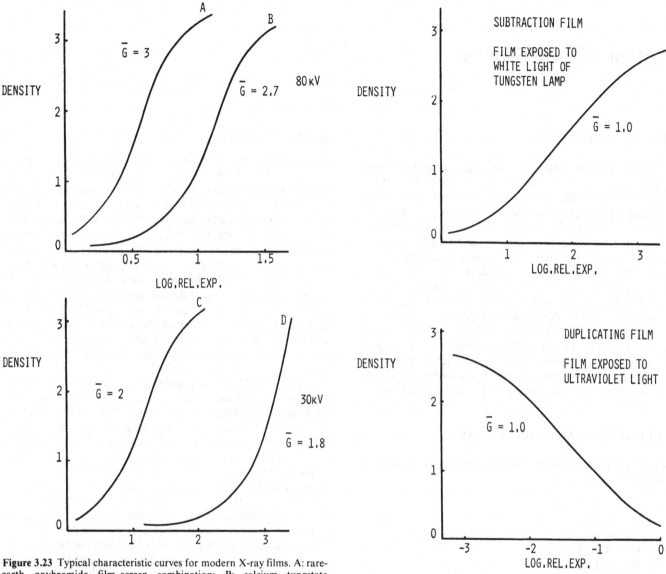

Figure 3.23 Typical characteristic curves for modern X-ray films. A: rare-earth oxybromide film–screen combination; B: calcium tungstate film–screen combination; C: single emulsion film–single rare-earth screen combination; D: direct exposure film

Figure 3.24 Characteristic curves for subtraction and duplicating film

4

Control of Film Stocks

INTRODUCTION

The image quality obtained with a given film material depends in part on the storage conditions. It is necessary to appreciate what constitutes optimum storage conditions and the possible effects on the image when these conditions are not met. A certain degree of latitude is possible in film storage conditions and to this end it is necessary to understand the principles and methods involved in the setting up and use of a film store.

In time, badly stored films progressively lose speed and contrast and their fog level increases. In general, the faster the material or the further into the red end of the spectrum the sensitivity of the film lies, the more rapidly it will deteriorate. Since radiographic procedures may employ monochromatic, orthochromatic or panchromatic film material (p. 6) it is obvious that the panchromatic film material will deteriorate more quickly than the other types.

GENERAL STORAGE CONDITIONS

The correct storage of unexposed, unprocessed film involves protecting it from:

(i) High relative humidity
(ii) High temperature
(iii) X-rays and γ-rays from radioactive materials
(iv) Harmful gases
(v) Physical damage.

In addition, the store should be easily accessible, relatively simple to operate and control and big enough to hold the calculated maximum stock level. Film material is extremely expensive and forms a considerable part of the functional budget of an X-ray department, and this should be reflected in the degree of importance placed on the management of film stocks. Attention should not be limited to unexposed film material but should also be given to exposed material, since, apart from exposed and unprocessed film, storage conditions for exposed and processed film can radically affect its useful life as records. Initially, however, attention will be directed at unexposed film material and each of the above listed criteria will be considered in greater detail.

High Relative Humidity

Too great a relative humidity has a disproportionately damaging effect on stored films, and to protect film material manufacturers sell their product in sealed packages. Sheet and roll film may be sold in sealed foil or polythene packaging. The film material is packed under controlled conditions of relative humidity (30–65%) and, once the package is sealed, the film material is completely protected until opened. This means that there should be no great worry about the relative humidity of the film store since, whatever it is, it will not alter the relative humidity of the environment in which the film material is sealed providing that seal is not broken. Thus, providing the film store is not obviously damp there is no necessity to worry about the relative humidity for films stored in their original, sealed packaging. All that is required is that the store be reasonably dry.

Once opened, films are used fairly rapidly but it will be unavoidable that there will be a certain time between using the first and last films from an opened box of 100 films. It is under these conditions of storage (seal broken, films waiting to be used) that attention must be paid to relative humidity.

The sensitometric characteristics (p. 15) of an emulsion can be altered by high relative humidity (once the film pack is opened) and high temperature (whether the film pack is opened or not). High relative humidity is the more damaging of the two. Moderate humidity and temperature is more satisfactory than low temperature and high relative humidity; for example, storage at 16°C (60°F) and 40% relative humidity is much better than storage at 4°C (40°F) and 80% relative humidity. Unsealed film packs are generally kept in a container or hopper within the darkroom. It is here that the problems of high temperature and high relative humidity are encountered especially if the darkroom contains a free-standing automatic processor with a non-ducted, hot-air film drying system. Here the temperature and relative humidity within the darkroom will be very high unless an efficient ventilation system exists or steps are taken to duct away the hot, humid air produced. Occasional tests on films contained in the hopper should be done to assess fog level, but for this a densitometer will be required. The results should be correlated with those obtained from the periodic sensitometric evaluation of image quality so that variations in processor performance can be accounted for in the density

measurements recorded. The test can be quite simple and only involve the periodic processing of a film selected from those in the hopper. This film is unexposed and to avoid any possibility of safelight fogging it should be inserted into the automatic processor in total darkness. The density of the processed film is then measured and a correction made for any variation in processor performance. The results are then compared with previous results obtained under the same conditions using films from the same pack. This should indicate how fog level varies during the storage period of the opened film pack. Films used for sensitometric evaluation of image quality should be of the same type as those used for general radiography but should not be stored in the darkroom if the relative humidity is high.

Under most existing conditions in this country, such variations in fog level are likely to be very small and insignificant, since in a busy department an opened box of films is unlikely to last (and hence be stored in an opened pack) for more than about 2 days. Thus in general radiography with a rapid turnover of films relative humidity considerations can generally be neglected. Even in the case of film sizes less regularly used the storage period is unlikely to be long enough for relative humidity to be problematical. It is only in a small department, with high relative humidity during periods of processor operation and opened boxes of film being stored in the darkroom for several weeks before being used up, that increased fog levels can be expected. In an attempt to overcome this, foil packing, once opened, can be resealed after squeezing excess air from it. A double fold should be made across the end of the package, sealing it with waterproof, adhesive tape. The package should not be resealed in very humid conditions, but otherwise package resealing does give the contained films protection from varying conditions of relative humidity. Resealing should be

Figure 4.1 The effect of storage time on speed, contrast and fog level. (By courtesy of Fujimex Ltd.)

done after processing has finished for the day and the darkroom first well ventilated to reduce humidity. This method is acceptable but above all, the recommendation is that, once opened, a box of films should be used up as quickly as possible.

High Temperature

While an unopened film box in store is completely protected from relative humidity conditions existing outside the box, it is not possible to provide a packing which will provide protection from variations in temperature. The method used for film stock control, to be described later, provides a maximum storage period for any box of films of about 1½ months. Figure 4.1 shows the effect of storage time on speed, contrast and fog level.

Materials which have been stored at temperatures above 21°C (70°F) – and this is certainly not hot – for more than 4 weeks may suffer perceptible changes in speed, contrast and fog level (Figure 4.2). The film materials store should be cool, dry and well ventilated all the time. There should be no

hot water or steam pipes passing through the store, and it should not be adjacent to a boiler room. If the film store has windows, then

(i) these windows should not be south-facing because, even if they are covered, the effect of sunlight can raise and maintain the temperature of the film store at an unacceptably high level
(ii) sunlight should not be allowed to fall directly on any container of film material.

In single storey buildings, the roof of the film store should be insulated from the heating effect of the sunlight.

Rooms with damp walls or prone to condensation and rooms subject to large temperature variations should not be used to store film material. The recommended maximum temperature (which should not be exceeded) for the storage of unexposed, unopened film material is 21°C (70°F) for periods of up to 3 months. Temperatures less than this are perfectly acceptable. In contrast, the recommended temperature range for the storage of exposed and processed

Figure 4.2 The effect of storage temperature on speed, contrast and fog level. (By courtesy of Fujimex Ltd.)

film is 15–27°C (60–80°F) in a dry environment. It is recommended that a thermometer be permanently mounted in the film store so that the appropriate steps can be taken if temperature changes are excessive or if the maximum temperature is exceeded.

Radioactive Materials and X-rays

High speed films, especially those designed for direct exposure to X-radiation, are the most susceptible to fogging from accidental exposure even when the radiation is of low intensity. Background radiation from different sources varies in magnitude from location to location (10–200 μR/h). House bricks, depending on type and composition, provide an example of a source of background radiation and boxes of film stored for a period in contact with walls built from such bricks have been fogged. Ideally for film storage the background radiation level should be $\leqslant 5 \mu$R/h.

When the film store is within the X-ray department and there is a possibility of film fogging from exposure to X-radiation or some radioactive source, steps must be taken to ensure that the walls of the store room are suitably constructed to prevent any possible radiation fogging of the film stock. Tests should be carried out using radiation monitoring film adhering to the walls at different locations and left there at least as long as the longest film storage period. These can then be processed and assessed by the radiation monitoring service. Possible solutions to penetration of the wall by radiation are

 (i) to coat the wall with a suitable thickness of barium plaster,
 (ii) to increase the thickness of the wall by building a false wall of concrete or brick lined with barium plaster. This unfortunately reduces the dimensions of the film store. Alternatively it is possible to build the false wall of barium bricks, or
 (iii) use a different location for the film store.

The above discussion applies in principle to the darkroom as well where opened packs of unexposed film material are stored. Any of the above measures should be adequate and it should not be necessary to go to the excessively expensive measure of lining the offending wall or part of the wall with a 2 mm thickness of lead. The door to the store should also be checked for radiation leakage as should the small gap around the door. Should there be any possibility of radiation leakage the door can be lined with lead ply sheet (e.g. Plymax). Lead ply sheet should also overlap the small gap around the door.

Obviously it is only necessary to check walls which are adjacent to X-ray rooms or radioisotope preparation rooms. To avoid fogging from background radiation emanating from bricks it is probably cheaper and easier to erect shelving in the centre of the store room (space permitting) rather than coat the walls with barium plaster and erect shelving attached to the walls. With a central storage arrangement film material is kept well clear of the walls.

Harmful Gases

This is unlikely to be any real problem within an X-ray department but the following information is presented in the rare event of film material suffering accidental exposure to certain gases which can fog films if they are not sealed in their original, unopened packaging. These gases include formaldehyde, hydrogen sulphide, ammonia and the vapours of some solvents and cleaners.

Physical Damage

Film material is particularly susceptible to damage by pressure and all film boxes should be stored on edge, side by side. The shelving arrangement should be such as to accommodate this arrangement. All similar size boxes of the same type of film should be kept together and the larger sizes, which are normally heavier, should occupy the lower shelves and the smaller sizes should occupy the higher shelves. This reduces the effort in using the film store and reduces the risk of dropping a box of films. Films of a given size and type should not be mixed with films of the same size but different type, but should be grouped separately. The spacing of the shelves must allow for ease of stocking and removal of film material without having to use a ladder. This means that the height of the shelves above the floor should be between about 30 and 160 cm. The arrangement of groupings of films should allow for easy and rapid stocktaking when required.

ORGANIZATION OF THE FILM STOCK

The storage arrangement for film materials should be such that

 (i) film materials can be easily seen, recognized and issued for use in strict rotation using the oldest first,
 (ii) all inputs and outputs can be recorded at the time they occur, and inputs arranged in rotation, and
 (iii) if the film store is any great distance from the darkroom, suitable film transport facilities should be available and used. Precautions should be taken to ensure that the film material is not exposed accidentally to radiation on its passage to the darkroom.

The amount of deterioration occurring in film material depends on the conditions of storage. Correct conditions of storage minimise the rate at which these changes occur. Since the majority of film materials are stored in less than perfect conditions it would be pointless to allocate film

expiry dates on an assumption that storage will be perfect. Instead assumptions are made based on likely usage and storage conditions and allowances are built-in by the manufacturer. Unfortunately the expiry dates marked on boxes from two consecutive deliveries can be the same, so a separate identification system must be used for film material to ensure use of stock in strict rotation. Any system used must be simple yet as versatile as possible.

In the system to be considered, monthly film deliveries are made and a simple system of marking of film boxes is used. It is not necessary to stamp a small date on the boxes corresponding to the delivery date since it is simpler and more obvious if a large number is written on the side of each box. The boxes can then be placed on the respective shelf with this side facing the onlooker. The number written on each box will correspond to the month of delivery. Boxes with small numbers should always be used before those with large numbers. The exception to this is when using boxes marked 12 (March) before boxes marked 1 (April) but this should present no real difficulty. The delivery date for each set of films of the same month number is needed for stock control and will be recorded at the time of delivery so it is unnecessary to put this date on each box or item of film material. It is convenient to match the month numbers with the financial year. Thus April will be month 1, May will be month 2 and so on. In the example of a stock control table (see Table 4.4) there is a sheet number in the top left-hand corner. This number is the delivery month number and thus it is very easy to identify a box of films with a particular stock control sheet and to say which box or boxes of films should be used up before any others.

Storage of Unexposed Film in the Darkroom

All unexposed film should be contained in a light-tight container safe from exposure (accidental or otherwise) to both safelighting and white light. Films are usually stored in a film hopper. A microswitch may link the film hopper to the white light system in the darkroom in such a way that if the hopper is accidentally opened with the white light switched on then the act of opening the hopper will switch the white light off, and film fogging is avoided. This, of course, is no use if the darkroom door is also open. Films are arranged in the hopper in their separate sizes and the minimum number of each is stored in this way to allow easy film withdrawal. Overloading the hopper introduces operational difficulties and can lead to film faults through handling.

Storage of Exposed, Unprocessed Film

This has, in the past, been necessary when carrying out image quality control using sensitometric film strips in an effort to achieve a degree of uniformity and standardization. The film strips are prepared and pre-stored before use. Now it is

possible to prepare individual control films for immediate use as and when the need arises so the problem of storage of exposed and unprocessed film should not occur. The use of pre-stored control strips provides a relatively insensitive test for image quality variation due to changes in automatic processing and such a method should be avoided.

Finally before considering stock control methods mention should be made of film stored in cassettes and awaiting use. Fortunately the storage interval here is relatively short and in any case the film is extremely well protected from changes in humidity and temperature when contained in a cassette. The only real precaution necessary is to avoid accidental exposure to X- or γ-radiation. Unexposed film stored in a film cassette is usually kept either in one side of a cassette hatch or in a cassette chest where there is adequate protection under normal circumstances.

FILM STOCK CONTROL

Film stocks represent considerable capital expenditure, and a reasonably efficient yet straightforward method of stock control is essential to avoid occurrences such as overstocking of slow-moving items and running out of stock for a particular film material. A good stock control method involves determining in advance the requirements of film materials, taking into consideration existing stocks, consumption rates and delivery times, to achieve a stock in hand that complies with existing stock control policy (National Health Service circular HM (55)76 for example). Thus it is necessary to form some estimate of likely future consumption of film material. Records kept of past performance can be used as a guide to future consumption, but it can be no more than a guide. It is essential to have as much reliable information as possible about future changes in likely film consumption due perhaps to alteration in techniques, introduction of new techniques,, reduction in facilities, changes in staff levels or even possible industrial action. To ensure an adequate centralized stock control system requires regular and effective contact with all user departments.

Film stock control can only be effective if accurate and up-to-date records are kept of film usage. The greater the amount of information available, and the shorter the period to be covered by the film order, the more accurate and effective stock control becomes. Unfortunately administration becomes more and more excessive, and some compromise is necessary. The longer the period for which estimates of film material use are made, the less dependable the estimates become. Weekly ordering, for instance, involves excessive administration and from this aspect is uneconomical; 4 to 6 week estimates are fairly reliable and can be made with reasonable precision allowing a reduction in the amount of administration. Any such estimate requires knowledge of

(i) availability of supplies,
(ii) frequency of delivery,
(iii) costs,
(iv) rate of use of individual stock items,
(v) seasonal fluctuations, and
(vi) storage capacity,

in addition to information on the factors mentioned earlier. Three approaches to film stock control are

(a) fixed quantity ordering with a variable time interval,
(b) fixed quantity, fixed interval ordering, and
(c) fixed interval ordering with a variable quantity.

Fixed Quantity, Variable Time Interval

The principle of controlling stock by fixed quantity is to fix, for each film size and material, a stock level which when reached acts as a trigger for re-ordering. This stock re-order level is usually the quantity required to meet maximum demand between the time of ordering and the time of delivery, plus a safety factor of say one week's supply. When this level is reached a given fixed quantity of film material is ordered.

In practice various sizes and types of film material are used. They are usually used at different rates and in different quantities. This means that each size and type can have a different stock re-order level, which need not necessarily be a constant but may require updating at regular intervals because of variations in work load. Usage rates for each size and type of film material will also vary from time to time because of, for example, variations in workload, changes in technique and the introduction and use of new equipment. This implies that the stock re-order level for each size and type of film will be reached at different times. The system dictates that each time a stock re-order level is reached for a particular size and type of film then an order for a new stock of that film must be placed. Thus ordering for each size and type can occur at different times resulting in a multiplicity of orders. At its worst, each order will be for only one size and type of film, which is administratively uneconomical.

In practice this would not occur because some latitude could be allowed in each stock re-order level. If there is sufficient latitude then it is possible to allow a delay in re-ordering of a particular item until several other items have reached their stock re-order levels and a single order placed for several items. To achieve this latitude the stock re-order level for each item must be made larger, but the amount of increase may not be practicable.

Consider the following example for three different film sizes only. For a particular department it is known from previous 12 months' stock records that the maximum demand for 18×24 cm, 30×40 cm and 35×43 cm films for a 1 month period is 16, 8 and 20 boxes, respectively and that the minimum demand is 4, 4 and 12 boxes. This means that

in any 1 month 4 to 16 boxes of 18×24 cm, 4 to 8 boxes of 30×40 cm and 12 to 20 boxes of 35×43 cm film will be used. The probability that a larger or smaller quantity of each size will be used cannot be excluded of course, hence the requirement for a safety factor. Under normal circumstances it is known that the delay between placing the order and receiving the films varies between 1 and 7 days depending on the day on which the order is placed. The film manufacturer in this example operates a system in which film deliveries occur in the same area of a region on the same day each week. If films are ordered the day before delivery there is obviously only a 1 day delay. Orders placed on the same day as delivery occurs will suffer a delay of 1 week. The possibility that a delivery will not occur in any particular week must not be neglected and a safety factor of 7 days' supply must be added to the 1 to 7 days' supply necessary between ordering and delivery of a film order. Stock re-order levels can now be set. A 14 day supply of films is required to account for the maximum time interval between ordering and delivery (the 'lead time'). To this must be added a further safety factor of 1 week's supply.

The stock re-order level represents 3 weeks' supply of film while the safety factor of 1 week's supply represents the minimum below which stock level should not be allowed to fall. The stock levels for the three film sizes are given in Table 4.1. HM(55)76 indicates that a maximum film stock of 6 weeks' supply should not be exceeded and this will be followed here. Note that as yet no latitude has been employed but this will be ignored for the moment. Since the stock re-order level represents 3 weeks' supply, the fixed quantity to be ordered can be 3 weeks' supply so that at no time is 6 weeks' supply ever exceeded or even reached.

Table 4.1 Stock levels for the three film sizes

Film size (cm)	Stock re-order level* (3 weeks' supply at maximum demand)	Minimum stock level (1 week's supply at maximum demand)
18 x 24	12† boxes	4 boxes
30 x 40	6 boxes	2 boxes
35 x 43	14 boxes	5 boxes

* The stock re-order level = lead time supply + minimum stock level
† This level assumes a 30 day month hence $16/30 \times 21 \simeq 12$ boxes of 18×24 cm film as the stock re-order level

A graph of actual film consumption is shown in Figure 4.3. This represents a centralized record of film consumption for a number of departments. (The abnormally high consumption of 18×24 cm film in week 5 was due to accidental fogging of 4 boxes of film.) It should be readily apparent that out-of-stock conditions can occur at any time and therefore continuous stocktaking is essential to determine the re-order point. This is administratively wasteful. Multiplicity of orders is readily apparent and more than one film delivery is

Figure 4.3 Actual film consumption of three sizes of film

made each month. Figure 4.3 shows that the order points, while occurring at different times, do occur reasonably close to one another. If some latitude could be introduced into the stock re-order level and the re-order point then the same re-order point could be used for all or nearly all film sizes thus reducing the number of orders placed.

Latitude in order point is certainly available since all orders can be left until the day before delivery and still ensure receipt of delivery under normal circumstances. Thus all re-order points occurring at different times in the same week between deliveries can be left until the last moment and one order made. This solves the problem when all re-order points occur in the same interdelivery period. However, continuous stocktaking is still necessary. To provide some latitude in the stock re-order level the safety factor must be increased to, say, 2 weeks' supply which means that the fixed quantity ordered must be reduced to 2 weeks' supply. A much bigger

increase in safety factor may be required. For example with a maximum stock level of 24 boxes of 18×24 cm films used at the minimum rate of 4 boxes per month, 3 months would pass before re-ordering this film size. On the other hand with a maximum stock level of 30 boxes of 35×43 cm film used at the maximum rate, only 3 weeks would pass before re-ordering. It is not practically possible to provide this degree of latitude, neither is it necessary. The increase in safety factor already mentioned is usually sufficient and from continuous stocktaking it is on most occasions possible to arrange a single order point for all or most film materials in any given interdelivery period, but periods between orders can vary considerably, for the most part being quite short. This method does offer the advantage of being non-mathematical but can be cumbersome and uneconomic to operate, requiring continuous stocktaking and possible multiplicity of orders.

Fixed Quantity, Fixed Interval

This is the easiest but least accurate method to operate. Maximum stock level is never known with certainty and can grow to enormous proportions or be reduced to nothing, but it is worth considering as a comparative method. All that is required is to obtain the average number of films of each size and type used per month over, say, the previous 12 months.

Month / Size	Feb	Mar	Apr	May	Jun	Jul	Aug	Sep	Oct	Nov	Dec	Jan
	Number of boxes											
35 x 43	24	24	21	22	26	22	28	23	24	26	25	22

These numbers are then ordered at the same time each month. Consider 35 × 43 cm film only. Table 4.2 shows the number of boxes used each month for a 12 month period:

Table 4.3 Demand for 35 × 43 cm film over 20 months

Month	Number of boxes of films ordered (A)	Number of boxes of films used (B)	B−A	Stock remaining
1	24	22	+2	2
2	24	22	+2	4
3	24	22	+2	6
4	24	21	+3	9
5	24	22	+2	11
6	24	21	+3	14
7	24	28	−4	10
8	24	22	+2	12
9	24	24	0	12
10	24	25	−1	11
11	24	25	−1	10
12	24	24	0	10
13	24	24	0	10
14	24	26	−2	8
15	24	25	−1	7
16	24	25	−1	6
17	24	26	−2	4
18	24	22	+2	6
19	24	28	−4	2
20	24	28	−4	−2*

* Run out of stock

the average is 24 boxes per month. To illustrate what can happen Table 4.3 presents demand for 35 × 43 cm film over a period of 20 months when film is ordered at the rate of 24 boxes per month irrespective of other considerations. Though simple this method is hardly applicable in practice.

Fixed Interval, Variable Quantity

Statistics can be used in the estimation of quantities of film material to order. The calculations while not difficult are lengthy if done by hand and a suitable calculator certainly simplifies the operation. Using this method it is possible to estimate with reasonable accuracy

- (i) the maximum film storage capacity required for 6 weeks' film supply, and
- (ii) the number of films of different sizes and types likely to be used.

Again for this method adequate records of film stock use are necessary. Consider a typical monthly record which may be produced from a centralized film store providing film material for use in a number of district hospitals (Table 4.4). The first step in establishing an effective stock control system is to determine the maximum and minimum film stock levels. This is achieved by establishing lead time.

In this example, the delivery day for film materials coming from the manufacturer is a Thursday of each week. As a routine, the film order will be placed on the last day of each month (or the day before if the last day is a Sunday). Doing this will ensure that the time interval between the placing of consecutive film orders is fairly constant, and that the end-of-month stock return is available on time. The film order is placed monthly rather than weekly to limit paper work and reduce the amount of other work involved. This means carrying a maximum film stock of 6 weeks' supply and a minimum of 8 days' supply but these figures will be justified below.

The lead time is simply the delivery period, that is, the time interval between placing the order and receiving it. In this case, it is possible to place an order at any time up to the day before the delivery day to be sure of receiving the film order on the delivery day. Thus the lead time can vary between 1 and 7 days depending on the interval between placing the order and the next delivery day. This interval will vary from month to month depending on how near to the delivery day the last day of the month falls.

A safety factor should be built into this lead time. If for some reason a delivery is not made in a particular week then there will be 1 week's additional delay before the next delivery. A further 7 days should be added to the above lead time of 1 to 7 days to take account of such a possible occurrence (albeit a rare one). The lead time is now established and it will vary between 8 and 14 days. This lead time determines the minimum stock level of 8 to 14 days' supply of

Table 4.4 Typical monthly record of a centralized film store

Sheet 10		Area Health Authority District — X-ray film stock return for month ending January 1977								
Film material	Size (cm)	Stock at previous month end	Stock received during month	Number of boxes of films used — Hospital A	Hospital B	Hospital C	Hospital D	Hospital E	Total amount used	Stock remaining (8–14 days supply)
Kodak RP 14 (Boxes of 100 sheets)	35 x 43	15	19	4	4			14	22	12
	35 x 35	5	16	3	2	1		9	15	6
	30 x 40	11	14	4	3			8	15	10
	15 x 40	1	4		1				1	4
	24 x 30	18	33	8	5	1		22	36	15
	18 x 24	10	27	6	3			17	26	11
Kodak RPL 54 (Boxes of 100 sheets)	24 x 30		1							1
	15 x 30	1								1
Kodak MA (Boxes of 25)	18 x 24	1	2					1	1	2
Occlusal DF 46 (25)	5.7 x 7.6	2		1					1	1
Occlusal BB 54	5.7 x 7.6	1								1
Dental 5P–150	3.2 x 4.1	1	1	1					1	1
Kodak Fluorospot	70 mm x 150 ft	3	2					2	2	3
Kidney Surgery Film		1	1					1	1	1

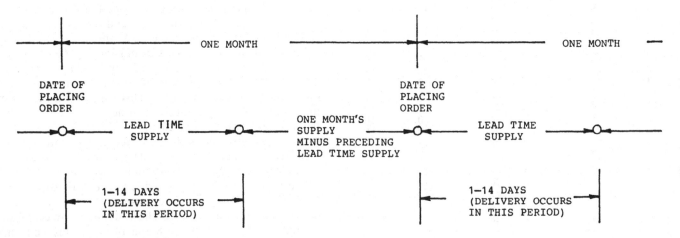

Figure 4.4 Monthly ordering schedule

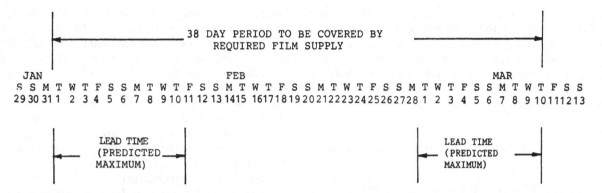

Figure 4.5 Section of ordering calendar

films. Precisely what value the minimum stock level will have depends on the month in which the film order is placed, but whatever value it is, it will not be less than 8 days' or more than 14 days' supply of films.

At the time of placing a film order, the film stock level should not be less than the minimum stock level as determined from the lead time appropriate to the day of ordering. At the end of each month, approximately 1 month's supply of films is required in addition to a minimum stock holding equal to the minimum stock level appropriate to that month. The maximum stock level will therefore not exceed 6 weeks' supply of films. This is the maximum stock level already mentioned several times and quoted in the National Health Service circular HM(55)76. Maximum and minimum stock levels are now known (Figure 4.4).

Consider a 3 month period covering January, February and March 1977. January 1977 ends on a Monday and so gives a lead time of 10 days for the February delivery of films (Figure 4.5). This takes us up to 10 February. February has 28 days so a further 18 days' supply is needed to last until the end of February. February ends on a Monday, again giving a lead time of 10 days for the March delivery of films. (It is fortuitous in this case that the lead times are both the same. This does not generally happen.) The sum of the two lead times together with the 18 days of February gives a total of 38 days. There is thus a maximum stock level of 38 days' supply of films required to cover the period from 1 February up to 10 March. Part of this period will be covered by the films in stock on 31 January. Enough films must be ordered to cover the remaining period.

To summarize – a film supply is needed to cover the month of February (28 days) and an additional 10 days' supply to guard against delays in the March delivery of films. For February, then, the minimum stock level is 10 days' supply (to cover the lead time in March) and the maximum stock level is 38 days' supply (about 5½ weeks).

Films cannot be ordered in terms of a certain number of days' supply. Knowledge is required of how many boxes of each size and type of film are needed to cover the calculated period. The number required must be at least as great as the largest number likely to be used during the calculated period. This requirement could easily be met by ordering some number so large that there is certain to be enough to meet requirements. This unfortunately does not meet the additional requirement that, for economic reasons, the number ordered should be as small as possible. It is necessary to find a number for each of the sizes and types of film used that is the smallest possible from an economic point of view and yet large enough to cope with maximum demand for film use during the calculated period. If this can be done it will immediately provide information on what film storage capacity is necessary. Being able to predict the required number of boxes of films to meet the above-stated criteria is an essential feature of successful functional budgeting. A functional budget is one which comprises the income or expenditure appropriate to a particular function. Here expenditure is being considered, but if silver recovery (p. 184) were discussed, income would be the consideration. From the point of view of functional budgeting, expenditure should be minimized and income maximized.

To calculate the number of boxes of films that fulfils all the stated criteria a statistical method is used. This method requires the availability of the immediately preceding 12 months' records of the number of boxes of films actually used. This information provides the raw statistical data. From the raw data the crude average (\bar{x}) can be found. The standard deviation (σ) can then be determined using

$$\sigma = \sqrt{\frac{\sum\limits_{i=1}^{N} (\dot{x}_i - \bar{x})^2}{N-1}}$$

A corrected average (\bar{x}_p) is then obtained from

$$\bar{x}_p = \frac{\bar{x} + 1.67\sigma}{\sqrt{N-1}}$$

The predicted maximum number of films to be used in the

forthcoming month, assumed to be a 30 day period, is $(\bar{x}_p + 1.67\sigma)$. This number forms the basis of the film order. The method is applied to each size and type of film in turn to determine the numbers required. The example below illustrates the method and once the numbers of each size and type of film are known this immediately gives the predicted maximum film storage capacity required.

Example

Only one size of film is considered and the steps are as follows:

(1) Determine, from previous records, the number of films actually used each month over the immediately preceding 12 months (Table 4.2)

(2) Determine \bar{x} from

$$\bar{x} = \frac{\text{total number of boxes of films}}{\text{total number of months}}$$

$$= 23.92$$

(3) Find σ as follows:

(i) subtract $\bar{x} = 23.92$ from each of the monthly figures above and square each of the answers. This gives,

$$24 - 23.92 = 0.08, \quad (0.08)^2 = 0.0064$$
$$24 - 23.92 = 0.08, \quad (0.08)^2 = 0.0064$$
$$21 - 23.92 = -2.92, \quad (-2.92)^2 = 8.53$$
$$22 - 23.92 = -1.92, \quad (-1.92)^2 = 3.69$$
$$26 - 23.92 = 2.08, \quad (2.08)^2 = 4.33$$
$$22 - 23.92 = -1.92, \quad (-1.92)^2 = 3.96$$
$$28 - 23.92 = 4.08, \quad (4.08)^2 = 16.65$$
$$23 - 23.92 = -0.92, \quad (-0.92)^2 = 0.85$$
$$24 - 23.92 = 0.08, \quad (0.08)^2 = 0.0064$$
$$26 - 23.92 = 2.08, \quad (2.08)^2 = 4.33$$
$$25 - 23.92 = 1.08, \quad (1.08)^2 = 1.17$$
$$22 - 23.92 = -1.92, \quad (-1.92)^2 = 3.96$$

$$\text{Total} \quad \overline{\quad 47.49 \quad}$$

(ii) Having added all 12 results together, divide the total by one less than the total number of months (i.e. $12 - 1 = 11$). This gives

$$\frac{47.49}{11} = 4.32$$

(iii) Find the square root of the result and the answer obtained is the required standard deviation. Thus

$$\text{standard deviation } (\sigma) = \sqrt{4.32}$$
$$= 2.08$$

(iv) \bar{x}_p is then easily calculated as

$$\bar{x}_p = \frac{23.92 + 1.67(2.08)}{\sqrt{11}} = 24.96$$

The maximum number of boxes of 35×43 cm film likely to be used is $(\bar{x}_p + 1.67\sigma)$. Here, $\bar{x}_p + 1.67\sigma = 28.4$ boxes.

It is possible to say with reasonable confidence, but not certainty, that no more than 29 boxes of 35×43 cm film will be used in the forthcoming 30 day period. This amounts to saying that the absolute maximum film usage between the five hospitals in the next 30 days will be 29 boxes, or approximately one box per day. The correct number required for the 38 day period is 36.7 boxes but 37 boxes would be ordered. As a matter of interest, 35 boxes were actually used in this particular 38 day period. Looking at the present stock holding of 35×43 cm film as at the end of January 1977 (Table 4.4) there are 12 boxes in stock. It is necessary to order $(37 - 12) = 25$ boxes of this size and type of film on 31 January 1977.

This procedure predicts maximum possible film usage for the forthcoming period, maintains a minimum safe stock level at the time of placing an order, and provides an acceptable stock level for audit purposes. This procedure also provides information on the maximum film storage capacity required to be set aside in the X-ray department (if this is where films are to be stored).

It has been noticed in practice, that, on average, the remaining shelf-life for X-ray films at the time of delivery is 1–1½ years under ideal storage conditions. Using the above method of stock control and ensuring a system whereby films are used in correct rotation then no box of films is likely to remain in the film store longer than about 1½ months. Certain film sizes may be recognized as slow-moving stock items in which case serious consideration should be given to changing to a more popular item to avoid wastage of film. The predicted film usage is based on previous known usage and therefore cannot take into account possible sudden large increases in film use that might be due, for example, to the introduction of a new clinic, the opening of an extension to the X-ray department or the addition of new radiographic techniques. In such cases, prior knowledge of these occurrences would be available and possible film requirements estimated. This method has distinct advantages over the other methods but is more time-consuming in terms of order estimation. Only one order is placed and this is done regularly each month. Continuous stock taking is not necessary. No statistical method can guarantee 100% accuracy; no prediction method can either but this should not be a deterrent to the use of this method.

Cost and Security

Film stocks are extremely costly and security should not be disregarded. Ideally film stores should be kept locked especially where popularly used film materials are stored – 35 mm black-and-white roll film, and Polaroid film for example – which could present a temptation to anyone so inclined.

5

Intensifying Screens

INTRODUCTION

The term intensifying screen refers to the screens used in X-ray cassettes in contact with the film. Where the film has a single emulsion, a single intensifying screen is used facing and in contact with the emulsion side of the film. Paired intensifying screens are used with duplitized screen-type film. In all cases, the emission spectrum of the screens is matched to the spectral sensitivity of the film emulsion. Intensifying screens intensify the effect of the X-ray beam energy on the film by energy conversion. Some X-ray energy is absorbed by the screen and re-emitted as u.v. and visible light energy (Figure 5.1), to which the film has a greater sensitivity, thus producing a greater film response. The total quantity of X-ray energy converted depends on the ability of the screen to detect or absorb X-ray photons or quanta. Providing the film spectral sensitivity is matched to the screen emission spectrum then the screen with the highest quantum detection efficiency (QDE) produces the greatest film effect for a given radiation dose, phosphor layer thickness and packing density. Phosphor materials (i.e. materials capable of luminescence), used in rare-earth intensifying screens have higher QDE's than calcium tungstate, which is employed as the phosphor material in the most widely used intensifying screens. Because screens have this intensifying effect then smaller exposures can be used when screens are employed.

LUMINESCENCE

Luminescence is the term used to describe the emission of light by a material when excited by any form of energy (the process of incandescence is excluded as being a form of luminescence). Here the excitation is due to absorption of X-ray photon energy by the phosphor material of the intensifying screen. The most important absorption process in intensifying screens involves the release of photoelectrons which in turn produce ionization in the phosphor material with the eventual release of energy as near-visible or visible light.

Luminescence is of two types:

 (i) fluorescence, and
 (ii) phosphorescence.

Fluorescence describes luminescence which ceases within 10^{-8} s of the removal of the exciting X-radiation. Luminescence which is delayed or continues for an indefinite period after the exciting X-radiation ceases is known as phosphorescence. If intensifying screens possess this property then the effect of exposure becomes unpredictable. A further disadvantage of phosphorescence is that if it continues after the cassette has been reloaded a double image will be apparent after use. In practical radiography, using intensifying screens, fluorescence is the only kind of luminescence required. Energy conversion and dissipation is immediate and the film effect predictable. This is certainly practically desirable. Afterglow is negligible in modern screens.

Intensifying screen emission is mainly responsible for forming the latent image. In a paired system, X-ray photons not involved in any interaction in one screen must pass into the film to reach the other intensifying screen. An interaction can occur in the film so X-ray photons can directly form a latent image. The degree to which this occurs is negligible in comparison with the effect of screen emission.

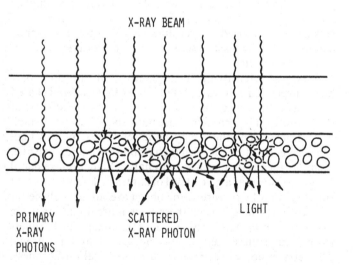

X-RAY BEAM

PRIMARY
X-RAY
PHOTONS

SCATTERED
X-RAY PHOTON

LIGHT

Figure 5.1 Interaction of X-rays with an intensifying screen fluorescent layer

kV, mA AND SCREEN EMISSION

QDE varies with X-ray photon energy and so the screen emission intensity will vary with the kV chosen for the exposure, and with the percentage of scattered radiation in the transmitted X-ray beam. The emission intensity also varies with the intensity of X-radiation absorbed by the screen, being higher the greater the intensity of X-radiation absorbed. Increasing the intensity of the X-ray beam by increasing mA will increase the emission intensity. Increasing kV also increases incident beam intensity producing an increase in emission intensity, but here the photon energy must also be considered so the relationship is not linear.

The absorption of an X-ray photon with the emission of light must follow the conservation of energy principle. The X-ray photon has a greater energy than a light photon and in general many light photons are emitted for the absorption of one X-ray photon. This is the intensification action already mentioned in Chapter 1.

The choice of exposure factors (p. 90) and the resulting image quality is strongly influenced by the type and relative speed of intensifying screens used with a film material. The use of intensifying screens makes possible a reduction in radiation dose required to produce the image. This facility can be used in a number of different ways. Intensifying screens introduce additional image unsharpness but increase radiographic image contrast. Assume that a direct exposure film is used for a particular technique. A change from this to a film–intensifying screen combination with a relative system speed of 4:1 would mean that only a quarter of the exposure would be required. How can this reduction best be utilized?

Increasing FFD, reducing focus size (p. 130) and reducing exposure time all reduce image unsharpness. If FFD used with the non-screen film produces a negligible geometric unsharpness (p. 130) then increasing FFD for the film–screen system is not likely to make any visible improvement. Focus size could be reduced but this is unlikely to make much of an improvement if the choice is already satisfactory. Similarly where patient movement is no problem a reduction in exposure time is unlikely to affect image quality. The greatest relative advantages are those of a reduction in patient dose and an increase in radiographic contrast, but the latter may be more of a nuisance in that it reduces film latitude. Obviously a reduction in exposure must be made but here it does not seem to matter how the dose reduction to the patient and film is achieved.

INTENSIFYING SCREEN STRUCTURE

Figure 5.2 shows the structure of a high speed intensifying screen for general radiography (A) and a very high resolution screen for extremity radiography (B). It should be noted

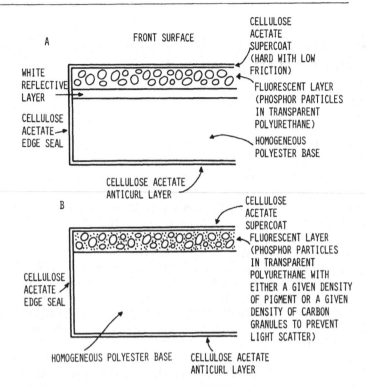

Figure 5.2 Structure of intensifying screens

that high resolution screens are used for extremity radiography not because extremity imaging requires higher resolution than other areas but because these parts are small. For an acceptable radiation dose a particularly high resolution can be obtained at the screen speed required. For larger patient parts, and for an acceptable radiation dose, higher screen speeds are required. An inverse relationship exists between screen speed and resolution for any given phosphor material so an increase in screen speed implies a reduction in screen resolution.

A typical intensifying screen consists of phosphor particles suspended in a transparent binder material and coated on a plastic base. The screen is very thin since the thickness of the fluorescent layer and base are both about 0.2 mm. In high resolution screens there may be fewer layers than in high speed screens. Here the term high resolution is a relative one. It simply means that such screens have a higher image detail resolving power at a given level of contrast. This implies that small details of structure of the object are subjectively better defined in the image when these screens are used than when faster screens are used. This assumes that image unsharpness from such sources as patient movement and positional geometry is not a major contribution to total unsharpness.

Protective Supercoat

This is a thin, waterproof protective coat. It must be thin and

transparent to allow the light produced by the fluorescent layer to reach the film with minimum unsharpness being produced. Because it is thin, its protective function is limited, and great care should be exercised in handling and cleaning intensifying screens. This is particularly important when considering the enormous cost of the rare-earth intensifying screens. In modern screens the layer is made of cellulose acetate and care must be taken to use the correct screen cleaner, otherwise the layer may be damaged. The supercoat extends round the edges of the screen and onto the back surface completely covering it. At the edges it forms a seal preventing water or cleaning fluid penetrating the fluorescent layer; some phosphors are hygroscopic and suffer reduced luminescence if they absorb water. The layer on the back surface prevents the screen curling.

Fluorescent Layer

The fluorescent layer consists of particles of fluorescent material suspended in a binding substance. There are a variety of substances used for the fluorescent material, the most important of which are listed below:

 (i) Calcium tungstate
 (ii) Barium strontium sulphate
(iii) Oxybromides or oxysulphides of gadolinium and lanthanum
 (iv) Barium fluorochloride
 (v) Barium lead sulphate

The binder serves to hold the fluorescent material together and may contain a pigment. The pigment reduces internal reflections within the fluorescent layer thus reducing the intensifying screen's contribution to image unsharpness. Unfortunately this measure also reduces the speed of the intensifying screen and more exposure is necessary to produce the required image. Intensifying screens used for extremity radiography generally employ binder pigments. In some modern screens, the internal screen irradiation is reduced and resolution thus improved by including carbon granules in the binder rather than a pigment material. Irradiation refers to the scattering of light within the fluorescent layer through reflection from phosphor particle to phosphor particle. Eventually the scattered light may reach the film and produce a latent image. Light emission from a single phosphor particle can thus spread over a considerable film area overlapping images produced by emission from other phosphor particles. This represents considerable unsharpness and reduction in image contrast. The binder material is polyurethane which again is important because of the hygroscopic property of the phosphor.

Figure 5.3 illustrates the function of the binder pigment. Note in this case the absence of the reflective layer where the binder pigment is used. In A, the light emitted by a single particle of fluorescent material is scattered to a considerable

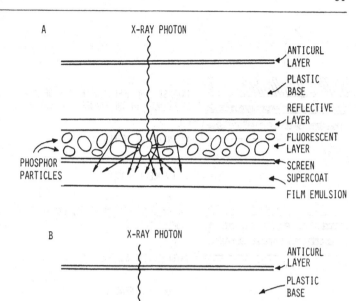

Figure 5.3 The function of the binder pigment

extent due to the transparency of the binder and the presence of the reflective layer and the other particles of fluorescent material. This gives rise to an extensive and unsharp image of the particle which emitted the light, but since virtually all the light produced has reached the film in this case then image density is high. In B, the pigmented binder presents a relatively high opacity to light and tends to preferentially absorb the light following a long path to the film (i.e. scattered light), allowing light following a much shorter path to reach the film. In other words the light following the short path is less attenuated by the pigment than the light following the longer path. This results in a less extensive image and less unsharpness but unfortunately since less light reaches the film the image density is much lower. Since intensifying screen speed is related to the exposure required to produce a given image density, it may be said that the screen in A has a higher speed than B.

Besides being used in 'high resolution' film–screen systems, pigmented binders may also be employed in some intensifying screen sets used in multisection cassettes (Figure 5.4). Here the concentration of pigment decreases from the first pair of screens to the last in a direction away from the tube side of the cassette in an effort to equalize screen speed, since radiation attenuation occurs at each screen and succeeding screen pairs must increase in speed to maintain a constant image density at each film.

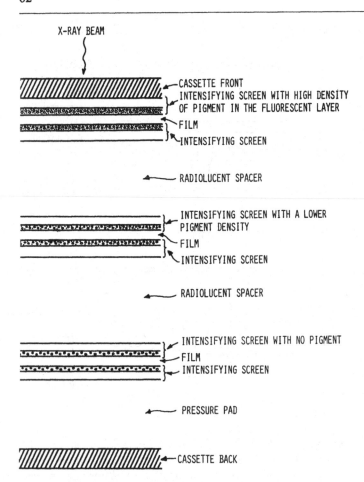

Figure 5.4 Section through a cassette for simultaneous multisection tomography

The Base or Support

This is usually made of clear plastic (the same as film base) and acts as a flexible support for the other layers. The base may or may not be coated with a reflective layer depending on the application of the intensifying screen. The polyester base is coated on its back surface with an anticurl layer of cellulose acetate, the same substance as is used for the supercoat of the screen. If a reflective layer is used then the base is impregnated with titanium dioxide which is a highly reflective white powder. The function of the reflective layer is to increase the speed of the screen by reflecting light towards the film (see Figure 5.3A).

Intensifying screens used in the older Siemans-Elema AOT changers have the phosphor layer coated onto aluminium rather than plastic which in turn is fixed to an aluminium pressure plate. This is necessary for mechanical strength. Unfortunately this thickness of aluminium has a considerable filtration effect which only serves to reduce radiographic contrast. A rare-earth intensifying screen pair

is now available where the screen fluorescent layer is coated onto plastic which is fixed to a carbon fibre pressure plate. This virtually eliminates the considerable beam filtration problem and much higher radiographic contrast is obtainable. Rather than coating the fluorescent layer on a plastic base screens are available where the base is baryta-coated paper (baryta is barium sulphate). This is said to improve the film transport reliability.

MOUNTING AND CARE OF INTENSIFYING SCREENS

Mounting

Intensifying screen pairs must be permanently and securely fixed in the cassette in which they are to be used. This helps reduce the possibility of screen damage when loading and unloading the cassette. In any pair of intensifying screens, one acts as a front screen and the other as a back screen. The front screen lies between the front of the cassette and the film and is nearer the X-ray tube than the back screen. If a distinction is made between front and back screens they must be mounted in the correct order in the cassette to avoid producing an image of poor quality. Some screen pairs offer no distinction between front and back screens and they may be used in any order. It is important to examine the literature supplied and the screen backs to see if a distinction is made.

Screens may be mounted in a new cassette or in a used cassette from which the old screens have first been removed. In the latter case all traces of screen adhesive should be removed from the cassette well and the pressure pad inspected for defects. A damaged pressure pad leads to poor film–screen contact and considerable image unsharpness. A damaged pressure pad must be replaced.

New screens are carefully unpacked and should be handled only at the edges. The inside of the cassette should be clean and dry. The protective strips are removed from the

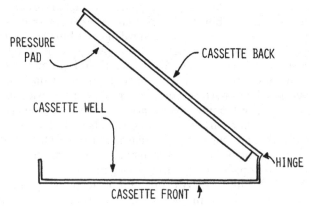

Figure 5.5 Structure of a typical cassette. (The cassette locking device has been omitted)

back of the front screen and it is placed carefully in the cassette well (Figure 5.5) for the adhesive to make contact with the floor of the well. The white paper layer protecting the active surface of the screen in its packing can be placed over its active surface. The protective strips are removed from the adhesive of the back screen which is then laid face down on the white paper covering the front screen. At no time should manual pressure be applied. The cassette is carefully closed avoiding trapping the back screen in the cassette hinge. The cassette is locked and left for a short while to allow proper adhesion. The paper is removed and the film can be loaded in the cassette and it is then ready for film–screen contact assessment (p. 74). If the result is satisfactory the cassette may be released for general use. The outside of the cassette should be identified with the type of screens it contains and the date of mounting. In practice the identification system must be considered. Generally a piece of lead (lead blocker) of suitable size and lead equivalent is stuck to the inside surface of the cassette well and a portion of the new front screen should be cut out to accommodate this. The screen should not be stuck down over the lead. Unfortunately the cut edge of the screen now has no edge seal and as a safeguard can be carefully coated with clear nail varnish, being careful not to coat the front of the screen. This is done before the front screen is mounted.

Finally, following mounting, adhesive identification numbers can be put along one edge of the active surface of one of the screens so that their image will appear on each film taken with the cassette. Similar numbers can be stuck to the outside of the cassette to identify the film with the cassette in the case of artefacts due to dirty screens. Cassettes can be purchased with screens ready mounted by the manufacturer. Screen pairs in some cassettes for multilayer tomography are not permanently mounted. They are hinged along one edge and held between spacers by elastic bands. The whole arrangement of screen pairs and spacers can then be opened as the pages of a book to facilitate film loading.

Screen Care

Screens employing oxybromides or oxysulphides of gadolinium and lanthanum are particularly expensive and every care should be taken in the handling and use of these as with all screens. Occasionally the surface of the supercoat requires cleaning, because a dirty screen surface reduces the intensity of light reaching the film from the screen. This represents a reduction in screen speed requiring a larger exposure dose to produce a given density. Before cleaning screens the hands should be washed and thoroughly dried. Screen surfaces only should be cleaned and a water and mild-soap solution or a recommended screen cleaner should be used. Cotton wool used to apply the screen cleaner should be damp and not wet and at no time should excess fluid appear on the screen. The screen is wiped carefully with the damp cotton wool and then wiped dry with a fresh, clean cotton wool ball. The cassette containing the screens should be left partly open and stood on its edges so that the screens are vertical. It should remain like this until the screens are dry. The date of cleaning should be recorded, for example on the back of the cassette.

TYPES OF INTENSIFYING SCREENS

Intensifying screens may be used either singly or in pairs. Single intensifying screens are relatively slow (i.e. have a low relative speed) but have a high resolution and are used for extremity radiography and soft tissue radiography of small body parts. Paired intensifying screens are used for general radiography and vary in speed and resolution depending on application. High speed, low resolution systems are employed where either radiation dose must be low, exposure time very short or the X-ray equipment is such that insufficient exposure can be delivered in a short enough time using slower systems with higher resolution. Medium speed systems provide sufficient resolution for an acceptable radiation dose when applied to general radiography and offer the best compromise in many situations. Low speed systems of paired screens have a sufficiently high resolution to be used for extremity radiography but not mammography. These systems are faster than the single screen system employing the same phosphor material.

The majority of intensifying screen pairs employ calcium tungstate as the phosphor, but the last few years have seen the introduction of several new phosphor materials each having distinct advantages relative to each other and to calcium tungstate. Barium strontium sulphate is the phosphor material used, in particular, in a high resolution imaging system to replace non-screen film for all extremity radiography, and it offers a significant reduction in required exposure dose. Its emission is predominantly ultraviolet. Barium fluorochloride as a phosphor material has a higher QDE than calcium tungstate and offers significant dose reduction because of its higher relative speed while maintaining a similar resolution. Barium fluorochloride emits mainly u.v. and violet light. The rare-earth materials gadolinium and lanthanum as oxybromides or oxysulphides are the phosphor materials in the various rare-earth screens. Like barium fluorochloride they have a higher relative speed than calcium tungstate for the same resolution. On the other hand if they are constructed to have the same speed as calcium tungstate screens they have a higher resolution. Gadolinium and lanthanum oxysulphides are predominantly green emitters while lanthanum oxybromide is a blue emitter. Rare-earth phosphors are used in paired and single screen systems suitable for the complete range of radiography but, due in part to their considerable cost, are not yet universally employed to replace calcium tungstate.

To reduce costs yet gain a little in speed a pair of rare-earth screens and a pair of calcium tungstate screens have been mixed to produce two pairs of intensifying screens each having one rare-earth screen. Of course, to do this the rare-earth screens must have a spectral emission matched to the film normally used with calcium tungstate screens.

Each type of screen so far discussed has a fluorescent layer which is of uniform thickness and packing density and, where applicable, a uniform pigment density throughout. Another type, the graduated intensifying screen, does not have a uniform fluorescent layer. The relative speed of this screen varies gradually from one side to the other. These screens are used in pairs with application in orthodontic radiography, for example. The outside of the cassette is usually identified to indicate the low and high relative speed sides of the screens. For example a '+' indicates the high relative speed end of the screens and a '–' the other end. However, these are specialized screens and their range of application is limited. Finally, a single high resolution u.v./blue emitting screen has been used with an Agfa-Gevaert Medichrome film for mammography to obtain all the required information from one exposure in each projection.

ACTIVATORS

Activators are substances added to the phosphor material during preparation to control both intensity of emission and emission spectrum. Terbium or europium are common activators used and like gadolinium and lanthanum belong to the lanthanide (rare-earth) series of elements which has atomic numbers from 57 to 71. Barium strontium sulphate doped with europium has a strong ultraviolet fluorescence while combined gadolinium and lanthanum oxysulphides doped with terbium produce a fluorescent material with a strong green emission suitable for use with an ortho-chromatic film. Another phosphor material with a strong ultraviolet fluorescence is barium fluorochloride doped with europium. Yttrium oxysulphide doped with terbium has a strong green emission and an even stronger blue emission, the overall appearance being that of a bluish-white fluorescence.

Film materials have been developed having spectral sensitivities matching the emission spectra of intensifying screens using the above phosphor materials and it is essential to use the optimum combination of film and screen. It is possible to obtain two film–screen combinations both having the same resolution but different contrast rendition characteristics and even different speeds. This problem did not exist when the only phosphor material available was calcium tungstate. Now the choice is very wide and it is essential before choosing any particular film–screen combination that a comparative evaluation be done on as many of the different phosphor screens available as possible under the existing conditions. Only then can a valid choice be made. The tests used in the evaluation process are relatively simple and mainly based on visual comparisons but before comparing image definition, film–screen contact should always be checked. Some of these tests are discussed later.

RECIPROCITY AND RECIPROCITY FAILURE

A film exposed to X- or γ-radiation of a given radiation intensity for a given time produces on development a certain image density. If the intensity (I) and time (t) are changed but the value of their product remains unchanged then the same density will be produced. This is a demonstration of the reciprocity relationship first described by Bunsen and Roscoe and known as the Bunsen–Roscoe law.

Unfortunately when the film is exposed to light, such as the emission from an intensifying screen, this reciprocity relationship fails at high and low intensities (or short and long exposure times). A given value of the product of intensity and time will produce a lower density when the intensity is very large or very small (i.e. when the exposure time is very short or very long) than when it has a value somewhere between the extremes. This reciprocity failure appears minimal for an exposure time of about 0.1 s but increases for shorter and longer times. Figure 5.6 shows the relationship between the product I_t and exposure time t for a given image density. The more t deviates from about 0.1 s in either direction the larger the product I_t must become to maintain a constant density. In practice, exposure times used normally lie within the interval indicated in Figure 5.7.

Figure 5.6 Relationship between I_t and t for a given image density

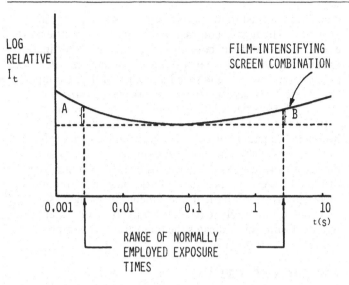

Figure 5.7 The range of normally employed exposure times. A and B represent the extra exposure required (above that required at 0.1 s) at the longest and shortest exposure times employed

For a given kV, compared to an exposure at 0.1 s an exposure at 0.003 s will require a larger mAs to achieve the same density. The amount of increase is some 10% but this is hardly significant in practice and reciprocity failure is usually ignored. The highest film–intensifying screen speed is obtained at 0.1 s but it is not possible to use this for all radiography, and some reciprocity failure must be accepted as inevitable in chest radiography and radiography of the lateral lumbar-sacral angle, for example.

Calibration of mA settings at a given kV may be carried out using a stepwedge and film–screen combination (assuming the exposure time values have previously been calibrated and found correct). Exposures are made at different mA values but at a constant mAs and kV. Where necessary the mA is adjusted by the engineer so that a constant density is achieved for each exposure. Any reciprocity failure is masked by this procedure because now the film–screen combination appears to obey the reciprocity law – i.e. a given mAs at a particular kV will produce a constant density irrespective of the mA value used. This apparent obeying of the reciprocity law is certainly helpful in practice because reciprocity failure can be completely ignored for film–intensifying screen combinations when changes are made in mA and exposure time values while maintaining a constant mAs. Unfortunately if non-screen film were used over the same range of exposure times with this X-ray equipment it would suffer apparent reciprocity failure in reverse! This film would appear relatively slow at 0.1 s but increase in speed at shorter and longer times. This of course is because of the method of calibration of mA values. Practical exposure times for non-screen films are relatively long and the range over which they are varied is small so this phenomenon is not

a problem. If mA calibration had been carried out using non-screen film then reciprocity failure would be apparent with film–intensifying screen combinations. Non-screen films do not suffer reciprocity failure under normal circumstances and the calibration would be independent of it. This would be a small disadvantage in practice when using intensifying screens. Because of reciprocity failure the need for a larger mAs at shorter or longer times than 0.1 s really represents a reduction in relative speed of the imaging system.

MOTTLE

A film alone exposed to a uniform beam of X-rays produces an image which has a visible unevenness in density. This unevenness is graininess and is due to the fact that the image is composed of a large number of distinct and separate black metallic silver deposits. Graininess increases with increasing film speed and with increasing kV. Fast films have a coarser grain structure than slower films and require less exposure. Increasing kV increases the kinetic energy of electrons released in the emulsion by X-ray photons. These electrons track through the emulsion forming a latent image and within the diagnostic range the higher the photon energy the longer the track and the larger the developed grain appears.

However, a film–intensifying screen combination exposed to a uniform beam of X-rays produces an image with irregular density giving the image a mottled appearance, which is not film graininess.

Mottle is much coarser than film graininess and is due to non-uniform light emission from the intensifying screen. The image is formed by light emitted by the screen which in turn is dependent on the energy transfer from an X-ray photon. If the emitted light is intense then little of it is needed to produce a given density. In other words it is only necessary to excite a few of the phosphor particles to get sufficient light to form the required density. Alternatively, the faster the film, the fewer the number of particles that need exciting to produce sufficient light to give the required density. The fewer the particles excited, the more widespread they will be when the whole film is exposed. The light from each particle produces a small local density in the image, and the more widespread these are the more noticeable they become. Subjectively this represents an increase in mottle.

From this discussion the faster the system becomes, the smaller the exposure required, and the greater the appearance of mottle. This is quantum mottle and arises because there is a sufficient number of X-ray photons to produce the required density but insufficient to provide all the information detail. The many minute parts that are missing make the parts that are present more noticeable as distinct and separate small entities, hence the mottled appearance. This immediately places a limit on the ultimate speed attainable. The higher the speed the greater the mottle.

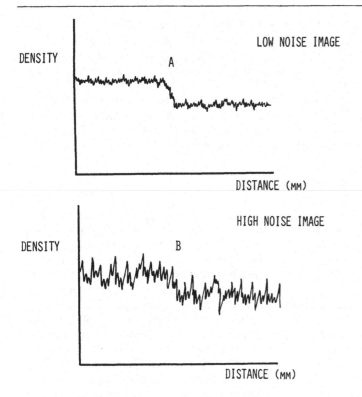

Figure 5.8 Microdensitometer traces across the edge of an object with (A) low noise image and (B) high noise image

Quantum mottle represents image noise and can eventually become so bad that it makes visualization of image detail virtually impossible. In Figure 5.8 a microdensitometer trace across the edge of an object (A and B) with a low contrast image and a low noise value shows that the edge can be visualized providing there is sufficient contrast (A). Increasing the noise (quantum mottle) makes visualization of the same information difficult if not impossible (B). The pattern due to quantum mottle is different each time even though the same film type, intensifying screen and exposure may be given, indicating the random nature of X-ray photon production.

A film–intensifying screen combination of low relative speed will have a relatively high resolution making quantum mottle more readily visible, but because the system is slow the exposure required is high and quantum mottle effect is small. The faster the system, the greater the quantum mottle, but as the speed increases the resolution decreases and quantum mottle while still present becomes less well defined. Unfortunately quantum mottle is readily apparent in high speed systems even with the reduced resolution and such systems are only suitable for imaging large details. There is too much noise to see minute detail.

In comparison with calcium tungstate screens one of the problems with some rare-earth intensifying screens is the

increased contrast they provide with the increased speed at a given kV. The higher contrast makes quantum mottle more easily visible and, in comparison at a given kV, images produced with the rare-earth system show more mottle. This can be overcome if some speed is sacrificed. For example a single rare-earth screen can be used with a calcium tungstate screen to form a pair. Alternatively a slower film can be used with the pair of rare-earth screens. It should be emphasized however that patient movement may produce so much image unsharpness with a slow system that the image is diagnostically useless. Using a faster system might give a disturbing level of quantum mottle but the reduction in unsharpness from patient movement by using a shorter exposure time is likely to result in a diagnostically acceptable image. Again, this indicates the importance of compromise.

EMISSION SPECTRA

The phosphor materials used for intensifying screens have been described on pp. 61–64. These intensifying screens will each emit light when irradiated with X-rays but their emission spectrum depends on the phosphor material used. It is important that the film spectral sensitivity is matched to the particular screen emission spectrum otherwise a reduction in imaging system relative speed will occur.

Figure 5.9 illustrates the emission spectra for three different intensifying screens. The three phosphors are known as broad band emitters. For each given phosphor the maximum emission intensity occurs at a particular wavelength and is arbitrarily designated 100. Intensities at

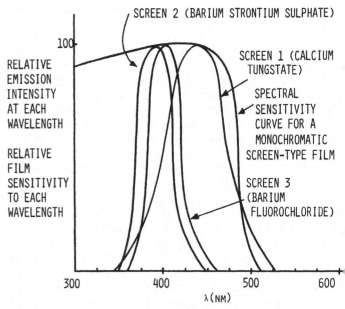

Figure 5.9 Emission spectra of three different intensifying screens

other wavelengths are measured relative to the maximum. Relative speed differences between the screens are thus hidden and such information cannot be obtained from this graph. In practice, for example, a typical barium fluorochloride screen is significantly faster than a calcium tungstate screen of equivalent resolution. A monochromatic screen-type film is certainly suitable for use with all these screens as this film is sensitive to all the emitted wavelengths.

The rare-earth materials are described as line emitters since they emit at discrete wavelengths (Figure 5.10). In A, both monochromatic and orthochromatic film could be used, but in B an orthochromatic film is essential to respond to the emission at 550 mm and beyond.

Temperature Effects

The relative speed of an intensifying screen–film combination gradually decreases with increasing temperature but the amount of variation over the temperature range normally encountered is insignificant and for all practical purposes can be neglected.

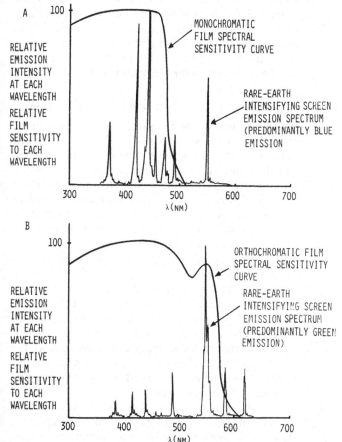

Figure 5.10 Emission spectra of rare-earth screens

INTENSIFICATION FACTOR

Intensification (or intensifying) factor is defined as the ratio of the exposure required to produce a given density on a screen-type film alone to the exposure required to produce the same density using the same film type with intensifying screens. It describes the magnitude of exposure reduction possible as a result of using intensifying screens.

Intensification factor is easily determined in practice by choosing a particular kV and mA for the FFD used and then selecting an exposure time to give the required density on the screen-type film. The intensifying screen–film combination is then exposed under the same conditions but adjusting exposure time until a similar density is produced. The ratio of the two exposure times represents the intensification factor for the exposure and processing conditions used and at the density chosen. Hence, intensification factor (IF) is simply

$$IF = \frac{t_2}{t_1}$$

where t_2 = exposure time without screens, and t_1 = exposure time with screens,

the same kV, mA, FFD, film type, processing conditions and density level being used for both exposures. Reciprocity failure can be ignored. If a different density level is chosen and the procedure repeated, the IF will be different. Furthermore, if the procedure is repeated using a different kV but the same density level another different value of IF will be obtained. Varying processing conditions will alter relative densities and hence affect the IF value obtained.

To summarize the procedure for obtaining a measure of IF:

(i) Two exposures are made. In each case the same film type is used (a screen-type film).

(ii) The two exposures must produce the same density. Obviously the same processing conditions must be used.

(iii) Any image density may be chosen but it is usual to choose a density within the useful density range, i.e. $D \simeq 1.0$.

(iv) One exposure is made with intensifying screens and the other without. In the first case the film is exposed to the effects of X-rays and light, while in the second X-rays alone are used. The light produced by the intensifying screens intensifies the effect of the X-rays on the film. It is the magnitude of this effect that is determined by the intensification factor.

(v) A kV value must be chosen and this value used for each exposure. Emission intensity from the screen increases with increasing kV. This means that for a given film and screen (or screen pair) different values

for IF will be obtained at different kV values selected. If an object is placed in the beam, the radiation reaching the imaging system will contain a certain percentage of scatter. The greater the scatter percentage at a given kV the lower will be the screen emission intensity. IF is then influenced by the amount of scatter in the beam. To approximate a practical situation IF measurements should perhaps be made using a suitable tissue equivalent phantom in the X-ray beam.

A value for intensifying factor can be obtained by reference to characteristic curves. Consider the characteristic curves of Figure 5.11. Y is the curve obtained from the screen-type film exposed to X-rays alone. X is the curve obtained for the film–screen combination exposed to X-rays. In both X and Y the same film type was used.

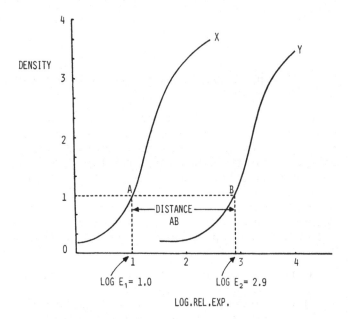

Figure 5.11 Characteristic curves of screen-type film with (X) and without (Y) intensifying screen

$$\text{Intensifying factor} = \frac{\text{Exposure without screens}}{\text{Exposure with screens}} = \frac{E_2}{E_1}$$

At $D = 1.0$ the distance AB is simply $(\log E_2 - \log E_1) = \log (E_2 / E_1)$

If intensification factor $= \dfrac{E_2}{E_1}$, then log (intensification factor)
$$= \log \left[\frac{E_2}{E_1} \right] = \text{the distance AB}$$

The distance AB is simply $(2.9 - 1.0) = 1.9$
Hence, log(intensification factor) = 1.9
and intensification factor = antilog $(1.9) \simeq 90$

However, the question must be asked 'how useful is IF in practice?'

The information relating to exposure which may be required in practice is the factor by which exposure must be changed when:

(i) Using a screen-type film for direct exposure (non-screen) extremity work when no direct exposure film is available nor a suitable film–screen combination. Here an approximate idea of the exposure required for extremities is known for the screen-type film used with the intensifying screens normally employed for general radiography. Knowing the IF for these screens at the kV to be used would enable an appropriate exposure to be selected. Suppose 45 kV is to be used for the particular extremity and the IF for the screens is 80 at this kV. Further, suppose that with the film–screen combination the exposure required is 2 mAs. Then the mAs required without screens will be 160 mAs, i.e. (2 × 80) mAs, since

Exposure (mAs) without screens = IF × exposure (mAs) with screens.

(ii) Using a direct exposure film for extremity work instead of a high resolution film–screen combination. Unfortunately, in this case, knowing the IF for the high resolution intensifying screens does not seem to be of much help because the direct exposure film is not the same type as the film used with the screens. To use the formula

Exposure without screens = IF × exposure with screens

the film type must be the same for both exposures, and in this case it is obviously not. The relative speed of the two imaging systems – the film–screen system and the non-screen system – is the essential information required, as this would indicate how much more mAs the slower system requires to produce a satisfactory image density. A simple test is required to determine relative system speed and should not require any knowledge of IF but, like IF, the measure obtained for speed depends on the kV used. Performing the test procedure at one fixed kV will give a measure quite different from that obtained by repeating the procedure at some other fixed kV. Fortunately, in practice, the kV range normally used for extremity work is limited and any speed variations due to kV changes will be small since the kV changes themselves are likely to be small. The test to determine the relative speed of a pair of imaging systems is described later.

(iii) Using an imaging system with different film and intensifying screens from those normally employed. Again a measure of relative speed is required rather than IF measurements.

RELATIVE SPEED

Relative speed is usually determined at some particular kV and mA and expressed as a ratio of exposure times. For example, if one imaging system requires 0.1 s to produce a particular density, and another imaging system requires 0.2 s to produce the same density at the same kV and mA, then the relative speed of the two systems is 0.2:0.1 or 2:1. In other words the first is twice the speed of the second.

A measure of relative speed may be required when changing from:

(i) direct exposure film to a film–screen combination,
(ii) one film–screen combination to another, and
(iii) one film type to another.

The test procedure required in each case is slightly different; (i) and (ii) are described below, and (iii) has been described in Chapter 3, p. 44.

Test Procedure to Determine the Relative Speed of a Direct Exposure Film and a Film–Screen Combination

This is in many ways similar to the test required for (iii). The behaviour of the film is assumed to be more or less uniform throughout the diagnostic range of kV values. This means that for any kV chosen, a given radiation dose will produce the same photographic density in the film. Unfortunately this is not true when intensifying screens are used. Here, as the kV increases, so does the intensification factor, and it is false to assume that having done the test at one kV value and obtained a measure of relative speed, the two systems will have the same relative speed at other kV values. As kV increases, so will the value for relative speed. Having done the test procedure once at one kV value it should be repeated at different kV values throughout the diagnostic range.

The equipment for the test is arranged for exposure as shown in Figure 5.12. A kV is chosen representative of the range within which the film is to be used in practice, say 50 kVp. An mAs is chosen to produce, on the screen-type film, an image which adequately demonstrates a reasonable number of steps with densities covering the useful density range. The FFD should be constant throughout the test. Following exposure, both films are processed together in the automatic processor (it is assumed that the non-screen film may be autoprocessed). On the screen-type film, the density of steps near the middle of the stepwedge image is measured. The step with the density nearest to $D = 1.0$ is chosen, its number is noted and its density recorded. Assume it is the middle step. The non-screen film image is inspected to gain an idea of how much it may be necessary to increase the exposure time (kV and mA remaining constant) so that the middle step of the stepwedge image on the non-screen film can be made the same density as the corresponding step on the screen-type film. A series of exposures is made at

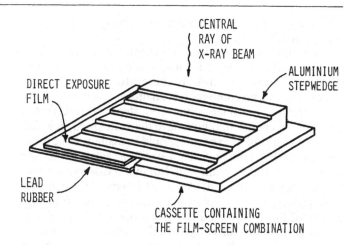

Figure 5.12 Arrangement of equipment for test (i)

different exposure times on a similar non-screen film until the same middle step density is achieved. If t_2 is the exposure time required to do this and t_1 is the exposure time used for the screen-type film then the measure of relative speed required is t_2/t_1.

Test Procedure to Determine the Relative Speed of Two Different Film–Screen Combinations

Here again the relative speed measure obtained will depend on the kV used, since once more intensifying screens are used. Similarly, once carried out at one kV value, the test should be repeated at other kV values representative of the kV range to be used. This is in case the intensification factors for the two screen pairs change at different rates with changing kV. In the case of two different film–screen combinations it is not an essential requirement that the film used for one pair of screens is the same as the film used for the other pair. This is certainly true when a calcium tungstate intensifying screen–monochromatic film system is compared

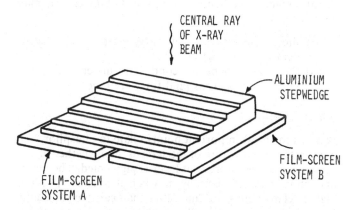

Figure 5.13 Arrangement of equipment for test (ii). (The film–screen systems are different but the cassettes are similar)

with a rare earth green-emitting intensifying screen–orthochromatic film system.

The equipment is arranged for exposure as in Figure 5.13. A kV near the middle of the diagnostic range is chosen to start, say 70 kVp. An mAs is chosen to produce, on the 'faster' film–screen combination, an image which adequately demonstrates a reasonable number of steps as before. It may be found, of course, that both have the same speed, in which case a further similar exposure should be made at some other kV (say 100 kVp) to see if they are still the same. If they are then the test can be terminated. But in this case assume that they are not the same at 70 kVp. The FFD should be constant throughout the test. Following exposure, both films are processed together in the automatic processor. On the image produced with the 'faster' system, the density of a few steps near the middle of the stepwedge image is measured. Again the one with the density nearest to $D = 1.0$ may be chosen. The step number is noted and the density recorded. Again for convenience assume it is the middle step. The image produced with the 'slower' film–screen system is inspected to gain some idea of how much the exposure time must be increased (kV and mA remaining constant) so that the middle step of the stepwedge image on the 'slower' system can be made the same density as the corresponding step on the image produced with the 'faster' system. A series of exposures is made at different exposure times on the 'slower' system until the same middle step density is achieved. If t_2 is the exposure time required to do this and t_1 is the exposure time used for the 'faster' system then the measure of relative speed is t_2/t_1. Repeat the whole procedure at other different kV values to obtain the appropriate relative speed at these kV values.

FACTORS AFFECTING INTENSIFICATION FACTOR

There are many factors which control the value of intensification factor and hence relative speed obtained, and may be described as

(i) those inherent in the intensifying screens and dependent on manufacture, and
(ii) those dependent on conditions under which the intensifying screens (and film) are used.

Inherent Factors

Perhaps the most important points relate to phosphor type used in the manufacture of the screens, and whether or not the binder of the fluorescent layer is pigmented. The newer phosphor materials employed, when irradiated, produce higher relative emission intensities than calcium tungstate. Of course the wavelengths emitted may be somewhat different and the light receptor (the film) will have to be matched to the screen. Nevertheless, the use of these newer phosphor materials gives rise to higher intensification factors than calcium tungstate and the higher relative speed can be fully utilized when used with matched films. Pigment materials may be used in the binder of the fluorescent layer of the intensifying screen to control resolution. Unfortunately the higher the resolution required, the 'slower' the intensifying screen becomes because of the increased amount of binder pigment used. Even though the same phosphor material may be used each time, the more pigment that is used the lower will be the value of intensification factor obtained at any given kV.

Factors Dependent on Conditions of Use

The factors which are considered as being practically important are

(i) the kV used at which to make the exposure, and
(ii) the photographic density used for determining the intensification factor.

The degree of development is often stated as one of the factors influencing the value obtained for intensification factor. This is interesting but hardly relevant when using an automatic processor in the determination of intensification factor, providing the processor is operating within normally acceptable limits, which is usually the case.

kV

The important fact in practice is what happens to intensification factor as kV is varied. Consider the table of kV values (Table 5.1) and associated intensification factors, each being measured at a density of $D = 1.0$. These figures might apply to a typical high speed calcium tungstate screen. Figure 5.14 shows a graph of the information in Table 5.1, and illustrates how the speed of the film–intensifying screen combination changes with changing kV. For example, the system used at 80 kVp has 1½ times the speed at 40 kVp. In other words the system becomes more efficient (relative to a system represented by a film alone) as kV increases, i.e. relative speed increases.

Table 5.1 Variation of intensification factor with kV, measured at $D = 1.0$, for a typical calcium tungstate screen

kVp	Intensification factor
40	70
50	80
60	90
70	100
80	105
90	108
100	110
110	112
120	114

Figure 5.14 Variation of IF with kV (from Table 5.1)

Photographic Density

Consider again the graph in Figure 5.11 used to obtain a measure of intensification factor shown again in Figure 5.15. Instead of measuring the intensification factor at $D = 1.0$, say, $D = 2.5$ may be used. Now the intensification factor will have the value,

$$IF = E_4/E_3$$

The distance CD is $(\log E_4 - \log E_3) = \log (E_4/E_3)$

If the intensification factor $IF = E_4/E_3$, then

$\log (IF) = \log (E_4/E_3) = $ distance CD.

CD is $(3.5 - 1.5) = 2.0$, hence $\log(IF) = 2.0$ and so $IF =$ antilog $2.0 = 100$

By choosing a higher photographic density at which to measure intensification factor, a higher value is obtained. When comparing intensification factors it is essential to know the density used for the measurements. It would be useless trying to make 'speed' comparisons for two systems if the intensification factors (or relative speeds) were obtained for different densities (or different kV values!)

It should be noted that the results of the test procedure for relative system speed must be used with caution. A relative speed test can be done on two systems without the use of a stepwedge if desired. Consider the case where both systems employ intensifying screens. A kV is chosen, and one of the systems is given the mAs required to produce an image density of 1.0. Using the same mA and kV, the exposure time is adjusted to produce the same density with the other system. The ratio of the two exposure times is a measure of the relative speed of the two systems when exposed only to primary

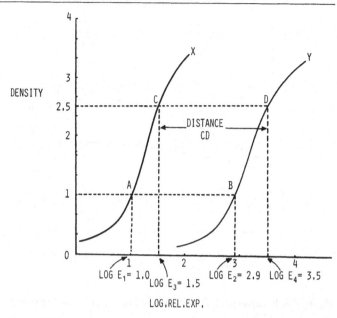

Figure 5.15 Characteristic curves of screen-type film with (X) and without (Y) intensifying screens

radiation. The question is: 'Will this relative speed figure be the same as that obtained using the stepwedge at the same kV?' When using the stepwedge, and even more so when using a patient, each system is exposed not only to primary radiation but also to scatter produced in the object being irradiated. From previous discussion we know the intensification factor increases with increasing kV. In other words, the intensification factor increases with decreasing wavelength of radiation. A beam consisting only of primary radiation gives a higher intensification factor compared with a beam consisting of both primary and scatter when the same kV factor is set for both. Indeed, for a given set kV, the intensification factor can be expected to be lower the greater the amount of scatter in the beam reaching the film, for the same film density. If a beam produced at a particular kV is passed through an object both primary and scatter will leave the object to reach the film to produce the density of 1.0, say. Since scatter is of longer wavelength than primary the average intensification factor obtained for primary and scatter will be lower than for primary alone. If primary radiation alone is used (and no object) the same intensification factor as for primary and scatter could be obtained if only a lower kV were used.

Assume that at 100 kVp the relative speed for two systems exposed to primary radiation alone is 5.75. If relative speed is measured again at the same kV by exposing the two systems to primary and scatter (as might occur when the X-ray beam has first passed through a patient) it will be found to be less, the difference depending on the percentage of scatter in the beam (say 4.25). The relative speed figure of 4.25 could also be obtained by exposing the two systems to

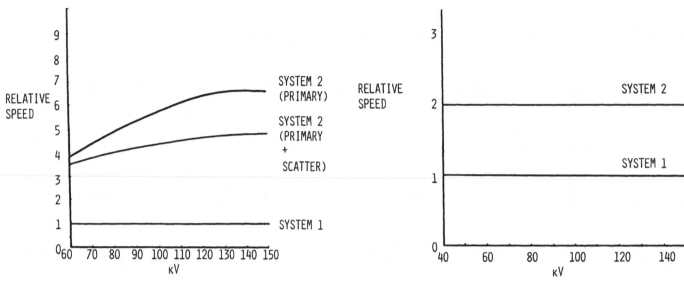

Figure 5.16 Relative speeds for two systems using primary beam alone, and primary + scatter

Figure 5.17 Relative speeds for two systems whose IFs change at the same rate

primary radiation only, produced at 65 kVp. These figures can be obtained from Figure 5.16, which demonstrates that rare-earth systems are more efficient at higher kV. The faster system (system 2) is a rare-earth screen–film combination while system 1 is a calcium tungstate screen–film system. The vertical axis shows the speed of system 2 relative to the speed of system 1 throughout the kV range shown. For example, if at 60 kVp, system 2 is 3½ times the speed of system 1, so the relative speed value of 1 can be given to system 1, and the value of 3½ to system 2 (these figures refer to the curve labelled 'primary + scatter'). Again, if at 100 kVp, system 2 is 4.25 times the speed of system 1, the relative speed value of 1 can be given to system 1, and the value of 4.25 to system 2. Proceeding in this way the value of 1 can be given to the calcium tungstate system throughout the kV range and show the speed of system 2 relative to this value of 1, both in the case of primary and primary + scatter. The graph clearly illustrates the effect of scatter on relative speed for these two systems.

What has been said regarding the effect of scatter is important when comparing the speeds of two systems in which one system employs a different phosphor type to the other. In this case the phosphor response to scatter may (or may not) be different in each case to different wavelength X-rays. This gives rise to what has just been discussed. On the other hand, if similar phosphors are used, although one screen pair may be 'faster' than the other, the intensification factors for the two screen pairs may change at the same rate with changing kV (Figure 5.17) irrespective of scatter. The relative speed curves would then be parallel. Relative speed values obtained with a stepwedge would then apply directly to practice. In addition the test need only be done at one kV

value. Figure 5.17 does not imply that the intensification factor is constant throughout the kV range indicated. For example at 60 kVp, the intensification factors for systems 1 and 2 might be 30 and 60 respectively giving a relative speed of 60 : 30 or 2 : 1. At 100 kV, the intensification factors for systems 1 and 2 might be 50 and 100 respectively, again giving a relative speed of 2 : 1. So although relative speed may remain constant, intensification factors may not.

The relative speed obtained depends on the amount of scatter in the beam reaching the two systems. The amount of scatter reaching the two systems, when using a stepwedge to measure relative speed, will certainly be smaller than that reaching the two systems when using a large patient's abdomen, for example. So a higher relative speed can be expected when using a stepwedge than when using a large patient. Do not expect results obtained with a stepwedge to tally exactly with conditions found to exist when patients are concerned. The stepwedge is so easy to use but unfortunately the results obtained can only be used as a guide. If greater accuracy is required, relative speed must be measured using a tissue equivalent phantom rather than a stepwedge alone to get somewhere near the amount of scatter found in practice.

SCREEN EFFECT ON IMAGE QUALITY

The imaging properties of an intensifying screen depend on many factors including

(i) phosphor material: type, particle size and packing density (number of particles per unit volume),
(ii) activator, and
(iii) fluorescent layer thickness.

These factors determine the practically important properties of screen resolution, speed and contrast amplification. It is important to realize that an image is not formed using just an intensifying screen. The system of screens, film and cassette must be used and each influences the quality of the final image. The cassette houses the film and screens in a light-tight environment and holds the film and screens together under pressure to ensure good contact. Poor contact reduces system resolution recognized as poor definition (and contrast) in the image.

Contrast

Radiographs, made using screen-type X-ray films in conjunction with intensifying screens, are of higher contrast than radiographs made by direct exposure on non-screen films. This effect is of great practical importance when comparing screen and non-screen exposures. It is due mainly to the nature of the radiation responsible for forming the image, i.e. light instead of X-rays, and, to a small degree, to scattered radiation being preferentially absorbed by the cassette front and the support of the front intensifying screen. Of course, scattered radiation is of lower energy than primary and produces a lower screen emission intensity in comparison. Primary radiation thus has a greater imaging effect than scatter with a resulting contrast amplification.

In Figure 5.18 X is the characteristic curve for a film–screen combination, while Y is the curve for the screen-type film used alone. The slope of AB is the average gradient for curve X between net densities of 0.25 and 2.0, while the slope of CD is the average gradient for curve Y over the same interval. It is obvious that the slope of AB is greater than that of CD. The use of intensifying screens has thus increased film contrast, i.e. given rise to contrast amplification.

Unsharpness

Unfortunately the use of intensifying screens introduces a comparatively large degree of unsharpness into the image recording system (see Figures 1.24 and 3.5) due to:

(i) The finite distance between emitting phosphor particles and film emulsion. The greater the distance the greater the divergence of light and the more diffuse and unsharp the image.

(ii) The cross-over effect, but this is avoided if a single screen–single emulsion film is used.

Due to the small but finite thickness of the fluorescent layer of an intensifying screen the phosphor particles lie at varying distances from the emulsion of a film placed in contact with the screen. X-radiation passing into an intensifying screen before reaching the film will produce most light from interactions with phosphor particles furthest from the film. This results in a relatively large unsharpness (Figure 5.19). With a back screen light is emitted by particles nearest the film with a reduction in unsharpness. This illustrates why there is usually an unequal coating weight of phosphor material between front and back intensifying screens especially in high resolution systems.

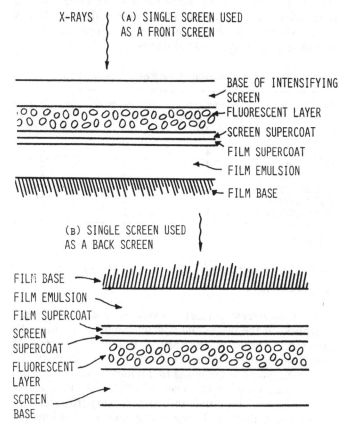

Figure 5.19 Single screens used as front and back screens

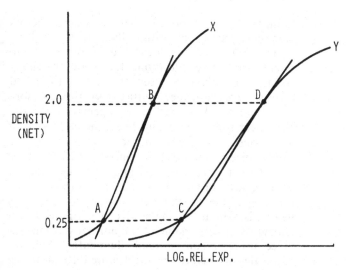

Figure 5.18 Characteristic curves for film–screen combination (X) and screen-type film alone (Y) showing contrast amplification

Speed

Suppose that two speeds of screen-type film are available for use, one twice the speed of the other. Further suppose that there are three types of screen available with relative speeds of 1, 2 and 4 at some particular kV value. To find the combination of film and intensifying screen pair which produce the 'fastest' system multiply the relative speed for the intensifying screen (x) by the relative speed for the film (y) (Table 5.2). The film–screen combination which gives the largest number on multiplication is the 'fastest' system. This has been done in Table 5.2 for each of the possible film–screen combinations. The combinations marked with an asterisk have the same relative speed, but can it be assumed that the high resolution system will provide the better image quality. Using the faster film may result in a higher radiographic contrast and this would render quantum mottle even more readily visible. Graininess would also be more apparent. The improvement in image quality hoped for is thus unlikely to be realized due to the increased image noise interfering with the visualization of image detail. The degree to which this effect is troublesome depends on the region of the body being investigated. A high resolution intensifying screen pair could well be used with a fast film for extremity work or other body parts where bone detail is required. On the other hand a fast screen with a slow film is better where fairly large, low contrast information is required, e.g. some types of gallstones.

Table 5.2 Possible combinations of two films and three screens

Intensifying screen	Relative speed of intensifying screen	Relative speed of film (y)	Relative speed of imaging system (xy)
High speed	4	2	8
High speed	4	1	4
Medium speed	2	2	4
Medium speed	2	1	2*
High resolution	1	2	2*
High resolution	1	1	1

* See text

FILM–INTENSIFYING SCREEN CONTACT ASSESSMENT

Poor film–screen contact introduces unacceptable unsharpness in the image and contact should be periodically assessed. The test is described in British Standard 4304 (1968) for testing cassettes. Unlike a test using wire mesh, it is not unsharpness in the image that is looked for, but regions of increased density in the areas of the film under the metal of the test object. This is described as a sheet of perforated zinc about 1 mm thick and with about nine perforations per square centimetre. It has a 1 cm² area cut out of the centre of

Figure 5.20 Test object for BS 4034 (1968)

the sheet. The image density in this area is used for correct density assessment. The dimensions of the sheet should be at least the same as those of the cassette to be tested. One sheet (35 × 43 cm) is suitable for all cassette sizes and is found to produce satisfactory results provided reasonable care is taken (Figure 5.20). The correct specification zinc sheet is expensive and when not in use must be stored flat.

Requirements for the test:

(i) Test object

(ii) Cassette to be tested, loaded with medium speed, unexposed film. Of course, the term medium speed is a relative term. Only one speed of film may be available in a department, and whatever its relative speed, it would have to be used

(iii) Equipment for exposure. The exposure factors recommended in the British Standard are 50 kV$_p$, 1.5 m FFD, 1–1.5 mm focus and 2.0 mm Al equivalent total tube filtration. It is not absolutely essential to adhere precisely to the kV, FFD and focus size recommended. Suffice to say that not more than about 50 kV$_p$ is used to avoid penetration of the zinc sheet since this would mask the effect due to unsharpness. The FFD and focus size suggested are to minimize geometric unsharpness. The correct mAs must be determined by trial and error such that an image density of between 2 and 3 is produced on the film under the central 1 cm² hole. Providing this density is obtained, then the effect of poor film screen contact is clearly visible at the normal viewing distance using a conventional illuminator. A lower image density makes the effect more difficult to see

(iv) Automatic processing facilities.

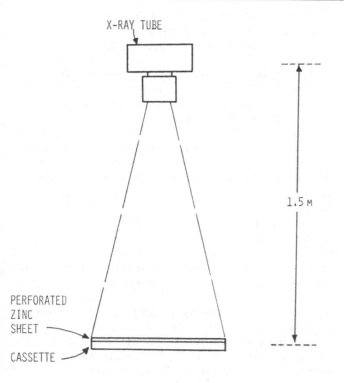

Figure 5.21 Equipment for BS 4034 (1968)

Figure 5.22 Test object placed on a cassette

Figures 5.21 and 5.22 show the equipment arrangement for exposure. Where the screens are not in an easily handled cassette but form a built-in part of an automated film handling system the zinc sheet must be supported over the imaging area as close as possible to the film.

Poor film–intensifying screen contact experienced when the cassette is used in a vertical position need not necessarily be apparent when the film is used horizontally. Unsharpness seen on a chest film, for example, taken erect and thought to be due to poor film–screen contact would require a test to be done with the cassette vertical if poor film–screen contact could not be demonstrated with the cassette horizontal.

Assessment of Film–Screen Contact

If the film–screen contact is satisfactory then the image will appear as a series of black dots representing the perforations and a black square representing the central cutout area, while the remainder of the film will be blank. If poor film–screen contact exists, then in the areas of poor film–screen contact the normally blank areas will record a visible density (Figures 5.23 and 5.24).

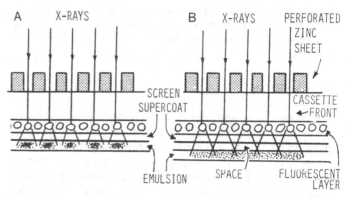

Figure 5.23 Good film–screen contact (A) gives distinct dots while poor contact (B) gives overlap, in severe cases producing a uniform high density area

Figure 5.24 Film–intensifying screen contact test film

INTENSIFYING SCREENS AND AUTOMATIC EXPOSURE

In Figure 5.17 it is seen that if an automatic exposure system is calibrated to produce a given density for system 1 at any kV within the interval shown then changing to system 2 requires only a simple change in the sensitivity of the automatic exposure device. It can then be operated at any of the kV values shown and the same density as before will result. The use of system 2 of Figure 5.16 however is much more complex. The relative speed is not constant at each kV value and a simple sensitivity change while suitable at one kV would not be suitable for the entire range. A different sensitivity is required at each kV. It is probable that a change to rare-earth intensifying screens would necessitate complete recalibration of the automatic exposure system if it is to be used throughout the diagnostic range of kV values for a constant density.

DISCUSSION

The factors to be considered when choosing practical imaging systems using intensifying screens are similar to those given on pp. 37–38, but any choice must be governed by the image results obtained and required. Comparative testing should always be done and a visual assessment of images made. Unfortunately there are many pitfalls and false conclusions which can be reached. For example, definition can be assessed visually by comparing the images produced in each of two systems but to do this effectively the image contrasts should be identical as should the unsharpness contribution due to geometry. A suitable tissue equivalent phantom should be used as a reasonable approximation to a patient and if possible contrasts equalized for the two systems using the kV control. Images should be visually assessed for noise content. Information concerning contrast can be obtained from plotting relative characteristic curves for the two systems considered and relative speed should be assessed at different kV values.

A variety of film–intensifying screen combinations is available. These include:

(i) single screen + single emulsion film
(ii) paired screens + duplitized film
(iii) multiscreen systems + duplitized films.

An example of (iii) is used in the multisection cassette for tomography. A number of film–intensifying screen combinations are contained in the same cassette each separated by radiolucent spacers of the required thickness. The relative speeds of these combinations are adjusted to give a constant film density. It should be remembered that the phosphor material of an intensifying screen absorbs energy from the X-ray beam and successive screen pairs will progressively attenuate the beam. This means that each succeeding film–intensifying screen combination must have a higher relative speed than its predecessor. In addition, the greater the number of intensifying screen pairs used the higher the energy required in the incident beam to produce a given density on the last film in the sequence. In comparison with plain radiography, subject contrast is much lower for tomographic examinations. This, together with the increasing kV required for an increasing number of film–intensifying screen combinations used simultaneously, places a limit on the usefulness of multisection tomography because of the low image contrast achieved. The smaller the number of combinations used the better the image contrast because of the lower kV possible. Unfortunately one of the advantages of multisection tomography is that images of several body layers can be obtained for just one exposure thus reducing exposure dose to the patient. Since one layer is imaged for each combination of film and intensifying screens used then reducing the number of combinations in order to achieve a particular image contrast reduces the number of layers imaged for a single exposure. In terms of radiation dose this again is a disadvantage particularly where a large number of layers are required. Further disadvantages accrue as a result of increasing the relative speed of each successive combination. Resolution and speed are reciprocally related. The reduction in resolution with increasing speed is not helped by the fact that film–intensifying screen contact is not as good in a multisection cassette as it can be in an ordinary radiographic cassette.

6

Cassettes

INTRODUCTION

A film cassette is a container for exposed or unexposed film. The size and shape of the cassette depends on the film it contains, which can be a single sheet of film of any of the manufactured sizes, a number of sheet films of similar size when unexposed, a number of similar or different size sheet films when exposed, or a roll of film. An exception to this is the xerographic cassette which contains not film, but a selenium-coated aluminium plate. Here the image is formed as a charge pattern on the selenium and only transferred to a paper image during the processing stage; this is discussed more fully in Chapter 15.

For direct exposure radiography the X-ray cassette contains only X-ray film and this cassette is simply a paper or plastic, light-tight envelope. For most radiographic techniques where intensifying screens are used the cassette is more robust and specialized to maintain close contact between film and screens. Alternatively, for economy and where strength is lacking, close contact is achieved by vacuum packing film and screen in a plastic envelope.

X-ray cassettes are available which can house more than one set of film and screens. The cassette for multisection tomography is an example. So-called 'daylight' film handling systems often employ outwardly conventional cassettes which are designed for opening, unloading, loading and closing automatically. Other automatic systems have film and screens as an integral and inseparable part of the system so neither a film nor a cassette containing screens is handled. Such systems can employ an automatic feed to the processor so that the only time the film is seen and handled is after processing. This eliminates film handling faults.

In automatic film changers such as the Siemans Elema sheet film AOT equipment two cassettes are used, neither of which contains intensifying screens. The screens are an integral part of the equipment. The only immediately detachable parts of the equipment are the two cassettes. One acts as a film-feed cassette into which unexposed films are loaded and stored. The other is the take-up cassette which houses exposed film prior to processing. Figure 6.1 shows an AOT changer with the two cassettes in place. The two cassettes are shown in Figure 6.2.

Cassettes for miniature film may contain sheet or roll film.

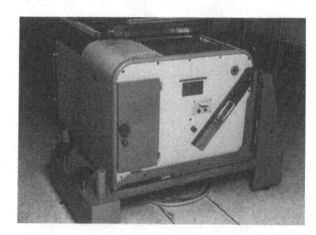

Figure 6.1 An AOT cut film changer

A

B

Figure 6.2 Film-feed cassette (A) and take-up cassette (B) for AOT changer

A

B

B

Figure 6.3 Film-feed cassette (A) and take-up cassette (B) for 70 mm roll film

Figure 6.4 A: 35 mm cinefilm film-feed and take-up cassette. B: cassette with cover removed

The Odelca camera for example employs 100 mm sheet film or 70 mm roll film depending on which camera model is used. Film-feed and take-up cassettes are again employed. 70 mm roll-film cameras used in photofluorography also have film-feed and take-up cassettes (Figure 6.3). In some automatic film handling systems the film-feed cassette supplies only one size and type of unexposed film to the system while the take-up cassette will accept all sizes and types used. Cine cameras for cinefluorography have cassettes in which the film-feed and take-up cassettes are incorporated in a single cassette attached to the camera (Figure 6.4). A film-feed cassette is often referred to as a film loading magazine.

THE X-RAY CASSETTE

Structure and Functional Requirements

The typical X-ray cassette (Figure 6.5) consists of a front and back hinged at one side. The front is a shallow box, the cavity

of which is often called the cassette well (Figure 6.6) and contains the front intensifying screen and the lead piece forming part of the film identification system. The back of the cassette forms a support for the pressure pad used for maintaining good film–intensifying screen contact, and may be made of steel, aluminium lined with steel or aluminium lined with lead foil. The back intensifying screen adheres to the surface of the pressure pad.

When loaded and closed the cassette

(i) keeps the film flat and sandwiched in position between the intensifying screens preventing movement of film relative to screens,

(ii) compresses the pressure pad to produce good film–intensifying screen contact,

(iii) provides a light-tight environment for the film before and after exposure. During exposure, of course, the film is affected by the light emission from the screens, but no other light source can affect the film while it is in the cassette (unless the cassette is faulty),

a

b

Figure 6.5 A typical X-ray cassette; closed (a), open (b)

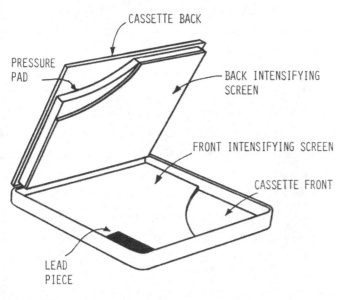

Figure 6.6 Main parts of a typical X-ray cassette

(iv) provides a relatively radiolucent window (the cassette front) for X-radiation to reach the film–intensifying screen combination,

(v) provides a relatively radio-opaque barrier (the cassette back) to X-radiation passing through the cassette thus reducing the intensity of radiation behind the cassette and reducing back scatter, and

(vi) protects the film and intensifying screens from damage.

The cassette serves as a support for the pressure pad and the intensifying screens. From an operational point of view it should be light in weight for transporting, strong to withstand the considerable mechanical stress and strain through normal handling, be easy to open and close for the purpose of film loading and unloading but not easy to open accidentally, and have rounded corners and edges to avoid injury. From an economic point of view it should be durable and of low cost and from an imaging point of view should fulfil the requirements listed in points (i) to (vi). In addition uniform and consistent film–screen contact should be possible throughout the working life of the cassette.

The cassette front is either plastic or metal of low radio-opacity to the photon energies transmitted by the patient. Aluminium is commonly employed. The front should be of uniform thickness and density and not show an image structure on exposure. The British Standard 4304 (1968) recommends that the cassette front should have no greater than a 1.6 mm Al equivalent at 60 kV$_p$ with a single phase unit having a total beam filtration of 2 mm Al equivalent. Plastic-fronted cassettes may have as little as 0.2 mm Al equivalent while most aluminium fronted cassettes have about 1 mm Al equivalent. The difference in image contrast between plastic and aluminium is usually not significant in practice particularly at higher values of kV.

The cassette back is usually steel or some much lighter material of lower radio-opacity lined with lead foil (Figures 6.7 and 6.8). Where lead foil is used it lies between the pressure pad and the cassette back. The cassette back should have a lead equivalent of at least 0.12 mm at 150 kV constant potential. If a phototiming device is employed for automatic exposure control and the device is placed behind the cassette to measure radiation dose then the cassette back must be radiolucent similar to the front. Ionization chamber devices used in automatic exposure control are placed in front of the cassette so this restriction does not apply and conventional X-ray cassettes can be used.

The pressure pad is usually composed of a plastic sponge material. It is important that the pressure pad when used under the front screen should be homogeneous and not show an image structure on exposure, and the plastic sponge material is ideal for this.

There are several varieties of locking devices for cassettes but each behave so as to apply and maintain pressure to the

Labels in Figure 6.6: CASSETTE BACK, PRESSURE PAD, BACK INTENSIFYING SCREEN, FRONT INTENSIFYING SCREEN, CASSETTE FRONT, LEAD PIECE

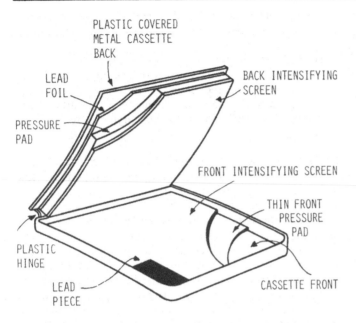

PLASTIC COVERED
METAL CASSETTE
BACK

LEAD
FOIL

BACK INTENSIFYING
SCREEN

PRESSURE
PAD

FRONT INTENSIFYING SCREEN

THIN FRONT
PRESSURE
PAD

PLASTIC
HINGE

LEAD
PIECE

CASSETTE FRONT

Figure 6.7 The Kodak X-omatic cassette. Note the additional pressure pad under the front screen, very much thinner than the back pad but with the same composition. The cassette is shown without an identification window. DuPont market a similar cassette but its intensifying screens are more easily exchanged

film–screen combination and thus achieve good contact. The spring back of the Kodak X-omatic cassette for example supplies the force while the clip lock ensures that when the cassette is closed the pressure force is applied and maintained on the film–screen combination.

The sides of the cassette are usually metal, as are the hinge and locking clips, but other materials can be used. The X-omatic cassette has plastic for three cassette sides and the hinge, the fourth side engaging the locking clip being of metal.

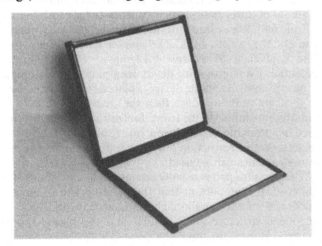

Figure 6.8 The Kodak X-omatic cassette, without the lead piece and identification window

When closed the cassette must be light-tight and often the internal surfaces are blackened. Unfortunately in some cassettes the material used for this purpose can flake off in very small pieces which inevitably drop in the intensifying screens preventing light emission reaching the film. This is often the result of careless and rough handling. All particles like this likely to get into the cassette and onto the screen surface can damage the protective supercoat exposing the fluorescent layer to screen cleaning fluid when used. The fluid can destroy the luminescent property of the phosphor particles with which it makes contact producing low density specks in the image.

The lead piece contained in the well of the cassette should be large enough, and in the correct position, to leave an unexposed area of film following exposure to allow subsequent film identification. The lead equivalent is important and should be sufficient to prevent film exposure up to the highest kV used. In most cases the film must be removed from the cassette before patient identification can be exposed onto it but in the Kodak X-omatic system an identification camera is available and the cassette has an identification window in one corner of the back of the cassette

A

B

Figure 6.9 Curved cassettes. A is for general radiography while B is used only for orthopantomography

coincident with the position of the lead piece in the cassette well. The card with the patient information is placed in the top of the camera while the cassette is slid into the bottom. The identification window is automatically slid open in darkness within the camera, the exposure made, and the window closed.

The outside of the back of a cassette may be used to attach labels identifying the intensifying screens and film contained, to indicate the date of last screen cleaning and carry any other identification marks required. Curved X-ray cassettes are available (Figure 6.9) for special applications.

The Gridded X-ray Cassette

This is similar to the conventional X-ray cassette but contains a stationary, secondary radiation grid (p. 104) in the cassette well, between the front screen and the front of the cassette (Figure 6.10). This cassette is used for radiography where it is inconvenient or impossible to use a moving grid for the technique. Details of the grid should appear on the outside of the cassette to assist the user in optimizing the exposure conditions.

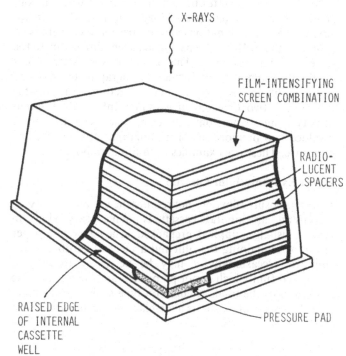

Figure 6.11 Cutaway of a multisection tomography cassette

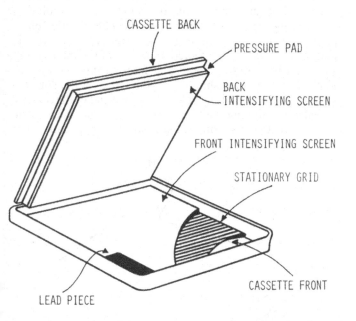

Figure 6.10 A gridded cassette

X-ray Cassette for Multisection Tomography

Figures 6.11 and 6.12 illustrate the typical structure of the cassette which is used in tomography to obtain several images for a single exposure and to ensure that the layers recorded are different and bear an approximately constant relationship to one another. The basic structure of the cassette is similar to that of a conventional X-ray cassette but

Figure 6.12 Cassette for multisection tomography

is larger to accommodate the additional intensifying screens, films and spacers. The cassette illustrated takes 24×30 cm film, has several radiolucent spacers, each 5 mm thick, which can be used separately or in groups providing different thicknesses of spacer (in multiples of 0.5 mm) as required with up to seven films being exposed simultaneously. The greater the number of films exposed simultaneously the greater the X-ray beam attenuation before the lowermost film is exposed, and therefore the higher the kV necessary.

Multisection cassettes have been described where a conventional X-ray cassette is used loaded only with film–intensifying screen combinations and no spacers since there is no room for them. Here the spacing between films is due to the screen thicknesses only. The use of this cassette is not confined to tomography. In plain radiography, by choosing suitable film–intensifying screen combinations it is possible to produce two or even three radiographs with different density ranges and contrasts using one exposure, or to produce two or more similar radiographs again using one exposure. These are examples of multiple radiography.

Direct Exposure Film Cassette

Direct exposure film does not require the use of intensifying screens and an elaborate cassette is not necessary. This film type is usually supplied prepacked in a light-tight paper envelope containing the film and a piece of cardboard for support. Occasionally it may be necessary to employ duplitized film which is not prepacked and then a suitable cassette must be used. A common type is shown in Figure 6.13. It is made of plastic, is matt-black inside, has a stiffened

A

B

Figure 6.13 A direct exposure film cassette; closed (A), open (B)

back and radiolucent front, and a Velcro fastener for closing the flap. With high resolution film–intensifying screen combinations now available for extremity radiography the application of such a cassette is very limited.

Vacuum Cassette

A vacuum cassette once loaded with film has the air evacuated using a pump so that an intimate contact is obtained between film and intensifying screen(s). Such cassettes have been developed and made available as the result of interest in mammographic techniques over the last few years, but their application is not confined to mammography. There are a variety of manufacturers of vacuum cassettes but a particularly simple to use system is that produced by the E-Z-Em Company Inc. Their Vac-U-Pac* cassette is made of flexible carbonized vinyl, high frequency welded along three sides, and incorporating a one-way valve (Figure 6.14). The cassettes are reusable, and are open at one side to allow insertion of film and intensifying screen. The vinyl material is opaque to light but not X-rays so as not to produce a structure pattern on the resulting radiograph especially at the low photon energies used in mammography. For mammography the single, high resolution intensifying screen is mounted on the blue plastic folder provided with each cassette. The emulsion side of the film is placed in contact with the active surface of the intensifying screen and the folder closed and inserted into the Vac-U-Pac* cassette (which should be lying flat on a flat surface) right up to the seat of the valve. The open end of the cassette is sealed by running the heel of the hand across the cassette just above the opening. In this way the opposing inner

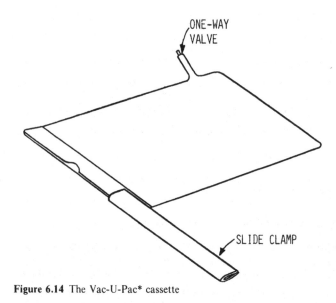

Figure 6.14 The Vac-U-Pac* cassette

* Vac-U-Pac is a trade mark of the E-Z-Em Company Inc.

surfaces of the cassette are brought into contact and adhere. The slide clamp is pushed into place, the vacuum pump is attached and the cassette evacuated. Once the air is removed the film and screen are held together by atmospheric pressure distributed uniformly. This minimizes unsharpness which in ordinary cassettes is due to less than perfect film–intensifying screen contact. In this type of cassette the use of a vacuum is the only way to ensure good film–intensifying screen contact.

The edges of the cassette and the valve stem, being flexible, may be folded under so that the edge of the film is right at the edge of the cassette and in mammography may be placed well up to the chest wall. Cassettes are available with the valve at the top or at the side and in sizes 18 × 24 cm and 24 × 30 cm. A 35 × 43 cm Vac-U-Pac cassette is being developed for use with paired intensifying screens and duplitized film. The smaller sizes are suitable for mammography and extremity radiography while the 35 × 43 cm size is intended for more general application.

Care should be exercised in handling these cassettes to avoid damage to the plastic bag or valve seat which would prevent a vacuum being obtained, and to avoid dust particles collecting on the intensifying screen. For general use a rigid plastic-fronted cassette tunnel is used to house the vacuum cassette. Another type of vacuum cassette system employs a plastic envelope in which the film–intensifying screen combination is placed. This envelope is placed inside equipment which evacuates the air from the envelope and heat seals the open edge. This method is very effective but the equipment is extremely expensive and the cassettes are not continuously reusable.

Xeroradiographic Cassette

The functions of this cassette are in many ways similar to those of a conventional X-ray cassette but the contents are different. In a conventional cassette the imaging medium is a film forced into close contact with single or paired intensifying screens. In the xeroradiographic cassette (Figure 6.15) the imaging medium consists of a very thin layer of photoreceptor semiconductor material deposited on a relatively thick conducting metal sheet. The metal sheet is inserted into a cassette just before use, a procedure carried out automatically. There is no pressure pad since a film and screens are not used.

The photoreceptor can only act as an imaging medium if it carries a uniform electrostatic charge and is contained in a light-tight cassette. Accidental exposure to light, X-rays or excessive heat will cause the charge to leak from the photoreceptor rendering it unsuitable for imaging until it can be recharged. Once the photoreceptor is fully charged and enclosed in the cassette it should be handled with care avoiding excessive pressure on the cassette front which could

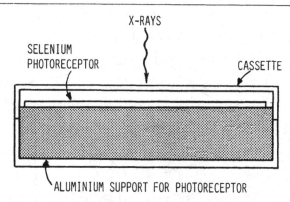

Figure 6.15 Diagrammatic section of a xeroradiographic cassette

cause it to flex and touch the photoreceptor surface causing local discharge.

Film-feed and Take-up Cassettes

These are used in automatic film handling systems using roll film and in systems employing sheet films. Four examples are considered, two sheet film systems and two roll film systems:

 (i) Siemans Elema AOT rapid film changer for sheet film (35 × 35 cm),
 (ii) Oldelft Odelca camera system using 100 mm sheet film,
(iii) Philips 70 mm camera system for photofluorography (roll film), and
 (iv) a typical cassette for 35 mm cinefluorography (roll film).

Other examples of cassettes used in automatic film handling systems will be considered later.

Siemans Elema AOT System
Siemans Elema AOT cassettes form an integral part of the AOT rapid film changer. The film-feed cassette (loading magazine) (Figure 6.16) contains unexposed sheet film to a maximum of 30 films, each placed between metal separators. The cassette is loaded with film under suitable safelighting conditions by opening the sliding panels and inserting the required number of films between the appropriate spacers one at a time. The panels are closed and the cassette, now light-tight, may be transported to and inserted in the AOT equipment. The take-up (receiving) cassette (Figure 6.17) has a sliding lid which is open when the cassette is in the AOT film changer. It receives films following exposure and at the end of the series the button on the side of the cassette is pressed, the lid closes and the cassette can be withdrawn from the AOT film changer and transported to the film processor. The relative positions occupied by the two cassettes are shown in Figure 6.18.

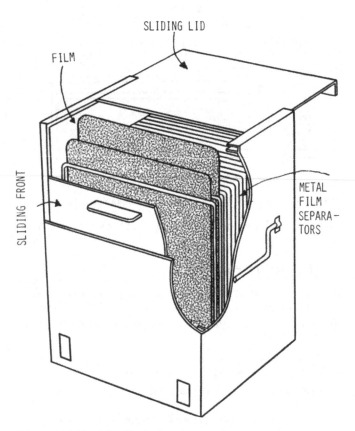

Figure 6.16 The AOT film-feed cassette

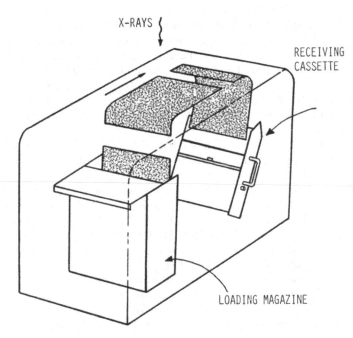

Figure 6.18 AOT film changer showing positions occupied by the two cassettes

cassette with film since the film used has a single emulsion and it must be loaded the correct way around. The film has an anti-halation (light absorbing) layer and if loaded incorrectly will be exposed with the anti-halation layer facing the exposing light source.

Odelca Camera System

The Odelca 100 camera uses 100×100 mm cut film fed from a cassette (Figure 6.19) loaded with up to 50 unexposed films. The film-feed cassette (magazine) is spring loaded so that once a film is removed another is pushed forward ready to be taken. Care must be exercised when loading this

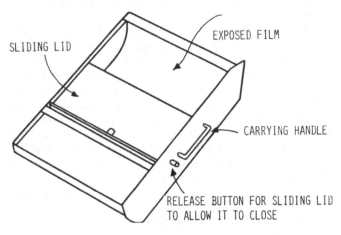

Figure 6.17 Film take-up (receiving) cassette shown with lid open

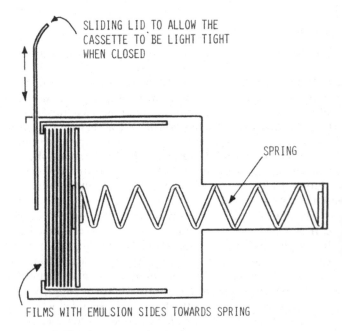

Figure 6.19 Film-feed cassette for Odelca camera

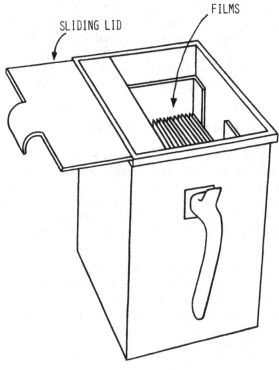

Figure 6.20 Take-up cassette for Odelca camera

The take-up cassette (Figure 6.20) is a light-tight box into which exposed films are passed to await transport to the darkroom for processing. Like the film-feed cassette it has a sliding lid which when closed provides a light-tight environment for the films. The lid must be opened after the take-up cassette is attached to the Odelca camera to allow exposed films to enter it. The sliding lids on film-feed and take-up cassettes are often called dark slides.

Philips 70 mm Camera System

The Philips 70 mm film camera (Figures 6.21 and 6.22) is used for recording the image produced at the output phosphor or the image intensifier tube. A 70 mm roll film is used and the camera employs automatic film threading from the film-feed cassette to take-up cassette. From the film-feed cassette the film runs into the take-up cassette until either the required number of exposures have been taken or the maximum number permissible has been reached. The take-up cassette can be removed at any time and the contained film sent to be processed. To do this the cutting blade button is depressed slicing through the film and then the take-up cassette can be removed from the camera. An empty, replacement take-up cassette is attached and the film automatically threads into it. The camera is now ready for use again but before making any further exposures, it is a wise precaution to wind on an additional 4 cm film into the take-up cassette by pressing the film transport button in case film fogging occurred to the

Figure 6.21 The Philips 70 mm roll film camera attached to the optical image distributor

A

B

Figure 6.22 The Philips 70 mm roll film camera with cover removed. The film-feed cassette is on the left. In A note the light source in the top left-hand corner of the camera for serially identifying the exposed frames. In B the pressure plate has been lifted to show the film

unexposed end of the film when the take-up cassette was removed. While this measure can waste film it avoids the necessity of repeat exposures due to possible film fogging.

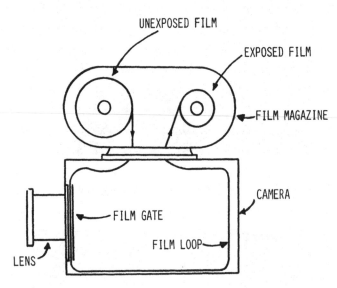

Figure 6.23 Typical cinecamera and film magazine. The magazine and camera cover have been removed

35 mm Cinefluorography

Figure 6.23 illustrates a 35 mm cinecamera and film magazine in which the same cassette contains both unexposed and exposed film. The unexposed film is fed into the camera and, once exposed, returns to the same cassette. Panchromatic film may be employed in which case the magazine should be loaded in darkness. Practice is needed and it is a good idea to use a roll of processed film and load and unload the magazine in daylight. Once proficient the same manoeuvre can be practised in total darkness until once again proficiency is achieved. Orthochromatic cine film is available and if used can be loaded using suitable safelighting conditions.

X-ray Cassettes and Automated Film Handling System

Some automatic film handling systems have been designed around conventional X-ray cassettes. These cassettes can be used with manual film loading and unloading and also when inserted into the automatic film handling equipment can be loaded and unloaded with film automatically and without the necessity of a darkroom. The unloading procedure can be done with film handling equipment attached to the feed-in side of an automatic processor when the film is automatically fed into the processor from the cassette, again without the necessity for a darkroom. The idea is that cassettes already in use can be used in the automatic film handling system when it is introduced thus saving on costs by avoiding purchase of

special cassettes. Other systems have specially designed cassettes which means that when a department becomes wholly committed the previously used cassettes become redundant. This is economically wasteful and these cassettes might well be used to replace older cassettes in a smaller department not employing automatic film handling.

CASSETTE ASSESSMENT TECHNIQUES

The properties of an X-ray cassette are among the many important factors influencing image quality and an understanding of the essential properties is necessary. Techniques for assessing cassette behaviour as a means of considering these properties should be appreciated.

Cassette design should demonstrate

 (i) light weight
 (ii) rounded corners and no sharp edges
 (iii) a perfectly flat, relatively radiolucent cassette front of uniform thickness and structure
 (iv) an effective hinge and locking clip easy to operate for film loading and unloading
 (v) light-tightness when closed
 (vi) a relatively radio-opaque cassette back or cassette back lining
 (vii) a pressure pad (or pads) of uniform thickness and structure, radiolucent and capable, when compressed, of applying uniform pressure
(viii) considerable strength and rigidity
 (ix) non-flaking paint where paint is used
 (x) a cassette front preferably not cold to the touch (perhaps plastic lined)
 (xi) suitability for use in an acceptable automatic film handling system where a total committal system is not contemplated
 (xii) acceptance of a standard metric film size
(xiii) compatibility with standard cassette holders and cassette transport systems
 (xiv) an external film–intensifying screen combination identification system easily recognized even under darkroom safelighting conditions.

Visual inspection, physical handling and trial use will allow assessment of the effectiveness of the design specification incorporating the above properties.

Lightweight cassettes have less strength than the older heavier cassettes and rough handling can damage the hinge and warp the flat cassette front. Hinge damage can result in light leakage into the cassette causing film fogging while a warped cassette front can result in poor film–screen contact.

The possibility of light leakage would be suspected from the appearance of processed films. Light fogging tends to produce high densities commonly around the edge of the

film but in severe cases can extend over larger areas. To test a suspect cassette it should be loaded with film and each side and edge exposed in turn for several minutes to a bright, white light source. The film is then processed and inspected for signs of light fogging. If fogging is present the cassette may be considered for repair, discarded or given to a school of radiography.

The effectiveness of film–screen contact is assessed by the method already discussed in Chapter 5. The light leakage and contact tests should be carried out whenever a new cassette and screens are introduced and then periodically as required, depending on the results of visual inspection of cassettes and radiographs. The intensifying screens when mounted form an integral part of the cassette and any visual inspection of the cassette should include the screens. The screen protective coat is very thin (to reduce photographic unsharpness) and is easily damaged. Flakes of paint from some cassettes or small pieces of grit can become embedded in the screen damaging the protective coat and exposing the fluorescent layer. Subsequent screen cleaning can cause desensitization of the phosphor material in the exposed areas and it will then not fluoresce. Regular cassette inspection and maintenance is essential.

Loading the cassette with film by sliding it into the cassette very quickly damages the protective coat. Films should be placed not slid into the cassette. Fingers should not be placed on the screens when loading and unloading as resulting grease marks can be seen as image artefacts. The screen surfaces should be frequently inspected. Defects in the protective coat can be easily seen using an ultraviolet light source. This procedure must be done with care.

The cassette front while relatively radiolucent does act as a filter for the X-ray beam and the magnitude of its aluminium equivalent will influence the radiographic image contrast. The radiographic contrast is less using a cassette with a 1.6 mm Al equivalent front than using a plastic-fronted cassette with 0.2 mm Al equivalent at the same low kV with a small patient part. Cassette fronts incorporating carbon fibre material, while having considerable strength, also have a low filtration but are expensive and are unlikely ever to become economic because at higher kV values in the diagnostic range there is no practical advantage to be gained an image quality between plastic, carbon fibre or aluminium-fronted cassettes.

The cassette front should not show a structure pattern on a film. This can be assessed by opening the cassette and, before screens are mounted, placing the cassette front in contact with a direct exposure film (Figure 6.24). To assess comparative filtration different thicknesses of aluminium or other material with similar aluminium equivalent can be placed on the same film next to the open cassette. An exposure is made on a single phase unit at 60 kV$_p$ (assessed using the Wisconsin cassette, for example) and the film processed and inspected. The image of the cassette front can

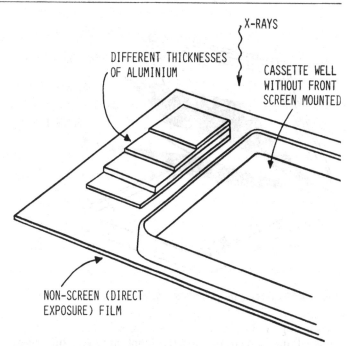

Figure 6.24 Assessing structure pattern of cassette front

be assessed for uniformity of density and its density value compared with the densities produced for the different aluminium or aluminium equivalent material thicknesses to determine the aluminium equivalent of the cassette front, at the kV chosen. Cassette fronts with different Al equivalents attenuate the beam to different extents and different radiation doses will be required for the same image density. This is important in specialized chest work, for example, where automatic exposure control is used. Here the radiation dose to the cassette will be constant but slight density and contrast variations occur if different types of cassettes are used in which the only difference is the attenuation property of the cassette front.

Film-feed magazines and take-up cassettes require periodic inspection and testing for effective operation, signs of excessive wear and possible damage and light leakage necessitating cassette repair or replacement. Intensifying screens in automatic film handling systems should also be checked periodically for effectiveness of film–intensifying screen contact using the standard technique already described but modifying it to suit the equipment under test.

Occasionally in an X-ray cassette low density image artefacts can be due to dirt, grit or even bits of metal trapped behind the front screen during mounting requiring removal of the front screen. This can happen even with the most careful of techniques. To check this a film can be sandwiched between two pieces of black paper, opaque to intensifying screen emission, of the same size as the film, and inserted into the cassette (Figure 6.25). An exposure is made to produce a density of about one and the film inspected following

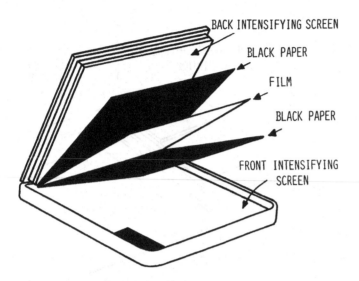

BACK INTENSIFYING SCREEN

BLACK PAPER

FILM

BLACK PAPER

FRONT INTENSIFYING SCREEN

Figure 6.25 Checking for particles of foreign material in the cassette

processing. If low density marks are seen then either the intensifying screen or cassette front are not uniformly radiolucent or particles of foreign material are sandwiched between the cassette front and front screen. The cassette front can be eliminated because it should have been assessed for uniformity of structure and attenuation properties before mounting the screens. The front screen could be eliminated if before mounting the screens it had been placed flat on a non-screen film and an exposure made and the resulting image inspected for uniformity of density.

During the period of use of a cassette the intensifying screens suffer considerable wear and image artefacts can result. Before replacing intensifying screens it is well worth determining the condition of each screen individually to determine the degree of wear. This is achieved following screen cleaning by loading the cassette with film, covering the front screen with black paper and making an exposure. A second exposure is made using another film but this time covering the back screen only. The two films are processed and inspected for uniformity of density. One film will have been exposed only to the emission of the front screen while the other will have received an exposure only from the back screen. If both films show many artefacts then a decision must be made to replace the screens. If only one film shows artefacts then the decision rests between replacing both or only one screen, but in any case film loading and unloading and cassette care and handling techniques should be investigated. If both screens demonstrate excessive wear in a short period and if the care and handling techniques employed are considered satisfactory the manufacturer's advice may be sought. In the light of present day costs it is probably well worth replacing a single screen if only one is affected, provided that the front and back screen pair

purchased are interchangeable and staff are notified of the relative speed change resulting. When changing a single screen in a cassette it is an advantage to do so in two cassettes requiring the change to avoid having to store single intensifying screens in the department.

X-RAY CASSETTES IN USE

Relative to X-ray equipment the cost of an X-ray cassette is insignificant, but its influence on image quality is out of all proportion to its cost. For this reason the cassette should receive as much care in handling and use as the most expensive instrumentation if consistently good results are to be obtained. Rough handling should be avoided since this inevitably leads to poor film–screen contact. Wherever possible, a cassette tunnel should be used to avoid the situation of a patient placing a considerable part of their weight on the cassette in no-grid techniques (These are radiographic imaging techniques where a secondary radiation grid is not used.)

Cassettes should be placed in waterproof, thin plastic covers where a liquid is likely to come in contact with the cassette and this cover should be removed before the cassette is transferred to a darkroom. Any liquid or wet plaster of paris for example which comes in contact with the cassette should be removed as soon as possible. Cassettes should be regularly cleaned with a damp (not wet) cloth. Identification labels and marks on cassettes should be periodically inspected and renewed if they become indistinct. Cassettes should not be carried gripped between the fingers because this way they are easily dropped. A cassette should preferably be carried, held between arm and body with fingers curled around the lower edge. No attempt should be made to carry more than two cassettes at a time especially if they are different sizes because this will greatly increase the risk of dropping them.

Cassettes are ideally stored flat on a flat surface but not one on top of the other. Unfortunately space requirements prevent this and cassettes are generally loaded and stored on edge in a closed cassette hatch or in a lead-lined cassette chest. Each cassette should be placed as near vertical as possible and not at an angle with other smaller cassettes leaning heavily against it. To allow systematic checks to be made on all cassettes, a record should be kept of what checks and tests are made and when. The date a new cassette is introduced into general use should be recorded so that its useful life can be measured. This will provide useful information for future cost estimation for funding. The same information should be recorded for intensifying screens.

Loading and unloading an X-ray cassette is a relatively simple procedure but requires care because the normal useful life of intensifying screens depends on the amount of physical wear they receive. They should be protected as

A

B

C

D

Figure 6.26 Removing exposed film from a cassette

much as possible from the abrasion which can occur when sliding an unexposed film into the cassette well or drawing an exposed film out of the cassette by sliding it over the screen surface. To remove an exposed film from an X-ray cassette, the cassette is opened (Figure 6.26a) under safe-lighting by gently raising the cassette back after the locking clip has been released. The film lies in the cassette well and to remove it the cassette back is laid flat on the bench by fully opening the cassette while at the same time the cassette front is lifted off the bench to the vertical position (Figure 6.26b) and gently rocked back and forth. The film will fall away

from the cassette well (Figure 6.26c) and should be caught at its edge by the free hand. It should be lifted from the cassette (Figure 6.26d) and the cassette allowed to close. An unexposed film is placed, not slid, into the cassette well, handling the film only at its edge. Make sure that the film is fully in the cassette well before gently closing and locking the cassette. A rough technique each time this procedure is carried out can encourage dirt and grit to enter the cassette, cause damage to the film and screens and ultimately result in damage to the cassette.

7

Exposure Factor Manipulation and Control

INTRODUCTION

The beam of X-radiation used in radiographic imaging must possess particular characteristics if the required image quality is to be obtained, and hence a control system is required. X-ray beam characteristics such as photon energy, intensity and duration are controlled by appropriate selection of voltage (kV), tube current (mA) and exposure time (t). The selected kV determines the minimum wavelength of radiation (λ_{min}) for the beam of X-ray photons, and also the beam intensity. The mA chosen determines beam intensity in common with kV, but for a given radiographic contrast the kV must remain constant and mA is used as the prime control of beam intensity. For a given kV and mA, beam intensity at any point may be varied by altering the distance between the X-ray source and the point. Exposure time determines the duration for which the X-ray beam is allowed to act on an imaging medium.

Voltages normally employed range from 20 kVp to 150 kVp. Depending on the type of generator and equipment exposure times range from 0.002 s upwards normally; from 0.01 s upwards with single phase units, from 0.003 s with 3-phase and from 0.002 s with capacitor discharge units.

Exposure factors are usually thought of as comprising kV, mA and exposure time but these three factors should not be considered in isolation. There are many variables which influence the final choice of these three factors and the variables should be considered simultaneously as related details. A statement of kV, mA and t is of little use to a radiographer without details of the circumstances under which the factors are used. The particular values chosen for kV, mA and t depend on the conditions under which the exposure is made and the image quality required to demonstrate adequately diagnostically important information. The choice of factors is usually a matter of experience in a manual selection system but it is common practice to employ an automatic exposure system to control t or both mA and t. Systems are available which take the choice of factors away from the radiographer reducing exposure selection to the pressing of a single button corresponding to the appropriate body part – a seemingly unrewarding task.

kV

The kV selected at the control panel determines the potential difference applied to the X-ray tube insert and controls the minimum wavelength (λ_{min}) of the radiation and hence maximum photon energy. Increasing kV increases photon energy and larger patients or patient parts require higher photon energies to produce the image. In general, the larger the patient or patient part or the more radiodense that part becomes due to pathological processes or the introduction of a contrast medium, the greater the kV required. For a given patient, increasing the kV has certain distinct disadvantages:

(i) The log exposure range of the transmitted X-ray beam is reduced with a corresponding reduction in radiographic contrast.

(ii) More of the scattered radiation produced reaches the film, further reducing radiographic contrast.

(iii) Due to the increased path lengths of electrons generated in the film emulsion at exposure, the appearance of graininess is increased.

In practice, to avoid these disadvantages the lowest suitable kV is often chosen. This produces a very large log exposure range and hence large radiographic contrasts and unless this log exposure range is equal in magnitude to and coincidental with the film latitude, information will be lost in the low and high density areas. A major dilemma is the difficulty of determining the optimum kV to use for a given patient part and imaging system. This optimum depends not only on the patient but also on the type of generator employed and the total beam filtration used. Calibration is also important when considering absolute values of kV.

X-rays are produced when a sufficiently high unidirectional voltage is applied between anode and cathode of an X-ray tube insert and an electron current passes from cathode to anode. Electrons interact with the material of the anode resulting in the emission of X-rays. The voltage applied to the X-ray tube insert is obtained from the mains supply; unfortunately this supply is neither unidirectional or of sufficiently high voltage for direct application. The high tension transformer and rectification system of the generator used converts the mains supply to unidirectional supply and steps up the voltage to the level required.

A constant potential applied to the X-ray tube would be useful in reducing exposure times but due to the way in

which the mains electricity is produced, the mains supply is an alternating voltage causing an alternating current to flow when the circuit is completed.

A single-phase rectification system reverses the negative half-cycle so that the pulsating voltage never becomes negative, while the high tension transformer steps up V_p to a much higher value consistent with X-ray production, but the end result is still a pulsating voltage (Figure 7.1). The magnitude of the oscillation can be reduced by using capacitor smoothing or a 3-phase system but a discussion of this aspect is not the purpose of this section.

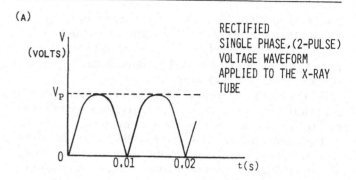

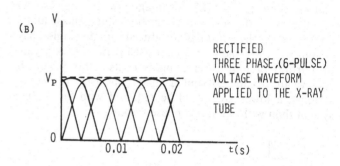

Figure 7.2 Rectified single-phase (a) and 3-phase (b) voltages

The output voltage and current waveforms are controlled by the generator. A single-phase generator output waveform is quite different from that from a 3-phase generator (Figure 7.2). Here it can be assumed for the moment that V_p represents 60 kVp, say. In Figure 7.3(a) at 0 volts no radiation is produced and it is not until V is sufficiently large that the X-ray photon energy is large enough to allow penetration of the inherent and any added beam filtration. Useful radiation is thus only produced over a small part of each half-cycle (Figure 7.3). As the voltage rises from 0, a voltage V_L is reached when the X-ray photons produced have sufficient energy to penetrate the beam filters and least radiodense part of the patient area being radiographed and

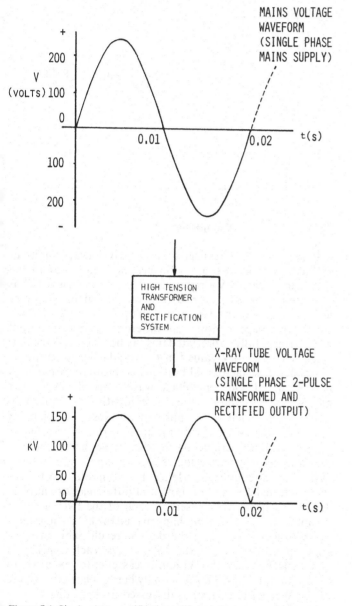

Figure 7.1 Single-phase rectification with transformer

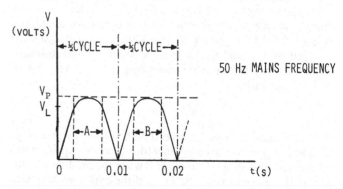

Figure 7.3 Rectified single-phase voltage will only produce useful radiation during the periods A, B, etc.

take part in image formation. As V increases to V_p the photon energy increases to a maximum at V_p. V_p determines λ_{min}. Beyond V_p the voltage decreases again to V_L at which point useful radiation ceases to be produced until V_L is again reached in the next half-cycle.

In Figure 7.4 a 3-phase (6-pulse) voltage waveform is shown (similar to Figure 7.3(b)). V_p and V_L have the same values as in Figure 7.4 but it is important to notice that now the voltage does not drop below V_m. V_p is the same as before so λ_{min} will not change, but because there is now a higher average voltage the average photon energy will be greater producing a beam of higher quality. The effect is rather like that of using a higher kV for imaging with a single-phase (2-pulse) unit. If $V_p = 60$ kVp for both single-phase and 3-phase systems then the image produced with the single-phase system will have the higher contrast because of the greater proportion of longer wavelengths in its X-ray beam. To achieve approximately similar image contrasts with the two systems, a lower kV would be required with the 3-phase system than with the single-phase system.

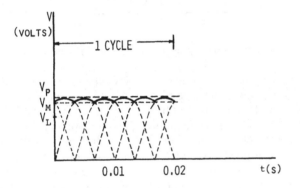

Figure 7.4 With rectified 3-phase voltage, useful radiation is produced throughout the cycle

A quite different system is that of the capacitor discharge unit. Here the X-ray tube derives its energy from charged high voltage capacitors. During exposure (X-ray production) the voltage applied to the X-ray tube insert from this energy source is unidirectional and continuously falling (Figure 7.5). V_0 is the kV to which the capacitor system is charged while t_0 and t_1 represent the beginning and ending of the exposure (the exposure time being $(t_1 - t_0)$). The charge on the capacitor, is

$$Q = CV_0$$

If only a small mAs is required then it is unlikely that all of the charge Q will be used up, in which case the exposure will commence at A and terminate at B when the residual voltage across the capacitor will be $V(t_1)$. If the exposure had been allowed to continue (by selecting a larger mAs) then voltages below $V(t_1)$ would produce longer wavelength radiation than

voltages between V_0 and $V(t_1)$. Hence, for a given kV, the spectrum of the X-ray beam is dependent on the mAs selected, and will affect image contrast. A low kV used with a large mAs will produce a beam with a large long wavelength component and will result in a higher contrast image than that produced on a 3-phase (6-pulse) unit at the same low starting kV.

Figure 7.5 Discharge of a capacitor

It should now be realized that not only does the choice of kV have a considerable influence on image contrast – increasing it when kV is reduced and decreasing it when kV is increased – but the type of generator used plays a very important part in the determination of image contrast. If the effect on image contrast of different generator output waveforms is fully appreciated this can be taken into account when selecting a kV value for a particular examination.

Besides these factors calibration and beam filtration must be considered. Output voltage waveforms of two similar pieces of X-ray equipment are never identical in shape but if it is accepted that they approximate closely enough for practical purposes kV calibration is certainly practically important. It is desirable that similar images be produced of the same patient part using the same exposure factors on each piece of equipment. Hence it is desirable that for the same selected kV, similar potential differences are applied across the X-ray tube insert in each of the two pieces of equipment. If this does not happen then the kV settings must be calibrated to achieve the desired result. This involves engineer adjustment of the kV settings, each adjustment being checked with the Wisconsin cassette, for example, to ensure that the stated kV is actually being achieved. The use of the Wisconsin cassette is discussed in Appendix 4.

The amount of X-ray beam filtration present influences

the image contrast obtained due to the selective attenuation effect on the longer wavelength radiation. For a given kV, a reduced beam filtration will allow a higher image contrast to be achieved, but if such a measure is to be contemplated care must be taken to comply with accepted recommendations regarding patient protection.

Consideration should be given to the patient structure when selecting a kV value. Certain pathologies produce an increase (or decrease) in the radiodensity of the region under investigation. This makes the normally accepted kV for that region unacceptable. In practice, unfortunately, the radiographer may be quite unaware that such pathology exists in the patient and a film of inadequate image quality will result from the use of an inappropriate kV value. The situation is improved to some extent, but not completely corrected by using an automatic exposure system. This system, if used correctly, will produce an image of correct average density, but will do nothing to ensure optimum image contrast.

Finally it is fair to say that any factor which influences image contrast must influence the choice of kV used in an attempt to achieve optimum image contrast. These factors are numerous and interrelated and it is little wonder that no two X-ray departments would use the same kV on the same patient to produce the same result. It is not possible to standardize the choice of kV for any particular subject. The best that can be done is to make the radiographer aware of the variables and their effect, and then at least the direction for improvement can be determined.

mA

For a given kV and exposure time, mA is the controlling factor for X-ray beam intensity, and, providing the given kV is the optimum selected for the subject under investigation, the mA factor can be used to control average image density. Increasing mA will increase average image density – in other words the image will appear darker. Provided image information is recorded within the useful density range and the characteristic curve is reasonably linear over this range then mA changes will not affect radiographic contrast. However it is possible to produce a change in image contrast when the mA change made allows some image information to be recorded outside the useful density range and some within (Figures 7.6 and 7.7). In both figures AB and A'B' represent the same information but at different mA values, kV remaining constant; ab and $a'b'$ represent the image densities produced. In Figure 7.6 $(b-a) = (b'-a')$ so the contrast has not been altered. However $\frac{1}{2}(b'+a') > \frac{1}{2}(b+a)$ which shows that image $a'b'$ has a higher average density than image ab, yet both are acceptable images of similar contrast. In Figure 7.7, however, a' lies outside the useful density range due to mA being too low. $(B-A) = (B'-A')$ but $(b'-a') < (b-a)$ so the mA change has resulted in an image of lower average density and reduced image contrast. It is interesting to note that if a low contrast image is produced with many confusing low (but differing) density images surrounding an important diagnostic detail of higher density then visualization is made easier by reducing average image density. This serves to reduce low density contrasts to below the level of perceptibility when the important, higher density tends to stand out and is more easily seen.

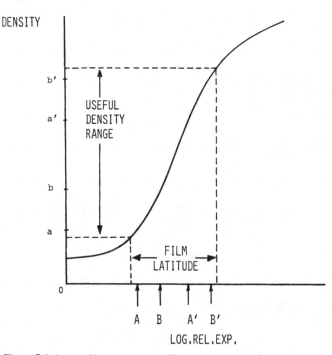

Figure 7.6 Acceptable contrasts at different average densities

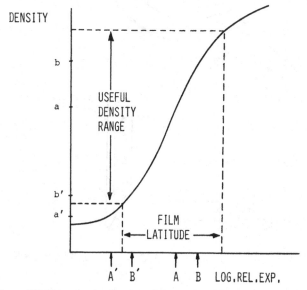

Figure 7.7 Here a reduction in mA has reduced image contrast to an unacceptable level

Both mA and exposure time may be used to control average image density and, as has been mentioned, it is usual to speak of the product of these two quantities as mAs (milliampere-seconds). For a particular set of exposure conditions a particular mAs will give a certain average image density but it should be realized that a given mAs can be obtained in a number of different ways. Consider the following example illustrating the reciprocity relationship:

mA	\times	s	=	mAs
600	\times	0.1	=	60
500	\times	0.12	=	60
400	\times	0.15	=	60
300	\times	0.2	=	60
200	\times	0.3	=	60
100	\times	0.6	=	60

Neglecting reciprocity failure, each of these settings will produce the same average image density. The problem is one of choice. Is any one of these settings better than the rest?

If patient movement is considered negligible then any one of the settings is acceptable in terms of exposure time, but what of mA? Unfortunately the value of mA used can influence the dimensions of the focus. The focus of an X-ray tube insert is the area of the anode bombarded by the electron beam arising from the cathode filament and accelerated towards the anode by the applied potential difference (Figure 7.8). The focus is the area from which the X-ray beam arises (except for the small amount of extrafocal radiation occurring through secondary electron emission). In practice a focus size is selected and assumed to remain that size but it is found that increasing mA may produce an increasing focal area. Depending on the tube age and condition, and the state of the filament and its position relative to the focusing hood, the focus size can more than double when changing from 100 mA to 400 mA. In newer tube inserts the change experienced may be insignificant.

In an X-ray tube insert the focal surface of the anode is angled relative to the electron beam so the anode area 'seen' by the electron beam will be different from the actual area. These again will be different from the effective focal area as 'seen' by each point in the subject being imaged. Each of these areas is interrelated and since image unsharpness depends in part on the dimensions of the effective focus, the

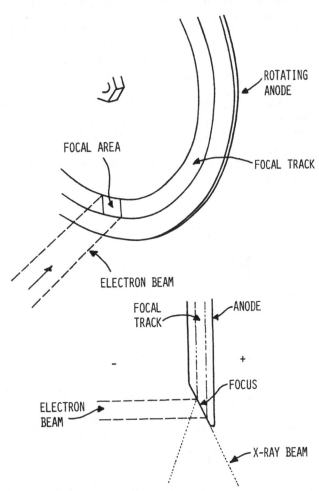

Figure 7.8 Position of focus

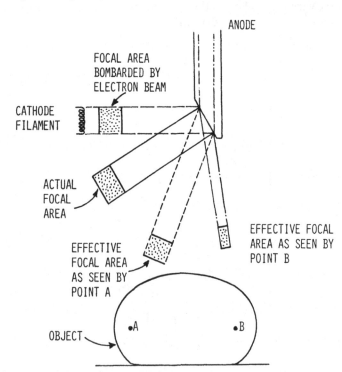

Figure 7.9 The effective focal areas

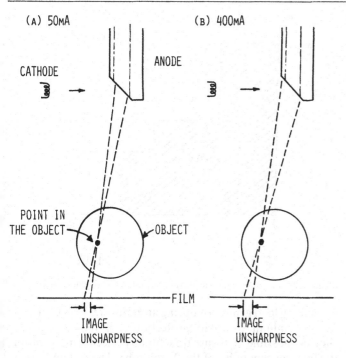

Figure 7.10 Increased mA causes increased image unsharpness

electron beam dimensions must affect image unsharpness. Figure 7.9 shows the relationship between the three different areas. As mA increases, the dimensions of the electron beam can increase and then so will image unsharpness (Figure 7.10). X-rays are produced from all parts of the focus and in all directions, but in the figure only two rays are drawn, from the extremities of the focal area converging on the object point. This shows how the geometry of the exposure determines the amount of image unsharpness. The above argument would suggest that a low mA and long time should be selected to minimize geometric unsharpness. Unfortunately in some cases movement unsharpness may be several orders of magnitude greater than geometric unsharpness and a shorter exposure time must be selected together with a higher mA. Where movement unsharpness is negligible (with a well immobilized extremity for example) the use of a low mA is feasible, but in very small patient parts such as extremities geometric unsharpness is insignificant even for the largest focus when the focus to film distance is of the order of 100 cm and the subject is in contact with the film. It is in the cases of large patient parts that problems occur.

Exposure time must be kept short because of patient movement necessitating the use of a high mA. High mA values can only be used with larger focal spot sizes due to energy considerations and the possibility of anode damage. The problem of geometric unsharpness is most acute where it is least wanted. Of course mAs can be reduced allowing a low mA to be used if kV were increased to compensate. This measure maintains the average image density but reduces

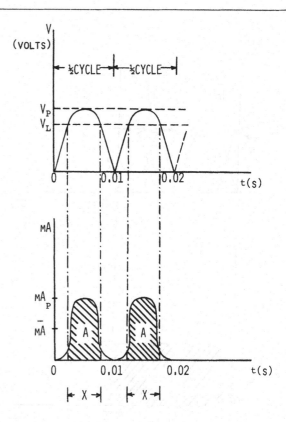

Figure 7.11 Current waveform for a single-phase generator. For comparison the output waveform of Figure 7.14 is included

image contrast which can be unacceptable. Obviously a compromise is necessary.

Information of practical significance can be obtained from a further consideration of generator output waveforms. Figure 7.11 shows the X-ray tube current waveform for a single-phase (2-pulse) unit. The area (A) under the curve is equivalent to mAs, remembering from the voltage output waveform that useful radiation is being produced for only part of each half-cycle. The peak tube current is mAp. The shape of the tube current waveform is achieved through appropriate X-ray tube cathode design and goes some way to achieving the ideal of allowing tube current to flow only during the period when tube voltage is high enough to allow useful radiation to be emitted. \overline{mA} is the value registered by an mA meter during the exposure.

Now consider the waveform shown in Figure 7.12. The area (**B**) under the curve is the effective mAs per cycle for a 3-phase (6-pulse) unit; mAp here is less than mAp in Figure 7.12. From Figures 7.11 and 7.12, even though Vp and \overline{mA} are the same in both cases, $B > 2A$. This implies that, providing loading permits, a greater mAs can be obtained in a given time with 3-phase than with single-phase. The important implication here is that for a given kV and mA it is possible to obtain the same mAs in a shorter exposure time

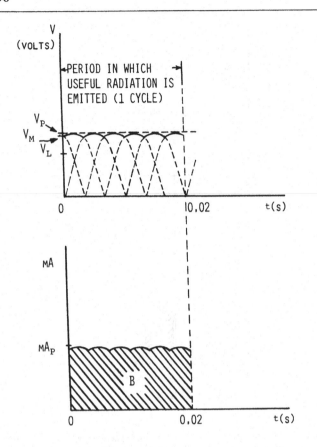

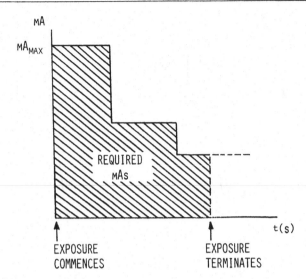

Figure 7.13 Output current waveform for a falling load generator

of a falling load generator during an exposure. This system is its own inbuilt overload protection and yet ensures the shortest possible exposure time for any selected mAs within the loading capability of the X-ray tube. The system is used to advantage with an automatic exposure control device to ensure the shortest exposure time consistent with a given average image density for any patient. The fall in loading may be stepped as in Figure 7.14 or may be continuous, in which case the loading falls gradually and smoothly .with time.

In the case of a capacitor discharge unit, mAs and not mA must be selected. As shown in Figure 7.5 the kV selected has

Figure 7.12 Current waveform for a 3-phase generator. The output waveform of Figure 7.4 is included

with 3-phase than is possible with a single-phase system. This leads to the misconception that smaller exposures are necessary with 3-phase equipment. This is, of course, quite false. A particular radiation dose is required to produce a given film blackening irrespective of generator type. The 3-phase equipment is capable of delivering this dose in a shorter time than single-phase equipment. This is further helped by the fact that, for the same V_p, the average kV is greater with 3-phase resulting in a higher intensity X-ray beam anyway.

It is possible to reduce further the time taken to deliver a particular dose by using a 'falling load' generator. Here, instead of selecting an mA, an mAs is selected and the generator provides the highest allowable mA at the start of the exposure, maintains this level for a short time and then, if the required mAs has not been achieved, reduces it to a lower level, maintains this lower level for a further period and if the desired mAs has still not been achieved reduces it to an even lower level to allow completion of exposure. These reductions in mA occur as the exposure is taking place. The principle is illustrated graphically in Figure 7.13, the information being the result of readings taken from the mA meter

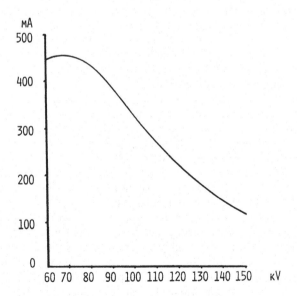

Figure 7.14 mA obtainable with a particular kV at the start of exposure with a 150 kV capacitor discharge unit

that value only at the instant the exposure commences. Thereafter it continues to fall until the exposure ceases. The same is also true of the mA value. The mA value at the commencement of exposure depends on the selected kV as shown in Figure 7.14.

Investigations with the capacitor discharge unit have shown that at 130–150 kV with a 2 mm focus the intensity distribution of X-rays from the focal area is more or less uniform. At lower selected kV values the intensity distribution is found to become more and more uneven, being increasingly concentrated on the two edges of the focal area (Figure 7.15). Intensity distribution has a considerable effect on resolution but this will be discussed more fully in Chapter 9. At the moment it is sufficient to point out that at the lower, more frequently used, kV values, the least favourable intensity distribution is obtained which provides the poorest resolution. The tube current waveform is shown in Figure 7.16 for an exposure lasting 0.33 s with the 150 kVp capacitor discharge unit.

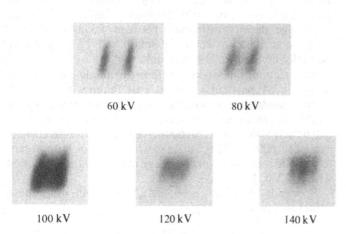

60 kV 80 kV

100 kV 120 kV 140 kV

Figure 7.15 Photo of focal spot images at 60, 80, 100, 120 and 140 kV

It should now be obvious that no single exposure for a given patient will produce the same image result on all types of X-ray equipment. In practice, for a given patient a different exposure is required for each different piece of X-ray equipment. A large department is likely to have a variety of equipment, each unit designed to perform a specific task well but able to function in other areas also. Here it is an advantage to have automatic exposure devices to at least obtain uniformity of average image density from unit to unit. This presupposes the correct use of the automatic exposure devices.

EXPOSURE TIME

The exposure time selected determines the length of the

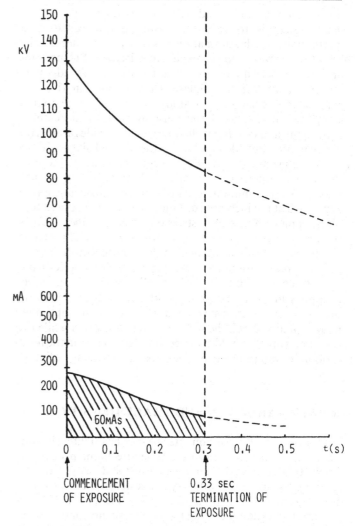

Figure 7.16 mA and kV variation in a 150 kV capacitor discharge unit during exposure

exposure. It is primarily selected as a means of limiting image unsharpness due to patient movement, but in the absence of movement may be used as a control of average image density. Increasing exposure time increases the length of the exposure allowing a larger exposure dose to reach the film and hence increasing film blackening. In the presence of patient movement, increasing exposure time increases image unsharpness.

In some X-ray equipment, the focal area of the X-ray tube can only dissipate a small amount of energy in a given time. This means that only relatively low kV and mA values may be used. Here exposure time is the deciding factor in obtaining sufficient image density. If this means excessive image unsharpness due to patient movement then a faster image recording system must be used with its attendant increased image noise level (Chapter 9) so that an exposure

time reduction can be made. The present tendency in equipment design is to reduce exposure times needed to a minimum through automation but this does not necessarily lead to optimum image quality in all cases. But perhaps optimum image quality is not necessary, merely adequate image quality for a diagnosis to be made. In this circumstance it is necessary to study the type of image quality adequate for diagnosis and perhaps avoid a more time-consuming and difficult technique which provides a superior image quality but adds nothing to the original diagnosis. An image quality optimization technique might indicate the use of a longer than normal FFD to reduce image unsharpness to a minimum. This would mean using larger exposures at the increased distance to obtain the desired film blackening with increased stress on the X-ray tube, whereas the unsharpness produced at a shorter FFD might well be greater but still small enough not to interfere with diagnosis.

Thus optimization may not represent the best policy from a cost-benefit point of view in all cases. It is certainly necessary in some cases but not in others. Areas requiring optimization of exposure conditions to obtain optimum image quality should be isolated and investigated while the remaining areas should undergo standardization in the most economic way in terms of time, cost and patient radiation dose.

mAs, kV VARIATION AND IMAGE DENSITY

Both mA and kV variation affect X-ray beam intensity and hence image density. Exposure time affects the product of intensity and time (It) upon which image density depends. Varying kV, mA and t will vary image density. It is possible, for a given patient, to choose a kV value so low that no radiation reaches the imaging system so no matter what value of It is used no image blackening results (the patient is irradiated for no result). It is important to appreciate by practical experience the value of kV appropriate to different examinations.

In practice it is necessary to know how kV and mAs variation affect image density. Perhaps the most important question is 'If a change is made in one factor, what change must be made in the others to maintain a constant average image density?' The obvious answer is to use an automatic exposure system but this may not always be available. In this case to achieve the desired result some mathematical manipulation is called for. For correctly calibrated kV values,

$$\frac{mAs_1}{mAs_2} = \left[\frac{kV_2}{kV_1}\right]^4 \tag{7.1}$$

when calcium tungstate intensifying screens are used with a screen-type X-ray film. This formula assumes that an initial exposure (mAs_1, kV_1) is known and a known change in mAs

or kV is to be made. Assuming a known change in kV so that the new kV is kV_2 then the required mAs (mAs_2) can be calculated. All other conditions must remain constant. The calculated result ensures that (mAs_1, kV_1) will produce the same average image density as (mAs_2, kV_2) but obviously not the same image contrast.

Consider an example. A certain patient part is known to require 60 kVp, 10 mAs for a given set of exposure conditions. It is desired to use 100 kVp. What value will the new mAs have under the same set of exposure conditions? Now $mAs_1 = 10$, $kV_1 = 60$, $kV_2 = 100$. Using these values in equation (7.1) gives,

$$\frac{10}{mAs_2} = \left[\frac{100}{60}\right]^4 = 7.72$$

so

$$mAs_2 = \frac{10}{7.72} = 1.3 \; mAs$$

This result ensures that 60 kVp, 10 mAs will give the same average image density as 100 kVp, 1.3 mAs. Of course, in practice it may be impossible to obtain 1.3 mAs precisely but the image density difference between 1.3 mAs and say 1.5 mAs at 100 kVp would be small, and 1.5 mAs would normally be used (0.03 s at 50 mA, say).

As a second, but slightly different example consider the following. A particular patient part requires 60 kVp and 10 mAs (made up of 100 mA and 0.1 s). It is known that to limit patient movement unsharpness in the image an exposure time of 0.01 s is required and that 600 mA is the highest tube current available. $600 \times 0.01 = 6$ mAs so what kV value is necessary to provide a similar average image density to that obtained with 60 kVp, 10 mAs?

Now $mAs_1 = 10$, $kV_1 = 60$, $mAs_2 = 6$. Again, using these values in equation (7.1) gives

$$\frac{10}{6} = \left[\frac{kV_2}{60}\right]^4 = \frac{kV_2^4}{60^4}$$

so

$$kV_2 = \left[\frac{10 \times 60^4}{6}\right]^{1/4} = 68 \; kVp$$

Using kV^4 when employing intensifying screens, while not absolutely accurate at all kV levels in the diagnostic range, is sufficiently accurate for most practical purposes.

When intensifying screens are not used the index should be 2. Thus for direct exposure film the equation becomes,

$$\frac{mAs_1}{mAs_2} = \left[\frac{kV_2}{kV_1}\right]^2 \tag{7.2}$$

The equation involving kV^4 has been evolved using calcium tungstate intensifying screens and would not apply to

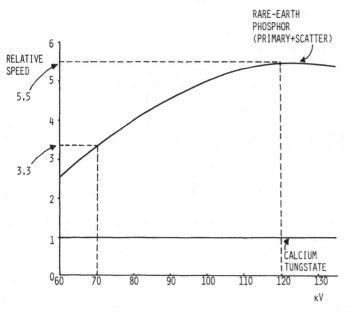

Figure 7.17 Relative speed–kV curves for calcium tungstate and rare-earth phosphor intensifying screens

phosphor materials based on gadolinium, lanthanum and yttrium (or barium fluorochloride). The kV response curves for these phosphor materials are different from calcium tungstate. The equation could be used, however, if the necessary correction for relative speed was made at the kV to be used. Consider the following as an example. Figure 7.17 shows a relative speed–kV curve for calcium tungstate and a rare-earth phosphor material (this is the type of graph which is produced from experimental determination of relative imaging system speed using the methods of Chapter 5). Assume that the rare-earth intensifying screens are being employed and that a satisfactory image is produced at 70 kVp and 20 mAs. Further assume that a second film is required at 120 kVp having the same average image density as the film taken at 70 kVp. At 70 kVp the rare-earth screens are 3.3 times faster than calcium tungstate. A satisfactory image could be produced with calcium tungstate screens, therefore, with an exposure of 70 kVp and (20×3.3) mAs. This gives $mAs_1 = 66$, $kV_1 = 70$, $kV_2 = 120$. Using

$$\frac{mAs_1}{mAs_2} = \left[\frac{kV_2}{kV_1}\right]^4$$

then $\quad mAs_2 = 66 \times \left[\frac{70}{120}\right]^4 = 7.6 \text{ mAs}$

Thus the required exposure at 120 kVp with calcium tungstate screens is 7.6 mAs. At 120 kVp the rare-earth screens are 5.5 times faster than calcium tungstate screens and so the exposure needed is $7.6/5.5 = 1.4$ mAs (0.03 s at 50 mA). Here the change in exposure necessary when using

rare-earth screens has been accomplished by reference to the relative speed–kV curve for the rare-earth screens and calcium tungstate, and using the calcium tungstate screen equation (7.1). Using this equation directly leads to an incorrect result since for the rare-earth screens the original exposure was 70 kVp, 20 mAs giving $mAs_1 = 20$, $kV_1 = 70$. kV_2 is 120 with the rare-earth screens and using equation (7.1) gives

$$mAs_2 = 20 \times \left[\frac{70}{140}\right]^4 = 2.31 \text{ mAs} \quad (0.05 \text{ s at } 50 \text{ mA})$$

a result nearly twice as great as the correct value. Provided the relative speed–kV curve is available then using the above equation correctly is an easier method than trying to evolve a different equation for each of the different phosphor materials. Note that the mA and exposure time values in brackets are those which might be used practically since the calculated mAs values could not be obtained exactly.

Figure 7.18 Aluminium stepwedge

kV VARIATION AND RADIOGRAPHIC CONTRAST

For simplicity, consider an aluminium stepwedge (Figure 7.18) as the object being radiographed, first with a low kV and then with a high kV. Figure 7.19 shows the range of transmitted radiation intensities forming the exposure to the film for both high and low kV exposures. The range in (A) is less than that in (B), i.e. $(I_6-I_4) < (I_{12}-I_7)$.

The characteristic curves shown in Figure 7.20 are similar because the same film type is used for imaging the stepwedge at low and high kV exposures. Here can be seen the range of densities resulting from both these exposures and it is readily apparent that it is smaller in the high kV case, i.e. $(D_6-D_1) < (D_{12}-D_7)$. The densities resulting from these exposures can be represented in a slightly different way which makes visual comparison less difficult. A horizontal line can be drawn to represent the density axis from 0 to D_{max} as in Figure 7.21. The two vertical lines P and Q represent the limits of the useful density range determined by the condition that any pair of densities lying below P or above Q

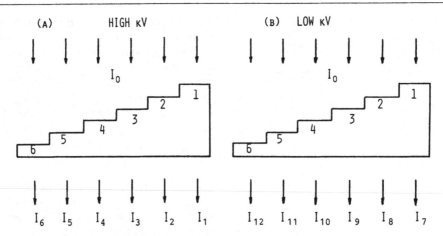

Figure 7.19 The range of transmitted intensities through a stepwedge with high (A) and low (B) kV

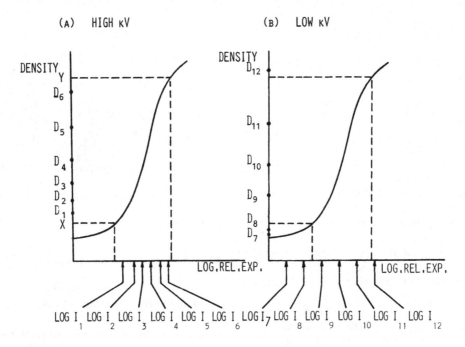

Figure 7.20 Range of densities produced by the arrangement of Figure 7.19

produce a visually undetectable contrast. Densities D_7 to D_{12} are shown on this line and it is apparent that D_7 and D_8 cannot be distinguished from each other. However, even though D_8 lies below P, (D_9-D_8) forms a visible contrast and in this respect D_8 is a useful density. Similarly $(D_{12}-D_{11})$ is a useful contrast. Assume that $D_9 = 1.0$ and represents the image of step 3 of the stepwedge for the low kV exposure. At the high kV, to produce a correctly exposed film, step 3 should again have an image with a density of one. From Figure 7.20 (A) step 3 has an image of density D_3 at high kV and since D_3 should be one then $D_3 = D_9$. With this in mind

Figure 7.22 shows the effect on density, density range and radiographic image contrast (density difference) of changing from low to high kV. If the kV is too high then $[D_n-D_{(n-1)}]$ can become less than that required for visual detection and information will be lost, but this is not likely to happen unless any $[D_n-D_{(n-1)}]$ is already very small for the low kV exposure.

An advantage of increasing the kV is that density differences previously undetectable, as described earlier, become visible. This represents an increase in information content of the image. Thus imaging at high kV may produce

Figure 7.21 Step densities from Figure 7.20 (B)

Figure 7.22 Variation in step densities between high and low kV

an image with different information visible from that at low kV, particularly in the low and high density regions of the image. If the increase in kV is such that any radiographic contrast is not reduced to the point where information disappears, yet is sufficient to introduce additional information in the high and low density regions of the image, then increasing kV will increase the total information content of the image but, because of the resulting reduction in radiographic contrast, the information is more difficult to see.

FOCUS-TO-FILM DISTANCE (FFD)

FFD is the distance from the tube focus to the surface of the film and is usually measured in centimetres. It is unfortunate that 'F' in FFD is not uniquely defined as either focus or film but its use is so widespread and its meaning so well known for no ambiguity to exist. Centimetre scales may be attached to the tube column, floor and ceiling to assist a radiographer in determining the FFD under different conditions. Alternatively a simple tape measure may be attached to the tube housing, and this method does not suffer from the same

disadvantage as that of the fixed scales for measuring FFD when the central ray is angled relative to the vertical or horizontal.

Consider the use of a fixed scale when the central ray of the X-ray beam is not parallel to the scale (e.g. in the case of a 30° fronto-occipital skull projection using a conventional table and overhead tube). The scale cannot be used to measure FFD directly. Here the FFD should not be guessed at, because

(i) The central ray passes through the patient obliquely – it traverses a greater thickness of patient – and this is equivalent to an increase in object-to-film distance (OFD) as shown in Figure 7.23 (in the average adult this can amount to 3 or 4 cm).

(ii) Where the skull is radiographed using a conventional table (rather than a skull unit) with a tabletop-to-film distance of about 5 cm, then with an angle of 30° this distance will be about 6 cm if measured in the direction of the central ray. This again amounts to an increase in OFD.

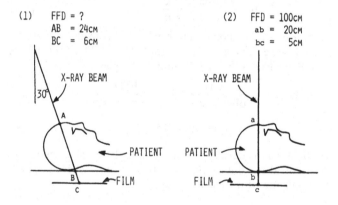

Figure 7.23 Increase in OFD due to angled beam

Increasing OFD in this way produces an increase in image magnification and unsharpness and FFD must be increased to compensate (see Chapter 8). For a given average image density, varying the FFD necessitates a variation in exposure according to the inverse square law from which the following expression is derived

$$\frac{mAs_1}{mAs_2} = \frac{d_1^2}{d_2^2} \qquad \text{where } d = FFD \qquad (7.3)$$

This expression is the one normally used to calculate changes in mAs related to changes in FFD.

An inverse square law relates X-ray beam intensity at a point to the distance of the point from the source of radiation. The source of radiation may be considered as a point source and the intensity considered as constant at each point P having the same distance from the source. Strictly

the source is not a point source and intensity does vary across the beam at each point P, having the same distance from the source, but for practical purposes the approximations already made are valid. A further approximation is necessary. Energy radiating from a point source will have a constant intensity at each point P at the same distance from the source (i.e. P lies on the circumference of a circle with the source as the centre). In practice point P is represented by a film of finite dimensions, while theoretically P should be infinitely small. Fortunately in practice the variation in intensity from point to point in a film exposed to a beam of radiation from an X-ray tube is small at the normally employed FFDs. Thus the whole film may be considered to represent an infinitely small point P or the film may be considered as composed of an infinite number of points P all equidistant from the source of radiation. In either case, from a practical viewpoint, an exposure value calculated to produce a specified image density at one point P in the film will apply to the whole film. It is useful to consider a practical example:

Magnification M is defined as

$$M = \frac{\text{Image size}}{\text{Object size}} \qquad (7.4)$$

It is only linear magnification which is considered here.

In Figure 7.24 it is shown that $M = \text{FFD}/\text{FOD}$, where FOD $=$ (FFD$-$OFD). By similar triangles

$$\frac{\text{FOD}}{\text{object size}} = \frac{\text{FFD}}{\text{image size}}$$

$$\text{and} \quad M = \frac{\text{FFD}}{\text{FOD}} \qquad (7.5)$$

If OFD is considered to be the distance from the point where the central ray enters the skull to the point where it passes through the film then in Figure 7.23 (2)

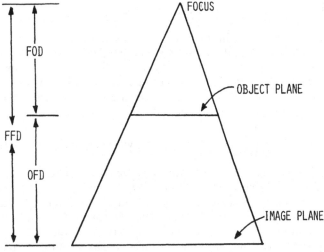

Figure 7.24 Magnification

$$M = \frac{100}{100 - 25} = 1.3$$

In Figure 7.23 (1), for a similar magnification factor and hence unsharpness, the FFD required can be found quite easily. Now $M = 1.3$, OFD $= 30$ cm, and using

$$M = \frac{\text{FFD}}{(\text{FFD}-\text{OFD})}$$

$$1.3 = \frac{\text{FFD}}{(\text{FFD}-30)}$$

$$\therefore \quad 1.3\,(\text{FFD}-30) = \text{FFD}$$

$$\therefore \quad 1.3 \times 30 = 1.3\,\text{FFD}-\text{FFD}$$

$$= 0.3\,\text{FFD}$$

$$\therefore \quad \text{FFD} = \frac{1.3 \times 30}{0.3}$$

$$= 130 \text{ cm}$$

This new FFD is considerably larger than the FFD of Figure 7.23(2) which is invariably used for the projection of Figure 7.23(1).

Assume that an exposure of 75 kVp, 70 mAs at 100 cm FFD produces a correctly exposed radiograph for the 30° fronto-occipital projection but that magnification and unsharpness are unacceptable. The expression derived from the inverse square law can be used to determine the exposure required at 130 cm based on the exposure required at 100 cm. kV is kept constant throughout, and using the derived expression equation (7.3) gives

$$\frac{70}{mAs_2} = \frac{100^2}{130^2}$$

from which $mAs_2 = 118$ mAs.

When determining the appropriate FFD to use in a particular situation, consideration should be given to the equipment used. Often, a cassette holder may be attached to the front of an upright moving grid and cassette tray assembly (upright 'bucky') to facilitate chest radiography. A horizontal ceiling-mounted scale for use with this assembly would not apply to films used in the cassette holder unless the amount of compensation in FFD required was known (Figure 7.25). In this example the correction to FFD is 50 cm.

Many factors influence the choice of FFD, some of which are:

(i) distance at which a grid, if used, is focussed
(ii) tube loading for a given focus size
(iii) standardization of image quality in terms of magnification and unsharpness

Figure 7.25 Assembly for chest radiography

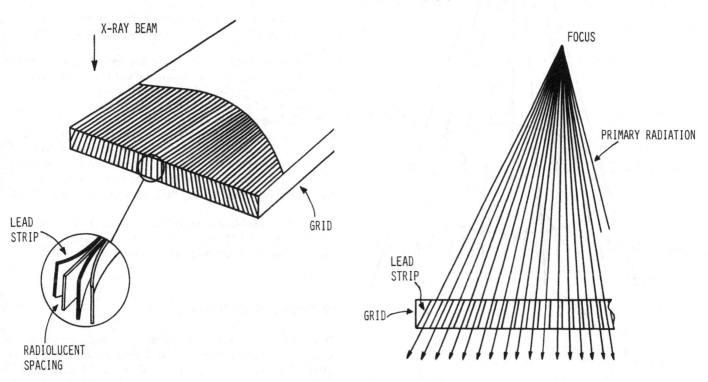

Figure 7.26 Structure of secondary radiation grid

Figure 7.27 Grid is transparent to much primary radiation

A secondary radiation grid consists of a series of thin lead strips separated from each other by radiolucent spacing material, with the lead strips having their long axis parallel to each other and their short axis pointing towards the tube focus (Figure 7.26). Its function is to absorb scatter radiation. Primary radiation emanating from the tube focus will be parallel to the short axis of the lead strips if the grid is placed at a tube focus-to-grid distance equal to the grid focus distance. This arrangement allows much of the primary radiation incident on the grid to pass through it. Some, however, is prevented from doing so by being absorbed by the lead (Figure 7.27). Scatter radiation, on the other hand, will not be parallel to the short axis of the lead strips and will be prevented from passing through the grid (Figure 7.28). The height of the lead strips to the distance between adjacent strips is the grid ratio.

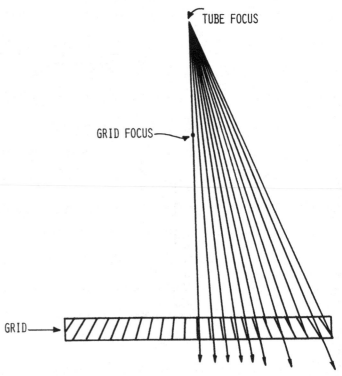

Figure 7.29 'Cut-off' occurs because the X-rays are no longer parallel to the short axis of the lead strips

This elementary introduction to the function of a grid is sufficient to allow an understanding of the grid 'cut-off' effect, illustrated in Figure 7.29.

If the grid is focussed at a particular distance and the FFD is much greater or less than this distance (item (i) above) then image fading (a gradual reduction in density) will be noticed towards the edges of the film parallel to the grid lines. This image fading is called grid 'cut-off'.

In item (ii) the FFD may be limited to a short distance because of the low loading limit on the tube focus. As FFD increases the exposure needed to produce a given density also increases and at some point the exposure needed will exceed the tube loading and no further increase in FFD can be made.

In (iii) the problem of magnification and unsharpness and the choice of FFD and exposure have been discussed by example where the importance of correct choice of FFD was indicated.

INTENSIFYING SCREENS

Intensifying screens have been discussed in detail in Chapter 5 where it was indicated that relative speed was affected by the type of screen and by the kV selected for making the exposure. In practice it is essential to have a

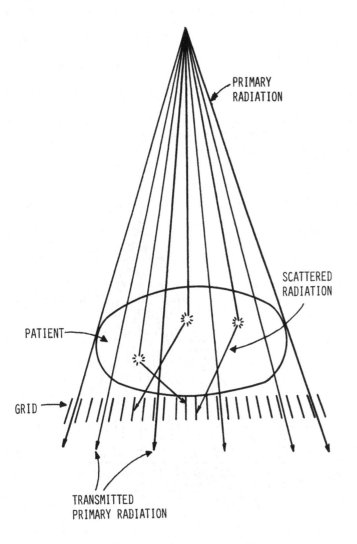

Figure 7.28 Scattered X-rays are absorbed by the grid

knowledge of relative speed for different imaging systems under different exposure conditions so that the appropriate exposure adjustment can be made when changing from one system to another to achieve the same average image density.

FILM SPEED

Relative film speed is the important parameter and again this has been considered in some detail (see Chapter 3). In the case of both intensifying screens and film it is important to note that for a constant kV a change to a combination of higher relative speed requires a reduction in mAs to maintain a given average image density. In general, provided kV is not changed, a change from a system of relative speed m to a system of relative speed n requires the mAs to be multiplied by the factor m/n. For example, in a particular technique a film–screen combination of relative speed 2 requires 60 mAs at 70 kVp. Using 70 kVp again and changing to a film screen combination of relative speed 3, the new mAs required must be $(\frac{2}{3} \times 60)$ mAs. If kV is also changed, then the situation is more complex. Here reference must be made to a relative speed–kV graph when applicable together with the use of equation (7.1).

GRID EXPOSURE FACTOR

In practice it is essential to have knowledge of the behaviour of the grid used under various exposure conditions and to take this into account when manipulating exposure factors. A useful concept is that of grid exposure factor often called 'grid factor'. This is defined as

$$\text{grid exposure factor} = \frac{\text{exposure required with a grid}}{\text{exposure required with no grid}}$$

The exposure here refers to mA, exposure time or mAs at a fixed kV. A tissue equivalent phantom is required for making the exposures so that the scatter component present under practical circumstances is approximated. The amount of scatter produced and reaching the film for a no-grid exposure depends on the structure and volume of patient irradiated and the kV used. The structure and volume of an average patient are approximated by the tissue equivalent phantom and it only remains to determine the effect of kV variation.

Figure 7.30 shows the effect of kV variation on grid exposure factor for a 6:1 ratio (p. 104), stationary grid. The exposure factors were chosen to produce a constant image density of $D = 1.0$ in a dominant area (a dominant area is one which if correctly exposed implies that the whole of the imaged area will also be correctly exposed). Figure 7.30 illustrates that grid factor does not remain constant with

Figure 7.30 Variation of grid exposure factor with kV

variation of kV. Firstly, grid factor is always greater than 1 because the exposure required with a grid is always greater than that without. The value of grid factor obtained at a given kV depends on the lead content, the grid ratio and the radiopacity of the interspacing material of the grid. The larger each of these factors, the greater will be the grid factor. Secondly, grid factor rises with increasing kV because increasing kV is accompanied by an increase in the amount of scatter radiation reaching the film. This contributes to film blackening in no-grid exposures meaning that less primary radiation is required. This implies a reduction in exposure required with increasing kV. Grid exposures, however, result in a different effect. The grid is designed to remove as much scatter as possible from a transmitted radiation beam without unacceptable attenuation of the primary component. Thus a grid prevents the scatter component from contributing to image density, unlike the no-grid exposure, and a similar reduction in primary beam intensity with increasing kV cannot be made with grid exposures if a constant density is to be maintained. As kV increases no-grid exposures are reduced more rapidly than grid exposures and so grid factor increases. At some point a kV is reached when the scattering angle is small enough to allow a significant amount of scatter through the grid and the grid becomes less and less effective. Beyond this point grid factor will reduce with increasing kV.

It should be appreciated from what has been said that grid factor is dependent on the amount of scatter produced and therefore on the patient structure. If it were possible to carry out experiments with different patients to determine grid factor variation with kV, slightly different results would be obtained for each patient. However the method outlined above does provide a useful guide to grid factor variations

and when applied does produce satisfactory results for most patients.

It is useful to consider how information relating to grid factor may be applied in practice in the absence of an automatic exposure device. Assume that at 90 kVp the grid factor, for a particular stationary grid, is 2.5, while at 120 kVp it is 4. Further, suppose that for a posteroanterior chest radiograph an exposure of 60 kVp and 20 mAs is required with no grid, and a request is made for the same chest to be radiographed using 120 kVp and the stationary grid. The mAs required at 120 kVp with the grid is easily calculated. Using

$$\frac{mAs_1}{mAs_2} = \left[\frac{kV_2}{kV_1}\right]^4$$

then the required mAs at 120 kVp (no grid) is 1.25 mAs. The grid factor at 120 kVp is given as 4, so the required mAs is $(1.25 \times 4) = 5$ mAs. Now assume that a lateral view of a chest is necessary and it is known that a no-grid exposure of 90 kVp and 30 mAs produces a low contrast image because of excessive scatter radiation reaching the film. Using the same grid as before means that the new mAs required at 90 kVp will be $(2.5 \times 30) = 75$ mAs.

The new exposures calculated in these two examples would produce a correct result, but only because a correct choice was made for grid factor appropriate to the kV being used. It must not be assumed that if the grid factor at 90 kVp is 2.5 (or some other figure depending on grid type) it will still be 2.5 at some higher or lower kV. When used, an automatic exposure device would control the image density obtained so it is not necessary to consider grid exposure factor variation with kV provided that the radiation sensing device of the automatic exposure control is placed behind the grid (between grid and cassette) and not between the patient and grid, which would be the case if a gridded cassette were employed.

Grid factor is dependent on an exposure made without a grid, and so is dependent on the amount of scatter radiation in the beam reaching the film. Because of this a slightly different graph in shape and position could be expected for the same grid when a stepwedge exposure is compared with a patient exposure. Grid factors are generally higher at all kV values for moving grids than for stationary grids and higher for higher ratio grids. As an example an 8 : 1 ratio moving grid may have a grid factor of 2.5 at 70 kV for a 20 cm tissue equivalent phantom while a 16 : 1 stationary grid may have a grid factor as high as 8 at 130 kV for the same phantom.

X-RAY BEAM DIMENSIONS

Scatter radiation is produced when a tissue is irradiated. The higher the kV used the less the quantity of scatter produced but the more likely it is that the scatter will have sufficient energy to reach the film and thereby degrade image contrast. The higher the intensity of radiation in the primary beam the greater the amount of scatter likely to be produced in the patient (Figure 7.31), but the probability of scatter occurring is dependent on the structure of the object irradiated, and whether or not this scatter reaches the film is dependent on the energy of the scattered photon. Scattered X-ray photons produced in high kV exposure of the chest reach the gonads relatively easily producing a higher gonad dose than would be found at low kV, but this consideration must surely be secondary to obtaining a diagnostic image.

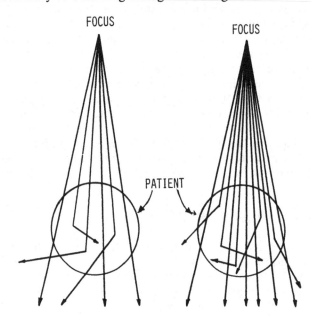

Figure 7.31 Higher intensity beam causing increased scatter

It should be apparent from Figure 7.31 that if instead of the whole beam only the central portion were used for imaging then the quantity of scatter reaching the film would be reduced. Figure 7.32 illustrates this effect. If an image of a smaller portion of the object is acceptable then it is possible to produce an image of higher contrast with an X-ray beam of smaller cross-sectional area. However, some contrast may have to be sacrificed in the image of a small area of interest because of the practical necessity of imaging a large area to include all the required information with one exposure. Limitation of beam dimensions (collimation) to a particular area is achieved with diaphragms and/or cones.

The object of controlling exposure is to minimize the loss of image contrast from all causes while maintaining kV as the principal method of varying image contrast to the level desired within the confines of a given imaging system. This limits the number of variables involved in controlling image contrast. With this in mind it is necessary to limit X-ray

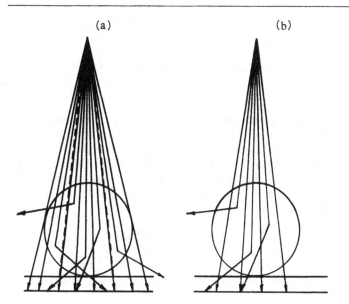

(a) (b)

Figure 7.32 Effect on scatter of reducing beam width. The dashed lines in (a) indicate the beam width used in (b)

beam dimensions to the smallest possible consistent with good radiographic technique, then, since a smaller area and hence volume of patient is irradiated, less scatter is produced with a resultant improvement in image contrast. This, of course, implies that there has been no alteration in the exposure factors. In practice, the change from a beam of large dimensions to one of smaller dimensions means a reduction in image density (because of the reduction in scatter reaching the film) and the tendency is to increase exposure to compensate. This action also tends to produce more scatter with the attendant reduction in image contrast particularly if the exposure increase is made by increasing kV.

EFFECT OF PROCESSING

The latent image in the emulsion of an exposed film is made visible and permanent by chemical processing. The image is made visible by a process of development and permanent by a process of fixation, washing and drying. It has been shown that fixation can affect the fog level of a film but by far the greatest effect on the image is produced by development. The parameters of development are formulated to give the desired image density and contrast in a specific time while minimizing any increase in fog level through development of unexposed silver halide (see Chapter 12). A freshly made developer solution can give the desired result for one film but in so doing becomes partially exhausted having reduced activity. Processing further similar films will show image density and contrast differences because of the gradual exhaustion of the developer. To overcome developer ex-

haustion and maintain a constant activity the developer must be replenished to replace lost volume and also to replace lost activity. This is simply achieved by removing an appropriate amount of partially exhausted developer solution and replacing it with fresh solution. The rate at which this is done depends on the type of film and indeed the type of image processed and is difficult and time-consuming to assess under practical conditions.

The usual technique is to accept the manufacturer's recommendations regarding process time, solution temperature and replenishment rates, and to check image quality at regular intervals. This involves processing specially prepared sensitometric strips which provide values for speed index, contrast index and fog level. These values are obtained (usually daily) and graphed. If they lie within the accepted tolerance limits then no action is necessary. The technique is fully discussed in Chapter 13.

PATIENT STRUCTURE

The structure of the patient part of interest must influence the choice of exposure factors selected. The kV value must produce an image contrast sufficient to detect visually the part of interest, but not of such high contrast that other useful contrasts are produced at density levels too high (or too low) to be seen. In general the smaller the patient part the lower the kV required but there are exceptions where the composition of a small body part requires the use of a higher kV than a larger, less radiodense body part. The mAs value required is determined by the size of the body part radiographed and the choice of kV already made consistent with the relative speed of the imaging system. A fuller discussion of the effect of patient structure on image quality will be found in Chapter 9.

EXPOSURE FACTOR CALCULATION

A complete set of exposure factors would give the following information (Table 7.1).

Table 7.1

kVp	mA	t (s)	Imaging system relative speed	FFD (cm)	Grid factor	Focus size (mm)
75	200	0.3	1	100	2	1

It may be assumed in this example that the exposure is suitable for an anteroposterior view of a certain patient's abdomen. This information can be used to produce a new set of exposure factors for another radiograph of the same patient part. For example, consider that it is known that a different set of X-ray equipment requires an equivalent

exposure to produce an acceptable image but the grid factor at 75 kVp is 2.5 and the maximum FFD obtainable is 90 cm. Using this information it is possible to determine a new exposure. The information available is shown in Table 7.2.

Table 7.2

	Exposure factors				Related details		
	kVp	mA	t (s)	Imaging system relative speed	FFD (cm)	Grid factor	Focus size (mm)
Old factors	75	200	0.3	1	100	2	1
New factors	75				90	2.5	1

The idea is to change the old factors step by step into the new factors. Every time a change is made in the related details, a compensatory change must be made in the exposure factors to maintain an equivalent exposure and hence a constant image density. It does not really matter where a start is made so for this example we will work through the factors from right to left. The focus size is not concerned with image density so it can be neglected. A change in grid factor does affect image density unless a compensatory change in kV, or mAs is made. Here kV will not be changed and any variation necessary will be made to mA, t, or mAs as appropriate. It was stated on p. 105 that

$$\text{Grid factor} = \frac{\text{exposure required with a grid}}{\text{exposure required with no grid}}$$

and using information given in the 'old factors' gives

$$2 = \frac{(200 \times 0.3) \text{ mAs}}{\text{mAs required with no grid}}$$

Again using information from the 'new factors' gives

$$2.5 = \frac{\text{mAs required with a grid}}{\text{mAs required with no grid}}$$

At this point a basic assumption must be made before any progress towards a solution can be made. The nature of this assumption will become apparent in a moment. The above equations can be solved by division, giving

$$\frac{2.5}{2} = \frac{\text{mAs required with a grid}}{\text{mAs required with no grid}} \bigg/ \frac{(200 \times 0.3) \text{ mAs}}{\text{mAs required with no grid}}$$

$$= \frac{\text{mAs required with a grid}}{\text{mAs required with no grid}} \times \frac{\text{mAs required with no grid}}{(200 \times 0.3) \text{ mAs}}$$

It must now obviously be assumed that the same imaging system is used in both cases; 'mAs required with no grid' will then be the same for both. The above expression then simplifies to

$$\frac{2.5}{2} = \frac{\text{mAs required with a grid}}{(200 \times 0.3) \text{ mAs}}$$

or mAs required with a grid of factor 2.5 $= \dfrac{2.5 \times 200 \times 0.3}{2}$

$$= 75 \text{ mAs}$$

This result can also be achieved using a similar method to that given on p. 105. A change from a system with grid factor m to another system with grid factor n requires the mAs to be multiplied by a factor n/m. Here the mAs is $(200 \times 0.3) = 60$ mAs and the change is to be made from a system having grid factor 2 to a system having grid factor 2.5. The 'new' mAs will be simply

$$60 \quad \times \quad \frac{2.5}{2} \quad = 75 \text{ mAs}$$

The exposure factors now appear as Table 7.3 where the 'old factors' mAs has been adjusted in line with the increased grid factor.

Table 7.3

	kVp	mAs	Imaging system relative speed	FFD (cm)	Grid factor	Focus size (mm)
	75	75	1	100	2.5	1
New factors	75		1	90	2.5	1

It now only remains to find what mAs is required for an FFD of 90 cm given that 75 mAs is required at 100 cm FFD. Using the relationship given on p. 101, i.e.

$$\frac{mAs_1}{mAs_2} = \frac{d_1^2}{d_2^2}$$

where $mAs_1 = 75$, $d_1 = 100$, $d_2 = 90$, gives

$$mAs_2 = 75 \times \left[\frac{90}{100}\right]^2 \simeq 60 \text{ mAs}$$

Thus the new exposure factors in terms of kV and mAs are exactly the same as the original old factors. The change in FFD has been compensated by the change in grid factor. The final form for the exposure factors is shown in Table 7.4.

Table 7.4

	kVp	mAs	t (s)	Imaging system relative speed	FFD (cm)	Grid factor	Focus size (mm)
Old factors	75	200	0.3	1	100	2	1
New factors	75	200	0.3	1	90	2.5	1

In this example kV remained constant but it is easy to consider examples where kV may be changed in addition to other factors. Consider the more complex example (Table 7.5).

Table 7.5

	kVp	mA	t (s)	Imaging system relative speed (RS)	FFD (cm)	Grid factor (GF)	Focus size (mm)
Old factors	60	300	0.2	3	90	2	1
New factors	95	100	x	2	100	3	1

where it is necessary to determine a new exposure time (x). One method is to proceed as follows:

(i) a change to a grid factor of 3 requires a new mAs of

$$\frac{3}{2} \times (300 \times 0.2) = 90 \text{ mAs giving Table 7.6}$$

Table 7.6

	kVp	mAs	RS	FFD	GF	Focus size
	60	90	3	90	3	1
New factors	95	100x	2	100	3	1

(ii) a change in FFD from 90 to 100 cm gives a new mAs of

$$90 \times \left[\frac{100}{90}\right]^2 = 111 \text{ mAs, giving Table 7.7}$$

Table 7.7

	kVp	mAs	RS	FFD	GF	Focus size
	60	111	3	100	3	1
New factors	95	100x	2	100	3	1

(iii) a change from relative speed 3 to relative speed 2 gives a new mAs of

$$111 \times \frac{3}{2} = 166.5 \text{ mAs, giving Table 7.8}$$

Table 7.8

	kVp	mAs	RS	FFD	GF	Focus size
	60	166.5	2	100	3	1
New factors	95	100x	2	100	3	1

(iv) finally a change from 60 kV to 95 kV gives a new mAs of

$$166.5 \times \left[\frac{60}{95}\right]^4 = 26.5 \text{ mAs, giving Table 7.8:}$$

Table 7.9

	kV	mAs	RS	FFD	GF	Focus size
	95	26.5	2	100	3	1
New factors	95	100x	2	100	3	1

All factors are now the same so

$$100x = 26.5$$
$$\therefore \quad x \simeq 0.25 \text{ s}$$

this being the closest practically usable value for exposure time.

It is interesting to note the multiplying factors used in each of the above calculations since these can be incorporated into one function involving just one calculation as

$$\left[(300 \times 0.2) \times \frac{3}{2} \times \left[\frac{100}{90}\right]^2 \frac{3}{2} \times \left[\frac{60}{95}\right]^4 \right]$$

In a more general form this becomes

$$mAs_2 = \left[\frac{\text{grid factor}_2}{\text{grid factor}_1} \times \left[\frac{FFD_2}{FFD_1}\right]^2 \frac{\text{relative speed}_1}{\text{relative speed}_2} \times \left[\frac{kV_1}{kV_2}\right]^4 \right] mAs_1$$

This general form is applicable to all exposure factor calculations involving systems obeying the kV⁴ rule. Consider the following example (Table 7.10).

Table 7.10

	kVp	mAs	t	RS	FFD	GF
Old factors	50	300	0.6	3	100	1.7
New factors	68	x	0.6	4	90	2.2

Now using the general form gives

$$(x \times 0.6) = (300 \times 0.6) \times \frac{2.2}{1.7} \times \left[\frac{90}{100}\right]^2 \times \frac{3}{4} \times \left[\frac{50}{68}\right]^4 = 41.36 \text{ mAs}$$

and $x \simeq 70$ mAs.

8
Automatic Exposure Control

INTRODUCTION

Automatic exposure control systems are now readily available and are widely used in radiography. Their use certainly alleviates many of the problems associated with the choice of exposure factors but unfortunately introduces new problems not apparent with manual exposure selection. Several devices are available but basically only two methods are used, phototiming and ionization timing. Phototiming is used for automatic exposure control for both large and small film formats while ionization timing is used exclusively for the large film format. An automatic exposure system may be sophisticated enough to allow virtually complete automation of exposure selection or, as is more widely available, may control mAs automatically while allowing the operator freedom of choice of kV. The eventual aim, however, is to produce a constant image density independent of patient parameters, and with an automatic exposure system very careful technique is required to achieve this.

CONSTANT DOSE PRINCIPLE

Within the 'useful' density range, film blackening (image density) at any point on a film is determined by the intensity of radiation reaching that point and also by the length of time for which that radiation is allowed to act (determined by the exposure time). Hence image density (D) at a particular point in the image is proportional to the product of the radiation intensity I reaching that point and the exposure time t, i.e.

$$D \propto It$$

X-radiation passing into a patient will be attenuated according to the structure of the patient and a variety of different X-radiation intensities will be transmitted by the patient as a result (Figure 8.1). In Figure 8.1 I_0 is the incident radiation intensity and depends on the kV and mA selected, whereas I_1 to I_5 are the attenuated intensities and their value depends on both the exposure factors and the patient parameters. Each of the intensities $I_i (i = 1, 2, \ldots 5)$ will act on the film for the same length of time (the selected exposure time) and the product of each of these intensities with exposure time t will result in a different image density being

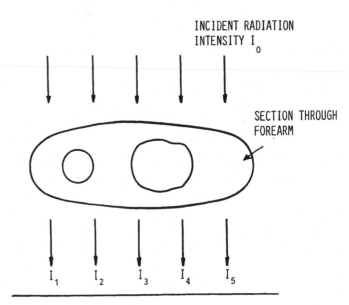

INCIDENT RADIATION
INTENSITY I_0

SECTION THROUGH FOREARM

I_1 I_2 I_3 I_4 I_5

FILM

Figure 8.1 Attenuation of X-radiation by patient

produced (assuming that no two of the I_i are equal), i.e.

$$D_1 \propto I_1 t, D_2 \propto I_2 t, D_3 \propto I_3 t, D_4 \propto I_4 t, D_5 \propto I_5 t$$

or, more generally, $D_i \propto I_i t (i = 1, 2, \ldots 5)$.

To achieve a constant density at any point in the image, the product It must be a constant. If I falls in value, then t must rise in value by an equal factor so that It can remain constant.

Assume that $D_i (i = 3)$ is an image density $D = 1.0$, say. If the exposure time t is now increased then D_3 will increase. But, not only will D_3 increase but so will all the other D_i. In fact, anything done to exposure time which affects one D_i will affect all other D_i equally. Now, assume kV remains constant and a reduction in I_0 is achieved by reducing mA. This certainly reduces I_3, but it will also reduce all the other I_i by the same factor. Since I_3 has been reduced, D_3 will also be less, and to maintain D_3 at the chosen density $D = 1.0$ would necessitate an increase in exposure time. As already stated, such a measure would affect each of the densities D_i equally.

110

Hence it is true to say that provided that D_3 is correct, all other densities will be correct relative to D_3 in the image. More generally, if one D_i is correct then all other D_i will be correct relative to it. For most images, the average density for correct exposure is about $D = 1.0$, and for reference purposes this is the density generally used.

Using this reasoning, it is reasonable to assume that the requirement is for a device which will monitor the product It during an exposure, and once it reaches a predetermined level, will stop the exposure. This will ensure that the resultant image density (at the point monitored) will be correct. If this particular image density was D_3, say, and it had the correct value, then all other image densities would also be correct relative to it for the kV chosen and hence the film would be correctly exposed.

Figure 8.2(a) shows a small patient and the transmitted intensity being monitored is I_x. The monitoring system has been set so that when the product It has reached a certain value, say k, then the exposure will terminate and the resulting image of the small area of the patient which was monitored will have an average density $D = 1.0$. The area of the patient chosen for monitoring the transmitted radiation intensity is one which if correctly exposed will have an average image density $D = 1.0$. This being the case it is reasonable to expect that the rest of the image will be correctly exposed. It is important to note here that the intensity being monitored is not the intensity of the X-ray beam before it enters the patient. It is the intensity transmitted by a small area of the patient. The product It represents a dose of radiation and It is a constant for a given image density; then to give this density, a constant dose of radiation is required irrespective of patient parameters.

In Figure 8.2(a) the patient is small, I_x is likely to have a relatively large value, and the exposure time t_1 is likely to be quite short since $(I_x t_1) = k$. In Figure 8.2(b) the patient is much larger but the same patient part is being examined and the same patient area as before is being monitored. Even though this patient is much larger, the same image density as before is required for a correctly exposed film. Since I_0 is the same as before, then I_y is less than I_x so the exposure time

Figure 8.2 Monitoring transmitted intensity with a small (a) and a large (b) patient

can be expected to be much longer. If this exposure time is t_2, then for a correctly exposed film

$$I_x t_1 = I_y t_2$$

These results can be shown graphically as in Figure 8.3. The product It must be the same in both cases so that image density can be the same. The value of It is represented by the area under the curve and if It must be a constant, each of the areas under the curve must be the same. Note that if for the larger patient I_0 had been increased so that $I_x = I_y$, then because It must be constant, $t_1 = t_2$.

Figure 8.3 Graph of I against t giving constant It

The monitoring device in this discussion is used for large film formats and may be a sensor for either a phototimer or ionization timer system.

The Sensor

No effort is made at this stage to differentiate between the different radiation sensors used in ionization timer and phototimer systems. The radiation sensing device may consist of a flat plate usually larger than the largest film, and having one or more areas (measuring fields) within the plate for monitoring radiation intensity. The automatic exposure system in use would normally be set so that the product $It = k$ results in a particular image density (the preference depending on the user). The sensor would then be placed between the patient and the film, under that part of the patient which in a correctly exposed film would have an average image density equal to that resulting from the setting k. It would now be possible to guarantee that if the density of this one particular part is correct then the other image densities relative to it will also be correct and a correctly exposed film will be achieved.

Since the sensor plate must be placed between patient and film, such a device must be radiolucent. The associated

amplifier and control circuitry is not, of course, radiolucent but can be placed remote from the sensor system yet connected to it. The structure of the sensors will be discussed later.

It is obvious that the correct placing of the monitoring device relative to the patient part is extremely important. To emphasize this, if the sensor is placed (for the duration of the exposure) beneath a part of the patient for which the recorded image density should be much lower than that which the automatic exposure system is set to give, then the whole film will be over-exposed. Since the underlying structure of the patient is unknown at the time of exposure incorrect placing of the sensor relative to the patient is very common and as a result exposure mistakes frequently occur.

The practical sensor for measuring intensity in time is a system having measuring fields, either one or three fields. With the three-field sensor there is often a choice of fields freely available, i.e. any one, any two or all three fields can be selected to operate during an exposure. In addition there is a variety of field shapes and sizes available, each specific to a particular range of examinations. The success of the examination depends on the field size and shape chosen, the number of fields selected to operate, and the placing of the patient relative to the fields. In a one-field system the choice is obvious especially when the field has the same dimensions as the film (as is the case in some phototimer systems for chest radiography).

Automatic Exposure System Density Settings

In practice, the automatic exposure system is preset to allow a particular average image density for a particular $k = It$. If k is set at a higher value then the resulting average image density will increase, and vice versa. In some systems there are three preset values for k and hence three 'density' settings which can be selected at the control panel. The operator is free to choose which value is the most appropriate according to the required average density for a particular part of the image. Although it is not necessary to know the particular k-value, it is necessary to know what k-value results in a particular average image density so that the appropriate k-value can be selected according to patient type and imaging system being used.

A further refinement is to have a control allowing smaller variations in k-value to allow smaller variations in image density for each of the three main settings. The latter are then referred to as a coarse control and the refinement as a fine control. Other systems may have up to 15 different settings on the coarse control with no fine control necessary while yet others may have an infinitely variable setting within prescribed limits. Whichever variety is available the aim remains the same: that of selecting a setting to achieve a particular average image density within a given imaging system. Once found, this setting need only be changed when

an imaging system of similar characteristics but different relative speed is used.

Dominant Zone

The required average image density for a correctly exposed film is known so it becomes necessary to gain information on which part or parts of a patient, in a correctly exposed film, are reproduced with this density in the image. It is then possible to place a measuring field under this part to obtain a correctly exposed film for the kV chosen. Such patient parts are called dominant zones because if the image density for these parts is correct and equal to that resulting from the chosen k-value setting then the image densities for all other image parts will also be correct. What constitutes a dominant zone of a patient for each particular projection can be seen by viewing correctly exposed films and noting those areas of the image (about the same dimensions as a measuring field) for which the average image density is about the same as that which the system is preset to give. Manufacturers provide charts indicating suitable dominant zones for each type of examination, and these are, in the main, satisfactory provided that care is taken to minimize the amount of scattered radiation produced and that primary radiation is not allowed to fall directly onto a selected measuring field. Such charts, unfortunately, do not provide the answers in all cases and only an understanding of the factors involved will allow the operator to achieve the optimum image result in each case. Thus, while the introduction of automatic exposure systems for large film formats has gone a long way towards eliminating incorrect exposures, their use has introduced many new problems. If these problems are not solved then the use of automatic exposure systems can lead to very poor image quality and excessive radiation dose to patients through repetition.

USING AN AUTOMATIC EXPOSURE SYSTEM

Many reasons have been given for using automatic exposure devices and these have been stated as definite advantages over a system in which automatic exposure control is not used. Some of these stated advantages are

(i) Exposure mistakes are eliminated provided the equipment is used correctly under optimized conditions

(ii) The patient dose is reduced, because of the reason given in (i)

(iii) The image quality is standardized. This refers to image densities and not image density differences

(iv) Film wastage is minimized because of the reason given in (i). In any cost-benefit analysis of automatic

exposure devices, a survey of the wasted film material should be made and the percentage cost of this balanced against the cost of introducing an automatic exposure system. This will indicate

(a) whether or not an automatic exposure system is actually necessary, especially if the total amount and cost of the wasted film material is negligible in comparison with the total quantity and cost of the film used, and

(b) how soon the cost of any new automatic exposure system can be recovered in terms of avoiding film wastage.

Unless a comprehensive staff training programme is initiated on the introduction of any new automatic exposure system, then the problem of film wastage may not be overcome. In fact, the situation may be exacerbated.

(v) Equipment is used efficiently. This refers to the fact that since the exposure is correct each time, the minimum exposure is being used. Also, since exposure mistakes are being avoided, then by comparison, fewer exposures are being made.

To use a large film format automatic exposure system satisfactorily, certain criteria should be observed. These are:

(i) The same film–intensifying screen combination, and the same type of cassette, should be used each time an exposure is made. This is because the measuring field monitors radiation dose and not image density. The automatic exposure system is set to terminate the exposure for a certain total radiation dose reaching the measuring field. For the image recording system chosen, this dose will produce a particular image density for the region monitored. If the image recording system has its speed increased, then the automatic exposure system will still terminate the exposure for the same radiation dose as before. This would result in an image which is over-exposed. Even if new and similar film–screen combinations are put into use it is always wise to check that their speeds are similar. It is apparent that if the image recording system is changed (changing to a film with a different speed, for example) then the automatic exposure system will require recalibration (i.e. its sensitivity adjusted).

(ii) Automatic film processing should be used. Image quality control through standardized exposure can only be really successful if film processing is also standardized.

(iii) The patient should be positioned precisely. The success of the final image does not just depend on standardization of exposure and processing. Film wastage can occur as a result of incorrect positioning of the patient, central ray and film. Fluoroscopy with image intensification and closed circuit television has been developed along lines intended to overcome this problem. The radiographer 'screens' the patient (once the patient is positioned as thought correct) to check and, if necessary, adjust the position of the patient before exposing the film. In one system, a controlled 3-second exposure is allowed for checking patient position. The mA used is very much lower than allowed for normal fluoroscopy and the TV monitor image shows a high degree of quantum noise. Nevertheless, there is sufficient image information to check positioning. The patient dose resulting from this fluoroscopic checking procedure is negligible in comparison with the actual film exposure. Finally, in any radiographic procedure, success also depends on adequate patient immobilization and the use of techniques for minimizing image unsharpness, together with the choice of the optimum kV.

(iv) The beam area should be minimized. Besides the normal improvement in image contrast resulting from the use of minimal beam area, the reduction in the amount of scatter radiation has a pronounced effect on image density obtained using the automatic exposure system. This will be discussed in more detail later but it is sufficient to note here that when using the automatic exposure device, the amount of scatter radiation produced and reaching the measuring field should be reduced as much as possible using any of the appropriate methods available.

(v) Correct choice of field configuration should be made. This refers to which and how many of the available fields are chosen to operate at any one time. In many systems one or more measuring fields may be selected to be operational during the exposure. The correct choice of fields must be made and each must coincide with a dominant zone of the patient. The choice of a single field may not always be the best configuration to use in a fixed system of measuring fields. Consider the example where an area the size of the measuring field and including the whole of the kidney may be taken as a dominant zone when this region is free of intestinal gas. Such an area is registered in the image as an average density of about one in a correctly exposed film. If intestinal gas encroaches on this area and not necessarily over the kidney then a greater than normal radiation intensity will reach the measuring field under this area. The exposure will then terminate sooner than it should, giving an image density less than one for the kidney part not covered by intestinal gas. In the correctly exposed film,

kidney image density is 1.0 while that for intestinal gas may be 2.5. If, instead, two fields are chosen, then the radiation dose falling on each of the fields will be summed until the sum multiplied by the exposure time reaches a value equal to about twice that normally set for a single field operating on its own. The exposure will then terminate. This has the effect of averaging the exposure doses to each field and (assuming there is little or no intestinal gas over the second measuring field) reduces the adverse effect on exposure time of the presence of intestinal gas.

If three fields are chosen, the radiation dose falling on each of the three measuring fields will be summed until their sum multiplied by the exposure time reaches a value equal to about three times that normally set for a single field operating on its own. The exposure will then terminate. This again has the effect of averaging the exposure doses for each of the fields, thus reducing the adverse effect of this intestinal gas.

Some systems may allow the use of only one measuring field during an exposure and this can prove a distinct disadvantage. When only one measuring field is selected, and

(a) intestinal gas lies within part of the dominant zone resulting in under-exposure of the film, or

(b) contrast agent lies within part of the dominant zone resulting in over-exposure of the film,

then there are a number of solutions available:

(1) Change the k value for the measuring field. The convention, $k = It$ has been used previously and in the case of (a) it is necessary for the exposure to continue longer. This requires a greater value for It to obtain the necessary image density. To achieve this, there are a number of 'density'-setting controls provided. If a greater image density is required then a higher density setting can be selected. A typical three-density setting control is shown in Figure 8.4. For (a) above, the right-hand button may be selected, and for (b), the left-hand button. The percentage increase or decrease in density obtained with this system can be preset, according to requirements, using test films.

(2) Use a different dominant zone. This means that either a different field is selected to operate or the selected field and patient are moved relative to one another to achieve coincidence of the measuring field and the new dominant zone. A combination of both of these may be required to achieve coincidence. In the first case, if a different field is selected to operate it must coincide with the dominant zone selected. In most systems it is not possible to move the field manually while the patient and

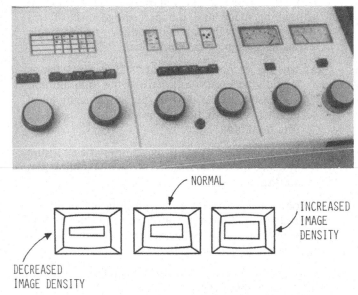

Figure 8.4 Typical three-setting density control seen on the left

film remain still. Some small adjustment of the film position within the cassette tray is possible of course but is not recommended since it increases the difficulty of the technique and errors are more likely to occur. The only alternative is to select one of the other two fields to try and achieve coincidence of dominant zone and measuring field. It is certainly not true that it is generally possible to displace the selected field manually, relative to the patient and film to ensure that the dominant zone and measuring field coincide.

(3) Select more than one field to operate during the exposure. This obtains the average of the radiation doses to each of the selected measuring fields. If the dose to one field is high, to another is low, and to the third is also high, then the image density produced will be somewhere between that resulting from a high dose and that resulting from a low dose, but nearer to that for the high dose. For the kidneys, the correct field configuration in one system is to select all three fields to operate during the exposure. Because of the physical arrangement of the measuring fields, such a combination means that the middle field must lie over the spine. A lower radiation dose is received by the middle field in comparison with either of the other two fields, which are under the respective kidney areas. This is illustrated in Figure 8.5. The correct technique is shown in Figure 8.5(a). The average image density will be different if the patient is arranged the opposite way as in Figure 8.5(b). Because three

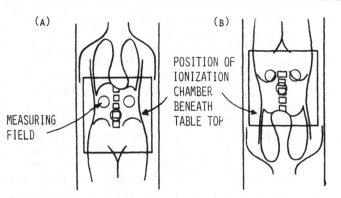

Figure 8.5 Positioning of fields for the kidneys: correct (a) and incorrect (b)

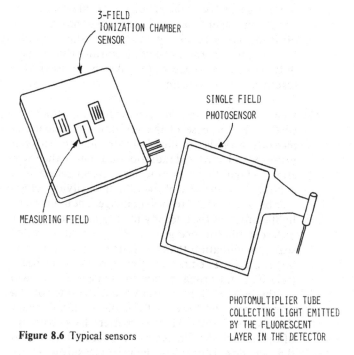

Figure 8.6 Typical sensors

fields are used to achieve the correct exposure, the three zones of the patient, so monitored, together form the dominant zone. With this in mind a dominant zone can be defined as 'the region (or combination of regions) of the patient containing information which, if represented at the image density resulting from the predetermined setting of the automatic exposure system, will be correctly represented'. This will ensure that the film is correctly exposed. The automatic exposure system is set to control the average image density of the dominant zone, thus ensuring the correct relative densities for the remainder of the film image. The system, so far described, is not an automatic control for kV (i.e. it does not automatically control radiographic contrast).

(vi) The dominant zone should be included within the measuring area. Figure 8.6 illustrates a typical ionization-type sensing device with its three measuring fields, and a single field photosensor. It should be obvious that if the dominant zone is not included in the measuring field then the film will be incorrectly exposed. If the measuring field is larger than the dominant zone, then some non-dominant region must be included within the measuring field and hence influence the exposure time, resulting in a degree of under- or over-exposure. If the measuring field is smaller than the dominant zone, then it cannot 'see' the whole zone. This gives rise to either

(a) a correctly exposed film, provided that the dominant zone is reasonably homogeneous, or

(b) an incorrectly exposed film (if the structures comprising the dominant zone differ widely in their radiolucency), because some of the radiation-transmitting structures will not be 'seen' by the measuring field and their transmitted dose will not be allowed to influence the exposure time.

The whole of the selected field must be used in the measurement of the radiation dose transmitted by the dominant zone. It is no use covering part of the selected measuring field with a dominant zone and allowing primary radiation to fall on the remaining uncovered part of the field. The intensity of primary radiation relative to the intensity of radiation reaching the measuring field through the dominant zone is as much as 1000 times greater. This would obviously lead to premature termination of the exposure producing under-exposure of the film.

A less obvious fact is that, while direct irradiation of a selected measuring field should be avoided, incorrect exposure may result if any part of the sensing plate is directly irradiated with part of the primary beam. Primary radiation falling on the plate, but outside any measuring field, will result in scattering of X-rays within the plate. These scattered rays will reach any selected measuring field increasing the dose. If this is a significant increase then premature exposure termination will result with under-exposure of the film. To avoid this, beam limits must be adjusted so that only radiation which has passed through the patient is allowed to reach the sensing system. Limiting the beam to within the confines of the patient is not always possible due to the shape of the beam cross-section relative to the shape of the patient part. Examples are skull radiography and extremity work where direct irradiation of the sensing plate occurs; this can be

minimized by using the smallest possible beam area and placing lead or lead-rubber around the periphery of the patient part. The beam area used should not be less than that of the selected measuring field as then only part of the measuring field is being used; this results in over-exposure.

(vii) Density setting and scatter compensation should be correct. In the case of the ionization chamber the measuring fields are unable to distinguish between primary and scattered radiation. Both have the same effect as far as the measuring device is concerned. This is not true in the case of the film–intensifying screen combination used to record the image. The intensity of light emitted by the intensifying screens is different for different photon energies. Less light is emitted for scattered radiation than for primary radiation. The larger the scattered radiation component of the beam (relative to the primary beam component) the less will be the emitted light intensity from the intensifying screen, and the lower will be the resultant image density. On the other hand, no matter what percentage of the dose to the film is formed by scatter, provided that the dose is constant then the measuring device behaviour will be constant. There is thus a difference in the response of the measuring device and the film–intensifying screen combination to different photon energies.

In summary it may be said that the greater the amount of scatter in the radiation reaching the film–intensifying screen combination the greater will be the dose required to produce a given image density. Since the main function of the automatic exposure system is to maintain a constant dose to the film–intensifying screen combination, the system cannot deal effectively with the problem of scattered radiation. It is left to the radiographer to deal with scattered radiation. The effect of scatter is illustrated in Figure 8.7. The radiation dose to the image recording system is constant in each case, but the ratio of the percentage of scatter to the percentage of primary in this dose is different for each. It is to be noted that since the patient size is different in each case, the output dose is also different for each.

The effect of scatter is less critical with the photosensor. Here the measuring fields consist of thin layers of fluorescent material, ideally with an identical phosphor to that used for the intensifying screens. The effect of scatter on the photosensor is then more or less identical to that on the intensifying screens. However, if the phosphor used in the photosensor is radically different to that in the intensifying screens then non-uniformity of results is to be expected at different kV levels.

To overcome the problem of over-exposure (Figure 8.7(a)) for small patients, it is only necessary to change to a lower density setting. This reduces the value for k and thus reduces average film density. To overcome the problem of under-exposure (Figure 8.7(c)) it is necessary to change to a higher density setting. This

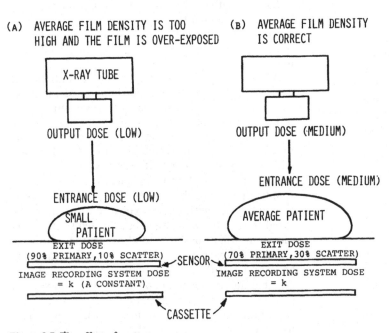
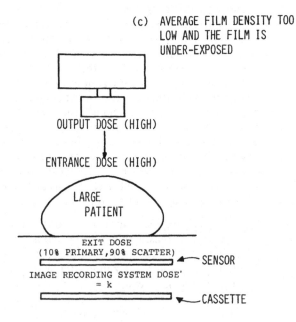

(A) AVERAGE FILM DENSITY IS TOO HIGH AND THE FILM IS OVER-EXPOSED

(B) AVERAGE FILM DENSITY IS CORRECT

(c) AVERAGE FILM DENSITY TOO LOW AND THE FILM IS UNDER-EXPOSED

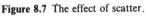

Figure 8.7 The effect of scatter.

will be perfectly satisfactory provided that the percentage of scatter in the film dose is not excessive. For very large patients, the relative percentage of scatter in the film dose can be very high if measures are not taken to reduce it and changing to the higher density setting would be inadequate to compensate for under-exposure. Every effort should be made to minimize the formation of scatter and to prevent as much as possible of that formed from reaching the film.

SENSING DEVICE POSITIONS FOR GENERAL RADIOGRAPHY

A number of arrangements are used in practice and the position of the sensing device in each case is illustrated in Figure 8.8. When either a moving or stationary grid is used, the sensing device is always placed between the grid and the cassette. It is possible to have an arrangement for chest radiography (Figure 8.8(i)) where the sensing device forms the front of a cassette tunnel against which the chest is placed. The cassette is then pushed into the tunnel behind the chamber, with its tube side facing the back of the chamber (Figure 8.9).

A grid is not normally used in chest radiography except for large patients and high kV. If it were, it would be placed in front of the sensor (between the patient and the sensor) and not between the sensor and the film. This is so because a measuring field measures dose incident on the sensor and for a correctly exposed film this same dose should reach the cassette. If a grid were placed between the sensor and the film then the dose reaching the cassette would be far less than the dose incident on the sensor. This would not matter if the grid factor remained constant for all kV values since the k-value for the sensor could be suitably adjusted. Unfortunately grid factor varies with kV and no single k-value will suit for the whole kV range. The k-value would have to be adjusted each time a different kV was used. This whole problem is overcome very simply by having the sensor between the grid and the film.

It is quite common for a gridded cassette to be used in radiography of ribs but it should never be used by placing it in the tunnel shown in Figure 8.9, because then the grid would lie interposed between the sensor and the film. The radiation having passed through the sensor is then attenuated by the grid and, unless the density setting is substantially changed to accommodate this, the film will be grossly under-exposed. Such a substantial change is not normally possible with the usual three density settings available. In any case any change would be difficult to make without a knowledge of the grid factor at the particular kV chosen.

Dominant Positioning Aid

When using particular measuring fields they must be very

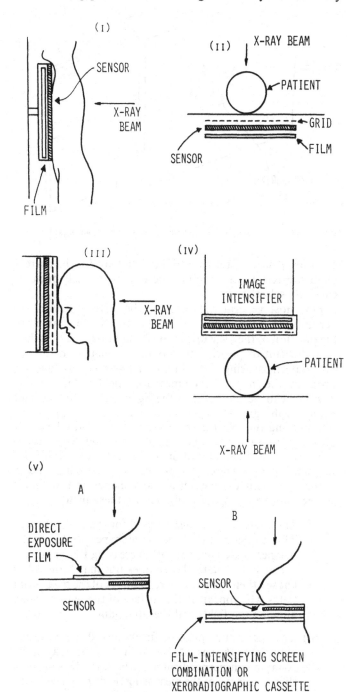

Figure 8.8 Placement of sensor in various cases

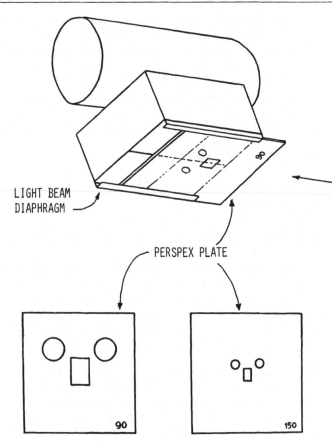

Figure 8.9 Sensor on front of cassette tunnel for chest radiography

carefully placed in relation to the dominant for the correct exposure result. In addition, the dominant itself must be carefully selected.

For most general radiography, the sensing device lies beneath the tabletop and, in the case of a floating tabletop, the position of the measuring fields cannot be seen. It is then very difficult to position the dominant relative to the appropriate measuring field. In an attempt to overcome this problem, the shape of each measuring field and its relative position can be indicated in the light path from the light beam diaphragm. The light beam diaphragm is a device for illuminating the exact area covered by the X-ray beam. It also serves to collimate both light beam and X-ray beam similarly. The field indication is achieved by having interchangeable perspex, slide-in plates for the light beam diaphragm with the measuring field shapes and positions printed on them (Figure 8.10). To use these plates:

Figure 8.10 Plates for projection of field outline

(i) The correct plate must be used for the FFD chosen. This is because the image of the shapes printed on the perspex plate enlarges with increasing FFD and vice versa. If the plate chosen does not match the FFD chosen then the wrong size of image of the measuring fields will appear on the surface of the patient when aligning the fields and the dominant

(ii) The X-ray tube must be firmly linked (via the tube column) to the cassette tray with the central ray of the X-ray beam perpendicular to the film. This ensures that the image of the measuring fields produced with the perspex plate coincides exactly with the measuring fields of the sensing device.

In cases where angled beams are required (and there are many) the perspex plates are no longer precise. When the

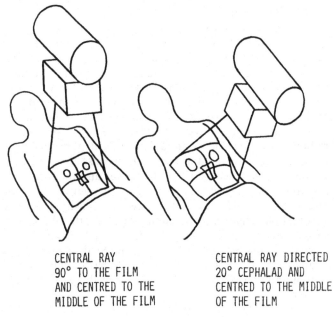

CENTRAL RAY
90° TO THE FILM
AND CENTRED TO THE
MIDDLE OF THE FILM

CENTRAL RAY DIRECTED
20° CEPHALAD AND
CENTRED TO THE MIDDLE
OF THE FILM

Figure 8.11 Use of plates with angled beam

central ray of the X-ray beam is not perpendicular to the film then the image of the measuring fields will be elongated producing an image on the surface of the patient which is quite different in size and shape to the actual measuring fields of the sensing device, and the plates can only be used as a rough guide (Figure 8.11).

A further problem occurs when the radiographic technique requires that the central ray of the X-ray beam does not coincide with the centre of the film even though the central ray is perpendicular to the film. Here again, the images of a measuring field will not coincide with the actual measuring field making it difficult to position the dominant relative to the measuring field selected. One possible solution (but not a good one) to this problem might be to displace the perspex plate from its central position so that the measuring fields and their images do coincide.

Measuring Field Configurations

There is a considerable variety of measuring field arrangements suited to different aspects of radiography and care should be taken in selecting the most appropriate sensing device with the measuring field configuration best suited to the majority of work to be undertaken. A sample of the variety available is shown in Figure 8.12. In Figure 8.12(I) the measuring field is shaped to follow the contour of the female breast. It can be used in position (A) or in position (B). In position (A) the resulting film would demonstrate the breast base while in position (B) the breast periphery and nipple would be better demonstrated. In Figure 8.13 the patient has been positioned for a superoinferior view of the right breast. The dotted lines indicate the possible positions of the single measuring field.

With few exceptions, the measuring fields occupy a fixed position relative to the cassette tray. When it is not possible to move the sensing device relative to the film, it is possible to move the film relative to the sensing device (within the confines of the cassette tray). As stated before, this should be avoided because it makes centring of the beam more difficult; it can lead to 'grid cut-off' if the cassette is displaced sideways and so mistakes are more likely to occur.

Because of the degree of separation and the fixed relationship of the measuring fields in a three-field system it is not possible to use all three of the fields together for all sizes of films. Examples of how different film sizes relate to the position of the three measuring fields is shown in Figure 8.14. This assumes that the film has been correctly placed in the cassette tray and not displaced in any way. It can be seen that if an 18 × 24 cm cassette is placed longitudinally in the cassette tray, there is no way in which it is possible to correctly use all three measuring fields simultaneously. On the other hand, if the same cassette is placed transversely in the cassette tray and then displaced towards the upper border of the sensing device, then all three fields can be used

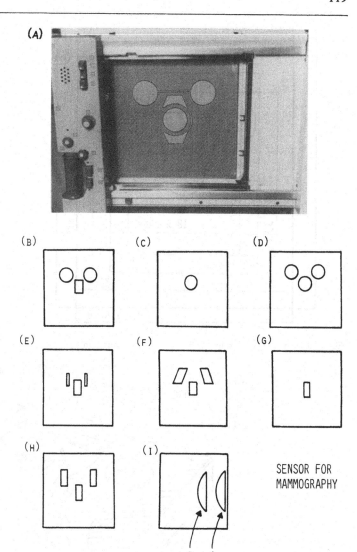

SENSOR FOR
MAMMOGRAPHY

Figure 8.12 Some available configurations of measuring fields. (A) is the sensor of figure 8.8 (iv)

together if so desired. In general, it is only the central field which is used with the small film sizes. The pattern in Figure 8.14 is printed on the surface of the erect 'bucky' to enable the radiographer to identify the position of the measuring fields relative to the different sizes of film used. In the case of the X-ray table, where the sensing device–grid assembly–cassette

Figure 8.13 Position of fields in mammography

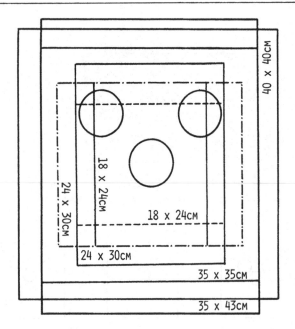

Figure 8.14 Three-field system compared with various film sizes

tray can move as one unit relative to the tabletop, it is useless marking the position of the measuring fields on the tabletop in an effort to locate them. In this case, reliance must be placed on the use of the perspex plates discussed earlier.

SENSOR STRUCTURE

The ionization chamber of the ionization timer typically has three measuring fields. These are simply three air-containing regions of known volume in a sheet of radiolucent insulating material. Radiolucent electrodes are placed either side of the contained volume of air and the ionization current generated by irradiation with X-rays is fed to an amplification system and hence to a capacitor. When the capacitor voltage reaches a predetermined level the exposure is terminated. Figure 8.15 illustrates the structure typical of an ionization chamber having a central rectangular measuring area and two circular measuring fields. Solid state ionization sensors are also available.

The photosensor in modern phototimer systems is placed, in a similar manner to the ionization chamber, in front of the

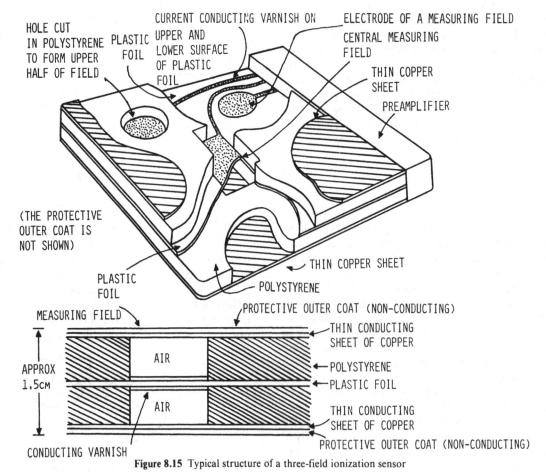

Figure 8.15 Typical structure of a three-field ionization sensor

film. The photosensor and the ionization chamber types must be radiolucent and produce no image at the radiation dose levels used for imaging. The photosensor consists of a thin layer of fluorescent material coated on a support. A photomultiplier tube placed at the side of the transparent support (and outside the X-ray beam) collects the light emitted by the phosphor. The collected light generates a current which is used in the same way as the current generated in the ionization chamber.

It is now apparent that when the automatic exposure system capacitor voltage reaches a particular reference value then exposure termination occurs. The rate at which the capacitor voltage reaches the reference voltage is determined by the time constant of the capacitor circuit. The k-value previously discussed is then simply a time constant value but this is directly related to the radiation dose required to produce a given image density. If the time constant is increased then the reference voltage value takes longer to reach, the total dose to the film is greater, and the average image density is also increased. The density control is a method of altering the circuit time constant which can then be related directly to the change in image density required. In practice, when using the density control, a radiographer is likely to think in terms of density variation rather than time constant variation.

System Calibration

Before moving on to consider the use of the sensing device for automatic exposure control in tomography, one final aspect should be considered. The majority of automatic exposure devices are calibrated for use with calcium tungstate intensifying screens. What would happen if a changeover to rare-earth intensifying screens was made?

Firstly, the rare-earth intensifying screens are, in general, faster than calcium tungstate intensifying screens. As an example, assume that 70 kVp a particular rare-earth intensifying screen pair is twice the speed of a certain pair of calcium tungstate intensifying screens. All that is now necessary is to reduce the density setting of the automatic exposure device to compensate for the increased intensifying screen speed. The rare-earth intensifying screens can now be used with the automatic exposure device at 70 kVp.

Secondly, the question must be asked whether the relative speed is constant for all kV values within the diagnostic range. If it is then it is possible to use the automatic exposure device with the new screens at any other kV value. Unfortunately, the answer to this question is 'no'. Between about 60 kVp and 120 kVp, the relative speed increases with increasing kV. The automatic exposure device would require complete recalibration to make it suitable for use with the new screens. Once recalibrated, the automatic exposure system is no longer suitable for use with calcium tungstate intensifying screens.

It is advisable to carry out checks every 4–6 months on film and intensifying screen speed for those film–intensifying screen combinations used with the automatic exposure system. This provides information of any gradual image recording system performance deterioration which might occur and for which compensation may be made.

AUTOMATIC EXPOSURE CONTROL IN TOMOGRAPHY

Again the automatic device controls the average film density so that a correctly exposed film is achieved, but here, in contrast to the use of the automatic exposure device in non-tomographic radiography, the necessary exposure time for tomography is set before starting. The exposure time is controlled by the magnitude of the exposure angle set and the speed of the tube in travelling through this angle. The smaller the exposure angle and the faster the tube travels, the shorter will be the exposure time. Since the required exposure time is fixed by the radiographer according to the exposure angle required, all that is needed is for the automatic exposure device to maintain a constant average radiation intensity at the film throughout the exposure time. Since D_{tot} (the total dose required to produce the required image density) is preset (the k-value already mentioned), and the exposure time t is also known before exposure, then the dose per unit time is known before exposure and is D_{tot}/t. The automatic exposure device simply ensures that this dose D_{tot}/t is maintained at every point in time throughout the exposure. The total dose at the end of the exposure is $(D_{tot}/t) \times t = D_{tot}$ resulting in a correctly exposed film.

In tomography, the exposure time is predetermined and the automatic exposure device is not concerned with initiating exposure termination. Here there is a given exposure time (t) and this immediately determines the value for I for a predetermined k. It is now the function of the automatic exposure device to ensure that the average radiation intensity at the film remains constant throughout the exposure time.

Consider Figure 8.16 illustrating tomography of the lumbar spine. The path the radiation follows through the patient at the commencement of the tube travel is shown as AB and this is considerable. Initially the output radiation intensity must be high to obtain the required intensity I at the film. At the midpoint of its travel, the path CD the radiation follows through the patient is much shorter than AB. If the output radiation intensity remains at the level it was at the start then the radiation intensity at the film at the midpoint of tube travel will be much higher than the starting value. In fact, for a constant output radiation intensity, the average radiation intensity at the film will gradually increase as the tube travels from its starting point to the midpoint. It should be equally obvious that from the midpoint to the end of the

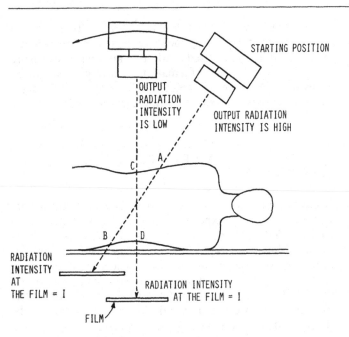

Figure 8.16 Arrangement for tomography with automatic exposure control (the sensing device and grid are not shown)

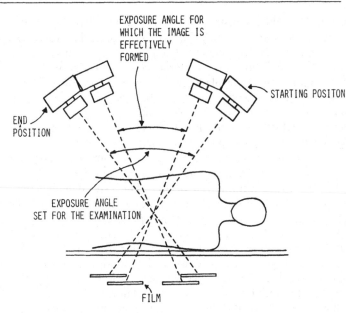

Figure 8.17 Tomography without automatic exposure control

tube travel, the average radiation intensity at the film will gradually decrease. The automatic exposure device serves here to monitor the average radiation intensity I at the film, and as I tends to rise during the first half of the tube travel, the device initiates a proportional decrease in output radiation intensity. As I tends to decrease during the second half of the tube travel then the device initiates a proportional increase in output radiation intensity. By this means the average radiation intensity at the film remains constant throughout the exposure time. This average radiation intensity I should be such that $It = k$ to achieve the correct image density.

The sensing device is placed between grid and cassette for this function (the same position as is used in plain radiography). The average radiation intensity at the film required (with each preset exposure time) to give a correctly exposed film will have been predetermined at installation using test films. As in non-tomographic radiography the same conditions apply with regard to scatter radiation and its effects.

It might be felt that this is the end of the story, but do not forget that the main concern is the resulting radiographic image, and with this method of automatic exposure control for tomography the result will be slightly different from that obtained without using automatic exposure control.

Without automatic exposure control (Figure 8.17), the output radiation intensity remains constant throughout the exposure and this means that the average radiation intensity at the film will vary throughout the exposure, being least at the beginning and end of the tube travel and greatest at the midpoint. Thus the radiation dose to the film during the middle part of the tube travel is the dose mainly responsible for producing the image, while the dose received by the film at the beginning and end parts of the tube travel have little effect by comparison. Not using an automatic exposure device produces an image result equivalent to using a smaller exposure angle than that actually set (i.e. a thicker 'cut' is produced).

With automatic exposure control, the average radiation intensity at the film at any time during the tube travel is constant while the output radiation intensity is made to vary. This implies that the radiation dose to the film through each part of the tube travel is equally effective in producing the image. The image result is then that which should be obtained for the exposure angle set. Thus, for a given set exposure angle, the use of an automatic exposure device produces 'thinner cuts'.

AUTOMATIC EXPOSURE CONTROL IN IMAGE INTENSIFIER PHOTOFLUOROGRAPHY

This system of exposure control is quite different from the previously discussed type. Here (Figure 8.18) the light emitted by the output phosphor of an image intensifier is passed through a tandem lens system onto a single emulsion film. The film is orthochromatic if 70 mm, 100 mm or 105 mm format is used, or if it is 16 mm or 35 mm cinefilm then it can be either orthochromatic or panchromatic. (The

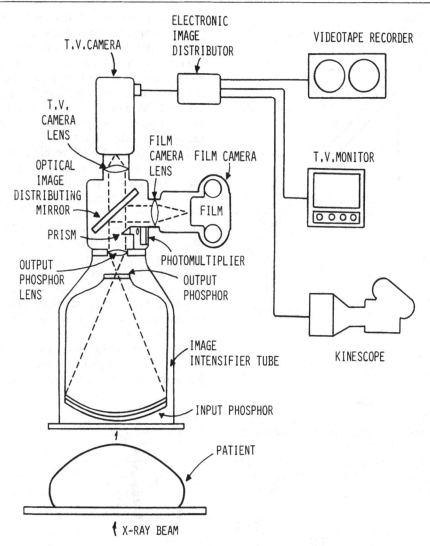

Figure 8.18 Automatic exposure control in image intensifier photofluorography

70 mm, 100 mm and 105 mm films are not called cinefilms. They are the largest of the miniature films and are for single exposure sequences or rapid sequence filming at up to 12 frames per second depending on the type of camera used.) The reason for the emulsion being either orthochromatic or panchromatic is that the light emission from the conventional image intensifier output phosphor is predominantly green. The reasons for single emulsion are

(i) the film is exposed from one side only,
(ii) the use of a single emulsion together with an anti-halation backing avoids cross-over effects, and
(iii) the film used in a minification (p. 276) system requires a far higher resolution than that used with a pair of intensifying screens. For example, a 16 mm cinefilm may be required to resolve 80 line pairs per millimetre

(80 lp/mm) while a typical screen-type film may be required to resolve, at most, 15 lp/mm.

Figure 8.18 illustrates the complete image intensifier system. The part of interest is that between the output phosphor of the image intensifier and the film camera. The automatic brightness stabilization system that ensures a constant output image quality in the television system will not be discussed. Figure 8.19 shows that the prism receives a narrow parallel beam of light from the output phosphor lens. This narrow parallel beam of light is composed of light from every part of the image intensifier output phosphor. Thus the light sample used by the automatic exposure system is representative of the whole output phosphor image. The light sample is approximately representative of the average light intensity emitted by the output phosphor of the image

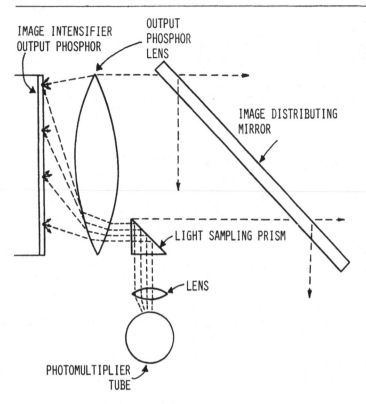

IMAGE INTENSIFIER
OUTPUT PHOSPHOR

OUTPUT
PHOSPHOR
LENS

IMAGE DISTRIBUTING
MIRROR

LIGHT SAMPLING PRISM

LENS

PHOTOMULTIPLIER
TUBE

Figure 8.19 Sampling system of photosensor

in the light path to the film does not prevent any information from reaching the film. All that happens is that the overall intensity of light available to form the image is diminished. An image of the prism is simply not recorded. This is shown in Figure 8.20. Seven points have been taken on the output phosphor and each one is emitting light in all directions. Figure 8.20 shows that even though the prism is directly between points 6 and 7 and the film, an image of point 7, for example, is still formed.

The intensity of light reaching the photomultiplier tube determines the current generated and hence the exposure time. The greater the intensity the larger is the generated current and the shorter will be the exposure time. Consider the following example (Figure 8.21) demonstrating this. The same patient part is radiographed each time but the area included is much greater in case (A) than in case (B), resulting in under-exposure of the large area image. This indicates that correctly exposed films are obtained by eliminating, as far as possible, all unattenuated radiation reaching the input phosphor. This is analogous to the requirement when using the ionization sensor for automatic exposure control.

The photomultiplier system, like the other systems discussed, requires a certain minimum inertia time in which to perform its exposure switching function. This inertia time

intensifier. Light is emitted from every point of the output phosphor and passes in all directions, hence, the narrow beam of light received by the prism comprises some light from each of the points, and the image on the film is formed by light from each of these points. The presence of the prism

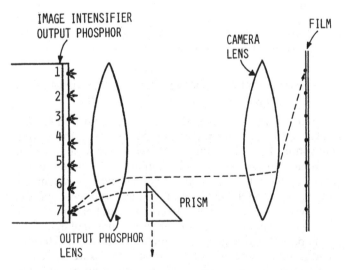

IMAGE INTENSIFIER
OUTPUT PHOSPHOR

CAMERA
LENS

FILM

1
2
3
4
5
6
7

PRISM

OUTPUT PHOSPHOR
LENS

Figure 8.20 The output phosphor lens and camera lens form one tandem lens system. The other tandem lens system is formed by the output phosphor lens and TV camera lens. The mirror has been omitted

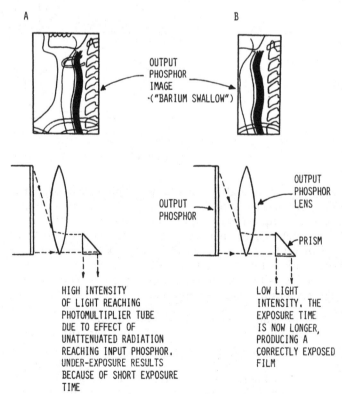

A B

OUTPUT
PHOSPHOR
IMAGE
·("BARIUM SWALLOW")

OUTPUT
PHOSPHOR

OUTPUT
PHOSPHOR
LENS

PRISM

HIGH INTENSITY
OF LIGHT REACHING
PHOTOMULTIPLIER TUBE
DUE TO EFFECT OF
UNATTENUATED RADIATION
REACHING INPUT PHOSPHOR.
UNDER-EXPOSURE RESULTS
BECAUSE OF SHORT EXPOSURE
TIME

LOW LIGHT
INTENSITY. THE
EXPOSURE TIME
IS NOW LONGER,
PRODUCING A
CORRECTLY EXPOSED
FILM

Figure 8.21 Effect of reducing image area

varies with type of system but in a photofluorographic system tends to be of the order of 10 to 50 milliseconds. If the kV has been set too high, or a falling load system is used for control of mA, then the exposure time for a correctly exposed film is likely to be shorter than the inertia time required for the automatic exposure device to carry out its exposure switching function. The exposure then carries on longer than it should producing over-exposure.

In image intensifier photofluorography there are several factors to consider in the achievement of suitable image quality:

(i) Using the falling-load system implies the application of the highest average mA for the shortest possible time. The sensitivity of the image intensifier–film system is considerable and the 'shortest possible time' mentioned is likely to be shorter than the inertia time, so over-exposure is inevitable. Also, since the falling-load system applies the highest average mA, then the effective focus size may be considerable at the commencement of the exposure, decreasing in size as the mA value falls during the exposure. What practical effect this is likely to have on geometric unsharpness has yet to be fully evaluated.

(ii) The falling-load system can be bypassed and a system of relatively low, fixed mA values used, from which one value can be selected. With the falling-load system, if the exposure time is less than the inertia time, then the only way in which the exposure time can be increased is by lowering the kV. While this measure results in a film of correct average density, the image contrast may be unacceptably high. Using a low fixed mA value ensures an exposure time longer than the inertia period thus allowing freedom of choice for kV to achieve the required image contrast. Selection of the appropriate mA to accompany the chosen kV so that the exposure time is longer than the inertia time (yet short enough to limit movement unsharpness) only comes with experience in using the equipment. Playing safe and using the lowest mA may give an exposure time which is too long resulting in an image with unacceptable image unsharpness. Use of the low mA does produce a small effective focus but this is essential in forming an acceptable image in a system which produces a minified image.

(iii) Use of the electronic magnification technique (using a 13 cm field instead of a 23 cm field) can mean an increase in exposure (p. 277). If the selected kV and mA remain unaltered then the exposure time required will be around four times greater. This may be unacceptable, especially in a film sequence taken at 6 or 12 frames per second, so an mA change may be required. A check can be made that the mA selected is correct (when using the 23 cm field), and that the exposure time thus obtained is longer than the inertia time, by exposing a suitable phantom. The same kV and mA should then be used to expose the same phantom with the 13 cm field. The average image density for each image should be comparable. If the exposure time is shorter than the inertia time then the image obtained using the 23 cm field will be considerably darker than the image obtained using the 13 cm field. An increase in mA is then necessary to obtain an exposure time longer than the inertia time when using the 23 cm field of the image intensifier.

(iv) The automatic exposure device will have been set for one speed of film. Should a different speed of film be used, then the device will require resetting to achieve an acceptable image quality. Another consideration when changing film speed is that relating to quantum noise. If the exposure required to produce an acceptable image is reduced because a faster film is used then quantum noise at the input side (and hence output side) of the image intensifier will increase. Quantum noise can be reduced by increasing the input radiation dose and reducing film speed.

AUTOMATIC EXPOSURE AND FALLING LOAD

In the absence of a falling-load system associated with automated exposure the usual technique is to select an mA value – having also selected the kV value thought appropriate for the examination – and set the exposure time to the maximum allowable for that kV and mA. The automatic exposure device then terminates exposure at some time less than the maximum set. It is unusual for the radiographer to select an mA and associated maximum exposure time such that the selected mAs value is less than that required to produce a correctly exposed film. If this were the case then the unit's timer will interrupt exposure when t_{max} for the set mA is reached and under-exposure results. As stated it is generally the case that the automatic exposure system terminates exposure before t_{max} is reached because together the selected mA and its associated t_{max} gives an mAs which is usually far greater than that required for a correctly exposed film at the kV set. The implications of this are easier to see if an actual example is considered. Assume that a P.A. chest radiograph required 65 kV and 20 mAs. Further assume that 400 mA was set and its associated t_{max} (the maximum exposure time possible at that mA and kV) is 0.3 s. This means a maximum possible exposure of 120 mAs at 65 kV. Now at 400 mA, since only 20 mAs is required, the automatic exposure system will terminate the exposure at 0.05 s whereas the actual exposure time set on the control table was 0.25 s too long. Some of this excess exposure time

could be used up as an increase in mA, say to 500. t_{max} for 500 mA is 0.15 s, say, giving a maximum of 75 mAs compared to the maximum of 120 mAs at 400 mA. Nevertheless when the exposure is made at 500 mA the automatic exposure system terminates the exposure at 0.04 s still well within the 0.15 s value for t_{max} at 500 mA.

Let us continue this process and use a higher mA, say 800. At 800 mA, t_{max} is 0.03 s, say, giving a maximum mAs of 24. This is still more than enough and with the automatic exposure system the exposure time is 0.025 s. This is just about the optimum setting because the shortest exposure time possible for the mAs required has been achieved (that is if the shortest possible exposure time is the principal requirement). Increasing mA further might produce a t_{max} such that the maximum obtainable mAs is less than that required for a correctly exposed film.

In practice the required mAs for a correctly exposed film is never known with certainty prior to exposure and to play safe an mA is chosen such that, with its associated t_{max}, it gives an mAs far in excess of that likely to be needed for a correctly exposed film. Thus the exposure time actually used is always likely to be longer than the shortest it is possible to achieve.

The falling load system is designed to achieve always the shortest possible exposure time for all patients by exploiting fully the tube focus loading capability in terms of mA at each exposure. In the continuous falling load system the exposure commences at the highest possible mA value which gradually falls throughout exposure until the automatic exposure system initiates exposure termination. The step falling-load system has already been described on p. 96. In the continuous falling load system the mA falls during the exposure according to maximum tube rating while the kV is held constant. The exposure time achieved then corresponds to the greatest allowable tube loading in that time and hence the exposure time, t, is the shortest obtainable for that examination with that imaging system. The tube is never overloaded but neither is it used below its full capacity. In the context of the above example which relates to a relatively low output X-ray unit the continuous falling load system would be an advantage. However, if funds are available to consider a falling load system it is of benefit to obtain an X-ray unit of higher output. In that case the falling load system becomes redundant. The most common system seems to be the stepped falling load and in the Picker Transix equipment the first step occurs at 0.3 s the second at 1 s and the third at 3 s. Hence for all exposures less than 0.3 s the equipment behaves as if there were no falling load; yet it is in the region 0 s–0.3 s that exposure time minimization is required. With modern equipment it would appear that a falling load system is a redundant facility.

DISCUSSION

The above details should provide the basic information concerning the correct use of an automatic exposure system. Whether or not a system is purchased for use depends on the cost-benefit exercise and whether a suitable staff training programme can be arranged since the success of such a system depends on the skill of the operator. A department with a rapid staff turnover is less likely to experience success in their use especially where the staff is short on experience. Nevertheless with care and experience great savings can be achieved with a considerable improvement in image quality.

9

The Radiographic Image (I)

INTRODUCTION

The aim in producing a radiograph is to provide information so that an assessment can be made of some aspect of a patient's condition. The more complete this information, the better and more valuable the assessment may be. Not only must the information be present in the image but it must be readily accessible visually (ideally under standardized conditions). Unfortunately, from a visual point of view, there is no general agreement as to what constitutes optimum image quality and it tends to be a rather intangible quantity. Fortunately, certain aspects relating to image quality lend themselves to objective analysis, and from such an understanding it can be demonstrated that if certain factors are correctly manipulated, an improvement in image quality results.

It is possible, in cases such as xeroradiography, to provide so much accessible information in the image that visual confusion results. This has been said of the images produced in electron radiography. It may be possible to overcome this condition by masking off all but a small area being viewed, or even adjusting the technique so that a reduction in image quality results (contradictory and undesirable) until such time as familiarity is gained with viewing this type of image.

The steps necessary to obtain radiographic information include

(a) choice of image recording system,
(b) optimization of radiographic technique usually by compromise,
(c) processing, and
(d) viewing and interpretation.

If a given image quality is to be consistently obtained it is necessary to control carefully each of the steps. Before this can be done an understanding of the processes involved must be gained together with a knowledge of exactly what it is that can be controlled. A detailed study will be made of the factors affecting image quality together with their effects and a summary provided. This chapter will be mainly concerned with the degree of unsharpness in the image, together with the associated concepts of magnification and distortion.

IMAGE DEFINITION

A subjective assessment of the unsharpness present in an image can easily be made by simply viewing the image. An impression is then gained of how well diagnostically significant image parts are defined. From the subjective aspect, image definition is defined as the distinctness with which image detail is seen. This will obviously vary from one individual to another and since in general such variations are not quantified, an objective measurement of unsharpness is required so that different images can be compared. An objective assessment of unsharpness expressed as a distance measured in millimetres is independent of image contrast while the subjective assessment is dependent on the level of image contrast. Hence the two assessments are likely not to be in agreement when comparing two images of different contrast with the same objective unsharpness.

The Degree of Unsharpness of Outline

It should be realized that it is not possible to produce a radiograph which is perfectly sharp (i.e. with zero unsharpness) so reference will be made to the degree of unsharpness. Secondly there is a minimum degree of unsharpness the eye can detect and beyond this the image will appear perfectly sharp. This degree of unsharpness is difficult to specify as a precise value since the visual appreciation of such unsharpness depends on many factors, including viewing distance, the visual ability of the viewer, the intensity and colour of illumination, density differences (radiographic contrast), and perhaps more important the rate of change of density across the boundary between a point of interest and its surrounding area.

Let us first consider the rate of change of density. Figure 9.1 illustrates two images of the same knife-edge object produced using the same intensifying screens but different films. On the left (Figure 9.1(a)) there is a large difference between the minimum and maximum densities present in the image while on the right the difference is much smaller. The image on the left may be described as a high contrast image while that on the right is of low contrast. For each image, density is measured along the dotted line (XY) and a graph plotted of density against distance (in mm). Note that it is the distance B in one case, and the distance b in the other which

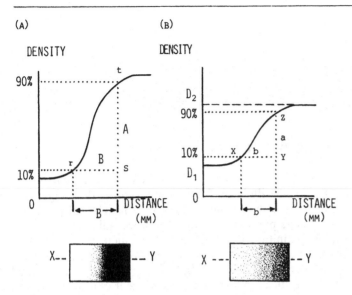

Figure 9.1 High contrast (a) and low contrast (b) images of a knife-edged object

represent the measurement of the degree of unsharpness of outline. In this example $B = b$. It is apparent that the difference in image contrast in the case of Figure 9.1 has not affected the objective assessment of unsharpness. It is the same for both images. Because of this and for the convenience of any subsequent mathematical analysis, the optical density measurements, obtained from the microdensitometer scan along the path XY, are normalized. For example, in Figure 9.1(b) for D_1 and D_2 then using

$$\frac{D - D_1}{D_2 - D_1}$$

will normalize the optical density scale so that $0 \leqslant D \leqslant 1$ whatever the value of D_1 and D_2. This simply means that the optical density scale extends from 0 to 1, rather than from D_1 to D_2. For example, if $D = D_1$, then

$$\frac{D - D_1}{D_2 - D_1} = \frac{D_1 - D_1}{D_2 - D_1} = 0$$

Again if $D = D_2$, then

$$\frac{D - D_1}{D_2 - D_1} = \frac{D_2 - D_1}{D_2 - D_1} = 1$$

Thus if each density value on the scale D_1 to D_2 is substituted for D in $D - D_1$, then the density scale is produced. This is the normalized scale and in this case $D - D_1 / D_2 - D_1$ is called a normalizing function.

The two curves of Figure 9.1 are shown again in Figures 9.2(a) and (b), and superimposed and with normalized

optical density axes in Figure 9.2(c). The reason the curves are superimposed is because all curves giving the same degree of unsharpness normalize to the same shaped curve. The normalized curve is therefore independent of image contrast. A convention used in making the unsharpness measurement from the normalized curve is to take the densities of 0.1 and 0.9 and then determine their corresponding co-ordinates on the distance axis. These coordinates if subtracted give the unsharpness measurement. In Figure 9.2(c) x_1 and x_2 are the appropriate co-ordinates giving an unsharpness measurement of $(x_2 - x_1)$ mm. Figures 9.2(a) and 9.2(b) are called edge spread functions (ESF) while Figure 9.2(c) is a normalized ESF. The zero co-ordinate on the distance axis occurs underneath the point of inflexion of the curve (i.e. where the slope of the curve ceases increasing and starts to decrease).

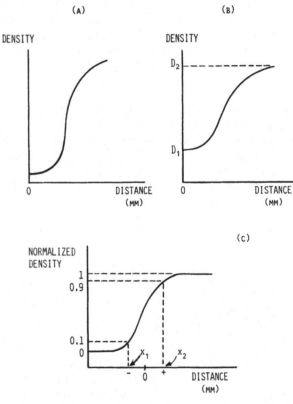

Figure 9.2 Density curves (a) and (b) from Figure 9.1 normalized and superimposed in (c)

Since a microdensitometer is required to produce these curves they are not likely to be produced as part of normal radiographic practice but, as will be seen later, the measurement of unsharpness obtained can and should be used by radiographers in the assessment of the suitability of a particular radiographic imaging system. Using $D = 0.1$ and

$D = 0.9$ is only one way of defining image unsharpness objectively. There are several other ways of defining the same quality, each correct in its own way but giving a different numerical answer because different quantities are used. For example one method uses the inverse slope measurement of the normalized ESF at the point of inflexion which provides a measurement which is perfectly adequate but quite different to a distance measurement. Whichever is used it is important to be consistent otherwise erroneous results may be obtained.

A in Figure 9.1(a) represents the change in density from s to t, i.e. A is simply a density difference. B represents a change in distance from r to s. Now

$$\frac{A}{B} = \frac{\text{change in density}}{\text{change in distance}} = \frac{\Delta D}{\Delta d}$$

$$= \text{the average rate of change of density}$$

In this case the average rate of change of density, i.e. the ratio A/B, has a relatively large value, and to the eye the unsharpness may be considered negligible.

In Figure 9.1(b)

$$\frac{a}{b} = \frac{\Delta D}{\Delta d}$$

and in this case, the average rate of change of density has a much lower value since $B = b$, $a < A$, so

$$\frac{a}{b} < \frac{A}{B}$$

and in the case of Figure 9.1(b) the appearance of unsharpness is by no means negligible, even though the measured unsharpness for both is the same. It is to be noted that in Figure 9.1(b) it is much more difficult to determine the extent (boundaries) of the object.

It should be apparent that the rate of change of density and the density levels between which the change takes place have a considerable influence on the appearance of unsharpness. A moment's reflection should indicate that on any radiograph there will be a considerable variation in rates of change of density and density levels for the different parts of interest on the film, and the visual appreciation of unsharpness will likewise vary.

In Figure 9.1(b), if b is changed to a value which would render the unsharpness visually negligible and the exposure altered so that there is a much greater difference between the highest and lowest densities (D_2 and D_1), then b could be altered considerably without unsharpness becoming visually apparent. This implies that if two images have the same measured unsharpness but a different image contrast then the one with the highest contrast will subjectively have the lesser degree of unsharpness. As a further example, even though unsharpness may be measurably different in two films of the same object, the visual appreciation of un-

sharpness can be identical for the two films if one has greater density differences and hence higher rates of change of density than the other.

In a given image for a high contrast region, a high level of unsharpness may be tolerated visually, while for a low contrast region a much lower level of unsharpness may be considered as intolerable. Let us assume that the aim should be to produce a total unsharpness everywhere in the image of 0.1 mm or less, and with this achieved the image, in terms of unsharpness, may be considered to have satisfactory image quality. It should be noted that in practice it may be impossible, in many cases, to meet this criterion. Then a suitable optimization of parameters should give the minimum total unsharpness for the given situation although this total unsharpness value may be several times greater than 0.1 mm because of tube loading limitations or the requirement to limit radiation dose to the patient. The figure of 0.1 mm has been suggested as the minimum detectable unsharpness, but the main objective is not to select an unsharpness figure and work to that, but rather to select a system of suitable imaging speed (i.e. a system requiring a satisfactory level of radiation dose to produce the image) and then minimize unsharpness in this system by optimizing the choice of variables.

In summary it can be said

(a) The appearance of unsharpness in a radiographic image is related to the radiographic contrast (ΔD)

(b) For two images having the same radiographic contrast, the one with the larger measured unsharpness will appear to the eye to have the greater degree of unsharpness

(c) For two images having the same measured unsharpness, the one with the greater radiographic contrast will appear to the eye to have the lesser degree of unsharpness.

These points have great practical significance. In a situation where it is not possible to reduce the measured unsharpness of the image (due to the geometry of the radiographic technique and the properties of the imaging system available) it is sometimes possible to reduce the unsharpness seen by the eye, by simply increasing the radiographic contrast. This may not always be possible. A reduction in kV to achieve the increase in radiographic contrast inevitably means an increase in either mA or exposure time, which can lead to an increase in unsharpness thus losing what was hoped to be gained.

Of course, there are other ways of achieving an increase in radiographic contrast without changing kV, and in practice all of these would be considered. Use of a compression (displacement) band (p. 152), reduction in X-ray beam area, or reduction in X-ray beam filtration (in accordance with

existing radiation protection regulations) are examples. Any reduction in either visual or measured unsharpness will make it easier to extract information from the image. As a result it may be said that image quality has improved. Note that increasing radiographic contrast does not affect the measured unsharpness as should be apparent from Figure 9.1.

The measured degree of unsharpness of outline is sometimes referred to as objective definition and may be defined as the breadth of the boundary between two adjacent areas of different density in the image. In Figure 9.1, the measurements B and b each represent the width of penumbra. Since the penumbra (Figure 9.3) represents the unsharpness in the image it is necessary to know what causes the penumbra and by what methods it may be reduced.

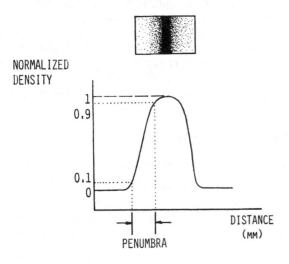

Figure 9.3 The penumbra

SOURCES OF UNSHARPNESS

It is common practice to describe unsharpness in a radiographic system – consisting of X-ray source, the object being radiographed and the imaging medium – as comprising

 (i) geometric,
 (ii) photographic, and
(iii) movement unsharpness.

All three contribute to total unsharpness in the radiographic image, except in the rare case when there is no patient or system movement.

Geometric Unsharpness

As the name suggests, this is unsharpness which results from the geometry of the technique employed. The methods used

below to determine the value of this unsharpness produce only good approximations to the true value. A more precise determination would involve the use of what is called a transfer function, but this will be briefly discussed later. Determination of the value for geometric unsharpness requires a consideration of the focus size, the plane of the effective focus relative to the plane of the film, the object–film distance, the focus–object distance and the value of the mA chosen for the exposure, since this may affect the focus size obtained. In certain circumstances even the value of kV chosen can effect image unsharpness but this will be considered in more detail later.

Focus Size

Consider Figure 9.4, illustrating the cathode and anode of an X-ray tube with an associated electron beam. Electrons bombard the anode giving rise to X-rays. Looking in the direction of the black arrow would show the area of the anode bombarded by the electron beam. Looking in the direction of the white arrow would show the bombarded area (focal spot) as 'seen' by the film along the central axis of the X-ray beam, and this is a much smaller area than 'seen' by the electron beam. This is very useful because:

 (i) The anode area 'seen' by the electron beam must be as large as possible so that the electron beam energy is spread over as large an area as possible. This reduces thermal stress on the anode focal spot area and hence allows a higher loading capability than a smaller area would.

 (ii) The anode area 'seen' by the film should be as small as possible because, as will be shown, geometric unsharpness is directly proportional to the size of the focal area of the anode as 'seen' by the film.

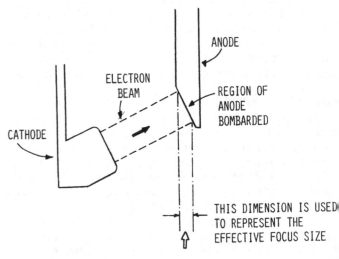

Figure 9.4 Effective focus size

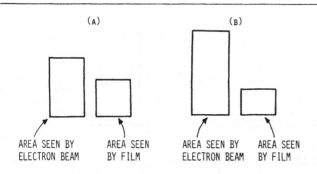

Figure 9.5 Focal areas seen by electron beam and film for larger (a) and smaller (b) anode angles

Figure 9.5 shows the two sizes of focal area, one seen by the electron beam and one seen by the film, and in Figure 9.5(b) the anode angle has been decreased. Here the anode angle θ is defined as the angle between the face of the anode containing the focal area and the central axis of the X-ray beam (Figure 9.6), and is typically 15°. The smaller (narrower) the anode angle (say 10–12°) the smaller the focal area 'seen' by the film. The focal area as seen along the central axis of the X-ray beam is called the effective focal area.

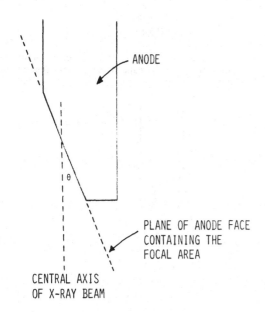

Figure 9.6 The anode angle θ

To show how geometric unsharpness (U_g) is related to effective focal area consider Figure 9.7. A point p is to be imaged in the film and any image other than a point will represent unsharpness. Since the object point is chosen as being infinitely small, the image of p in the film and represented as of dimension x must be composed entirely of unsharpness (penumbra). By this is meant that the image of

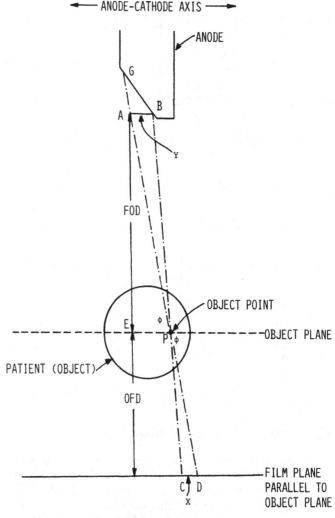

Figure 9.7 Image of a point p

point p is blurred over an area of film having diameter x mm. The effective focus is either square or rectangular depending on which direction is chosen along which to view it. Although effective focus has been defined for one particular direction only (along the central axis of the beam) it is equally applicable to other directions. For example, point p would 'see' a particular focus size having one dimension represented by AB = y mm and, since AB is parallel to the film, this is the focus dimension effective in formation of the image. This discussion concerns geometric unsharpness and the effect of focus size so a relationship relating the two quantities is required.

Nominal focus size is given by the manufacturer as the effective focus size along the central axis of the beam but in Figure 9.7 point p does not lie on the central axis. Hence AB does not represent one dimension of the nominal focus area, but is slightly smaller than the size given by the manufac-

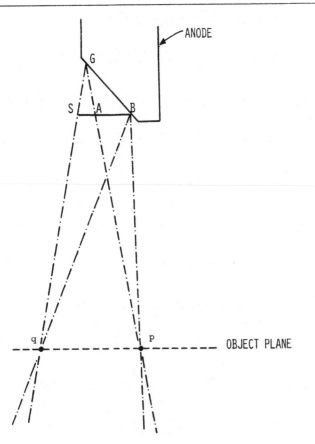

Figure 9.8 Effective focal areas seen by points p and q

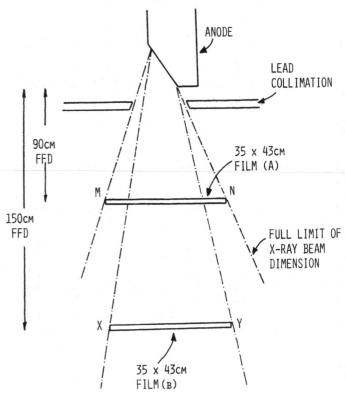

Figure 9.9 Less than full limit of the X-ray beam is needed for film B. Focus dimension variation from X to Y is smaller than variation expected from M to N for film A

turer. Figure 9.8 illustrates this for two points p and q in the same object plane. Point p is the same as in Figure 9.7 while point q lies on the opposite side of the central axis of the beam. It is readily apparent that the focus dimension (SB) seen by q is larger than that (AB) seen by p. Hence unsharpness calculated by using nominal focus size is only applicable to the part of the image formed by the centre of the X-ray beam. The difference between SB and AB is generally assumed to be small such that $SB \simeq AB \simeq$ nominal focus dimension. Unfortunately in practice it has been found, just for one example of a 17° anode angle tube, that moving from cathode to anode side of the beam, this particular focus dimension changed by a factor of 2.3. The beam dimensions used were those for a postero-anterior (PA) chest radiograph on a 35 × 43 cm film at 150 cm FFD. These dimensions do not represent the full limits of the beam. For example, an antero-posterior (AP) abdomen on a 35 × 43 cm film at 90 cm FFD would just about require the full limits of beam dimensions. The variation in focus size across this film would be considerably more than the factor of 2.3. Figure 9.9 illustrates these points. It is interesting to note that decreasing anode angle accentuated this effect.

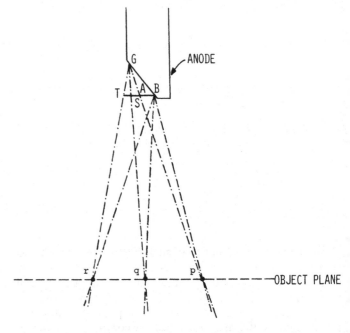

Figure 9.10 Effective focal dimensions seen by points p, q and r

Consider Figure 9.10. By reference to three points in the object plane it is shown that the point nearest the cathode side of the X-ray tube 'sees' the largest effect focus, while the point nearest the anode side sees the smallest effective focus. Point p sees a focus of length AB, while q sees SB and r sees TB. AB < SB < TB so r sees a greater length than either q or p. In general, effective focus size is greatest for points on the cathode side at the limit of the X-ray beam, and least on the anode side. Subjectively image definition would certainly be worse in the case of point r.

Returning to Figure 9.7, even though dimension AB is not known, a general expression for geometric unsharpness can be found. Two similar triangles are noted. They are CDP and BAP and because they are similar

$$\frac{x}{Dp} = \frac{y}{Ap} \tag{9.1}$$

AEp is right-angled so

$$Ap = \frac{FOD}{\sin \phi}$$

Similarly

$$Dp = \frac{OFD}{\sin \phi}$$

Substituting in (9.1) gives

$$\frac{x}{OFD/\sin \phi} = \frac{y}{FOD/\sin \phi}$$

or

$$x = y \left[\frac{OFD}{FOD} \right]$$

This applies for any angle ϕ.

Hence U_g is directly proportional to focus size and to the ratio (OFD/FOD).

It should be obvious that if the distance between object and film is increased so is U_g. Similarly if the distance from focus to object (or focus to film) is decreased, U_g will increase. It is assumed here that the focus is a rectangular area emitting radiation uniformly. This is not so in practice and for all unsharpness calculations the equivalent focus dimensions (see below) should be used.

Focus Measurement

Calculating the magnitude of the geometric unsharpness at any point still requires knowledge of the focus dimensions. This information can be obtained from direct experiment. A useful way of determining focus dimensions is to use a Siemans star pattern resolution grid (Figure 9.11). This consists of a series of spokes engraved in a sheet of lead. The angle between successive spokes is 2° and the distance

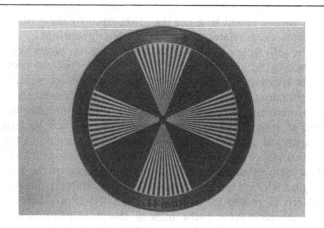

Figure 9.11 Siemans star pattern resolution grid

between any pair of spokes is equal to the width of a spoke. Each spoke and the corresponding space between it and the next spoke is called a line pair.

Using this method rather than the pinhole method (see p. 136) does provide more useful information. Focus size as determined by the star pattern method depends not only on the physical size of the focus but also on the intensity distribution of X-rays from the focus. In most cases the intensity distribution is far from uniform and has a significant effect on the visual appreciation of unsharpness. The measurement obtained by this method is that for an equivalent rectangular focus (of uniform intensity distribution) which has the same resolving power as the actual focus.

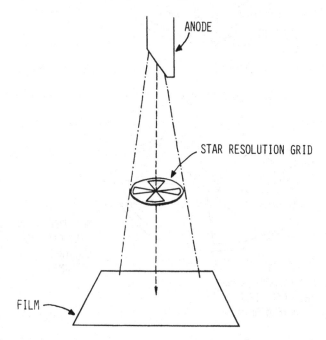

Figure 9.12 Position of star pattern

This measurement is larger than that given by the pinhole method which relates to the actual focus dimensions.

The following description shows how the star pattern can be used to measure the length of the focus, i.e. the dimension of the focus in the anode–cathode direction. As an example the measurement will be made in the central beam axis (a measurement can readily be made at any other point in the field of the beam using a similar technique). The star pattern is arranged parallel to the film and perpendicular to the central axis of the beam with the central ray passing through the centre of the star pattern and the middle of the film (Figure 9.12). Using a typical FFD (say 100 cm) the star pattern is placed at a distance from the film to give a magnification factor in the image of $M = (4/3\,NFS) + 1$ where M is the magnification factor and NSF is the nominal size of the focus. Use of this formula is designed to limit subsequent measurement errors.

An exposure is made using screens plus film and 50–70 kVp with sufficient mAs to give a reasonable image. Higher kV values may be used but the measurements become more difficult to make because of the reduction in image contrast. The star should be aligned with one set of spokes along the anode–cathode direction, in order to measure the breadth (f_b) of the focus. The other set of spokes at 90° to these are used for measuring the length (f_1) of the focus (Figure 9.13).

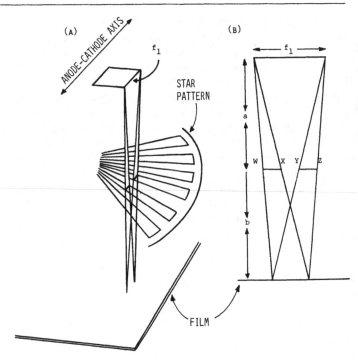

Figure 9.14 Overlapping of adjacent images at a certain line pair width w

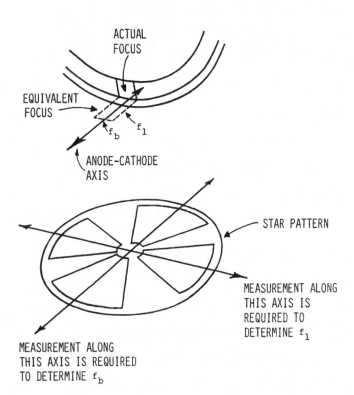

Figure 9.13 Measurement of f_1 and f_b

With the focus, star and film in the configuration of Figure 9.14(a), there is a certain line pair width at which the image on the film is completely blurred. This has happened in Figure 9.14(b) where the images of the two lead spokes have coincided completely obliterating the image of the intervening space. In this situation, from Figure 9.14(b), by similar triangles,

$$\frac{f_1}{(a+b)} = \frac{WX + XY}{b} = \frac{2w}{b}$$

$$\therefore \qquad f_1 = 2w\left[\frac{a+b}{b}\right] \qquad (9.2)$$

Distance a is difficult to measure accurately in practice. On p. 143 it is shown that magnification factor is

$$M = \frac{FFD}{FOD}$$

$$M = \frac{a+b}{a} \qquad (9.3)$$

In (9.2) the ratio $\left(\frac{a+b}{b}\right)$ can be transformed by substitution from (9.3). From (9.3)

$$a + b = aM$$

$$\therefore \qquad b = aM - a$$

Substituting gives

$$\frac{a+b}{b} = \frac{aM}{aM \cdot - a}$$

$$= \frac{aM}{a(M-1)}$$

$$= \frac{M}{M-1}$$

Hence

$$f_1 = 2w \left[\frac{M}{M-1}\right]$$

Substituting $(M/M-1)$ for $(a+b/b)$ is convenient because M is easily measured by relating the size of the image to the size of the object.

In practice, to measure w would be extremely difficult so it would again be convenient to substitute a quantity more easily measured. Figure 9.15 shows an image of the star

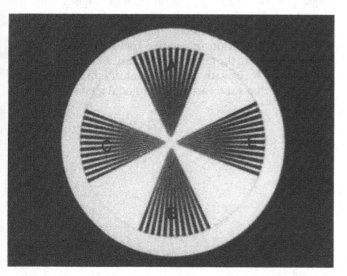

Figure 9.15 Image of star pattern taken with nominal 2 mm focus. AB is the anode–cathode direction. Since f_1 is being measured, the distance in the direction CE is used

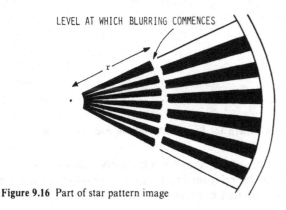

LEVEL AT WHICH BLURRING COMMENCES

r

Figure 9.16 Part of star pattern image

pattern taken with a nominal 2 mm focus. Referring to quadrant E of the star pattern image, if the image is visually scanned from the outside edge towards the middle a point is reached where the images of the spokes and their intervening spaces become totally blurred. It is the magnitude of w at the point of blurring which is required and must be measured indirectly. Consider Figure 9.16 where the image of quadrant E is represented diagrammatically. To determine w it is necessary to consider just the space between two adjacent spokes (Figure 9.17). AB is the distance between spokes at the point where blurring commences and is the length of the arc joining A to B. The angle between OA and OB is 2°. The circumference of a circle of radius r is $2\pi r$ and the length of arc AB is $[(2/360) \times 2\pi r]$ mm. The length of this arc might be taken as the required magnitude of w except that it is too great by a factor equal to the magnification factor. This is easily remedied and the true value for w is

$$w = \frac{1}{M} \left[\frac{2}{360} \times 2\pi r\right]$$

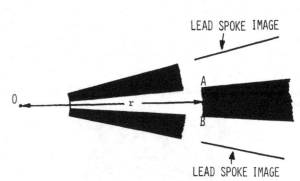

LEAD SPOKE IMAGE

LEAD SPOKE IMAGE

Figure 9.17 Two adjacent spokes of Figure 9.16

The distance from the centre of the star pattern to the point where blurring commences is r mm and can certainly be measured accurate to the nearest mm in the magnified image. This is sufficient to ensure only a very small error in the true measurement of f_1. In practice r is not the measurement taken. Quadrant C (Figure 9.15) will also show blurring due to the finite size of f_1 and there will be an associated r for this blurring. It is the sum of the two r values which is measured, i.e. the distance from where the blurring commences in C to where the blurring commences in E. The two r values are equal and $2r = D$, the distance measured in the magnified image between the two regions of blurring. Substituting for $2r$ in the expression for w gives the true value of w as

$$w = \frac{1}{M} \left[\frac{2}{360} \times \pi D\right] = \frac{\pi D}{180 M}$$

Recalling the fact that $\qquad f_1 = \dfrac{2Mw}{M-1}$

and substituting for w gives

$$f_1 \quad = \quad \frac{\pi}{90} \quad \times \quad \frac{D}{M-1} \quad = \quad \frac{0.035\,D}{M-1}$$

The focus width f_b, can be found in a similar manner to f_1 by considering the blurring in quadrants A and B (Figure 9.15). In the case of a focus, for example, where the distribution is distinctly bimodal (Figure 9.18(b)) with little X-ray emission from the central region of the focus then f_1 and f_b will be the measurements of a rectangular focus of uniform intensity distribution with resolving power equivalent to that of this non-uniform focus. The measurements obtained are always those of an equivalent rectangular focus no matter what intensity distribution the actual focus has.

Figure 9.18 Intensity distributions (a) approximately uniform at 130 kV (b) bimodal at 65 kV

Figure 9.19 Lead sheet regularly perforated with pinholes

Pinhole radiographs of the focus of any X-ray tube are easily produced using a piece of lead sheet suspended between X-ray tube and film. The lead sheet contains a pinhole and to obtain sufficient magnification and image density for a small exposure it is necessary to

(i) use an FFD of 150 cm with the lead taped to the front of the light beam diaphragm. The pinhole should be aligned with the central axis of the beam, and

(ii) use a high-speed film–intensifying screen combination. For reasonable precision, particularly if measurements are to be made, the pinhole must conform to BS 5269: Part 1 (1975), and a non-screen film used.

Figure 9.20 Multiple pinhole photograph showing variation in focus size across the image field at 60 kVp (left) and 130 kVp (right)

To show the effect of variation in focus size relative to field position it is necessary to use a sheet of lead with many pinholes (Figure 9.19). This is used in the same manner as the single pinhole, with the central pinhole aligned with the central ray. This should produce a square focus image at the centre of the field but not elsewhere (Figure 9.20). Note the considerable variation in relative focus size and shape at different points in the image field. Figure 9.21 shows the field pattern for a focus with uniform intensity distribution, and Figure 9.22 that for a focus with bimodal intensity distribution.

Figure 9.21 Pattern for focus with uniform intensity distribution. The anode side is on the left

Effect of Focus Size, Shape and Intensity Distribution
On p. 133 the relationship between U_g and focus size was obtained but this expression assumes a uniform intensity

Figure 9.22 Pattern for focus with bimodal intensity distribution. The anode side is on the left

distribution for the focus and in many cases a uniform intensity distribution is not demonstrated and it would be wrong to calculate U_g based on manufacturers' nominal focus dimensions. Consider the pinhole image of a focus with bimodal intensity distribution (Figure 9.23). The side f_b of the actual focus consists of two distinct radiation emitting areas which is equivalent to using two foci simultaneously and this would obviously produce two separate images of a single object. In Figure 9.24 an object point, p, is imaged using this focus and two unsharp images, y and z, are produced. It is certainly a disadvantage to produce two separate images of a single object. If cb > 0.1 mm then it is likely that two distinct images will be seen. If cb < 0.1 mm but ab > 0.1 mm then a single but apparently very blurred image will be seen. If ab < 0.1 mm a single image is seen with no recognizable unsharpness. For this to occur

$$\frac{2(f_b/3)}{\text{FOD}} = \frac{\text{ab}}{\text{OFD}}$$

From which

$$\frac{2}{3} f_b \left[\frac{\text{OFD}}{\text{FOD}} \right] = \text{ab} < 0.1 \text{ mm}$$

and

$$f_b < 0.1 \times \frac{3}{2} \times \frac{\text{FOD}}{\text{OFD}}$$

$$= 0.15 \left[\frac{\text{FOD}}{\text{OFD}} \right]$$

Figure 9.23 Diagram of pinhole image of the focus with bimodal in intensity distribution; $s \simeq \frac{1}{3} f_b$

Pinhole images of foci indicate that a great many are neither truly bimodal nor uniform in intensity distribution but somewhere in-between, and the geometric approach to unsharpness cannot be used in comparing the imaging properties of different foci unless equivalent focus dimensions are used. The conceptually more difficult transfer functions must be used for each of the foci being compared if such a comparison is to be really accurate. Returning to Figure 9.24, the continuation of the geometric approach using nominal focus measurements although inaccurate is useful to show what happens. For this bimodal focus, f_b was measured and found to be 2.7 mm and at 65 kV$_p$ the two separate foci each had a width of approximately 0.9 mm. Consider a small linear opacity of width 0.5 mm in a perfect image of a lung field on a chest radiograph. Assume that this lesion in the chest is some 20 cm from the film and that the FFD is 150 cm. The magnification factor is

$$M = \frac{150}{150-20} = 1.15$$

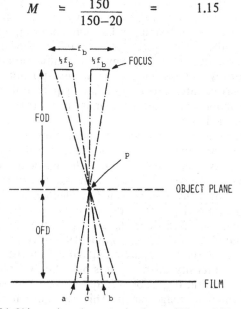

Figure 9.24 Object point p imaged using focus of Figure 9.23

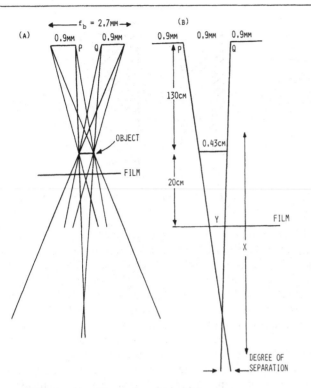

Figure 9.25 Overlap of image from bimodal focus

Figure 9.26 shows the double imaging effect of a focus with a bimodal intensity distribution while Figure 9.27 shows the overlapping effect due to the same focus.

Figure 9.26 Double imaging

Figure 9.27 Overlapping effect

and the true width of the lesion is $(0.5/1.15) = 0.43$ mm. Further assume that this lesion is aligned such that its width is parallel to f_b. The situation is now as shown in Figure 9.25. Distance x is approximately 119 cm. Thus distinctly separate images are not shown since it is only for $x > 119$ cm that this phenomenon occurs in this example. Just for radiation arising from P and Q, the two images will overlap an amount y mm. Here y is approximately 0.35 mm. The primary image is then spread over a distance $(0.5 + 0.5 - 0.35) = 0.65$ mm. This is greater than that predicted by the magnification factor. If penumbra is now included then it is quite possible that the lesion may be interpreted as something quite different from what it actually is, because the image is not truly representative of the lesion.

In macroradiography, for a magnification factor of 2, for example, then two quite distinct images will be formed separated by more than 0.1 mm if this particular bimodal focus is used. Of course, the use of a nominal 2.0 mm focus in macroradiography is unrealistic but whether or not double imaging occurs depends on the relationship between focus size, object size and the distances separating focus, object plane and film in the case of a bimodal intensity distribution. In Figure 9.25(b) it is apparent that reducing focus size, even when the intensity distribution is bimodal, will reduce the magnitude of the degree of overlap of images resulting in an improvement of image quality. This is equally true if FFD is increased.

Factors Affecting Focus Size

The size of focus selected in any examination is dependent on the exposure required to produce an acceptable image. If the mA used is high then the focus size is, of necessity, large. A smaller focus size might be selected for the same overall exposure if a higher kV were selected to allow a reduction in mA. Whether or not the accompanying reduction in radiographic contrast is acceptable must be carefully considered since subjectively a contrast change affects the appreciation of image unsharpness.

Experiments have shown that in some cases the choice of mA influences the effective focus size and hence the equivalent focus size. In the worst reported cases the focus size can double when changing from a low mA to a high mA even though the focus selection has not been changed. In other cases the change is limited to 0.2 or 0.3 mm for a nominal 1.5 mm focus for example. It is always worth assessing focus parameters at different mA values for a constant kV and mAs to see if there are any significant changes which could be compensated for in the practical technique by changing distances, for example. Unfortunately this method of compensation may not always be possible because other forms of unsharpness are also present in the image. Improving geometric unsharpness may worsen one of the other forms of unsharpness, and nothing is gained.

Altering the focussing arrangement of the electron beam in the X-ray tube will also alter the focus size, shape and intensity distribution. X-ray tubes are available where the filament is insulated from the focussing cup so that the cup can be made negative relative to the filament. This is called focus biasing and serves to compress the electron beam around its circumference. The beam thus bombards a smaller anode area and produces a smaller effective focus which is circular rather than square. The intensity distribution from a biased focus is gaussian (bell-shaped) as shown in Figure 9.28 and is somewhere near the ideal of a point source of radiation. Of course, compressing the same number of electrons into a smaller anode area reduces the loading limit on the tube and the application of biased foci are limited.

It is noted that the position in the image field determines the size of the focus 'seen'. The focus is largest over the cathode side of the image field and smallest over the anode side. There are techniques where the central ray is not centred to the middle of the object area or the middle of the film, as in the PA chest radiograph (Figure 9.29) for example. If the cathode end of the X-ray tube is lowermost then the part of the radiation field with the worst imaging characteristics is being used. The part of the radiation field where the smallest focus area is seen is outside the image field. This is easily overcome by having the anode lowermost, but this does not overcome the problem of irradiation of the head of the patient which is not imaged. Since the X-ray tube is designed to revolve about the focus, the best compromise is probably Figure 9.30(a) but Figure 9.30(b) is equally acceptable. Figure 9.30(a) gives marginally better definition in the lung apices while Figure 9.30(b) gives marginally better definition in the lung bases due to the X-ray beam not being angled but in this example the difference is almost negligible because the X-ray beam is only angled by about 5°.

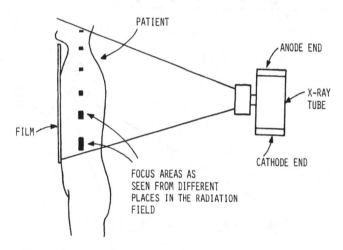

Figure 9.29 PA chest radiography

Figure 9.28 Gaussian distribution of intensity from a biased focus

Figure 9.30 Angled X-ray tube in chest radiography

Finally, relatively large angles between X-ray beam and film should be considered. Figure 9.31 shows the effect on focus size as seen from different image field positions when the X-ray tube is angled 30° from the vertical in two different ways.

Figure 9.31 Effect on effective focal size of a 30° angle

Distance
The equation on p. 133, namely,

$$\text{geometric unsharpness } (U_g) = \text{focus size} \times \frac{\text{OFD}}{\text{FOD}}$$

shows that U_g is dependent on the FFD chosen and the size of the patient. Consider an AP lumbar spine projection done on a table with a floating top and again done on a non-floating-top table. The distance from the film to the patient in the case of the floating-top table is greater than that for the non-floating-top table. If FOD_1 is used for the non-floating-

top table then $FOD_1[(a+y)/(a+x)]$ must be used in the case of the floating-top table to maintain the same value of U_g, where a is the object-to-table-top distance, x is the table-top-to-film distance for the non-floating-top table, and y is the table-top-to-film distance for the floating-top table. In this example, let $a = 10$ cm, $x = 5$ cm, $y = 8$ cm, and $FOD_1 = 75$ cm. This gives an original FFD of 90 cm with the non-floating-top table. The FFD required for the same U_g with the floating-top table is 108 cm. This is a considerable difference but would the difference in U_g be noticeable if 90 cm FFD were used in both cases with a 1.5 mm focus? The figures for U_g in each case are respectively 0.3 and 0.37 and this difference is unlikely to be noticed.

Another example is that of the lateral lumbar spine projection with an object-to-table-top distance of 20 cm. Using 90 cm FFD on both tables gives values for U_g of 0.58 mm and 0.68 mm and such a difference is likely to be noticeable. Obviously, whether any alteration to the FFD is necessary when using a floating-top table depends on the OFD.

Photographic Unsharpness

Probably the most common imaging system in radiography is that of the film–intensifying screen pair combination and both film and screens must be considered as sources of unsharpness in the image.

Unsharpness due to intensifying screens arises because of the divergence of light from the emitting phosphor particles. In the film, unsharpness of a much lower order of magnitude occurs due to light scattering within the emulsion. This latter process (Figure 9.32) is called irradiation. In particular, with intensifying screens of higher relative speed, light scattering within the fluorescent layer is considerable and serves to increase the effect due to light divergence. Image unsharpness due to light divergence effects is of course much worse if poor film–intensifying screen contact is present.

A simple way of assessing these effects is by use of a resolution test grid. The ability of the imaging system to define the information contained in the input signal to the system is called resolution. The more closely the true infor-

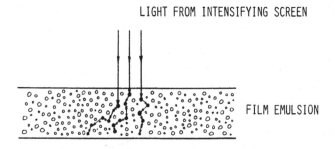

Figure 9.32 Irradiation (light diffusion). The exposed silver halide is shown blackened

mation can be defined the higher is the resolution of the system. The star pattern already mentioned is a resolution test grid but it is more convenient if a linear resolution test grid is used (Figure 9.33). Like the star pattern, this consists of a number of thin strips of lead but arranged in order of decreasing width. Each pair of strips is separated by a space of width equal to that of the strips. Each lead strip together with its adjacent space is referred to as a line pair (lp). If the lead strip width is 0.5 mm and the space is 0.5 mm this constitutes 1 lp mm^{-1}. As the strip and space widths decrease there will be a greater number of line pairs per mm. If a radiograph is made of this test grid and examined under magnification, then it is possible to determine the greatest number of lp mm^{-1} which can be seen before their images become merged. This provides a measure of the maximum resolution of the imaging system for this test object. In exposing this radiograph the kV chosen must be low to avoid penetrating the lead strips as this will affect the subjective assessment. The resolving power of a film is much greater than that of an intensifying screen and in combination it is the intensifying screen contribution that predominates.

Figure 9.33 Linear resolution test grid

Another factor contributing to photographic unsharpness is the cross-over effect in paired intensifying screen–duplitized film systems but this has already been discussed (see page 11)).

In a manner analogous to that for geometric unsharpness, a measure can be obtained for photographic unsharpness (U_p). Producing an edge-spread function to determine U_g requires the use of a high resolution direct-exposure film so that U_g is negligible (Figure 9.34). The knife-edge is stationary so movement unsharpness (U_m) is zero. To determine U_p requires $U_g = 0$. This requires that the knife-edge be in as close a contact as possible with the film–intensifying screen combination and that the FFD be very large and the X-ray beam highly collimated to achieve a parallel beam of X-rays. These measures minimize U_g and if the knife-edge is stationary then $U_m = 0$. The resulting image of

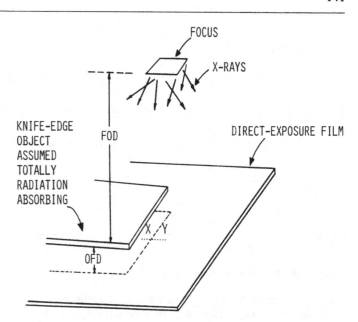

Figure 9.34 Determination of U_g. XY is the path scanned by the microdensitometer

the knife-edge can be scanned and the ESF produced. From this can be determined an unsharpness measurement in mm for the film–intensifying screen combination using the same convention as before. In producing this ESF it is assumed that film–screen contact is perfect. Imperfect contact would increase U_p.

For different film–intensifying screen combinations and good film/screen contact, U_p varies from about 0.08 mm to 0.4 mm, the highest figure being representative of the combination with the greatest relative speed. A slight improvement in these figures could be obtained by using the various combinations in a vacuum-packed cassette.

Movement Unsharpness

Movement of the human body is both voluntary and involuntary and such movement occurring during the exposure results in image unsharpness. This type of image unsharpness due to motion is limited by the correct use of patient immobilization methods and devices, and by employing the shortest possible exposure time consistent with overall exposure requirements. Often because of the size of the patient part, the overall exposure is too great to allow the use of an appropriately short exposure time at the kV required. Movement unsharpness is then most likely to be the single biggest contributor to total image unsharpness.

During any radiographic exposure, the direction in which the motion occurs is important in determining the image contribution of movement unsharpness (Figure 9.35). Motion perpendicular to the film plane produces less unsharpness than the same degree of motion parallel to the film.

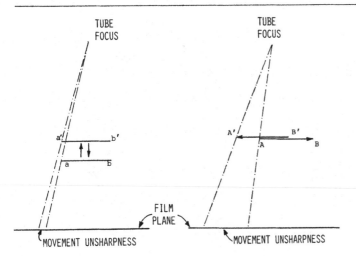

Figure 9.35 Movement unsharpness (here bb' = AA')

The shape and size of the object, and its orientation in the path of the X-ray beam, are also important, not in the objective determination of the U_m, but in the visual effect. From the subjective aspect image contrast is also another vital factor not only relative to U_m but also to U_g and U_p. After all, a radiographic image is being produced for a subjective assessment in diagnostic terms and it is the combined contributions of U_m, U_p and U_g to the over-all total image unsharpness (U_t) that are important, together with the effect on the visual appreciation of U_t of image contrast and noise. It would be very useful, as a first step, to have a method of determining U_t, and then a process by which U_t could be minimized for any given set of conditions but this is best done in terms of transfer functions. However a method of approximating U_t is given below.

Total Image Unsharpness

Much has been written about the classical expression for total unsharpness,

$$U_t = \left[\sum_i u_i^n \right]^{1/n}$$

where each of the U_i are U_p, U_m and U_g and n is some number, historically given as 1, 2 or 3. Various formulae with different n-values have been used but perhaps the most commonly used and quoted amongst radiographers is

$$U_t = (U_p^2 + U_m^2 + U_g^2)^{1/2}$$

Recent published work has cast doubt on the validity of values for n used, this resulting from a rigorous mathematical analysis using transfer functions. In practice, with good technique it is unlikely that any single unsharpness factor will dominate and at least two of the factors will have values which are approximately the same. These are usually

U_p and U_m. In this case it has been suggested that $n = 1.55$, giving

$$U_t = (U_p^{1.55} + U_m^{1.55} + U_g^{1.55})^{\frac{1}{1.55}}$$

Given a calculator or log tables this is a straightforward expression to evaluate.

These equations, however, only give an approximate result and an alternative formulation of the problem is necessary if a more accurate result is required. This is complex and will not be done here. Nevertheless the geometric approach is useful and its use will be continued.

Consider the example of the chest radiograph discussed earlier, having a 0.5 mm lesion some 20 cm from the film, and using a nominal 2 mm focus having a bimodal intensity distribution. To minimize U_g it was found necessary to have

$$f_b < 0.15 \left[\frac{FOD}{OFD} \right]$$

Here f_b = 2.7 mm and OFD = 20 cm, then

$$FOD > f_b \frac{OFD}{0.15} = 360 \text{ cm}$$

To meet this condition would require an FFD greater than 380 cm. This is possible if a high kV technique is accepted otherwise the exposure time will be too long and $U_m \gg U_p$, $U_m \gg U_g$, so

$$U_t \simeq U_m$$

and this is quite unacceptable. A high kV technique will be adopted and a stationary grid used (in this case the use of an air gap would necessitate an even larger FFD). 150 kV will be used with 8 mAs at 0.04 s and 200 mA, the rare-earth intensifying screen–film combination employed having a $U_p \simeq$ 0.1 mm. $U_m \simeq 0.1$ mm if it is assumed that only involuntary movement occurs for the heart at 3 mm s^{-1}. Total unsharpness is then

$$U_t \simeq \left[0.1^{1.55} + 0.1^{1.55} + 0.1^{1.55} \right]^{\frac{1}{1.55}} \simeq 0.2 \text{ mm}$$

and this is satisfactory. The question remains as to whether this 150 kV image will be acceptable to the person who interprets the film.

MOTTLE

Quantum mottle has already been discussed in some detail previously, but there are other factors which contribute to the noise in the image which is visualized as mottle. For example, the higher the kV used, the greater the mottle due

to the longer electron paths in the emulsion. This gives the impression of increased graininess where graininess is defined as the subjective impression of non-uniformity in the image of a uniformly exposed film. Physical grain size in the film has little to do with the subjective appreciation of image noise unless optical magnification is employed. Mottle due to the structure of the intensifying screen fluorescent layer being imaged is not visually apparent under normal viewing conditions.

It should be noted that image noise tends to become more noticeable the closer the film is viewed and the higher the resolution of the film–screen combination when resolution has been achieved without reduction in relative speed. A pair of intensifying screens used in a cassette giving better film–screen contact will exhibit greater image noise for a similar exposure. This is simply due to improved resolution.

Image noise interferes with the visualization of image detail and its effect is rather dependent on the type of image. For example, unsharpness is preferable to noise when viewing a low contrast image detail whereas in high contrast image details a high degree of noise can be tolerated. The film processing used influences graininess. Certainly images processed in 90-second automatic processors exhibit more image noise than manually processed film. Image noise can be quantified and the results displayed in the form of a power spectrum but this has little relevance to the practising radiographer. However, it is useful to realize that reducing average gradient or speed for a film will reduce mottle visibility.

MAGNIFICATION

Magnification is defined as the ratio of image size to object size, where the image produced is the same size as or larger than the object.

$$\text{Magnification } (M) = \frac{\text{Image size } (I)}{\text{Object size } (O)} \quad \left(\text{where } \frac{I}{O} \geqslant 1\right)$$

(Image size and object size are linear dimensions.)
Where the image produced is smaller in size than the object then minification rather than magnification has occurred. Minification is defined as

$$\text{Minification} = \frac{I}{O}$$

(where I and O have the same meaning as before with the proviso that, $\frac{I}{O} < 1$)

In Figure 9.36 the line AB drawn through the object represents an object plane and it is the magnification of this plane (not the object as a whole) that is normally considered. Triangles FXY and FAB are similar, where F is the tube focus,

$$\frac{FFD}{XY} = \frac{FOD}{AB}$$

i.e.

$$\frac{FFD}{I} = \frac{FOD}{O}$$

or

$$\frac{I}{O} = \frac{FFD}{FOD}$$

Hence magnification is defined as

$$M = \frac{FFD}{FOD}$$

In Figure 9.36 the plane AB was magnified and this is again shown in Figure 9.37. Here a plane CD has been drawn which is closer to the film than AB.

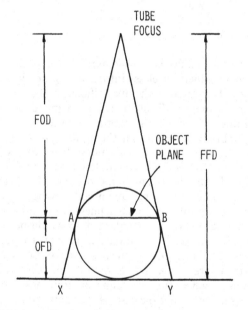

Figure 9.36 Magnification of object plane

Given that

$$M = \frac{FFD}{FOD}$$

and that FFD is a constant, then $M \propto \dfrac{1}{FOD}$

From this it can be seen that if FOD increases M gets smaller, and that planes nearer the film are magnified less than planes further away.

Now if a plane is magnified then any information con-

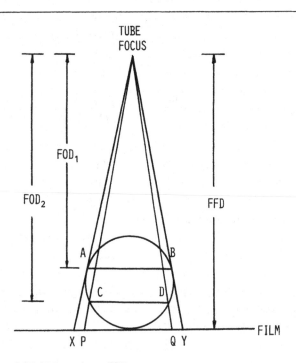

Figure 9.37 *M* depends on FFD

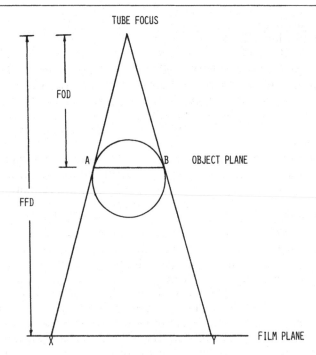

Figure 9.38 Macroradiography

tained in that plane is also magnified. Unsharpness is information (albeit useless information) so it also is magnified. The greater the magnification the worse the image unsharpness, all other things being constant. In radiographic magnification techniques (i.e. macroradiography), to limit unsharpness in the resulting image an effort must be made to reduce unsharpness from two sources, namely, geometric and movement, to a much greater extent than would be required in plain radiography. Photographic unsharpness, of course, is not magnified. On the other hand, if a plain radiograph (with unsharpness contributions from the two sources) is optically enlarged, as would be the case when the film was viewed through a lens, or projected onto a screen, then the image unsharpness is made worse by a factor equal to the degree of magnification. In such a case, mottle is equally magnified so the appearance of graininess would be made worse. This is not the case when macroradiography is used.

In macroradiography the film is placed at a considerable distance from the object as shown in Figure 9.38. Obviously the film size must now be larger than it was before. Let us consider the same plane (AB) as before. Here the FOD is the same but the FFD is increased.

Remember $M = \text{FFD}/\text{FOD}$, or, since FOD is held constant,

$$M \propto \text{FFD}.$$

So as FFD is increased, the degree of magnification increases. In practice, for a magnification of 1, FFD = FOD

and, as far as plane AB is concerned, this is clearly impossible to achieve. For a magnification of 2, then FFD = 2FOD, Since FFD = OFD + FOD, then, for a magnification of 2, OFD = FOD. In other words the distance from the focus to the object plane must be the same as the distance from the object plane to the film.

In practice, the FOD is sometimes measured from the table top to the focus, and for a magnification of 2, the film is placed at an equal distance from the tabletop on the opposite side to the tube. In this arrangement all the object planes lie above the tabletop (i.e. closer to the tube than the film) so will all be magnified more than twice (Figure 9.39). If it is assumed that photographic and movement unsharpness are negligible in comparison with geometric unsharpness, then a choice of focus size which limits unsharpness to an acceptable level for a magnification of 2 will not in this case produce the desired effect since all the object planes will be magnified more than twice. For small patient parts this can be ignored but the larger the patient part the more significant the effect becomes, and, if it is wished to demonstrate small density differences in the image, these may well be masked by the increased unsharpness produced. If, for a particular magnification factor, a focus size is calculated and subsequently chosen to limit image unsharpness to the maximum tolerable level, then to achieve this the FOD must be measured from the focus to the part of the object being investigated. If the part is near the body surface then that surface should be placed nearest the film. If the information required is generally dispersed (i.e. contained on several

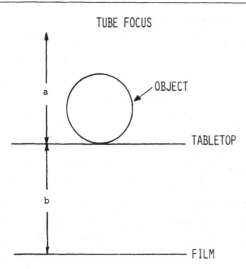

TUBE FOCUS

OBJECT

TABLETOP

FILM

Figure 9.39 When a = b, all planes in the object are magnified more than twice

different planes) the FOD is measured from focus to body surface nearest the focus. The greatest degree of magnification any body plane undergoes is then twice and one can be sure of the required image quality in terms of geometric unsharpness.

DISTORTION

So far magnification of a plane which lies parallel to the film has been considered. What happens when the plane is not parallel to the film? This is illustrated in Figure 9.40. The object and hence object plane have been rotated and plane AB is no longer parallel to the film.

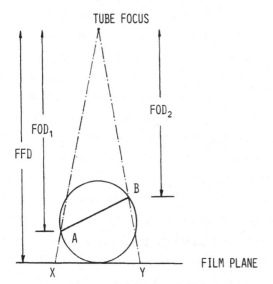

TUBE FOCUS

FOD_2

FOD_1

FFD

B

A

FILM PLANE

X Y

Figure 9.40 Magnification of a plane not parallel to the film

Consider points A and B on the object plane AB. For A

$$M_1 = \frac{FFD}{FOD_1}$$

and for B

$$M_2 = \frac{FFD}{FOD_2}$$

It is apparent that $FOD_1 > FOD_2$ so $M_2 > M_1$, and one part of the plane is magnified more than the other. This is rather like producing an image of a face where the chin is magnified much more than the forehead. The effect where one part of the object is magnified to a greater extent than another produces an image in which the different parts will not have the correct relationship to one another in terms of shape and size, and is known as distortion (e.g. elongation or foreshortening). The degree of distortion of one part relative to another is defined as the ratio of the magnification factor for one part to the magnification factor of the other, i.e.

$$\text{degree of distortion} = \frac{M_2}{M_1} = \left[\frac{FFD}{FOD_2} \bigg/ \frac{FFD}{FOD_1}\right]$$

$$= \frac{FFD}{FOD_2} \times \frac{FOD_1}{FFD} = \frac{FOD_1}{FOD_2}$$

To minimize distortion this ratio must be as close to one as possible. In other words, plane AB must be parallel to the image plane.

Arrangements of object plane, film and focus position other than those shown in Figure 9.40 can result in the production of a distorted image, and besides the various image parts not bearing the correct relationship to one another, the degree of unsharpness produced for each point on the plane AB will also vary.

To summarize, distortion is an alteration in the relative size due to uneven geometric enlargement, i.e. the radiographic image is a deformed representation of the object. It occurs because

 (i) all the parts of the object are not on the same plane,
 (ii) the object plane is tilted relative to the film plane, or
 (iii) the film plane is tilted relative to the object plane.

To avoid distortion, the object plane and film plane should be parallel. This is the only requirement. For example it might be supposed that in Figure 9.41 point A is magnified to a lesser extent than B but in fact they are magnified equally. In this situation distortion does not occur. As far as the central ray is concerned, FQ = FFD, FP = FOD, and by similar triangles

$$\frac{FA}{AX} = \frac{FP}{PQ} = \frac{FB}{BY}$$

(FA/AX is the magnification at A, and (FP/BY) and (FB/BY) are the magnifications at P and B respectively. They all have the same value, so there is no distortion (e.g. M_1 at A is the same as M_2 at B, so $(M_2/M_1) = 1$, giving no distortion).

The mathematical argument for this is straightforward, and will not be given here.

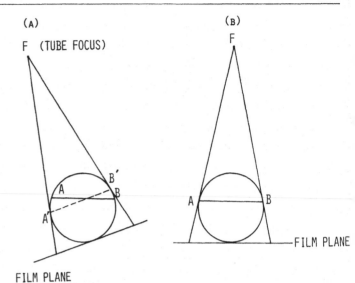

Figure 9.42 Film parallel (b) and not parallel (a) to the plane AB

position capable of producing an image of the object), the image recorded will show the true shape (not size, because magnification has occurred) of the object plane as long as the film is parallel to the object plane.

This basic fact allows tomography to be a reality. Figure 9.43 shows the plane AB recorded by the film in

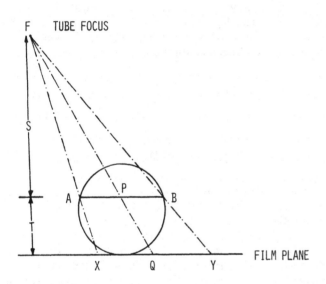

Figure 9.41 Distortion does not occur in this case

One might argue that if AB represents a circle within the object (the plane of the circle lying parallel to the film) then the image on the film using the conditions of Figure 9.41 would be an ellipse, because if the eye is placed at F the plane has an elliptical shape. However, it is not what the eye would see that matters, it is what the film 'sees'. If the film were placed at right angles to the line of sight from F (Figure 9.42(a)) the film would see what the eye sees but the film is placed parallel to the plane. For the eye now to see what the film sees the line of sight must be placed at 90° to the film (Figure 9.42(b)). If this is done a circle not an ellipse is seen. Referring to Figure 9.41 again, the eye placed at F sees an ellipse but the film, as long as it is parallel to plane AB, will 'see' a circle, the true shape of the plane AB.

No matter where the focus is (i.e. no matter what angle the central ray makes with the film as long as the beam is in a

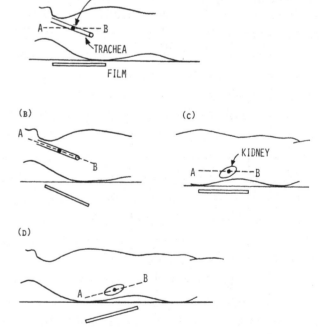

Figure 9.43 Film tilting in tomography

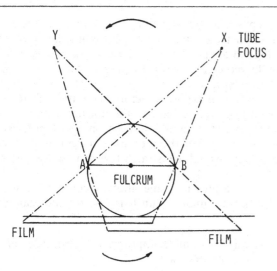

Figure 9.44 Film parallel to object plane in tomography

tomography. The fulcrum level is set at the level of the plane and at its middle. Of course, film tilting as shown in Figure 9.43 is not possible with many types of tomographic equipment, so that patient position would have to be altered to achieve parallelism. In Figure 9.44 the film remains parallel to the object plane throughout the tomographic excursion. Even though the focus–object plane relationship constantly changes from X to Y the image produced by the tube at X is the same shape as the image produced at Y. All that is needed is to ensure that the ratio, image size: object size, produced at X will be the same as at Y, so that each part of the object plane will undergo a constant degree of magnification throughout the tomographic excursion. If this does not happen it is equivalent to blurring of the object plane (Figure 9.35(a)). For example, if AB is a circular plane, then throughout its travel the tomographic system will be producing and superimposing circles of different sizes to form the image which would have considerable unsharpness.

Finally, consider multisection tomography. This is shown in Figure 9.45 with five films spaced equally in the multisection cassette. The tube focus is now moved so that it is directly above the middle of the film as in Figure 9.46. The distance from F to plane A′ is FOD_1. Hence the magnification factor for plane A′ is

$$M_1 = \frac{FOD_1 + OFD_1}{FOD_1}$$

If focus to plane B′ distance is FOD_2 and plane B to film B distance is OFD_2 (since plane B′ is recorded on film B) then M_2 for plane B is

$$M_2 = \frac{FOD_2 + OFD_2}{FOD_2}$$

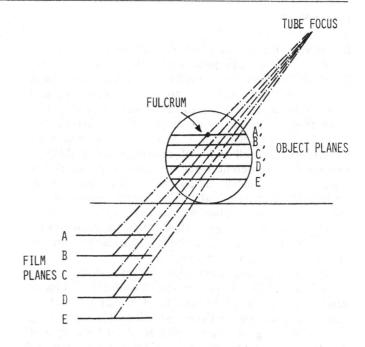

Figure 9.45 Multisection tomography

It can be shown that $M_2 = M_1$, so it can be said that the magnification factors for films A and B are the same. This argument can be extended to include films C, D and E. So all the image layers undergo the same degree of magnification in the multisection system.

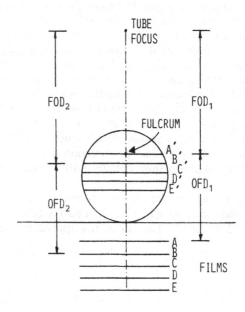

Figure 9.46 Multisection tomography with beam vertical

DISCUSSION

It requires considerable effort to minimize degradation of the image due to unsharpness so that the image is representative of the object. Large objects can tolerate more image unsharpness than small ones, so it is not surprising that considerable attention is paid to imaging of small details when they are diagnostically important. Standardization of radiographic technique is unsuitable for minimizing unsharpness for all types of patient, because different patients have different tissue thicknesses giving rise to different object-to-film distances. Standardization on an acceptable (and reasonably achievable) minimum unsharpness is perhaps more rational than standardization on technique. It should also be apparent that standardization on unsharpness also represents standardization on magnification, for a given focus size.

Unfortunately standardization on unsharpness is immensely more difficult than standardization of technique. In practice the unsharpness considered is that of total unsharpness consisting of the contributions U_g, U_p and U_m. For U_p, an image of a point would be blurred equally in all directions, i.e. an object point would undergo symmetrical image blurring. For practical purposes U_p is independent of direction. This is not the case with U_g or U_m unless, for U_g, the focus is a point source (or at least circular with a gaussian intensity distribution) and, for U_m, the velocity is identical for all directions away from or towards the given point. This latter requirement is clearly impossible for all object points simultaneously and to determine U_m the velocity must be determined in the direction in which the measurement of unsharpness is being made. For example, when considering unsharpness related to focus size, the penumbra is determined in the direction parallel to the focus dimension being used. U_m must also be determined for the same direction otherwise when combining U_g, U_p and U_m the resulting U_t would be meaningless. Again in relation to U_g it should be noted that if the focus is rectangular, where $f_l \neq f_b$, then unsharpness in the direction f_l will be different to that in the direction f_b and it must be made clear which direction is being considered. It is apparent that, in most cases, for a given object, U_t varies depending on direction, and hence some parts of the image may show visually more unsharpness than others.

Obviously the problem is very complex and it is little wonder that an approach other than purely geometric has been found necessary. This alternative approach is through the concept of the transfer function. Again, like the power spectrum, the techniques involved have little to concern the practising radiographer but for those whose interest extends beyond the geometric approach Appendix 5 deals superficially with this topic.

Optimization of exposure factors to minimize U_t requires computer time but, perhaps in the not-too-distant future, computer-generated tables may become available which provide information on the optimum settings in a given set of conditions. It would be straightforward to use these in practice.

Even so, at present some attempt could be made by radiographers to minimize unsharpness by, for example,

(i) choosing the most appropriate orientation of the anode–cathode axis

(ii) selecting the appropriate focus size

(iii) using an FFD appropriate to the thickness of the object and which does not necessitate an increase in exposure time such that U_m predominates

(iv) employing efficient patient immobilization

(v) choosing the minimum exposure time

(vi) using an automatic exposure system on falling load to minimize overall exposure as a method of obtaining the shortest possible exposure time for the selected parameters

(vii) using high resolution intensifying screens with a high quantum detection efficiency (e.g. Kodak Lanex Fine) provided this does not necessitate such an increase in exposure that again U_m predominates

(viii) selecting, from those available, the focus with the most uniform intensity distribution at the focus size required

(ix) employing a high kV technique as a method of minimizing exposure time, if this is acceptable.

The list can be made longer but it is unfortunate that often these methods are neglected because insufficient assessment testing has been carried out to determine the characteristics of the complete imaging system. Neglect is then due to lack of information.

10

The Radiographic Image (II)

INTRODUCTION

Unsharpness in a radiographic image is important when considering image quality but it should not be considered in isolation. Unsharpness can be measured ignoring image contrast but when the image is viewed it is image contrast which affects not only the visual appreciation of unsharpness but also the ease with which information is visually retrieved even in the absence of any unsharpness. No discussion of image quality would be complete without consideration of image contrast and the factors influencing it. The subject of image contrast has been mentioned several times previously but it is now time for a more detailed discussion. As an area of study, image contrast should not be divorced from other image quality factors such as unsharpness, resolution and noise, and cross-reference should continually be made to achieve an overall impression of the immensely complex subject of image quality.

CONTRAST

It should be remembered that to distinguish information in a radiographic image there must be a certain minimum density difference (ΔD_{min}). Anything less than this and the information represented by the density difference will be lost. Visualization of image information is made less difficult if the rate of change of density across the boundary between two given densities is increased. Increasing ΔD and reducing unsharpness are two ways of doing this. Of course, information in some parts of the image may be lost if ΔD is made larger in some other parts. This can happen because when ΔD is increased D_2 becomes larger and D_1 smaller. Any ΔD formed of densities below D_1 can, if the densities are small enough, be pushed down into the toe region of the characteristic curve. Here the gradient is much reduced and the density difference is then reduced giving $\Delta D < \Delta D_{min}$ resulting in information loss. This is illustrated in Figure 10.1 and it should be apparent that a high radiographic image contrast does not necessarily provide the best image quality in terms of overall information content. The value for ΔD_{min} depends on the average density level for D_1 and D_2 and is not constant over the useful density interval for typical viewing illuminator intensity, which further complicates any study of contrast.

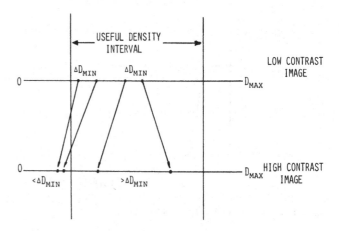

Figure 10.1 Loss of detail when increasing contrast

What constitutes optimum contrast must depend on many factors and because a diagnosis is made by an individual using eyes and brain any recommendations on optimum image contrast relating to this individual will not necessarily apply to any other. Recommendations on what is considered optimum image quality is a matter of personal preference expressed by the individual making the diagnosis. Age, visual fatigue, emotional state and other similar factors influence opinion of image quality. Much work has been done and is still being done on investigating and quantifying these variables. In the present context, how image contrast is influenced by factors of a less indefinite nature will be discussed. These factors may be conveniently grouped as:

 (i) the subject being radiographed,
 (ii) the imaging system, and
 (iii) the viewing conditions.

THE SUBJECT

Here the subject refers to that part of the patient being radiographed, and it is usual to define a quantity known as subject contrast and consider its relationship to, and effect on, radiographic image contrast. Before doing so, however, absorption 'unsharpness' should be mentioned. In Figure 10.2 the elliptical structure represents a gall bladder con-

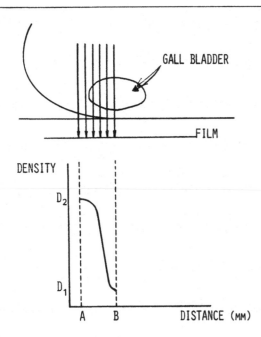

Figure 10.2 Example of absorption unsharpness

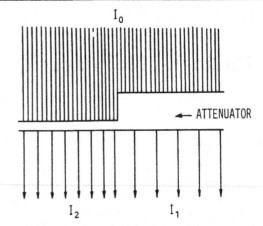

Figure 10.3 Subject contrast defined as I_2/I_1

taining a radio-opaque chemical called a contrast agent. The graph beneath it is a densitometer tracing across the film between the points A and B. The change from D_2 to D_1 is not instantaneous but takes place gradually over the distance AB. It is assumed that $U_g = U_p = U_m = 0$ so unsharpness in the strictest sense does not exist, yet in Figure 10.2 the graph is of an identical shape to that used to determine unsharpness (see Chapter 9). In this case, without prior knowledge, it would be assumed that unsharpness existed. In fact this effect is due to the variation in X-ray beam attenuation across the boundary region of the structure. Differences in X-ray beam attenuation produce the different image densities forming the contrasts so this effect is a contrast effect rather than an unsharpness effect. Nevertheless it is often called absorption unsharpness and the effect depends on the shape and structure of the part imaged.

Subject Contrast

Subject contrast may be defined as the ratio of the intensity of radiation transmitted by a particular body part to the intensity transmitted by an adjacent more absorbing part, i.e.

$$\text{subject contrast} = \frac{I_2}{I_1}$$

where I_1 and I_2 are the transmitted radiation intensities. I_2 is always taken as greater than I_1. Figure 10.3 shows the formation of the two intensities I_1 and I_2. It is unfortunate that this is but one of the many ways in which this quantity

can be defined. The above definition, while simple, is not very useful and other definitions will be given.

The total energy of the X-ray beam is reduced as it passes through the patient and the intensity of the transmitted radiation will be less than that of the incident radiation. The density recorded on the film depends on the intensity of the X-radiation transmitted by the patient. There are several factors upon which the transmitted X-radiation intensity depends. These are:

(i) thickness of the patient part
(ii) atomic number, tissue density, kVp and beam filtration used
(iii) whether a contrast agent is used
(iv) intensity and distribution of scattered radiation.

Subject contrast is independent of the film processing, mA and FFD.

Before discussing each of the above consider Figure 10.4

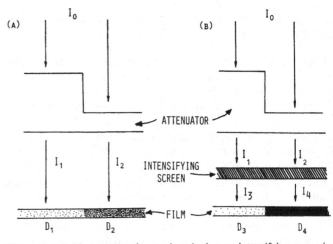

Figure 10.4 Subject contrast is not altered when an intensifying screen is used. (For clarity the intensifying screen is shown separated from the film. This is not so in practice)

where the radiographic contrast and the densities recorded in B are different from those in A. The subject contrast in each case is the ratio of intensities transmitted by the subject, i.e., I_2/I_1. This ratio is independent of the use of intensifying screens. It is only when considering the densities and density differences recorded on the film that we must take into account the effect of intensifying screens when they are used. It is to be noted that the intensifying screen in Figure 10.4 converts a proportion of the X-ray energy to light energy. I_3 and I_4 are formed by a combination of light and X-rays. I_4/I_3 is normally much greater than I_2/I_1 by a factor called the contrast amplification factor of the intensifying screen.

We will now return to the above list and consider the factors affecting subject contrast.

(i) The greater the thickness of the patient part, the greater the loss of energy by the X-ray beam as it passes through and the lower the intensity of transmitted radiation. If two adjacent body parts are of different thickness but similar structure (e.g. metatarsal and tarsal regions) the transmitted radiation intensities will be different giving rise to a subject contrast. The thicker one part is, compared to the adjacent part, the greater is the difference in transmitted radiation intensities, and the greater will be the subject contrast. The radiographic contrast (ΔD) recorded by the film depends on the radiation intensity difference at the film. The larger the radiation intensity difference at the film the larger will be the radiographic contrast.

In Figure 10.5, A and C are similar tissues and thicknesses. B is a similar tissue to D but is much thicker. I_1 is thus greater than I_2, and hence I_3/I_2 is greater than I_3/I_1. The subject contrast is less in (2) than in (1). If there were no difference in the transmitted radiation intensities, the radiographic contrast would be zero, and the subject contrast would be equal to 1 according to the definition given. Here, intuitively, it would make better sense if the subject contrast was equal to zero

rather than 1. This can be achieved if subject contrast is defined as

$$\text{subject contrast} = \log \frac{I_2}{I_1}$$

Now if $I_2 = I_2$ then I_2/I_1 and $\log 1_1 = 0$. Hence subject contrast is equal to zero, which is what would be expected.

(ii) It is convenient to discuss atomic number, tissue density and X-ray beam quality (here considered in terms of kVp and beam filtration) and their relation to subject contrast in terms of the linear attenuation coefficient. For thin layers of material the linear attenuation coefficient, μ, is

$$\mu = \frac{\text{fractional attenuation in a thin layer}}{\text{thickness of the layer (cm)}}$$

For a given material, providing the layers are thin, then equal thicknesses attenuate the X-ray beam by the same amount each time.

Increasing atomic number or tissue density increases the linear attenuation coefficient, while increasing photon energy (by increasing kV) or attenuating the longer wavelength X-ray photons by using beam filtration will reduce the linear attenuation coefficient. Atomic number differences within the subject usually have a much greater effect on subject contrast than do thickness differences. Tissue density is defined as mass per unit volume. By compressing a tissue it is possible to put a greater mass of the tissue into a given volume, i.e. its density will increase. A compressed tissue will absorb more X-radiation energy than a tissue without compression applied, provided that under the applied conditions they have the same thickness and volume. Both tissues are of the same type, and all other conditions are the same in both cases. The above implies that if tissue density increases, the transmitted X-radiation intensity decreases (Figure 10.6).

Figure 10.5 Thickness of tissue affects subject contrast

Figure 10.6 Compressed and uncompressed tissue. Tissue thickness and type are the same in both cases, and $I_2 > I_1$

In practice when a 'compression' band is applied to a patient's abdomen the tissues are displaced rather than compressed. This results in a useful reduction in patient thickness with very little increase in density of the tissue traversed by the X-ray beam (Figure 10.7). An antero-posterior erect abdomen requires a larger exposure than a supine abdomen. This is because in the erect position, not only is there a slight increase in thickness of the abdomen, but the abdominal contents fall to a lower level and in so doing become compressed.

(A) NO 'COMPRESSION' (B) 'COMPRESSION' APPLIED

Figure 10.7 Compression band applied to a patient. In (b) there is reduced thickness with lateral displacement of tissue

Extending the argument relating to linear attenuation coefficient the attenuating effect of any thickness of material is found from the exponential formula

$$I(t) = I(o) \exp(-\mu x)$$

where $I(t)$ is the radiation intensity transmitted by a material of thickness x cm with an attenuation coefficient, μ. $I(o)$ is the incident intensity of a beam of monoenergetic X-rays.

Now, for two adjacent radiation intensities, I_1 and I_2 $(I_2 > I_1)$, transmitted by a heterogeneous structure of uniform thickness we have

$$I_1 = I(o)\exp(-\mu_2 x) \text{ and } I_2 = I(o)\exp(-\mu_1 x)$$

$(\mu_2 > \mu_1)$, giving a subject contrast (in terms of the first definition given on p. 150) of

$$\frac{I_2}{I_1} = \frac{I(o)\exp(-\mu_1 x)}{I(o)\exp(-\mu_2 x)} = \exp(x(\mu_2 - \mu_1))$$

By redefining subject contrast as

$$\text{subject contrast} = \ln\left[\frac{I_2}{I_1}\right]$$

where ln is the natural logarithm, then since the function (ln) is the inverse of the function (exp),

$$\ln\left[\frac{I_2}{I_1}\right] = \ln\left[\exp(x(\mu_2 - \mu_1))\right]$$
$$= x(\mu_2 - \mu_1)$$

This is a remarkably simple statement for subject contrast and it is little wonder that this definition, namely,

$$\text{subject contrast} = \ln\left[\frac{I_2}{I_1}\right]$$

is perhaps the most useful. From a knowledge of linear attenuation coefficients for different structures it is possible to predict the subject contrast. For example, if μ_2 is increased by filling the tissue with radio-opaque contrast agent then the subject contrast is increased.

(iii) Radiographic contrast agents may be described as 'positive' or 'negative'. Positive contrast agents contain elements of relatively high atomic number such as iodine or barium. When a positive contrast agent is introduced into the body, the difference in linear attenuation coefficients between the organ in which it lies and the surrounding tissue is increased and an increase in subject contrast is achieved.

Negative contrast agents are gases. A gas, when introduced into the body, increases subject contrast, again by alteration of the linear attenuation coefficient.

The simple statement, $x(\mu_2 - \mu_1)$ also predicts that increasing the thickness will increase subject contrast. This is true but only for the primary X-ray photons. In practice scattered photons are present in abundance and $x(\mu_2 - \mu_1)$ does not take this into account. It is well known that, practically, increasing thickness reduces subject contrast but only because of the increasing amount of scatter.

(iv) In Figure 10.8, the short arrows represent the scattered radiation intensity leaving the patient, while the longer arrows represent transmitted primary radiation intensity. It can be seen that for a given film density, as kV increases, so does the relative proportion of scattered radiation leaving the patient. When kV is increased, the amount of scattered radiation produced within the patient decreases. The scattered radiation produced, however, is of higher energy (compared to the scattered radiation produced at low kV) and is scattered in a more forward direction, i.e. towards the film, and can more easily reach the film due to its higher energy. The overall effect is that the intensity of scattered radiation passing from the patient towards the film is increased.

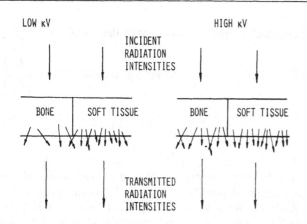

Figure 10.8 Increasing kV increases scattered radiation intensity reaching the image receptor

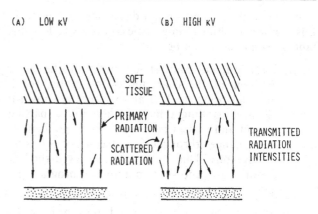

Figure 10.9 Primary and scattered radiation at high and low kV. The same film density is produced in each case

Assume that once again we are interested in the soft tissue, and when changing from a low kV to a higher kV we wish to maintain the same image density for the soft tissue.

The transmitted radiation intensity is a combination of primary and scattered radiation and, as kV increases, so does the proportion of transmitted scattered radiation relative to transmitted primary.

In Figure 10.9(B) there is a large proportion of scattered radiation relative to primary. In (A) there is a small proportion relative to primary. Should we wish to maintain a given density on the film when the transmitted scattered radiation intensity increases, then the transmitted primary radiation intensity must be made less. The only way to do this is to reduce the incident primary radiation intensity until the combination of transmitted primary and scattered radiation intensities produces the correct film density.

This means that as the kV increases, the contribution made by scattered radiation in forming an image density increases while that of primary radiation decreases. Since scattered radiation produces non-useful image densities, then as kV increases, the information content of the image will decrease unless steps are taken to reduce its effect. Primary radiation transmitted by the patient gives rise to the diagnostically useful information in the image so what must be done in practice is to maintain the transmitted primary radiation intensity as kV increases and eliminate as far as possible the transmitted scattered radiation. This is normally done by using a secondary radiation grid or an air gap, and by reducing patient thickness (and hence the irradiated volume) and reducing beam dimensions if possible so further reducing irradiated volume. Scattered radiation becomes increasingly important as a contributing factor to the

reduction of subject contrast as kV increases. An improvement can only be obtained if the transmitted scattered radiation is preferentially reduced in intensity.

If it is assumed that scattered radiation reaching the image receptor is uniform over its whole surface then subject contrast is,

$$\text{subject contrast} = \ln \left[\frac{I_2 + I_s}{I_1 + I_s} \right]$$

where I_s is the mean transmitted intensity of scattered radiation. Let I_p be the mean primary beam intensity and $I_s / I_p = k$. At low contrasts $I_p = I_1 = I_2$ and,

$$\text{subject contrast} = xK (\mu_2 - \mu_1)$$

$$\text{where } K = \left[\frac{1}{1 + k} \right].$$

From p. 22, $D = \overline{G} \log (E_2 / E_1)$ and since the light exposures to the film are proportional to the X-ray exposures to the intensifying screens (in a film–screen combination) then

$$\Delta D = 0.43 \, \overline{G} \ln \left[\frac{I_2 + I_s}{I_1 + I_s} \right]$$

$$= 0.43 \, x \, \overline{G} K (\mu_2 - \mu_1)$$

This allows prediction of the radiographic image contrast if the other factors are known.

Although this subsection is a discussion on subject contrast it is the resulting radiographic contrast which is important. In summary it can be said:

(i) Radiographic contrast depends on the average gradient of the characteristic curve for the film material being used. If an exposure is known that optimizes radiographic contrast for a particular patient and patient part then average gradient must not change throughout a sequence of similar radiographs. This is normally achieved through a continuous processor monitoring programme to ensure consistency.

(ii) Radiographic contrast depends on subject contrast. If subject contrast changes then radiographic contrast changes also. For a given patient part, changing kV will alter subject contrast so radiographic contrast can be controlled by varying kV. There are many factors which affect subject contrast so kV variation is not the only way of controlling it, but it is the most usual method employed.

(iii) Radiographic contrast depends on the factors which affect the radiation intensity pattern of the beam between patient and film. These are given in the list above. The cassette front and tabletop offer little attenuation and so negligibly affect contrast, but added beam filtration such as the aluminium plate base for the front AOT intensifying screen together with the aluminium pressure plate can significantly reduce contrast in the image. This is because it is thick enough to selectively attenuate most longer wavelength X-ray photons including scatter, allowing only high energy photons to be involved in image formation. This seems to contradict the fact that thin tin filters are used over the cassette to improve radiographic contrast in the absence of a grid or air gap. Here the filter is much thinner than the AOT screen base plate and serves mainly to attenuate scatter. The result is a broader spectrum of photon energies involved in image formation but very much less scatter. The effect is an increase in image contrast. For some time now the AOT changer has been available with a carbon fibre pressure plate offering a much lower attenuation than that of aluminium, but there are still many in use without this refinement.

While many of the factors mentioned above can reduce radiographic contrast, the use of intensifying screens and secondary radiation grid can increase radiographic contrast.

Finally before leaving the topic of subject contrast consider the characteristic curve of Figure 10.10 for a typical screen-type X-ray film-intensifying screen combination. Using the equation for radiographic contrast we obtain

$$\text{radiographic contrast} = \text{gradient of the line XY} \log\left[\frac{E_2}{E_1}\right]$$

$$\simeq \text{gradient of the line PQ} \log\left[\frac{E_2}{E_1}\right]$$

$$= \bar{G} \log\left[\frac{E_2}{E_1}\right]$$

Assume that the two densities D_3 and D_4 both lie outside the 'useful' range of densities. Log (E_4/E_3) is the same as log (E_2/E_1) but now the value of the gradient is less, so the value for radiographic contrast will be much smaller. A similar reasoning applies if the two densities lie below the 'useful' range of densities.

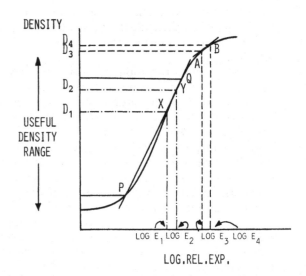

Figure 10.10 Typical film–screen combination characteristic curve

Recording small subject contrasts using densities lying above the useful range, and using a high intensity illuminator to view them, can mean that the radiographic contrast may be so small that the densities cannot be differentiated visually, and the information will be lost. This information might well be visible if recorded as density differences using densities from within the useful density range. This is another reason why exposure factors should be carefully chosen especially when an automatic exposure device is not available.

In general, for a given average gradient, a reduction in subject contrast produces a reduction in radiographic contrast, but we can improve the radiographic contrast, in certain circumstances, by using a secondary radiation grid, for example, or a pair of intensifying screens.

THE IMAGING RECORDING SYSTEM

The type of film used in the imaging process directly affects radiographic contrast. In Figure 10.11, E_1 and E_2 are radiation intensities forming the exposure to the film. Films A and B have been used to record the image. $D_2 - D_1$ is the radiographic contrast produced by film A and $D_4 - D_3$ by film B. $D_2 - D_1 > D_4 - D_3$. This result is expected from the relationship

radiographic contrast \propto film contrast

which has already been discussed (p. 26). In the region of the curve over which average gradient may be measured, film contrast is higher for film A than for film B. Relative film contrast may be assessed in this way by comparing the characteristic curves for different films, these curves being produced under user conditions. Then an indication is obtained of the effect of the film on radiographic contrast. Assuming film B is at present in use in the department and the results are considered satisfactory, would film A offer an improvement in result? Certainly film A has a greater film contrast but is this necessarily an advantage? It would certainly have a smaller film latitude and exposure would be more critical leading to increased exposure mistakes in the absence of automated exposure. In addition film A has a lower relative speed below the cross-over point.

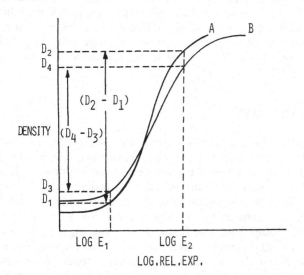

Figure 10.11 Characteristic curves of films A and B

Screen-type films are made specifically for use with intensifying screens but have been used without intensifying screens as direct exposure films. Film contrast of a screen-type film combined with an intensifying screen is dependent on the spectral emission of the screen. Where this film is used as a direct exposure film, X-rays, not light, are being used

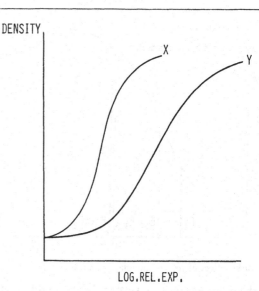

Figure 10.12 Characteristic curves for screen-type film used with intensifying screens (X) and as a direct exposure film (Y)

and the characteristic curve for the film–screen system no longer applies. Figure 10.12 illustrates the characteristic curves for a screen-type film used with intensifying screens (X), and the same film used as a direct exposure film (Y). Note the relative speed and contrast at different density levels. In combination with screens the film characteristic curve has a higher average gradient. This is due to the contrast amplification property of the intensifying screens brought about by the preferential response to the shorter wavelength radiation in the patient-transmitted X-ray beam. Contrast amplification may be an essential requirement in some cases where subject contrast is low and without amplification information may be lost because $\Delta D < \Delta D_{min}$.

FOG

An indication of the fog density present on a film can be determined by finding the density difference between two halves, one having been fully processed, the other only fixed. Fog density can affect radiographic contrast considerably depending on its magnitude. If a film which is slightly but uniformly fogged is used for a radiographic exposure the resulting image will have a lower radiographic contrast than a similar film which is not fogged. The effect of the fogging is to increase image density in low density areas more than in high density areas. Thus any two densities used to form a density difference will produce a smaller density difference in the fogged film compared to the film which is not fogged. In Figure 10.13, assume that the film, the characteristic curve of which is illustrated, receives two exposures at the same kV. One half of the film receives the equivalent of 1.0 mAs (E_1)

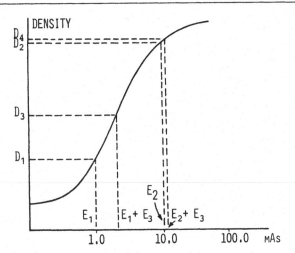

Figure 10.13 Effect of fogging on image contrast

while the other receives 10.0 mAs (E_2). Now add the effect of fog by giving the whole film the equivalent of an additional 1.0 mAs (E_3). The image contrast in the absence of fog is (D_2-D_1) while with fog it is (D_4-D_3), a much smaller value.

There are, of course, many conditions which can promote fog. Some are

(i) developing a film for too long
(ii) developing a film at too high a temperature
(iii) storing film at too high a temperature
(iv) storing opened film packs in excessive humidity conditions
(v) accidental exposure to radiation to which the film is sensitive, while in storage, during transport and handling, in the cassette or during development.

A gross fog density no more than 0.15 should be the practical objective. In (i) and (ii) above the fog density produced is due to the action of the developer. Under appropriately controlled conditions the developer is reasonably selective between exposed and unexposed parts of the film. Unfortunately some unexposed silver halide is developed and the resulting density is called development fog. Increasing developer temperature excessively, for example, can increase the rate at which unexposed silver halide is developed.

SUBJECTIVE CONTRAST AND VIEWING CONDITIONS

Subjective contrast is the difference in brightness between adjacent image parts experienced by the person viewing the film image. As already stated, this impression of a brightness difference is influenced by many factors, not least of which are the viewing conditions. The ability of a person to pick out image details depends on the amount of additional confusing information present. Extraneous information should be eliminated as far as possible. For example, the image contrast is experienced as a brightness difference. This is easy to see if the brightness difference is large. Any additional light entering the eye can alter this brightness difference depending on the intensity. Extraneous light can in some cases be so intense as to render many small image brightness differences invisible.

Subjective contrast is maximized if all extraneous light is removed when viewing the image. This involves viewing in a darkened room where the only light source is that of the X-ray film illuminator, avoiding surface reflections from the film and masking all but the small area of film of interest. Often, films are viewed in a well-lit room, the film is not masked and surface reflections abound. Greater brightness differences are then required to see the same information which can lead to the opinion that the film has insufficient image contrast. The intensity of illumination also affects the visualization of image brightness differences. If the intensity is too low or too high the brightness differences are impossible to detect visually. Again if the illumination used to view the film is non-uniform the appreciation of a brightness difference in the image is affected. Film images should not be viewed on defective viewing boxes. The colour of illumination will influence the appreciation of brightness differences in the image. This is determined both by the film and the illuminator (viewing box). Some older films which have been badly processed may appear to have a yellow tint. Some films have a stronger blue tint in the film base than others. The light spectrum from different illuminators of different types is often quite different. This should indicate that standardization is essential and film viewing conditions form an important part of the concept of image quality control (Chapter 14). The viewing of radiographs is discussed further in Chapter 11.

DISCUSSION

This has been a brief but important chapter. Many of the points mentioned have received superficial treatment but that is only because they have been discussed more fully in other chapters. The information contained in Chapters 9 and 10 leads to the conclusion that required image quality usually means minimum unsharpness, low noise and optimum image contrast. To go to any great lengths to achieve this for all images is unnecessary and often requires a more than acceptable radiation dose. All that is required for many cases is an image of 'average' quality where radiation dose is minimized, but an image sufficient for a diagnosis to be made. Thus it is impossible to give a set of rules to reach a level of image quality (in terms of contrast, definition and noise) suitable for all applications. All that can be said is that if the foregoing information is known and image quality is considered unsatisfactory then it should be possible to correct it to produce an image which appeals to the person making the complaint.

11
Identification, Presentation and Viewing of Radiographs

INTRODUCTION

Much has been said about radiographic image quality and the dependent factors but in practice a great deal of the effort directed towards optimizing image quality (if that is what is required) can be wasted through lack of attention to the identification, presentation, and conditions for viewing of the radiograph. Choice of viewing conditions can dramatically alter the subjective assessment of image quality. Incorrect identification or lack of it is all too easy to achieve in a busy department. This can lead to further, correctly identified radiographs being required with additional radiation exposure to the patient or, if the fault remains unnoticed, can possibly represent a real threat to the patient. Presentation is equally important. All the information required should be seen in the image without the attendant problems of inadequate centring and a radiation beam area which is either too large or too small. It is all too easy to neglect these aspects in a busy, overworked department, which leads to a general decline in imaging standards and results.

IDENTIFICATION INFORMATION

Although it may be possible to make a definitive diagnosis from an unidentified radiograph, the patient is obviously at a disadvantage because there is no information available to relate the film to the patient. It is unwise to adopt a process of elimination to match film with patient especially if no other information is available. For a good identification system it is necessary to consider in detail what patient identification is available and to select from this the information that should appear on the film. To ensure complete identification as much information as possible should appear on the film, while for operational reasons it is necessary to restrict this to the minimum consistent with positive identification.

Even when this information appears on the film there can still be an error in the information. For example, the individual items of information may be correct but be placed on the wrong film. This can be insoluble when two patients of the same age and build each have films taken of the same body area. This type of error must be avoided. Any identification system put into operation should be analysed and

simulation used to determine the points in the system where errors are likely to occur. For example, fewer mistakes are likely to occur if only one person, the radiographer, is responsible for film identification, and checks are introduced at critical points in the process to ensure that the information is correct and that the film to which it relates does in fact match.

Not all radiographic images require the same extent of identification. The identification which must be considered as basic to all radiographic images is

- (i) patient details
- (ii) code number
- (iii) date
- (iv) hospital name
- (v) R or L to identify the right or left side of the patient in the image.

This information should be clearly visible and should not obscure any diagnostically important part of the image. In addition this information should read the correct way round when the film is placed the appropriate way for viewing. As so often happens in practice the name is upside-down at the bottom of the film when the film is placed correctly for viewing. This is a common fault and is due to the film being used upside-down. Again, the R or L is often upside-down, sideways or just not visible because a circular beam area has been used for imaging allowing little or no radiation to image the R or L when placed on one corner of the cassette. Occasionally the patient details, code number, date and hospital name cannot be read because the information is recorded on the film either too faintly or too darkly which produces the same result as no identification at all. Careful choice and control of an identification system is therefore essential.

According to the technique used and type of image produced then additional information should be present. This may be as follows:

- (i) A sequencing number is required for a series of films taken over a period of time when the films all relate to the same patient part. This is in addition to any date which appears on the film. The date could easily be used to sequence the films but it is easier and quicker to use a number for this task

(ii) To indicate the position of the patient when the radiograph was produced, as would be necessary when searching for an air–fluid level for example, information such as 'erect', 'supine', 'prone', 'RAO', 'LAO', 'RPO', 'LPO' or 'decubitus' may be included

(iii) Rather than numbering films in a sequence it is sometimes necessary to indicate the precise time when the film was exposed. This is the usual practice when the sequence of films is taken over a short period of time (minutes rather than weeks or months). However when the period of time is measured in seconds rather than minutes numbers are again used for sequencing. A technique where films require sequencing over a period of minutes is excretion urography. Aortography is a technique where films need sequencing over a period of a few seconds

(iv) In some examinations where a sequence of films is taken a stage may be reached when some important aspect of the technique requires additional identification. Post-micturition in excretion urography, post-evacuation in contrast studies of the large bowel and post-fatty meal in cholecystography are all examples

(v) To indicate the depth of a tomographic layer it is necessary to identify the film with a number and its units (e.g. centimetres)

(vi) Stereoradiographs require careful identification. These films are produced as stereoradiographic pairs, one to be viewed by the right eye and the other by the left. To produce these the X-ray tube is displaced either side of centre, simulating the position of the eyes. These shifts must be identified on the film and so that a sufficient stereoscopic effect can be produced it is important for the viewer to know the FFD at which the radiographs are produced. Hence the additional identification required is which radiograph is to be viewed by which eye, the FFD used and the magnitude of the tube shift. Inadequate identification can lead to viewing faults such as reversal and transposition. These are discussed fully in the section on stereoradiography.

IDENTIFICATION METHODS

It is usual for the patient details, code number, date and hospital name to be registered on the film in a different manner from all the other identification requirements. For obvious reasons it is necessary to record all identification information permanently on the film and this is done by actinic marking. This process uses the effect of white light on

the film emulsion. The information is either written or typed on paper or card which is then transferred to the film (using light) by transmission or reflection, depending on the equipment used. Another method makes use of X-rays rather than light to transfer the identification information to the film. The equipment for this method is considerably more expensive to purchase and the running costs are higher than those involved in the method using light. Any additional identification needed is transferred to the film at the time the X-ray exposure is made using radio-opaque legends, letters and numbers (as the case may be) placed on the cassette.

Actinic Markers

The most common source of electromagnetic radiation used for actinic marking is white light produced by a small light bulb. Actinism refers to the effect electromagnetic radiation has on a photographic emulsion and actinic marking is simply the use of electromagnetic radiation to expose the film. If the identification information is typed (or written with black ink) on the paper provided then light passing through the paper will expose the film. The type or black writing will be opaque to light and provided the paper and film are in intimate contact the area of film under the typing or writing will not be exposed. The result is type or writing of low image density read against a high density background.

Figure 11.1 illustrates the technique and Figure 11.2

Figure 11.1 Technique of actinic marking

Figure 11.2 Result of actinic marking

shows the result. To achieve this result it is necessary to leave a portion of the film unexposed when the actual radiographic exposure is made. This is achieved using the lead blocker mentioned above in Chapter 6. The actinic marking device which uses light consists of a light-tight box housing the light source and control circuitry. The upper surface of the box has a small window through which the light generated by the bulb is allowed to pass. This window is the same size as the lead blocker in the cassette and the area of paper on which the identification information is written. Film stops are used to locate the film correctly over the window. The position of the lead blocker in the cassette occupies the same film position as the window in the actinic marker when the film is located against the stops.

care must be taken here but once a routine is adopted the procedure is quick and simple and mistakes are rare. The identification information should appear on the film in such a way that it can be read correctly when the film is the correct way around for viewing. This is achieved simply by reversing the paper slip on which the identification information is written according to whether the film was taken antero-posterior or postero-anterior.

The technique discussed so far must be carried out under safelight conditions. However, the present tendency is to perform this procedure in daylight, with the radiographer

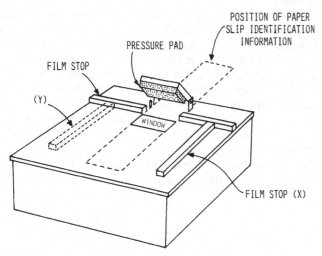

Figure 11.3 A typical actinic marker

Figure 11.3 shows a typical actinic marker. The exposure button is depressed by one arm of the device holding the pressure pad. The paper slip is divided into a number of equal areas similar in magnitude to the window. Each area can be used for a different set of identification information. The area required is located over the window and the film placed over the paper slip and located against the film stops. The pressure pad is depressed onto the film. This action initiates exposure which terminates automatically when the film is correctly exposed. The actinic exposure time is preset according to the speed of film in use. With this system it is possible to make a mistake in the way in which the film is placed over the window. The type of mistake that usually occurs is placing the identification information on the wrong side of the film, i.e. the area of film exposed with the information does not correspond with the unexposed area of film. This happens because the film is withdrawn from the cassette and the operator either cannot remember which part of the film to place over the window or has inadvertently turned the film over before actinic marking. Considerable

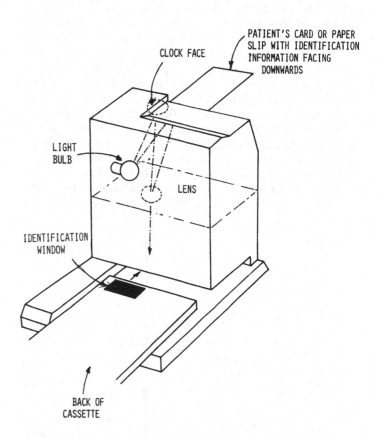

Figure 11.4 Diagram of the identification camera with example of result (note time)

being responsible for the film identification. A good example of the equipment for this is the Kodak X-omatic system using the identification camera. Here each cassette has an identification window covered with a plastic slide. For identification the paper slip is inserted at the top of the camera while the cassette is slipped into the bottom of the camera. The camera mechanism opens the window, operates the actinic light exposing the film while still in the cassette and closes the window again. The cassette is then passed to the darkroom. The actinic marker of Figure 11.3 allows transmission of actinic light through the paper slip to identify the film. The identification camera uses light reflected off the paper slip and focussed by a lens system onto the film. In addition, the identification camera houses a clock and the time can be actinically marked onto the film alongside the other identification information. A diagrammatic representation of this system is shown in Figure 11.4.

Thus the actinic marker is a piece of equipment which allows a latent image of identification information to be formed on an appropriate unexposed part of the film without the remainder of the film becoming fogged. The light source must be controlled and the exposure related to the film speed to result in the correct image density. A simple capacitative circuit is often used and is illustrated in Figure 11.5. With switch B as shown in (i) the capacitor is charged from the mains; (ii) represents the situation where the exposure button B is depressed. The capacitor discharges

through the bulb. The variable resistance determines the voltage drop across the bulb and hence its brightness. This allows the light source to be adjusted for films of different speed.

The actinic markers discussed so far are representative of the many available for identifying full-size films. Another type using an electroluminescent panel, discussed in Chapter 15, is used as part of a 'daylight' system. Actinic marking systems are also used in identifying miniature films such as those used in a 70 mm camera, for example. The system is simple and is illustrated in Figure 11.6. The card with the identification information is inserted into a slot at the top of the camera facing downwards. The remainder is automatic and each frame on the 70 mm film is identified at each exposure.

The film identification marker using X-rays rather than light employs a small dental X-ray tube. The identification information, however, is not printed on paper but is engraved on a small metal plate coated with lead. The X-rays pass through the engraved portion (but nowhere else) to reach the film. The image produced is one of high density written information against a low density background. To operate this system it is necessary to have the X-ray marker, the supply of metal plates and the complex, rather expensive engraving machine.

The X-ray marker is not the only system producing high image density writing against a low image density

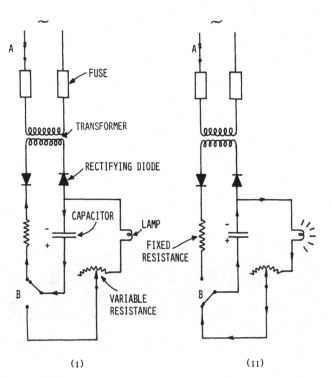

(i) (ii)

Figure 11.5 Circuit of exposure timer

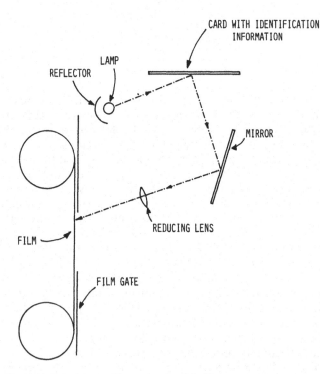

Figure 11.6 Actinic marking system used in 70 mm camera

background. A similar effect is produced when using a carbon-backed paper slip with a light actinic marker. When the information is written on the slip the carbon under the writing is removed. Light can pass through this area but nowhere else. This produces black writing against a light background on the film.

Radio-opaque Legends, Letters and Numbers

These are used to provide additional, essential, identification information on the film. They are placed on the film either right way up or reversed (depending on whether the projection is antero-posterior or postero-anterior) and in a position such that X-radiation will reach them during the radiographic exposure but not in any position which will obscure details of diagnostic importance.

Radio-opaque legends are generally plastic strips with the required words impressed into them, and the impressions filled with radio-opaque material. Alternatively the legend can be in the form of a stencil in a metal (steel) strip.

Radio-opaque letters and numbers can be made in the same way as the legends or be simply pressed out of lead. Perhaps the most common radio-opaque letters in use are the clip-on type. The clip-on marker as it is often called is shown in Figure 11.7. These simply clip on the side of the cassette and either type (i) or (ii) may be used depending on the projection being done.

(i) (ii)

Figure 11.7 Clip-on radio-opaque markers

Other Identification Systems

Perforating devices are available for putting identification marks on radiographs. They are simply punches which put many small holes through the film, the holes forming a letter, number or word as required. Dental films are too small to have identification printed on them so the manufacturers impress a dot into the film so this can be used to identify the particular side of the patient.

VIEWING OF RADIOGRAPHS

Once a radiograph is produced the radiographer responsible will view the film to assess its suitability as a diagnostic aid in terms of image quality. Contrast, definition and average density will be examined among other things and it is these qualities which can be considerably affected by the viewing conditions.

Illumination Intensity

An illuminator is used to view radiographs and it is here that careful choice and standardization is essential. Figure 11.8 shows a typical illuminator. The viewing screen is illuminated right to the edges so that several illuminators can

Figure 11.8 An illuminator. (By courtesy of Wardray Products Ltd.)

be placed side by side to form a single, larger illuminator on which a series of films can be placed and compared simultaneously. Viewing boxes (illuminators) banked in this way must demonstrate a uniform illumination intensity over the whole surface. Single and banked viewing boxes are shown in Figure 11.9.

Variations in illumination intensity will alter the subjective assessment of contrast, definition and average density. Reducing intensity for example will give a subjective reduction in image contrast and an increase in average density. High illumination intensities, however, are used for viewing over-exposed films to achieve a subjective improvement in contrast and reduction in apparent film blackening. A localized high intensity illuminator is shown in Figure 11.10. A similar facility is shown in Figure 11.11 as an integral part of the viewing box.

Figure 11.9 Single and banked viewing boxes. (By courtesy of Wardray Products Ltd.)

Figure 11.11 Localized high intensity illuminator as part of a viewing box. (By courtesy of Wardray Products Ltd.)

Variation in illumination intensity affects the qualities mentioned and it is also apparent that different makes (and ages) of viewing boxes have different illumination intensities. Image quality assessed as good on one viewing box may not be so good when assessed on a different viewing box. This leads naturally to the requirement for standardization on illumination intensity by using similar viewing boxes throughout the department. A viewing box typically has two vertically placed fluorescent tubes behind an opal perspex viewing screen. A continuous, white reflecting surface is placed behind and to the sides of both tubes. Occasionally one of the tubes may dim and the viewing screen will show a reduced illumination intensity over one half. It is surprising how often such a situation is tolerated in practice with continued use of the viewing box without correction of the fault, which is often due to poor electrical contact.

Figure 11.10 Localized high intensity illuminator. (By courtesy of Wardray Products Ltd.)

Colour of Illumination

Some illuminators, particularly the older types, have a considerable yellow component in their light spectrum. This tends to reduce subjective contrast and, since contrast and definition are interrelated, it appears that the definition has decreased (the image appears more blurred).

Films from different manufacturers have different degrees of tint in the film base. The tint when used is blue and serves to suppress the effect of the yellow component thus improving subjective contrast. When different types of film from different manufacturers are employed in a department it may prove impossible to standardize visually on image quality because of variations in subjective contrast. As much care should be exercised in choosing illuminators as choosing film material. There is much to be said for optimizing the combination of film and illuminator then standardizing on this combination throughout the department.

Masking and Glare

When the film being viewed is smaller than the area of the viewing screen of the illuminator then the eye will be affected by the light reaching it from around the film. This subjectively increases average film blackening and reduces image contrast. The effect of this glare can be eliminated by masking off the extraneous light. A further improvement can be obtained by increasing the masked area so that only a small portion of the film is viewed. A large viewing area, as obtained with banked illuminators, can produce considerable glare when viewing a single film with all illuminators functioning. In this case only the illuminator being used should be operating. However, what seems to happen in practice is that several radiographers are viewing films as they come out of the processor and it is inconvenient to keep switching on and off frequently. The whole bank is thus left operating and in general considerable glare is apparent when viewing films and assessing their suitability. This is far from ideal.

Glare can also be apparent as a result of extraneous light arising from room lighting, sunlight through windows, surface reflection from the films themselves and light from nearby illuminators. Strictly these sources of extraneous light should be eliminated when film viewing but it is often impracticable to do so. Radiologists, however, when film reporting, are better able to create ideal viewing conditions and so see a different image quality from that seen by the radiographer.

Variable Colour Illumination

This is necessary when viewing a particular type of film known as Medichrome and produced by Agfa Gevaert. The trasts is reproducible. Thus from one image a series of images with varying image contrast can be obtained.

Viewing Small Format Film

Here it is 70 mm, 100 mm and 105 mm films that must be considered together with 16 mm and 35 mm films. The resolution of these images is high but once magnification is used to view them the resolution decreases in proportion. Radiographers normally use conventional illuminators to view 70 mm, 100 mm or 105 mm film to assess their image quality, while for reporting a radiologist may use special viewing equipment which projects an enlarged image onto a screen. Image degradation occurs because of the magnification and the imaging properties of the screen onto which the image is projected. The degree of magnification normally employed is small to limit the reduction in resolution.

16 mm and 35 mm films are normally cine films and require a cine projector for viewing. Here it is dynamics rather than fine detail that is studied so the reduction in resolution occurring as a result of the magnification for projection is less important than before.

RODS AND CONES

The retina of the eye contains both rods and cones. In the fovea there are only cones while both rods and cones are present elsewhere. On exposure to bright light, pigment granules migrate into the regions between the cones. This prevents spread of light from one cone to another thus improving visual acuity. This idea has been used in the most modern of intensifying screens where carbon granules are included in the phosphor binding layer to reduce light scattering in the fluorescent layer thus improving resolution. In dim light the granules of pigment material in the retina return to their original position and light spread between cones occurs. This improves sensitivity but visual acuity certainly diminishes as a result. Below a certain light level cones stop functioning and vision is then dependent on rods. Cones are necessary for colour vision. When rods only are functioning, the different colours are experienced as white (for blue) or black (for red) or varying shades of grey (for colours between blue and red).

The retina has a mixture of rods and cones except at the fovea centralis where only cones are to be found tightly packed together. In very dim light the pigment granules also migrate away from the spaces between the rods allowing spread of light between rods for maximum sensitivity. Unfortunately visual acuity is then very poor. Rods act in groups whereas cones act separately so visual acuity with rods is poorer than with cones.

Rod and Cone Response to Light

The brightnesses encountered in radiographic film viewing using an illuminator extend from a little less than 10 lux in the dark regions of the film up to about 10^3 lux. On a logarithmic scale this represents a range of about 2. Since the response of the eye to light is logarithmic in nature, then this range of brightness corresponds to an image density range of about 2. Within this range of brightnesses cones, and not rods, are being used. As will be seen later this is within the range of cone vision giving extremely good visual acuity.

Visual Acuity

This is the ability of the eye to distinguish between two objects very close together. The perception of such fine detail is referred to as visual acuity. The separation (in mm) of these close objects is a measure of acuity and forms the vertical axis of the graph of Figure 11.12. The smaller the measurement the greater is the visual acuity. Poorer acuity is achieved with rod vision than with cone vision because of the light-scattering effect through migration of the pigment granules from between the rods. The use of cones alone is called photopic vision while the use of the rods alone is called scotopic vision.

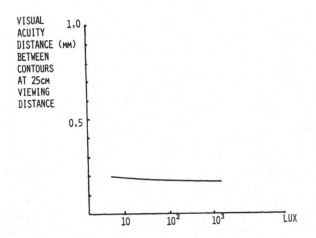

Figure 11.12 Visual acuity against brightness

The Effect of Colour and Density Level on Contrast Perception

The appreciation of brightness depends not only on the intensity of the light but also on its colour. To experience colour, cones are needed, since rods appreciate differences in colour only as different shades of grey. Colour of illumination certainly affects the perceptibility of image information as is evident from a study of perceptibility curves. It has been pointed out that a certain minimum density difference

$(\Delta D)_{min}$ is necessary between image detail and its background before this detail can be perceived. The value for $(\Delta D)_{min}$ under normal viewing conditions varies with the background density value in such a way that as the background density increases so does $(\Delta D)_{min}$. This relationship is not linear. At a low background density level $(\Delta D)_{min}$ is small and changes only slowly as background density initially increases. Above a background density of about $D = 0.5$, $(\Delta D)_{min}$ begins to increase more rapidly while above $D = 2$ the rise in $(\Delta D)_{min}$ is very much more rapid. It is interesting to compare two high kV chest radiographs, both of the same subject taken at the same kV, but having different average image densities. As the average image density is reduced the contrast appears to increase. This would appear to indicate that high kV images should have a lower average image density than their low kV counterparts.

In the above discussion, each value for background density corresponds to a given log E value (when related to the characteristic curve), and each $(\Delta D)_{min}$ has an associated $(\Delta \log E)_{min}$. If $1/(\Delta \log E)_{min}$ is plotted against log E a perceptibility curve is produced. The shape of the curve depends on the characteristics of the imaging system and in particular the characteristic curve for the film. A perceptibility curve is shown in Figure 11.13. If the average

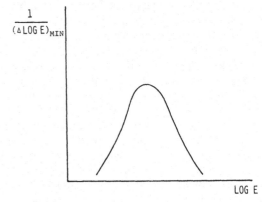

Figure 11.13 Perceptibility curve

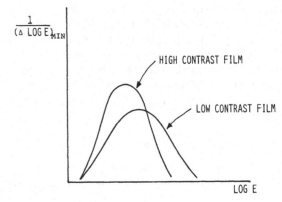

Figure 11.14 Perceptibility curves for high and low contrast film

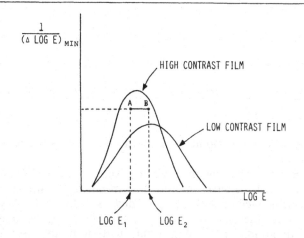

Figure 11.15 Visibility of image detail depends on perceptibility curve of film

gradient of the straight line portion of the characteristic curve increases, then the height of the perceptibility curve increases but the width of its base decreases (Figure 11.14). Figure 11.15 shows a perceptibility curve for a particular imaging system. A given image detail is considered for which $\log E_1$ and $\log E_2$ are the respective log exposure values producing the image densities providing the contrast. This particular log exposure difference corresponds to the $1/(\Delta \log E)_{min}$ value shown if the image detail is to be perceived. The solid line AB is drawn to represent this image detail against its background. This line lies within the boundary defined by the perceptibility curve for the high contrast film and so this image detail will be clearly seen. If the low contrast film were used to image this same detail, the detail would not be visible when the processed film were viewed under normal viewing conditions, because the line AB does not lie within the boundaries of the perceptibility curve for this film.

Varying the colour of illumination can alter the perceptibility curve for a given film material which in turn affects the visibility of image information. The change may be insufficient to prevent visualization but can be sufficient to render visualization significantly more difficult. Width and height of the perceptibility curve are like average film contrast and film latitude. Increasing one generally decreases the other and ideally the requirement is for the best compromise between height and width to allow as much image information as possible to be seen in any particular case.

Strictly the minimum perceptible density difference under normal viewing conditions is viewer-dependent, and slightly different perceptibility curves will be obtained for different viewers even for the same imaging and viewing system. This provides a reason why certain image information is readily

visible by all, but other image information may not be seen by some unless the image contrast is increased. Again the physiological and psychological condition of the viewer will influence perceptibility of image information. For example, perceptibility diminishes with increased visual fatigue, decreased brightness level and reduced visual acuity. These are some of the reasons why no agreement can be reached on what constitutes optimum image quality in any given case.

Resolution and Viewing Distance

At a viewing distance of 40 cm, the peak response of the eye is at about 1 lp/mm and is zero at 10 lp/mm. High-resolution screen exposures and non-screen exposures would then appear to produce about the same degree of unsharpness in the image and a real saving in radiation dose to the patient could be achieved if high resolution screen exposures were adopted. If all the required information can be obtained by the viewer at a distance of 40 cm or more, then high resolution screen systems can replace non-screen systems and the saving is achieved. This, of course, has already happened quite widely, not only in extremity work but also in mammography. If a lesser viewing distance were used, or alternatively if optical magnification were used, then the eye response would peak at a higher resolution figure and greater differences in unsharpness between screen and non-screen images would become apparent, the high resolution screen image showing the greatest unsharpness. This situation is easily seen in Figure 11.16. Here MTF is the modulation transfer factor (see Appendix 5).

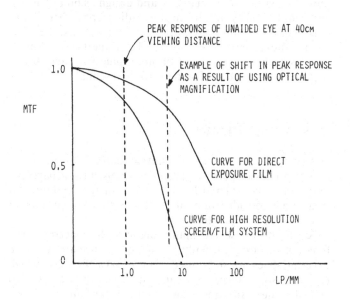

Figure 11.16 Change in peak eye response

12
Film Processing: The Darkroom, Silver Recovery and Pollution

INTRODUCTION

In radiographic practice provision must be made to handle unprocessed film material outside the protective environment of its cassette. All film material used in radiography is sensitive to white light with resultant film fogging and to avoid this when handling unprocessed film it is usual to provide

(i) a film handling room from which white light can be excluded when required. Historically, such a room is called the radiographic darkroom
(ii) light sources within the darkroom providing a visible light spectrum outside the range of spectral sensitivity of the film being handled.

Condition (ii) is an idealized requirement since it is not possible to provide a safelight source for all film materials, but this will be discussed in greater detail in the section on darkroom safelighting (p. 176).

The radiographic darkroom is an integral part of the complete imaging system, and as much care and attention should be spent on its planning and design as on any other important facility in diagnostic radiography. Since the introduction of automated film handling systems, the need for a radiographic darkroom has been questioned, but as long as techniques such as photographic subtraction are required a darkroom of some form is essential.

DARKROOM DESIGN

Designing a darkroom is no simple matter and like most design processes personal preference must play a part. All that will be considered here are some of the fundamental ideas and considerations involved in the sequence from inception to completion.

At inception, severe limitations may be placed on the freedom of design, usually by lack of finance and because existing space must be used. This makes the design task easier in some respects because it avoids the necessity to consider ideal size and siting of the darkroom. However, working with an existing room may create difficulties in providing sufficient working space for personnel and equipment. From this point of view the design task is more difficult.

Before considering any specific design, all the tasks and functions of the darkroom must be specified. If automatic processing facilities are to be provided, as undoubtedly they will, then the type of processor must be a preplanning consideration. For example, information needed is the total film throughput envisaged. This can be compared with the output capacity of the processor required and a decision made as to whether more than one processer is needed to deal with the workload. Once all tasks and functions are known, it is an easy step to decide on the associated equipment, but a further major consideration is that of centralization and staffing. Again for example, the existing design of the department may dictate that centralization is most convenient, in which case possibly only one operator is required at any one time in the darkroom. On the other hand centralization may be inconvenient, in which case duplication of facilities and staff must be considered as a costly alternative. In older radiodiagnostic departments which have undergone progressive expansion and redesigning, and which tend to be spread out, one solution has been to centralize processing facilities and provide satellite feeder darkrooms. Radiographic suites at some distance from the centralized darkroom may have an integral satellite darkroom in such a system. This is a small darkroom with simple provision for loading and unloading cassettes, with the exposed film being sent to the central darkroom by pneumatic tube (or some other film transport system) from the satellite darkroom.

Having defined the tasks and functions and chosen the equipment it is then necessary to choose a suitable equipment arrangement (assuming there is sufficient room). Personnel working space requirements must be considered, and where possible the maximum amount consistent with comfortable and efficient operation should be provided. This usually means avoiding freestanding automatic processors within the darkroom, and arranging for only the film feed tray to project into the darkroom while the majority of the processor is on the other side of the wall, i.e. within the viewing room. Equipment arrangement should be decided by the required workflow pattern. The process of work simplification can be used here to provide the most efficient flow pattern. This involves reducing the tasks to

sequences of simple statements, and systematically analysing all the factors affecting these tasks. Finally reorganization is carried out to achieve the simplification, the aim being to produce the greatest output for the least effort, the shortest time and the least cost and with the necessary safety.

In any optimization problem like this, there must be due consideration of the human element, because the task can be reduced to a point where it quickly becomes monotonous and boredom results; mistakes can occur and safety can be impaired. This is, of course, an extreme case, and in practice the technician can be involved in many varied tasks including film processing, cassette and intensifying screen maintenance, processor chemistry preparation, processor operation and maintenance, silver recovery, chemical and film stock control, film identification and sorting, safelight testing and image quality control. The technician could also be involved with duplication and subtraction, altogether providing considerable interest and variety but ideally requiring some kind of formal training.

Equipment design and arrangement in a darkroom must take into account other parts of the complete system. For example, are the processors to form an integral part of an automated film handling ('daylight') system using automatic film feed into the processor? Where are the cassette hatches to be placed and how will this influence the internal structure of the darkroom? Next must be a consideration of the services required (power, water, heating, drains and ventilation) and these must conform to required safety regulations. Construction of walls, floors and ceiling must not be neglected, particularly from the viewpoint of radiation protection, and equally important is the type of entrance required. Finally white lighting, safelighting and the colour scheme must be decided.

When the design is complete it is wise to imagine each of the tasks being carried out within the context of the design and in as much detail as possible in order to spot difficulties and inconsistencies in design. If any exist then modifications can be made and the process repeated. If found satisfactory the design can be taken from paper to completion. Here it is important to realize that no design is perfect and that subsequent modifications may be necessary, and provision should be made for this.

Tasks and Functions

In detailing any specification for a darkroom design it is useful to commence by stating all the functions it is required to serve and all the tasks to be performed within it. The design must then meet these needs. The basic functions are to provide

(i) For handling of unprocessed film material, both exposed and unexposed, without producing unacceptable film fogging in the normal film handling time

(ii) Suitable storage facilities for unexposed film material in use

(iii) A satisfactory level of safelight illumination in which to work

(iv) Sufficient space to house equipment for film identification, processing and any other photographic procedures carried out

(v) Working areas for film and cassette handling, film identification when performed in the darkroom and any other necessary photographic procedures

(vi) Facilities for preparation of photographic processing solutions and manual processing where necessary

(vii) Adequate ventilation and ambient temperature control, sufficient electrical sockets and switches to operate all the necessary and contained equipment (this provision must comply with existing safety regulations) and drainage access for waste processing fluids.

(viii) Two-way access by cassette hatch or pneumatic tube (or other film transport system) for film materials, and access for personnel usually by means of a light-tight door (this complying with existing safety regulations relating to emergency access and exit, fire and ventilation). The need for complex entrances forming light traps allowing unrestricted access has disappeared as a result of the almost universal availability of automatic processing.

Specifying the range of tasks to be performed in a darkroom really depends on the chosen design. For example, a design involving a freestanding automatic processor in the darkroom, and having integral replenisher reservoirs, would involve the preparation of processing solutions within the darkroom. This is true of any system where the replenisher reservoirs are contained in the darkroom. Maintenance procedures on a freestanding automatic processor would also be carried out in the darkroom. Alternatively designs are possible where these tasks can be performed outside the darkroom. Ideally the processor should not be free-standing in the darkroom because this means there cannot be immediate access (by the radiographer) to processed film. Where the processor is contained almost wholly in an adjacent viewing room with only the feed-tray side of the processor in the darkroom then access is immediate.

Below are listed the possible tasks to be performed in the darkroom, but, as stated, whether or not all are performed within the darkroom depends on the design, which in turn may be dictated by available space and the equipment involved. The tasks likely to be performed are

(i) Handling of films in safelighting
(ii) Loading and unloading of cassettes

(iii) Receipt and dispatch of loaded cassettes
(iv) Film feeding to an autoprocessor
(v) Film identification
(vi) Manual processing
(vii) Processing solution preparation
(viii) Intensifying screen and cassette maintenance
(ix) Routine processor maintenance
(x) Silver recovery
(xi) Duplication and subtraction
(xii) Provision of an adequate supply of unexposed film material
(xiii) Safelight testing

Identifying tasks and functions in this way makes possible a critical appraisal of a darkroom design and its suitability as part of the radiographic system by testing the design for each task and function.

Processing Facilities

One aim of present-day systems is to dispense with all forms of manual processing and this is indeed possible. Here, only automatic processing facilities will be considered. Factors influencing the choice of automatic processing facilities are

(i) Workload
(ii) Workflow rate required
(iii) Number of processors required
(iv) Output capacity
(v) Capital cost and reliability
(vi) Servicing and running costs
(vii) Size and available space
(viii) Ease of operation and routine maintenance
(ix) Film feed-in rate
(x) Cycle time and temperature operating conditions required
(xi) Possible integration in 'daylight' system

As a first step it is necessary to determine the projected workload and workflow rate at the busiest points of a working day. This will help to determine the maximum output capacity and the output rate required. It must be remembered that the further into the future the projections are made the more unreliable they become. Trends may indicate a continuing increase in workload, but what of the period covering the life of the processor? One course of action is to base requirements on the projected figures for the next 12 months and make provision in the design for future expansion or contraction as needed. Predicting the output capacity and rate needed requires knowledge of statistics relating to past and present performance. Then the prediction can be made more reliable if information is available relating to future expansion or contraction which could affect workload. Included here should be information on future changes in staff numbers, equipment, techniques and methods.

Having determined the maximum capacity and rate neeeded, a choice of processing facility must be made. The list above must then be considered. The capital cost, for example, of the ideal processor for the purpose may be outside the financial restraints of the budget. A review of the situation may lead to the conclusion that any other alternative would prove costly, in the long run, in terms of maintenance or, for example, satisfy demand initially but not in the future. Given this, without any financial readjustment, perhaps departmental operating methods could be reviewed. This may lead to a workload reorganization allowing a cheaper automatic processor to meet the present and near-future demands. Again, would a single processor meet all requirements? Does the system call for at least two processors to provide continuity during periods of breakdown and servicing?

Considerations such as those mentioned indicate quite clearly that automatic processing facilities form part of a total radiographic system and should not be considered in isolation. The trend in automatic processing facilities is towards simplicity and compactness. Many processors now require only a cold water input, a single-phase power supply and a drain connection. Many also have the processing solution reservoirs as an integral part of the unit. The processing time cycle on some is variable from as low as 60 s up to about 4 min. Using a 60 s cycle with low temperature chemistry at 35 °C provides a very high speed system for constant, large workloads. The so-called low temperature chemistry is capable of operating over a wide temperature range (with the appropriate cycle time) with little change in output image quality. This allows a low capacity system to operate at a low temperature to achieve low replenishment rates and produce the same results as a high capacity system operating at a high temperature with about the same replenishment rates. A low capacity system (operating intermittently) using a high temperature and short cycle time would suffer considerable processing chemical oxidation between films and would require a high replenishment rate to counteract the effects. A balanced and consistently good image quality is difficult in this case because there is insufficient restrainer being added from the films being processed (because of the small numbers) to balance the large amount of replenisher being added to counteract oxidation.

Case Study

Figure 12.1 shows the plan of a four-room radiodiagnostic department where X is the only site available for a darkroom. In this case the site is fixed and a limit is immediately placed on the maximum likely size of the darkroom. The flow of films is likely to be from right to left. Once processed, the films originating from the two general rooms will need to be seen and the radiographers will require

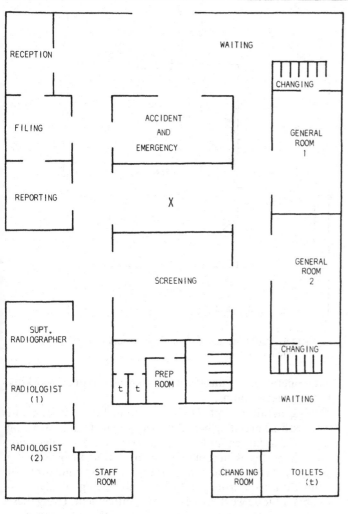

Figure 12.1 Plan of a specimen four-room radiodiagnostic department

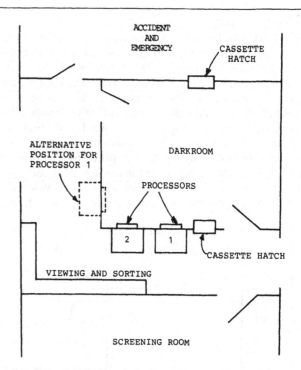

Figure 12.2 Possible design of viewing room – no cassette hatch from screening room

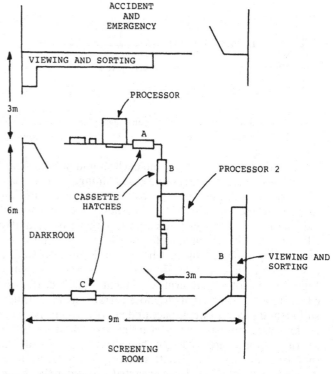

Figure 12.3 Possible design of viewing room – no cassette hatch from accident and emergency room

to walk the minimum distance to do this. In addition, once seen, these films must be reported, but without the necessity for the radiographer to walk around the central block of rooms. A direct link from right to left is required. One answer to this problem, if space permits, is to arrange for the film viewing room to be accessible from either side of the building. One design is shown in Figure 12.2, where access to the viewing room is also shown as direct from the accident and emergency room and from the screening room. This arrangement allows for only two main positions for the darkroom, one of which is illustrated in Figure 12.2.

Now the first disadvantage becomes apparent. There is no direct access, via a cassette hatch, for films between screening room and darkroom. This may not be considered as a disadvantage by some since there is ready access to the darkroom via the viewing room. However, an alternative arrangement might be as shown in Figure 12.3, but here direct access to the darkroom via a cassette hatch is denied

the accident and emergency room. Another arrangement could be that of Figure 12.4, which would allow direct access to the darkroom but prevent the flow of films from the two general rooms to the reporting room except by walking around the central block of rooms. To avoid this it would be possible to provide a film transport system from one side to the other, but this increases costs. Also in the arrangement of Figure 12.4 the viewing facilities would be duplicated, further increasing costs. Again this arrangement virtually dictates that two processors are required to feed processed films to each side whereas in the arrangements of Figures 12.2 and 12.3 only one processor need be provided if the workload permits (but, for convenience, two are shown).

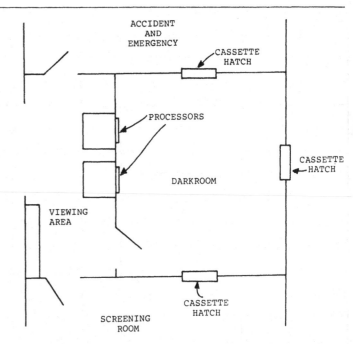

Figure 12.5 Possible design giving more darkroom space – yet again three cassette hatches are required

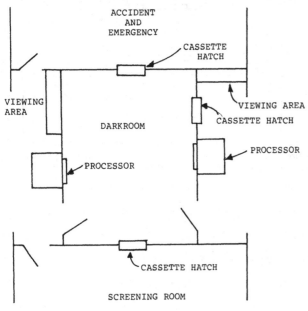

Figure 12.4 Third design for viewing room – again three cassette hatches are required

Other designs are possible and each should be considered and its relative advantages and disadvantages determined. This process is really part of a cost–benefit exercise leading to the most appropriate choice of design. Whatever choice is made must be influenced by the results of this process, and to a lesser extent by personal preference. Personal preference is most likely to be involved when several choices of equal cost–benefit are available. Here the choice made is that of Figure 12.3. Notice that no measurements have been discussed. It is assumed here that the chosen arrangement will allow sufficient darkroom workspace and viewing room space but if this were not so and measurements placed a further restriction on choice of design then a less favourable design (not one already considered) suffering many operational drawbacks would have to be accepted. Consider the design in Figure 12.5, for example, which has more space available

but is operationally unsatisfactory for the personnel working in the general rooms.

It is generally accepted that a minimum floor area of about $9\,m^2$ with a 3 m ceiling height provides a satisfactory working space for a darkroom technician. However a smaller floor area than this is acceptable for an automatic processing layout providing there is good ventilation and ambient temperature control and there is no feeling of claustrophobia for long working periods of confinement. Using these measurements it is possible to determine the available space for viewing areas and to decide if a particular design allows sufficient space. Now, assume that the design of Figure 12.3 has been chosen as the first acceptable and that the total available space is $9.0\,m \times 9.0\,m$ to accommodate both darkroom and viewing and sorting areas. Thus space is not a problem. It will also be assumed that there are no processors directly coupled to automatic film changing equipment in this department.

Before commencing a detailed equipment layout the processing facilities must be chosen together with the mode of operation and such a decision requires knowledge of the departmental workload. This department's film throughput for the last five years is shown in Figure 12.6. Using these figures, by extrapolation, it would appear that some 95 600 films will be dealt with in 1978 and some 98 000 films in 1979 (if the trend continues). Information is obviously needed about future policy changes and changes in operational techniques likely to affect the future workload and workflow of the radiodiagnostic department.

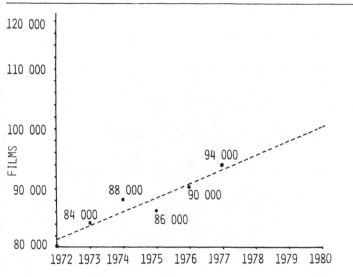

Figure 12.6 Departmental film throughput over 5 years

Other information necessary is the types of film material to be processed. For example is it necessary to have a long cycle time processor for special films or can such a system be replaced by a suitable high speed alternative? Are any processors to be dedicated? (By this is meant that one or more processors are to be used solely for one purpose or to process only one particular type of film. This is not economical and is to be avoided if possible unless the dedicated processor is utilized to virtually its full capacity.) Here the assumption is made that no special processing requirements are needed (in terms of long cycle time or dedicated processors) and the processing facility should be able to cope with an annual throughput of 100 000 films. Even working on a 5-day week this represents an average of only 385 films (mixed sizes) per day and most high speed processors can deal with this quantity in about 2 hours of continuous processing. The processing of 385 films spread over a working day, however, would mean that a single high speed processor (60 or 90 s cycle time for example) would be employed at very much under capacity. Can the purchase of two automatic processors be justified in this case when even one would hardly be used to capacity? If only one processor is justified, what processing facilities would be used during service periods? Planned service periods to occur during a quiet part of the day coupled with a prearranged workload reorganization is often used to overcome this problem. This condition might well be met here and only one processor purchased, but consider the following:

(i) What processing facility can be used during an unforeseen and protracted period of breakdown?

(ii) The average daily film figure says nothing about the peak workload (but it is unlikely to be greater than the processor can cope with in this case)

(iii) What happens if a dedicated processor is required for a trial of some new film type in the near future? Planning the processing facility around a single processor may make the addition of a second processor more difficult than if a two-processor design were planned (and installed) at the outset

(iv) Does the purchase of two processors represent a cost that can be recovered in terms of efficient, continuous workflow and less costly servicing?

(v) Is excessively lengthy queueing of films likely to occur in a single processor system when, for example, several lengths of 70 mm film are being processed?

Many other similar points may be found to justify the purchase of two automatic processors in this situation. Ideally, for operational reasons, the two processors should be identical in terms of similar cycle times, temperatures, replenishment rates, water supply and other services. Often, a processor with a relatively low output capacity is simpler and cheaper than a high capacity model. Two low capacity models (Ilford R200, for example) would suffice here, although any of the other processors such as the Dupont Cronex T6, the Kodak M101 and the 3M XP507 are equally acceptable and reliable but somewhat more expensive.

Now, assuming that a two-processor system is chosen, a reasonably good arrangement is that of Figure 12.3. Cassette hatch A could be used to feed processor 1 from the accident and emergency room and general room 1. Cassette hatch B could be used by general room 2 and cassette hatch C by the screening room, both B and C feeding processor 2. Two viewing areas are provided for the outputs from the two processors with the flow of sorted films being from right to left towards the reporting room (or the radiologists' rooms). This arrangement provides for a more or less equal workload for the two processors, but there is sufficient latitude in the design to allow other operating systems.

Superficially, the design seems satisfactory with no real problems remaining, so let us consider the remaining design features:

(i) Darkroom equipment and its arrangement
(ii) Services
(iii) Ventilation and ambient temperature
(iv) Safety
(v) Radiation protection
(vi) Floors, walls and ceilings
(vii) Colour scheme
(viii) Access
(ix) Safelighting

Darkroom Equipment

A consideration of the functions and tasks indicates darkroom equipment required. The handling of unprocessed

film material and cassettes requires a reasonable size of working surface with waste and storage facilities. The work surface area will depend on the number of working staff in the darkroom, the number and site of cassette hatches and the available space.

Figure 12.7 Typical darkroom work surface unit. (Reproduced by kind permission of Wardray Products (Clerkenwell) Ltd., London)

A typical example of a suitable work surface with underneath film storage, cupboard space and waste bin is shown in Figure 12.7. It is often recommended that the work surface should not be patterned since a film lying on it would record an image of the pattern by reflection of safelight transmitted through the film to the work surface. If the safelighting has been designed to allow a safe film handling time of about 45 s then this type of film fogging should not occur because (i) the film should not be allowed to lie on the work surface, and (ii) if the film is placed on the surface for any reason it is not likely to be there more than a few seconds and it will require a minimum of 45 s to image the pattern. The safe film handling time quoted refers to the length of time which is just greater than the longest time taken in unloading an exposed film from a cassette and inserting it completely into the automatic processor. The shorter the safe film handling time the greater the allowable intensity of safelight in which to work. The greater the film feed-in rate for the processor the shorter this time can become. The safe film handling time for existing safelighting refers to the length of time which an exposed but unprocessed film (of the highest speed used in the department) can be subjected to the safelight without any visible increase in gross fog level.

In Figure 12.7 the container (often called a film hopper) for unexposed films is shown on the right with the large

Figure 12.8 Film hopper. (Reproduced by kind permission of Wardray Products (Clerkenwell) Ltd., London)

handle. This hopper is shown (separate from the work unit) in Figure 12.8. Here the hopper is open and shows the compartments into which films of different sizes can be placed for ease of selection under safelighting conditions. This hopper, when full, should only be opened under safelighting and for complete safety an electronic lock is desirable linked to both darkroom door(s) and white lighting system so that if the darkroom white lighting is on or if either of the darkroom doors is open then it should not be possible to open the hopper.

An actinic marker may be recessed in the working surface where such a film identification system is used. A typical example is shown in Figure 12.9 with patient identification and the film in position for actinic marking. There are, of course, other systems of actinic marking which can be completed by the radiographer outside the darkroom. Examples are the Kodak identification camera used with the X-omatic cassettes and the identification system of the Du-Pont 'daylight' equipment. There is much to commend a system where the radiographer responsible for the films also identifies them.

A typical cassette hatch is shown in Figure 12.10. The side shown lies outside the darkroom. The door shown open is lead lined because in many designs the hatch opens directly into an X-ray room. The other side of the cassette hatch is in the darkroom and also has an opening door. The two doors operate on an interlocking system such that only one door can be open at any one time. This prevents light entering the darkroom through the cassette hatch. The cavity of the cassette hatch is usually partitioned so that exposed films can enter the darkroom on one side and reloaded cassettes leave on the other. 'Exposed' and 'Unexposed' labels normally identify the respective sides of the hatch. A cassette hatch containing cassettes loaded with film should not be sited such that an X-ray beam would be projected directly at it during normal work routine. If this is absolutely unavoidable it would be necessary to increase the thickness of lead lining in the hatch itself.

Figure 12.9 A flush-mounted actinic film identification marker

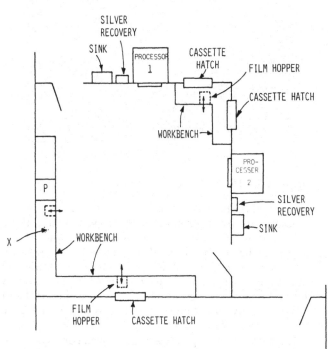

Figure 12.11 The darkroom area of Figure 12.3

A convenient arrangement of all this equipment is illustrated in Figure 12.11. Two film hoppers are installed, arranged here to open and close in the direction of the arrows. A considerable length of work surface is available (marked X). This is to provide space for accessory equipment-such as the DuPont Cronex copier/subtraction unit (Figure 12.12) for duplicating of radiographs and performing photographic subtraction. As Figure 12.12 shows, the bench top width needs to be sufficient to support the width of the unit and allow easy opening of the lid. The bench top illustrated is certainly not wide enough. Also, placing the

Figure 12.10 A typical cassette hatch. (Reproduced by kind permission of Wardray Products (Clerkenwell) Ltd., London)

Figure 12.13 Suitable housing for copier/subtraction unit

Figure 12.12 The DuPont Cronex copier/subtraction unit

unit on top of the bench may make it too high for some people to operate. Ideally a custom-made support would allow integration of the unit with the workbench and at the appropriate height (position P in Figure 12.11), with an associated film hopper containing films for duplication and subtraction. A reasonable design is shown in Figure 12.13. A different copier/subtraction unit is shown in Figure 12.14 which is equally easy to integrate (at position P in Figure 12.11) with the workbench.

Some departments operate a miniaturized copy system in which large X-ray films are copied onto a 100 mm × 100 mm format, for example, to provide more efficient use of film storage space, the large films then being recycled. It is assumed here that, when done, this type of work would be carried out in its own purpose-built room.

The two automatic processors have integral replenisher reservoirs and thus lie outside the darkroom so no 'wet' facilities are required within the darkroom. In Figure 12.11, facilities have been provided outside the darkroom for cleaning of roller racks, and a water supply for replenisher chemical preparation and processor tank cleaning. A space is provided between each sink and processor to allow access for servicing of the processor.

Figure 12.14 The Wardray copier/subtraction unit. (Reproduced by kind permission of Wardray Products (Clerkenwell) Ltd., London)

Now that the main darkroom equipment has been considered (the present arrangement resulting from the siting of the cassette hatches relative to the X-ray rooms), what of the workflow patterns? Are the constituent paths sufficiently short and low in number? The workflow patterns within the darkroom are shown in Figure 12.15. With the present dimensions of the darkroom these paths are conveniently short and yet well separated indicating that the equipment arrangement is reasonable. Two points should be noted, however. The workflow paths indicate that virtually only the periphery of the darkroom is utilized and thus indicate the optimum positions for safelights. Secondly, there is a redundant area of workbench in the darkroom so this could be a suitable area for necessary periodic cassette and intensifying screen maintenance, for example.

Figure 12.15 Workflow paths within the darkroom

Services
Sufficient electrical sockets must be provided to operate the contained equipment, such as actinic markers, ventilation system, duplication/subtraction unit and wall-mounted safelights. The operating positions of this equipment must be decided at the outset so as to provide the optimum socket positions. The siting of ceiling-suspended safelights must also be predetermined as must the method and site of the switching arrangement. It is most convenient if all wall-mounted and ceiling-suspended safelights (except those used as processor film-feed indicators) are operated from a single switch but, unfortunately, this would make the task of individual safelight testing very difficult because of the requirement to extinguish all safelights except the one being

tested. For this reason many designs provide a separate switch for each safelight.

In the past it has been recommended that safelight switching be achieved by using pull cords to avoid any direct contact with the electrical supply in the case of wet hands. In the present design there are no wet processes undertaken in the darkroom under safelight conditions, and with externally placed processors the relative humidity in the darkroom will not make the handling of electrical equipment hazardous. In this situation it might be considered convenient to have a centralized array of labelled wall switches controlling all accessory equipment in the darkroom, including safelighting and white lighting.

The control of the electrical supply to the automatic processors is different, however. Here the electrical supply is provided to a machine which operates with chemical solutions and represents a real hazard. Provision must be made for mains isolation switches both within and outside the darkroom so that in the event of an emergency the processor is readily disconnected from the electrical mains. This regulation applies to each individual processor.

In the present design the water supply is confined to outside the darkroom, only a cold water supply being needed for the processors. Both hot and cold water are required for the two sinks, the hot specifically for cleaning roller racks and other utensils. Finally, a drain connection is required for each processor to allow waste developer and wash water to be removed from the processor. A drain connection is also required for the two sinks.

White lighting is often a neglected issue, but two points arise. First, and most important, there should be no afterglow occurring when the white light is extinguished as occurs with some fluorescent lights. Such afterglow results in film fogging. This means that the choice of light source is important. Secondly, the white lighting should be arranged to provide an even and sufficient illumination.

Ventilation and Ambient Temperature
Referring to Figure 12.1, the site for the darkroom is surrounded by either corridor or X-ray room, so there is no outside wall. Placing a ventilation fan in one of the darkroom walls would simply provide used rather than fresh air to the darkroom. With the ventilation fan operating to remove air from the darkroom and ventilation grills in the darkroom doors to provide replacement air this would result in a stuffy and hot environment within the darkroom. A ducted ventilation system is required for both air in and out. In older buildings this may be difficult, if not impossible, to provide cheaply. This is the single biggest drawback, not in the design, but in the siting of this particular darkroom. There is often little need to provide additional heating in the darkroom to provide a comfortable working temperature since the heat generated by the two processors operating is usually sufficient.

Safety

With the advent of the Health and Safety at Work Act, much emphasis has been placed on the health and safety of the individual. Greater responsibility is placed on the individual to ensure safe and healthy working conditions, and indeed to exercise the right to refuse to work in a situation reasonably considered unsafe or unhealthy. The darkroom technician should be aware of regulations relating to safety at work and comply with these. Most are no more than common sense, such as wearing protective gear when preparing processing chemical solutions and isolating equipment from the electrical mains when carrying out routine maintenance. Ideally, training in all applicable aspects of safety should be available to all staff.

Radiation Protection

Since the darkroom and screening room share an adjacent wall, the wall should offer protection against the effects of radiation to both staff and film material within the darkroom. All walls and doors of the darkroom should be tested for their efficiency as radiation protection barriers and additional protection provided where necessary. The measures required have already been discussed above in Chapter 4.

Floors, Walls and Ceilings

Providing the radiation protection aspect is satisfied then there is no real constraint on the choice of materials used as coverings. No wet processing is done within the darkroom so it is satisfactory to use just emulsion paint on walls and ceilings and have plastic tiles for the floor.

Colour Scheme

For satisfactory working conditions it is necessary to produce safelighting conditions giving a uniform light intensity throughout the darkroom, the intensity being as high as possible consistent with the required safe film handling time. To minimize the number of safelights required the colours chosen for floors, walls, and ceilings should be light. Even the work benches can be light in colour to avoid the region near the floor being unnecessarily dark. Highly reflective surfaces should not be employed since they may produce localized points of high intensity safelight with a resulting unacceptably short safe film handling time. Matt surfaces are better to produce a more uniform safelighting.

Colour schemes are a matter of personal preference; even an all-white scheme is not unacceptable. It is often useful, but not essential, to have a cassette hatch and work surface of a different colour from the remainder so as to provide a contrast which is easily seen under safelighting. Remember that any item of a colour whose wavelength is not transmitted by the safelight filter will appear black under safelighting.

Access

In the design of Figure 12.11 access to the darkroom is provided by two doors, both of which are light-tight when closed but can be opened from either side in an emergency. This is the simplest and cheapest form of access and is all that is required here. The elaborate types of darkroom entrance such as light trap tunnels, double interlocking doors, or a revolving door system are all quite unnecessary for a modern darkroom since it is only necessary for someone other than the darkroom technician to gain access to the darkroom in an emergency or breakdown. Two doors are provided here for convenience of access to the processors and to provide an alternative escape route in case of emergency.

Safelighting

Unless an automatic, light-tight unloading device is available to pass an exposed film to a suitable automatic processor, then it is inevitable that the film must be handled outside its cassette. The exposed but unprocessed film, in general, must not be handled in normal or even subdued daylight, because it is sensitive to part of the white light spectrum if it is a monochromatic emulsion or to all of the white light spectrum if it is panchromatic. If the film is exposed to white light it will be instantly fogged. The function of darkroom safelighting is to allow unexposed or exposed but unprocessed film materials to be handled with a reasonable lack of any significant fogging, while providing as much illumination as possible for working.

The spectrum of the light produced by the safelighting and the permissible illumination intensity are chosen in part by considering the colour sensitivity and speed of the film material to be handled. Here colour sensitivity refers to the range of wavelengths of electromagnetic radiation to which the film is sensitive. In fact, the film has some sensitivity to a wide range of wavelengths but, in general, protective measures are only taken against those wavelengths which produce a significantly high image density (on processing) for a relatively small exposure. For most practical purposes the slight sensitivity to other wavelengths (those wavelengths transmitted by the safelight filter) is insignificant providing the safelight illumination intensity is low and the length of time for which the film is exposed to safelight is kept short. However tests must always be carried out (and repeated periodically) to ensure that significant fogging does not occur in the length of time the film is exposed to the safelighting during normal handling.

In its simplest form a safelight consists of a light-tight housing containing a white light source (tungsten bulb). There is an opening in the housing covered with a safelight filter. The filter absorbs light of wavelengths to which the film is most sensitive to a much greater degree than those to which it is least sensitive, the latter being transmitted by the filter to form the 'safelight'. Unfortunately the safelight filter does transmit all wavelengths to some extent since it does not

completely absorb all the light of wavelengths to which the film is most sensitive. The intensity of this unsafe transmitted light is however very small but it does mean that the film cannot be indefinitely exposed to safelight without fogging. The higher the wattage of the bulb used in the safelight the higher the intensity of transmitted light of all wavelengths and the shorter the period the film can be exposed to the safelight without fogging occurring. This has led to a natural balance occurring between the need for the greatest illumination intensity for working and the need to achieve a certain maximum exposure time to safelight (in which fogging is insignificant) for film handling purposes. This time is referred to as the safe film handling time for the particular film type and safelighting conditions. The safe film handling time is usually based on the longest time it takes to handle an exposed but unprocessed film from cassette unloading to being fully fed into the processor. Including film identification this process would normally take less than 30 s but for a variety of reasons it would be prudent to choose a safe film handling time of about 45 s. This allows a reasonable safety margin but a more than adequate safelight illumination intensity for working with monochromatic film material. When handling orthochromatic film the light considered safe covers only a very limited wavelength range and a different safelight filter is required, but a much lower safelight illumination intensity must be tolerated as subjectively measured by eye. This is because the eye is less sensitive to the light transmitted by this type of filter. For panchromatic film material it is wise to handle in complete darkness.

Film material which has received an exposure is more sensitive to safelight than unexposed film. This is true of monochromatic, orthochromatic and panchromatic film material. Figure 12.16(a) shows the characteristic curve of a typical screen-type film which has received no initial exposure. The safelight exposure is represented by x_1 and the image density produced as a result of this exposure is D_1, which is the same value as the gross fog value and so this exposure has had no noticeable effect on the film. If however (Figure 12.16(b)) the film has been previously exposed (x_2) then a subsequent safelight exposure of similar magnitude to that given to the unexposed film (x_1) will produce a change in image density from D_2 to D_3, i.e. the film is now more responsive to a similar safelight exposure. In practice the idea is to achieve a safelight illumination intensity such that the difference between D_3 and D_2 is visually undetectable when a pre-exposed film is subsequently exposed to safelight for the length of time described as the maximum safe film handling time (45 s in this case).

Safelight illumination arranged to provide a maximum safe film handling time of say 45 s for a relatively slow film would give film fogging in the same time for a faster film. The level of safelight illumination must therefore be related to the maximum safe film handling time for the fastest film used in

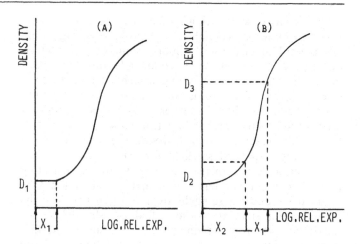

Figure 12.16 Safelight exposure x_1 (a) to unexposed film and (b) to film previously given exposure x_2

the department. If this film is monochromatic and a change is made to orthochromatic film material then fogging would again occur since a different safelight filter is now required. If both types of film material are regularly processed then the safelight filters must be those suitable for orthochromatic film material, since this type of filter gives a transmitted light spectrum suitable for both monochromatic and orthochromatic film. A filter suitable for monochromatic film would not be suitable for orthochromatic film. Adopting this system of safelighting means that at times when only monochromatic film material is processed the level of safelight illumination is unnecessarily low. Some departments have attempted to overcome this problem by employing a dual safelighting system with a single switch for changing from one to the other. This of course means duplicating every safelight (a not inexpensive operation) and providing one set of safelights with filters suitable for monochromatic film and the other set with filters for orthochromatic film.

The next point to consider is the uniformity of safelight illumination. If the safelight illumination intensity is approximately uniform throughout the darkroom then a test for maximum safe film handling time can be carried out at any point along the path of travel of the film. If, on the other hand, the illumination intensity is very uneven the test must be altered. These tests will be described later (p. 180). Since an unexposed film is less sensitive to safelight exposure than pre-exposed film then it is only necessary to perform the safelight test using a pre-exposed film of the fastest type used. The length of time necessary for handling an unexposed film when cassette loading is usually shorter than the handling time for exposed film. Hence, providing the test is satisfactory for exposed film, it can be assumed to be satisfactory for unexposed film and testing both is unnecessary.

Uniformity of safelighting is affected by the type, number, and distribution of safelights, the light bulb wattage used, and the colour of the walls, floors, ceilings and contained furniture and equipment. Recommendations have been made about the number of ceiling-suspended safelights for a given ceiling area and this is satisfactory as a starting point but the actual number and disposition required depends on the maximum safe film handling time considered necessary for the film material handled. Kodak Ltd. have suggested one ceiling-suspended safelight for every 6 m² of ceiling space but, as stated, this should only be used as a starting point. On the other hand, film material should not be handled closer to a safelight than recommended by the manufacturer since to do so will drastically reduce the maximum safe film handling time with significant film fogging occurring in a much shorter safelight exposure time. This should be obvious, since bringing the film closer to the source of safelight means that the film is exposed to a higher intensity of safelight so fogging occurs more quickly. Again Kodak Ltd. have recommended that film material should not be handled at distances closer than 1.2 m to a safelight.

For a given intensity of overall illumination, the larger the darkroom the greater the number of safelights required and this to a great extent controls the intensity of safelight at the film surface. Reference was made to colour above and this needs further explanation. A white wall or ceiling will reflect practically all the light incident upon it, whereas a black wall will reflect practically none at all, but instead absorbs most of it. Obviously for the same number and distribution of safelights in darkrooms of similar dimensions the intensity of safelight illumination at the film surface will be higher in a darkroom with white walls. A colour may be chosen other than black or white. In this case there will be almost total reflection if the colour of the wall is the same as the colour of safelight illumination. Otherwise, unless all the colour elements that are in the 'safe' light are also in the colour of the wall or ceiling, then there will only be partial reflection of the incident light, the remainder being absorbed. The amount of light reflected and the amount absorbed depends on the colour chosen and the shade of that colour. A dark shade will increase the amount absorbed, leaving little to be reflected. The opposite occurs with a lighter shade of the same colour.

As a hypothetical example consider safelight illumination which contains all the colours except blue. A blue surface will reflect blue but absorb all other colours. Since there is no blue element in the safelight illumination under consideration the blue surface will not reflect any of the light incident upon it, and will appear black. If a large area of workbench for example is blue, the intensity of safelight illumination will appear low due to lack of reflection. To ensure that minimal absorption occurs the darkroom walls, ceilings and cupboards should be white. The use of white surfaces means

that the required illumination intensity can be obtained for the least number of safelights.

When handling films under safelighting they should be exposed to safelight for the minimum time possible and certainly not longer than the maximum safe film handling time. This implies that if a number of films are to be processed each should remain in its closed cassette until absolutely ready for processing. A film should not be held in one hand while waiting for another to pass from the feed tray into the processor particularly in the case of a slow film feed-in rate.

To be able to see sufficiently well for ease of film handling, safelight illumination is required most at the

(i) film loading/unloading areas,
(ii) processor film feed-in points, and
(iii) paths between (i) and (ii).

For (i), localized safelight illumination of relatively high intensity may be employed to see to perform the necessary tasks. This is usually provided by what is called direct safelight illumination. For (ii) and (iii), a lower intensity of safelighting can be tolerated and this is usually provided by what is called indirect safelight illumination. The aim should be to employ a combination of direct and indirect safelighting to achieve a more or less uniform illumination intensity throughout the darkroom.

Direct safelighting implies that the 'safe' light is allowed to

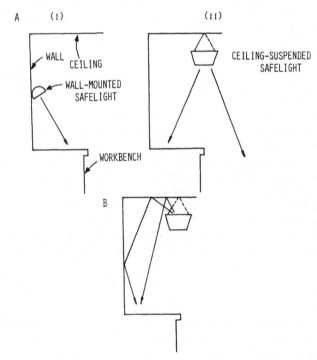

Figure 12.17 Principle of direct (A) and indirect (B) safelighting

fall directly on the film during the handling stage while indirect safelighting implies that the 'safe' light has first been reflected from some surface remote from the safelight (walls and ceiling, for example) before it is allowed to fall on the film. Figure 12.17 illustrates the principle of direct and indirect safelighting. With indirect safelighting the illumination intensity at any point will be dependent on the nature of the reflecting surface and dimensions within the darkroom. The wall-mounted safelight is usually placed some 1.2 m above the workbench surface. The ceiling-suspended safelight should be high enough above the floor to be above the head level of the tallest person working in the darkroom, and where possible be suspended at least 30–40 cm below the level of the ceiling, in the case of indirect safelighting, to try and achieve as uniform an illumination of the ceiling as possible. In use all safelight filters collect dust but this is particularly true of the filter used in the ceiling-suspended safelight for indirect safelighting. Here, so much dust can collect that indirect safelighting becomes negligible and regular periodic dusting is essential.

Figure 12.19 A wall-mounted safelight

Figure 12.18 A ceiling-suspended safelight

Figure 12.20 The constituent parts of a typical wall-mounted safelight

The design of safelights varies depending on manufacturer but two safelights typical of those used are shown in Figures 12.18 and 12.19. The structure of the wall-mounted safelight filter is shown in Figure 12.20. The housing is seen containing the lamp (usually 15 W or 25 W). The safelight filter is lying flat in front of the housing and the screw cap into which the filter fits is seen on the left. The ceiling-suspended safelight is simply a box structure with slots top and bottom into which the upper and lower safelight filters slide (Figure 12.21). The lower safelight filter may be replaced by an opaque sheet of similar size and thickness thus limiting the safelight to indirect safelighting only. These safelights become very hot when operating due to the heat generated by the bulb. This can cause progressive damage to the filter which should be periodically inspected and tested and replaced if found faulty. The amount of heat generated depends on the bulb wattage and using a bulb rated higher than 25 W can result in premature heat damage to the filter besides increasing the safelight illumination intensity to a possibly unsafe level.

Safelight filters are available in various sizes and shapes and are coded as to application. The code used depends on the manufacturer and is non-standard. The important information required in choosing a filter is

(i) the shape and dimensions if fitting a filter to an existing safelight housing,
(ii) whether it is for direct or indirect safelighting, and
(iii) the type of film material to be handled since the filter must be matched to the film.

UPPER FILTER

SAFELIGHT
HOUSING

LOWER FILTER

Figure 12.21 Structure of a ceiling-suspended safelight

A safelight filter usually consists of a suitably dyed layer sandwiched between two sheets of glass. The glass may be plain in which case it is possible to see through the filter and recognize all the contents of the safelight housing. Alternatively one glass may act as a diffusing layer in which case it is not possible to see through the filter. Neither types can be said to have any overwhelming advantage over the other.

The testing of safelights is straightforward. In practice it is essential to know that general safelight illumination is safe (i.e. produces no significant fogging) within the maximum safe film handling time. This requires a test for all the safelights simultaneously irrespective of whether or not the safelight illumination is uniform throughout the darkroom. To do this the following steps are taken:

(i) In complete darkness cut an unexposed film into four equal pieces. Place one piece (labelled A) in an empty light-tight film box and return the other pieces to the film hopper. To ensure that all pieces are of a size suitable for automatic processing a 35 cm × 43 cm film is a convenient size to start with. The film should be of the fastest screen-type film used in the department

(ii) With all safelights switched on remove the three pieces from the film hopper and load them side by side into a 35 cm × 43 cm cassette. Then in complete darkness

unload one piece (labelled B) and place it in the same box as piece A

(iii) Expose the loaded cassette to X-radiation using an exposure suitable to produce an image density on processing of about 0.8. An exposure cannot be stated here because the values used will depend on the film–intensifying screen combination used, the FFD employed and the type of X-ray generator. However, if a department-produced characteristic curve is available for the film–intensifying screen combination used and the processing conditions have not changed significantly since the curve was produced then it is easy to determine the required exposure. If, for example, the curve was produced using 70 kV, 100 mA and 100 cm FFD then all that is necessary is to determine the log relative exposure time value corresponding to $D = 0.8$. If this value happens to be 1 then the antilog of this value gives the relative exposure time (in this case 10). If the starting value of exposure time when producing the curve was 0.01 s with a relative exposure time value of 1, then 10 times this is 0.1 s which is the exposure time to use with the above factors to produce a $D = 0.8$.

(iv) In complete darkness unload one piece only (piece C) from the cassette and place it in the light-tight box with pieces A and B. Close the cassette. The cassette now contains only one piece (D)

(v) With all safelights switched on unload the cassette in the usual manner. Use an actinic marker to identify the film piece (but only if such a device is used in the darkroom in routine practice) and then feed piece D into the processor

(vi) When piece D has fully entered the processor switch off all safelights and in complete darkness feed pieces A, B and C simultaneously into the processor.

(vii) Using a densitometer, measure the densities of all four pieces. The density of piece A will show the value for gross fog; that of piece B will show the effect of the safelighting on the unexposed film during cassette loading; that of piece C will show the effect of safelight exposure during cassette loading and subsequent exposure to X-radiation; that of piece D will show the effect of safelight exposure during loading, X-radiation exposure and subsequent safelight exposure during unloading and feeding into the automatic processor. Ideally there should be no density difference between pieces A and B and no density difference between pieces C and D. Depending on the manufacturer the density of A and B will be equal and somewhere between 0.1 and 0.2. Pieces C and D will have $D = 0.8$.

If the safelighting is unsafe or the chosen maximum safe film handling time too short then a density difference will be obtained between C and D. If the safelighting is very unsafe, as might happen if white light was leaking from a safelight housing or if a 60 W bulb, for example, was used in one of the safelights, then a density difference would even be noticed between A and B. If a density difference of 0.02 or more is measured between pieces C and D then one of several things could be wrong and requires investigation (this assumes, of course, that it is only the safelighting at fault). These are:

(i) White light leakage from one or more safelights. This could be due to a damaged housing or safelight filter

(ii) Too high an illumination intensity from one or more safelights due to using bulbs of too high a wattage

(iii) The overall illumination intensity is too high (even though the bulbs are correct and the filters and housings are in good condition) and gives too short a maximum safe film handling time for the film being handled

(iv) The spectral transmission of the safelight filters is incorrect for the spectral sensitivity of the film being handled. In other words the wrong filters are being used for the type of film handled.

The first problem can be investigated simply by visual inspection. Turn off all white lights and safelights except the one being examined. Cover the filter with an opaque card and look to see if any white light is escaping from the housing. Then remove the filter and examine it under a strong light both by transmission and reflection. Any non-uniformity in the filter layer makes it suspect and it requires testing. Any fault found to cause film fogging should be dealt with by repair or if unsuccessful or impossible then replacement.

Testing a single safelight is again straightforward and is as follows:

(i) With all safelights off place a pre-exposed film of the fastest type at the normal working distance from the suspect safelight. The film is pre-exposed in the way described above using X-radiation to give on processing $D = 0.8$

(ii) Lay a row of coins across the film and using a piece of cardboard cover all but one coin. If the expected maximum safe film handling time should be 45 s (say) then choose a time interval longer than this (say 50 s) and divide this new time interval into convenient equal parts (say 5 s intervals). Since there are ten such intervals then ten coins will be needed

(iii) Turn on the one safelight and at 5 s intervals uncover another coin until all coins are uncovered; when the last coin has been exposed for 5 s turn off the safelight. This means that the first coin has received an exposure of 50 s, the next 45 s, the next 40 s and so on

(iv) In complete darkness feed the film into the processor

(v) Visual inspection is sufficient to see if any coin outlines are visible. If a maximum safe film handling time of 45 s is in fact correct then only the outline of the coin exposed for 50 s should be seen on the film. If outlines of coins are seen for both 50 s and 45 s exposure, for example, but no other, this can imply (if no other fault is found) that the distance from safelight to film is too short. The remedy is then simple. If nearly all coin outlines are seen and the distance between safelight and film is reasonable then most likely the filter is at fault (if no escape of white light can be detected and the bulb wattage is correct) and should be replaced.

The above test is conducted if visual inspection of the safelight reveals no obvious fault yet film fogging has occurred. Besides visual inspection for damage the check should also include looking at the bulb wattage and the filter code number to see if it is suitable for the film being handled. If the overall safelight illumination intensity is too high (giving too short a maximum safe film handling time) then the number of safelights must be reduced or lower wattage bulbs than those recommended can be tried. This situation is likely to arise where the existing safelighting has been set up for a particular film material and then a new much faster material is introduced having the same spectral sensitivity as the old.

The test for a single safelight could be used to test the safety of the general safelight illumination providing it was fairly uniform in which case the test could be carried out on the work bench with all the safelights switched on. However, the first test described is considered a better measure of general safelight illumination.

Since faulty safelighting is associated with film fogging then it is an important aspect in image quality control and considerable care should be taken in the design and choice of darkroom safelighting as well as in its periodic testing and maintenance. When designing safelighting it is important to consider how many times in particular an exposed film will be further exposed to safelighting. Where only a single darkroom exists it is reasonably straightforward to arrange for the safelighting to provide for a maximum safe film handling time for the fastest film used (this is assuming that the material is not panchromatic in which case total darkness is recommended.). If, however, a number of satellite darkrooms act as feeders to a main darkroom via a film tube transport system then the maximum safe film handling time must include the handling time in both satellite and main

darkrooms. For a given film material, this generally means a lower overall level of safelight illumination in both satellite and main darkrooms (compared to a single darkroom system) because of the longer overall handling time required.

Again, as previously implied, any change in the type of film material used may require an alteration in darkroom safelighting. Whenever such a change in film material occurs, the general safelight test described above should be carried out to determine the new maximum safe film handling time for existing safelighting (i.e. where the change in film material means only an increase in film speed). If this new handling time is too short then the safelighting must be altered if the new film must be used. Where the change means an alteration in speed and colour sensitivity, not only may the intensity of safelighting require alteration but the safelight filter type may also need changing to obtain spectral transmission characteristics suitable for the film such that no fogging is produced.

The white light from a tungsten bulb (used as the light source in safelights) contains radiation to which the typically used film materials in radiography are sensitive. It is necessary to use a filter to absorb this radiation and allow the remainder to pass through with minimum absorption. Absorbing the unwanted part of the white light spectrum changes the colour, the resulting colour of safelight depending on the spectral absorption properties of the filter used. Thus the idea of safelighting is to use a white light source and filter which will prevent the passage through it of light of wavelengths to which the film has a considerable sensitivity, while allowing through sufficient light of other wavelengths to see for film handling.

The part of the visible spectrum transmitted by the filter depends on the type of filter and this should be chosen to match the colour sensitivity (and speed) of the film material being handled. Matching implies that all light to which the film is most sensitive must be stopped by the filter. Choice of filters can be made by reference to their spectral transmission graphs. A typical graph is shown in Figure 12.22 for a safelight filter suitable for direct safelighting in the case of a monochromatic film material. Notice that the vertical scale is the reverse way to that normally expected. This, in effect, produces an upside-down curve so care is needed in the interpretation. This is the usual way that manufacturers present this type of information. Notice that less than 0.1% transmittance is ignored, being considered as insignificant but only with the correct light source. Should a more powerful light source be employed then the % transmittance of light of all wavelengths would be increased. The % transmittance of light of wavelengths between 400 nm and about 530 nm would then no longer be insignificant and film fogging would occur. However, assuming that the correct light source is employed, the curve of Figure 12.22 is obtained showing that the filter only transmits a significant quantity of light of wavelengths greater than approximately

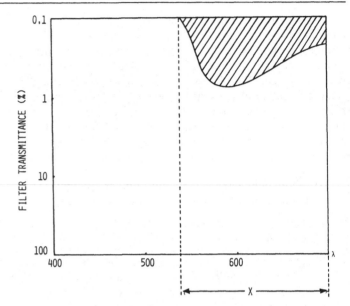

Figure 12.22 Typical filter transmission graph

530 nm (the interval X in Figure 12.22). The spectral sensitivity curve for a monochromatic film does not extend as far as 530 nm so this particular safelight filter is a satisfactory one to use with monochromatic film but would be unsuitable for either orthochromatic or panchromatic film material, since their spectral sensitivity curves would overlap with the spectral transmission curve shown. In other words, the filter whose curve is shown in Figure 12.22 would transmit light of wavelengths to which both an orthochromatic and panchromatic emulsion would be sensitive.

Figure 12.23 illustrates the film and safelight filter characteristics matching necessary in practice to obtain no significant film fogging within the maximum safe film handling time. Most film materials used at present in radiodiagnostic departments are monochromatic or orthochromatic and care must be taken to achieve the correct safelighting when used. Of course in a complete daylight system safelighting is not normally required. The conventional form of safelighting obtained by filtering a source of white light is not completely satisfactory because of the relatively low level of illumination obtained. Increasing the power of the light source is no answer to the problem because this not only increases illumination intensity of the wanted light but also does the same for the unwanted light. Rather than use a white light source it would be an advantage to find a source which emitted light of comparatively few wavelengths (a line emitter rather than a broad spectrum emitter). Then the light of wavelengths to which the film is most sensitive would simply not be present if the appropriate line emitter were chosen, and a higher illumination intensity could be used.

The PTW Safelight marketed by Radiatron Ltd. of

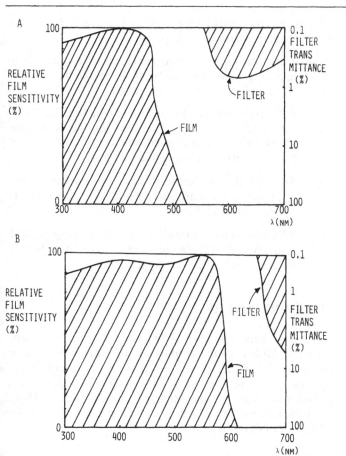

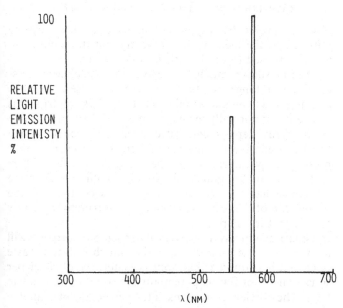

Figure 12.23 Film–safelight filer matching for monochromatic (A) and orthochromatic (B) emulsions

Figure 12.24 Spectral emission of PTW safelight

Twickenham is of this type. It consists of a housing containing a high pressure mercury lamp and an homogeneous glass filter replacing the safelight filter. The spectral emission from this safelight is shown in Figure 12.24. Unfortunately, even though this safelight provides a considerably higher illumination intensity providing superior safelight conditions for working, it is unsuitable for either orthochromatic or panchromatic emulsions. Departments undertaking photofluorography and/or using a green-emitting rare-earth intensifying screen system could not exclusively use this type of safelight, but all other departments might find it a distinct advantage.

An alternative form of safelighting is that produced by an electroluminescent panel. This consists of a suitable phosphor incorporated in a very thin layer of high dielectric constant. Conducting electrodes are then placed either side of the phosphor-containing dielectric. Application of an alternating electric field across the dielectric layer causes the phosphor to emit light. One electrode of this rather sophisticated capacitor (which is all the electroluminescent panel is in reality) is transparent but electrically conducting. The other electrode is coated with a reflecting layer (Figure 12.25). The panel operates from a 250 V, 50 Hz supply and

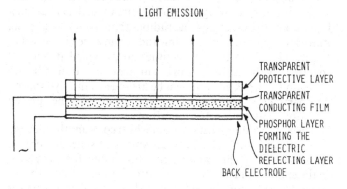

Figure 12.25 Structure of electroluminescent panel

has a mean life expectancy of about 5 years continuous running. Over this period a very gradual reduction in light output is experienced. Light emission is instantaneous at switch-on and there is no afterglow when extinguished. This latter point can be important if electroluminescent panels are used as one half of a dual safelighting system suitable for both monochromatic and orthochromatic materials. Power consumption is very small so there is virtually no temperature rise above ambient during operation even when completely enclosed. Wardray Products Ltd. market the panels. They are each about 20 cm × 25 cm × 2 cm and can be wall-mounted (Figure 12.26) or ceiling-suspended facing down for direct safelighting or facing the ceiling for indirect safelighting. Placing two panels back to back and ceiling-suspended provides both direct and indirect safelighting.

Figure 12.26 Wall-mounted electroluminescent panels

Viewing and Sorting Facility

The design of Figure 12.11 leaves an area of suitable dimensions for a film viewing and sorting area which is near each individual processor and the radiographic rooms where the films are exposed. The viewing and sorting area is shown in Figure 12.3. Film viewing facilities are provided at A and B together with suitable work surfaces for film sorting. Beneath the work surfaces can be arranged suitably labelled compartments into which sorted films can be placed awaiting distribution for reporting.

The area around the darkroom which contains the viewing and sorting facility also provides sufficient space to contain the bulk of the processors, the sink units for processor maintenance and processing solution preparation, storage space for the utensils and materials required in processor maintenance and solution preparation, and space for silver recovery units if used (or waste fixer storage vessels if departmental silver recovery is not practised).

Since the viewing and sorting areas will for the most part be brightly lit there will be a possibility of light leakage into the darkroom. This should be tested by standing in the darkroom with all darkroom lights extinguished and the doors shut. Allowing two or three minutes for the eyes to become adapted to the dark, a visual search can then be made for light leakage into the darkroom at the doors, around the processors or any other points where pipes enter or leave the darkroom. Any light leakage found should be remedied before using the darkroom.

Cleanliness

Besides processor maintenance to ensure clean rollers and

avoidance of film marks it is essential if image artefacts are to be avoided to ensure the following:

(i) Hands are clean and free from grease and sweat when handling films. In any event, films should only be handled by their corners or edges

(ii) All surfaces on which films are handled are free from dust and grit. All cassettes entering the darkroom should of course be cleaned, where applicable, of any foreign matter such as plaster of Paris

(iii) When loading or unloading films the cassettes are not left open on the work surface possibly to collect dust on the screen surface

(iv) All darkroom bench surfaces which are damp cleaned must be dry before use in film handling. Hands should also be thoroughly dry.

SILVER RECOVERY

Silver is an expensive commodity and a diminishing world resource. All X-ray films employ silver mainly in the form of silver bromide but only part of this silver remains in the emulsion at the fully processed image stage. The remainder is passed into solution in the fixing bath during fixation. There are thus two important sources of potentially recoverable silver in radiography:

(i) The film whether it be a fully processed film or a fogged and non-usable unprocessed film, and

(ii) A fixer solution which has been used for fixing X-ray films (an unused fixer contains no silver).

Silver recovered from these two important sources can be returned to the industry for recycling and the money obtained returned to the Health Service budget.

The first source only becomes available when the processed film is no longer required for record purposes. The films are then sold in bulk to a bullion dealer as the silver from this source is not normally recovered by any process practicable in an X-ray department. Silver from the second source (waste, used fixer) can conveniently be recovered by a process easily carried out in the X-ray department. Alternatively the bulk liquid can be sold to a bullion dealer once agreement has been reached on the silver content and the proportion of the recovered monies to be paid to the dealer for his part in the process.

Departmental silver recovery if carried out correctly will allow recovery of some 98.5% of the available silver in waste fixer and it is quoted that approximately 5 g of silver per square metre of film is potentially recoverable from waste fixer. The efficiency (in terms of the percentage of available silver recovered) of departmentally operated silver recovery

systems is extremely variable and depends on the method used and the way in which it is operated. It is often advised that to achieve a high efficiency it is necessary to centralize silver recovery using an efficient system with proper control.

In addition to recovering silver it is possible to reduce film costs by using

(i) The smallest film size appropriate to the examination
(ii) Screen-type film instead of the non-screen films having a higher coating weight of silver
(iii) Small-format film instead of full-size film
(iv) A non-silver image recording system such as xerography or videotape. However, in this case, to obtain the required diagnostic information the costs may be higher.

Silver Estimation

There are several methods used for the recovery of silver from waste fixer but for use in X-ray departments high current density electrolysis is recommended by the DHSS. To operate the electrolytic system effectively, knowledge is required of the silver concentration (in g/l because these are the units for which the estimation system is calibrated) and it is a simple matter to estimate this quantity reliably. Silver estimation test papers are used for this purpose and a good test paper is that of the Merckoquant Fixing Bath Test produced by the Merck Organization.

The test paper is simply immersed in the fixing solution for 1 s and then withdrawn. After 30 s the silver content can be determined by comparing the colour of the test paper with a colour chart. As the silver content of a waste fixer bath increases so the colour change is from light yellow to black. The colour scale is calibrated 0, 0.5, 1, 1.7, 3, 5, 7 and 10 g/l of silver. Besides determining the silver content of a fixing bath prior to silver recovery the test paper can also be used to assess the remaining silver content after silver recovery has supposedly been completed. This is a method of assessing the efficiency of silver recovery and is a necessary part of the control of the system. The test paper should be inserted into the supposedly desilvered fixer for 1 s. A time interval of 1–2 min should then elapse before comparison with the colour chart. As little as 0.1 g/l can then be detected by the change of the light yellow reagent zone of the test paper to dark yellow. Comparison with the colour chart should be done in ordinary electric lighting and not fluorescent. The silver content of the waste fixer from an automatic processor will be around 5–7 g/l. After silver recovery, if the colour change is at most from light yellow to dark yellow, then 0.1 g/l or less of silver is present. If the pre-silver recovery silver content was 7 g/l, for example, this means that at least 6.9 g/l of the available silver had been recovered. Thus at least $(6.9/7) \times 100 = 98.5\%$ of the available silver is being recovered. It should be noted that the estimation is based on a very small sample of fixer solution and to achieve reasonably accurate results the bath from which the sample was made should have been thoroughly agitated to obtain equilibrium of silver concentration throughout the solution.

Methods of Silver Recovery

There are several different methods of silver recovery, some of which are more suited to a commercial situation than an X-ray department. However, there are three silver recovery techniques which have been used in departmental silver recovery, and these are

(i) low current density electrolysis
(ii) high current density electrolysis, and
(iii) metallic replacement.

The DHSS in its Hospital Equipment Information No. 49 (1973) appears to prefer the high current density electrolytic technique for silver recovery.

Low current density electrolysis was originally used to recover silver at a very low rate from a fixing solution which was in use for fixing films in a manual processing unit. In automatic processing it is not feasible to introduce the equipment for electrolysis into the fixer tank in the processing unit because there would be no room. The presence of the roller rack would prevent it. The equipment could however be inserted in the vessel for collecting the used, waste fixer from the automatic processor. The rate of silver recovery, unfortunately, would be too slow even though the silver recovered by this technique is of a high purity. From a processor in continuous use, the flow of waste fixer is continuous and large quantities of used, waste fixer are soon collected. The problem is how to recover the silver efficiently and quickly. Even though the low current density electrolytic technique has not been explained here, the implication of a low current density is that it is a slow way to recover silver. This particular technique has no place in a modern X-ray department with completely automated processing facilities and it will not be discussed further.

The metallic replacement technique is certainly a method which can be used in conjunction with automatic processing and requires no power consumption as does the technique of electrolysis. However it is stated that a lower financial return is available with this method because of the costs involved with the additional refining of the end product necessary and the continuous cost of the steel wool pads used in the unit as the metal being exchanged for the silver. However, many of these units are in use and an explanation of this technique is necessary.

The high current density electrolytic technique operates on the same principle as the low current density system but allows for more rapid recovery of silver. Unfortunately the initial cost of the equipment is high but the argument is that this is soon recovered in terms of the silver reclaimed and sold and thereafter the running costs are low giving a good financial return.

High Current Density Electrolysis

In principle, an electrolytic technique employs two electrodes (anode and cathode) inserted in the used fixer solution. A potential difference is applied between the electrodes causing a current to flow through the completed circuit, part of which is formed by the solution itself. The ionized silver in solution, being positively charged, is attracted to the cathode on which it plates. Provided there is sufficient available silver in the vicinity of the cathode and the appropriate current density is employed then the silver plating of the cathode will be efficient. If, however, there is insufficient silver available for the current density employed then the system will reduce the thiosulphate complexes in the solution to form silver sulphide. Normally, when everything is progressing well, the deposited silver at the cathode has a cream colour. If there is a lack of silver in the vicinity of the cathode the current must consist of other positively charged ions obtained from the breakdown of the thiosulphate. When this happens the deposit at the cathode gradually changes from cream to brown. The formation of sulphide in this way is referred to as sulphiding. The tendency, nowadays, is to recover silver from waste fixer and recycle a proportion of the fixer using a suitable regeneration system, with disposal of the remaining proportion. If sulphiding is allowed to occur then the fixer becomes unsuitable for further use.

In high current density electrolysis the silver is collected at a high rate which will depend on the type of recovery unit employed, the fixer silver content, and the current density employed. In one system the fixer is collected in a vessel until a predetermined level is reached, when the flow of fixer is stopped to this vessel. The electrodes of the silver recovery unit are then inserted and the current density selected for the unit running time required and the estimated silver content.

Because of the high current density employed the solution requires agitation to ensure that a constant supply of silver ions is brought into the vicinity of the cathode. The agitation is achieved by forming the cathode out of approximately 12 flexible, parallel, circular blades, equally separated and fixed on a central shaft which is rotated by electric motor. The blades are made of stainless steel while the anode consists of four stationary carbon rods. The anode and cathode are surrounded by a cage to protect the electrode system. The electrode system is immersed in the fixer while the cathode motor and electronic control circuitry lie above the level of the solution. In most cases the desilvered solution is discarded so as much silver as possible should be recovered.

Taking a fixed volume of used fixer for silver recovery in this manner is often referred to as a batch cell system. With automatic processing and the fact that waste fixer trickles in small volumes from the fixer overflow every time a film is introduced to the processor, a continuous feed cell system of silver recovery is most convenient.

In low current density electrolysis without solution agita-

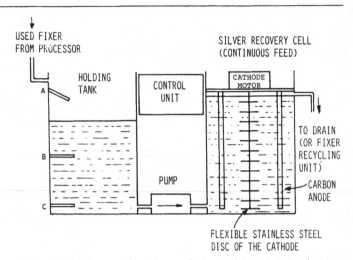

Figure 12.27 Diagram of continuous feed cell high current density electrolysis silver recovery system

tion the potential difference between the anode and cathode is 0.5 V while a direct current of density 2.2 A/m² of cathode is allowed to flow. In high current density electrolysis with solution agitation, the current density can be as high as 330 A/m². This gives some idea of the electrical parameters involved.

In a continuous feed cell unit (Figure 12.27) the used fixer solution is fed into a holding tank in the silver recovery unit as it is bled from the fixer tank in the automatic processor. From the holding tank spent fixer is fed at a fixed flow rate into the recovery cell. This precisely controlled rate of flow can then be matched with the exact strength of plating current required to give optimum recovery for the known silver content of the solution. This is the operating system of the PSR Silver King silver recovery unit. The silver content of the fixer in the holding tank can be checked using silver estimating papers. Using this information and referring to the chart supplied by the manufacturer will allow the appropriate flow rate and current setting to be obtained. The appropriate flow rate is obtained by adjusting the metering pump in the unit. During operation the silver concentration of the fixer in the actual recovery cell is always close to zero, the electrochemical efficiency (or 'recovery rate') is lower than expected and an equilibrium is set up in the cell whereby, once the metering pump and plating current are correctly set to correspond to the average silver concentration received in the waste fixer, the recovery rate of the cell is self-compensating for variations in silver concentration of up to about 20% or so. As the metering pump is passing fixer from the holding tank to the recovery cell, desilvered fixer overflows to the drain. The overflow should be checked periodically for silver content to monitor the process. Films of different sizes with different images release different amounts of silver to the fixer and the silver content of the used fixer flowing to the holding tank can vary so the self-

compensation for variations in silver concentration is an essential feature.

The holding tank has two solution level switches installed ((b) and (c) in Figure 12.27) and when the level of solution reaches the upper switch (b), the metering pump and electric motor which rotates the cathode are automatically started and the plating current switched on. When the level falls to the lower switch (c), the unit is switched off. The use of two level switches in this way obviates the continual switching on and off which could occur if only one switch were used. Above the level of these two switches is a further switch (a) near the top of the tank which operates a warning light showing the tank is full. This can happen if there is a blockage to the flow of fixer.

Once the equipment has been set up and switched on it will operate completely automatically round the clock, starting up and closing down the process as spent solution enters the holding tank from the processor.

Examples of the flow rates and current settings for particular silver concentrations are shown in Table 12.1 for the Silver King 15/28 by courtesy of PSR Ltd. Notice that for a given current setting, as the silver concentration increases, the flow rate must reduce because there is more silver to recover.

Table 12.1 Flow rates and current settings for given silver concentrations for the Silver King 15/28. (By courtesy of PSR Ltd.)

Silver concentration of used fixer	Pump settings		Current A
	(l/h)	(ml/min)	
4	7.2	120	8.0
	7.8	130	9.0
	8.4	140	9.5
	9.0	150	10.5
5	5.4	90	8.0
	6.0	100	9.0
	6.6	110	10.0
	7.2	120	11.0
6	4.8	80	8.0
	5.4	90	9.5
	6.0	100	10.5
	6.6	110	11.5
7	3.9	65	8.0
	4.5	75	9.0
	5.1	85	11.0
	5.7	95	12.0

Depending on throughput, the silver has to be removed from the cathode every 6 to 10 weeks. This is achieved by removing the cathode complete from the unit then disassembling the cathode to allow each disc to be flexed individually to crack off the silver. The cathode parts are thoroughly cleaned and reassembled. There are carbon spacers between discs and these should be clean and undamaged. Any grease accidentally put on the discs will impair subsequent silver recovery. The cathode should be checked periodically during the recovery period to ensure that the deposited silver is not allowed to thicken to the stage where there is no space between adjacent discs otherwise agitation will be greatly reduced with the possibility of sulphiding occurring.

The type of fixer used determines to some extent the current density which can be used and ammonium thiosulphate fixer can tolerate higher current densities than sodium thiosulphate fixer. Ammonium thiosulphate fixer is used exclusively in automatic processing.

As the pH of the fixer rises the maximum tolerated current density falls and, for a fixed current density, if pH rises for any reason then sulphiding can occur. The pH of the fixer in both holding tank and especially the recovery cell should be checked periodically and if it rises it should be compensated by addition of 80% glacial acetic acid. The optimum pH is around 4.25.

The sulphite stabilizer in the fixer is consumed during electrolysis since, even under correct operating conditions, free sulphur is formed but this combines with the sulphite to form thiosulphate thus preventing silver sulphide being plated instead of just silver. The sulphite concentration should be maintained at more than 8 g/l. Both pH and sulphite concentration can be maintained simultaneously by the periodic addition of bisulphite. Sulphiding can also occur as a result of dirt in the system. Dirt trapped on a cathode disc can act as a preferential plating site. Silver is deposited here in greater quantity than elsewhere with possible bridging of cathode discs, giving reduced agitation at that site with localized sulphiding which can spread over the whole cathode.

A properly controlled silver recovery system based on high current density electrolysis should give no problems and produce silver plate which assays 92–98% silver. The PSR Silver King, for example, is easy to control and can be locked during operation to prevent theft of silver and unauthorized tampering with the metered pump and current settings.

Finally it is possible with a correctly operating high current density electrolytic unit such as the Silver King to pass the fixer, which has had the silver content reduced to around 1 g/l, to a fixer recycle unit in which a proportion of the fixer is blended automatically with a regenerating solution which enables the fixer to be recycled to the processor in common with fixer replenisher from the usual fixer replenisher reservoir of the automatic processor.

Metallic Replacement

The cleanest and easiest way of carrying out silver recovery by this method is to obtain the commercially produced equipment. The method itself is simple: if a solution containing a silver salt is brought into contact with a metal such as steel wool, zinc or copper, for example, the less noble

metal is replaced by silver. Metals such as silver, gold and platinum are referred to as noble metals since they do not tarnish or corrode in air or water and are not easily attacked by acids. In carrying out this process only plastic utensils are used to avoid corrosion and steel wool is the usual metal used. One kg of steel wool will normally collect about 3–4 kg of silver. While no electricity is required, the steel wool charges used must be replaced as they are consumed in the process.

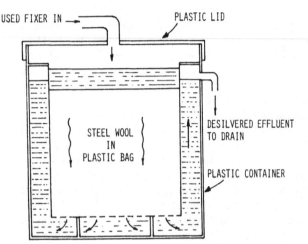

Figure 12.28 Typical metallic replacement silver recovery unit. It should be noted that the level of the fixer outlet from the automatic processor must be above the highest fluid level in the unit

Figure 12.28 shows a typical metallic replacement silver recovery unit. The used fixer from the automatic processor is passed into the unit to percolate amongst the steel wool charge for metallic replacement to occur. The resulting chemical solution is unsuitable for reuse and is allowed to flow to waste. A continuous flow of fluid is possible through the unit allowing direct coupling to the automatic processor fixer overflow (as in the case of the Silver King) with a flow rate of some 2 l/min. Continuous flow units however can sometimes have a high proportion of silver remaining in the outflow as insufficient time has been allowed for metallic replacement on its way through the unit. A tailing unit is then a wise precaution to remove the remaining small percentage of silver. The tailing unit is simply a second metallic replacement unit in series with the first (Figure 12.29).

It is possible to use the metallic replacement unit as a batch cell unit in which case a volume of fixer is poured into the unit and left until replacement is complete.

Once the steel wool is about 60% replaced the replacement process occurring in a continuous flow unit has slowed down and the outflow contains a much higher proportion of silver making a tailing unit a necessity. The steel wool charge must then be replaced particularly if only one unit is used. The exhausted charge is returned to the refiners.

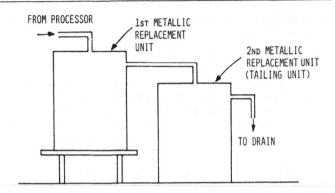

Figure 12.29 Use of a tailing unit

Even though metallic replacement units are now simple and clean to operate, unless the proper control is exercised over the process the results in terms of silver recovered can be very variable. Whether or not the fixer has been desilvered can be easily tested by collecting the outflow and inserting a copper strip into it and leaving awhile. If after this period the copper is silvered then the process is not efficient indicating the need for a replacement charge of steel wool.

A metallic replacement unit could be used in conjunction with a continuous feed cell, high current density electrolytic unit as a tailing unit, but this is not likely to be cost-effective.

Practical Considerations

Silver recovery is cost-effective and an important source of revenue when properly controlled. To avoid variability of result it is advisable to centralize the silver recovery system. In a situation where a group of fairly widespread hospitals are under the supervision of a district superintendent radiographer the used fixer could be saved and collected from each point and transported to a central point. Here the fixer can be added to a large reservoir feeding one or more high current density electrolytic units. Where this system is practised there is likely to be quite a variation in silver content in the central reservoir from time to time and considerable care and attention is required in controlling the silver recovery process. When choosing a system it is necessary to cost each system in detail as one which is suitable in certain situations may not be cost-effective in others.

POLLUTION

Effluents arising from the photographic processing of X-ray film are discharged into the sewer system. None of the ingredients usually found are extremely detrimental to the environment since they are chemically or biochemically degradable and no accumulation in the natural resources is known. The substances discharged include hydroquinone,

phenidone, sulphite, alkali hydroxide and carbonate, alkali bromide, organic acid, borate, organic stabilizer and hardener, thiosulphate and water.

Normally the amount of wash water running from a processor is very high in comparison with the small amounts of developer and fixer overflow. The developer and fixer mix anyway so the effluent is near neutral in pH. Such effluent can be discharged into the sewer without any resulting disturbances in the biological process at the treatment plant. Note that here the reference to fixer overflow is that from the silver recovery unit.

When changing chemicals in the main tanks large amounts of these substances are delivered to the sewer in a short time. Several things can be done here:

(i) Drain both fixer (desilvered) and developer solutions simultaneously so that they neutralize each other to give a pH of 6.5–9.0. In addition run plenty of water into the drain. This is probably the most convenient way of doing this operation

(ii) Alternatively the solution or solutions can be saved and released slowly to the drain over a period of several hours with plenty of water. This method is more effective but inconvenient.

These measures are sufficient according to recent evidence to avoid unacceptable pollution. However, before releasing any such chemicals to the drainage system it is necessary to check existing regulations with the local authority.

13
Film Processing: Equipment and Procedures

INTRODUCTION

Figure 13.1 shows one arrangement of the sequence of factors to be considered in the radiographic imaging process. It is the last in this chain that determines the success of the end result when all other factors have been suitably determined and controlled. This last factor – film processing – should always be considered as an integral part of the imaging process and as much care and attention devoted to it as to the other members of the sequence.

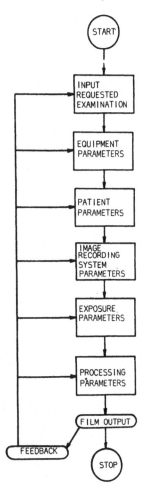

Figure 13.1 The radiographic imaging process sequence

Film processing involves several stages, but it is usually the first of these, namely the development stage, that has the most profound effect on image quality. As a result of exposure a latent image is formed in the film emulsion. It is the processing which renders the latent image visible and permanent.

LATENT IMAGE

Silver and bromide ions are arranged in a cubic structure to form the silver bromide crystals contained in the photographic emulsion. Structure defects are deliberately introduced into an otherwise perfect structure and it is these which form electron traps. During exposure, electrons are ejected from their normal position in the crystal lattice and tend to be caught by the electron traps. This happens very quickly and the electron traps (sensitivity centres) soon acquire a relatively large negative charge. This attracts the free silver ions resulting from the silver bromide reduction occurring during exposure. These ions have a positive charge and once they reach the sensitivity centres they combine with the electrons to form black metallic silver.

The amount of silver formed in this way is too small to be seen but is sufficient to act as a trigger for further reduction when the film is placed in the developer. The action of the developer clearly reveals a difference between the exposed crystals which contain metallic silver atoms at the sensitivity centres and the unexposed crystals which do not. Development starts from the latent image at the sensitivity centres and spreads throughout the crystal inducing further reduction of the silver bromide. Development of unexposed silver bromide crystals does occur but at a very much lower rate than exposed crystals. The difference in rates depends on the structure of the developer. Densities produced through development of unexposed silver bromide are called development fog.

In the interval between exposure and processing, recombination of silver and bromine can occur. Fortunately halogen acceptors absorb the bromine largely preventing recombination. If bromide ions were not retained in this way by the gelatin, recombination would occur with resulting fading of the latent image. On development the bromide ions pass into aqueous solution.

The process of development consists of the donation of electrons by the developer to the silver halide producing reduction and the formation of metallic silver thus amplifying the effect of exposure and making the latent image visible. Any chemical which achieves its action by donating electrons becomes oxidized, since the action of losing electrons represents oxidation. The acceptance of electrons by a substance represents chemical reduction of that substance. The developer donates electrons which are accepted by the silver halide in the emulsion. The developer becomes oxidized and the silver halide is reduced. The developer can be said to be a reducing agent for silver halide and tends to reduce all of the remaining silver halide in each of the exposed silver halide crystals in the emulsion.

THE IMAGING PROCESS

The imaging process consists of exposure, processing and viewing but such a simple statement does not indicate the complexities involved. The film must pass through many different stages before an acceptable final result is obtained. In outline, the stages are

(i) *Exposure* – exposure to X-rays in direct exposure (non-screen) work or exposure to light and X-rays when intensifying screens are used produces a latent image in the emulsion. The intensity of the latent image depends on the value of the exposure and the average grain size in the emulsion as well as on the use of sensitizers.

(ii) *Development* – immersion of the exposed film in a chemical developer to make the latent image visible. This occurs as a result of the reduction of the silver halide to black metallic silver mainly in the grains which have been affected by the exposure. The unexposed grains remain relatively unaffected by the developer (the degree to which they are affected depends on the selectivity ratio of the developer) but can still be affected by light or X-rays. Chemical fixation is required to remove the unexposed, unreduced silver halide grains from the emulsion.

(iii) *Rinsing* – this is necessary to remove, as far as possible, the developer from the film before it passes into the fixer tank. Developer is alkaline and fixer is acid and neutralization of one by the other should be avoided. There is also the likelihood of dichroic fog occurring should development actively continue within the fixing solution. Dichroic fog appears as a discolouration of the image. In roller-type automatic processing, the act of rinsing is replaced by a roller squeezing action. Rollers with this function are often referred to as 'squeegee' rollers, and remove excess fluid from the emulsion.

(iv) *Fixing* – the fixing solution acts as a solvent for unexposed silver halide. Following fixation the film is unaffected by further exposure to light or X-rays. Processes

(ii) and (iii), and the first part of (iv), must be carried out under suitable safelighting conditions or in total darkness. The fixer also contains chemicals to harden the soft and swollen emulsion and make it less liable to damage through handling. High energy fixers using ammonium salts and high temperatures can also act as a slow solvent for silver itself. Prolonged fixation may result in some image density loss.

(v) *Washing* – this reduces the concentration of fixer solution and fixer waste products in the emulsion and thus increases the storage life of the finished film. If the concentration of these substances in the emulsion remains high then staining of the film will occur through oxidation, reducing the usefulness of the image.

(vi) *Drying* – this reduces the water content of the film producing shrinking of the emulsion in thickness. This makes the emulsion tougher and easier to handle. It improves image visualization by eliminating the effects of refraction and reflection due to the presence of liquid within and on the surface of the emulsion.

(vii) *Viewing* – the final image is viewed by transmitted light using an illuminator (viewing box). This final image is usually a negative image.

Emulsion Additives

It was stated earlier that the emulsion contains certain additives to give the film its desired properties. Some of these additives are essential in the processing of the film, and it is necessary to mention them here.

During processing the emulsion becomes laden with fluid and swells. At this stage it is easily damaged. The inclusion of a metal salt, for example, can limit the degree to which the emulsion swells and softens making it less liable to damage particularly in a roller automatic processor. Of course, prehardening the emulsion in this way makes chemical penetration more difficult and a balance must be struck between the amount of hardening necessary to prevent damage and the penetration rate for chemicals in high-speed automatic processing.

In contrast to hardening, not only must chemical penetration be fairly rapid it must also occur evenly otherwise some parts of the image may develop more quickly than others. To prevent this a wetting agent is added. Other additives include a bactericide and fungicide to prevent growth of mould, for example, a plasticizer to prevent the emulsion cracking when dried or bent and an antifoggant.

The film base is equally important in the imaging process. It must not be affected in any way by processing since it must maintain its transparency and dimensional stability otherwise the image in the emulsion will alter in contrast and shape. The usual polyester material employed has all the desired properties of sufficient flexibility to allow roller processing and sufficient rigidity not to kink in film transport mechanisms, and can be made thin enough not to

interfere with image definition while still maintaining the other desirable properties.

THE PROCESSING CYCLE

For medical X-ray films this may be manual or automatic, and the system used will depend on the type of film used. Processing takes place following exposure and unloading of the film from the cassette. Both manual and automatic processes are wet, chemical processes. The automatic process uses solutions (developer and fixer) at higher concentrations and temperatures than the manual process. Whereas the minimum time taken for the automatic process is some 90–100 s, depending on the type of processor, the manual process can take well over an hour. Usually, films designed for automatic processing can also be manually processed, but not all films suitable for manual processing can be autoprocessed. Some films are unsuitable for automatic processing because of their high coating weight of silver halide which is too great for the processor to deal with in the short time allowed. Below are typical examples of processing times at each stage in the manual and automatic processes.

The Manual Processing Cycle

Development is usually 4 min at 20 °C. Variations are possible according to a time–temperature graph and the optimum time and temperature will depend on the type of developer used. An example of a time–temperature graph is shown in Figure 13.2 for two types of developer which could be used in manual processing. Note that at 20 °C the recommended development times are not the same for both developers. Above 24 °C the reduction in radiographic contrast reaches unacceptable limits with uneven development and possible emulsion damage. Special formulations are required for use at such high temperatures, but of course this is exactly what is required in automatic processing and for rapid processing in an operating theatre, for example.

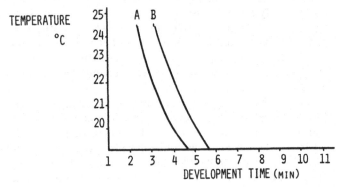

Figure 13.2 Time–temperature graph for two types of manual process developer

The film should be drained for a few seconds back into the developer solution before using the spray rinse. This avoids an excessive (and expensive) carry-over rate. A spray rinse is used for 5–6 s, with the film immersed in the spray. This will certainly remove surface developer from the film before it is immersed in the fixer.

The film is next fixed for 10 min by immersion in the fixing bath. Of course, these times are only a rough guide and will depend on many factors such as fixer type, concentration, agitation, degree of exhaustion, and temperature. Again, before washing the film, it should be drained for a few seconds back into the fixer, again to avoid an excessive carry-over rate. This action also means less silver passing away with the wash water. The temperature at which fixing takes place is usually about the same as that for development.

The film is then washed in running water for some 10–30 min. Again the length of time depends on many factors (and these will be discussed in detail later) including water flow rate and temperature. A further important factor worth mentioning here is that if a film is passed from the fixer to the wash while another film is being washed, the washing time will be increased for the already washing film. This is because the wash water will become contaminated with fixer carried over with the new film and will tend to slow down the rate at which fixer is removed from the already washing film.

Finally the film passes through the drying stage. In the manual process, drying may take place

(i) In a drying cabinet when the drying time is around 20 min. This can be shortened if a wetting agent is used. A wetting agent reduces surface tension of fluid on the film surface and reduces drying time
(ii) In a roller drier. Here the machine used is rather like an elaborate drier section of a roller automatic processor. The film is inserted wet at one side, and comes out dry at the other side in less than a minute.

Drying cabinets and roller driers are becoming rare now due to the almost total changeover to complete automation in film processing in X-ray departments.

The Automatic Processing Cycle

As an example, development in an automatic processor may be 30 s at 30 °C, but this can vary according to processor type and the process time cycle used. The figures given here relate to an Ilford R200 processor with a 120 s cycle time.

In the case of automatic processing a time–temperature graph is unnecessary because of the constancy of processing solution temperature and the constant processing time. What is useful is a speed index/contrast index/fog versus developer solution temperature graph. Such a graph allows determination of the temperature which produces the highest speed and contrast for an acceptable fog level within

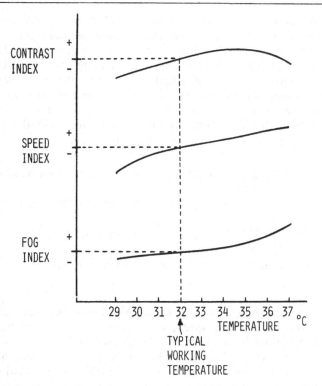

Figure 13.3 Speed index/contrast index/fog versus development solution temperature graph

the processing time set. Such a graph is shown in Figure 13.3 and discussed in greater detail in Chapter 14. Although the contrast is greater around 35 °C, it can be seen that the fog is rapidly rising and would be unacceptable at this temperature. A 120 s processing cycle is assumed using low temperature chemistry.

There is normally no spray rinse in the automatic processor. Before passing into the fixer tank the film leaves the developer solution and passes between cross-over rollers.

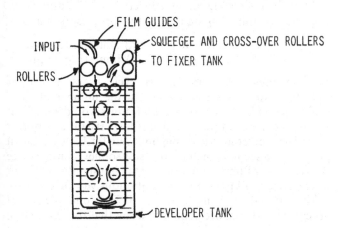

Figure 13.4 Developer rack. The film path is shown by arrows. A staggered system of rollers is shown, but a paired system may be used instead

These gently squeeze the film removing the surface developer which falls back into the developer solution. In most processes the cross-over rollers are an integral part of the developer rack of rollers as shown in Figure 13.4. The developer rack of rollers can be seen in Figure 13.5. From the developer the film passes into the fixer tank for about 30 s at 30 °C. In some processors it may require less time to fix the film (or wash it) than to develop it and the fixer and wash tanks may be shallower than the developer tank, and consequently each has a smaller number of rollers on their racks.

Figure 13.5 Developer rack. The film guide can be seen at the top of the roller rack

All the rollers on all the racks are moving at a constant rotational speed. Hence the only way to vary the time the film remains in one tank relative to another is to vary the total length of path through each tank. For example, it can be reduced by

(i) reducing the depth of the tank, and
(ii) reducing the number of pairs of rollers through which the film passes while submerged in the solution.

The fixer roller rack also has integral 'squeegee' and cross-over rollers to avoid excessive loss of silver into the wash and excessive carry-over of fixer.

Like the manual process, film washing is required and this lasts about 30 s at 20 °C. The washing process involves the film passing through a system of rollers in the wash tank. In some processors the wash tank may contain warm water (32 °C) flowing at the rate of several litres per minute depending on type. Other processors (e.g. R200) may employ a cold water wash avoiding the use of additional energy to heat the water. A cold water spray rinse may be used instead of a bath of fast running water as a means of saving energy and water. Thus there are a number of ways in which water is used in the wash stage:

(i) A hot and cold water supply is provided for the processor via a mixer valve which ensures the correct wash water temperature and allows adjustment of the flow rate. The wash is a bath of running water through which the film passes

(ii) A cold water supply only, in which case the water is heated in the processor before passing into the wash tank. The wash is a bath of running water through which the film passes

(iii) A cold water supply only, where the water is not heated. Here, unlike (i) and (ii), the water is used in the form of a spray rinse in the wash stage.

Depending on the processor type the water can be used at about 3 litres per minute or more for film washing.

After washing the film requires drying. Again, during the few seconds it takes for the film to pass from wash exit to drier entrance, it passes between a further set of 'squeegee' rollers. A further 30 s is then needed for the film to pass through the drier section. Here hot air is blown onto both surfaces of the film. In some cases the damp air resulting from this process of film drying is not ducted away. It is, instead, left to find its own way out of the processor. The working area around the processor tends to become very warm and humid and an efficient extraction fan is required particularly if the working area is very small. Whereas in some processors heated air is ducted to the drier section and blown on to the film, in others as the film passes through the drier section both its surfaces are exposed to infrared lamps. The water vapour generated is then blown away with cold air. Again ducting is not used for the removal of air from the drier section and, while this time the air is cold, it is still humid.

Differences occur in the processing cycle time for manual and automatic processing, the manual processing time being excessively long in comparison. There are of course differences in processing time between individual automatic processors. For example:

(i) The Ilford Rapid R200 processor has a cycle time of about 104 s. Alternatively, by turning a switch, a 3 min cycle time can be achieved (actual time is quoted as 186 s). However, the controls are such that it is possible to vary the cycle time about the values quoted

(ii) The 3M processor (XP507) cycle time is continuously variable from about 40 s upwards. It is only necessary to select the cycle time required and this will remain constant

(iii) The Kodak M101 processor cycle time is about 110 s.

A manufacturer may state the cycle time as referring to the time taken from when the leading edge of the film enters the first pair of rollers in the machine to when the trailing edge leaves the last pair of rollers. The process cycle time defined in this way depends on the film size (i.e. its length). Although two films of different length may enter the machine simultaneously, the shorter of the two films will drop out first, and hence the process time for this film is shorter.

Perhaps a more meaningful comparison can be made if the linear speeds of the processors are considered, as follows:

(i) Ilford Rapid R200 – 0.43 m/min (3 min cycle)
 processor

 0.76 m/min (104 s cycle)

(ii) The 3M processor – 1.0 m/min (90 s cycle)
 (XP507)

(iii) Kodak M101 processor – 1.24 m/min (110 s cycle)

It might be thought that the Kodak M101 processor, since it has the highest linear speed, would produce the result in the shortest time, but again careful thought will indicate that not only is linear speed important but so also is total path length for the film travel. It would be naïve to say that one processor produces the end result faster because its linear speed is greater. It might have a considerably longer path length making it slower in producing the end result. The important point is that such information is of little help to the radiographer, unless it is complete so that valid comparisons can be made.

Another figure often supplied in advertising literature is the processor output, as a number of films of mixed sizes per hour. This is not really very helpful as it is of more use for the particular department to work out their own figure for this to suit their own situation. This will help in determining the number and type of processors required.

Another interesting point concerns film feed-in rates. Consider the following figures for two processors A and B:

(i) A – 120 films (35 cm × 43 cm) hour/throughput
(ii) B – 185 films (35 cm × 43 cm) hour/throughput

These figures apply for similar cycle times quoted as 104–105 s, so why the difference in the number of films processed per hour? The similar cycle times would imply that each processor can process a single film in the same period of time. The greater hourly throughput rate for B means that it can receive a second film for processing sooner than A. Hence B has a higher film feed-in rate, a small but significant factor where there is a high capacity, continuous workload.

The preceding consideration of just one aspect of processor performance should indicate that the choice of a processor is no simple matter. Besides energy and cost considerations one must ask whether a particular processor

can process a single day's films in a day irrespective of the normally expected fluctuations of workload and without any significant delay at extremely busy points of the day. These considerations then lead naturally into processor reliability, servicing, available space and planning and so on, and this can be a complex exercise.

PROCESSING CHEMICALS

Processing chemicals are harmful if mishandled. This is certainly true in the case of the liquid concentrates used in automatic processing and every care should be taken to avoid contact of skin or eyes with developer or fixer. It is recommended that rubber gloves and goggles be worn when preparing these chemicals for use, in addition to any rubber apron employed to protect clothes from splashes. Inhalation of fumes from these chemicals should also be avoided and chemical preparation carried out in a well-ventilated room.

Processing chemicals may be presented in liquid concentrate form as in all automatic processing chemicals or as a powder in some manual processing chemicals. In fact there is no need to employ anything but liquid concentrates for the preparation of both manual and automatic processing chemicals providing the correct formulation is used. Liquid concentrates are available which are suitable for manual processors as distinct from the liquid concentrates specially designed for high-speed automatic processing.

Manual process liquid concentrate developer is generally presented as a single liquid just requiring suitable dilution with water. Autoprocess liquid concentrate developer on the other hand is presented as three separate liquids to be united when the chemical bath is prepared and then only in the correct order. In addition, the autoprocess liquid concentrate developer is only suitable as a developer after the addition of a fourth liquid, the starter solution. Without starter, the chemical solution acts as a replenisher solution whereas in the manual processor the replenisher chemical is a quite separate formulation to the developer. Additional substances are present in autoprocess developer compared with manual developer, necessitating the chemical separation until required for use, otherwise storage life would be poor because of chemical reaction and solution deterioration. Liquid concentrate fixer for both manual and automatic processors is usually supplied as two separate solutions, one containing the ammonium thiosulphate fixing solution and the other containing the hardener. The autoprocess liquid concentrate fixer can be used for manual processing provided the correct dilution ratio is used.

So-called low temperature autoprocess chemicals are now available which offer the same image quality and speed but at a reduced working temperature (32 °C for example, instead of 35 °C). This allows a small energy saving in processor operation, not to be lightly dismissed in these days of environment consciousness. There is no doubt that, used correctly, the present day imaging systems using automatic processing with low temperature chemistry can result in excellent image quality leaving little to be desired.

Autoprocess liquid concentrate processing chemicals should not be cooled to below 5 °C because crystallization will occur. This is not harmful but it does make preparation more difficult.

Preparation of Working Solutions

As previously stated the preparation of working strength solutions of film processing chemicals from liquid concentrates should not be undertaken lightly. Precautions are necessary in the handling of the chemicals to ensure safety, in the preparation to ensure correct order of mixing and in the mixing itself to ensure uniform concentration. Utensils used for the mixing of the fixer should not be used for the mixing of the developer unless all traces of fixer have first been removed. This is not possible to determine easily in practice and separate utensils are an advantage – a set for the developer and a set for the fixer. This avoids the possibility of contamination of one or other of the solutions. All utensils should be thoroughly cleaned after use. Utensils must be of a structure that will not react with the chemicals when mixing. Commercially available plastic or stainless steel utensils can be used. Automatic chemical mixing systems are also available. Whichever system is used, thorough mixing is essential. Improper mixing technique leading to non-uniform concentration can lead to variable image quality output.

Liquid concentrates must be mixed with the correct quantity of water to ensure correct working strength and hence consistency of image quality. The water used for mixing need not be specially treated before use because the solution chemistry is adequately buffered (p. 201) to account for this. Recommendations relating to water temperature for mixing should be observed.

Manufacturers' recommendations relating to mixing must be adhered to. This is only common sense because the manufacturer is the only one who knows the chemical constituents and their behaviour in solution. Certain of the constituents of both developer and fixer are declared by the manufacturer on the preparation leaflet supplied with the chemicals. This is because if any accident occurs requiring medical treatment for the effects of the chemicals (other than first aid) the doctor requires information on the noxious elements before deciding on a course of treatment. Possible results of improper handling can be skin burns, contact dermatitis, damage to the eyes from splashing, respiratory effects from inhalation of the fumes or at worst poisoning from accidentally swallowing the solution. With the reasonable care that is usually taken in preparing the chemicals such accidents are very unlikely to occur but

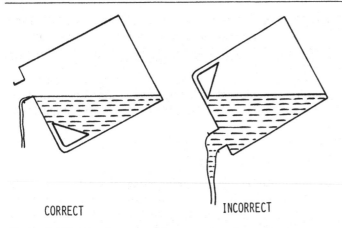

CORRECT INCORRECT

Figure 13.6 Pouring from a container

complacency is no excuse for carelessness. In particular, splashing can frequently occur pouring the liquid concentrate from its container incorrectly. Figure 13.6 shows the correct and incorrect methods. Liquid concentrates should be poured slowly and carefully to avoid splashes.

In automatic processing the liquid concentrate replenisher can be mixed to form a developer solution if the appropriate starter solution is added. This must be added in the developer tank and not in the reservoir. The replenisher solution contains no antifog chemicals and would therefore be unsuitable as a developing solution. The activity modifiers and antifog chemicals in the starter solution allow replenisher solution to be used as a developer. As the developer bath is used and replenished as a result of processing the concentration of starter decreases but its function is taken over by the substances released from the film emulsion during processing. It is then theoretically possible to use a replenisher solution without starter as a developer solution providing sufficient waste, but exposed films are passed through it (with the replenisher pump switched off) before it is used as a developer.

Chemical solutions should not be prepared in dirty tanks. If tanks or reservoirs are dirty they should be emptied and thoroughly cleaned. Cleanliness is essential for good and consistent image quality.

Manual Processor Solution Preparation

Before commencing to prepare the developer and fixer baths the appropriate protective clothing should be worn. The developer and fixer tanks may contain exhausted chemicals which must first be emptied and the tanks thoroughly cleaned. Emptying the tanks is straightforward as there is usually a drain plug at the bottom which is easily removed. The plug is either attached to a chain, the other end of which is clipped over the side of the tank, or it is of the screw type which is opened by inserting the appropriate tool supplied with the unit. In any case it should not be necessary to insert an

arm into the solution to remove the drain plug. Once empty the tank should be thoroughly cleaned. It is probably sufficient to use hot water and a sponge. After a final rinsing with hot water the plug can be re-inserted once the tank is empty. All that now remains is to prepare the fresh chemical solutions.

Using liquid concentrates, preparation is straightforward. About ⅔rds of the total required volume of water is first introduced into the tank followed by the appropriate liquid concentrate with thorough stirring. If the liquid concentrate is made up of more than one part then each part must be added to the water in the tank in the correct order. Following this the remaining quantity of water is added to fill the tank to the required level. The solution should then be stirred for two or three minutes. If the tank is first filled with warm water to ⅔rds of its volume, the topping-up can be done with cold water to achieve the desired working temperature. Before use, the temperature of the developer bath should be measured and the development time required determined from a time–temperature graph (such as Figure 13.2) appropriate to the developer in use. Since the tanks are generally immersed in a common heated water bath, the solution temperatures should be about the same. This water bath has its temperature theormostatically controlled so solution temperature should remain constant.

After a lengthy period of non-use (overnight, for example), and before re-use, the chemical solutions in the tanks should be thoroughly stirred because of the possibility of non-uniform concentration and activity throughout the solution. The temperature should also be checked after stirring. Exhaustion of the developer can occur through aerial oxidation and to limit this the developer tank lid must be in place whenever possible. The fixer tank does not normally have a lid. Except for specific references to the developer, the above method of preparation applies to both developer and fixer.

During use of the developer, the solution is carried over to the rinse tank in small volumes with each film. In addition, each film developed increases the degree of exhaustion of the developer. Both reduction in volume and developer exhaustion must be compensated by the addition of a developer replenisher solution which has a different composition to that of the developer. Usually replenisher solution is added to the developer in small quantities in a topping-up procedure (there are more sophisticated methods but only this one will be considered here). It would be inconvenient to make up a small quantity each time it is required, yet on the other hand gradual deterioration occurs with time in the prepared solution as it does with prepared developer solution. Thus replenisher solution might be made up in a quantity large enough for several topping-up operations but not too large a quantity such that excessive deterioration occurs before the last of the solution is used. The quantity prepared will depend on the rate of use of the developer. In

general, manual processing is little used now and several days or even weeks may pass between periods of use. In such a case it is prudent to prepare replenisher as and when required.

Automatic Processor Solution Preparation

Here one solution is used as both developer and replenisher. For use as a developer a special starter fluid is added while for use as a replenisher no additions are necessary. Each time a film passes through the developer, replenisher is pumped into the developer tank from the replenisher reservoir and excess developer overflows to the drain. This technique is known as the feed and bleed method of replenishing the developer solution. A similar system is used for the fixer. The replenishment rate is usually stated as a certain volume for a given length of film which is 35 cm wide. For example, the replenishment rate for the developer may be 90 ml per 35 cm length (i.e. 90 ml for a 35 \times 35 cm film). This method of stating replenishment rate is independent of cycle time and care should be exercised with such information. If the cycle time is changed so generally is temperature and a different replenishment rate may be necessary. Replenishment rate also depends on the amount of use of the processor.

A reservoir holding perhaps up to 50 l of developer (and a similar one for fixer) is attached to the appropriate replenisher pump by plastic tube. Solution is automatically pumped to the appropriate tank each time a film passes between detector rollers into the processor. The detector rollers initiate replenisher pump action which continues as long as the film is passing between these rollers. The replenisher solutions are thus gradually depleted and from time to time the replenisher solutions themselves require topping up. When preparing fresh replenisher solution in the reservoirs (developer or fixer) it is worth noting that the minimum quantity that is usually made is about 20 l and there should be sufficient room in the reservoir to accommodate this volume.

The technique of solution preparation is to introduce about ¾ of the total volume of water required into the reservoir, stirring continuously. After this is added the developer or fixer replenisher, whichever is being prepared, from the labelled containers, in the order suggested by the manufacturer, again stirring continuously. Finally the remaining volume of water is added and the contents of the reservoir thoroughly stireed for 3 or 4 min. Cold water from the tap may be used as there is no need to aim to produce the solution at working temperature in the reservoir. The developer in the main tank is maintained at a constant temperature by an immersion heater with thermostatic contro.. The addition of a small quantity of cold replenisher (90 ml, say) to a deveooper tank volume of some 16 l, say, will not change the developer temperature appreciably. Continuous film throughput means that replenisher is continuously added, but the addi-

tion rate is low and temperature changes are therefore slow to occur and this is easily dealt with by the thermostatic control. Temperature can normally be maintained to within $\pm \frac{1}{2}°$C under all working conditions, especially with the new microprocessor controlled processor.

Reservoir solution volume should not be allowed to drop low enough to allow air to enter the feed pipe (from reservoir to pump) during the replenisher pumping operation because of the possibility of an air-lock occurring. This can alter the replenishment rate and subsequently affect image quality. Reservoirs which are dirty should first be emptied and cleaned with warm water and a sponge before making a fresh solution. The reservoirs are supplied with two lids. One is a floating lid which rests on the solution surface reducing aerial oxidation and the other fits over the top of the reservoir mainly as a dust cover and contamination preventer. These should always be in place except when replenishing the reservoir and then only one reservoir should be uncovered at any one time. This prevents chemical contamination of the solution in the other reservoir from splashing. Finally when the replenisher reservoirs are refilled their outside surfaces should be wiped with a clean damp cloth to prevent splash marks forming.

The developer solution in the main tank is easily made. First the old developer solution is drained off, the roller rack removed and thoroughly cleaned, and the developer tank cleaned. When doing this the fixer tank and rollers must be adequately covered to protect from contamination by developer splashing. During developer tank (and fixer tank) cleaning the tank should be filled with water and the recirculation pumps operated to flush out the recirculation system. This water is then drained off. The roller rack is then replaced and the drain plug re-inserted. One simple method of preparing the solution is carefully to ladle replenisher solution from the reservoir into the developer tank until it is about ⅔rds full. Add the correct volume of starter solution according to the total capacity of the developer tank. For example if the developer tank holds 16 l and 25 ml of starter solution is required for every litre of replenisher then 400 ml of starter solution is added. Further replenisher is added to fill the tank. The recirculation pump should be switched on to mix the chemicals and several spare films processed thus avoiding the possibility of roller marks on subsequently processed films. Except for starter solution a similar procedure can be employed for preparing fixer solution in the main fixer tank.

Occasionally running water and a sponge is insufficient to clean rollers and tank. Then a recommended liquid cleaning solution is required. Often simple detergent is all that is necessary but occasionally a more effective cleaner may be required which can be obtained from the manufacturer of the processing chemicals. Some of the cleaning solutions are dangerous causing skin burning. It is essential to protect eyes, skin and clothes and if splashes do occur to wash the

affected area immediately. Some cleaning fluids are hazardous to the environment and the regulations regarding their disposal should be observed.

The above discussion on processor chemical preparation is only an outline and in all cases manufacturers' instructions should be carefully read and then followed. When changing chemicals, the disposal of the discarded chemicals should conform to regulations in force regarding environmental pollution.

The Developer Constituents and Effect

The developer is the first chemical bath into which the film is immersed in the processing cycle. As already stated the primary purpose of the developer is to reduce the exposed areas of the film to black metallic silver without affecting the unexposed areas. The extent to which a developer can distinguish between exposed and unexposed silver halide is described in terms of selectivity. Poor selectivity results in excessive development fog and reduced image contrast. Development fog is simply the density produced in the image by development of unexposed silver halide. A high energy developer will have a low selectivity and will produce high image densities in a relatively short time with low image contrast. A low energy developer will produce high image contrast but take a much longer time to produce the required image density levels. The temperature and concentration of the developer solution affect the selectivity, as also do the concentration and type of certain developer additives.

The developing agents in the solution are responsible for reducing exposed silver halide but to do this in an acceptable way to produce the required image requires the addition of several different chemicals to the developer solution. This delicate balance of chemicals must be maintained by a system of replenishment to overcome the progressive solution exhaustion occurring normally when films are developed.

The constituents of a typical developer for manual processing are

 (i) developing agents
 (ii) accelerator
 (iii) restrainer
 (iv) preservative
 (v) buffer
 (vi) sequestering agents
(vii) fungicide
(viii) solvent

Later this formulation will be compared with that for 90 s automatic processing where it will be noted that except for a few additional items the constituents are basically the same.

Developing Agents
Three developing agents have found popularity. These are phenidone, metol and hydroquinone. The developer usually contains two developing agents and the pairs normally used are metol + hydroquinone or phenidone + hydroquinone.

(a) *Metol* – Metol is a developing agent which produces rapid development and readily reduces silver halide which has received only a small exposure. The densities produced however are not sufficiently high and the resulting image lacks the required contrast. The activity of metol is depressed by bromide ions. These are released as the normal result of silver halide reduction in the development process and so without efficient regeneration would quickly become exhausted. Metol is used in powder developers.

(b) *Phenidone* – This is used in liquid concentrate developers. It produces a similar image result to metol, i.e. image density with low contrast. This density is low and less rapidly produced than with metol. When used alone phenidone is less active than metol but demonstrates a greater superadditivity (see below) when used together with hydroquinone. Phenidone has a low selectivity but is higher than that of metol. To improve selectivity, an organic restrainer is required. Phenidone is relatively unaffected by inorganic restrainer, consisting of bromide ions which so effectively depress the activity of metol.

(c) *Hydroquinone* – This is slower in action than either phenidone or metol. It needs an alkaline solution for reasonable activity and it is almost inactive below pH 9. Hydroquinone has a high selectivity and produces image density with high contrast. The density is high but is produced slowly. The speed of action is increased by increasing pH but this reduces the selectivity, which is improved using an inorganic restrainer but this unfortunately depresses its activity, though not to the same extent as metol. A compromise is thus necessary.

Metol and phenidone produce similar image effects and are not used together in the same developer. Neither can be used on their own if a high contrast is required. Although hydroquinone used on its own in a suitable formulation would give sufficient contrast, its action is too slow. Metol is used in conjunction with hydroquinone in a suitable formulation as an 'MQ' developer which has been used in manual processing only. Phenidone and hydroquinone form a 'PQ' developer which can be used for either manual or automatic processing. PQ developers are now used exclusively for both manual and automatic processing and the MQ developer will not be discussed further except as a comparison. The PQ developer is available in liquid concentrate form and is prepared for use by dilution with water. Phenidone deteriorates in alkaline solution and for high speed automatic processing must be kept separate from the alkali until it is to be used. The order of mixing is important. In high energy developers in particular uniformity of developing energy throughout the volume is necessary if a uniform image is required.

Superadditivity

The PQ combination gives rise to a greater developing energy than the sum of the individual energies predicts. This phenomenon is called superadditivity, and results from hydroquinone reducing the oxidation products of phenidone which form as a result of the developing action. Phenidone is reformed out of these oxidation products as a result of the reduction. The concentration of phenidone is thus maintained but the concentration of hydroquinone falls as a result. The maximum obtainable contrast gradually falls and developer activity is reduced. Superadditivity is much greater in PQ than in MQ developers. For the same activity the weight of phenidone required is very much less than that of metol. Hence phenidone can usefully be used in liquid concentrates.

During development the silver bromide (AgBr) is reduced to metallic silver when the positively charged silver ion (Ag^+) gains an electron donated by the developer. The loss of the electron from the developer represents oxidation. In simple form, the reaction is

$$AgBr + developer \rightarrow Ag + developer\ (oxidized) + Br^-$$

The negatively charged bromide ion (Br^-) passes from the emulsion into the developer solution in the form of hydrobromic acid (HBr). This is rapidly neutralized by the alkaline accelerator present in solution and this reaction produces sodium or potassium bromide (depending on whether the accelerator is a sodium or potassium salt—the accelerator is discussed below). The accelerator is only slightly depleted and, far more important, the bromide content of the developer solution is increased. Since the inorganic restrainer mentioned earlier is a bromide, this addition helps depress developer activity and reduce image contrast. The greater the number of films processed the more the developer activity decreases and the lower the image contrast obtainable.

The Accelerator

From what has been said about the activity of hydroquinone it will be seen that the accelerator, which is an alkali, is an essential constituent of any developer. Developer solutions are alkaline; in particular RP (rapid process) developers are strongly alkaline. Developer agent activity increases with increasing alkalinity and RP developers are thus high energy developers. The availability of electrons in the developer determines its activity, and this availability increases with increasing alkalinity, hence a reasonably high degree of alkalinity is necessary to give an acceptable level of activity to the developing agent, hydroquinone.

Potassium carbonate is used as the accelerator in PQ developers for manual processing while the more active alkali potassium hydroxide is the accelerator in the automatic processor developer and in replenisher solutions.

The more active alkaline is used when

(a) A normal contrast is required in a short time (as in RP processing)
(b) A higher contrast is required in a normal time (by the addition of replenisher solution) when using a partially exhausted developer solution.

The alkali, besides acting as an accelerator, will also

(a) Neutralize hydrobromic acid formed during development, and
(b) Produce some decomposition of developer oxidation products thus slowing the rate of developer exhaustion. This arises because the alkali produces a solution of high pH and the developer oxidation products are unstable at high pH. This effect is small.

Controlled high alkalinity, besides reducing development time and increasing contrast, has some adverse effects:

(a) It increases graininess (noise) in the image
(b) It increases developer activity, meaning a higher developer oxidation rate from oxidation by the air
(c) It produces skin burns and is dangerous if splashed in the eyes.

The usual pH of a developer solution for X-ray films is about 10.5 but can be higher in rapid developer solutions. The pH of the developer will change during use due to the production of developer reaction end products. The pH must be carefully controlled if consistent image quality is to be maintained. The pH value is usually maintained within ±0.2 by means of a buffer. It is no good assessing variation in pH by means of litmus paper since the accuracy is at best ±0.5 and this is no use for a variation of ±0.2.

pH

pH is a measure of the acidity or alkalinity of an aqueous solution. Pure water exists as undissociated H_2O molecules, and in a dissociated form as hydrogen ions (H^+ ions) and hydroxyl ions (OH^- ions). Only a small proportion of the water exists in the dissociated form. The above may be expressed as

$$H_2O \leftrightharpoons H^+ + OH^- \quad (\leftrightharpoons \text{ indicates that the reaction is reversible})$$

Every water molecule that dissociates gives rise to one H^+ ion and one OH^- ion. Thus in pure water there must be equal numbers of both types of ion. Providing the concentration is expressed in terms of moles per litre (mol/l) then the concentration of H^+ ions (written as $[H^+]$) multiplied by the concentration of OH^- ions (written as $[OH^-]$) will be a constant, k say, i.e.

$$\left[H^+ \right] \times \left[OH^- \right] = k$$

The constant is referred to as the ionization constant of water and its value depends only on temperature. When the temperature is 23°C this constant has the value 10^{-14}. This figure is the same for all aqueous solutions of the same temperature and does not alter even when ions of other types are present in the solution. Increasing the temperature of the solution increases the magnitude of the constant. In pure water at 23°C the concentration of each type of ion is 10^{-7} mol/l, giving

$$\left[H^+\right] \times \left[OH^-\right] = 10^{-7} \times 10^{-7} = 10^{-14}$$

Dissociation of H_2O molecules into H^+ ions and OH^- ions, or recombination of ions to form H_2O molecules, occurs should there be any tendency to variation in the ionization constant. Thus change is resisted and the constant maintained.

Water is said to be neutral when

$$\left[H^+\right] = \left[OH^-\right]$$

The presence of some substances dissolved in water can upset this equality by adding H^+ ions to solution or removing OH^- ions from solution. Adding H^+ ions would cause OH ions to be removed from solution by transferring them to an undissociated form thus maintaining the ionization constant. Removing OH^- ions from the solution would liberate H^+ ions, once again maintaining the ionization constant. In either of the above cases there will be an excess of H^+ ions, i.e.

$$\left[H^+\right] > \left[OH^-\right]$$

Substances which when added to solution produce the above effect are said to be acid and any aqueous solution where

$$\left[H^+\right] > \left[OH^-\right]$$

is said to be acid solution. The greater the concentration of hydrogen ions the more acid the solution becomes (the more reactive it is).

The opposite effect can occur, where the addition of a substance to water can add OH^- ions to solution or alternatively remove H^+ ions. The end result will be an excess of OH^- ions, i.e.

$$\left[H^+\right] < \left[OH^-\right]$$

Substances producing this effect are said to be alkaline and any aqueous solution where

$$\left[H^+\right] < \left[OH^-\right]$$

is alkaline. The lower the concentration of H^+ ions the more alkaline the solution becomes (the more reactive it is).

Some substances when added to water produce no alteration in the relationship

$$\left[H^+\right] = \left[OH^-\right]$$

Such substances and their aqueous solutions are said to be neutral. Urea and sodium chloride are examples.

It must be emphasized that whether

$$\left[H^+\right] > \left[OH^-\right] \quad \text{as in an aqueous solution which is acid,}$$

$$\text{or} \quad \left[H^+\right] < \left[OH^-\right] \quad \text{as in an aqueous solution which is alkaline,}$$

$$\text{or} \quad \left[H^+\right] = \left[OH^-\right] \quad \text{as in a neutral solution,}$$

$$\left[H^+\right] \times \left[OH^-\right] \quad \text{is always equal to } 10^{-14} \text{ at 23 °C}$$

$[H^+]$ is used to indicate the degree of acidity or alkalinity of an aqueous solution. For pure water (neutral)

$$\left[H^+\right] = 10^{-7} \text{ mol/l}$$

The figure 10^{-7} is an awkward number to deal with and by using a little mathematics can be transformed into a small positive whole number. This number is then called a pH value.

pH is defined as

the logarithm to the base 10 of the reciprocal of the hydrogen ion concentration expressed in mol/l.

This can be interpreted as follows taking 10^{-7} as an example. 10^{-7} is another way of stating $\frac{1}{10^7}$. The reciprocal of this is 10^7. The logarithm to the base 10 of 10^7 is equal to 7, i.e.

$$\log_{10} 10^7 = 7$$

By the above, acidic aqueous solutions have a pH < 7, while alkaline aqueous solutions have a pH > 7.

Normal solutions are used to determine the beginning and end points of the pH scale. A normal solution of a substance is one which has a concentration of 1 mol/l of that substance. A normal solution of hydrochloric acid has 1 mol/l of H^+ ions. Since

$$\left[H^+\right] \times \left[OH^-\right] = 10^{-14}$$

then for a normal solution of hydrochloric acid

$$\left[H^+\right] = 1 \text{ mol/l} \quad \text{and}$$
$$\left[OH^-\right] = 10^{-14} \text{ mol/l}$$

Instead of using the value 1 for $[H^+]$ it must be expressed as the number 10 raised to a particular power. Any number raised to the power 0 is equal to 1. Hence

$$10^0 = 1 = \frac{1}{10^0}$$

Thus $\qquad \left[H^+\right] = \frac{1}{10^0}\,mol/l$

for which the pH value is 0.

By much the same reasoning, a normal solution of sodium hydroxide will have a pH = 14. The pH scale can be represented as follows

```
0          acidic      7      alkaline      14
|------------------------|--------------------|
                   neutral ↗
```

A unit change on the pH scale represents a 10-fold change in $[H^+]$ and hence a considerable change in activity.

To minimize pH change and hence its effect on processor chemical reactions, buffer systems are introduced into the solutions. A buffer system is a system of chemicals which will remove from solution any excess H^+ ions or OH^- ions. Thus pH tends to remain fairly constant.

The Restrainer
The function of the restrainer is to improve the selectivity (and hence image contrast) of the developer. It retards the build-up of fog in the unexposed areas of the film. By carefully balancing accelerator and restrainer, image contrast can be controlled. The usual (inorganic) restrainer is sodium or potassium bromide.

Prolonged immersion in developer produces increased fogging, the amount depending on the developer activity. There is thus an optimum development time (and temperature) for a given optimum image contrast. As films are developed, the bromide from the film adds to the restrainer content of the developer and developer activity decreases. Hence developer exhaustion is progressive and depends in part on the number of films processed. Replenisher solution contains little or no restrainer because of this bromide addition to the solution from the film.

In PQ developers, a very small amount of an organic restrainer (e.g. benzotriazole) is required in addition to the inorganic bromide restrainer. Organic restrainers are called antifoggants to distinguish them from inorganic restrainers because the mode of action is different but they nevertheless reduce development fog and improve developer selectivity. Antifoggants are also included in the film emulsion.

The Preservative
During the development of the film, the developer donates electrons and this represents oxidation of the developer. The oxidation products so formed promote further oxidation and the developer rapidly deteriorates. The inclusion of a preservative (sodium or potassium sulphite) prevents further oxidation by reacting with the oxidation products to produce sulphonates. These sulphonates are incapable of promoting further oxidation and hence developer life may be prolonged. The preservative thus reduces excessive oxidation but cannot eliminate it.

Any developer exposed to air will be rapidly oxidized using up the available preservative very quickly indeed. The preservative content is not primarily intended to combat this aerial oxidation. This type of oxidation should be minimized by using a cover (floating lid) on the developer solution in a manual processor or the replenisher solution in the reservoirs of an automatic processor. This is particularly important in the case of the developer replenisher reservoir for an automatic processor since this will contain high energy developer which rapidly oxidizes when exposed to air.

The Buffer
A buffer system is a chemical system which limits pH changes. From what has been said previously it will be seen that this system is an essential requirement in X-ray developers. To obtain the correct degree of developer activity and hence optimum image quality the pH of the developer must remain fairly constant during its working life. This is only possible if a buffer system is used. Where a buffer is not used the developer pH will drop fairly rapidly with use and quickly become useless.

A solution is said to be buffered when it is capable of accepting appreciable quantities of an acid (or alkali) without any substantial alteration in pH. During use the pH should vary only by 0.1 – 0.2 units. As already stated, litmus papers (accuracy ± 0.5 pH units) for testing developer pH to ensure correct activity are of little use. The most useful test method is to assess developer activity in terms of the image quality produced by processing sensitometric test film strips at regular intervals and plotting speed and contrast index against time and fog level against time. These measures can be determined with a densitometer. When doing this test the developing conditions must be constant and identical for each strip of film but this is discussed fully in Chapter 14. This test is not to determine pH, but simply monitors the consistency of image quality, and should this change intolerably then checks can be carried out on such things as pH to determine the possible cause. An electronic pH meter is a convenient and accurate instrument to measure pH.

The buffer system in the developer is designed to absorb hydrogen ions formed as a result of the development process, thus preventing any change in pH. The system used is usually a combination of weak acidic and alkaline compounds. Strong acids and alkali are almost completely dissociated

into an ionic state when in solution. Weak acids and alkalis are only partially dissociated. The number of available ions is an indication of activity, the greater the number the greater the activity. The idea is to include in the developer substances which will react with these highly active substances released in a developing solution (as a result of the developer action) converting them to a relatively un-ionized form, i.e. the hydrogen ion concentration varies little and hence pH remains fairly stable.

Solvent

The solvent is water and

 (i) Acts as a vehicle in which the film emulsion and processing chemicals can react
 (ii) Allows chemicals to penetrate the emulsion
 (iii) Acts as a diluent to produce the required activity and concentration
 (iv) Allows chemicals to obtain an active ionic form.

The water used to dissolve a powder developer or dilute a liquid concentrate may have a varying degree of 'hardness' dependent on the type of soil through which the original rain water passed. This hardness is due to the water containing one or more of the following:

 (a) calcium bicarbonate
 (b) calcium sulphate
 (c) magnesium bicarbonate
 (d) magnesium sulphate

The bicarbonates confer 'temporary hardness' (removed by boiling), and the sulphates confer 'permanent hardness' (not affected by boiling).

In general these substances would react with the developer to produce insoluble precipitates, particularly in liquid concentrates, if it were not for the fact that the concentrate contains a sequestering agent acting to prevent this. The type of water used to mix solutions is thus not important as long as it is clean containing no particulate matter.

Fungicide

Many different chemicals can perform this function of preventing the growth of bacteria in the developer during use and while being stored and one is included in all developers for use in X-ray departments. Certain bacteria can reduce sulphite to sulphide thus producing a powerful fogging agent and this must certainly be avoided.

Antiswelling Agent

In manual processing above 75° F (24° C) where the excessively high temperature is unavoidable, the addition of sodium sulphate to the developer will prevent excessive swelling of the emulsion. Excessive swelling makes film damage more likely. Sodium sulphate also slows down the development rate thus

obtaining uniformity of development and a useful contrast. In automatic processing the developer works at a much higher temperature than in manual processing, and antiswelling and hardening agents (aldehydes) are added so preventing film damage on its passage through the rollers. These aldehydes can also act as a fungicide.

The Need for Replenishment

During the use of the developer

(a) The bromide concentration increases	bromide from the films being developed adds to the restrainer content. Developer activity gradually falls
(b) Developer level falls	developer solution is carried out of the tank in and on the film emulsion. Evaporation also occurs
(c) Oxidation occurs and the preservative content is slowly depleted	more preservative must be added
(d) Developing agents are used up	developer activity drops. To maintain activity more developing agents must be added
(e) Alkalinity is reduced	developer activity is further reduced. More alkali accelerator must be added.

To counteract each of these the developer solution requires replenishing for both solution level and chemical constituents. Unfortunately the rate at which the developing solution level requires replenishing is usually different from the rate at which the chemicals themselves need replenishing to maintain a constant activity. Since there is only one solution for replenishment, maintaining a constant developer activity and solution level is a difficult procedure in manual processing. One of many empirical methods may be employed but each requires frequent and regular testing with film strips to see if the method adopted is maintaining a constant developer activity in terms of the image quality produced.

In automatic processing in particular the activity of the processing solution is maintained rather than the solution level being a prime consideration. Using squeegee rollers very little developer solution is carried out of the tank and there is little change in solution level. When replenisher is added to maintain chemical activity this is more than enough

to maintain solution level and overflow to the drain always occurs. Thus replenishment accounts for both solution activity and level simultaneously. This technique of replenishment is often called the 'feed and bleed' method.

Replenishment rate to achieve constancy of chemical activity depends on the number and frequency of films processed and the type of image. A high density image requires a high replenishment rate. The image density in practice varies from film to film, and only by trial and error can the optimum replenishment rate be determined. Processing a small number of films infrequently requires a higher replenishment rate than continuous processing of a large number of films. Replenishment rate not only depends on the number and frequency of films processed and the average image density but also on such factors as (a) developer temperature and (b) developer concentration. The higher the temperature, for example, the higher will be the oxidation rate and the greater the replenishment rate required. In automatic processors due to the high temperature and concentration the developer progressively deteriorates even when films are not being processed. The actual determination of an optimum replenishment rate is thus difficult.

As films pass into the developer tank replenisher is added continuously. Freshly added replenisher is mixed with developer already present partly through the action of normal roller rotation but mainly by recirculation pumping of chemicals which also serves to maintain temperature equilibrium in the solution. Any excess developer flows over the top of the tank and away to a drain thus automatically accounting for replenishment for solution level. Adding replenisher and allowing the excess to flow away during thorough mixing maintains a constant level of activity. Constancy of chemical activity can and should be checked with a suitable process control method to assess image quality.

Once in operation the bromide added by developing films is continually being drawn off and the restrainer activity remains fairly constant.

Replenishment in Manual Processing
In manual processing replenishment consists of:

 (i) Addition of alkali to increase pH. This is to overcome the depression of the developing agent's activity due to bromide build-up in the developer
 (ii) Addition of water to counter the evaporation and carry-over
(iii) Addition of developing agents to replace those used up
 (iv) Addition of preservative to reduce oxidation rate and replace that used up
 (v) Addition of fresh buffer to prevent too rapid a reduction in pH.

Two common methods of developer replenishment are:

(a) *Maintaining developer solution level only* – During use the solution level is simply maintained by the addition of developer replenisher solution. This method seems to be the one most frequently employed because it is the simplest. It is sometimes called the 'topping-up' method. During use of the developer over a period of time bromide concentration increases. This does not go on indefinitely since the higher the concentration the more is carried out of the developer with the film. An equilibrium concentration of bromide is soon reached and remains constant providing the carry-over volume remains fairly constant, the carry-over volume being the volume of developer removed with each film. Providing developer activity is not depressed unreasonably by the equilibrium concentration of bromide then the 'topping-up' method is acceptable.

(b) *Area/volume replenishment* – For a given developer activity a particular density and contrast is obtained in a given development time. This situation can be maintained if the volume of developer replenisher added is related to the area of film processed. The actual volume per unit area required depends on several factors and is best determined by experiment using as a starting point the manufacturers' recommendations.

The factors affecting the success of this method are:

 (i) Length of period of film draining time
 (ii) Type of hanger used for the film as this can influence the carry-over rate (a hanger is the metal frame supporting the film)
(iii) Density to which the film is developed
 (iv) Type of film
 (v) Temperature of the developing solution
 (vi) Operator's method of developing a film.

Unfortunately this method of developer replenishment may not match the rate required to maintain the developer solution level. The replenishment rate may be too great or too little to maintain the developer solution level. Various methods have been used to overcome this but in use it is difficult to obtain any better results than with the first method.

This method is further complicated by the fact that now automatic processors are so common that the manual process is used only for special purposes. Large volumes of processing chemicals made up in a manual processor are used less frequently and often become unusable due to oxidation before an economic quantity of films have been processed in them. There is little point in replenishing a solution which is not being used simply to combat the effects of oxidation. In future, perhaps, where manual processing is infrequently required, it will be done with small volumes of fresh chemicals, prepared especially for the job and then discarded. This obviates the need for any form of replenishment. With correct replenishment, the life of the developer is

considerable, discard of solution often being unnecessary until far more than the original volume of developer has been replaced by replenisher.

Replenishment in Automatic Processing

This is the 'feed and bleed' method already mentioned. The developer solution is contained in one tank in which the rollers are immersed and through which the film passes. This tank is supplied with replenisher solution from a reservoir tank by means of a pump. When the film for processing enters the first pair of rollers the replenisher pump is switched on and replenisher solution is added to the developer tank. Any excess flows away to the drain from the developer tank. This is shown in Figure 13.7. If the replenishment rate is correct then both developer activity and solution

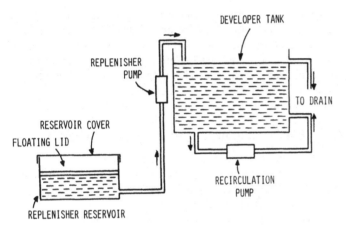

Figure 13.7 The 'feed and bleed' replenishment system. The temperature control system has been omitted, as have the film transport rollers

level will be constant providing film feed-in technique is consistent. When a film is pushed towards the first pair of rollers a microswitch is operated by the film detector to start the replenisher pump which will continue as long as the film is passing the detector (Figure 13.8). Replenishment rate is usually quoted for a 35 cm length of film when the film is 35 cm in width.

The length of time for which the replenisher pump is activated depends on the length of the film and is independent of film width. Consider for a moment what would happen to replenishment volume and related developer activity when a 35 × 43 cm film for example is fed into the processor in two different ways. The area of this film is 1505 cm² and assuming a replenishment rate of 90 ml per 35 cm length of film then feeding the film into the processor (i) with the 35 cm length parallel to the side of the film feed tray provides a total replenishment volume of 90 ml for this film, and (ii) with the 43 cm length parallel to the side of the film feed tray provides a total replenishment volume of 110 ml for this film.

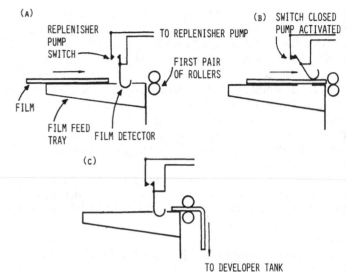

Figure 13.8 One method of film detection

Obviously replenishment rate depends on the way in which the film is fed into the processor. An even greater discrepancy in replenishment volumes occurs when the two dimensions of the film are very different. Consider a 18 cm × 43 cm film. Fed in one way the replenishment volume is 110 ml while if fed in with the short edge parallel to the side of the film feed tray the replenishment volume is 46 ml. It is apparent that an inconsistent method of film feed into the processor can lead to considerable variations in resulting image quality because of the different replenishment volumes being delivered for the same area of film.

Consideration should also be given to the processing of single emulsion roll film. If a great deal of this is to be processed at any one time then replenishment rates must be altered. For example, with a replenishment rate set at 90 ml per 35 cm length of 35 cm × 35 cm duplitized film, a 100 m length of 35 mm cine film would provide a total replenishment volume of about 2570 ml. The area of this film is 3500 cm² (about twice that of a 35 cm × 43 cm film) and, since it is single emulsion film, would require a total replenishment volume of about the same as the 35 × 43 cm film, i.e. 110 ml. If this is accepted then the correct replenishment rate for the cine film is considerably lower than the 90 ml per 35 cm length of film.

The film detector operates the replenisher pumps for both developer and fixer simultaneously. The type of detector used depends on the make of processor. That illustrated in Figure 13.9 is representative of the Ilford and 3M processors. One particularly sophisticated film detector used by DuPont in the Cronex T5 processor is an infrared beam and photocell. There are four infrared sources and four photocells arranged in pairs equally spaced above and across the width of the tray. The alteration in reflectivity as the film passes beneath the

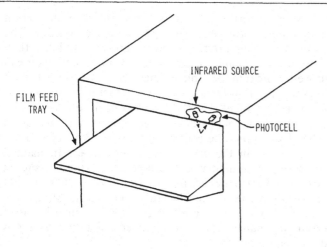

INFRARED SOURCE

FILM FEED
TRAY

PHOTOCELL

Figure 13.9 The DuPont film detection system

detectors triggers the replenisher pumps. The main advantage of this method is that it avoids pressure on the film when it passes the detector system.

Developer for Automatic Processing

The automatic process is considerably shorter than the manual process, requiring higher temperatures, concentration and pH values and a shorter developing (and fixing) time. Because of this the chemistry employed is substantially different from that used in manual processing. In manual processing two solutions – developer and replenisher – are used each having quite a different formulation from the other. This is not so in automatic processing. Here only one formulation is used (to constitute a replenisher). For use as a developer the replenisher is modified by the addition of acid starter solution.

Initially the reservoir contains replenisher and so does the developer tank. The replenisher in the developer tank is too active as it stands and would produce too much development fog since it contains no restrainer. The acid starter is an acidified solution containing restrainer and is only added to the developer tank when it is initially filled. Subsequently, developer bath depletion of acid starter through feed and bleed replenishment is counteracted by the addition of restrainer elements from the film emulsion during development. Depression of developer activity by film emulsion additions must be balanced by developer activity enhancement through replenishment and the replenishment rate must be carefully chosen.

The developing agents are similar to those used in manual processing chemicals, namely phenidone and hydroquinone, but work at a much higher temperature. The length of time these agents have to act is comparatively short and to facilitate rapid and even penetration of the film emulsion, modern emulsions are made from a mixture of gelatin and synthetic polymers of vinyl compounds and are much thinner than the older type of manual process film. The emulsion is also pre-hardened and contains organic antifoggants (or stabilizers) to combat development fog at the high temperatures and activity employed.

The developing agent phenidone is relatively unstable in strong alkaline solution, as in the case of replenisher solution for automatic processing, and deterioration is progressive when the solution is prepared. Deterioration would be rapid in the liquid concentrate form if the phenidone and strong alkali used were in the same solution. For this reason phenidone and alkali are supplied as separate solutions. Again, for a similar reason the hardener content is supplied as a separate solution from the alkali. Replenisher for automatic processing is thus a three-solution system prior to preparation, with a fourth solution, the starter, required initially when using replenisher solution as a developer. These solutions are normally supplied as parts A, B, and C in liquid concentrate form to make replenisher. Part A will usually contain hydroquinone, accelerator and preservative, part B will have the other developing agent phenidone and the last part, C, will contain the hardener (glutaraldehyde) and hardener preservative. There are many other additions present in these solutions such as wetting agents, sequestering agents, buffers, plasticizer, and evaporation suppression chemicals. Precise formulation and constituents are usually a closely guarded secret and indeed it is unnecessary for the practising radiographer to require such information.

Developer in the automatic processor could, in theory, be replenished indefinitely but a sludge develops in the tank resulting from film processing and tends to collect on the rollers producing dirty marks on the films. The sludge also impedes efficient solution recirculation and so periodically it is necessary to change the solution completely. The frequency with which this is done depends on the volume of work but the necessity for a solution change can be determined by inspection each time the developer rollers are removed for cleaning, and by reference to the image quality control chart (Chapter 14).

Developer (and fixer) for automatic processing are now referred to in terms of low temperature chemistry. Changes in formulation in terms of quantities and nature of subsidiary constituents have resulted in developer (and fixer) which can operate at a lower temperature without alteration in image quality indices.

Fixer Constituents and Effect

The function of the fixing solution is to remove unexposed (and hence undeveloped) silver halide from the emulsion so that any subsequent exposure to electromagnetic radiation produces no further change in the image. The silver halide emulsion is opalescent because of the halides suspended in it. As the fixer reduces an area containing undeveloped silver

halides, the area becomes transparent (clear) and the clearing time provides the basis for deciding the fixing time.

The fixing solution is generally made acidic because this allows hardening of the emulsion to be achieved (the hardener functions in an acidic solution) simultaneously with the fixing action. The acid also prevents fixing agent decomposition due to alkali carry-over from the developer. Besides removal of unexposed silver halide the fixer prevents further development occurring by neutralizing carried-over developer, renders the image permanent and hardens the emulsion gelatin.

With an increasing number of films passing through the fixer solution, gradual exhaustion is apparent. The fixer gradually becomes unusable because of fixing agent decomposition (due to developer carry-over) as the acid is gradually neutralized. Dichroic fog (see below) is then most likely to occur. This happens in manual processing and it is apparent that after a period either a fresh solution must be prepared, discarding the old, or a suitable replenishment technique established.

In automatic processing gradual exhaustion is not allowed to occur since a feed and bleed replenishment system is used. Within two or three days of film processing in a freshly prepared fixing bath equilibrium is reached where there is a constant level of waste products of the fixing reaction. The equilibrium condition is maintained by a suitable replenishment rate and a greater level of exhaustion of the fixing bath as a whole is prevented.

The waste products of the fixing reaction are the bromide and the soluble silver complex. The quantity of these end products increases with an increasing number of films fixed and unless replenishment is carried out, the build-up of end product gradually slows down the fixing reaction and eventually prevents it taking place. The fixing solution is then described as being fully exhausted.

Silver can be recovered from waste fixer and recycled, and in a busy department processing many thousands of films each year is economically viable giving a considerable financial return.

The main constituents of a typical fixer are

(i) fixing agent
(ii) acid
(iii) preservative
(iv) hardener
(v) buffer
(vi) solvent.

Fixing Agent

Either sodium or ammonium thiosulphate is used as the fixing agent. Sodium thiosulphate is employed in powder fixer (now little used) which must be dissolved in water for use and ammonium thiosulphate is used in liquid concentrate fixer suitable for use in both manual and automatic process-

ing. Ammonium thiosulphate is more rapid in its fixing action than sodium thiosulphate, giving a shorter clearing time. The silver complexes produced have a greater solubility than those of sodium and the ammonium thiosulphate fixer can process more films per unit volume (i.e. its rate of exhaustion is slower per film fixed). The fixing reaction produces two main end products as already stated, one of which is important from the point of view of silver recovery. For this reason waste fixer should be collected for silver recovery and not discarded as in the case of waste developer. In manual processing without fixer replenishment the fixing bath should be replaced when the clearing time (p. 208) is about twice that of a freshly made fixer or when the silver concentration of the solution has reached about $10\,g/l$ as determined by silver estimating papers. The use of silver estimating papers is discussed on pp. 185.

Acid

The fixing agent will decompose in the presence of a strong acid and this is the reason why a two-part preparation of fixer is available in liquid concentrate form for automatic processing (and manual processing). The acid used in autoprocess liquid concentrate fixer is given as sulphuric acid and is in a separate container from the fixing agent. In preparing the fixer solution the liquid concentrates are considerably diluted with water reducing the risk of decomposition of fixing agent in freshly prepared working strength solution.

The function of the acid is to ensure a suitable pH value is achieved for efficient hardening of the emulsion during fixation. The acid also neutralizes carried-over developer preventing dichroic fog occurring as the result of development continuing in the presence of a silver halide solvent; it terminates development when the appropriate average image density is reached; it helps reduce excessive emulsion swelling and prevents staining of the emulsion by oxidized products of the developing agents.

Dichroic fog stains the film pink when viewed on an illuminator. The stain appears yellow when viewed with reflected light. It is the result of silver particles being deposited on the film when development continues in the fixer.

Preservative

Even though the acid is weak when in working strength solution the fixing agent can still decompose and a preservative (stabilizer) is required to prevent this. If decomposition occurs then sulphur is precipitated and this is called sulphurization (as opposed to sulphiding which occurs through breakdown of the thiosulphate by electrolysis in silver recovery when the recovery rate is too high without agitation. Sulphur is again released). The presence of a sulphite acts as a preservative slowing down the rate of decomposition but not preventing it.

Hardener

Alkali in the developer will soften emulsion allowing it to become swollen with fluid and easily damaged. In manual processing potassium alum has been used as a hardening agent while the more soluble aluminium chloride or sulphate has been used in liquid concentrates. In rapid processing the hardening rate may be slower than the fixing rate and consequently a degree of emulsion prehardening is employed in film manufacture and both autoprocess developer and fixer contain hardening agents. Glutaraldehyde in the developer is a particularly powerful hardener necessary because of the strongly alkaline conditions and the physical stress of roller transport. This reduces the amount of hardening necessary in the fixer and allows a relatively short time for the film to remain in the fixer.

In terms of pollution, glutaraldehyde is a potent chemical, and by reducing the stress on the film due to roller transport (by employing a linear path) it is possible to reduce the hardener content of the developer thus reducing the pollution hazard. The 3M-XP510C processor employs a linear film travel avoiding the necessity for the film to bend at film guides at least until the film is fully washed after fixing. Using developer chemistry containing the usual complement of glutaraldehyde in this processor will mean a longer development time because of slower penetration of developer agents. With low pollution chemistry (reduced glutaraldehyde) 90 s or slightly less can be achieved for the cycle time. Unfortunately with a linear film path the film feed in rate tends to be slow because the total path length is very much less than in a typical deep tank autoprocessor, while the cycle time remains unchanged.

In manual processing using an ammonium thiosulphate liquid concentrate diluted to working strength the fixing action is achieved much more quickly than adequate hardening. The clearing time (p. 208) shows when the film is fixed but for adequate hardening it has been recommended that twice the clearing time be employed.

Buffer

Aluminium hardening agents require a pH of 4.0 to 4.5 for efficient function and above this pH range precipitation of aluminium as aluminium hydroxide will occur. Buffers are used to prevent this.

Solvent

Water is used and

(i) Acts as a vehicle in which the film emulsion and processing chemicals can react
(ii) Allows chemicals to penetrate the emulsion
(iii) Acts as a diluent to produce the required activity and concentration
(iv) Allows the chemicals to obtain an active ionic form.

Fixer Replenishment

In common with the developer, use of the fixer brings about solution exhaustion, the rate of which depends on the conditions under which the fixer is used and the number of films fixed.

In use, in the absence of an adequate replenishment system,

(a) The bromide concentration increases	bromide from the reduced unexposed silver halide builds up as an end product of the fixer reaction. The greater the quantity of end product the slower the initial reaction becomes
(b) Fixer level tends to remain reasonably constant	this occurs because water is carried into the fixer (in a manual processor) from the spray rinse while fixer solution is removed with the film to the wash tank. In autoprocessing the very small amount of developer brought into the tank is balanced by the small amount of fixer taken out when the film leaves. Replenishment of fixer is mainly for activity rather than solution level
(c) Fixing agent concentration decreases	this occurs as a normal result of the fixing reaction when the fixing agent is gradually used up
(d) The soluble silver complex concentration increases	this again is an end product of the fixing reaction and the build-up tends to slow down the initial reaction
(e) Fixer is diluted by water carried over (manual process)	this reduces fixing agent concentration and slows fixing rate. pH also rises as the buffer is gradually depleted by carry-over
(f) Hardener content is reduced	films are less efficiently hardened and drying time will be increased.

Replenishment in Manual Processing

Where this is practised one of several different techniques could be employed but each involves the removal of a

volume of used fixer and the addition of a replacement volume of fresh fixer (working strength).

The amount of fixer removed can be related to the total area of film which when processed through a fresh fixer solution produces exhaustion (when the clearing time is doubled). If this total area is experimentally determined as $x\,m^2$ and the fixer tank capacity is 45 l then when a convenient fraction of $x\,m^2$ has been processed, that same fraction of 45 l can be removed and replaced with fresh fixer. For example if $x = 800\,m^2$ of film then when 100 m^2 has been fixed then $\frac{1}{8} \times 45$ l of fixer can be replaced.

Unfortunately this technique while maintaining fixing agent activity will not necessarily maintain a constant pH and this should be checked.

The tendency is towards complete replacement when the clearing time has doubled rather than attempt fixer replenishment in the limited situations where manual processing is still carried out.

Replenishment in Automatic Processing

In common with the developer replenishment system this is a feed and bleed method and the process is identical to that for the developer replenishment. The replenishment rate varies depending on the conditions of use but is usually around 100 ml for a 35 cm film length of 35 cm wide film and a 90 s cycle time. Too high a replenishment rate simply wastes chemicals, while too low a replenishment rate can result in incomplete fixation and hardening reducing the storage life of the finished film. In addition the film leaves the processor incompletely dried.

The replenishment of the fixer is aimed at maintaining fixer activity and more fixer replenisher is added than is needed to maintain solution level. The overflow of used fixer is collected for silver recovery. Following silver recovery a proportion of the used fixer may be recycled following the addition of suitable chemicals thus reducing the amount of desilvered fixer poured down the drain.

Fixing Time

In automatic processing the fixing time is determined by the speed of travel of the film and the path length in the fixer. The speed of travel is in turn set according to the temperature and concentration of the fixer and the replenishment rate required. Primarily, of course, development conditions determine process cycle time and in practice fixer conditions are adjusted to suit this cycle time.

In manual processing there is no such control. The fixing time is generally taken as twice the clearing time but when the clearing time has increased to twice the value for a fresh solution the fixer should be discarded. To determine the clearing time an unprocessed film is used and the test can be carried out in white light. Partly immerse the film in the fixer and hold it steady for about a minute. A boundary will have formed showing clear film on one part and unprocessed film on the other. Immerse the film so that the boundary is below the fixer solution surface but can be clearly seen. Note the time. The clearing time is the length of time it takes for the boundary to disappear.

FACTORS AFFECTING DEVELOPMENT AND FIXATION

Development is affected by

(i) temperature
(ii) concentration
(iii) type of developer used
(iv) time for which the film is immersed
(v) degree of agitation
(vi) degree of exhaustion
(vii) replenishment rate.

Temperature influences the rate at which development proceeds but in general in manual processing the image contrast obtainable decreases with increasing developer temperature. As temperature rises an increasing amount of unexposed silver halide is reduced with resultant development fog reducing contrast. The development time necessary to produce a given image density reduces with increasing temperature. In automatic processing experience has shown that the change in image contrast with changing developer temperature, while apparent, is less than with manual processing. Because temperature influences development rate, development time and temperature are inversely related. In manual processing a time–temperature curve may be used to determine the appropriate development time at a given temperature. The higher the temperature the greater the replenishment necessary for a particular activity. In automatic processing a fixed temperature and cycle time are generally adopted and a time–temperature curve is redundant.

The concentration of developing solution influences its activity and hence determines development time at a given temperature. Practically, the most important point relates to unequal concentration throughout a working strength solution because of inadequate mixing during preparation. Different parts of the film image then develop at different rates in manual processing. In automatic processing this would not occur in the developer tank because of constant agitation through solution recirculation. However, inadequate stirring during preparation of replenisher can lead to replenisher of varying concentration being delivered to the developer tank each time a film is processed. This will affect resulting image quality.

The type of developer used and the chemicals it contains will determine the speed and contrast obtained. This is not

necessarily an important consideration because there is a striking similarity in performance of liquid concentrate chemicals for radiographic film processing from the various manufacturers and image quality is determined more by cycle time, temperature and replenishment rate together with the choice of other imaging parameters such as film type, intensifying screens, exposure factors, scatter control etc.

In a particular developer preparation the film immersion time is temperature dependent and is determined from the appropriate time–temperature curve in manual processing as already stated. In automatic processing a particular immersion time is required at a particular working temperature depending on manufacturers' recommendations for the chemistry used, and this must be coupled with an appropriate replenishment rate. Unlike automatic processing, the developer in manual processing is not continuously agitated. A stationary film in a static developer solution is slower to develop than if intermittent or continuous agitation is used. Agitation increases the rate at which fresh developer replaces exhausted developer at the film surface and hence development is more rapid.

A replenishment rate which is too great produces an overactive developer of lowered selectivity. This produces increased speed but reduced image contrast. At high operating temperatures the developer oxidation rate is increased and a proportionally higher replenishment rate is required to prevent excessive developer exhaustion. A processor used only intermittently but continuously maintained on standby when not in use will also suffer gradual developer exhaustion from oxidation, which will not be fully counteracted by the replenisher delivered when the next film is processed unless the rate is increased to account for the film processed and the oxidation. It is apparent that a very high replenishment rate is necessary in high temperature, 90 s processing with intermittent film processing. A reduced replenishment rate can be achieved if a longer time cycle is used with lower temperatures. This also reduces the amount of developer overflow to the drain with a consequent reduction in environment pollution. In manual processing gradual developer exhaustion is experienced as a reduction in speed and image contrast.

Fixation is affected by

(i) temperature
(ii) concentration of thiosulphate
(iii) type of fixing agent used
(iv) degree of agitation
(v) degree of exhaustion.

Temperature and concentration of fixing solution determines the rate at which fixation takes place, influencing the emulsion permeability to fixing agent and the rate of silver complex diffusion. The thinnest emulsion films fix most rapidly. Screen-type films are designed specially for rapid processing whereas some direct-exposure films have such a thick emulsion that fixation cannot be completed in the time allowed in 90 s processing. This type of film should not be autoprocessed. Again, the type of image influences the fixation rate. An image which has received little exposure will require longer to fix than a completely exposed film which has received a large exposure. Fixer replenishment rates are determined in part by the type of film image to be fixed.

In automatic processing the agitation of the fixer is vigorous, being performed by rapid solution recirculation. This increases the rate of fixation by rapid replacement of exhausted fixer at the film surface and removal of silver complexes from the film into solution. In manual processing, the use of continuous manual agitation of the film can reduce fixation time by up to 25% for the same reasons. Again in manual processing the possibility of dichroic fog is reduced if the film is vigorously agitated when first placed in the fixer since this would rapidly neutralize carried-over developer. Hardening of the emulsion has little effect on fixation rate.

Fixer Elimination in Manual Processing

Before washing and drying the film it should be thoroughly drained into the fixer so minimizing silver carry-over to the wash tank. Nevertheless the film is still saturated with fixer solution. Removal of this is generally by washing the film in running water for up to 1 hour if archival storage of radiographs is required. Only about 30 min washing is required for the normal storage period. Use of a fixer eliminator prior to washing can reduce the required washing time to 5 min, but almost complete replacement of manual by automatic processing has made this technique more or less redundant.

WASHING

The function of washing is to remove fixer products from the film surface and within the emulsion. These can cause image fading or discolouration on storage and must be removed if image permanence is to be achieved. Removal of retained fixer is achieved through washing as a result of

(a) Diffusion from within the emulsion which is dependent on the concentration gradient (circulating water being rapidly replaced by fresh would maintain the highest gradient)

(b) Rapid replacement of water from the surface and immediate vicinity of the film. The contaminated water is replaced by fresh either as a running water bath or as a spray rinse.

Using running water in this way produces the most efficient and quickest method of washing, but it is uneconomical in terms of water usage. A greater economy may be achieved by raising the temperature of the water, using less of it, and washing for the same length of time as before. This unfortunately uses power to heat the water.

The longer the washing time the greater the length of time the film can be stored without noticeable image deterioration.

Where long storage is required (archival storage) and water is short a fixer eliminator may be used coupled with a relatively short wash when manual processing is all that is available. The fixer eliminator is a specially formulated alkaline solution.

A long washing period may soften the emulsion leading to increased risk of damage undoing the work of the hardening agent, but this is only likely in manual processing.

In manual processing the wash time following normal fixation is about 10 min providing circulating water is used at the rate of four complete changes per hour. The wash time should be taken from the time the last film was immersed, since each time a film is immersed the concentration of fixer in the wash bath increases.

In automatic processing washing time is fixed at a given interval; it is very rapid and high water temperatures may be used, but more often the tendency is to use a cold water spray (or water bath).

DRYING

This is usually accomplished by evaporation through the use of hot air both in manual and automatic processing (in some autoprocessors the drying is done using infared heaters with a cold air blower). Evaporation is only effective if air is circulating and the relative humidity is low. In manual processing drying time can be reduced by immersing the film in a suitable wetting agent after washing. Wetting agents are commercially available for this purpose but again with the advent of automatic processing this procedure is not widely practised.

AUTOMATIC PROCESSING

Automatic film processing is now a common and essential part of a radiographic department. Often there is more than one processor operating and manual processing is virtually eliminated except for special non-screen (direct exposure) films such as dental films which are too small to be accepted in the large film autoprocessor.

Automation in film processing has speeded up the process of obtaining the dry film end result and in general has reduced the amount of time a patient spends in an X-ray department. Automatic processing has also helped to achieve a greater patient throughput but its main contribution has been to help standardization of image quality.

Automatic processors employ a system of rotating rollers between which the film passes, being directed first into one tank then the next until development, fixation and washing of the film are completed. The roller transport system then directs the film into the drying section where the processing cycle is completed, the film being delivered to an output tray at the end of the cycle.

Figure 13.10 Kodak M100 autoprocessor

Figure 13.10 shows the Kodak M100 processor used as a free-standing automatic processor wholly within the darkroom. The long film feed tray allows the input side of the processor to be within the darkroom while the remainder of the processor lies the other side of the wall outside the darkroom if another method of arranging the processor is required. The arrangement used depends on the position and size of the darkroom and its relationship to other rooms. Figure 13.11 shows the same processor with the lid removed illustrating the rollers *in situ*. As another example Figure 13.12 shows the Ilford R200 processor with its lid removed and Figure 13.13 shows a close-up of the three sets of rollers. On the left is the developer, in the middle the fixer and on the

Figure 13.11 Kodak M100 autoprocessor with lid removed

Figure 13.13 Close-up of rollers in Figure 13.12

Figure 13.12 Ilford R200 processor with lid removed. The replenisher reservoirs can be seen at the bottom of the processor on the right

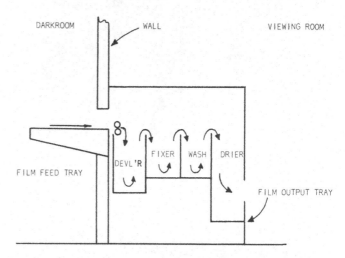

Figure 13.14 Diagram of path taken by film. Only the first pair of film transport rollers are shown

right is the wash tank set of rollers. The two curved, white tubes leading from the side over into the developer and fixer tanks are the replenisher pipes. The cogs seen in Figure 13.13 are all driven by the same motor so all rollers rotate at the same rate.

A diagrammatic representation of the path taken by the film is shown in Figure 13.14. The total process cycle time is usually 90 s but some processors have a control allowing the user to choose their own cycle time from about 60 s to 4½ min. Automatic processors are in use with even longer cycle times but they are the exception rather than the rule. 90 s or 3½ min are common process cycle times used but many processors have just a single cycle time of 90 s.

It is apparent that the developer tank shown in Figure 13.14 is deeper than the others and in some processors

development takes longer than fixing and washing. As an example Table 13.1 shows typical times for development, fixing, washing and drying for a 90 s cycle. Since the development stage in some processors takes longer than fixing or washing and the rollers rotate at the same rate in all sections the path length must be greater in the developer to achieve a longer film immersion time to complete development. In other processors the extra depth to the development tank is simply to allow sufficient room for the heating element, thermometer probe and heat exchange system beneath the roller rack. Otherwise the three sets of roller racks, namely developer, fixer and wash, are identical and each stage in the process takes the same length of time. Figure 13.15 shows the tanks of the R200 processor with the rollers and chemicals removed. Note the added depth of the developer tank on the

Table 13.1 Typical times for development, fixing, washing and drying in a 90 s cycle

Processor section	Time (s)
Developer	27
Fixer	21
Wash	21
Drier	21

Figure 13.15 Tanks of the R200 processor with chemicals and rollers removed. The main drive shaft is indicated by the arrows

right. The developer and fixer heating elements can be seen at the bottom of the tanks and the replenisher pipes hanging over the sides. An additional pipe is seen at the bottom of the developer tank. This is the heat exchanger. In the R200 and 3M-XP507, for example, each of the three processes, development, fixing and washing, take the same length of time.

For normal autoprocessor chemistry, the developer and fixer working temperature averages 35 °C. For the developer this must be maintained within ± 0.5 °C while for the fixer it

is sufficient if the temperature is maintained within ± 1°C. These figures refer to a 90 s cycle time. A different cycle time would require a different temperature. For example, a 3½ min cycle could be used for a developer and fixer temperature of about 30°C. Using low temperature chemistry, the 3½ min cycle, for example, can be achieved using as low a temperature as 27.5°C without alteration of exposure factors. The solution temperature is indicated by the temperature gauge on the front of the unit (Figure 13.16) and is thermostatically controlled.

Figure 13.16 Front of unit showing temperature gauge and switches

A closed recirculating system is used to agitate the developer solution with a similar system for the fixer. This together with the replenishment system maintains a constant activity throughout the respective solutions. The film is washed in a bath of fast running water or else by spray and is then dried either by having hot air blown onto the film or using infrared radiant heaters to dry the film and blowing cold air across the film to remove evaporated water.

Having given a brief introduction to automatic processing it is necessary to consider the different aspects of an automatic roller processor in greater detail.

Film Input

The film is fed into the processor by placing it on the film feed tray with one of its edges in contact with the feed tray edge. This ensures that the film is fed correctly into the first pair of rollers. The film feed tray and first pair of rollers must be clean and dry to avoid staining the film. The first pair of rollers are not part of the developer rack of rollers and simply serve to ensure correct feed into the first rack of rollers.

The presence of the film entering the processor is determined by the film detector system (Figures 13.8, 13.9), which starts developer and fixer replenishment (Figure 13.7) which

continues until the film has passed the detector. Replenishment then ceases. Before placing the first film in the processor it is necessary to check that

(i) The processor is switched on
(ii) The roller drive is activated ensuring roller rotation
(iii) The solution temperature is correct
(iv) The water is flowing and the flow rate is correct
(v) The level of replenisher in the developer and fixer tanks is adequate. This is determined by inspection of the reservoir level indicators.

It is assumed that the replenishment rates are correct. If when switching on the processor nothing happens check that the processor lid is seated properly, as for safety reasons when the lid is removed a switch is operated shutting off the processor. This measure prevents accidents such as a tie, sleeve or finger being caught in the roller drive mechanism. If the processor is still not working make sure that the isolator switches are in the 'on' position. If this fails, isolate the processor from the mains before looking for blown fuses within the machine, providing that the reason for failure is not a power cut.

The film detector circuit may be connected to a safelight above the film feed tray in such a way that it is turned off when the replenisher pumps are activated (when a film is activating the detector). When the film has passed the detector the safelight switches on and this can be taken as an indication that the processor is ready to receive another film. In addition, or as an alternative, a similar signal light may be an integral part of the processor being situated by the feed tray on the processor control panel. Feeding a second film too soon will cause overlap of films and they will adhere to each other and may not go through the roller system possibly sticking at some point.

For correct replenishment the films must be fed into the processor in the correct way and if two narrow films are fed in together they should enter the first pair of rollers simultaneously to ensure correct film transport. Manufacturers make recommendations on methods of film feeding in accordance with the replenishment rates they advise.

Figure 13.17 shows the angled film feed tray of the R200 processor with the three detector arms clearly seen in front of the first pair of rollers.

The Developer Section

From the first pair of rollers the film enters the rack of rollers suspended in developer solution in the developer tank. The developer tank is deeper than the fixer and wash tanks. In one case as mentioned earlier this is because a longer time is necessary for development than fixation or washing and a longer path length must be created in addition to allowing extra room for the heater, heat exchanger and thermometer

Figure 13.17 Film feed tray of the R200 processor showing film detector fingers

probe. In the R200 and 3M-XP507, for example, the additional depth allows room for the heater, heat exchanger and thermometer probe only and is not to create additional path length. In these two processors the developer, fixer and wash racks of rollers are more or less similar (and are colour

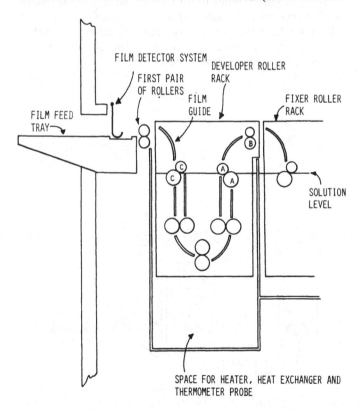

Figure 13.18 The developer roller rack. Rollers A serve as squeegee rollers while rollers B are the cross-over rollers

coded) and hence the path lengths in each tank are similar. All three processes thus take the same length of time. The colour coding is necessary to avoid solution contamination from interchanging racks, but more importantly to avoid film transport errors. The roller racks are designed as a system to ensure correct film transport from one roller rack to the next. This may not occur if the racks are placed in the wrong order since there may be slight differences in the entry and exit sections of each roller rack.

The developer roller rack is only partly immersed in the developer solution (Figure 13.18) and the rollers above the developer which transport the film into the fixer can collect crystallized developer resulting from evaporation. This eventually leads to film staining unless a suitable cleaning schedule is adopted. The cross-over rollers are generally easily removed for daily cleaning without removing the whole roller rack since crystallization is more likely to occur on rollers B than A or C (Figure 13.18). Weekly cleaning is generally sufficient for the remaining rollers on the rack, necessitating careful removal of the roller rack from the developer tank. To avoid contaminating the fixer it should be covered either with a splash guard if provided or at least a towel placed over the fixer tank and roller rack when the developer roller rack is withdrawn and replaced.

A black sludge tends to form on the rollers and sponging with warm running water is generally sufficient to remove it. After washing the rollers, the rack should be drained of excess water and carefully replaced. This should be done slowly to avoid overflow of developer.

When removing a roller rack for cleaning it is wise to inspect the tank itself to see if cleaning is required, necessitating draining of tank solution and preparation of fresh developer.

Figure 13.19 shows the developer tank with the roller rack removed to illustrate the heating element, the thermometer probe and the heat exchanger pipe. Also shown is the drain overflow and the inlet and outlet for solution recirculation. This is a typical example showing the elements contained in the developer tank. The drain overflow is a standpipe the height of which determines the level of the developer in the tank. If the standpipe is unscrewed by inserting the appropriate tool into the top of it and turning anticlockwise the standpipe can be removed and the developer drains away. The tank can then be cleaned and refilled with fresh developer once the standpipe is reinserted. When replenisher is pumped into the tank the overflow passes down the standpipe to the drain. The heat exchanger in this example is a pipe through which the wash water passes without mixing with the developer. The wash water is colder than the developer and heat from the developer passes through the wall of the heat exchanger pipe to the water thus preventing overheating of the developer particularly in hot climates. The increase in water temperature as a result is minimal and does not contribute to washing efficiency. Some processors require a warm water wash for the film and this is provided by using both a hot and cold water supply through a mixer valve which provides a water output to the processor of the required temperature. Figure 13.20 shows

Figure 13.19 Developer tank with roller rack removed

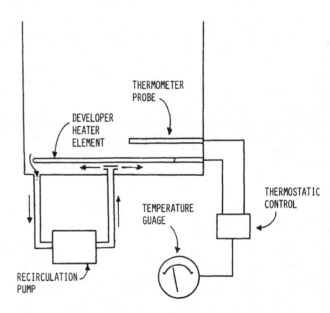

Figure 13.20 Recirculation and temperature control system for Figure 13.19. The heat exchanger pipe is not shown

the recirculation system and the temperature control system for the example of Figure 13.19.

The rollers in the developer are driven from a common drive otherwise one rack of rollers may rotate faster than another. This would create disaster when the film passed from one roller rack to the next. The cog of the developer roller rack (Figure 13.21), shown arrowed, is interlocked to drive threads which can be seen at the bottom of Figure 13.15. All the cogs on the rack are plastic and do not require lubrication.

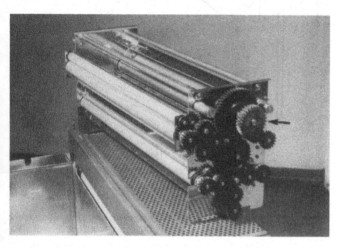

Figure 13.21 Cogs on the roller rack. The arrow indicates the cog linked with the processor main drive shaft

The Fixer Section

The fixer tank is shallower than the developer tank and consequently contains a smaller fluid volume. This tank together with the developer and wash tanks are made of stainless steel as an integrated unit. The developer and fixer tanks thus have one wall in common and so do the fixer and wash tank.

When the film wash is achieved using a spray rinse, cooling of the fixer by heat exchange with the wash water through the common wall is minimal. The fixer temperature is then more or less the same as the developer temperature, this being achieved by heat exchange (conduction) through the wall common to both developer and fixer tanks.

When the film wash is achieved using a running cold water bath then heat loss from the fixer to the wash water through their common tank wall is more than can be compensated for by heat exchange between developer and fixer. The fixer tank then incorporates a heating element of its own this being controlled by the thermostat associated with the developer temperature control.

The fixer tank heating element, drain overflow and solution recirculation inlet and outlet are shown in Figure 13.15 in the middle tank. The recirculation system for the fixer is separate to that of the developer, but is a similar system, and both operate continuously while the processor is switched on. Also in Figure 13.15 can be seen the fixer replenisher pipe. The film detector operates both fixer and developer replenishment simultaneously.

The rack of rollers in the fixer tank is similar to that in the developer tank and like the developer rack has only some of the rollers immersed in fluid. Those completely out of fluid will collect crystallized fixer on the output side (rollers E in Figure 13.22). Rollers E can be removed for daily cleaning

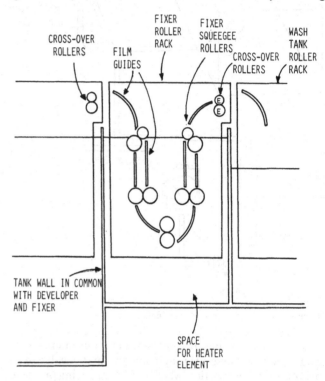

Figure 13.22 Rollers in the fixer tank

without having to remove the fixer roller rack. When the fixer roller rack is removed for weekly cleaning care must be taken that developer solution contamination does not occur by using a splash guard, or if one is not specially provided then a towel can be used. Replacing the cleaned rollers should be done slowly to prevent overflow of fixer into the developer tank. The process for cleaning the fixer roller rack is the same as for the developer.

The Wash Section

The wash tank is shown on the left of Figure 13.15 without its roller rack. This particular example uses a running water bath obtained from a cold water supply. The method of water circulation employed is shown in Figure 13.23 and a flow meter is used to obtain the correct water flow rate for

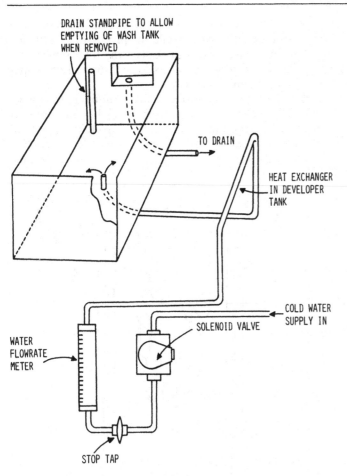

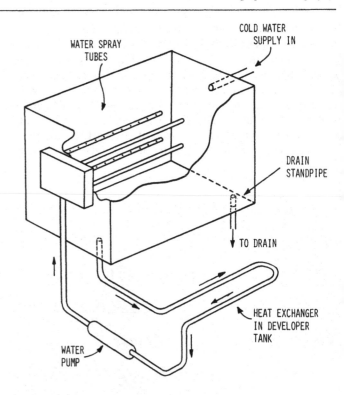

Figure 13.24 Spray wash tank. The spray tubes form an integral part of the wash tank roller rack. For clarity, only the spray tubes are shown

Figure 13.23 Running water wash bath

efficient film washing. Before the water input enters the flow rate meter it passes through an automatic valve which prevents wash water flow when no films are being processed. This conserves water. The water circuit of an automatic processor is usually arranged so that no backflow occurs if mains supply water pressure drops. This is the system of the 3M-XP507 and is shown in Figure 13.24. The input supply enters above the water level in the bottom of the wash tank so backflow cannot occur. Water collects in the bottom of the wash tank to a level of a couple of inches and this volume is continuously circulated by the pump. As fresh water is added overflow to the drain occurs.

The water flow rate used depends on the washing method employed. A running water bath technique requires a higher flow rate than a spray method. The XP507 uses 3 litres of cold water per minute, while the R200 with its running water bath uses 6 litres of cold water per minute. The roller rack in the wash tank is similar to those in the developer and fixer tanks. Occasionally a water filter may be necessary in the mains supply input to improve the quality of the water supply for washing films.

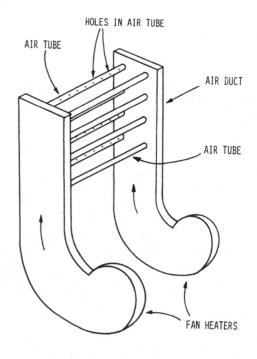

Figure 13.25 Heated air drier

The Drier Section

Either of two methods is used to dry films in automatic processing. The first employs a heater element across which air is blown. The heated air is then directed through holes in air tubes directly onto the film surface (Figure 13.25). The drier section film transport rollers are interspersed with the air tubes so that the film is directed between successive pairs of air tubes (Figure 13.26).

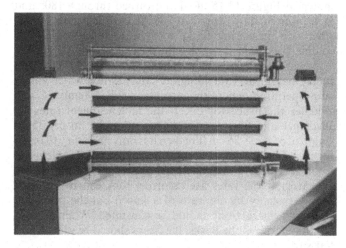

Figure 13.27 Radiant heater drier section. The arrows indicate the direction of airflow

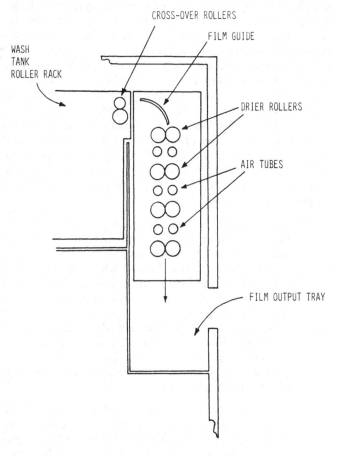

Figure 13.26 Roller rack in the drier section

Alternatively the drier rollers may be interspersed with radiant heating lamps. The 3M-XP507 employs radiant heating lamps and so does the Ilford R200. The drier section of the 3M-XP507 is shown in Figure 13.27 and fully opened in Figure 13.28. The radiant heaters dry the film as the result of heating with infrared radiation and cold air is blown across the film to remove the water vapour. The cold air is produced by fans and ducted to the film in the direction shown by the arrows in Figure 13.27. The thin wires stretched across the front of the heater tubes in Figure 13.28 serve to keep the film on its correct path and prevent it touching the tubes.

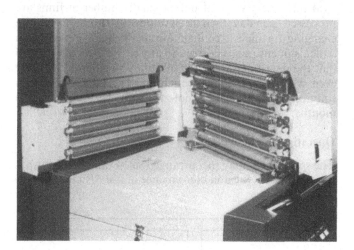

Figure 13.28 Rack in Figure 13.27 fully opened

The Replenisher Section

The developer tank and fixer tank are fed from their respective replenisher reservoirs, the principle of which is illustrated in Figure 13.7 and has already been discussed at length. Some processors have replenisher flow rate meters which merely indicate that replenisher is being delivered when a film is passing the detector. Others do not have this facility but the replenisher pumps can be heard operating. This, of course, does not prove that replenisher is being delivered to the tanks and it is wise to check the replenishment rates periodically and check the reservoir chemical level daily.

Replenishment rates are easy to check and the processor of Figure 13.15 will be used as an example. The processor cover must first be removed and the two replenisher pipes

shown in Figure 13.15 lifted and turned through 180° and each inserted into their own 200 ml measuring flask. Any other size measuring flasks may be used as long as the volume they hold is more than the volume of replenisher delivered during the check. Next activate the detector unit which may mean overriding the safety switch which comes into operation when the processor lid is removed and switches the processor off. If the replenishment rates for developer and fixer are given as x ml and y ml per 35 cm length of 35 cm \times 35 cm film then it is only necessary to insert such a film into the processor and collect the replenisher from developer and fixer reservoirs while the pumps are activated. If the rates are incorrect they can be adjusted simply (usually by the turn of a knob) but the processor operating instructions should be consulted. When reading the fluid levels in the flasks, the flasks should be placed on a flat surface.

As stated before, replenishment rates are dependent on many factors but it is worth noting that if the processor is used infrequently, i.e. if only a small number of films are processed each day, then the developer will probably require changing fortnightly to maintain image quality even when replenishment rate is correct. In any case it is recommended that the developer and fixer solutions be renewed monthly even with a high film throughput. The interval between solution changes should not normally be longer than 3 months.

Operating the Processor

The processor may be arranged in a number of ways depending on type and convenience of use. Usually the film

Figure 13.29 Possible position of processor

feed tray at the input side is contained within the darkroom while the remainder of the processor with the film output side lies on the other side of the wall in the viewing room (Figure 13.29). Other alternative arrangements are possible as mentioned earlier. A mains isolator switch is placed in the darkroom and another outside in the viewing room. The isolator switch, when off, breaks both live and neutral lines of the single phase supply to the processor. In other words the processor is totally isolated from the electrical mains supply. Two isolators are provided for safety reasons. If the situation demands that the processor be isolated from the mains this is possible even if one is unable to enter the darkroom. When either one or other of the isolators is in the off position the processor will not operate and both must be on for film processing. In practice if the processor fails to operate, the isolator switches are the first items to check to see if they are turned to the 'on' position.

The control switches for the processor are normally housed on the same side of the processor as the feed tray and usually consist of an on/off switch, solution temperature gauge and a film feed indicator light. Additional controls and indicators may be present depending on type and make of processor, and these include

(i) Roller drive switch which is useful when the processor cover must be removed and the safety switch overridden for checking replenishment rates. The drive can be switched off while the detector is operated by hand for a given period equal to the time for a 35 cm \times 35 cm to pass the detector, this time being dependent on the processor cycle time selected. Other manufacturers such as Kodak Ltd. provide a replenisher rate check which requires removal of an end or side panel and not the lid. Thus there is no danger of an accident occurring with the rollers or roller drive mechanism

(ii) Correct temperature indicator. This is a light which indicates when the correct solution temperature has been reached. The usual arrangement is that the light is on when the solution temperature is below that required for correct operation and is extinguished when the temperature is correct. This indicator is superfluous when there is also a temperature gauge from which solution temperature can be read directly but is necessary when a temperature gauge is not provided

(iii) Mains indicator light showing that the mains supply to the processor is on. This also seems superfluous since if the film feed indicator light and correct temperature indicator light are extinguished it is easy to tell that the processor is operational because of the noise it makes while functioning. When no film is in the processor and it is in the standby mode then the

film feed indicator light can be on serving the function of a mains indicator light. The R200 for example has a film feed indicator light which is on when a film is passing the detector system but off otherwise, and with the processor in standby with correct solution temperature the film feed and correct temperature indicator lights are off. The processor is more or less silent during standby and a mains indicator light is required to show that the processor is operational. Often coupled with the operation of the film feed indicator light is a bell which sounds when the processor is ready to receive another film. A remote safelight can also be made to switch on or off as a film feed indicator. Indicator lights should emit a light spectrum which does not fog films of the type used

(iv) Automatic standby switch. When on this ensures that the processor reverts to a standby condition when no film is being processed. This change over to standby condition occurs within ½ minute of the last film being fully processed. Change-over to standby condition is automatic anyway in some processors without an automatic standby switch being provided and the interval between the last film being fully processed and change-over to standby is adjustable. This is necessary in some cases when the processor is provided with a variable time cycle to make sure the change-over to standby does not occur while a film is being processed. When a roll film is processed the automatic standby can be switched off thus ensuring that the processor does not revert to standby during processing. In a well-designed system, change-over to standby means that the drier section, roller drive and wash water flow switch off automatically thus conserving energy and water. In standby the developer and, where fitted, the fixer heaters remain operational as do the solution recirculation pumps ensuring that the processor is ready for immediate use. Feeding in the next film causes the detector system not only to operate the replenisher pumps but also to activate the drier section, the roller drive and the wash water flow thus reverting from standby to an operational state

(v) Replenisher flow meters. These indicate that replenisher is flowing for both developer and fixer but do not provide a measure of replenishment rate. It is surprising that an automatic replenishment rate indicator with digital display is not provided on processors. With the availability of solid state microprocessors it should not be too difficult a matter to provide a digital display panel giving an information output suitable in a quality control programme

(vi) An additional temperature gauge indicating drier section temperature.

Before switching on the processor remove the lid and check the solution levels in the main tanks. If they are above the drain standpipe level the drain is blocked and the processor should not be used until the drain is cleared. To switch on the processor

(i) Ensure that the safety switch is not preventing processor operation by checking that the lid is correctly seated

(ii) Turn on the main water supply having first closed the wash tank drain valve if open

(iii) Switch on one or both isolators to provide electrical mains supply to the processor. This depends whether one or both were switched off

(iv) Switch on the processor at the control panel. Also switch on any accessory switches provided they are necessary for processor operation. The solution heaters and recirculation pumps should be operational at this point. It should be possible to hear the pumps operating.

Check the reservoir levels of replenisher solution and replenish them if necessary while waiting for the solutions in the main tanks to reach the required temperature. When this temperature is reached the processor becomes fully operational. About 5–30 min is the interval required from cold for the solutions to reach the operating temperature.

Next process several waste films and inspect them for marks and stains. If none are seen then it is safe to proceed with the film workload. While the waste films are passing through the processor check that the water is flowing and the flow rate is correct. Where an automatic standby switch is provided it can be turned off, then water flow and flow rate can be checked and if necessary adjusted before any films are inserted into the processor. Following this the automatic standby switch should be turned on again. In some processors the standby control does not affect water flow unless a special solenoid valve is fitted as an extra. In this case water flow and flow rate can be checked as soon as the water supply is turned on. Also check that the main drain is clear.

When feeding films into the processor, ensure that

(i) The film is fed in with one of its sides parallel to the side of the film feed tray
(ii) Narrow films are fed in simultaneously side by side
(iii) A consistent film feed method is adopted for each size of film
(iv) The film is large enough to be processed by the automatic processor.

Attention to these points aids correct film transport and balanced replenishment.

Stopping the processor is simply the reverse of the start procedure and requires the following:

(i) Turn the processor switches to the off position
(ii) Switch off one mains isolator
(iii) Turn off the water supply
(iv) Leave the processor lid partly open to avoid condensation and allow free circulation of air. It is also advisable to open the wash tank drain valve to empty the tank of water.

When changing chemicals in the main tanks the stopping procedure should first be carried out. For emphasis and reference the main steps are listed below:

(i) Stop the processor, isolate from the mains electricity and turn off the water supply
(ii) Remove processor lid and lift out developer and fixer roller racks
(iii) Drain both tanks by removing the drain standpipes. Clean the tanks with a sponge and running water
(iv) Replace the standpipes
(v) Fill both tanks with water
(vi) Relocate the processor lid, switch on the isolator and depress the processor on/off switch. This activates the recirculation system and flushes it with water
(vii) Turn off the processor and mains isolator, and remove the processor lid
(viii) Drain both developer and fixer tanks of water then replace the drain standpipes
(ix) Clean roller racks and replace in position checking the alignment
(x) Prepare the fixer solution
(xi) Prepare the developer solution
(xii) Clean up any splashes and replace the processor lid.

The processor can now be turned on following the starting procedure given above. If when new chemistry is prepared in the developer and fixer tanks the process cycle is altered then a different solution temperature will be required. When changing solution temperature it is necessary to allow sufficient time for the change to become effective. Temperature increases are generally achieved more quickly than temperature reductions.

Processor Maintenance

A three-monthly service contract is usually negotiated between supplier and user of the equipment and the service is carried out by a competent service engineer. However additional and more frequent maintenance is necessary if output image quality is not to deteriorate. This may be divided into daily, weekly and monthly maintenance procedures. Before any maintenance is carried out the processor must be switched off and isolated from the mains electricity.

Daily Maintenance
The procedure here is simple and involves:

(i) Removing and cleaning the cross-over rollers between developer and fixer, and between fixer and wash. Carefully replace the rollers when cleaned
(ii) Wiping off all chemical deposits in the processing area and cleaning the film feed tray as well as the film detector arms
(iii) Draining the wash tank.

These procedures are done at the end of each working day. At the beginning of each working day it is necessary to process several waste films. If these films appear marked or stained it is necessary to carry out the weekly maintenance procedure before processing the daily film workload.

Weekly Maintenance
The weekly maintenance procedure consists of removal, cleaning and replacement of the developer and fixer roller racks. This is generally done at the end of each week together with the daily maintenance procedure. Removal, cleaning and replacement of roller racks has been described earlier.

Monthly Maintenance
This is a combination of daily and weekly maintenance together with renewal of the developer and fixer solutions as described on pp. 195–198. Periodically the accuracy of the solution temperature gauge should be checked by inserting a long thermometer directly into the developer and fixer solutions. Make sure that the thermometer is free from developer before insertion in the fixer and vice versa to avoid solution contamination. The service engineer should be consulted if a temperature discrepancy $> \pm 1/2°C$ is detected.

Silver Recovery
The drain in the fixer tank should be connected to a pipe leading to a vessel for waste fixer collection. This can then be subsequently introduced into a silver recovery unit or sold in bulk to a bullion dealer who purchases and processes waste fixer solution.

THE MANUAL PROCESSING UNIT

A typical manual processing unit is shown in Figure 13.30. D is the developer, R the rinse, F the fixer and W the wash tank. The developer, rinse and fixer sections are surrounded by a water jacket in which a heating element is inserted. The temperature of the water jacket is thermostatically controlled and its temperature is indicated on the temperature gauge at the front of the processing unit. Since the developer

Figure 13.30 Typical manual processing unit

and fixer tank are contained in the heated water bath their temperature will be similar as a result of heat exchange through the tank walls. Even so temperature equilibrium must be achieved by stirring the processing solutions.

The tanks shown each have a capacity of about 45 l (approx. 10 gallons) but larger capacity tanks can be used where the film throughput demands. The tanks are usually stainless steel but can be plastic. The wall dividing the water jacket and wash bath has heat insulating properties to prevent too great a heat loss from the water jacket to the wash water. The water jacket in some manual processors is sealed (i.e. has a lid over it). Less energy is then expended in maintaining water jacket temperature and the necessity for water jacket cleaning is eliminated.

Technique in manual processing is discussed in Appendix 6 while various other aspects of manual processing have been discussed as the necessity arose throughout this chapter. Greater emphasis has been placed on automatic processing because of its almost exclusive use. The reader requiring further information on the manual processing units available should consult the appropriate manufacturers.

DISCUSSION

The film processing ultimately determines the image quality and great care must be paid to this stage of imaging. Automatic processing is now well established and has virtually displaced the manual processor. Besides large film autoprocessors, small autoprocessors are available specifically for processing small format roll film but their principle of operation is similar. Automatic processors are now being equipped with automatic film feed systems as part of a so-called 'daylight' system. This obviates the need for a darkroom except perhaps in the case of a systems failure.

14
Image Quality Control

INTRODUCTION

Image quality control is often considered as just involving the processing of sensitometric strips, measuring resulting densities and graphing these as a way of monitoring automatic processor performance. This is very far from the truth. The concept of image quality control is very wide ranging and must include virtually every aspect of the radiographic procedure. The following points give some indication of just how large a sphere is involved

(a) Imaging system
 (i) image recording medium
 (ii) imaging parameters relating to exposure factors
 (iii) processing
 (iv) X-ray equipment and accessories
 (v) use of automation
(b) Patient
 (i) structure
 (ii) size
 (iii) condition and degree of co-operation
(c) Technique
 (i) method
 (ii) degree of difficulty
 (iii) operator competence and level of experience
(d) Technical resource management
 (i) work load distribution
 (ii) staffing level
 (iii) staff distribution and experience
 (iv) in-service training
 (v) liaison and communication
 (vi) equipment performance assessment and maintenance
 (vii) film and chemical stock control and condition
 (viii) supervision
 (ix) reject analysis and correction methods
 (x) effective use and control of a functional budget

This list is by no means exhaustive but it is already apparent that the problem of image quality control is enormous, with a large part concerning management of resources. Technical resource management in radiography is still in its infancy and it is only in recent years that it is receiving the attention it deserves. Because of the extensive ramifications and im-plications of image quality control it is only possible to discuss a very limited number of the points listed here.

Except for image quality control related to processing, the points in (a) and (b) have been covered, some extensively, in earlier chapters. This exclusion must now be remedied and below is a discussion of this aspect. From (d) some aspects of equipment performance assessment and film and chemical stock control and condition have already been dealt with but other points will be briefly discussed.

SENSITOMETRIC ASSESSMENT OF IMAGE CHARACTERISTICS

So far we have considered, in some detail, the effects of exposure and subject structure on the radiographic contrast in the image. We have also talked at some length about film speed. Now it is necessary to consider the effects of variation in processing conditions on contrast, film speed and fog level. We will also develop a technique for checking constancy of image quality both in manual and automatic processing of X-ray films.

The radiographic image must contain the required diagnostic information and it should be in a form that is easy to extract visually (under suitable conditions). How easily this information can be extracted will determine the subjective assessment of the quality of this image. The ease with which this information can be extracted depends, in part, on the magnitude of the density differences present in the image (the radiographic contrasts) and the values of the densities forming these differences. Processing the film provides these densities, and it is natural to assume that processing (development in particular) will affect the values of the densities obtained and the magnitudes of the density differences by its influence on the fog level produced. For a given exposure, the value obtained for the film density will determine the speed of the film. Since processing is concerned with the provision of these densities, we can assume that the processing conditions employed will influence the speed of a given type of film.

The processing factors which affect image quality in terms of the factors mentioned above are:

 (i) The type of developer and its concentration
 (ii) Development time

(iii) Developer temperature
(iv) Degree of agitation of the film or developer during development
(v) Degree of exhaustion of the developer
(vi) Replenishment rate relative to film throughput and the type of image processed
(vii) Type of fixer and its concentration
(viii) Fixing time

For each of the above factors, it is not important to know why, if we alter any one or more of them, a particular event occurs. The important thing to know is what is the effect on image quality of varying any one or more of the factors mentioned. If we know this, then any investigation into why a reduction in image quality has occurred is made easier.

The above list of processing factors can be divided into two distinct groups: (i) those relating to the developer and (ii) those relating to the fixer. Those from group (i) have a much greater effect on image density, contrast and fog level than do those from group (ii).

A closer look will be taken at some of these factors to see what effect a variation might have on image quality.

As an example of some of the results which can be expected with automatic processing, graphs illustrating the effect of temperature change on film speed, contrast and fog level are shown in Figure 14.1. It can be seen that the density chosen at

which to measure relative speed (i.e. the variation in speed) is a density of 1.0 *above* gross fog level. While providing much the same information, the graphs shown later differ slightly from those shown in Figure 14.1 but the presentation is simply a matter of personal preference.

The changes occurring in image quality as a result of a variation in processing conditions are often described in the literature in terms of the effect of this variation on the shape of the characteristic curve for the film being processed. This is then related to image quality in terms of image contrast, fog and density (speed) changes. In practice, it is necessary to assess the continuing performance of manual and automatic processing facilities for the purpose of standardization of image quality. This is not done in terms of characteristic curves, but is done directly in terms of:

(i) Density as a result of exposure. This provides information on how the processing affects film speed (in a relative sense) over a period of time. This measurement is often referred to as the speed index
(ii) Density difference. This provides information relating to relative variation in radiographic contrast. This measurement is often referred to as the contrast index
(iii) Density occurring with no exposure. This is basic or gross fog. It is usually found in practice that with automatic processing there will be little if any variation in this quantity even when there are relatively large changes in (i) and (ii). Gross changes are apparent in this quantity in such cases as safelight fogging. This measurement is often referred to as the fog index.

The measurements made for (i), (ii) and (iii) are not important in an absolute sense, but are important, and are used, in a relative sense. In other words, the measurements made at one time relative to those made at some other time will show clearly any changes in the behaviour of the processor. Obviously the absolute values are important at the starting point of the assessment process since these values should be confined to the most useful density interval of the characteristic curve. Variations occurring in these measurements are only significant if a corresponding visual change is noticed in the radiographic films processed, otherwise such variations in the measurements can be considered as lying within the acceptable limits for variation. This is not true where specialized processes such as image subtraction are carried out. Then closer tolerance limits are needed.

To emphasize the importance of the above three measures consider Figure 14.2. A and B are the results produced by an automatic processor on two consecutive days when a calibrated stepwedge was employed to produce the characteristic curves. The same film–intensifying screen combination was used on each occasion under identical exposure conditions.

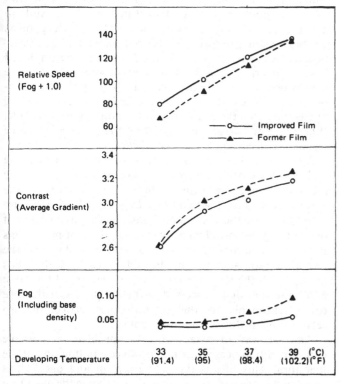

Figure 14.1 Effect of temperature change on relative speed, contrast and fog level. (Reproduced by kind permission of Fujimex Ltd.)

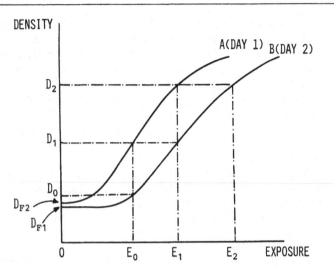

Figure 14.2 Characteristic curve produced by an autoprocessor on two consecutive days

The given exposure, E_1, produced D_2 on day 1 and D_1 on day 2. The question is whether the difference between D_2 and D_1 is noticeable or not. If not then the density change, ΔD, which has occurred can be accepted as being within tolerance limits. If the change is noticeable, and the film on day 1 is considered satisfactory, then a decision is necessary as to whether the film on day 2 is satisfactory in a comparative sense. If not it must be repeated using exposure E_2. Obviously repeated films must be avoided both from the point of radiation protection and economy. Producing films on day 2 which are comparable with those on day 1 requires the use of exposure E_2. Again the increase from E_1 to E_2 may be quite unacceptable in terms of image quality and radiation dose. The only solution is then to alter the processing conditions of day 2 until they are the same as day 1. In practice this is rarely necessary because if the correct maintenance techniques are employed together with correct processor operating procedure then the image quality variations encountered will all lie within acceptable limits.

Referring again to Figure 14.2, on day 1 exposures E_0 and E_1 produce an image contrast of $(D_2 - D_1)$ which here is considered acceptable. On day 2 the same exposure difference produces an image contrast of $(D_1 - D_0)$. $(D_1 - D_0) < (D_2 - D_1)$ because curve B has a lower average gradient than curve A. Again the question must be asked whether this reduction is acceptable or not. If not then something is amiss and the processing conditions must be investigated, changing them if necessary. Finally looking at gross fog it is seen that its value is lower on day 2. Again it must be decided whether or not this change from D_{F2} to D_{F1} is noticeable or not, and how much it affects overall image contrast. All the above information was obtained by giving a particular film–intensifying screen combination a fixed exposure on each occasion and measuring the density values resulting after processing.

AUTOPROCESSOR PERFORMANCE ASSESSMENT FOLLOWING INSTALLATION

It should be noted that it would be a long and tedious business to determine experimentally the optimum operating conditions for the processor upon installation. Reliance must be placed on manufacturers' recommendations which, again it is important to note, apply to a specific set of conditions. Any deviation from these conditions is likely to produce results different from those predicted by the manufacturer – they may be considered worse, or even better.

One way in which to assess the performance of a newly installed autoprocessor is to compare the image result produced by it with a known acceptable standard. This can be done by processing two films of a suitable phantom (exposed under similar conditions), one in the new processor and one by the old method. The results are visually compared and any necessary adjustments made. These adjustments may be necessary if the two films are not reasonably similar in appearance, or if the film processed in the new processor is not considered diagnostically suitable. Exactly what the adjustments may be, if required, could be a long and tedious business to determine and may involve change of chemicals, change of film, alterations in temperature, replenishment rate, processing cycle time, and so on. It should be realized that it may not be possible to produce a result with the new processor which is as good as the best result produced by the old method. This is particularly true where the old method of processing employed lower temperatures and a longer processing time, and the new processor is a high speed, high temperature autoprocessor. If the new processor installed is similar to existing processors, then the results obtained should be comparable. Where the processors are operating together, comparable results are necessary for standardization of film quality.

A criticism of the test using the phantom described above is that any variation noticed may not be due to processing differences but possibly due to slight differences between the exposures used for the two films (even though the exposure factors set were the same in both cases). One possible way of overcoming this problem is by exposing four or more films under the same conditions and processing half of them in the new processor and half in the old. If each of the films processed in the new processor are similar and if the same applies to the films processed in the old processor then we can be reasonably sure that any difference between the two sets of films is due to the processing.

Another way of overcoming the problem of possible exposure differences is again to produce a radiograph of the phantom. This film is then carefully cut and one half is processed in the new processor and the other in the old. Once processed, the two halves are brought together and com-

pared. Differences should immediately be apparent. When this test is done it must be ensured that the film is of a size so that, when cut, either half is large enough to be processed in an automatic processor.

Additional simple tests which can be made on installation are:

(i) Processing unexposed films to test for light leakage
(ii) Processing to assess correct transport of film, processing cycle time, artefacts or any other film damage
(iii) Visual inspection of the processor to check for any fluid leak
(iv) Checking replenisher rates, water pressures as flow rates, and all temperatures
(v) Checking that all outflows to drains are functioning correctly.

CONTINUAL ASSESSMENT OF PROCESSOR PERFORMANCE

Installation problems aside, the main purpose here is to assess the capability of the processor to maintain constancy of image quality over an indefinite period. Information concerning image contrast, speed and gross fog can be obtained by processing and evaluating control strips. This will provide a valuable guide to processor performance by indicating any variations occurring and is particularly useful in indicating any trend such as a persistent drift towards and beyond the acceptable limit of change. The test is relatively sensitive and will indicate changes which may not be visually apparent on processed radiographs, i.e. any trends will clearly show long before any change in image quality is visible on viewing a processed film.

Small variations in control strip measurements are to be expected since for slightly different film areas processed in a given time, the same volume of replenisher solution can be delivered to the developer tank. This results in slight variation in developer activity. Long periods of processor inactivity can result in changes in image quality (because of deterioration of developer chemicals by oxidation, for example) when the next film is processed. If frequent long periods of inactivity are expected an increase in replenishment rate may help. Processing chemical temperature cannot be controlled precisely and some variation, however small, is inevitable, and this again leads to small variations in results. The problem here is to distinguish between variations due to these causes and variations from other causes, which, if unchecked, can lead to unacceptable image quality.

Small variations aside, whenever a permanent trend in one direction is establishing itself the cause should be investigated, located and corrected before radiographic image quality is affected. On processing a given control strip, if a sudden change occurs without a trend becoming established,

a second strip should be processed immediately to confirm the results of the first strip. This second strip will determine whether or not the first strip is indicating a false result, e.g. the first strip may have been fogged. If both strips are identical, then the cause of the trouble must be located and corrected, preferably before processing any further films.

Preparation of the Control Strips

These could be prepared by exposing a screen-type film (between intensifying screens in a cassette) through a wide stepwedge. A piece of lead is placed across part of the film not covered by the stepwedge. The arrangement is shown in Figure 14.3. The film is then cut into strips in complete darkness. The direction of cut is such that each strip will contain an image of each of the steps of the stepwedge. These strips are stored in a light-tight box throughout the period of the test, and away from excessive heat and humidity, fumes harmful to the emulsion, and radiation to which the emulsion is sensitive. These strips are used one at a time in the assessment of processor performance, whether manual or automatic.

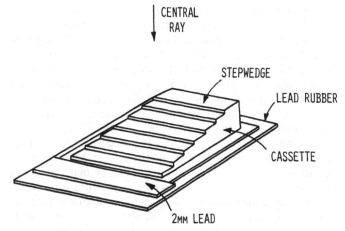

Figure 14.3 Arrangement for producing control strips. (The FFD used is 150 cm)

Assume ten strips have been prepared. These are all prepared together because each strip should have received the same exposure if the final results are to be meaningful. If one strip is processed each day, the last strip processed will have a latent image 10 days older than the first. Unfortunately it has been shown that, compared with freshly prepared strips, control strips having a latent image several days old are relatively insensitive to changes in processing conditions, and producing and using control strips in this way may not provide a useful result. Another objection to this method is that of storage conditions for the exposed strips. The possibility of fogging cannot be excluded, and it would be difficult to determine whether the additional density due to

this fogging was the result of processing or of storage. Processor control strips may be available from individual manufacturers and these will have been produced under carefully controlled conditions, but, if one strip per day is processed, it is unavoidable that a stock of these strips must be held. In this case we are back to the problem of the aged latent image and, of course, storage problems.

The only sure way of doing this is to produce the strips immediately prior to their required use. Unfortunately this is also saturated with problems. For a start, if this is done using X-rays and a screen–film combination to produce the stepwedge image, consistency of exposure cannot be guaranteed. This will mean that the processor result could change without it necessarily being the fault of the processor. Another possible way of trying to meet the necessary requirements is to use a film image of a stepwedge, and contact print this onto the usual type of film employed in the department. A white light source of constant intensity could be used, at a fixed source–film distance, to expose a control strip when required. Unfortunately, the shape of the characteristic curve for a film depends on the spectrum of the light source used. The response of the X-ray film to white light will be different from its response to the light from intensifying screens.

A light source approximating to that of the emission from intensifying screens is what seems to be required. This may be achieved by using a tungsten lamp together with a suitable colour filter. This method of producing a control strip is illustrated in principle in Figure 14.4. The instrument employed for making the exposure is called a sensitometer, and any department seriously considering a processor monitoring programme should possess one. Unfortunately, sensitometers are not generally used in radiography departments and some other method must be used in the meantime. Thus if a serious effort is to be made at image quality control then it is necessary to produce the control strips using a film–intensifying screen combination typical of that used in the department. Strictly the kV should be

checked each time a control film is made by using a Wisconsin (or Sussex) cassette, and to produce the control strip a calibrated stepwedge is recommended. The same exposure conditions and equipment should be used each time a control strip is made and the exposed film should be processed as soon as possible after exposure.

The above items of test equipment are not generally available in most departments and at best all that can be hoped for is to ensure that the exposure conditions are as near as possible the same each time without checking the accuracy of kV, mA and exposure time on every occasion an exposure is made. Thus for most purposes it is assumed reasonably accurate to use the same exposure conditions, film–intensifying screen combination and cassette and to produce a fresh control strip each time one is required. If, having produced strips in this way, a dramatic change in readings is noticed, then both processor and exposure should be checked in an effort to eliminate one or the other as being the cause for the change.

Obviously a variety of methods is available each having its own disadvantages. It is up to the user to decide which method is most suitable and then strive for as great an accuracy as possible. There is considerable controversy regarding the frequency of testing image quality variability from an automatic processor. One opinion states that it is only necessary to process a control strip once every 1 or 2 weeks but it is felt that this will not indicate trends because of lack of information from the intervening period. The other opinion states that testing should be carried out every day at the same time. This ensures that all information is available and trends will be easily seen. Then if they are tending towards the unacceptable steps may be taken to reverse the trend. The argument against testing every day is that, providing daily maintenance procedures are adequate and thorough, nothing usually goes wrong, and the daily processing of strips is time-consuming and wasteful. Surely, it is better to be safe than sorry, and anything which goes some way to avoiding a costly and disruptive breakdown and repair job is worthwhile. It would be a worthwhile exercise to cost the total number of breakdown and repair jobs not budgeted for and balance this against the total cost of daily control strip processing and the number of breakdown and repair jobs which could have been avoided by such a frequent monitoring programme.

Using the Control Strips

Manual Processors
It is important, if the results obtained from the processed strips are to be meaningful, that a standard set of conditions be used for the processing of each strip. These conditions are:

(i) The developer temperature and the time of development should be the same each time a control strip is processed

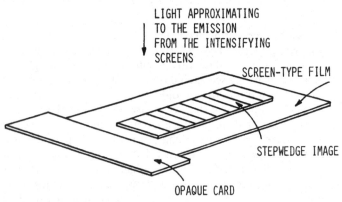

LIGHT APPROXIMATING
TO THE EMISSION
FROM THE INTENSIFYING
SCREENS

SCREEN-TYPE FILM

STEPWEDGE IMAGE

OPAQUE CARD

Figure 14.4 Principle of a sensitometer

(ii) The temperature should be checked and confirmed as the correct value immediately prior to the processing of each control strip. The temperature should be measured only after thoroughly agitating the developer solution, as this will ensure that the temperature measured will be fairly representative of the temperature throughout the solution. It will also ensure a reasonably uniform activity throughout the solution

(iii) The developer level should be the same for all control strips processed, since here the assessment technique is used to determine the effectiveness of the developer replenishment method for maintaining a constant image quality

(iv) Each control strip may be processed after a given total area of film has passed through the developer in cases where replenishment rate is related to the area of film processed. The value for the area of film chosen should be such that at least one control strip is processed each day, or, if the processor is in constant heavy use, two strips per day.

Strictly, the condition for fixing the film should also be constant since, as stated before, the fog level can be affected.

(v) All other processing conditions, such as film drain time, intermediate rinse (method and length of time), degree of agitation etc., should be the same for each film and control strip.

With the above conditions imposed, it should now be realized how difficult it is to maintain a constant image quality with manual processing. It should also be apparent how difficult it is to assess how well the processing method employed maintains a given image quality. Now at least the problems are known, but let us assume that the above conditions have been fulfilled reasonably well, and we now have a processed control strip. Before we decide what to do with it, consider the processing of control strips in an automatic processor.

Automatic Processors
(i) Each strip should be processed at about the same time each day. For example, mid-morning or mid-afternoon, or both if required. The results are likely to be unreliable if a strip is processed mid-morning on one day, and first thing in the morning on the next day after the chemicals have been standing idle overnight, or for at least part of the night

(ii) For the same total volume of replenishment chemicals used at any given time, different total film areas may have been processed. Slight variations in speed, contrast, and fog values as measured are then

to be expected and must be considered as acceptable. The acceptable limits of the variation must be decided by the individual departments. Any variation occurring outside the limits set should then produce an unacceptable change in the image quality of the radiographs processed. As an example, the acceptable limits of variation in speed and contrast may be considered as ± 0.10.

In the same way, acceptable limits of variation in the values measured on the control strips are applicable to manual processing. These limits can be determined subjectively by noting when the image obtained in processed films is becoming unacceptable and noting the values obtained for the control strip just processed. In manual processing, where the solutions are used only for special purposes in conjunction with an automatic processor, the technique of control may be somewhat modified. The developer will have stood without use perhaps for some considerable time – days or even weeks. We would not now consider processing a control strip after a certain total area of film had been processed. Instead a control strip may be processed immediately before each of the occasions when films are processed. Strictly this control strip should be assessed by comparison with previous strips before the first film is processed. This is particularly important, since it may be found that the image quality likely to be produced may be poor (i.e. values occur outside the acceptable limits). This is particularly important where the series of films to be processed might not be repeatable. We might further expose and process a radiograph of a suitable phantom. If this film is considered of suitable diagnostic quality then the other films can be processed. Note that information obtained from such tests will only be valid if the processing conditions in each case are the same.

To digress for a moment, if manual processing facilities are required on rare occasions only, then perhaps consideration should be given to the following points:

(i) Is there an alternative method of producing films requiring manual processing so that they may be processed in an automatic processor? This would obviate the need for manual processing facilities

(ii) If the manual processor is also required as a standby unit in case of an autoprocessor breakdown, is it economical to maintain the manual processor in a state of readiness, with chemical solutions prepared? Also, is it economical to replace the chemicals regularly whether they have been used or not?

(iii) Where the manual processor is used only for processing the odd film now and again, is it necessary to use the volume of chemicals usually required to fill the tanks? Can a unit be used with shallow, low capacity tanks? In the latter case, is it economical to replace an existing high capacity manual processor with a low capacity model?

These are interesting problems, but whatever the individual solution, image quality tests should be carried out, and these tests should be tailored to provide the required information, whatever facilities are available for film processing.

Having considered the foregoing points, a suggested practical method is as follows:

(i) Reserve a box of the smallest screen-type films (typical of those in use in the department) for the processor monitoring programme. During the time films are being used from this box it should be stored under conditions which are optimized as far as available facilities allow

(ii) Reserve a cassette, and use the same cassette each time an X-ray exposure is made. Always use the same piece of X-ray equipment and the same exposure conditions each time, as well as the same stepwedge. Ideally this will be done at the same time each day. Preferably, if available, use a sensitometer for the controlled exposure to the film.

(iii) Each time a control film strip is required for processing it should be produced immediately prior to processing

(iv) The control film strip is exposed as shown in Figure 14.3 when an X-ray source is used

(v) The X-ray exposure used for the first control film strip at the commencement of the processor monitoring programme should be such that an acceptable image of the stepwedge is produced showing sufficient steps covering densities from gross fog to at least 2.5.

Having obtained the processed film strip we are now in a position to record the results graphically to obtain a picture of what is happening. For this, a densitometer is required, otherwise there is little point in using this particular monitoring process. The plotted graphs are called processor control charts but one difficulty which will arise is knowing what to accept as the limits of variation in processor performance. One way of overcoming this difficulty is to expose (under the same conditions each time) and process a film of a suitable phantom (a 3M skull phantom for example, as in Figure 14.5) each time a control strip is done. Compare the skull images produced on the series taken and see if any are unacceptable in comparison and in isolation. If any are found to be unacceptable then refer to the associated control strip readings and mark these on the graph as unacceptable variations. This will certainly help to determine the limits of acceptable variation.

Processor Control Charts

The information from the control strips can be plotted on a graph in such a way that any trend will become immediately apparent. Figure 14.6 shows the processed control strip image obtained as explained above. The steps may be numbered and it will be assumed that this is the first of the series of control film strips. Note that if fresh chemicals are made up in the autoprocessor main tanks then it is wise to wait about three days before commencing the monitoring programme. This will allow the developer/replenisher system to achieve a reasonable state of equilibrium.

Figure 14.6 Control strip stepwedge image and the stepwedge used to produce it

Figure 14.5 3M skull and hand phantoms

The density of certain steps on the film must now be measured and whenever a density measurement is made the middle of a step image should be used. Once a decision has been made on which steps to use, we will continue to use the same step numbers from which to make density measurements on all subsequent films. For the moment assume that on the first film step number 6 (counting from the step with the least density) has a density $D = 1.0$. This density will form the starting point for the recording of speed index measurements. Choosing $D = 1.0$ means that we are using a density near the lower end of the straight-line portion of the characteristic curve (but nevertheless on the straight-line portion). Also using a density of 1.0 means that we can relate changes in speed index directly to visual changes in image brightness.

Assume that a control film strip has been produced once a day for 5 days and a set of measurements for speed index has been recorded. These are set out in Table 14.1. In this table each value for variation in column 2 is found by subtracting the first value in column 1 from each of the values in column 1. It is the values in column 2 which are referred to as speed indices and are plotted on the graph. This is done in

Figure 14.7. Alternatively the values given in column 1 could be plotted as indicating speed variations. The graph would be the same. It is simply a matter of choice. In this example it is assumed that the limits of acceptable variation are ± 0.15 density units. It may be found in practice that these limits are too large but this will depend on circumstances.

Now consider the contrast index measurement. Objective radiographic contrast is defined as $(D_2 - D_1)$ as previously discussed. So here, as a measure of contrast index, it will be based on the difference between two densities. We already have one density measurement (that used for speed index) so it will be used as D_1. Now a slightly higher density is needed for D_2. For this it is sufficient to choose the density of the next (adjacent) step of higher density. This is because these two densities lie within the straight-line portion and will therefore be representative of the average gradient of the characteristic curve over the region designated as the straight-line portion. Typical results are shown in Table 14.2, which indicates how contrast index is determined from these measurements. The values in column 4 are obtained by subtracting the first value in column 3 from each of the values in column 3. The results of column 4 are plotted as

Table 14.1 Speed index measurement over five days

1	2	3
Density of step 6 on the control film	Speed index (variation in density of step 6 relative to density on day 1)	Day
1.0	0	1
1.08	+0.08	2
0.9	−0.1	3
0.95	−0.05	4
1.1	+0.1	5

Table 14.2 Contrast index measurement over five days

1	2	3	4	5
D_2 (Density of step 7)	D_1 (Density of step 6)	$D_2 - D_1$	Contrast index (variation in $(D_2 - D_1)$ relative to the value on day 1)	Day
1.8	1.0	0.8	0	1
1.9	1.08	0.82	+0.02	2
1.62	0.9	0.72	−0.08	3
1.68	0.95	0.73	−0.07	4
2.0	1.1	0.9	+0.1	5

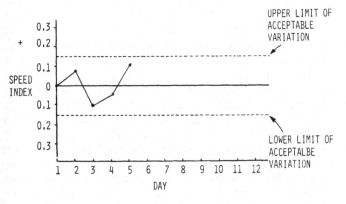

Figure 14.7 Speed index variation over five days

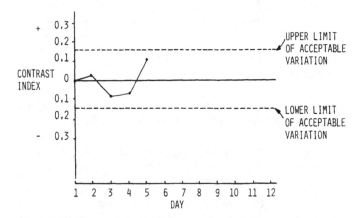

Figure 14.8 Contrast index variation over five days

shown in Figure 14.8. Again, as an alternative, the values in column 3 could be plotted as contrast index.

Finally we turn our attention to the fog index. This graph indicates how gross fog level varies, but it is the least sensitive of the measures used. Speed and contrast indices are far more sensitive measures. To obtain values for fog index simply measure the density of the area of the control film strip that has been covered over with lead. These values for the 5-day period are given in Table 14.3. Again the values in column 2 are obtained by subtracting the first value in column 1 from each of the values in column 1. The graph for the values in column 2 is shown in Figure 14.9.

Table 14.3 Fog index measurement over five days

1	*2*	*3*
Density of unexposed area	*Fog index (variation in this density)*	*Day*
0.12	0	1
0.12	0	2
0.11	−0.01	3
0.11	−0.01	4
0.12	0	5

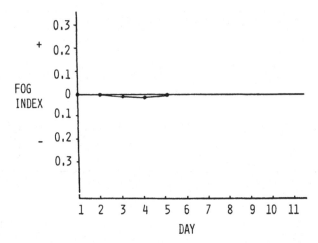

Figure 14.9 Fog index variation over five days

Changes in contrast index are indicative of changes in average gradient. This can be shown as follows:

Let step density 7 be D_2 and step density 6 be D_1. Now

$$\text{average gradient (between } D_1 \text{ and } D_2) = \frac{D_2 - D_1}{\log E_2 - \log E_1}$$

The exposure received by any control strip is a constant, and hence the log exposure difference, above, will be a constant. We can thus replace $1/(\log E_2 - \log E_1)$ by a constant, say k, and

$$\text{average gradient} = k\,(D_2 - D_1)$$

or, average gradient \propto contrast index

Figure 14.10 shows an example of the results obtained over a period of one week. The processor was a Kodak M100. No noticeable change in image quality occurred so it was not possible subjectively to determine any limits for acceptable variation.

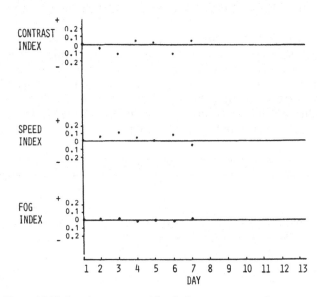

Figure 14.10 Speed, contrast and fog indices over one week

With reference to the density chosen for the original speed index measurement – the higher the density chosen the greater the sensitivity of the test for speed index variation. A base value of 0.9–1.1 has been suggested as the optimum.

In addition to assessing processor performance over a period of time, a similar control method can be employed to assess the performance of one processor relative to another, where more than one processor is in use in the department. This is done as a test for standardization of result. A typical result is illustrated in Figure 14.11. It can be seen that processor number 4 is not producing a result similar to that produced by the other three processors. If a densitometer is not available for this latter test, a subjective assessment can be made by exposing a film of a suitable phantom. In total darkness, carefully cut this film into strips, enough for each processor. Process one strip in each of the processors. Now re-assemble the strips to form a complete image. Any gross differences should be immediately apparent, and should be immediately rechecked. In the above chart processor

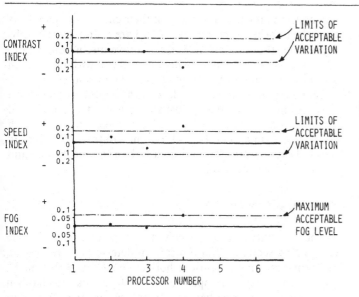

Figure 14.11 Relative performances of four processors

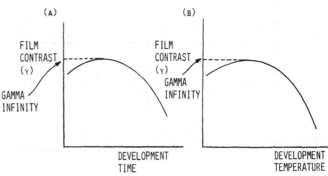

Figure 14.12 Contrast–time and contrast–temperature curves

number 1 has been chosen as the control. The performance of the other processors has been measured against this, only because processor 1 was considered as producing the most acceptable image quality.

When carrying out processor performance assessment tests using control strips, it helps in interpretation of results if additional information is also recorded each time a control strip is processed. This information consists of:

(i) replenishment rates for developer and fixer
(ii) cycle time and operating temperatures if known
(iii) total film area and number of films processed since the previous control strip was processed
(iv) total volume of developer and fixer used since the previous control strip was processed (assessed from reservoir tanks).

Contrast–Time Curves

Characteristic curves can be plotted for similar film types where each film is developed for a different time at a constant temperature, or at different temperatures for a constant development time. If the maximum value for film contrast is determined from each curve then a contrast–time curve (or in the second case a contrast–temperature curve) can be plotted. Such curves are often called gamma–time and gamma–temperature curves. Examples of these curves are shown in Figure 14.12. In the contrast–time curve, the value for 'gamma infinity' is found by drawing a line, parallel to the horizontal axis, from the highest point of the curve across to the vertical axis. The intersection of this line with the vertical axis gives the value of contrast known as gamma infinity. A corresponding value of gamma infinity can be found from the contrast–temperature curve. This value will not, in

general, be the same as that obtained from the contrast–time curve. The contrast values plotted on the vertical axis refer to the gradient of the straight-line portion of the characteristic curve. The important reason for obtaining the above information relating to contrast is that it is necessary to have some indication of the effect of a change in developing conditions on radiographic contrast.

Instead of going to the lengths of plotting a contrast–time curve, the required information can be obtained from the control strips we have been talking about previously. All that is required is to plot the change in contrast index against change in development time. The resulting graph approximates to the shape of the contrast–time curve and will indicate at what development time the contrast index will have the highest value. This is virtually the same as determining the development time producing gamma infinity.

In some automatic processors, facilities are provided for changing the processing cycle time. When the cycle time is changed, not only is the development time changed, but corresponding time changes occur in the fix and wash times. Replenishment rates and temperatures then have to be altered to maintain a constant average image density; such changes can affect the values obtained for the three measurement indices. At the moment replenishment rates will not be altered so the cycle time required to produce the maximum value of contrast index can be obtained for the existing conditions.

For a given set of conditions, the shorter the development time, the lower the value of the speed index, and the longer it will take to fix the film since less silver halide will have been reduced by the developer. This means a higher exposure will be required to maintain a given image density and achieve correct fixation. Temperature variations also affect the value of contrast, and contrast–temperature curves have been used to determine the temperature at which maximum gamma can be achieved. Once again, in practice, a graph of contrast index against developer temperature can be plotted. It must be remembered that for each temperature change, temperature equilibrium must be achieved throughout the developer solution before the control strip is processed. This can take some time, and since manufacturers make recom-

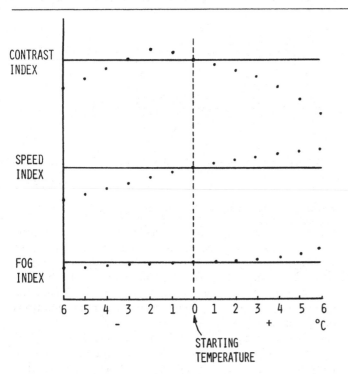

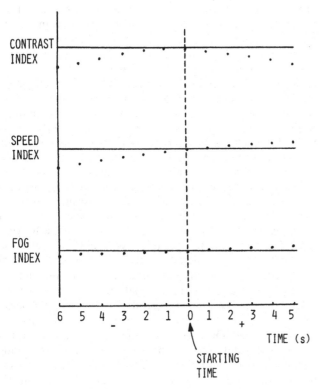

Figure 14.13 Variation in contrast, speed and fog indices with developer temperature

Figure 14.14 Variation in contrast, speed and fog indices with development time

mendations regarding the use of their chemicals, such tests may be unnecessary. In Figure 14.13 are examples of graphs typical of those mentioned in the above discussion. Figure 14.13 illustrates changes which can occur with changes in developer temperature, and Figure 14.14 shows changes occurring with variation in development time. In practice a processing system does not usually operate at a condition of gamma infinity because the fog level is likely to be too high and hence unacceptable. Optimum contrast is achieved visually at operating conditions less than gamma infinity and hence a lower fog level.

DISCUSSION

Process control charts such as those discussed in the preceding sections offer a means of determining processing system operating conditions both effectively and efficiently. The control system operates by a feedback mechanism (Figure 14.15). Whether or not processing operating conditions are changed depends on the magnitude of the variation detected at the output. Even if no change is detected, this is an important result because it immediately gives a feedback that processor operating conditions are satisfactory. This implies that the system management technique is satisfactory.

If, on the other hand, the variation in output image quality is detected as unacceptable then the feedback will aid the decision on whether the input is at fault or processor operating condition changes are necessary. Perhaps more important is that it also indicates a breakdown in the system management which must be rectified if the same fault is to be prevented from recurring. As a superficial example, a recurring fault may be due to human error or negligence through lack of knowledge, understanding or experience thus necessitating, perhaps, some form of retraining or even temporary supervision. In general, monitoring the output is the simplest part of the procedure. Finding the cause and then a solution to an unacceptable output can often be quite difficult.

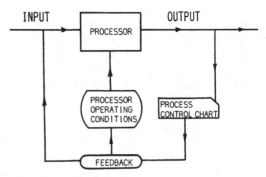

Figure 14.15 Process control system

Reject Analysis

One form of output is a film result which is totally unacceptable and the only course of action is to reject the film implying that a repeat is necessary. Consider, for a moment, the implications of this reject film. It has no diagnostic use but it does have a cost associated with it. What is this cost as a proportion of the functional budget? What is the proportion of reject films to the total number of films? What is the total cost associated with reject films? Is this total cost large enough to warrant action to reduce the number of reject films? What course of action should be adopted and how is it determined? How effective is this course of action likely to be? Is there a minimum total number of reject films below which a reduction is impossible to achieve for a given set of conditions? At what total proportional cost should action be taken? Does the proposed course of action involve spending more money than can be saved?

These are important questions in systems management and effective answers are needed. This does not imply that satisfactory answers can be found that will suit every set of conditions. Often personal opinion is involved and this is usually the overriding factor. In view of this there are no hard and fast rules for obtaining an answer. At best, certain statistics result from an analysis of available data and these can be used as a basis for a decision. The decision must be based on personal preference and the influence of existing conditions and external pressures which can vary from time to time. Once a decision is reached and a course of action adopted, continuous assessment procedures should be brought into operation to monitor the efficiency and effectiveness of the decision and course of action. By feedback it is usually found that frequent changes are necessary to maintain efficiency and effectiveness.

Before commencing an analysis it must be clear what is meant by a reject film. Above it was stated that a reject film is one which is totally unacceptable because it is diagnostically useless. In fact the problem can be more subtle. A radiographer can produce, or a radiologist can request, an additional radiograph which effectively adds nothing to an initial diagnosis. This film may be perfectly acceptable in terms of image quality and would normally be included with the other films in the patient's file, but the film has turned out to be diagnostically unnecessary and can therefore be regarded in similar terms to a reject. Here, for simplicity, this type of reject film will be ignored.

As a first step, totally unacceptable radiographs should be retained at one collection point for analysis. If staff relations permit, the cause for rejection (if known) should be noted on each film together with the name of the person concerned. This aspect, while enormously helpful in the analysis for determining a suitable course of action, involves the very delicate area of industrial relations in avoiding the charge of staff persecution. It may very well be found that a high proportion of rejects can be attributed to one or two persons but this may be due to the fact that they have both used the same faulty equipment each time. This is then a fault in systems management technique and not necessarily in the two persons mentioned. Here however we will again move for simplification and assume that the production of reject films is equally distributed amongst the staff.

It is useful if at the end of each week the reject films are grouped into specific faults. Any other interval could be used but one week is suggested as weekly results provide a not too infrequent feedback mechanism on the effectiveness of the system. Assume that the results given in Figure 14.16 are produced at the end of a one week period. It is noted here that the radiograph should not be rejected because it is aesthetically unacceptable. It should only be rejected if it is diagnostically unacceptable and only the radiologist should decide this in theory. Often in practice it is obvious that a film is diagnostically unacceptable, because, for example, no image is present on the film or it is blurred.

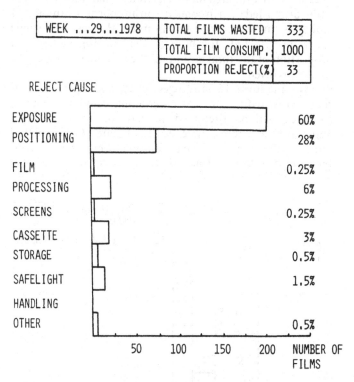

Figure 14.16 Weekly reject films grouped into specific faults

In Figure 14.16, if the divisions used under the heading 'reject cause' are found to be inadequate or more detailed information is required, further subdivisions can be used. For example, consider 'positioning'. Possible subdivisions could be errors due to

(i) centring
(ii) beam delineation
(iii) light beam/X-ray beam misalignment
(iv) patient position
(v) incorrect FFD
(vi) inappropriate size cassette

and so on. Alternatively if only a small amount of the information obtained as results can be subsequently used in the decision process then the analysis has been too detailed, but it is difficult at this stage to decide how much detail is likely to be required.

Obviously in Figure 14.16, the greatest single cause of reject films is exposure error, but before proceeding let us consider some of the questions posed at the beginning of this section. What is the cost of a reject film? Naively, one can consider that since a box of 35×43 cm films cost £X per 100 that the cost of one reject is £$(X/100)$. Since this is usually the largest size employed, and smaller sizes cost less, then the cost of a reject, at most, will be £$(X/1000)$. If, however, the question is investigated more fully and all activities involving a film are costed then in comparison an enormous amount of money is involved. With this in mind, the cost of a single reject must include the price of the film together with a proportion of the total cost of all the activities in which the film is involved.

From Figure 14.16 a 30% reject is seen and urgent action is required to reduce this. As an example only one of many solutions will be attempted, namely the introduction of automatic exposure systems. In Figure 14.17, day 0 indicates the point at which the automatic exposure systems became operational. Has it been an effective operational

decision? The reader is left to decide but in so doing consider the following:

(i) Was a staff training programme on automated exposure systems introduced at the time the systems became operational?

(ii) Was the programme assessed as effective?

(iii) Was the method of assessment an effective and efficient method?

(iv) Do the latest figures in the graph indicate any significant points? If so what are they and what investigations and decisions are to be made? How is this feedback to be most effectively used?

(v) Can the cost of automation be recovered in terms of reduced film wastage?

(vi) How long do staff need to become fully competent in the use of automatic exposure devices?

In providing answers to such questions, sight must not be lost of the main aim – that of reducing film wastage. Without good systems management the cost of introducing automated exposure systems cannot be recovered, in fact the film reject problem can be exacerbated!

Once a decision is made and an operational policy adopted it is useful to use successive results as feedback to determine its effect. Consider again Figure 14.16. If one of these charts is produced each week then the results relating to exposure error alone can be graphed to check on operational policy effectiveness (Figure 14.18). This is just a slightly different way of representing the information given in Figure 14.17. A trend line can be drawn for these four points as shown by using the formula,

$$y = mx + b$$

where

$$m = \frac{N\Sigma x_i y_i - \Sigma x_i \Sigma y_i}{N\Sigma x_i^2 - (\Sigma x_i)^2} \qquad (1)$$

and

$$b = \frac{\Sigma y_i \Sigma x_i^2 - \Sigma x_i \Sigma x_i y_i}{N\Sigma x_i^2 - (\Sigma x_i)^2} \qquad (2)$$

Here $N = 4$ because there are only 4 points in the graph, and i represents the integers 1 to 4 where $x_1 = 1, x_2 = 2, x_3 = 3, x_4 = 4$. Likewise $y_1 = 25, y_2 = 20, y_3 = 15, y_4 = 30$. The sigma symbol, Σ, means 'sum' so, for example, $\Sigma x_i y_i$ means $x_1 y_1 + x_2 y_2 + x_3 y_3 + x_4 y_4 = 230$. Σx_i^2 means $x_1^2 + x_2^2 + x_3^2 + x_4^2 = 30$. $(\Sigma x_i)^2 = (x_1 + x_2 + x_3 + x_4)^2 = 100$.

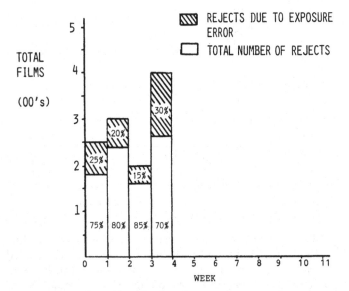

Figure 14.17 Effect of introduction of automatic exposure system

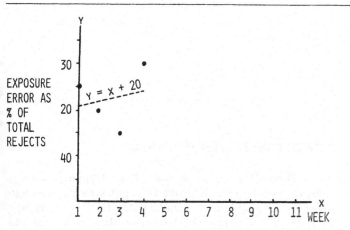

Figure 14.18 Figure 14.17 presented in graph form

Equations (1) and (2) are now straightforward to evaluate, giving $m = 1$, $b = 20$. The trend line then has equation,

$$y = x + 20$$

and this is given by the dashed line in Figure 14.18. Apparently the trend is towards an increase in exposure errors even though automatic exposure devices have been introduced, but is it fair to make an assumption like this with such limited information? If the fourth week is excluded the trend is definitely downwards showing a very significant decrease in exposure error. Why then is there a sudden increase in exposure error in the 4th week? Was it due to pressure of work since apparently more patients were dealt with in week 4? One way out of the dilemma is to withhold a decision until more information is available such as the exposure error statistics for the 5th week. These may confirm the suspicion that the statistics associated with week 4 do not reflect the true effect of automatic exposure control.

Graphs such as Figure 14.18 can be used to decide whether or not the introduction of a particular operational policy has had a significant influence. These graphs will also show the influence of any new factors which were not apparent at the time of the operational policy introduction: for example staff changes, new equipment and new techniques. It should be emphasized that it is not just the aim to reduce film rejects from any individual cause but to reduce total film wastage. It has been suggested in other published material that a total film wastage of about 10% should be regarded as the practical minimum but there is no hard and fast rule here.

15
Automated Film Handling

INTRODUCTION

There has been an accelerating increase in the production of automated film handling systems for radiography in recent years. At the outset the automation was limited to small format films where it was used to provide film changing for exposure in photofluorography but now automated systems for handling large format films are becoming more common and are widely used.

Some systems operate with a conventional cassette which can be loaded and unloaded automatically using the automated equipment. Film feed to an automatic processer is also achieved with this equipment without the need for a darkroom. The Agfa Gevaert and Kodak systems are of this type. With the Agfa Gevaert system, for example, film unloading from a cassette may be into a storage magazine which can be subsequently attached to the film processor providing automatic film feed into the processor of all the contained films. Alternatively the film may be unloaded from the cassette automatically and directly to the film processor. Such systems using a typical cassette do not normally require any special film type.

The DuPont Daylight System employs a specially designed cassette and uses a notched film. This is possibly a disadvantage because it limits the choice of film that can be used with the system but the cassette can be used, exactly as a conventional cassette, in all existing X-ray equipment. Another system announced by Philips Medical Systems employs a specially designed film magazine (cassette) which to use fully requires investment in new X-ray equipment, while the systems mentioned above can be conveniently used with existing equipment.

An automated film handling system when adopted as a complete and integrated system will render a darkroom unnecessary. It is possible however to use an automated film handling system in part only when there is insufficient capital to purchase a complete system. Use of a part system in this manner does not necessarily eliminate the darkroom as a system requirement but does allow for increased efficiency due to work simplification. Automated film handling systems are often referred to as daylight systems because in their complete and integrated form a darkroom supposedly is not required.

THE DuPont DAYLIGHT SYSTEM

At the time of writing the availability of daylight systems is limited mainly to the DuPont Daylight system. Although other film and equipment manufacturers are developing their own daylight systems information on these is limited and experience with installations not known. The information given here is on the DuPont Daylight system as it is the only system on which sufficient user information and practical experience from installations is available.

Diagnostic radiography essentially begins with imaging an affected part of a patient. Most of the equipment and supplies used in an X-ray department are for this purpose. X-ray film is a key item as it is the usual medium for carrying the image for study and diagnosis by a radiologist. Conventionally, a light-tight cassette contains the film for exposure to X-rays. This cassette must be manually loaded and unloaded under safelight conditions and carried to the diagnostic room for exposure. In a busy department this happens many hundreds of times a day. The DuPont Daylight system utilizes specially designed cassettes, and film handling equipment permits the films from factory sealed packages to be dispensed into cassettes. These cassettes can then be utilized in the same way as conventional cassettes with X-ray equipment. Following use these cassettes can be automatically unloaded and fed to an automatic processor and no safelighting conditions are necessary. All these operations are carried out in normal illumination thus obviating the need for a darkroom. In principle the system so far described is shown in Figure 15.1.

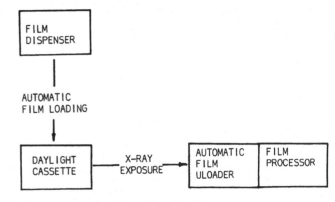

Figure 15.1 Principle of the DuPont Daylight system

236

Although a darkroom is no longer necessary it is still essential to provide space for the film processor and film viewing facilities.

DuPont Ltd. have shown that with a complete and fully integrated Daylight system patient examinations can be made up to 30% faster with existing X-ray equipment. This allows a faster patient throughput allowing a greater workload without necessarily increasing staff numbers or employing more equipment and space. Again, this increase in the rate at which X-ray examinations can be completed is likely to reduce patient waiting time and congestion. In Figure 15.1 the film is loaded from the cassette directly to the processor. However an intermediate unloader is available in which a number of exposed films can be stored prior to processing. When ready the unloader can be attached to the processor and films automatically fed singly from it to the processor. The DuPont Daylight system is illustrated in its complete form in Figure 15.2. Only one film dispenser is considered but in

practice it is necessary to have one dispenser for each different size of film used. Each size of cassette is matched to its own dispenser. It is apparent from Figure 15.2 that a number of options are available. The choice of option will depend on the particular work situation, cost effectiveness and financial constraints existing.

Option 1

The simplest option uses the dispensers, daylight cassettes, film identifier, cassette unloader and film transport case. Notice, however, that a darkroom and safelighting is a necessary requirement since exposed films must be manually unloaded from the transport case for feeding to the automatic processor. Figure 15.3 illustrates this option. Film identification and cassette loading are the responsibility of the radiographer, while unloading of the film transport case would be undertaken normally by the darkroom operator. The system is simple. The cassette is loaded automatically from a dispenser loaded with film. The film is identified in the cassette after exposure to X-rays by using the film identifier. The cassette is then automatically unloaded into the transport case by using the cassette unloader. At some convenient point the transport case containing exposed films can be delivered to the darkroom. This option is rather inconvenient especially

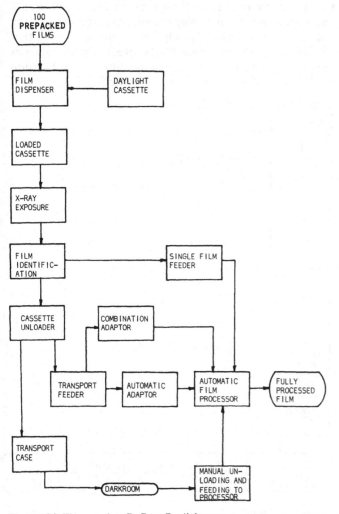

Figure 15.2 The complete DuPont Daylight system

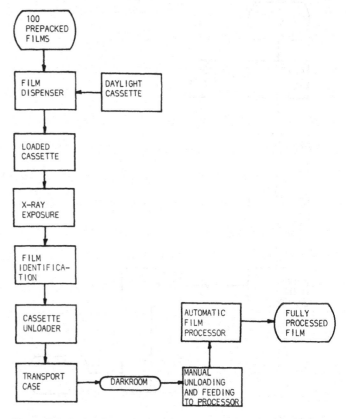

Figure 15.3 Option 1

when films must be processed individually as soon as they are taken. In practice, the transport case is simply a film storage magazine for films awaiting processing. In the majority of cases for routine radiography, use of the single film feeder is a better option and is truly a daylight system since a darkroom with safelighting is no longer required.

Option 2

In this option the cassette unloader and transport case are not used. Instead, to avoid the requirement of safelighting, a single film feeder device is attached to the film input side of the processor. The daylight cassette can be inserted into this device for the film to be automatically withdrawn and fed into the processor. This operation is carried out in normal illumination. Figure 15.4 illustrates the option. Of course, in practice, this option will not satisfy all needs. For example, a series of films may be exposed in rapid succession and it is convenient to store these until the last one has been exposed when they may all be processed together. This can occur, for example, in barium meal studies using large format film. To avoid the requirement of darkroom and safelighting, a transport feeder rather than a transport case can be used. This is described as option 3.

Option 3

Option 3 makes use of the transport feeder as a film storage magazine. The difference between this and the transport case, however, is that by using the adaptor the films contained in the transport feeder can be automatically fed to the processor in normal illumination. If the daylight system is purchased for a single application only – to service the screening room for example – then possibly a single film feeder facility would not be required. All that is then needed to allow automatic unloading of the transport feeder is the automatic adaptor fitted to the film input side of the processor. The automatic adaptor only allows attachment of the transport feeder. It will not allow direct attachment of a daylight cassette for single film feeding to the automatic film processor. Figure 15.5 shows the limited option using only the transport feeder and the automatic adaptor. While single films cannot be loaded directly into the processor from daylight cassettes, the cassettes can be unloaded into the transport feeder which in turn can be unloaded into the processor. This, however, is a tedious and inconvenient way of feeding a single film into the automatic film processor. Option 4 provides for either daylight cassette unloading to the processor or transport feeder unloading to the processor by using the combination adaptor instead of the automatic adaptor.

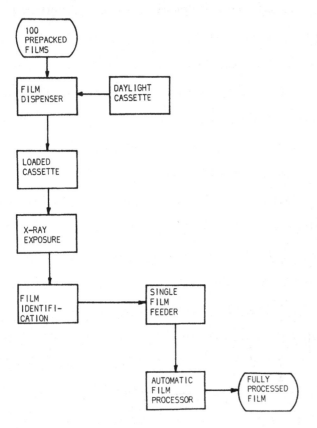

Figure 15.4 Option 2

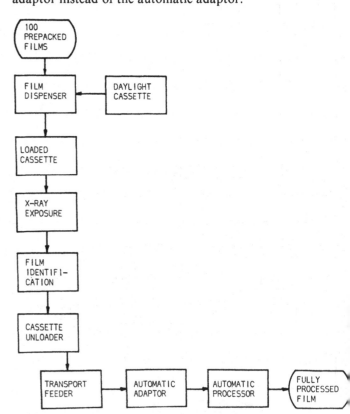

Figure 15.5 Option 3

Option 4

This is the most comprehensive and perhaps the most sensible option for a complete daylight system. This option uses the combination adaptor attached to the automatic film processor. This allows automatic unloading of both single daylight cassettes and the transport feeder. This option is shown in Figure 15.6. The daylight complete system is a highly specialized and total committal system. Originally only DuPont equipment and matching film material could be used but now it is possible to obtain different manufacturers' films for use in the DuPont Daylight system according to the preference of the user. The system itself has been outlined but for a fuller understanding it is necessary to consider each of the individual parts.

The Film Dispenser

The Cronex* Daylight Film Dispenser, to give it its full title, is a wall-mounted cassette loading system (Figure 15.7) for use in normal illumination. The dispenser is loaded in white

* DuPont Ltd. Registered Trademark.

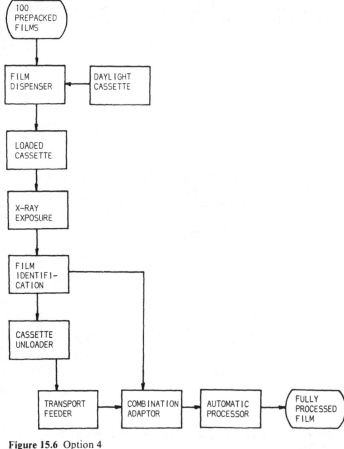

Figure 15.6 Option 4

Figure 15.7 Cronex Daylight film dispenser. (By courtesy of DuPont Ltd)

light with 100 sheets of screen-type film in a black polythene wrapping (Figure 15.8). Once loaded, the dispenser feeds film, one sheet at a time, into a daylight cassette, again in white light (Figure 15.9). A separate dispenser is required for each size of film to be used and the dispensers are available for six sizes of film (all metric). These are (in cm) 35×43, 35×35, 30×40, 20×40, 24×30 and 18×24. Each dispenser (Figure 15.10) consists of two sections, (i) an upper film storage section and (ii) a lower film loading section. The film storage section at the top of the dispenser is protected by lead to prevent the stored film from being fogged by scattered radiation. This is necessary because the film dispensers are usually wall-mounted within each X-ray room. Between the upper and lower sections of the dispenser is a light seal which is automatically opened as a cassette is inserted for loading. When a cassette is inserted for loading, a single sheet of film is fed into it (Figure 15.11). The loading system is basically gravity feed but a pair of motor-driven rollers are used to assist this mechanism.

Figure 15.8 Film pack for dispenser. (By courtesy of DuPont Ltd.)

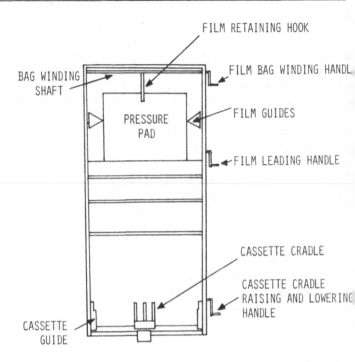

Figure 15.10 Front view of film dispenser with access door removed. (By courtesy of DuPont Ltd.)

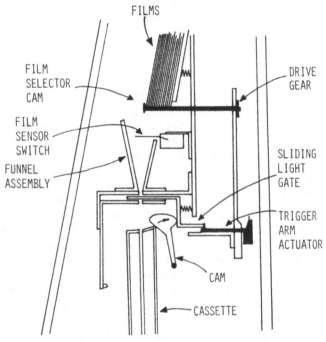

Figure 15.9 Diagram of film dispenser. (By courtesy of DuPont Ltd.)

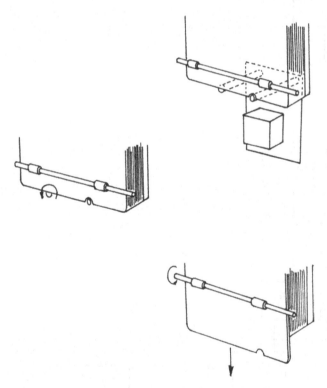

Figure 15.11 Simplified diagram of film release in dispenser. (By courtesy of DuPont Ltd.)

Figure 15.12 Loading the film packages. (By courtesy of DuPont Ltd.)

Figure 15.14 The Daylight cassette. (By courtesy of DuPont Ltd.)

To load the dispenser with film, the prepacked black polythene bag containing 100 films of the appropriate size is loaded as it is into the top of the dispenser. The top flap of the package is lifted (Figure 15.12) and fed into the split metal bar at the top of the dispenser. The bottom flap is cut off. The unit is then closed and by turning the upper external handle the bag is withdrawn from the films. The dispenser can then be used for automatic daylight loading of the cassettes. There is a film counter on the front of the dispenser and an indicator panel on the side. One indicator lights when the film storage compartment is empty and another lights as a film is being loaded into the cassette. To load the cassette it must be inserted into the lower section of the dispenser (Figure 15.13). Two locating pins register with two buttons on the cassette to separate the intensifying screens for film insertion from the dispenser.

The Daylight Cassette

The Daylight cassette (Figure 15.14) has essentially the same features as a conventional cassette but differs in several important aspects. The cassette is sealed on three sides while the fourth side has an opening with a light seal to facilitate loading the cassette with film from the dispenser in normal illumination. At the opposite end of the cassette to the light seal is another smaller opening (Figure 15.15) to facilitate insertion of the required identification using the film identifier (Figure 15.16). At this same end of the cassette is a film

Figure 15.15 End of cassette showing identifier opening. (By courtesy of DuPont Ltd.)

Figure 15.13 Inserting the cassette. (By courtesy of DuPont Ltd.)

Figure 15.16 Film identifier inserted in cassette. (By courtesy of DuPont Ltd.)

indicator pin which verifies whether or not the cassette is loaded and also assists in unloading the film.

The cassette differs internally from a conventional cassette in that the back intensifying screen is pressed against the front screen by a spring mechanism ensuring good film-screen contact (Figures 15.17, 15.18). The intensifying screen surfaces are specially coated to reduce friction when the film is inserted (from the dispenser) between the screens. The screen surfaces have many minute elevations to reduce the possibility of the film adhering to the screens during unloading. This system reduces the possibility of dirt collecting on the screens and film faults due to film handling. Because of its construction the Daylight cassette is more robust than a conventional cassette.

Figure 15.19 The cassette unloader. (By courtesy of DuPont Ltd.)

venient position within the X-ray room and is shielded from the effects of radiation. It requires a power supply for operation.

Figure 15.17 Interior of cassette showing the pressure mechanism. (By courtesy of DuPont Ltd.)

Figure 15.18 Parts of cassette. (By courtesy of DuPont Ltd.)

The Cassette Unloader

This is a device for unloading the film from a Daylight cassette (Figure 15.19) into either a transport feeder or a transport case. The cassette unloader has an adjustable port on the top into which all sizes of Daylight cassette may be inserted and unloaded. The cassette unloader may be placed in any con-

The Transport Feeder

This is a film storage magazine with an automatic film unloading facility. The transport feeder will accommodate all six sizes of film used in the Daylight system and will accept up to a maximum of 30 films. When required or when full, the transport feeder is removed from the base of the cassette unloader (Figure 15.20) and attached to the combination adaptor (or automatic adaptor) on the automatic processor (Figure 15.21). Films are then automatically fed from the transport feeder to the processor. An indicator shows when the transport feeder is empty. It can then be removed from the adaptor and returned to the cassette unloader to accept more exposed films.

The Transport Case

This has a similar function to the transport feeder but does not allow automatic unloading of film to the processor. It can

Figure 15.20 Removing the transport feeder from the cassette unloader. (By courtesy of DuPont Ltd.)

Figure 15.21 Attaching the transport feeder to the autoprocessor. (By courtesy of DuPont Ltd.)

Figure 15.23 Loading a cassette into the combination adaptor. (By courtesy of DuPont Ltd.)

Figure 15.22 The combination adaptor. (By courtesy of DuPont Ltd.)

Figure 15.24 A cassette in the combination adaptor. (By courtesy of DuPont Ltd.)

store up to 50 films of mixed sizes from the Daylight cassettes but requires a darkroom and safelight illumination for unloading prior to feeding its contained films to the automatic processor.

The Combination Adaptor

This attaches to the feed tray of automatic film processors and converts it for the automating unloading and film feeding to the processor either from a Daylight cassette or the transport feeder (Figure 15.22). The adaptor accepts all sizes of Daylight cassette (Figures 15.23, 15.24). Like the film dispenser and cassette unloader there are locating pins on the adaptor to allow intensifying screen separation and release of film from the cassette. These pins are adjustable to allow all cassette sizes to be accommodated. A different version of the adaptor allows only for automatic film feed to the processor from a transport feeder. Single Daylight cassettes cannot be accommodated. Where use of a transport feeder is considered unnecessary the adaptor is not required. Then a single film feeder (the Daylight processor loader) can be used which

accepts all sizes of Daylight cassette but will not accommodate a transport feeder.

The Film Identifier

This is a battery-powered electronic unit producing a timed light emission from an electroluminescent panel. The patient information slip is placed around the panel and inserted into the appropriate slot in the Daylight cassette. Activating the unit results in actinic marking of the film (Figures 15.25, 15.26 and 15.27).

The Daylight Film

Unlike ordinary screen-type film the Daylight film has small notches to accommodate the automatic film dispensing mechanism. In all other respects the film is conventional.

Figure 15.25 Loading the patient information slip into the film identifier. (By courtesy of DuPont Ltd.)

Figure 15.26 Interior of the film identifier. (By courtesy of DuPont Ltd.)

Figure 15.27 Interior of film identifier with patient information slip in place. (By courtesy of DuPont Ltd.)

THE SYSTEM IN USE

Perhaps the biggest advantage in adopting a Daylight system is the virtual elimination of film handling faults and the elimination of a safelighting requirement. The darkroom if it is allowed to exist in its unaltered state can be operated in normal illumination. Alternatively the darkroom and film viewing and sorting rooms can be redesigned for best use of the appropriate segments of the Daylight system. Because of cost, centralized processing is still a requirement and an advantage because of image quality control, processor maintenance and reservoir replenishment. Reservoir replenishment is made easier by using the DuPont system of automatic chemical preparation and mixing. Even so, it is difficult to see the time when darkroom technicians will not be necessary, even accepting that their role will be rather different in many respects in a total daylight system.

Basically, the Daylight system discussed is intended to replace a single film cassette system so that all operations may be performed without the necessity of darkroom safelighting. Departments operating a rapid film changer for large format films, the Siemans-Elema or Puck film changers for example, would still require darkroom facilities with safelighting for film loading and unloading even if the Daylight system were introduced. These film changers are incompatible with the daylight system. Retaining rapid film changer facilities and introducing a Daylight system must both be considered in the preplanning stage to make best use of the facilities available. However, 105 mm film is increasingly being used for applications usually reserved for large format rapid film changers, but again, unless an automatic cassette unloader for the 105 mm film is available, together with a system for automatic feed to the processor, then a darkroom is still required with safelighting facilities. Thus purchase of a Daylight system need not necessarily mean that the darkroom can be eliminated. Of course, the majority of radiography is of the single film cassette type and the use of a Daylight system can offer many distinct advantages even when the darkroom with safelighting is a retained feature.

Functional Design and the Daylight System

To plan the introduction of a Daylight system requires knowledge of the functional zones or areas of the department. A functional zone is an area of the X-ray department to which a particular function can be attributed. Typical functional areas are

 (i) entrance areas
 (ii) general diagnostic areas
 (iii) special diagnostic areas
 (iv) decentralized diagnostic areas
 (v) information and processing areas
 (vi) communication and filing areas
(vii) service and recreation areas.

areas as possible, particularly to reduce the amount of walking done by the radiographer. In some cases, investment costs can be saved by elimination of little-used film sizes and using the next larger size. However, before doing so, running costs should be considered. Generally, fewer cassettes are required than in a conventional system because of the faster loading and unloading and elimination of cassette hatches. Usually a maximum of three cassettes of each size are required for each room. This number could possibly be reduced where there are two or more rooms operating off one Daylight system and the cassettes are kept in a central 'pool'. Similarly with film identifiers – one or two identifiers may be needed for each room. However, if they are kept in a 'pool' at the processing base it is possible to reduce the number required. Figures 15.28, 15.29 and 15.30 illustrate different designs incorporating the Daylight system.

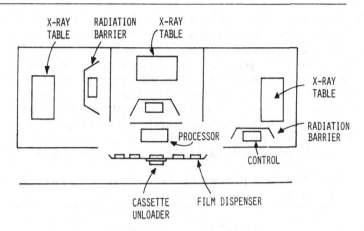

Figure 15.30 Third possible layout of Daylight system. (By courtesy of DuPont Ltd.)

An interesting, and compatible, addition to the Daylight system is the DuPont Chest Changer. This is loaded with 100 prepacked 35 × 43 cm films in normal illumination. The film identifier can be accommodated in the side of the unit and the system operates automatically. Films are fed from the top of the unit to a pair of intensifying screens in the unit. After exposure each film is passed into either a transport case or transport feeder (whichever is fitted to the base of the unit). Figures 15.31 and 15.32 illustrate the unit. As an alternative to the transport feeder or transport case the chest unit can be fitted directly to an automatic processor to form a completely self-contained unit. It is unfortunate that this unit cannot accommodate 40 × 40 cm size.

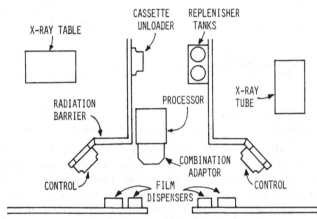

Figure 15.28 Possible layout of Daylight system. (By courtesy of DuPont Ltd.)

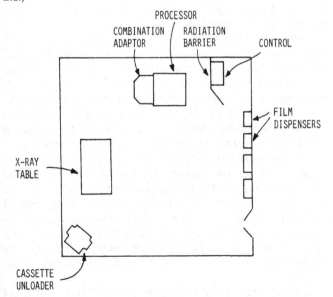

Figure 15.29 Another possible layout of Daylight systems. (By courtesy of DuPont Ltd.)

Figure 15.31 The DuPont Chest Changer (1). (By courtesy of DuPont Ltd.)

Detailed information relating to the functional zones is a necessary preplanning requisite. The information relates to time, flow, space and structural analyses. Time analysis is of the occurrence, periodicity and frequency of events; flow analysis is of point-to-point movement in the performance of all operations; space analysis is of the relative positioning of and area requirements for the equipment; structural analysis is of the logical linking of equipment for optimized operation.

From experience, space requirements are known for the individual functional areas and figures are given in Table 15.1.

Table 15.1 Space requirements for functional areas. (By courtesy of DuPont Ltd.)

Entrance zones	22.5%
Diagnostic areas	22.5%
Information and processing areas	25%
Communication and filling areas	15%
Service and recreation areas	15%

There has been a considerable expansion in complexity of radiological techniques in the past few years with examinations and techniques becoming more differentiated, complex and expensive to perform. The average percentages for type of examination and time needed are shown in Table 15.2. Of course, these are only average values and the actual value in any particular case may vary considerably from these, notably in the case of special examinations.

Table 15.2 Types of examination and times needed. (By courtesy of DuPont Ltd.)

Examination type	Examination type as a proportion of the total number of examinations	Examination type as a proportion of the total time requirement
Gastrointestinal	14%	18.5%
Thorax	26%	9.5%
Skeletal	38%	26.5%
Tomography	3%	4%
Kidney, gall bladder	6%	15%
Neuroradiography	7%	7.5%
Angiography	3%	12.5%
Other	3%	6.5%

Table 15.3 Time and flow analysis for chest examination. (By courtesy of DuPont Ltd.)

Function	Time in min. Patient	Staff
Check records and call		1.5
Undressing	1.5	
Exposure and walking	2.4	2.4
Time for radiographer to return	7.6	
		1.4
Fluoroscopy in separate room	4	
		1
Waiting time	3.5	
		0.5
Information to patient and dressing	2	
Total	21	6.8

As a further illustration of time and flow analysis consider Table 15.3. This is an example of a chest examination carried out in a large hospital with a less than favourable work flow pattern. This example illustrates the relationship between the radiographer's utilized time and the total examination time for the patient. This ratio is often quite small and indicates an area where it may be more practical and economical to employ the use of a Daylight system to reduce the radiographer's unemployed time.

Between 5000 and 7000 examinations per year are carried out in an average diagnostic X-ray room. As indicated previously, fluoroscopy rooms are at the low end of this range while rooms doing general work are at the high end. In instances where rooms are operating at above average workloads, provision of Daylight cassette loading and unloading for each room can permit handling of the greater workload with less patient waiting time and less unemployed staff time. Rooms operating at average workloads can share Daylight cassette loading and unloading equipment with a second room particularly if the layout places the two areas in close proximity. Alternatively, sharing of a centrally placed Daylight system is possible. A high concentration of examinations at certain times and on certain days may dictate the purchase of more Daylight equipment even though the annual total may indicate that Daylight equipment can be shared.

In designing Daylight equipment layout, film dispensers should be located as close to the exposure control area or

Figure 15.32 The DuPont Chest Changer (2). (By courtesy of DuPont Ltd.)

16
Imaging Techniques and Processes

INTRODUCTION

Two important imaging processes undertaken in radiography are subtraction and duplication and these will be discussed. Furthermore, the dividing line between radiographic technique and radiographic photography is indistinct and important imaging principles are involved in certain techniques which up to now have either not been mentioned or only briefly touched upon. These techniques include macroradiography, stereoradiography, tomography, xeroradiography, ionography and photofluorography. These will also be discussed.

PHOTOGRAPHIC SUBTRACTION

The procedure for photographic subtraction involves the following steps:

 (i) Two original radiographs with identical patient position are produced. One radiograph will have information not contained in the image of the other
 (ii) A 'positive' is made of one of the originals
 (iii) The other original is superimposed on the 'positive'
 (iv) A print is made of the superimposed combination.

This is photographic subtraction in its simplest form and is usually called single-order radiographic image subtraction. The idea of image subtraction is to reduce to zero the image contrast of all information which is similar in the two original radiographs. The final print then shows only that information not common to both original radiographs. The technique is particularly useful in angiographic studies where only vessel distribution is sought: for example, when one original can be the film before contrast agent is injected and the other after. The final print should then show only the vessels with filled contrast agent.

The Original Radiographs

It is a necessary condition for all subtraction techniques that the patient's position on each of the two original films used must be the same. Superimposition of positive and negative will then result in zero contrast for all common image information. Image information not common to both original films will remain visible. If, however, the patient's position is different in the originals then no information will be common to both and image subtraction is not possible by this method. Figure 16.1 shows two original films from an angiographic series. Both show contrast agent but one is from the beginning of the series and the other from the end.

Figure 16.1 Two original films from an angiographic series

Normally to achieve the same patient position in the two original radiographs requires the use of adequate patient immobilization and a minimum time interval between the exposures for the two films. Unfortunately, in practice, while it is possible to achieve similar patient positions as far as the skeleton is concerned it is not always possible to achieve similar positions for diaphragm, heart, lung structure, or intestinal gas. This latter can prove particularly troublesome in abdominal angiography with image subtraction because, due to involuntary intestinal movement, both shape and

position of gas can vary between films. In Figure 16.1 the intestinal gas shape and position is fortunately the same in both images. Dealing with troublesome intestinal gas images is more complex and will be discussed later. The image contrast of the two original films is also an important consideration. For satisfactory subtraction the image contrast in both films of all parts requiring subtraction should be as nearly identical as possible. The degree of unsharpness in both films should also be identical. If not, the information contained in both images is not similar and subtraction becomes impossible.

The 'Positive' Mask

The mask image refers to the positive image made from one of the originals by contact printing. Which of the two originals is chosen to make the mask is arbitrary but the usual preference seems to be for the mask to be made from the original film showing no contrast agent. The blood vessels shown on the final print will then appear 'black'. If the positive was made from the original film showing contrast agent then the final print would show 'white' vessels (Figure 16.2).

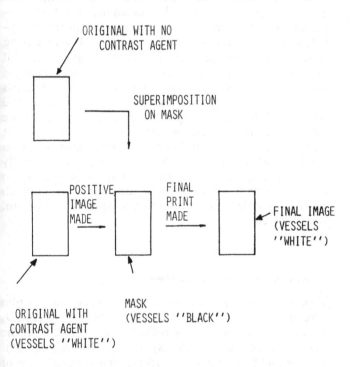

Figure 16.2 Production of a 'positive' mask

The film used to produce the mask image from the original must have special characteristics if subtraction is to be successful. To understand what these characteristics are it is useful to consider an original film consisting simply of a series of steps of different image densities (Figure 16.3). Thus the

original film (A) is simply the image of a stepwedge. The mask (B) is produced from film (A) by contact printing and in practice both films would be in contact for this procedure which can be performed using the DuPont Cronex printer. The film used to produce the mask image is called a subtraction mask film and has a single emulsion. This is to reduce unsharpness in the image to a minimum. When exposing the subtraction mask film the emulsion side of the single emulsion film should be in contact with one emulsion of the original film. The original film is, of course, duplitized. The arrangement for exposure is shown in Figure 16.4.

Figure 16.3 The stepwedge film image used as an original film

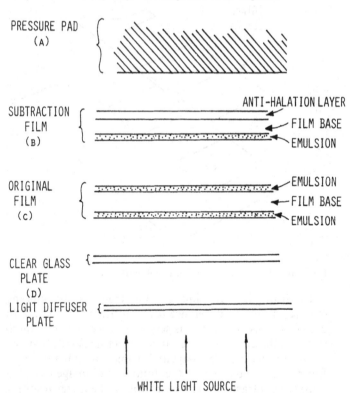

Figure 16.4 Arrangement for exposing subtraction mask. Layers a, b, c and d are shown separated for clarity but would normally all be in contact

It is necessary to consider what are the special characteristics mentioned above. In Figure 16.5, the original film and mask film are shown (separated for clarity) at the

time of exposure. In Figure 16.5, D_1 and D_2 are adjacent areas of different photographic density in the original film, D_2 being greater than D_1. Light, from a tungsten bulb, passing through D_1 and D_2, gives rise to densities D_4 and D_3 respectively in the mask image. Since $D_2 > D_1$, then $D_4 > D_3$. The image contrast in the original (film A) for the two steps being considered is $(D_2 - D_1)$. The corresponding contrast in the mask is $(D_4 - D_3)$. Now assume that after processing the mask it is superimposed on the original film exactly in register. Then D_1 is superimposed over D_4 to form a composite density $(D_1 + D_4)$ while D_2 is superimposed over D_3 to form another composite density $(D_2 + D_3)$. The contrast in the image resulting from superimposition of the original and mask is thus

$$(D_1 + D_4) - (D_2 + D_w$$

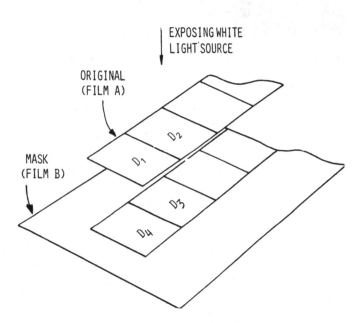

Figure 16.5 Densities in the original and mask

To distinguish any image detail from its surrounding requires a density difference (ΔD) sufficient for the eye to detect. If this difference is less than a certain minimum (ΔD_{min}), then no difference can be detected visually between the various parts of the image and no image detail can be seen. For complete subtraction (i.e. total loss of image information) the contrast should be zero within the image resulting from superimposition. This is the condition which must be met if the information in the image common to both original film and mask is to disappear. This condition can be expressed mathematically as

$$(D_1 + D_4) - (D_2 + D_3) = 0$$

or

$$(D_4 - D_3) = (D_2 - D_1)$$

This last equation states that the image contrast in the mask must be identical to the image contrast in the original film.

Assume for a moment that an original film has a maximum image density of D_2 and a minimum of D_1, then $(D_2 - D_1)$ is the density range for that film. Since

$$(D_4 - D_3) = (D_2 - D_1)$$

then the mask image must have the same density range as the original film (not necessarily the same densities, just the same density range). Films having a single emulsion, and designed specifically for subtraction, tend to have a limited density range over which complete subtraction is possible. Original films should have the same limited image density range, otherwise complete subtraction can never be achieved using a single-order method. In practice it is nearly always found that the density range of the original film image is greater than that which can be matched for subtraction by the mask film. If successful subtraction is necessary then careful consideration must be given to depressing the density range in the original film when it is first produced. Limiting the density range in this way represents a reduction in image contrast, generally achieved by increasing kV and adjusting mAs to compensate. Whether or not this low contrast original can be accepted for diagnosis must be carefully considered. In areas having increase image information content even though contrast will be reduced. Visual loss of information, as a result of contrast reduction, will not occur unless any useful ΔD is made less than D_{min} when the film is viewed. In many cases the required kV increase in exposure value can be made before this occurs, but in some cases, for the radiograph as a whole, it may not be possible to obtain the required density range no matter what increase is made in kV within the normally employed range. In yet other cases, it may not be necessary to alter kV, as the density range in the part of the image for which subtraction is desirable may already be equal to, or less than, that required.

Characteristic Curve for the Mask

Figure 16.6 illustrates a characteristic curve typical of a film used in subtraction for the production of the mask. D_3 and D_4 are densities recorded in the mask film and I_1 and I_2 are the light intensities forming the exposure producing these densities. A and B are two points on the curve at the extremities of the straight line portion. The gradient, \bar{G}, of the linear part of the curve between A and B is

$$\bar{G} = \frac{D_4 - D_3}{\log I_2 - \log I_1}$$

Density is defined as

$$D = \log \frac{I_o}{I_t}$$

where I_o is the incident light intensity and I_t is the transmitted light intensity. Figure 16.7 shows the relationship between I_1, I_2 and D_1, D_2 for a given I_o. I_2 is the intensity transmitted by D_1 and I_1 the intensity transmitted by D_2. Since $D_2 > D_1$ then $I_2 > I_1$. Using the equation for density then

$$D_1 = \log \frac{I_o}{I_2} \text{ and } D_2 = \log \frac{I_o}{I_1}$$

Subtracting these gives

$$D_2 - D_1 = \log \frac{I_o}{I_1} - \log \frac{I_o}{I_2}$$

$$= (\log I_o - \log I_1) - (\log I_o - \log I_2)$$

$$= \log I_2 - \log I_1$$

Substituting for $(\log I_2 - \log I_1)$ in the equation for \bar{G} gives

$$\bar{G} = \frac{D_4 - D_3}{D_2 - D_1}$$

and since for satisfactory subtraction $(D_4 - D_3)$ and $(D_2 - D_1)$ must be identical, then $\bar{G} = 1$. This is the requirement for a film used for the subtraction mask, i.e. the gradient of the characteristic curve must be equal to 1 throughout the range of densities to be subtracted. Unfortunately, in practice, the density range over which $\bar{G} = 1$ is limited. In Figure 16.6, $\bar{G} = 1$ between A and B. Above B and below A, $\bar{G} < 1$.

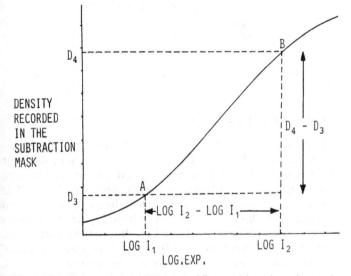

Figure 16.6 Characteristic curve typical of film used for subtraction mask

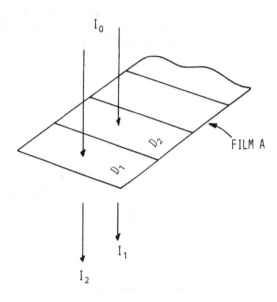

Figure 16.7 Production of intensities I_1 and I_2

For the practical technique of single order image subtraction it is necessary to check that the processing conditions existing in the department do in fact produce a $\bar{G} = 1$, otherwise all attempts at single order subtraction are likely to be unsuccessful. This check can be done by producing a characteristic curve for the subtraction mask film for the existing processing conditions. This can be done as follows:

(i) A film image of a stepwedge (original film) is contact-printed on the subtraction film using white light. The emulsion sides of the two films should be placed together for contact printing to limit unsharpness. An exposure time is chosen so that the densities recorded on the subtraction film cover the range 0.15–2.5. These figures are only approximate but if this range is not found in the subtraction film image then only part of the whole characteristic curve will appear on the graph

(ii) The film is processed and the densities on this and the original film measured and recorded. It was shown earlier that

$$D_2 - D_1 = \log I_2 - \log I_1$$

This implies that on the log exposure axis of the characteristic curve any pair of $\log I$ values can be replaced by the associated pair of density values. Extending this idea it is possible to replace the log exposure axis by an associated density axis. Since a low value for intensity is associated with a high value for density this axis is reversed relative to the log exposure axis. In Figure 16.8 the log exposure axis has

been replaced by the corresponding density axis, the densities being those of the original film. The vertical axis shows densities in the subtraction film image

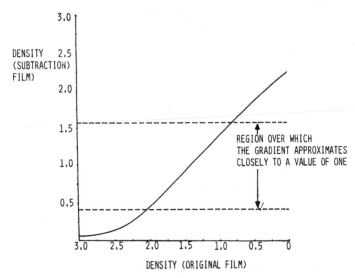

Figure 16.8 Replacing log exposure axis with original film density axis

(iii) The densities recorded earlier can now be used to plot the required characteristic curve. Each density in the subtraction film image is produced by a given light intensity and hence corresponds to a particular density in the original film. Each corresponding pair of densities is taken as the co-ordinates for plotting the characteristic curve. The result for Cronex subtraction film is shown in Figure 16.8.

Figure 16.9 shows the same curve as Figure 16.8. In Figure 16.9, by simple measurement, the curve has $\bar{G} = 1$ between points X and Y. This corresponds to a subtraction film density range (on the vertical axis) of

$$1.6 - 0.4 = 1.2$$

The original film should have a similar density range in its image if DuPont Cronex film is to be used for the subtraction. Rather than simple measurement from the characteristic curve to determine the density range over which subtraction will be successful, a photographic method can be used. Since here the original film is a stepwedge image this can be superimposed, emulsion to emulsion, on the subtraction film image and a note made of which steps can and cannot be differentiated. The steps which cannot be differentiated will have densities lying within the 'subtraction useful' part of the curve and the steps which can be differentiated will have densities lying outside this region. The step densities lying at the extremes of the range of non-differentiated steps in the original film can be compared with the maximum and minimum densities (in the region to be subtracted) of some

other original film. If the maximum density of this other original is less than or equal to that at the upper extreme of non-differentiated steps and the minimum density greater than or equal to that at the lower extreme, then subtraction will be successful for this other original film if the same white light exposure is used.

In Figure 16.9 it is seen that the 'subtraction useful' density range of 1.2 covers densities in the original film of 0.85 to 2.05. Any density in the original film which is above or below these limits cannot be subtracted. An original film with the same density range but different density limits can undergo satisfactory subtraction but the exposure time required when making the mask must be changed. Consider for example an original film with density limits of 1.3 and 2.5. Its density range is 1.2 but from Figure 16.9 it is obvious that densities above 2.05 cannot be subtracted. This may be overcome by shifting the whole curve to the left so that the 'subtraction useful' region covers densities 1.3 to 2.5 in the original film. This shifting is achieved by altering the white light exposure, increasing it in this instance.

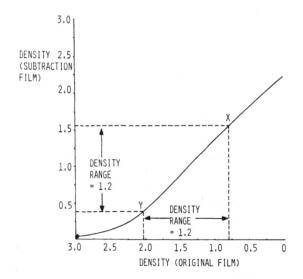

Figure 16.9 Characteristic curve of Figure 16.8 showing 'subtraction useful' density range

Choosing an Exposure Time

Using the original film image of a stepwedge several subtraction masks can be made in succession using for each a different exposure time. The characteristic curve for each can then be plotted (Figure 16.10) in the same manner as previously. The 'subtraction useful' region for each of the curves is contained between the dashed lines. It is seen from Figure 16.10 that as the exposure is increased from 1 s to 48 s, in this example, the curve moves towards the left but the 'subtraction useful' density range remains constant at 1.2. An exposure time of 3 s, for example, allows successful subtraction for densities from

0.6 to 1.8 in the original film while an exposure of 24 s allows successful subtraction for densities from 1.3 to 2.5.

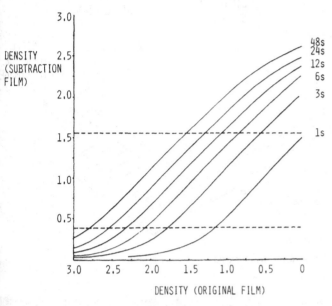

Figure 16.10 Characteristic curves of several masks made from same original with different exposure times

There are two useful ways of determining the required exposure time in practice for making the mask and these will be described but it should be noted (from Figure 16.10) that the darker the original film the larger the exposure time required to produce the mask. The first method requires the use of a densitometer. Referring again to Figure 16.10, for an exposure time of 1 s densities from 0.1 to 1.2 can be subtracted. The density halfway between these limits (i.e. 0.65) is designated the midrange density in the original film. For a 3 s exposure the midrange density is 1.2, and for a 12 s exposure is 1.9. Continuing in this way, values for exposure time and midrange density are obtained and a graph plotted (Figure 16.11). This graph is used in the following way:

(i) Densities in the region of interest on the original film are sampled to determine maximum and minimum densities in the regions of the image requiring subtraction. It is assumed that the density range in the original film determined by the measured minimum and maximum densities does not exceed 1.2

(ii) The midrange density is determined from $\frac{1}{2}(D_{min} + D_{max})$, where D_{min} and D_{max} are the minimum and maximum densities measured in the regions of the image requiring subtraction

(iii) Finally all that is necessary is to use this value for midrange density to find the required exposure time from the graph of Figure 16.11. It should be noted that the graph of Figure 16.11 applies only to the process-

ing conditions used here to produce these results, although the curve for other automatic processing conditions should not differ too greatly from this curve.

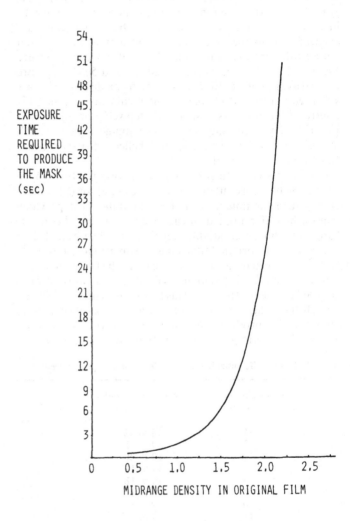

Figure 16.11 Midrange density against exposure time

Provided that processing conditions do not change then the graph of Figure 16.11 can be successfully used. If, however, the speed index changes then a correction must be made. If, for example, the speed index for the film (as determined from processor quality control monitoring) decreases by 0.15, this value of density should be added to the midrange density value obtained. If the speed index increases then the value should be subtracted from the obtained midrange density value.

An alternative method of determining the exposure time required for the production of the mask does not require the use of a densitometer, but it does require the production of a

series of stepwedge images which taken altogether constitute the control film. The control film is then used to determine the correct exposure time in each case.

First, the original stepwedge image is contact printed onto a subtraction film using a short exposure time (1 s, say). That part of the subtraction film not being exposed is covered with black paper. A series of exposures can be made in this way, each adjacent to one another on the subtraction film, and each with a different exposure time. A useful range of exposure times is 1, 2, 3, 4, 5, 7, 10, 15, 20, 30 and 50 s. These are quoted as applying to the exposure being made using Cronex subtraction film and a Cronex printer/subtraction unit. This control film now has a series of stepwedge images on it progressively increasing in average image density. Each successive stepwedge image can be labelled with the exposure time used to produce it.

The next step is to superimpose the original film image (emulsion to emulsion) over each of the images on the control film in turn and note in each case the number of steps which cannot be differentiated. If each step is numbered then the range of non-differentiable steps can be determined. For example, if the original film image is superimposed over the image produced for a 50 s exposure it may be found that steps 4 to 12 cannot be differentiated visually. This information is marked on the control film. This procedure can be performed for all the images on the control film. The exposure times quoted above produced the results of Table 16.1. The density of step 4 was 0.15 while the density of step 22 was 2.5.

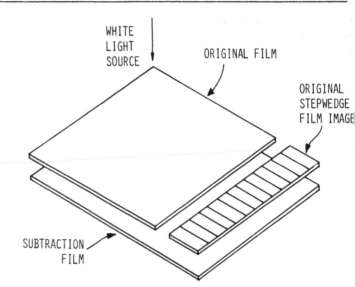

Figure 16.12 Arrangement for contact printing

Table 16.1 Non-differentiable step range for various exposure times

Exposure time (s)	Non-differentiable step range
1	14 to 22
2	13 to 21
3	12 to 20
4	11 to 19
5	10 to 18
7	9 to 17
10	8 to 16
15	7 to 15
20	6 to 14
30	5 to 13
50	4 to 12

The original film image and the control film can now be used to determine the correct exposure time for producing the mask. First, the original stepwedge film image is placed on a viewing box by the side of the film from which a subtraction mask is to be made (eliminating glare as far as possible). The minimum and maximum densities in the region to be subtracted are visually matched to corresponding step densities on the adjacent stepwedge film image. The appropriate step numbers are noted (6 and 14, for example). Second, by reference to the control film, it is seen, in this example, that an

Figure 16.13 Example of image produced in Figure 16.12

exposure time of 20 s is required to produce a subtraction mask which will provide successful subtraction for densities such as those represented in steps 6 to 14. The mask is made by contact printing with the films arranged as in Figure 16.12. The stepwedge image is contact printed at the same time because its image will be used to check the exposure. Upon processing, the image produced shows a 'positive' image of the original film to be subtracted alongside a 'positive' image of the stepwedge original film. An example is shown in Figure 16.13.

All the images on the control film are 'positive' images of the stepwedge original film. If there has been no change in processing conditions then the 'positive' image of the stepwedge on the mask will exactly match its counterpart with the same exposure time on the control film. In this case the exposure time (x) used for the mask is the same as the exposure time number (y) for the matched control film image. If, however, the processing conditions have changed then when a match is found x and y may not be equal and the mask will not be entirely suitable for subtraction. The solution is then to make another mask using an exposure time of (x^2/y) s, using the values for x and y obtained from the matching. Consider the example given above where a 20 s exposure was necessary for successful subtraction of all densities from step 6 to 14. This would indeed be correct if the processing conditions do not change. Assume, however, that the processing conditions have changed and that the resulting 'positive' image of the stepwedge film matches with an image on the control film that resulted from a 30 s exposure. Another mask should then be produced using an exposure time of $(20^2/30)$ s. This mask is then satisfactory for subtraction.

Superimposition of Mask and Original

Superimposition will not be successful unless the emulsion side of the mask is in contact with an emulsion side of the original film. The process of superimposition must be done carefully and if the mask has the appropriate properties it is obvious when the final position has been achieved since all image information disappears except that not common to both images. Figure 16.14 shows the composite image obtained by superimposing the 'positive' image of A (in Figure 16.1) on B (in Figure 16.1). The 'positive' image of A was shown in Figure 16.13. Once superimposition is successfully achieved the two films can be taped together in position. Then all that is ncessary is to produce the final print. One body of opinion is against complete subtraction because there is no anatomy to which to relate the position of the vessels in the final print. Of course this is readily solved by superimposing the final print image over the original film.

The Final Print

Any film image contains a noise element in its structure and

Figure 16.14 Composite image obtained by superimposition of positive image of A on B (from Figure 16.1)

when the image is copied the noise element is copied and added to the quantum noise of the exposure. The copy, the 'positive' mask in this case, therefore has a higher noise content than the original but because it is slightly less sharp than the original it is not readily noticeable. However when the final print is made the noise element is further increased and final print images appear with considerable mottle.

There are two films which could be used to produce the final print. Both are single emulsion films but one, produced especially for making final prints, has an average gradient of

about 1.75. The other is the subtraction film itself and this has an average gradient of 1. The film with $\overline{G} = 1.75$ is a high contrast film which enhances the mottle and is really inadequate for showing fine vessel structure. Although the contrast is lower with the subtraction film it does suppress the noise to an acceptable level and visualization of finer vessels does seem easier.

Figure 16.15 illustrates a final print made on subtraction film. The two original films used were the arterial and venous phases of a carotid arteriogram, and the 'positive' mask was made from the venous phase film. Figure 16.16 shows three final prints of the same image, each with a different exposure time. It is a matter of choice which image is preferred but if none is particularly suitable it is easy to double the contrast by superimposing two final prints. Visually there is less noise doing this than in the final print image using the film with $\overline{G} = 1.75$.

In producing the final print it is necessary to maximize the contrast between blood vessel and its background without producing excessive image noise. If the subtraction film is used to make the final print then it is necessary to ensure that the exposure chosen will result in image densities of importance lying within the straight-line portion of the films characteristic curve. Since the straight-line portion is the steepest part of the curve, the contrast here will be greatest. This also results in the correct average image density for the final print. It should be noted that although the term 'print' is used all these films are viewed by transmitted light.

Selective Subtraction

The problem of intestinal gas was mentioned earlier with respect to single order image subtraction in abdominal angiography and it is interesting to investigate a method of overcoming this. Theoretically it should be possible from a consideration of the characteristic curve of the subtraction film. Figure 16.17 shows again the characteristic curve for a subtraction film. AB is the region within which subtraction can be achieved. Outside this region subtraction is not possible. Now consider an original film showing intestinal gas overlapping vessels filled with contrast agent where it is required to subtract the gas and leave the vessels. There will be a certain density difference between the gas and the vessels. Assume that, in Figure 16.17, X represents the vessel density and Y represents the gas density. In Figure 16.10 it is seen that the position of the characteristic curve relative to the axes depends on the exposure time chosen. If the exposure time used is such that the curve is positioned relative to densities X and Y as shown in Figure 16.16 then Y can be subtracted while X can not. Superimposition of the mask produced with this exposure time will allow subtraction of gas only. Subtraction has then been performed with only one original film rather than two. By varying exposure time for the mask other densities can be selectively subtracted.

Figure 16.15 Final print made on subtraction film

Figure 16.16 Three final print images. Subtraction is incomplete because the original films had too great an image contrast

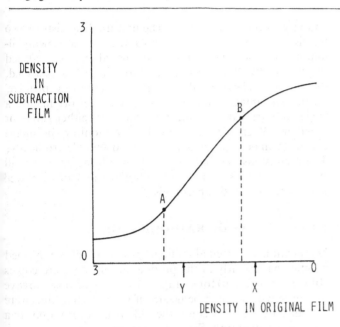

Figure 16.17 Characteristic curve for a subtraction film

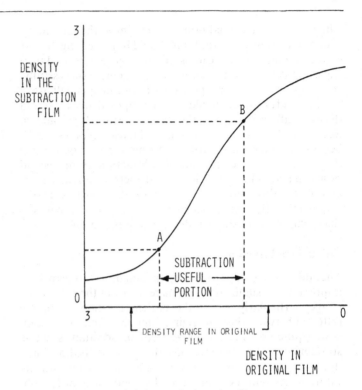

Figure 16.18 Characteristic curve of subtraction film

Second Order Image Subtraction

This technique is often resorted to when the contrast in the original films is too great to allow successful single order image subtraction. Reference to Figure 16.18 indicates that the densities in the original film extend outside the 'subtraction useful' portion of the curve. For subtraction

$$\bar{G} = \frac{D_4 - D_3}{D_2 - D_1} = 1$$

i.e. $(D_2 - D_1) = (D_4 - D_3)$ (since $\bar{G} = 1$)

Below A and above B, $\bar{G} < 1$ and for density differences in these regions

$$(D_2 - D_1) > (D_4 - D_3)$$ (since $\bar{G} < 1$)

where D_1, D_2 are densities in the original and D_3, D_4 are densities in the mask.

When the two films are superimposed subtraction is not complete because $(D_1 + D_4) \neq (D_2 + D_3)$. However the density difference in the composite image, i.e. $(D_1 + D_4) - (D_2 + D_3)$ is always far less than the contrast $(D_2 - D_1)$ for the same information in the original. If a further mask is made of the composite image then the image densities $(D_1 + D_4)$ and $(D_2 + D_3)$ will always lie within the 'subtraction useful' portion of the characteristic curve provided the correct exposure time is chosen. When this mask is superimposed on the composite image the small contrast $(D_1 + D_4) - (D_2 + D_3)$ disappears and subtraction is complete.

Figure 16.19 Arrangement of films for second order image subtraction

This sounds simple but as a practical technique it is difficult to achieve good results. Firstly, unsharpness is greater because there are three thicknesses of film superimposed from

which to make the final print. To minimize this and make superimposition easier the films should be placed together as shown in Figure 16.19. Unless this arrangement is used then superimposition is almost impossible to achieve successfully. In any event, the superimposition of three images will prove difficult and two films should be superimposed (one mask and the original) and taped together before the third film is added. Secondly there is the problem of increased image noise because of the noise contribution from three images rather than two as in single order image subtraction. While second order image subtraction is a good method for achieving complete subtraction irrespective of the contrast of the original film, the resultant image quality is poor compared to that achieved with single order image subtraction.

Colour in Subtraction

The addition of colour to the subtraction process does help to improve the visualization of image detail in the subtracted image particularly where the patient position is slightly different between the two original films used and subtraction is not quite complete. However, colour addition is not as straightforward as the methods already described and it is doubtful whether the results are any more diagnostically informative than those produced by good single order subtraction without colour.

Electronic Subtraction

This is a useful first and rapid step in the subtraction process to decide whether or not photographic subtraction will be

Figure 16.20 Electronic subtraction equipment

successful from the patient position aspect and in fact to decide whether or not photographic subtraction is likely to

add any further information. The unit used consists of two television cameras focussed onto their own viewing illuminators upon which the two original films are placed (Figure 16.20). Whichever of the two original films is selected, the image is electronically reversed to obtain a 'positive' image. This image and the image of the other original (as a 'negative') are fed to a single TV monitor, either singly or together. When fed singly to the TV monitor the image contrast can be adjusted to any required level electronically. This facility ensures that a successfully subtracted image will be seen on the TV monitor when both images are displayed simultaneously and superimposed.

DUPLICATION OF RADIOGRAPHS

Duplication of original radiographs is a well-established practice particularly in the production of miniature copies (100 mm × 100 mm) for storage and record purposes to save the space which would be needed if large format films were stored. However this is not the only reason for requiring a copy of a radiograph. Several other reasons are:

(i) Teaching and research
(ii) Publication
(iii) Replacement of large film file with miniature copies
(iv) For reference and distribution to avoid damage or loss of original
(v) For reference by a large number of people when a single original would be insufficient for the purpose.

Where an original radiograph is of considerable importance in the demonstration of a medical condition and a copy (or copies) is required, the copy should be, as near as possible, a faithful reproduction of the original. In practice, however, the copy tends to have a considerably higher image contrast than the original. This is to overcome the increase in unsharpness which accompanies the image transfer process when copying the original radiograph. There is also an increase in the noise content of the transferred image. The increase in unsharpness is very small as is the increase in image noise yet most copies seem to have an excessively high image contrast which is often mistakenly interpreted as an improved image quality.

Duplicating Film Characteristic Curve

Before running a duplicating system it is useful to obtain the characteristic curve for the duplicating film and exposing and processing conditions in use as all of these will affect the quality of the end result. It is also essential to have the right equipment for the job such as the DuPont Cronex printer or the Wardray copier/subtraction unit.

Whereas subtraction is performed using white light, duplication of radiographs requires the use of ultraviolet (UV) light. Figure 16.21 shows characteristic curves for the same

duplicating film and processing conditions, one made using white light and the other using ultraviolet light as the exposing light source. It is apparent that the spectrum of the exposing light source affects the gradient of the characteristic curve and that using white light would result in an image with too great a contrast. Producing the characteristic curve for a duplicating film is straightforward. A copy is made (using the duplicating film) of a stepwedge image showing densities of about 0.15–3.0. A graph is then plotted showing densities in the original stepwedge image on the horizontal axis and densities in the copy on the vertical axis. The resulting curve is the characteristic curve for the duplicating film and for the exposing and processing conditions used.

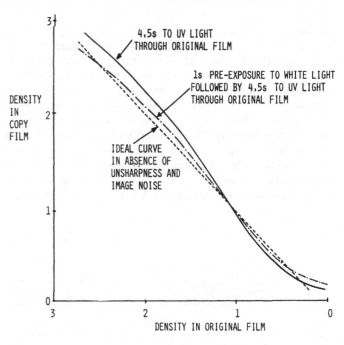

Figure 16.22 Characteristic curves for same duplicating film exposed with and without pre-exposure to white light, together with ideal curve

was exposed through the original film for 4.5 s using UV light in a Cronex printer. The film was then processed in a 2 min cycle automatic processor with a developer temperature of 30 °C. Both Ilford and DuPont low temperature chemistry gave the same result for this process time and temperature. In the other case, the duplicating film was pre-exposed to white light in the same printer for 1 s before being exposed through the original film to UV light for 4.5 s. The dashed line represents the ideal curve shape in the absence of any unsharpness or noise increase. In practice, however, a small unsharpness increase is experienced and a slight contrast increase is beneficial to suppress this visually. Too high a contrast renders the noise too readily visible.

Producing the characteristic curve in this way renders the curve's position relative to the axes dependent on exposure time (as in the case of the subtraction film). The exposure time must be adjusted until the curve position results in a copy density equal to that of the original at as many points on the curve as possible. This is then the ideal exposure time to use (Figure 16.22). It is then theoretically possible to use the same exposure time for all copies but in practice it is found that slight variations about an average time are necessary if good copies are to be produced on all films.

Producing the Duplicate

Like the subtraction mask film, the duplicating film is a single emulsion film so must be used the correct way round for the duplicating process. The arrangement of films for exposure is

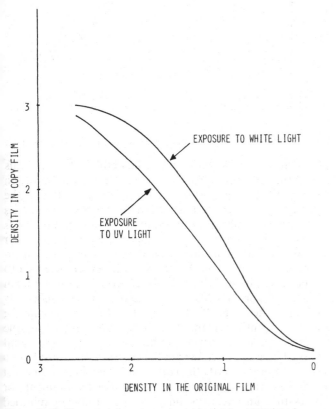

Figure 16.21 Characteristic curves using white light and UV light for same duplicating film and processing conditions

It is often found, however, that, even using UV light as the exposing light source, the gradient of the duplicating film characteristic curve is excessively steep and some means is required of reducing it. Using low temperature chemistry, varying the solution temperature with a corresponding change in process cycle time, has a negligible effect on the image contrast of the copy, but pre-exposure of the duplicating film to white light before use in the copy process does help. Figure 16.22 shows two characteristic curves for the same duplicating film. In the one case the duplicating film

shown in Figure 16.23. Figure 16.23(a) shows the film arrangement for pre-exposure. The exposure time used here depends on the intensity of the white light source and its distance from the film, but assuming that a Cronex printer is used the optimum pre-exposure time is around 1 s. Increasing the pre-exposure time depresses D_{max} for the copy film. Beyond about 2 s the characteristic curve tends to become flat for densities above about 2 in the original film and this is totally unsatisfactory. The effect on the characteristic curve of increasing pre-exposure time is shown in Figure 16.24. It is interesting to note that a similar pre-exposure time to UV light excessively depresses D_{max}. To obtain an equivalent effect to white light the exposure time to UV light must be many times smaller.

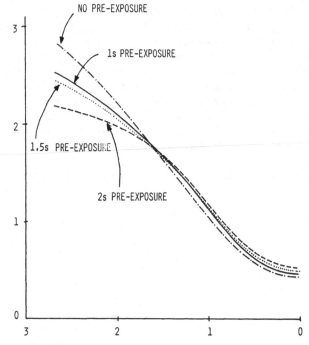

Figure 16.24 Effect on characteristic curve of varying pre-exposure time

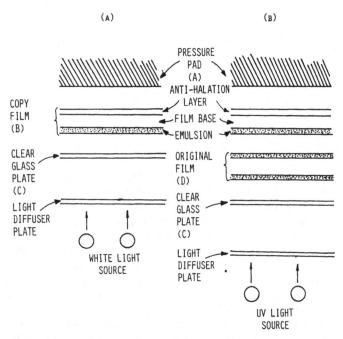

Figure 16.23 Arrangement of films for duplication – (a) pre-exposure; (b) duplication. Layers A, B, C and D are shown separated for clarity but would normally be in contact

The above discussion relates to the copying of large format film but in addition to this minified copies are also done, often on a large scale. Minified copies (100 mm × 100 mm) are used to replace large format film files to save on space but this is only one of many applications. Equipment such as the Delcomat manufactured by Old Delft is used for producing minified copies of large format films. The process is fully automatic and can be operated without a darkroom provided Daylight cassettes and the Odelcamatic automatic processor for 100 mm × 100 mm films are available, when the whole forms a complete Daylight system for film copying. The reduction in size from large film to 100 mm × 100 mm format is achieved by a lens system. The film to be copied is

placed on the glass support and the lid of the unit closed. This brings the UV light source (contained in the lid) into position over the film. On exposure, the UV light transmitted by the film to be copied is collected by the reducing lens system and is focussed onto a 100 mm × 100 mm film. This film emulsion is similar to that of the large format copy film and similar problems relating to film quality are encountered. An increase in image noise and unsharpness are experienced due to the copying process. Unsharpness contributions occur from the lens system and the optical viewer when subsequently looking at the image. If a film with $\bar{G} = 1$ is used for copying then small contrasts in the original will be lost in the copy due to these image quality degrading factors. If these small contrasts are to be retained in the copy the film must have a $\bar{G} > 1$. In other words the copy will have a higher contrast than the original. This is an inevitable requirement for successful transfer of fine image detail. Producing minified copies with subsequent optical enlargement for viewing results in greater image quality deterioration (relatively speaking) than large film format copying so the $\bar{G} > 1$ requirement is more critical for the 100 mm × 100 mm film.

STEREORADIOGRAPHY

The sensation of depth can be experienced in a radiographic image if two separate, slightly different images of the same patient part are viewed in a special way. The two films required for this are called a stereoradiographic pair, or stereoscopic pair.

When an object is viewed using binocular vision each eye sees the object from a slightly different aspect. The degree of difference in the view of the object seen by each eye depends on the interpupillary distance. If the X-ray tube is regarded as an eye, two radiographs can be produced using two different X-ray tube positions, one corresponding to each eye. When viewing an object only a very small area of the object is seen in focus at any one time and both eyes are directed to the same small area. If the direction of sight of each eye is called a central viewing axis then the central ray of the X-ray beam corresponds to the central viewing axis. When producing stereoradiographs the central ray is directed to the same point in the film plane from each of the two tube positions, to simulate the action of the eyes. Since the three-dimensional structure information in the object is compressed to a two-dimensional image on film this is an acceptable centring method.

Producing Stereoradiographs

Two films of the same patient part are required to form a stereoradiographic pair. These films are exposed separately using a different X-ray tube position for each. Figure

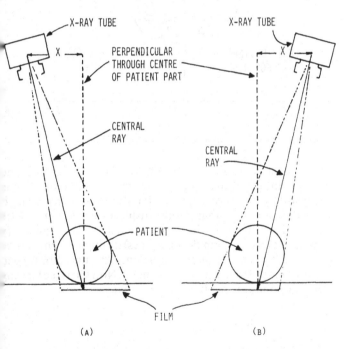

Figure 16.25 Method of stereoradiography; x is the tube displacement

16.25(a) and (b) illustrate the technique for producing the films. It should be noted that the patient part must not move its relative position throughout the procedure. The tube displacement either side of the perpendicular through the centre of the patient part is equal and the total displacement would be equal to the interpupillary distance if, when

viewing, the eyes were placed at the same distance from the film as the FFD. The viewing distance, however, is rarely equal to the FFD so normally the total tube displacement will not be equal to the interpupillary distance. The displacement required is easy to determine and the method will be discussed later. For both (a) and (b) the FFD is the same and is measured along the direction of the central ray of the X-ray beam.

There are certain conditions besides those already mentioned which must be met when taking stereoradiographs. These are:

(i) Both films must be identically exposed to obtain the same average image brightness when viewing. If not, then one image will visually predominate and make the perception of depth in the radiographs more difficult

(ii) If a grid (either moving or stationary) is used, angulation of the beam across the grid must be limited if the angulation is at 90° to the direction of the grid lines. This will limit the total amount of tube displacement possible before grid 'cut-off' is experienced. This in turn will affect the degree of depth experienced in the image on viewing. As will be apparent later, where the FFD is greater than the viewing distance and total tube displacement is limited, the degree of depth experienced in the image can be increased by increasing the viewing distance. Decreasing the FFD with a fixed maximum tube displacement is not a suitable solution because this simply increases the degree of angulation across the grid. Wherever possible the tube displacement should be parallel to the grid lines to avoid the effect of grid 'cut-off'

(iii) The FFD as measured along the central ray must be the same for both films to simulate the condition for the eyes. This means that a line connecting the tube focus in the two positions will lie parallel to the film plane

(iv) The same cassette or at least cassette type should be used for each film and the intensifying screens and film type should be similar for both exposures

(v) The films must be correctly and completely identified to allow for correct viewing

(vi) Both films must receive similar processing.

In Figure 16.25 the two film positions are not quite the same. The film in each case is slightly displaced in the direction of beam angulation to ensure that the whole of the patient part is included on the film but the point in the film plane through which the central ray passes is the same in both cases. Slight film displacement in a cassette tray is possible in order to achieve this.

In producing stereoradiographs, as seen in Figure 16.25, the X-ray tube is displaced x cm either side of a central line and it is important to know what value of x to use to produce the desired stereoscopic effect. Consider Figure 16.26 where the viewing distance is different from the FFD. Note that here the central viewing axis for each eye and the central ray at each tube position are coincidental. From Figure 16.26, the FFD is AB and the viewing distance is CB. Also $2x$ is the total tube displacement and $2y$ is the interpupillary distance of the observer. The interpupillary distance is usually assumed to be 6 cm but this does vary considerably and should be measured in each case. Assume for this example an interpupillary distance of 7 cm, say, an FFD of 100 cm and a viewing distance of 50 cm. Then using similar triangles

$$\frac{x}{AB} = \frac{y}{CB}$$

i.e.

$$x = y\left[\frac{AB}{CB}\right]$$

or

$$2x = 2y\left[\frac{AB}{CB}\right]$$

In words, this is

$$\text{total tube displacement} = \frac{\text{interpupillary distance} \times \text{FFD}}{\text{viewing distance}} \tag{1}$$

For this example

$$\text{total tube displacement} = \frac{7 \times 100}{50} = 14 \text{ cm}$$

Thus a tube displacement of 7 cm either side of the central line is required for a normal stereoscopic effect. For this FFD and viewing distance the impression of depth is enhanced by using greater than the calculated tube displacement while the impression of depth is diminished by using less than the calculated tube displacement. This is useful when producing stereoradiographs of small and large patient volumes. In a small volume all the individual parts can lie close to one another and a greater than normal impression of depth is required to obtain sufficient separation of parts. In a large volume the individual parts may be widely separated and viewing is easier if the depth effect is diminished slightly. For an enhanced impression of depth the tube displacement must be, as already stated, increased but there is a limit to the amount of increase. A point is reached where the displacement is too great for the eyes and brain to create an impression of depth and the stereoscopic effect is lost. Rather than use increased or decreased tube displacement to alter the impression of depth the viewing distance can be increased or decreased to bring about the same effect.

Referring to the equation above, it is noted that when the viewing distance is equal to the FFD then the total tube displacement is equal to the interpupillary distance. In some

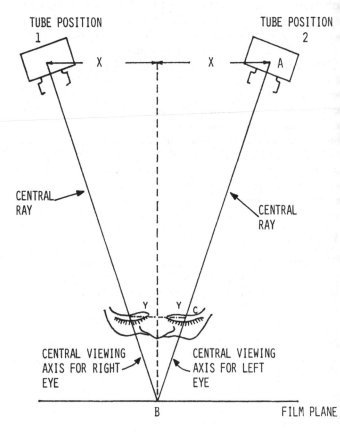

Figure 16.26 Viewing distance not equal to FFD

equipment (some skull units, for example) movement of the tube x cm in a straight line is not possible since the tube is only allowed to move in an arc. It is then more convenient to calculate an angle than a tube displacement in cm. Figure 16.27 illustrates this. Here y cm is half the interpupillary distance and θ is the angle (in degrees) through which the tube must be displaced from the centre line. An angle 2θ is needed to provide the total tube displacement. Now CB is the viewing distance and it is readily apparent that

$$\text{Sin } \theta = \frac{y}{CB}$$

or

$$\theta = \sin^{-1}\left[\frac{y}{CB}\right]$$

In words this is

required angle of displacement (θ)

$$= \sin^{-1}\left[\frac{\frac{1}{2}\text{ interpupillary distance}}{\text{viewing distance}}\right]$$

For the example quoted previously with an interpupillary distance of 7 cm and a viewing distance of 50 cm, then

$$\theta = \sin^{-1}\left[\frac{\frac{1}{2} \times 7}{50}\right] = \sin^{-1}(0.07) \simeq 4°$$

Note that the equation for $\sin\theta$ is independent of FFD so the value for θ would be the same no matter what FFD is used. This is certainly not true for linear tube displacement where it is dependent on the choice of FFD.

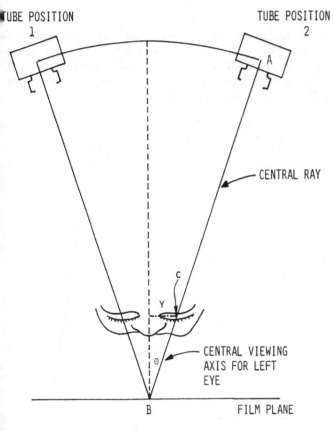

Figure 16.27 Angular displacement of tube

Identification of Stereoradiographs

It is important to identify stereoradiographs accurately to avoid errors in interpretation at the viewing stage. Information for complete identification would be

(i) Direction of tube displacement. This can be indicated by using a lead arrow on the cassette at the time of exposure. A greater impression of depth is achieved if the tube displacement is at right angles to the long axis of any particular part sought. The displacement direction is normally identified as if looking at the

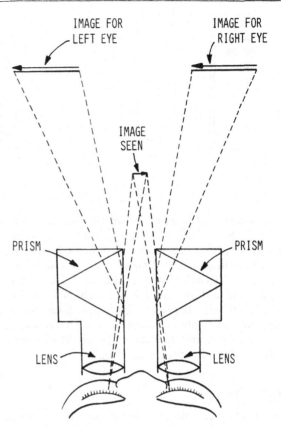

Figure 16.28 Viewing stereoradiographs with prismatic binoculars

patient from the X-ray tube whether the patient is antero-posterior or postero-anterior

(ii) Amount of tube displacement to one side of the midline

(iii) FFD used. This together with the amount of tube displacement allows the correct viewing distance to be chosen.

(iv) X-ray tube side of the film to assist in placing the films for viewing

(v) An R or L on the film to indicate by which eye the film must be viewed and also to act as an anatomical marker.

Methods of Viewing Stereoradiographs

There are two principal methods of viewing stereoradiographs, by using (i) prismatic binoculars or (ii) a Wheatstone stereoscope. Figure 16.28 shows the prismatic binoculars and Figure 16.29 shows the Wheatstone stereoscope. In both these systems the image is seen after having been reflected once at a mirror surface. This reflection, as seen from Figures 16.28 and 16.29, produces reversal

Figure 16.29 The Wheatstone stereoscope principle

of the image, and in order to see the image information, including the identification information, the correct way around it is necessary to reverse each film when placing it on the viewing illuminator. Two viewing illuminators are required, one for each film. The film for the left eye to view should be placed on the left-hand illuminator but back to front. The film for the right eye to view should be similarly placed on the right-hand illuminator. The viewing equipment is adjusted until the two images are superimposed and the impression of depth experienced.

Viewing Faults

Several faults can occur from an incorrect viewing technique:

(i) Reversal occurs when the films are placed on the correct viewing illuminators but have not been reversed to compensate for reversal by the viewing system. The image is then seen as if from the film side and the identification information will appear backwards. An incorrect appearance like this, for example, is termed pseudoscopic

(ii) Transposition occurs if the films are placed the right way round to compensate for inherent reversal but this time are placed on the wrong illuminators, i.e. the left eye sees the right image and vice versa. In transposition all image relationships appear as mirror images of the true relationships

(iii) Both reversal and transposition errors will not occur simultaneously. Placing the films the incorrect way around and on the wrong illuminators will correct the fault of reversal, but not transposition which will still remain.

MACRORADIOGRAPHY

Magnification technique was discussed in some detail in Chapter 9 and it only remains here to look at some of the

basic differences between plain radiography and macro-radiography. Figure 16.30 shows the basic imaging system for both plain radiography (a) and macroradiography (b). When a comparison is made between the two systems the differences become apparent. These are:

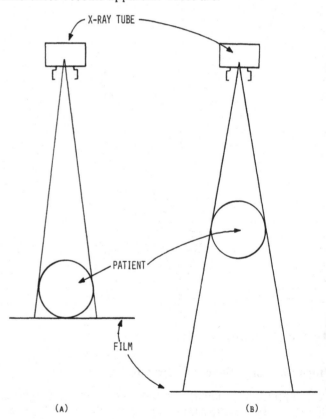

Figure 16.30 Basic principle of (a) plain radiography and (b) macroradiography

(i) The object–film distance is greater in (b) than in (a)
(ii) Even when a grid is used in (a), no grid is needed in (b) because of the large object–film distance providing the necessary air-gap

(iii) Because of magnification of the image in (b) a larger film is required

(iv) A smaller focus size is needed in (b) to limit unsharpness in the magnified image

(v) The FFD is greater in (b) necessitating a much larger value for exposure. The large FFD and small focus size are contradictory requirements often limiting the size of object on which macroradiography can be performed

(vi) The larger exposure value needed in (b) together with the smaller focus size requirement necessitate the use of low mA values with a relatively long exposure time. Thus adequate immobilization is essential.

Limiting Factors

Because of these requirements in macroradiography there are several limiting factors which must be considered:

First, the magnification factor is limited by the size of the focus. For a given focus size, the greater the magnification the greater the degree of unsharpness. It has been shown previously that

$$U_g = f\left[\frac{OFD}{FOD}\right]$$

and

$$M = \frac{FFD}{FOD}$$

where U_g is geometric unsharpness, f is focus size, OFD is object–film distance, FOD is focus–object distance, M is magnification factor and FFD is focus–film distance.

Now

$$M = \frac{FFD}{FOD} = \frac{FOD + OFD}{FOD}$$

$$= \frac{FOD}{FOD} + \frac{OFD}{FOD} = 1 + \left[\frac{OFD}{FOD}\right]$$

or

$$\frac{OFD}{FOD} = (M-1)$$

This gives, on substitution,

$$U_g = f(M-1)$$

and it can be seen immediately that for a given focus size the geometric unsharpness increases with increasing magnification.

It is interesting to digress a moment and consider the focal spot in a slightly different way. From a study of focal spot size using the star pattern it is possible to express the imaging capability of a focal spot in terms of a resolving power

(lp/mm) at a particular magnification factor. It has been shown that

$$f = 2w\left[\frac{a+b}{b}\right]$$

where f is focus dimension, w is the width of a line (or space) in a line pair, a is the focus–object distance and b is the object–film distance. Again it was shown that

$$M = \frac{a+b}{a}$$

which, when introduced into the equation for f, gives

$$f = 2w\left[\frac{M}{M-1}\right]$$

where M is the magnification factor. Rearranging this gives

$$2w = f\left[\frac{M-1}{M}\right]$$

Now $2w$ represents the width of a line pair and $(1/2w)$ gives the number of line pairs per millimetre. Thus resolution (lp/mm) can be stated as

$$\frac{1}{2w} = \frac{M}{f(M-1)}\ \text{1p/mm}$$

When the focal spot imaging capability is stated in terms of a certain number of lp/mm at a particular magnification, the focal spot size is readily obtainable. For example, a certain focal spot is described as producing 7 1p/mm resolution at 4× magnification. Using the above equation gives

$$7 = \frac{4}{f(4-1)}$$

$$f = \frac{4}{7\times3} = 0.19\ \text{mm}$$

This is the equivalent size of focus obtainable by biasing a nominal 0.13 mm focus (actual, .27 mm as measured by star pattern) available as the small focus in the Dynamax 78E X-ray tube insert. This tube has a 0.6 mm and 0.13 mm focus both of which can be biased. This provides, in effect, a 4-focus tube and together with the large loading capability provides for exceptional versatility.

In macroradiography it is the focus size which is the predominant factor producing unsharpness and a real improvement is obtained when using such a small focus provided sufficient exposure can be obtained, and in a short enough time if movement is a problem. Consider some examples demonstrating these points:

(i) In contact radiography with imaging parameters of $U_p = 0.15$ mm, $U_m = 0.2$ mm, $U_g = 0.1$ mm (using an equivalent focus size of 1 mm)

Total unsharpness here is

$$U_t = \left[U_p^{1.5} + U_m^{1.5} + U_g^{1.5} \right]^{0.66} = 0.32 \text{ mm}$$

Now if the focus size is reduced to 0.19 mm, U_g is reduced to 0.019 mm and $U_t = 0.28$ mm. This represents a difference of 0.04 mm which does not produce a visible change.

(ii) In macroradiography using $2 \times$ magnification and similar values for U_p and U_m, then $U_p = 0.15$ mm, $U_m = 0.2$ mm, $U_g = 1$ mm (using a focus size of 1 mm) and $U_t = 1.09$ mm (quite unacceptable). Changing to a focus size of 0.19 mm, for example, gives $U_g = 0.19$ mm $U_t = 0.38$ mm and this is a real improvement readily apparent visually.

Second, the exposure value is limited by the loading capability of the small focus necessary for macroradiography. The smaller the focus the less the allowable loading in a given time. A larger exposure is possible provided it is spread over a longer time but then immobilization problems arise. It is a considerable help if the FFD is made as short as possible always providing the focus–skin distance is not too short. It is imprudent, for example, to use a standard FOD of 100 cm. The exposure is considerably reduced if the FOD and OFD are both 60 cm, say, which still provides the same magnification factor and unsharpness. Caution must be exercised, however, because of the variation in intensity across the beam when using a large beam area at short distances, although this is unlikely to be a problem in practice.

Third, the speed of the image recording system influences the value of exposure required and this should be as high as possible consistent with sufficient resolution. The degree of tolerable unsharpness depends on the size of the image detail, its shape, how easily it can be distinguished from confusing, surrounding information, and the image contrast. Macroradiography enlarges image details and it may be found that relatively high-speed image recording systems can be used enabling higher magnification factors to be attained, or at least allowing macroradiography to be performed on larger body parts. Practical tests need to be done to determine the value of different image recording systems in macroradiography. A high-resolution image recording system is not always a necessity. Depending on the structure of the object (contrast-limited rather than noise-limited for example) it may prove beneficial for a given system speed to use fast film plus slow screens rather than vice versa.

Strictly, however, images of large objects are not the priority in macroradiography. Macroradiography is reserved for imaging object details too small to be seen on the normal radiograph. A high contrast image detail of 0.08 mm diameter is about the limit of resolution for the unaided eye in the normal radiograph. In macroradiography image details of this order of size, if detected, represent image information undetectable in the normal radiographic image, so macroradiographic images and optically enlarged normal radiographs must be quite different in information content.

Many other image phenomena arise as a result of employing macroradiography. For example, a small structure superimposed over a complex structure tissue is visually confusing. Magnification tends to disperse the complex structure making the small structure more easily visualized, besides the fact that it is also larger. It has also been stated that if an object detail is less than or equal in size to the focal spot then image contrast for that detail is increased on radiographic enlargement. Object details, however, which are less than half the size of the focus tend to become faint or disappear altogether if the imaging geometry is right.

One of the main disadvantages of using macroradiography is the radiation dose to the patient. In general the FFD used is greater than normal requiring a higher exposure dose to produce the image. In addition the FOD is very much less than in normal radiography for the FFD used. This provides a higher skin dose than would be obtained with normal radiography.

XERORADIOGRAPHY

Xeroradiography, as the name suggests, is a dry imaging process not involving the use of liquid chemistry as in conventional radiographic imaging with silver halide emulsions. It is useful in understanding the xeroradiographic imaging process to compare it with the conventional radiographic imaging system using the silver halide emulsion. In contrast with the silver halide emulsion, the image receptor in xeroradiography is a selenium-coated, electrically conducting metal plate, with the selenium-coated surface carrying a uniformly distributed electric charge. The selenium is a photoconductive material which when not exposed to radiation contains few charge carriers. When exposed to radiation, the energy transfer liberates many new charge carriers with a sufficiently long lifetime to increase greatly the conductivity of the selenium. In the areas of the selenium plate exposed to radiation there is an increase in conductivity with resulting dissipation of surface charge, but only in the exposed areas. The remaining charge pattern forms the 'latent image'.

The silver halide emulsion can be exposed immediately to radiation to form a latent image provided it is contained in a suitable light-tight cassette. The selenium-coated plate, however, will not form a latent image (on exposure) which can subsequently be made visible unless the surface is first

given a uniformly distributed electric charge. Thus each time the xeroradiographic plate is used it must first be charged. Once charged, it must also be contained in a light-tight cassette since light ($\lambda < 550$ nm) as well as X-rays will increase the conductivity of selenium with resulting dissipation of surface charge. X-ray films may be single emulsion or duplitized. The xeroradiographic plate has the selenium coating on one side of the metal plate only and it is this side which must be directed towards the X-ray tube for exposure and not the uncoated surface.

The latent image in a silver halide emulsion must undergo chemical processing before it becomes visible. The latent image of the xeroradiographic plate is made visible by exposing the electrostatic 'latent image' to a cloud of electrically charged powder particles. Depending on the charge on the plate and the charge given to the powder particles, the particles collect principally in areas of high field strength or low field strength producing either a 'positive' or 'negative' powder image as required. To produce a permanent image the powder pattern on the selenium plate is transferred and fused into paper thus producing an image which must be viewed by reflected light. The selenium plate is then cleaned of residual powder and charged ready for re-use. The process of latent image powder development and transfer and fusion to paper is carried out in the absence of light. Figure 16.31 illustrates the steps in the process.

The selenium layer of a xeroradiographic plate is easily contaminated and damaged by handling so the whole process is best automated. The commercially available equipment is called Xerox System 125 in which only the cassettes containing the plates are manually handled for exposure. The remainder of the process is carried out automatically. To discuss the xeroradiographic process in detail it is useful to divide the complete xeroradiographic process into several separate functions. These are:

(i) Plate charging
(ii) Exposure
(iii) Development
(iv) Image transfer and fixation
(v) Plate cleaning and relaxation.

Plate Charging

Before an electrostatic latent image can be formed on the selenium coating it must receive and hold a uniform electric charge. To hold the charge the selenium must not be exposed to radiation until the actual X-ray exposure is made. After this the selenium must not be exposed to radiation until after the processing of the image is complete otherwise fading of the latent image will occur through surface charge dissipation. In addition, once charged, no object must come into contact with the selenium surface as this can cause alteration in the charge distribution in this area and produce an artefact in the final image. Excessive pressure on the tube side of the cassette can cause it to touch the selenium producing this effect.

In the commercially available system plate charging is achieved by passing the selenium-coated metal plate beneath an air ionization device. This device generates positive ions which are allowed to collect on the selenium surface. Applying a high potential to a non-insulated wire in air causes the air to ionize in the immediate vicinity of the wire. If the wire is positively biased then the positively charged ions generated in this way will be forced to drift away from the ion-generating wire. A surface charge of positive ions can thus be collected on the selenium surface when placed close to this ion-generating system. In practice, more than one ion-generating wire is used and between these and the selenium surface is placed a screen of metal wires to which a biasing

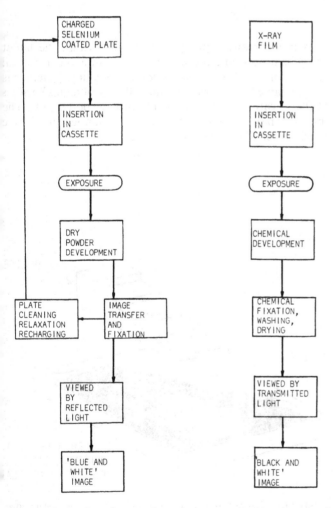

Figure 16.31 Process of xeroradiography compared with conventional radiography

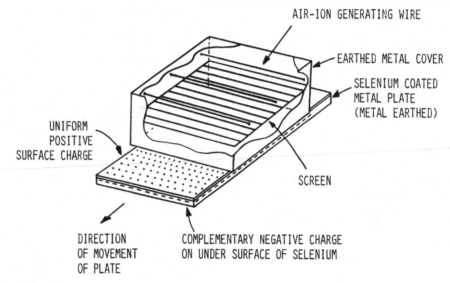

Figure 16.32 Principle of charging system

potential can be applied. Varying the screen biasing potential varies the level of surface charge on the selenium which in turn controls the final image contrast and to some extent image density. Figure 16.32 illustrates the charging system in principle. After charging the selenium-coated metal plate is automatically inserted in a light-tight cassette. The cassette can then be handled in the normal way. The charging and cassette-loading procedure is automatic and carried out in total darkness. Under these conditions no charge carriers are available in the selenium to allow neutralization of surface charge by the complementary negative charge. Only when the selenium is irradiated are charge carriers generated in the selenium (at the point of irradiation) which allow positive and negative charges to meet and the surface charge at that point to dissipate.

Exposure

The cassette containing the charged selenium plate is used in the same manner as a conventional cassette but choice of application must be considered carefully since the imaging radiation dose is very much higher than for a film–intensifying screen combination used for the same procedure. Exposure of the charged selenium plate to X-radiation causes dissipation of the surface charge. The remaining surface charge pattern is similar to the radiation intensity pattern in the X-ray beam (Figure 16.33). This surface charge pattern constitutes a very high resolution latent image which should be developed as soon as possible. In the absence of exposure it has already been stated that charge carrier generation in the selenium is very small and over a long period of time will produce gradual dissipation of any surface charge with deterioration in latent image quality.

This is not really a practical problem because the latent image is processed quite soon after exposure under normal circumstances. The xeroradiographic imaging system has considerable latitude which enables the use of high kV values in the 'negative' mode as these produce the best results. The 'positive' mode is normally used for mammography where much lower kV values are employed.

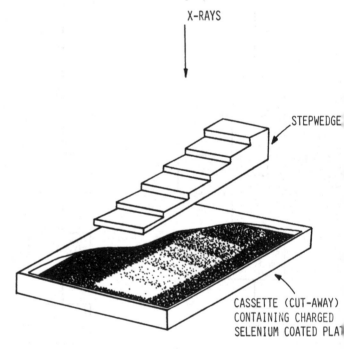

Figure 16.33 Exposure of selenium plate to X-rays through a stepwedge. The degree of shading represents the amount of residual charge

Development

This is achieved by allowing a cloud of charged plastic particles to fall on the selenium surface. If the charge on the powder particles is opposite to that of the charged regions on the selenium surface then the powder will collect here. This produces a denser collection of powder in the less exposed portions of the selenium producing a 'positive' image. If, however, the charge on the powder particles is the same as that of the charged regions on the selenium surface then the powder will collect in the uncharged areas. This produces a denser collection of powder in the more exposed portions of the selenium producing a 'negative' image. The powder particles are charged by the friction of particle-to-particle contact when the powder cloud is formed by being blown by puffs of air. Equal numbers of positively and negatively charged powder particles are formed.

In the 'positive' image mode the aluminium plate on which the selenium layer is coated is positively biased to a high voltage to attract the negatively charged powder particles to the selenium and repel the positively charged powder particles. In the 'negative' mode the aluminium plate bias potential is reversed producing the opposite effect. To improve the powder coating of the selenium a grid of wires is placed a few millimetres away from the surface of the selenium and biased similarly in sign to that of the aluminium. Figures 16.34(a) and (b) illustrate the effect of development of the electrostatic latent image. The process of development is carried out automatically (as are all the subsequent processes) in complete darkness and involves the removal of the selenium-coated metal plate (holding the latent image) from the cassette.

The most useful feature of the xeroradiographic imaging system is its capability for edge contrast enhancement. In

Figure 16.34 Development of the electrostatic latent image

the latent image, at boundaries between different charge densities (representing image boundaries), the electric field distribution is such as to cause an extra deposition of powder in comparison with areas of more uniform charge density. This effect is more clearly demonstrated in Figure 16.35 where the 'positive' image mode has been used. Note that in forming the extra deposition of powder, adjacent powder has been stolen causing a reduction in deposit. This further enhances the visibility of the boundary. The degree of edge contrast enhancement is dependent on the initial charge given to the selenium prior to exposure. The greater this is, the greater will be the edge contrast enhancement.

Image Transfer and Fixation

The powder image must be transferred to paper and fixed before it can be viewed. This is achieved by saturating the selenium surface with ions to ease the transfer of powder to paper. The one surface of the paper is rolled into contact with the powder on the surface of the selenium while the other side of the paper is given an electrostatic charge to encourage the powder to adhere to the paper surface in contact with it. Most of the powder is transferred to the

Figure 16.35 Edge contrast enhancement

paper in this way with the stability of pattern being maintained. Once transferred the powder is only held to the paper by an electrostatic charge and must thus be fixed to render it permanent. Fixation is simply achieved by heating the paper during which process the powder fuses with the plastic lining of the paper. It can then be handled and viewed without disturbance of image pattern.

Plate Cleaning and Relaxation

To prepare the plate for further use the remaining surface charge holding the small amount of residual powder not transferred to the paper must be neutralized by ion bombardment. This allows the powder to be removed by simply cleaning the selenium surface with a rotating, soft brush. This completes the cleaning process and removes remaining

surface latent image. Unfortunately the latent image is not only confined to the surface of the selenium but because of the penetrating nature of X-rays also exists beneath the surface. To eliminate this, which is essential before re-use to avoid production of a double image, charge carriers must be generated within the selenium. This could be achieved by exposure to a beam of X-rays but is more easily done by heating the selenium. This heating process is called relaxation and, once done, the selenium-coated plate is ready for re-insertion into a cassette and re-use in the charging process.

IONOGRAPHY

This is an imaging system introduced as a more sensitive imaging system than xeroradiography yet maintaining the facility of edge contrast enhancement. At present the system is experimental and not commercially available, but is an extremely interesting development. In principle the system uses an imaging chamber filled with gas at very high pressure (xenon at 10 atm pressure, for example). The gas occupies the small gap which exists between the two electrodes, anode and cathode, present in the imaging chamber. The 'window' in the chamber through which X-rays enter (X-rays transmitted by the patient) is a thin plate of carbon fibre. A non-conducting plastic sheet (imaging foil) is placed in contact with the cathode so that it lies between cathode and anode. A high potential difference is applied between anode and cathode. X-ray photons entering the imaging chamber produce ionization of the gas. The positive ions are collected on the foil due to the influence of the cathode. The foil is removed after exposure and the electrostatic latent image developed in a manner similar to that for xeroradiographs.

Figure 16.36 Principle of ionography

System resolution is high and its sensitivity is greater than that of an X-ray film used with intensifying screens, but sensitivity decreases the greater the edge contrast enhancement required. The principle of ionography is illustrated in Figure 16.36. The electron radiography (ERG) system announced by Xonics Inc. of America is similar in principle to ionography but until such a system becomes generally available in the UK it is difficult to state the extent of application of this new imaging system.

TOMOGRAPHY

The use of tomography is a common imaging procedure in radiographic practice and one to which the imaging principles developed in earlier chapters can be applied. The range of tomographic equipment available is quite diverse, and two examples are shown in Figures 16.37, 16.38 (the Philips MT2) and Figure 16.39 (the Orthopantomograph). To illustrate the principles of tomography, the tomographic movement of the MT2 will be used as the example.

Figure 16.38 Philips MT2 equipment (2)

Figure 16.37 Philips MT2 equipment (1)

Figure 16.39 The Orthopantomograph

The Aim of Tomography

It is often of considerable benefit when making a diagnosis if

superimposing, and confusing, image information can be blurred to allow the information of interest to be seen more easily and clearly, and with minimal blurring. This can be achieved using tomography. The technique results in an image being formed of an infinitely thin plane of the object having minimal blurring, with all adjacent planes above and below having progressively increasing unsharpness. The images of all these planes are of course superimposed. Those planes lying above and below the plane having minimal image unsharpness and close to it will also have an acceptable level of image unsharpness. All these planes superimposed will form a thick plane with a relatively small and acceptable level of image unsharpness while all other planes will have unacceptable image unsharpness and appear visibly blurred. If this thick plane contains the object of interest then its image will appear relatively sharp compared with all other information outside this plane. There is no sharp transition from the thick plane with acceptable image unsharpness to adjacent planes with unacceptable image unsharpness so the interpretation of thickness of plane 'in focus' tends to be rather subjective and the subject of much argument. This aside, there is no doubt that tomography is a valuable diagnostic tool.

The Tomographic Principle

To achieve the blurring mentioned above it is necessary to move, in a co-ordinated manner, any two of the object, the tube focus and the film during the exposure, while the third remains static. It is probably most common to move tube focus and film during the exposure while the patient is static. The infinitely thin object plane having minimal unsharpness will be called simply the object plane. Any object plane can be selected within the patient but the co-ordinated movement of tube focus and film must be such that the magnification factor (M) is constant at any instant during the exposure for all points in the object plane.

When tube focus and film move during the exposure, with the patient static, then the movement of tube focus must be in the opposite direction to that of the film. The movement of the MT2 unit is shown in Figure 16.40 where it is seen that the point (A) around which tube focus and film move lies at the level of the object plane. If the rotation point (often referred to as the pivot point or fulcrum) is changed, the object plane also changes. To ensure the required co-ordinated movement, the X-ray tube and cassette tray are linked together. F_1, F_2 and F_3 are tube focus positions while f_1, f_2 and f_3 are the corresponding film positions. Both tube focus and film plane move in an arc during the exposure and this ensures that

$$\frac{F_1 f_1}{F_1 A} = \frac{F_2 f_1}{F_2 A} = \frac{F_3 f_3}{F_3 A} = M$$

If M was not constant then the image formed at each instant during the exposure would vary in size. Superimposing

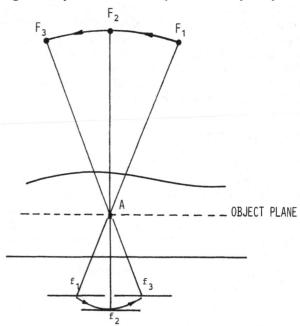

Figure 16.40 Movement in the MT2 unit

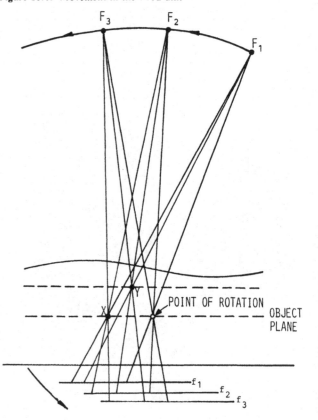

Figure 16.41 Blurring in the tomographic image

similar images of different degrees of magnification produces an image with considerable unsharpness. To understand how blurring occurs in tomography consider Figure 16.41. Here two points are shown, one in the object plane (X) and the other in a plane above this (Y). The points are arbitrarily chosen. Throughout the tomographic movement the images of all points in the object plane maintain the same position on the film and are thus not blurred. The images of all points above (and below) do not maintain the same relative film position and are thus blurred. The greater the distance of any given object point from the plane the greater the degree of blurring of its image.

The point of rotation always lies in the object plane while the film position determines the angle of the plane. This is illustrated in Figure 16.42. It can be seen that the object plane always lies parallel to the film plane. This is useful, because if a structure within the patient lies at some angle to the horizontal it is possible to adjust the film angle to obtain an object plane through the whole structure. In many tomographic techniques the films are exposed singly with a different fulcrum position at each exposure. If the fulcrum position is changed then the ratio FFD/FOD changes because the FOD changes but not the FFD. Thus each time the fulcrum changes, the magnification factor changes and

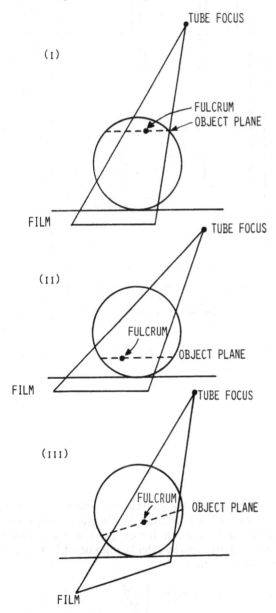

Figure 16.42 Varying the angle and height of the object plane

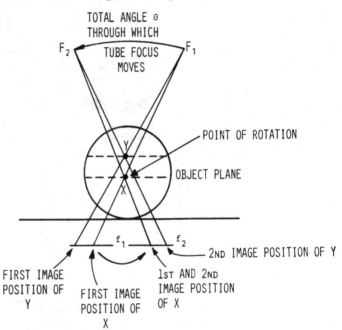

Figure 16.43 Blurring of point Y

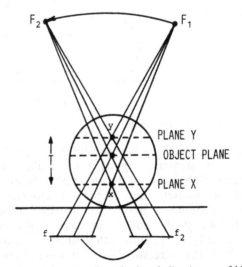

Figure 16.44 Distance between planes having similar degrees of blurring

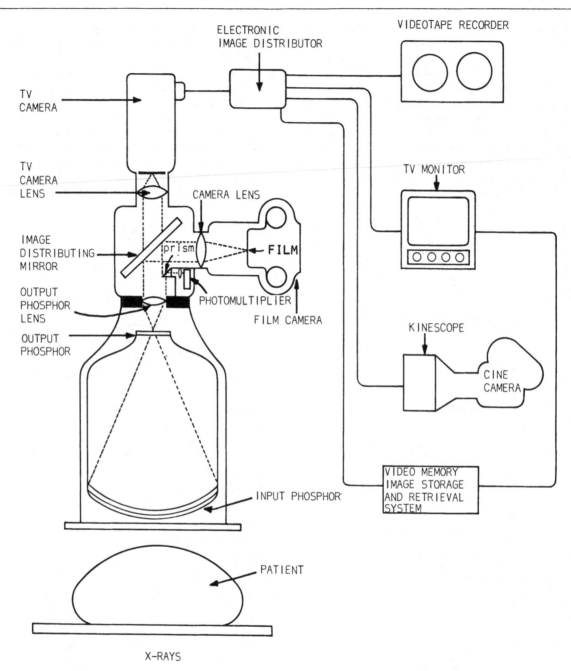

Figure 16.45 Photofluorography system

hence so does image unsharpness for the image of the object plane. It is essential for good image quality that the unsharpness in the image of the object plane be minimal. The change in magnification factor for different apparent fulcrum positions is not present in simultaneous multisection tomography but the problem of obtaining good image quality in all films with a single exposure is made difficult by the increasing beam filtration offered by each

successive film–intensifying screen combination. With single exposures and different fulcrum positions it is easy to maintain a constant magnification factor (and hence a constant geometric unsharpness) by calculating a new FFD to use with each new FOD from

$$FFD = OFD \left[\frac{M}{M-1} \right]$$

where OFD is the film to object plane distance and where M is the required magnification factor.

Consider Figure 16.43 which shows the distance through which the film image of Y is blurred. The magnitude of the blurring depends on the angle θ (called the exposure angle), the larger the exposure angle the greater the magnitude of blurring in any given plane away from the object plane. A large exposure angle gives a thinner layer 'in focus' than a small exposure angle.

Again, considering Figure 16.44, between the two film positions f_1, f_2 the image positions for points y and x are interchanged indicating that both points y and x have been blurred to the same extent. If points y and x have been blurred to just the maximum tolerable degree of unsharpness then all points between y and x will be blurred less and T can be considered as the layer thickness 'in focus'.

Only rectilinear movement of the X-ray tube and film has been considered. This gives rise to linear blurring which can obscure small details in the image so great care must be taken in aligning the patient relative to the direction of tomographic movement so as to avoid this. Movements other than rectilinear are used and are often considered

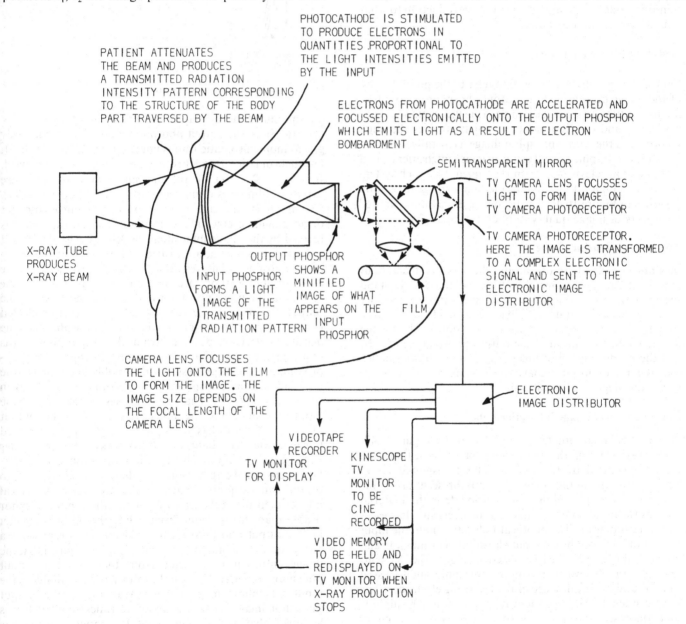

Figure 16.46 Method of image formation in photofluorography

necessary because they eliminate the linear blurring image which can so often be visually confusing. Each, however, introduces its own type of blurring image and care must be taken with choice of movement related to the shape of the object parts to be tomographed if image artefacts are to be minimized. Other tomographic movements include circular, elliptical, hypocycloidal, spiral and sinusoidal. Although a rectilinear movement was used to illustrate the tomographic imaging principle, the same applies whatever the path followed by the tube focus provided a similar path in the opposite direction is followed by the film. The above discussion is intended only as an elementary introduction to what is a vast and complex subject.

PHOTOFLUOROGRAPHY

Photofluorography here is used to refer to the photography of the image produced at the output phosphor of an image intensifier tube and includes single exposure, rapid sequence exposures and cinefluorography, which involves the cine-recording of the output phosphor image. Generally, with any photofluorographic system using an image intensifier tube, a closed circuit television system is coupled. One such system is shown in Figure 16.45 and the method of image formation is shown in Figure 16.46. The following discussion is limited to aspects of image quality in photofluorography.

The Image Intensifier Tube

It is not intended here to consider the detailed structure of image intensifier tubes, merely sufficient detail to understand the imaging process. Two important types of image intensifier tube are available, (i) single field and (ii) dual field. With the dual field image intensifier tube it is possible to change the degree of magnification of the output phosphor image. In fact the output phosphor image size is many times smaller than the input phosphor image so it is more correct to speak of various degrees of minification.

The Single Field Image Intensifier Tube

A single field image intensifier tube is shown in Figure 16.47. The X-rays entering the input phosphor are those that have been transmitted by the patient. This transmitted X-ray beam forms the initial image on the fluorescent layer forming the input phosphor. Caesium iodide is the material used as the input phosphor fluorescent layer, and fluoresces blue on irradiation. The photocathode adjacent to the input phosphor is excited by the input phosphor light emission and converts the light image to an electron image. The electrons are accelerated towards the output phosphor and focussed upon it under the influence of the focussing electrodes. The output phosphor is silver-activated zinc cadmium sulphide and fluoresces green. It is this image which is either

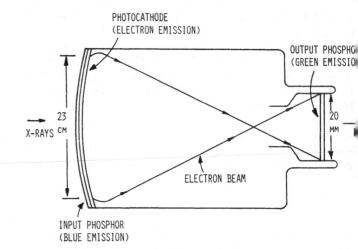

Figure 16.47 Single field image intensifier tube

photographed or displayed on a TV monitor via a TV camera. Since the output phosphor image is predominantly green, monochromatic film is not suitable to photograph it. Orthochromatic or panchromatic emulsions must be used. In general 70, 100 or 105 mm single or rapid sequence exposure filming is done using orthochromatic emulsions. 16 mm or 35 mm cine film is mostly panchromatic but orthochromatic cine film is available. When the image is formed by the image intensifier, the X-rays, with the largest allowable beam area, are distributed over the whole of the input phosphor. The resulting electrons produced by the adjacent photocathode are collected from an area the same as that of the input phosphor and accelerated towards the output phosphor. Since virtually all the electrons collected from the input phosphor reach the output phosphor then the density of electrons per unit area at the output phosphor is much greater than that at the input phosphor. Very approximately the brightness (intensity) of light emitted at the input and output phosphors is proportional to the electron density per unit area. Thus the brightness of the image at the input phosphor will be much less than at the output phosphor. Not only has the brightness of the image increased but its colour has changed in the process of image transfer from input to output. This light amplification is an important factor in the reduction of radiation dose required to produce an acceptable image on film. Considering a typical image intensifier tube as an example, the input phosphor usable diameter is about 23 cm while the usable diameter of the output phosphor is about 20 mm. This represents a reduction in size of about 12 times. If it is imagined that the image information transfer from the output to input phosphors is perfect then all the information available in the input phosphor image is also available in the output phosphor image, only it is about 12 times smaller. If it is assumed that the resolution of the input phosphor is

2-4 lp/mm then, since the output phosphor image is roughly 12 times smaller, the resolution at the output phosphor will be about 24-48 lp/mm.

Using lenses, the output phosphor image may be transferred onto film using a tandem lens system as shown in Figure 16.48. The output phosphor lens together with the TV camera lens forms a tandem lens system. The output phosphor lens together with the film camera lens also forms a tandem lens system (note that the light beam between the lenses has been turned through 90° but this does not alter the fact that they form a tandem lens system). A tandem lens system is one in which two lenses separated by a given distance have a parallel beam of light passing from one to the other transferring the image information. To achieve this parallel beam the lenses must be perfect and the light source producing the image must be placed at the focal point of its adjacent lens. To record the image the film must be placed at the focal point of the other lens. Of course the lenses are not perfect and the light beam between the lenses is not absolutely parallel. Beam divergence here reduces the light intensity in its passage from one lens to the other.

OUTPUT PHOSPHOR PRODUCES THE LIGHT

TANDEM LENSES

PARALLEL LIGHT BEAM

FILM

f_1

f_2

OUTPUT PHOSPHOR LENS HAS FOCAL LENGTH f_1 AND IS RESPONSIBLE FOR PRODUCING THE PARALLEL BEAM

FILM CAMERA LENS HAS FOCAL LENGTH f_2 AND IS RESPONSIBLE FOR PRODUCING AN IMAGE IN FOCUS ON THE FILM

Figure 16.48 Tandem lens system

If a 70 mm film, for example, is used to photograph the output phosphor image then 70 mm is the width of the film while the actual diameter of the image (which can be measured from the film) is about 65 mm. Thus the film image will be roughly three times larger than the output phosphor image and so have about one-third the resolution (i.e. 8-16 lp/mm). The 70 mm film must therefore be capable of resolving 8-16 lp/mm to be a satisfactory medium and in practice it can easily cope with this. We now have a film image with a resolution of some 8-16 lp/mm but it is only 65 mm in diameter, and provided movement unsharpness and geometric unsharpness have been minimized this image

will appear, to the unaided eye, to have virtually no unsharpness. Unfortunately some people cannot view such a small image and obtain all the required diagnostic information and so some degree of image magnification is necessary. If a hand lens is used, for example, giving a magnification of 2 times, then even though the image will appear twice the size the resolution will be halved. Looking at this from a different aspect, magnification of the image will make any unsharpness more noticeable (unsharpness increases) and because of this there will be a subjective reduction in radiographic contrast.

To avoid the use of a magnifying glass it is possible to obtain a larger image directly by using a larger film format. The largest size in the miniature film range is the 105 mm film. This produces an image 100 mm in diameter. Producing a 100 mm image direct is equivalent to magnifying the 65 mm image 100/65 times (i.e. about 1½ times). Producing a 100 mm image means that the light emitted by the output phosphor is spread over a bigger area than before. It should be obvious that to do this and yet maintain a given image density will require an exposure increase.

In general, in an image intensifier system, the larger the film format the greater the radiation dose required to produce the image, and this has to be balanced against the capability of obtaining the required diagnostic information. In addition to the above mentioned points, since the 100 mm image is 5 times larger than the output phosphor image, it will have only one-fifth of its resolution. This is worse than in the case of the 65 mm image. In this discussion on resolution it has been assumed that transfer of image information through the system is perfect which in practice it is not. Thus it is to be expected that the final resolution figure will be somewhat less than that calculated here.

Of course, the choice of film format depends in the final analysis on the viewing capabilities of the radiologist and personal preferences, as well as availability of associated equipment. The magnification capability is not limited to a change in film format and the use of a hand-held magnifying glass or special viewing device. Other methods are available and two of these are:

(i) Use of a dual field image intensifier tube
(ii) Overframing.

The Dual Field Image Intensifier Tube

The dual field image intensifier tube is shown in Figure 16.49. In comparison with the single field type it has an additional focussing electrode system. When this additional electrode system is not used the dual field intensifier behaves as a single field type and everything said above applies to it. When the additional electrode is used, electrons from just the middle 12.5 cm diameter area of the input side are collected instead of from the whole 23 cm diameter area. These

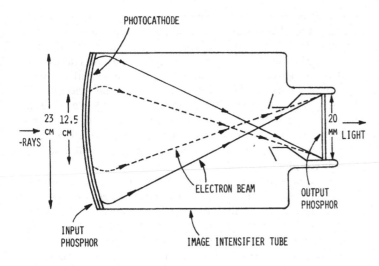

PHOTOCATHODE

23 12.5
CM CM
-RAYS

20
MM LIGHT

INPUT
PHOSPHOR

ELECTRON BEAM

OUTPUT
PHOSPHOR

IMAGE INTENSIFIER TUBE

Figure 16.49 Dual field image intensifier tube

(A) NON-MAGNIFICATION MODE

2-4 lp/mm 24-48 lp/mm 8-16 lp/mm

X-RAYS

70mm
FILM

OUTPUT
PHOSPHOR
IMAGE
(20mm)

FILM IMAGE
(65mm)

A

(B) MAGNIFICATION MODE

12-24 lp/mm

X-RAYS

4-8 lp/mm

2-4 lp/mm

OUTPUT
PHOSPHOR
IMAGE
(20mm)

FILM IMAGE
(65mm)

B

Figure 16.50 Modes of use of the dual field image intensifier tube

electrons are then spread over the whole of the output phosphor. The 12.5 cm diameter area from which electrons are now being collected is only $\frac{1}{4}$ of the total useful area of the input side and yet these electrons are being made to produce the same sized output image as before. The output image will thus only be about $\frac{1}{4}$ of the brightness obtained previously and to obtain the same brightness as before requires a considerable exposure increase. What has been achieved by using this additional focussing electrode system? In the single field image intensifier tube a 230 mm image was reduced to 20 mm (a minification of some 12 times). In this case a 125 mm image is reduced to 20 mm (a minification of only some six times). Thus the second output phosphor image is about twice the magnification of the first. Hence the use of the additional electrode system has given rise to a 2 × magnification. If this 'magnified' image is now recorded on the 70 mm film it has about half the resolution of the 'non-magnified' image but is twice as large and the hand lens probably will not be needed to view it. Unfortunately it has taken about four times the exposure to produce, and information previously present is not included in this image. These results are represented in Figure 16.50.

Overframing

If a dual field image intensifier tube is not available an image similar to B in Figure 16.50 can be produced by a technique known as overframing. This suffers the same advantages and disadvantages as the magnification mode of the dual field system. Overframing is achieved simply by changing the camera lens for one of a longer focal length. If the original lens produced an image similar to A in Figure 16.50 then using a lens with a longer focal length will result in an image similar to B being produced. Of course using a longer focal length lens means that there must be a greater distance between camera lens and film. This is achieved by moving the lens further from the film. Using a longer focal length spreads the light over a bigger area and focusses it further from the lens but only the same film area as before is exposed. An effect similar to that using the magnification mode of the dual field image intensifier is produced and only part of the complete image is recorded on the film; the rest lies outside the area of film exposed (i.e. outside the film frame). This is overframing. Again unfortunately a 2 × magnification results in an increased exposure requirement so in this respect we are no better off than using the dual field system for magnification. One advantage of the dual field system is that it is simpler to operate.

It is easy to calculate the required focal length to give a particular degree of magnification. The following formula is used:

$$\frac{\text{diameter of the image on the output phosphor}}{\text{focal length of the output phosphor lens}} =$$

$$\frac{\text{image diameter at film frame}}{\text{camera lens focal length}}$$

If we are using the whole of the useful diameter of the output phosphor then the image diameter at the output phosphor will be about 20 mm. The focal length of the output phosphor lens in the Philips system is about 65 mm. The maximum image diameter on the 70 mm film is about 65–68 mm. From these figures we can find out what the camera lens focal length should be to achieve correct framing. Using

$$\frac{\text{diameter of the image on the output phosphor}}{\text{focal length of the output phosphor lens}} =$$

$$\frac{\text{image diameter at film frame}}{\text{camera lens focal length}}$$

we have

$$\frac{20}{65} = \frac{65}{x}$$

where x is the camera lens focal length So, $x = 210$ mm

Figure 16.51 illustrates correct framing, overframing and total overframing. Figure 16.52 shows the frame sizes for

Figure 16.52 Frame sizes

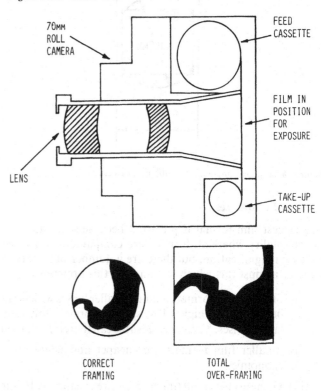

Figure 16.53 Total overframing in 70 mm camera

35 mm and 16 mm cine film. Notice that the 35 mm film frame is rectangular (22 mm wide). With conventional cine equipment this is unavoidable. To obtain a circular film

Figure 16.51 Overframing

frame (22 mm wide) would require altering the claw mechanism moving the film so that the film moved slightly further for each frame to avoid overlapping the circular images. This would require a purpose-built cine camera and these are available.

One 70 mm camera uses a 270 mm focal length lens for the camera to produce normal framing and a 360 mm lens for total overframing. This is shown in Figure 16.53. To overcome the necessity for magnification a 105 mm camera can be used rather than the 70 mm camera. This larger camera in one system produces an image 100 mm wide by about 95 mm high (i.e. a rectangular frame). The diameter of the output phosphor image at the film is 107 mm so the maximum size of the film image is represented by a 'squared' circle as shown in Figure 16.54.

Figure 16.54 Image obtained with 105 mm camera

Choice of Film Sizes

The largest film format is preferred because of its superior image quality where all formats are compared at the same viewing magnification, but there are a number of factors to balance against this which may modify this preference:

(i) Smaller film formats require smaller lenses which can be made with higher lens speeds more cheaply than larger lenses. Smaller exposures can therefore be used

(ii) Smaller film formats are cheaper and hence more economical

(iii) Cameras for small film formats are cheaper. A 16 mm cine camera is much cheaper than a 35 mm cine camera for example (the projector is also cheaper)

(iv) Smaller film images need less exposure dose to produce than larger images.

Resolution

There are many different types and sizes of image intensifier tube but for general purpose the dual field 9/5 is probably the most appropriate. This intensifer tube as stated above has a maximum usable diameter of about 23 cm at the input

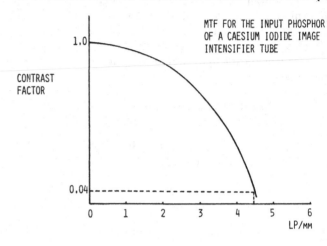

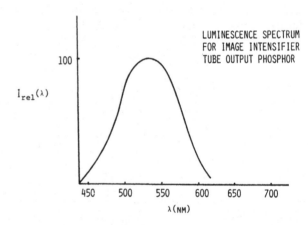

Figure 16.55 Luminescence spectrum and modulation transfer function (MTF) for a dual field 9/5 image intensifier tube

side. The luminescence spectrum and modulation transfer function for such an intensifier tube are shown in Figure 16.55. Assuming a minimum acceptable contrast factor of 4% then the maximum resolution is around 4–5 lp/mm at the centre of the image produced by the input phosphor. The resolution falls off towards the edges of the imaging field. With the older type of image intensifier tube using zinc cadmium sulphide at the input as well as the output the maximum resolution was about 1.6 lp/mm at the centre of the input phosphor and 1.2 lp/mm at the periphery. The use of caesium iodide has resulted in a significant improvement in resolution.

Figure 16.56 shows the parts of the system through which the image is transferred. Using the figures of the previous example for the 70 mm film

$$\text{Magnification factor} \quad = \frac{\text{image size}}{\text{object size}} = \frac{65}{230} = 0.28$$

The image size refers to the image on the film and the object size refers to the size of the image at the input phosphor.

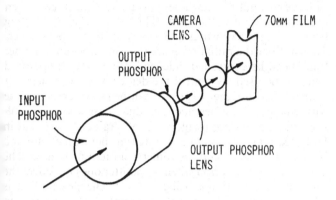

Figure 16.56 Parts of the image intensifier system

From this

$$\text{required film resolution} \quad = \frac{\text{input phosphor resolution}}{\text{magnification factor}}$$

$$= 4.5/0.28 \quad = 15.75 \text{ lp/mm}$$

The above system can be replaced by one having the older zinc cadmium sulphide-type intensifier tube and a 16 mm cine film to record the image. We will assume that we are imaging with correct framing. It is apparent that the image at the film will be 7.5 mm in diameter, so the magnification factor will be

$$\text{magnification factor} \quad = \frac{\text{image size}}{\text{object size}} = \frac{7.5}{230} = 0.03$$

It is known also that the image intensifier resolution is about 1.6 lp/mm. Thus

$$\text{required film resolution} \quad = \frac{\text{input phosphor resolution}}{\text{magnification factor}}$$

$$= 1.6/0.03 \quad \simeq 54 \text{ lp/mm}$$

The 16 mm cine film is capable of resolving 70–80 lp/mm so 54 lp/mm is well within the capabilities of the 16 mm film.
The situation is somewhat different, however, if a caesium iodide intensifier is used with a 16 mm cine film and correct framing. Again the magnification factor is 0.03 but now the maximum resolution of the image intensifier is 4–5 lp/mm. Using 4.5 as the figure for the resolution, the required film resolution becomes

$$\text{required film resolution} \quad = \frac{\text{image intensifier input resolution}}{\text{magnification factor}}$$

$$= 4.5/0.03 \quad = 150 \text{ lp/mm}$$

Now the 16 mm film is incapable of resolving all the information in the image so the new system is no longer a suitable imaging system. Would overframing help if loss of part of the image area could be tolerated (unavoidable with overframing)? With overframing, the diameter of the image at the film becomes 10.5 mm (approx) so

$$\text{magnification factor} = \frac{10.5}{230} = 0.04$$

and now the required film resolution is

$$\text{required film resolution} \quad = \frac{\text{image intensifier input phosphor resolution}}{\text{magnification factor}}$$

$$= 4.5/0.04 \quad \simeq 113 \text{ lp/mm}$$

This is better but the 16 mm film is still incapable of resolving this. With total overframing the film image diameter is approximately 13 mm giving a magnification factor of 0.06. The required film resolution is then 79.65 lp/mm which is just within the capability of the 16 mm film. While total overframing provides an answer a better solution is to use a larger format film even though this would be more expensive.

Noise

Image noise is present in all radiographic images and, as in plain radiography, the use of a fast film and a low exposure dose in photofluorography results in an image with relatively high quantum noise. The use of a slower film and higher input dose will reduce quantum noise effects but of course the radiation dose to the patient is greater. In practice the choice must be one where the least possible radiation dose is used to produce an acceptable image quality. In cinefluorography the image noise per frame can be high and quite unacceptable when examining each frame individually. When projected, however, the relatively high frame speeds used means that persistence of vision allows integration of several frames into a single image. Integrating image noise in this way greatly reduces the effect of quantum mottle. However, occasions may arise where single frames must be carefully inspected. Then the exposure per frame must be

increased and this is where cine pulsing equipment is essential. Figure 16.57 illustrates the exposure curves for pulsed

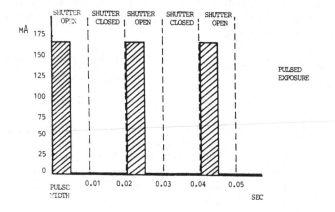

Figure 16.57 Exposure curves for pulsed and non-pulsed cine systems

and non-pulsed cine systems where the cine camera has a 180° shutter open phase and a frame speed of 50 fps. The hatched area gives the value of mAs. Note that in the non-pulsed system the patient is being irradiated even when the camera shutter is closed and the film is not being exposed. Here radiation is produced continuously necessitating use of a low mA, and the frame speed controls the exposure time per frame. High frame speeds mean the use of high kV with resultant low contrast images. The situation is improved with the cine pulse unit where exposure is only allowed when the camera shutter is open. This allows anode cooling between frame exposures and the use of higher mA values. The width of the radiation pulse (i.e. the exposure time per frame) can be controlled independently of the frame speed and can be used to control the degree of unsharpness per frame. Since a higher exposure can be delivered per frame with cine pulsing it becomes possible to use a slower emulsion film and reduce image noise per frame. Notice that in both cases the maximum exposure time per frame is limited by the frame speed and the camera shutter open phase. The open phase is the period when the shutter does not cover the film gate and the film is being exposed. The closed phase is when the shutter covers the film gate and the film is moved to provide a new frame for exposure. Since the shutter is part of a circle the closed phase = 360° − open phase. For a 180° shutter the open and closed phases are equal. This means that for a frame speed of 50 fps the maximum exposure time per frame is 0.01 s. With the cine pulse unit, increasing the frame speed increases the number of X-ray exposures per unit time and hence increases the radiation dose to the patient. Thus careful consideration should be given to the use of high frame speeds.

Appendix 1

Testing Exposure Timer Accuracy

The Wisconsin timing and mAs test tool is both easy and quick to use to determine the accuracy of the exposure timer. The accuracy and consistency of short exposure times is important since a small error in exposure time could be larger than the set exposure. For example, if for a set exposure time of 0.01 s there is an error of 0.01 s this represents a 100% error. However, this same 0.01 s error in an exposure time of 1 s represents only a 1% error. Timing errors, if present, are usually small and it is the effect of these on the short exposures which is important. The test tool contains a brass disc, the rotation of which is controlled by a synchronous motor. Because of this it is suitable for testing single phase and 3-phase units as well as capacitor discharge equipment. The disc has two slits (near the perimeter) which are spaced 180° apart. Each slit subtends an angle of 2° and this finite slit width must be taken into account when assessing exposure time in 3-phase and capacitor discharge units. The brass disc rotates at 1 revolution per second (rps) (model 121) and so can be used to determine timer accuracy for exposure times up to 1 s. In addition to the disc and synchronous motor, the test tool also houses a copper stepwedge to allow relative mA value assessment. A given mAs should produce the same density in the image for a set kV irrespective of the mA used. This can be checked by comparing step densities in the image produced at different mA values for the same mAs and kV. It is possible to combine both mA and exposure time assessments by careful choice of exposure values.

The manufacturers recommend using 80 kV for testing single phase units and 70 kV for 3-phase and capacitor discharge units. When both mA calibration and exposure timer accuracy are assessed together the appropriate kV is selected and an mAs value chosen by trial and error to provide a reasonable stepwedge image. Assume for example that at 100 cm FFD, 12 mAs was required for the image recording medium used (a film–intensifying screen combination). A series of exposures could be made as in Table A1.1.

If it is required to assess the accuracy of a sequence of adjacent exposure time values then it may not be possible to choose the same mAs for each exposure. Here mA calibration cannot be assessed simultaneously so it is perfectly acceptable just to change exposure time at each exposure

Table A1.1 Settings for exposures at 12 mAs

Exposure number	mAs	mA	Exposure time (s)
1	12	100	0.12
2	12	200	0.06
3	12	300	0.04
4	12	400	0.03
5	12	600	0.02

while maintaining a constant kV and mA. Each successive image is then darker than the previous one but this does not matter when just checking timer accuracy.

When checking timer accuracy in a single phase unit operating on a 50 Hz mains supply there will be one distinct pulse of useful radiation (image density forming) every 0.01 s. These pulses will be imaged as separate slits around the periphery of the disc image. Each slit image represents a time of 0.01 s, and just counting the number of such images and multiplying by 0.01 gives the total exposure time in seconds providing it is not a self-rectified unit. An extra slit image may be present for each of the times checked. This image should be less than half the density of the other images, in which case it is acceptable and should not be counted. This is caused by a pulse of low intensity radiation at the commencement of exposure and is due to a premagnetizing effect. For the short exposure times of less than 0.1 s the number of pulses should be exact. For times longer than this a small error of one or two in the number of pulses is acceptable. Where the pulse images are so close together that they are impossible to distinguish separately (in the case of 3-phase, 12 pulse), or where the output is continuous (but decreasing) as in the case of capacitor discharge, then the angle for the arc image produced can be measured. Since the slit is of width 2° then the arc produced will be too great by 2°. This must be subtracted from the angle measured for the arc before calculating the exposure time. Determination of exposure time is straightforward. The disc rotates at 1 rps i.e. 360° in 1 s, so for an exposure time of 0.01 s for example the arc angle measured will be $(0.01 \times 360°) + 2° = 5.6°$ (Figure A1.1). Thus to determine the

exposure time value in this case it is only necessary to measure the angle subtended by the arc and use

$$\text{Exposure time (s)} = \frac{(\text{angle subtended by arc}) - 2^{\circ}}{360^{\circ}}$$

The manufacturers do provide a protractor for such measurements (Figure A1.2). Figure A1.3 shows the film result for an exposure of 0.03 s with a single-phase unit (a) and 0.2 s with a capacitor discharge unit (b). Accuracy in determination of exposure time depends on the accuracy in arc angle measurement and rotational speed of the disc.

a

Figure A1.1 Measuring arc angle

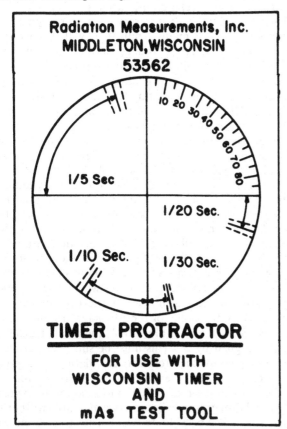

Figure A1.2 Protractor provided for use with Wisconsin timer and mAs test tool. (By courtesy of D. A. Pitman Ltd.)

b

Figure A1.3 Examples of images produced

Appendix 2

The Sensitometer

Another of the range of RMI instruments for image quality control in X-ray departments is the sensitometer. This is robust and measures 6 cm × 17.5 cm × 13.5 cm. It has a slot at one end into which a film may be inserted for exposure. The instrument is extremely simple to operate since there is only one control consisting of a push button to operate the exposure of the film to the regulated light source, exposure being indicated by the adjacent red light which glows for the duration of the exposure. The light source is white and is of constant intensity and the exposure is stated to be 1.33 s. Behind the metal plate of the slot (into which the film is

placed for exposure) are three circular holes each offering a different optical density to the light from the regulated source. The film exposure produces, on processing, three circular areas of differing density which can be used to determine speed and contrast indices. The remainder of the film receives no exposure so can be used for fog index measurement. Using a controlled light source in this way eliminates the exposure as a source of variation, any image quality index variations then being due solely to variations in processing chemical activity. For general use it would be useful to have some means of matching the light spectrum to the intensifying screen emission employed with the film and to have some means of varying the light intensity so the sensitometer can be satisfactorily used with any speed of film.

The size of film used with this sensitometer need only be small and it is useful if a box of the smallest size of the type normally used is put aside and used for the monitoring programme. A typical sensitometer result is shown in Figure A2.1. The middle density was used for the speed index and the difference between this and the highest density was used for contrast index. The fog index was taken from the density reading for the unexposed portion of the film. For speed and contrast indices, density measurements were made from the middle of each of the circular density areas. This type of sensitometer could not be used for producing a characteristic curve since only three densities are produced in the image. In addition only one side of the film is exposed.

Figure A2.1 Typical sensitometer result

Appendix 3

Relative Speed

A novel approach to the determination of relative speed for given systems can be achieved using a calibrated stepwedge. The system can be a direct exposure film, a screen-type film used without intensifying screens or a film–intensifying screen combination.

A system is chosen and its characteristic curve produced by the method of Chapter 2 using the copper filter. A typical result for a film–intensifying screen combination is shown in Figure A3.1. Using the same system but without the copper filter another film is exposed through an aluminium stepwedge on the same X-ray equipment with the same kV and mA and an exposure time suitable to show a reasonable number of distinct step densities. The film is processed under identical conditions to the sensitometric film which produced the characteristic curve. Each step density is measured and, using the characteristic curve, the log relative exposure value required to produce each of these densities is noted at the side of each step in the image. This acts as the reference image since the stepwedge has now been calibrated for this imaging system (Figure A3.2). The step with density closest

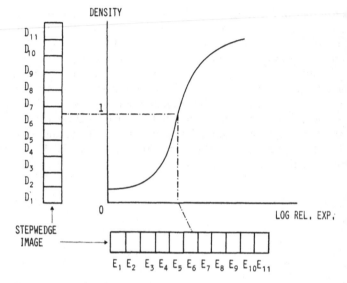

Figure A3.2 Calibration of the stepwedge. The E values are the log relative exposure values corresponding to the D values

to one is also indicated and this step is always used in the matching process to be described.

If the speed of another system relative to the original system is required, an image of the stepwedge is produced with the new system using the original stepwedge film exposure and processing conditions. The calibrated stepwedge image produced with the old system is placed by the side of the stepwedge image for the new system and the two moved parallel to one another until matching step densities at $D = 1.0$ are obtained (Figure A3.3). In this example matching densities are obtained for steps 6 and 4. Now using only the calibrated stepwedge image note the log relative exposure value for steps 6 and 4. Subtract the log relative exposure value for the matching step density for the old system from that for the new (i.e. the value for step 6 from that of step 4 in this example). If the result is positive, the new system is slower than the old, whereas if the result is negative, the new system is faster. If the result is zero, both systems have the same relative speed.

Here step 6 has the log relative exposure value 0.9 while that for step 4 is 0.6 (Figure A3.4). The value for the matching step for the old system is 0.9 which must be

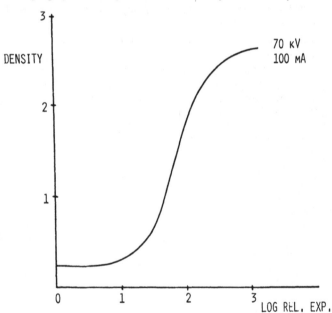

Figure A3.1 Typical characteristic curve for a film-intensifying screen combination

286

STEPWEDGE IMAGE PRODUCED
WITH THE NEW SYSTEM USING THE SAME
EXPOSURE AS FOR THE OLD

STEP 6 → ← STEP 4 (MATCHING DENSITIES)

CALIBRATED STEPWEDGE IMAGE
PRODUCED WITH OLD SYSTEM

Figure A3.3 Density matching with two stepwedge images

subtracted from the value for the matching step for the new system (its value being obtained from the calibrated stepwedge image) which is 0.6. The result (0.3) is negative and the new system is faster than the old. If now the antilog of the result is found (ignoring the negative sign) the answer obtained is the required relative speed value. Antilog $0.3 \simeq 2$

STEPWEDGE IMAGE
FOR THE OLD SYSTEM

STEPWEDGE IMAGE
FOR THE NEW SYSTEM

D=1.0
LRE=0.9

STEP 6

STEP 4

LRE=0.6

STEP 4

Figure A3.4 Log relative exposure (LRE) values for matched stepwedge images

and the new system is twice the speed of the old. Figure A3.5 shows examples for cases where the two systems have a similar speed (a) and where the old system is faster than the new (b). If density matching is obtained at only one pair of steps the image contrast obtainable with the two systems will be quite different. If on the other hand matching is obtained at all step pairs, image contrasts will be identical.

While this is a very convenient method there are many limitations which should be recognized:

(i) If the two films have slightly differing film base tints, visual comparison of densities can be difficult and the only solution to the dilemma is to use a densitometer

(ii) Precise matching of step pair densities may not occur (Figure A3.6). If the density difference between the two matched steps is large, only a rough estimate of relative speed can be obtained using the described method. A better estimate is obtained with an averaging procedure but it is hardly necessary to go to this length for practical purposes. Such an error can be made small if the stepwedge used produces an image in which the density change from step to step is small. In other cases choose the matching step which minimizes the density difference

(iii) If the calibrated stepwedge image was produced some considerable time ago, say 9 to 12 months, then changes could have occurred in the original system which were not apparent at the time the original stepwedge image was produced. The speed of the screens may have fallen over this period of use; the manufacturer may have made changes in the film properties; the processing conditions may not be similar; the exposure values may have altered as the result of equipment servicing, possible replacement of circuit parts or deterioration in X-ray tube performance giving a reduced output; the original cassette type may have been replaced by a new type; the original X-ray equipment used may have been replaced. Because of the possibility of such changes, the calibrated stepwedge image should be periodically replaced with an updated version using different equipment if necessary

(iv) Using a stepwedge not only produces varying transmitted radiation intensities from step to step but also varying radiation beam quality. This is not the same situation as occurred in producing the characteristic curve. There the intensity remained constant and the exposure time varied. The radiation beam quality also remained constant. Any slight discrepancies occurring because of this can be ignored in practice.

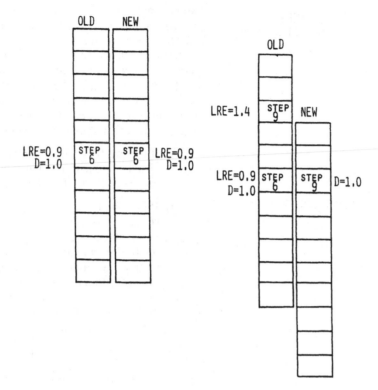

(A) NEW - OLD ≡
 VALUE FOR STEP 6 - VALUE FOR STEP 6
 = 0.9 - 0.9 = 0.
 ANTILOG 0 = 1, I.E. RELATIVE
 SPEED IS 1:1 AND THE SYSTEMS
 HAVE SIMILAR SPEEDS

(B) NEW - OLD ≡
 VALUE FOR STEP 9 - VALUE FOR STEP 6
 = 1.4 - 0.9 = 0.5,
 ANTILOG 0.5 ≈ 3, I.E. RELATIVE
 SPEED IS 3:1, AND THE NEW
 SYSTEM SLOWER THAN THE OLD

Figure A3.5 Examples of systems with (a) similar speeds and (b) new system slower than old

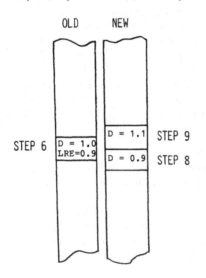

Figure A3.6 Precise matching of step densities is not possible here

Discussion

Despite its many limitations this is a quick and easy method to use in practice where only an approximate measure of relative speed is required anyway. The method requires familiarity with log tables or, if these are to be avoided,

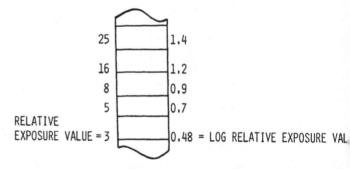

Figure A3.7 Alternative calibration method

relative speed numbers can be used directly by taking antilog values of the log relative exposures for each step (Figure A3.7). Now instead of marking log relative exposure values by each step, relative exposure values can be used. Whereas, before, to determine relative speed it was necessary to subtract the two values obtained and find the antilog, now all that is required is to divide the larger value by the smaller value to obtain relative speed (Figure A3.8). Finally, the calibration of the stepwedge is kV-dependent and if relative speed figures are required at different kV values then recalibration for each kV is required.

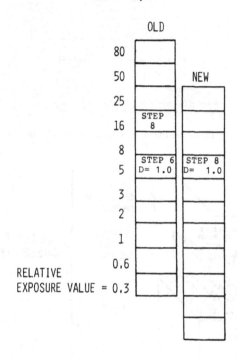

Figure A3.8 Alternative method. The relative speed here is $16/5 \simeq 3:1$, the new system being slower than the old

Appendix 4

Estimation of kV

For a given X-ray generator knowledge of absolute kV values is of little importance to the practising radiographer. What is really required is the relationship between different kV settings and the consistency of kV value from exposure to exposure. For example, does a 10 kV change set at the control panel actually give a 10 kV change in tube potential? This information would be required when estimating the associated mAs to achieve a correct exposure in the absence of an automatic exposure system. For example, a certain exposure may be satisfactory in producing the correct average image density but have an associated exposure time which is too long. Increasing kV is one way of obtaining a reduced exposure time. Achieving the correct average image density when doing this requires a knowledge of the exact kV variation.

kV estimation can be made from a comparison of image densities using the image produced in a Wisconsin X-ray test cassette exposure. Two cassettes are available, one for measuring kV_p (peak kilovoltage) in the range 28 to 55 kV_p and the other more generally used for measurements in the 50 to 130 kV_p range. Figure A4.1 illustrates the outside of the Wisconsin cassette (a modified 20 cm × 25 cm X-ray cassette). The system is seen to consist of two main pieces:

(i) A fairly thick layer screwed to the outside of the cassette. This layer contains the copper sheet, copper stepwedges and the lead mask drilled with five columns, each column consisting of ten paired holes. The outside of this layer is protected with plastic and labelled to show the different regions

(ii) The cassette itself containing a single intensifying screen, part of the surface of which is covered with five optical attenuators. These serve to attenuate the light emitted by the intensifying screen. For use, the cassette is loaded with duplitized, screen-type X-ray film typical of that used in the department.

Figure A4.2 shows the structure of the different layers and the cassette is shown open in Figure A4.3. Here the five optical attenuators can be seen. Considering just one column of holes in the lead, it consists of two parallel sets of ten holes. One set of ten holes is covered with a copper stepwedge. A different stepwedge is used in each of the five columns. Under the other set of holes and on the intensifying screen is an optical attenuator.

Figure A4.1 The outside of the Wisconsin cassette. (By courtesy of D. A. Pitman Ltd.)

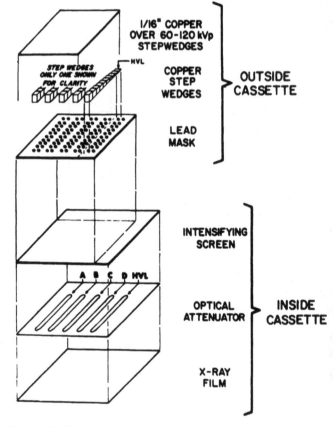

Figure A4.2 The structure of the Wisconsin cassette. (By courtesy of D. A. Pitman Ltd.)

Figure A4.3 The Wisconsin cassette open. (By courtesy of D. A. Pitman Ltd.)

When the cassette is exposed to X-rays, the intensifying screen emits light and the X-ray film is used as a detector. There is a particular thickness of copper absorber which, when placed over the unattenuated intensifying screen, produces an image with an optical density equal to that obtained with no absorber but with the optical attenuator. The 'match' thickness, which is almost a linear function of kV_p, is used to measure the kV_p. The 60 kV region can be used for kV measurement in the range 50–70 kV_p; the 80 kV region can be used for the range 70–90 kV_p; the 100 kV_p region for 90–110 kV_p and the 120 kV_p region for the remaining kV_p values up to 130 kV_p. Depending on the kV_p used, each region is exposed separately.

Figure A4.4 shows a film image from the Wisconsin cassette where two exposures have been made with the settings 70 kV_p. The right-hand sets of dots of column A and column B each act as a reference set. The reference dots result from exposure of the film through the optical attenuator. The mAs used at the kV_p being assessed should be such that each of the dots in the reference set has $D \approx 1.0$. Considering column A for example, it is only necessary to find a pair of dots having the same image density (in this case pair number 6) as measured with a densitometer and read off the kV_p value from the set of graphs supplied with the cassette. There are four regions used for measuring kV_p and one graph is supplied for each region. Figure A4.5 is typical of the graphs supplied and in this case is for region A. The graph shows step number against kV_p. Two lines are shown, one for X-ray equipment using a 3-phase supply and the other for single phase. The film in Figure A4.4 was produced with a single-phase unit. Matching densities were obtained at step 6 in region A which gives a kV_p of 70 from the graph. This was in fact the kV_p set at the control panel. At 80 kV_p as set at the control panel, matching densities were obtained at step 3 in region B. The graph for region B indicated that the correct kV_p was 80. Here the kV_p calibration is correct for 70 and 80 kV_p at least.

This discussion gives only a brief description of kV

estimation. Further information can be obtained from D. A. Pitman Ltd., Surrey.

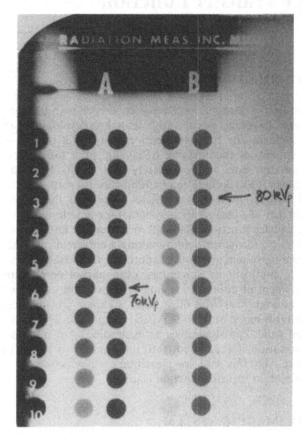

Figure A4.4 Film image from the Wisconsin cassette

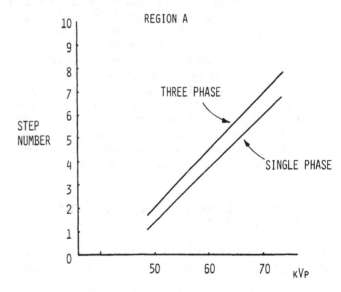

Figure A4.5 Typical graph supplied with the Wisconsin cassette

Appendix 5

The Transfer Function

INTRODUCTION

Routine radiographic practice is concerned with the use of different imaging systems rather than their development and assessment. The transfer function is a useful tool in the assessment of the imaging behaviour of a radiographic system but does not completely describe its behaviour. However it has become common practice for manufacturers and authors of technical articles to talk of the imaging capability of a radiographic system, for example, in terms of the transfer function. Radiographers require knowledge of system performance before making a choice of one image recording system in favour of another. Often, test equipment for a complete or sometimes even partial comparative assessment of different imaging systems is not available to the radiographer who must make a choice. This choice is inevitably based on a limited visual comparison which, while often valid, can sometimes be misleading. Any additional information, if it can be correctly interpreted, will help in this choice. To this end an elementary introduction to the modulation transfer function is given.

THE IMAGING SYSTEM

The imaging system can be considered as a transducer receiving an input and producing an output. If the input is known together with the effect of this transducer on the input then the output can be predicted. The input is transformed by the transducer to an ouput and this transformation is described in terms of a transfer characteristic. No imaging system is perfect and knowing the transfer characteristic for a given imaging system allows determination of the degree of image deterioration for any given object. This obviously is one of the measures necessary in determination of image quality. It should be noted, however, that no single measure completely predicts image quality.

THE POINT SPREAD FUNCTION AND THE LINE SPREAD FUNCTION

To simplify this study certain assumptions are made about the imaging system. It is assumed that the system is both linear and invariant, and further that it is isotropic. Being linear means that the system obeys the property of superposition in which the output corresponding to a sum of inputs is equal to the sum of the outputs corresponding to the inputs acting separately. In addition, multiplication of the input by a constant multiplies the output by the same constant. If all these conditions are met the system is linear. Invariance means that the image of a point retains its shape as the object point is moved over the object plane. A point object will in a perfect imaging system be recorded as a point image. However, no system is perfect and in the practical imaging system the image will not be a point but a disc of finite diameter the density of which diminishes when proceeding from its centre towards the periphery. The radiation intensity pattern producing this less than perfect image can be plotted as a three-dimensional graph represented as a hump on the image plane. This hump is the point spread function (Figure A5.1). It is assumed for the purpose of this discussion that the point spread function has rotational symmetry, hence the earlier use of the word isotropic, which

Figure A5.1 The point spread function. The xy plane is the image plane

means 'similar in all directions'. The point spread function determines the structure of the image (the output) for a point object input and is hence a transfer characteristic.

An object is made up of many points. Each of these points may be regarded as a point source of radiation each having a point spread function associated with it. Because of these properties mentioned earlier the point spread function is the same for all points but since each point source may vary in intensity then the output for each point is the point spread function multiplied by a constant factor to take account of the intensity. The output image is the sum of all the point images. If the point spread function for the imaging system can be measured then the mathematical operation of multiplying each point in the intensity distribution for the object by the point spread function and summing can be performed to produce the output for the system. This procedure is known as convolution of system input with the system transfer characteristic (the point spread function). The importance of this is that the imaging of a complex object can be reduced to the simpler study of point imaging.

The point spread function, however, is difficult to measure because alignment difficulties are experienced where trying to perform a density scan of the image of an infinitely small point. The point spread function would be obtained by obtaining a density plot of the point image and then using the characteristic curve to transform this to a radiation intensity plot. In practice a line image rather than a point image is used and the transfer characteristic obtained is called the line spread function. Here the object is a line source of radiation and the image is again imperfect demonstrating unsharpness at the edges. The obtained line spread function gives a measure of this unsharpness. Once the point spread function or line spread function is known for a system it is possible to predict the output image for any object.

THE MODULATION TRANSFER FUNCTION

If the input to the system varies sinusoidally with distance the system is readily accessible to mathematical analysis. The frequency of the sinusoidal pattern is described as a spatial frequency and is measured in cycles/mm. The image will have the same spatial frequency but the amplitude of the sinusoidal output will be reduced due to the imperfect imaging nature of the system. The reduction in amplitude again represents a reduction of resolution.

To define the modulation transfer function one must first consider modulation. Modulation is measured in the object and image planes as the ratio of the amplitude to the average value of the sinusoidal distribution of radiation intensity. The ratio of the output modulation to the input modulation, when expressed as a function of spatial frequency, is called the modulation transfer function. This information is generally presented in graph form with modulation transfer factor (the ratio above) plotted on the vertical axis and spatial frequency on the horizontal axis. The beauty of the modulation transfer function (MTF) is in the simplicity in which the output is predicted from the input. With the point spread or line spread functions the complex operation of convolution is necessary to predict the output. Here all that is necessary is to multiply the MTF by the input modulation to obtain the output modulation.

In practice most inputs are not sinusoidal but it is well known that a non-sinusoidal input can be represented by a sum of sinusoidal components. There are an infinite number of sinusoidal components in the sum with different amplitudes and frequencies. Reducing a non-sinusoidal input to its component sinusoidal parts is achieved by a process known as Fourier transformation. Thus the MTF can be calculated from the line spread function by Fourier transformation. The MTF provides a measure of the optical performance of the system together with the degree of optical degradation of important information in the image. An MTF for a typical high-speed film–intensifying screen system is shown in Figure A5.2. If a sharp edge of a piece of lead, for example, is imaged the radiation intensity pattern across the edge goes abruptly from zero to a maximum and is often called a step function. The Fourier series describing a step function is the sum of an infinite number of terms each representing a progressively higher spatial frequency. For a perfect image, the MTF curve should be a line parallel to the spatial frequency axis and passing through 1 on the vertical axis. Unfortunately, as seen in Figure A5.2, the curve falls gradually from a value of 1 at low spatial frequency to almost zero at slightly higher spatial frequency. This means that the

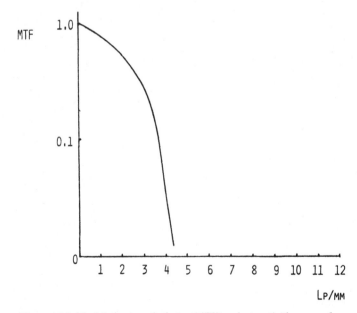

Figure A5.2 Modulation transfer factor (MTF) against spatial frequency for a typical high-speed film intensifying screen combination

Appendix 6

System Faults in Film Processing

Image quality will show a noticeable deterioration if the values recorded for the image quality control indices of speed, contrast and fog lie outside allowable limits. In such a case the cause should be determined and the fault corrected. Here the faults discussed will be limited to those associated with the processor and processing chemistry but it must not be assumed that all image faults are due to processing error. For example, a low density image giving an unacceptably reduced speed index may be due to incorrect exposure, use of wrong film–intensifying screen combination, or incorrect FFD for exposure selected, and not due to any processing fault. There are many possible causes for image quality variations, which may be due to electrical or mechanical filaure, simple human error in processor solution preparation, film handling faults during manual processing or film transport faults in automatic processing. The following discussion is not exhaustive and is merely presented to indicate the more common sources of error.

MANUAL PROCESSING

The technique used in manual processing can often be a source of error resulting in a film fault of one kind or another. Development by inspection is a technique sometimes employed but which is best avoided. During development by inspection the film is withdrawn from the developer and the image inspected by safelight. Prolonged inspection produces:

(i) Increased safelight fogging
(ii) Increased oxidation and hence exhaustion of developer on the film. This is introduced into the developer solution on returning the film and serves to increase the rate of exhaustion of the developer in the tank.

Strictly speaking, a film should be placed in the developer solution, should remain there and should receive intermittent agitation throughout the development time. Without agitation exhausted chemicals resulting from the developing action in the film emulsion are slow to be replaced by fresh chemicals at the film and uneven development can result. Uneven development is likely to occur anyway if the developer solution is not thoroughly stirred periodically to obtain a uniform developer concentration and temperature. This problem does not occur in automatic processing because the solutions in the developer tank and fixer tank are continuously agitated by recirculation.

The developer temperature is maintained usually by heat exhange through the developer tank wall from the heated water jacket. The water jacket is heated by an immersion heater and the temperature controlled thermostatically. Control of developer solution temperature variation by this method is a slow process and wider temperature variations are experienced in manual processing than in automatic processing. For this reason it is wise to check solution temperature periodically and if necessary adjust development time according to a time–temperature graph.

Inadequate replenishment to maintain solution level can lead to an area of film not being immersed during development and results in a clear strip of film after fixing unless the fixer solution level is also too low. Inadequate replenishment technique resulting in over- or under-replenishment for solution activity can lead to considerable variations in the image quality control indices, but both result in reduced image contrast. Again, if thorough stirring is not carried out when replenisher solution is added, then uneven development will occur.

In automatic processing over- or underexposure cannot be compensated for but in manual processing the temptation exists to under- or overdevelop (i.e. increase or decrease the development time) in an attempt to compensate. Overexposure and underdevelopment produces an image of correct average density but low contrast, with streaking produced by uneven development in the short time used. Underexposure and overdevelopment produces an image which generally has a lower than acceptable average image density with a relatively high development fog and hence low contrast.

Removing the film from the developing tank to the rinse tank at the end of development results in carry-over of developer with the film. If the film is drained back into the developer for a few seconds before passage to the rinse tank the carry-over rate becomes reasonably low and replenishment volume for solution level maintenance acceptable. Excessive draining of the film back into the developer simply puts too large a quantity of developer waste products back in

the developer increasing the exhaustion rate but not reducing the solution level sufficiently to provide for adequate replenishment. In this case a volume of developer would have to be removed from the developer tank before adding replenisher if solution activity was to be maintained at a reasonably constant level. Ideally, carry-over rate should be such that the topping-up method serves to maintain solution level and adequately maintain solution activity. In any case, the film handling technique employed should be such as to produce a consistent carry-over rate. An inconsistent carry-over rate renders adequate replenishment impossible and standardization of image quality cannot be obtained.

Inadequate draining of the film after rinsing can mean a large water carry-over rate into the fixer producing excessive dilution, and the fixer life is reduced because fixing times become unacceptably long. Alternatively inadequate or no rinsing can mean a relatively large carry-over rate of developer to the fixer producing dichroic fogging and fixer neutralization because the fixer is acidic while developer is alkaline.

Inadequate washing reduces the storage life of the finished film and increases drying time. Drying time is increased because fixer solution evaporates very slowly in comparison with water and leaves behind a crystalline, sticky deposit on the film. This oxidizes, turns brown and stains the film destroying the usefulness of the image. Finally chemical preparation and mixing are important as incorrectly prepared chemicals can lead to low density images being produced.

AUTOMATIC PROCESSING

Here the problems are quite different since none of the faults exist which are associated with processing technique. The transport of the film through the processor is automatic and carry-over rates are negligible implying that replenishment is more for maintaining solution activity than solution level. In any case this is done automatically and consistently by feed and bleed replenishment and it is only when this system is faulty that problems occur.

Human error while reduced to a minimum by automation can still account for some film faults. For example the operator can feed a film into the processor having forgotten to turn on the water supply. The film is then not washed and appears from the dryer section only partly dry and badly stained. Cleaning of rollers in the wash and drying section may then be necessary.

Again, replenisher reservoir volume may inadvertently be allowed to drop too low when no replenisher is delivered to the developer tank even though the replenisher pumps are working. This can lead to air being trapped in the replenisher pipes giving an inconsistent replenishment rate even when the reservoir is refilled.

The following list provides a guide to some of the film faults and the possible causes.

Fault	*Cause*
(a) Low average image density	(i) too short a cycle time for the developer temperature used
	(ii) developer contamination
	(iii) replenisher rate too low
	(iv) flow of replenisher impeded
	(v) replenisher level in reservoir too low
	(vi) replenisher contamination
	(vii) incorrect preparation and mixing of replenisher
	(viii) too much starter used
	(ix) developer temperature too low
(b) High average image density	(i) too great a cycle time for the developer temperature used
	(ii) developer contamination
	(iii) replenisher rate too great
	(iv) replenisher contamination
	(v) incorrect preparation and mixing of replenisher
	(vi) too little starter used
	(vii) developer temperature too high

(c) Uneven density

 (i) insufficient agitation in the developer from inadequate solution recirculation

 (ii) variation in film transport rate

(d) Film fogging

 (i) little or no starter used in preparing the developer

 (ii) replenishment rate incorrect

 (iii) contamination of developer

 (iv) developer temperature too high

 (v) too low a cycle time for the temperature used

 (vi) safelight fogging from holding film on feed tray for too long before feeding film into processor

(e) Marks or scratches on film

 (i) damaged rollers

 (ii) improperly functioning rollers

 (iii) dirty film feed tray

 (iv) damaged surface to film feed tray

 (v) damaged film detector

 (vi) damaged film guides in the roller racks

 (vii) dirty water supply

(f) Improperly fixed film

 (i) wrong film type processed

 (ii) fixer replenishment rate incorrect

 (iii) fixer temperature too low

 (iv) fixer replenisher incorrectly mixed

 (v) too short a cycle time for the fixer temperature used

 (vi) level of fixer replenisher in reservoir too low

 (vii) fixer contaminated

 (viii) inadequate fixer recirculation

(g) Improperly dried film

 (i) water supply not turned on

 (ii) drier section not operating

 (iii) fixer replenishment rate incorrect

 (iv) radiant heater tube malfunction

 (v) wrong film type processed

Index

absorption 1, 3–4
absorption unsharpness 149
accelerator 199
access, darkroom 176
acetic acid 187
acid 199
acidity 199
actinic marker 158–9, 243
activators 64
actual focus 94
acuity 164
additives 9–10
adhesive layer 9, 11
afterglow 59
aldehyde 202, 207
alkali 199
alkalinity 199
alternating current 91
alternating voltage 91
aluminium equivalent 4
ambient temperature 175
ammonium salts 191, 206–7
angular shift 262
anode 2, 130
anode angle 131–2
antifoggant 191
antihalation layer 11
antistatic 9
antiswelling agent 202
AOT 77, 83
applied voltage 2
atomic number 150
attenuation 3–4, 151
attenuation coefficient, linear 151
automatic exposure 4–5, 76, 106, 110, 234
 beam area 113
 calibration 113, 121
 density setting 112, 114
 dominant zone 112–15
 field configuration 113, 119
 intensifying screens and films 121
 measuring field 113–14
 monitoring device 112
 patient positioning 113, 117
 primary radiation 115
 scatter compensation 116
 scattered radiation 113, 116
 sensor 111, 115, 117, 119–20

tomography 121
 use 112, 117
automatic film handling 86, 236
automatic processing 210
 cycle 192
 developer section 213
 drier section 217
automatic processing film input 212
 fixer section 215
 maintenance 220
 operation 218
 performance assessment 224
 replenishment section 217
 reservoirs 219
 standby 219
 system 232
average gradient 19, 22–5, 155

background radiation 51
barium fluorochloride 5, 61
 lead sulphate 5
 plaster 51
 strontium sulphate 5, 61
batch cell 186
beam angulation 139
 dimensions 106, 113
 filtration 4, 90, 150
benzotriazole 201
binder 61
bite-wing film 40
blackening, film 5, 110
bleached 11
brightness difference 19
British Standard 136
bromide ions 190
 silver 4, 190
Bucky 102
buffer, developer 201
buffer, fixer 207

calcium tungstate 5, 7, 61
calculations, exposure 98
calibrated stepwedge 286
calibration, equipment 5, 90
capacitor 160
 discharge 16, 92, 96
carbon fibre 62

cassette 13, 39, 59, 62, 77
 assessment 86
 direct exposure 82
 film-feed 83
 front 79
 functional requirements 78
 gridded 81
 multilayer (multisection) 81
 pressure pad 79
 structural requirements 78
 take-up 83
 unloader 242
 vacuum 82
 well 78
 window 79
 xeroradiographic 83
cathode 2
characteristic curve 15, 46, 223
 factors affecting 15, 16
 of duplicating film 258
 producing a 16
 shoulder 17
 straight line portion 17
 toe 17
 deterioration of chemicals 197
 photosensitive 4
 processing 195
cinefilm 8, 41
cinefluorography 8, 281
cinepulsing 281
cleanliness 196
coating weight 10
collimation 106
colour in subtraction 257
 of illumination 163
 scheme, darkroom 176
combination adaptor 243
compression band 152
cones and rods 163
conservation of energy 60
constant dose principle 110
constant potential 16, 90
contract assessment, cassette 86
continual processor assessment 225
continuous feed cell 186
contrast 3, 13, 19, 22, 48, 73, 93, 99, 149, 155, 199, 223
 amplification 36, 73

factor 280
 index 193, 229
 medium (agent) 90, 149
 perception 164
 subject 152, 156
contrast-time curves 231
control strips 225, 226
copying of radiographs 258
copy/subtraction unit 174
crossover effect 11, 12, 73
crossover rollers 193, 214
current 2, 4–5

darkroom access 167, 176
 case study 168
 centralization 166
 cleanliness 184
 colour scheme 176
 design 166
 equipment 171
 floors, walls, ceiling 176
 functions 167
 radiation protection 176
 safelighting 176
 safety 176
 satellite 166
 services 175
 tasks 167
 temperature 175
 viewing and sorting area in 184
 work surface 172
daylight cassette 241
 film 243
 system 236
 functional requirements of 244
definition 11, 13, 127
densitometer 13, 19
density 12, 17, 19, 90, 93, 97
 difference 129
 range 23, 25, 31, 93
 rate of change 149
 settings 112
 visual assessment of 45
dental film 40
detector, film 204
developer 19
 agents 198
 agitation 209
 concentration 208
 constituents 198, 205
 energy 19
 exhaustion 209
 latitude 24
 replenishment rate 208, 209
 temperature 19, 208
 type 208
development 5, 19, 190–1, 268
dichroic fog 191, 206
diffuse light 13

diffuse transmission densitometer 13
diffusion 209
direct exposure film 39
distortion 145
D_{max} 20
dominant area 105
 zone 112–5
dose, radiation 5, 110
dose rate
double imaging 138
double-sided emulsion 9
drying 191, 210
drying cabinet 192
duplicating 20, 41, 258
duplitized 9, 11, 13, 39
duplitizing effect 12

edge enhancement 32
edge seal 63
effective focus 94
electroluminescent panel 183
electrolysis 185
electromagnetic radiation 2, 4–5, 7
electron 2, 90
 beam 94
 image 7
 path 90
 radiography 32, 270
electronic magnification 125
electronic subtraction 257

emission spectra 66
emulsion 4–5, 9
 additives 191
 characteristics 10
 manufacture 10
energy 2, 5
 kinetic 2
equipment calibration 5
equivalent focus size 265
europium 64
exit port 4
exposure 5, 191
 calculations 98, 107
 factors 5, 90
 factor latitude 24
 latitude 24–5, 27, 28, 38
 time 4–5, 90, 97, 283, 284
exponential formula 152
eye response 165

film/screen contact 74
 sensitivity 7
 speed 10, 13, 18–19, 38, 105, 223
 stock control 52
 stock control methods 53
 stock control statistics 58
 stock reorder level 53
 stock rotation 52

stock safety factor 55
stocktaking 54
storage 14, 19, 52
storage capacity 55
storage temperature 50
store 48
transport 167
types 37
filter 4
filtration 4, 90
fixer agitation 209
 concentration 209
 constituents 205
 elimination 209
 exhaustion 209
 replenishment 207
 temperature 209
 type 209
fixing 191
 agent 206
 time 208
floating lid 201
 table top 118, 140
flow rate 193, 216
fluorographic film 8, 41
fluorescence 59
fluorescent layer 5
fluorescent tube 162
focal area 94, 97
 length 278
focus 94
 actual 94
 effective 94
 equivalent 133
 factors affecting size 139
 intensity distribution 133
 measurement 133
 size 130, 264
 variation across beam of 131
focussing hood 94
fogging 51
fog index 193, 230
 level 17, 19, 48, 155, 223
frames per second 8
frequency 2
fulcrum (pivot) 271
fumes 43
functional budgeting 57
fungicide 202
falling load 96, 125
 continuous 96, 125
 stepped 96, 125
faults in processing 295
FFD 13, 17, 101, 102, 134
filament 94
film 1, 4–5
 base 10
 blackening 5, 8, 10, 97, 110
 contrast 26, 155

film *(cont.)*
 cost and security 58
 detector 204
 dispenser 239
 emulsion 4
 expiry date 52
 feed-in rate 194
 fogging 51
 handling 43
 hopper 48, 172
 identifier 243
 latitude 24–5, 27, 31, 38, 90
 layers 10
 maximum stock level of 54
 order latitude of 54
 order points of 54
 packaging 43
 processing 43
 response 9, 59

gadolinium oxysulphide 61
gamma 21
gamma-rays 1–2, 51
gaussian distribution 139
gelatin 9, 190
generator 90
geometric unsharpness 130–1, 264
glare 163
glutaraldehyde 207
gradient 19, 21
graininess 65, 90, 199
grid 4, 102, 104
 'cut off' 104, 119, 261
 exposure factor 105–6
 ratio 104

halation 11
halide, silver 4
halo 11
harmful gases 51
harmonization, image 33
heat exchanger 214
heater, radiant 217
heated air drier 216
heating element 214
heterogeneous beam 2
hopper, film 48, 52, 172
humidity, relative 43, 48
hydrobromic acid 199
hydrogen ion concentration 199
hydrogen ions 199
hydroquinone 198
hydroxyl ions 199

identification camera 160
 methods 158
 of radiographs 157
 of stereoradiographs 262
illumination 127

colour of 163
 intensity of 161–2
illuminator 161
image 1, 4–5
 characteristics 222
 contrast 93, 149
 definition 127
 density 93, 98
 fixation 268
 intensifier 122
 intensifier tube 5, 7, 123, 275
 latent 4–5, 9, 39, 65, 190, 266
 noise 97, 143, 257
 quality 5, 48, 72, 98, 112, 156
 quality control 222
 quality optimization 98
 receptor 1, 4
 transfer 268
 unsharpness 97
 visible 5
imaging process 191
incident radiation 10
infrared 2
information 3, 15
information content 26
inherent filtration 4
input phosphor 7, 123, 276
intensification 60
 factor 67, 70
intensifying screen 4–7, 38, 54, 104
 base 62
 binder 61
 care 63
 fluorescent layer 61
 mounting 62
 pigment 61
 rare earth 62
 reflective layer 61
 spacers 63
 structure 60
 temperature 67
intensity 3–6, 96
intensity distribution 97, 133
intensity pattern 3
interpupillary distance 261
inverse square law 101
ion generating system 267
ionography 270
ionization timer 110
ionization timer sensor 120
irradiation 61, 140

kilovoltage 2, 4, 17, 90
 estimation 290
 peak 5
 variation 98
kinefluorography 41
kinescope 274
kinetic energy 2

lanthanum oxybromide 61
latent image 4–5, 9, 39, 65, 190, 266
latitude 24, 28
lead blocker 63
 foil 40
 legends 161
 letters 161
 numbers 161
lead time 53
lens system 7
light 2
light photons 6
light sampling prism 124
light source 226
linear attenuation coefficient 143
linear magnification 143
linear shift 262
line emitter 67
line pairs 123, 141
line spread function 292
liquid concentrates 195
log exposure difference 21
 range 24, 28, 31, 90
log relative exposure 18, 25
luminescence 59
luminescence sprectrum 280

mA 5, 17, 90, 93, 94
macroradiography 138, 264
 limiting factors 264
magazine, film 78
magnification 102, 134, 143
 electronic 125
 factor 143, 144, 280
maintenance, processor 220
mammography 165
manual processing cycle 192
manual processing unit 220
marker, actinic 158–9
 X-ray 160
mAs 94
mAs variation 98
masking 163
measuring field 114
Medichrome 33, 64, 163
metal exchange 185
metallic replacement 185
metallic silver 2, 190
metol 198
metric film sizes 43
microdensitometer 66
 scan 128
milliampere seconds 94
minimum density difference (ΔD_{min}) 149
minimum wavelength 2
monochromatic 8, 48
monitoring device 112
mottle 65, 142
modulation transfer factor 165, 293

modulation transfer function 165, 280, 293
movement unsharpness 130, 141
MTF 165, 280, 293
multilayer (multisection) tomography 63, 147
multiple radiography 26, 32

net density 19, 73
noise 97, 143, 281
nominal focus size 131
non-screen film 39
normalization 128
normal solution 200

objective contrast 19
Odelca 78, 84
OFD 13, 102, 130
optical density 12
optical image distributor 7, 8
orthochromatic 7, 41, 48, 122
output phosphor 7, 123, 276
oxidation 191, 199
overframing 277, 278

panchromatic 7, 41, 48, 122
patient positioning 113
patient structure 107
pattern 3
penetrameter cassette (Wisconsin, Sussex) 290
penumbra 11, 130
perceptibility curve 164, 165
perception of contrast 164
pH 11, 19, 199
pH estimation 201
phase 90
phenidone 198
phosphor 5, 7, 59, 63, 99
 (screen) emission 7
phosphorescence 59
photocell 13
photofluorography 7, 22, 274
photographic harmonization 33
photographic (optical) density 71
photographic subtraction 166, 248
photographic unsharpness 130, 140
photon 2–3, 5, 10, 59
 energy 90
photosensitive chemicals 4
phototimer 110
physical damage to films 51
pinhole camera 133
pinhole photograph 136
pivot (fulcrum) 271
plasticizer 191
plate charging 267
 cleaning 269

relaxation 269
Plymax 51
point spread function 292
pollution, chemical 188, 198
Polaroid film 41
polyester 11, 191
polyurethane 61
port 4
positive image 41
preservative (developer) 201
preservative (fixer) 206
pressure pad 62, 79
primary photons 3, 71
primary radiation 104
prismatic binoculars 263
processing 4, 190
 automatic 192
 chemicals 195
 chemical preparation 195
 cycle 192
 effects 107
 faults 295
 facilities 107
 manual 192
processor control charts 228
 maintenance 220
 system 232
PSR Silver King 186
PTW Safelight 183

quanta 2, 59
quantum detection efficiency (QDE) 59
quantum mottle 65–6, 142

radiation dose 5
radiation intensity 10
radiation monitoring film 43, 51
radiation protection 5, 176
radioactive materials 51
radio waves 2
radiographic image contrast 13, 26, 90, 99, 129, 154
rare earth 5, 63
reciprocity failure 18, 44, 64, 67, 97
 law 65
 relationship 94
rectification 90
recycling, fixer 206
recirculation system 214–15
reduction 191
reject analysis 263
relative film speed 18, 105
 determination of 29, 44
 factors affecting 46
relative humidity 43, 48
relative speed 69, 99, 105, 286
replenishment developer 202, 217
 fixer 207
 rate 204

replenisher pump 204
resolution 38, 63, 74, 76, 97, 123, 133, 141, 149, 165, 265, 279,
restrainer 201
reversal 20, 262
rising 191
rods and cones 163
Roentgen, W. 1
roller rack 213, 215, 217

safelight filter 176
 transmission 182
safelight testing 180–1
safelighting 43, 167, 176–84
satellite darkroom 166
scales 18, 101
scatter 3, 46
scattered photons 10, 71
scattered radiation 90, 106, 113, 150, 152
scattering 3
screen emission 7
screen-type film 38
secondary radiation grid 4, 102, 104
selective attenuation 93
selectivity 209
selenium 266, 268
sensitivity 4, 7
 centre 190
sensitizers 10
sensitometer 18, 285
sensitometric assessment 222
 characteristics 48
 film strip 52, 225
sensor 111
shoulder 17
silver bromide 4–5, 9, 190
silver complex 206
 estimation 185
 halide 4, 9, 205
silver recovery 184
 batch cell 186
 continuous feed cell 186
 methods 185
 tailing unit 188
single phase 91
solarization 20
solution preparation 196
solvent 202, 207
spectrum 2, 5, 7
specular light 13
speed 48, 74
 index 193, 229
spinning top 16
spray wash 216
squeegee rollers 193
stabilizer 187, 206
star pattern 133
stepwedge 44, 225
 calibrated 17

stereoradiography 260
straight line portion 17
stock control 52–3, 58
 reorder level 53
subbing layer 11
subject contrast 150, 156
subjective contrast 19
subtraction 41, 166, 256
subtraction unit 174
sulphiding 187
sulphide stabilizer 187
supercoat 9, 60

tandem lens 124, 276
tailing unit 188
target 2
temperature 48, 50, 67
 gauge 214
 indicator 218
terbium 64
terminology 14
thermometer probe 214
thermostatic control 214
time, exposure 4
time–temperature graph 192
timer accuracy 16
timer testing 283
tissue density 150
 equivalent phantom 105
 thickness 150
titanium dioxide 62
toe 17

tomographic principle 271
tomography 270
total unsharpness 142
transfer function 292
transformer 90
transmitted beam 1, 3
 radiation 111
transport case 242
 feeder 242
transposition 264
thread line (linear regression curve) 234–5
tube current 2
 insert 2
 shift 261
 voltage 10

ultrasound 42
ultraviolet 2, 5, 258
unsharpness 73, 94–5, 97, 127, 129, 149
 geometric 130, 264
 measurement 128
 movement 128
 photographic 130, 265
 total 142, 265
useful density range 23, 45, 93, 110

Vac-U-Pac 82
velocity of light 2
ventilation, darkroom 167, 175
viewing 191
 box 161
 conditions 156

distance 127, 165, 261
 faults 263
 radiographs 161
 stereoradiographs 263
visible light spectrum 5
visual ability 127
visual acuity 164
voltage 2–3, 5, 90
voltage, applied 2

wash, spray 216
washing 191, 209
water flow rate 193, 216
 jacket 220
waveform 91, 95
wavelength 2, 4
wavelength, minimum 2, 90
wetting agent 192
Wheatstone stereoscope 263
white light 258
Wisconsin test tool 16, 92
workflow pattern 166
 simplification 167

Xeroradiography 32, 127, 266
X-ray marker 160
X-ray photon 5
X-ray tube 4
X-rays 1–2, 51

Yttrium oxysulphide 64